TYPOJANCHI 2011: Seoul International Typography Biennale

TYPOJANCHI
International Typography Biennale

2011 SEOUL

TYPOJANCHI 2011: Seoul International Typography Biennale

first printing
december, 2011

planner
typoJanchi organization

publisher
kim.ok-chyul.

publishing house
ahn graphics

532-1 paju book city,
munbal-li, gyoha-eup,
paju-si, gyunggi-do, korea
tel. +82-31-955-7755
fax. +82-31-955-7744
email. agbook@ag.co.kr
www.agbook.co.kr

print
hyosung printing

creative director
ahn.sang-soo.

art director
park.young-hoon.

design
kim.sung-hoon.

project manager
lee.ji-hyun.

editorial coordination
ahn.mano.
song.you-min.
hwang.liling.

translators
(korean to english)
kay.jun.
kelly.m..choi.
kim.hyunkyung.
ku.ja-eun.

(chinese to korean)
huang.lina.
lee.hye-kyung.
li.zhe.
lin.xinghui.

(japanese to korean)
sim.ji-hyeun.
sakabe.hitomi.

proofreading
lee.eun.sil.

english supervision
lee.mi.jin.

registration number
2-236

isbn
978-89-7059-607-5 (03600)

타이포잔치 2011: 서울 국제 타이포그라피 비엔날레

2011년 12월 26일 초판 인쇄
2011년 12월 31일 초판 발행

기획
타이포잔치 조직위원회

펴낸이
김옥철.金玉喆.

펴낸곳
(주)안그라픽스

413-756
경기도 파주시 교하읍 문발리
파주출판도시 532-1
전화. 031-955-7755(마케팅)
02-743-8065(본관)
팩스. 031-955-7744
이메일. agbook@ag.co.kr
www.ag.co.kr

인쇄
효성문화

크리에이티브 디렉터
안상수.安尙秀.

아트 디렉터
박영훈.朴榮勳.

디자인
김성훈.金城薰.

프로젝트 매니저
이지현.李智賢.

코디네이터
송유민.宋侑珉.
안마노.安мано.
황리링.黃俐玲.

번역
(국문 – 영문)
구자은.具滋恩.
김현경.金賢京.
전가경.田佳京.
최문경.崔文璟.

(중문 – 국문)
이철.李哲.
이혜경.李惠景.
임성혜.林星惠.
황리나.黃俐娜.

(일문 – 국문)
시카베.히토미.坂部仁美.
심지현.沈智賢.

교정교열
이은실.李恩實.

영문 감수
이미진.李美眞.

등록번호
제2-236(1975.7.7)

isbn
978-89-7059-607-5 (03600)

정가
55,000원

03600

9 788970 596075

ISBN 978-89-7059-607-5

fire flower of east asia | 동아시아의 불꽃 | 東亞火花

Greeting message from the minister

The world today
is often referred to as being "The Era of Culture." culture is a way of life, as well as an important factor that determines the nature of society. Culture is embodied through design in everyday life. Design is more than simple aesthetics; it encompasses creative activities and products that help shape the way we live. Targets for design include objects, images, and spaces, all of which make up our lives and define life's qualities.

The Ministry of Culture, Sports, and Tourism established the design space culture department in 2005 and has been involved in various design-related projects such as "Public Design Development," "Happy School through Culture," and the "Public Design Awards." the ultimate goal of these projects is to improve the quality of our lives and enhance Korea's national image. <TYPOJANCHI 2011: Seoul International Biennale> is held in step with this core vision of The Ministry of Culture, Sports, and Tourism.

Typography functions
as a communication medium, while at the same time, creating a national image. Encountering typography when travelling abroad reminds us of where we are. We may not understand the exact meaning, yet the exotic aesthetics grab our attention. Typography is so incredibly valuable.

<TYPOJANCHI 2011: Seoul International Typography Biennale>
is the only event of its kind in the world to treat typography as a creative medium. It is intended to showcase the design heritage of HANGEUL to the world, and to promote intercultural exchange and communication through East Asian typography.

Choe Kwang-shik
Minister of Culture, Sports and Tourism

장관 축사

오늘날을
　　　　　흔히 문화의 시대라고 합니다. 문화는 삶의 방식이자 한 사회의 성격을 규정하는 중요한 요소입니다. 일상에서 문화는 디자인을 통해 구체화됩니다. 디자인은 단순한 외형이 아니라 삶을 결정짓는 창조적 활동이자 그 산물입니다. 디자인이 관여하는 대상은 다양합니다. 사물·이미지·공간이 모두 디자인의 대상이고, 이러한 것들은 우리 삶을 구성하고 삶의 질을 결정합니다.

　　　　　문화체육관광부에서는 2005년 디자인공간문화과를 설치하여 '공공디자인 조성 사업', '문화로 행복한 학교 만들기', '공공디자인 대상' 등과 같은 디자인 관련 사업들을 펼쳐왔습니다. 이러한 사업들의 궁극적인 목적은 창의성을 기반으로 국민들의 삶의 질을 향상시키고 국가 이미지를 제고하는 데 있습니다. 〈타이포잔치 2011: 서울 국제 타이포그래피 비엔날레〉도 같은 맥락 속에서 진행된 문화체육관광부의 핵심 비전을 담은 사업입니다.

타이포그래피는
　　　　　커뮤니케이션을 위한 매개의 역할을 하는 동시에 한 국가의 이미지를 만들어냅니다. 해외여행을 할 때 접하게 되는 타이포그래피는 우리로 하여금 그 나라에 와 있다는 느낌을 줍니다. 비록 우리가 그 타이포그래피의 의미를 이해하지 못한다 하더라도, 그것은 이국적인 조형성으로 우리의 시선을 붙잡습니다. 그만큼 타이포그래피는 중요한 것이라 할 수 있습니다.

〈타이포잔치 2011: 서울 국제 타이포그래피 비엔날레〉는
　　　　　문자를 창의적 미디어로 취급하는 세계 유일의 타이포그래피 비엔날레로서 한글이 가진 고유의 디자인적 유산을 세계 속에 알리고, 동아시아 타이포그래피를 통해 서로의 문화를 교류하고 소통하는 장으로 마련되었습니다. 이 행사가 동아시아를 시작으로 더욱 다양한 글자 문화와 디자인의 교류 및 소통을 주도할 수 있는 세계적인 디자인 비엔날레로 자리매김하길 기대합니다.

문화체육관광부 장관
최광식

KCDF congratulatory message

Korea Craft & Design Foundation, one of subsidiaries of the Ministry of Culture, Sports and Tourism, was founded in last April. KCDF has been promoting various projects in order to find ways to develop Korean identity, culture and design. <TYPOJANCHI 2011: Seoul International Typography Biennale>, organized by KCDF this year, domestically shed a new light on the cultural potentials and artistic values of Hanguel. Not only the geopolitical factors, but also design capabilities seemed no less competent as the hosting country. It surely expanded the international exchange.

Letter is an important cultural asset that reveals the identity of its country. <TYPOJANCHI 2011: Seoul International Typography Biennale>, held under the theme of 'Fire Flower of East Asia', provided the opportunity to share valuable letter cultures of the three East Asian countries. The exhibition of 14 days, forum, work presentation, and lectures were completed successfully under a keen interest. Though the feast has ended, its passion seems to have continued until today. The *TYPOJANCHI 2011 Book* with vivid records of passionate memories is published. Following the footsteps of the *TYPOJANCHI 2001 book*, it is hoped to become a valuable result of the feast which will be remembered by the world once again.

We hope that TYPOJANCHI will consolidate the interest and pride in Hanguel and become the one and only international typography biennale in the world. Once again, congratulations on the publication of this book.

Choi Jeong-sim
President of the Korea Craft & Design Foundation

발간 축사

한국공예·디자인문화진흥원은 2010년 4월 문화체육관광부 산하기관으로 출범하여 한국적 정체성과 공예, 그리고 디자인이 발전할 수 있는 다양한 방법을 모색하며 여러 가지 관련 사업을 진행하고 있습니다. 그중 올해 〈타이포잔치 2011: 서울 국제 타이포그래피 비엔날레〉을 주관하며 이 행사를 통해 한글이 가진 문화적 잠재성과 예술성을 국내에서 재조명함은 물론 지정학적인 이유뿐 아니라 디자인 역량 또한 개최국으로서 부족함이 없음을 보여주고, 나아가 국제적 교류를 확대했다고 생각합니다.

문자는 그것을 사용하는 국가의 정체성을 드러내는 중요한 문화자산입니다. '동아시아의 불꽃'을 주제로 열렸던 〈타이포잔치 2011: 서울 국제 타이포그래피 비엔날레〉는 동아시아 3개국의 가치 있는 문자 문화를 공유하고 나아가 한글의 우수성을 세계로 알릴 수 있는 장으로 마련되었습니다. 14일 동안 진행된 전시를 비롯해 포럼과 작가설명회, 특강 등 많은 관심을 받으며 성공적으로 마쳤고, 행사가 끝난 지금까지도 그 열기가 식지 않고 이어지고 있는 듯합니다. 그 뜨거운 기억을 고스란히 생생하게 기록하는 『타이포잔치 2011 도록』이 출판됨으로써 2001년 『타이포잔치 도록』에 이어 값진 행사의 결과물로 다시 한 번 전 세계에 기억되리라 기대합니다.

'타이포잔치'가 한글에 대한 관심과 자부심을 굳건히 다지면서 세계인들에게 유일무이한 타이포그래피 비엔날레로 자리매김하길 기대하며 도록 출판을 다시 한 번 기쁜 마음으로 축하합니다.

한국 공예·디자인 문화진흥원장
최정심

Seoul.International.Typography.Biennale.
The.dream.of."TYPOJANCHI.2011".after.a.10-year.hiatus..

Culture,.placed.in.the.bowl.of.letters,.
is.evidence.of.humanity.and.wisdom..
Among.the.many.regions.of.the.world,.
East.Asia,.has.a.unique.culture..

Chinese.characters,.kana,.and.hangeul.are.used.,often.in.combination..
the.countries.in.this.region.have.different.languages,.
yet.share.chinese.characters.as.a.fundamental.part.of.their.written.expression..

Even.before.the.term."Typography".arrived.from.the.west,.
a.profound,.enriching,.and.flourishing.culture.of.letters.long.existed.

Popular.sentiments.toward.the.written.word.are.
deep.and.resonate.with.artistry.
and.even.shamanism..

The.mainstream.of.universal.culture.is.
ever-more.quickly.circulating,.heading.towards.this.region..
thus.we.consciously.continue.this.celebration.of.writing..

We.wish.to.promote.universal.peace.
via.letters.and.characters,.
through.the."harmony.of.differences"..

This.is.an.opportunity.to.share
universal.human.values.among.
regions.with.different.beliefs.and.sentiments.about.
the.written.word..
Also,.by.highlighting.these.differences.
the.identity.of.East.Asian.typography.will.
be.ascertained..

Ahn Sang-soo
Chair, Organizing Committee

서울.국제.타이포그래피.비엔날레.
열.해만에.열리는."타이포잔치.2011"의.꿈..

문화.그것은.글자의.그릇에.담기는.
인류의.흔적이며.슬기이다..
세계.여러.지역.가운데.동아시아는.
특히나.독특한.문화를.지니고.있다..

한자,가나,한글이.어우러져.쓰이는.이곳.
이곳에.속한.나라들은.입말은.서로.다르지만..
한자를.글자살이의.뿌리로.하는.글자이웃이다..

타이포그래피라는.말이.서쪽에서.오기.전.
이미.이곳은.글자−활자문화가.깊고.풍요롭게.번성했다..

이곳.사람들의.글자에.대한.정서는.
사뭇.깊고.큰.울림을.지니며.
예술적이고.주술적이기까지.하다..

011

온누리.문화의.큰.흐름은.
느리듯.빠르게.순환하며.이곳으로.향하고.있다..
우리는.그.시선을.의식하며,이.글자잔치를.잇는다..

이는.'다름의.어울림(和而不同)'.속에서.
글자를.통해.
누리에.평화를.화답(花畓)하기.위함이다..

이.잔치를.계기로.
글자를.다루고.모시는.생각과.느낌이.다른.지역과.
보편적.인류의.가치를.공유하고..
또한.다름을.드러내면서..
동아시아.타이포그래피의.제다움을.확인할.것이다..

조직위원장
안상수

TYPOJANCHI opens again

The International Typography Biennale
first opened in 2001, and is now back with <TYPO-
JANCHI 2011: Seoul International Typography Biennale>. The spirit of TYPOJANCHI is to
examine the standing of language scripts and Korea's native HANGEUL heritage, which
is becoming more significant globally in the 21c era of digital media and will remain
within the universal typographic flow.

TYPOJANCHI 2011
begins from where we are standing at present.
Korea's neighbors, China and Japan, both are key countries in East Asia, deeply rooted
in the sinitic language tradition. These three countries, strong in cultural and traditional
pride, have attracted the world's attention with their remarkable economic development.
Therefore, there is little doubt they are becoming a central focus of global culture.

The first glimpse at a nation's culture can be found in its system of writing.
By showing the visual form of letters and characters, typography is a key-
word encompassing linguistic as well as visual arts. In this regard, TYPO-
JANCHI 2011 seeks to function as a mirror that reflects the typography of
these three East Asian countries. Visitors will be able to identify the similari-
ties and differences - the here and hereafter of three writing traditions that
seem so close yet so far apart.

The designers participating in TYPOJANCHI 2011 were invited by a combined effort of
The Organizing Committee Members. The special exhibition features eight masters,
who have left significant legacies in East Asian typography, while the main exhibit pres-
ents 99 designers with enormous potential.

TYPOJANCHI 2011
is the only international typography biennale in the
world. As a universal cultural event, the world's attention will be focused upon Seoul.

Lee Byung-ju
Curating Director

타이포잔치가 다시 열립니다

2001년 서울 타이포그래피 비엔날레로
첫발을 내디뎠던 타이포잔치가 〈타이포잔치 2011: 서울 국제 타이포그래피 비엔날레〉로 다시 그 모습을 드러냅니다. 21세기 디지털매체 시대 진입과 더불어 더욱 중요해진 글자 문화의 위상과 한글 고유의 디자인적 유산을 세계 타이포그래피의 흐름 속에서 조망하고자 했던 타이포잔치의 정신은 계속될 것입니다.

〈타이포잔치 2011: 서울 국제 타이포그래피 비엔날레〉는
바로 우리가 서 있는 지점에서 시작하고자 합니다. 한국의 바로 주변 국가는 중국과 일본입니다. 이들의 공통점은 같은 한자 문화권에 뿌리를 둔 동아시아의 핵심 국가라는 점입니다. 문화와 전통에 대한 자부심이 강한 세 나라는 눈부신 경제 발전상으로 세계의 이목을 집중시켰으며, 이제 세계 문화의 큰 중심축이 될 것이라는 점에서도 이견이 없을 것입니다.

한 나라의 문화를 접하게 되는 첫 통로는 글자 문화입니다. 타이포그래피는 글자의 시각적 형태를 보여주는 것으로써 그 나라의 글자 문화뿐 아니라 시각 문화를 가장 잘 집약해서 볼 수 있는 키워드이기도 합니다. 이점에서 〈타이포잔치 2011〉은 동아시아 3개국의 타이포그래피를 낱낱이 비추는 거울의 역할을 하고자 합니다. 관람객들은 가깝고도 먼 나라로 여겨졌던 세 나라의 글자 문화의 같음과 다름, 혹은 현재와 미래를 찾아낼 수 있을 것입니다.

013

타이포잔치에 참가하는 작가들은 조직위원들의 의견을 수렴하여 선정되었습니다. 이번 전시에서는 동아시아 타이포그래피 역사에 족적을 남긴 8인의 거장이 참여하는 특별전과, 무한한 잠재력을 가진 99인의 작품들을 선보이는 본전시를 만나볼 수 있습니다.

〈타이포잔치 2011: 서울 국제 타이포그래피 비엔날레〉는
세계 유일의 국제 타이포그래피 비엔날레입니다. 세계적 문화 행사인 만큼 전 세계의 관심이 서울로 집중될 것입니다.

총감독
이병주

Fire Flower of East Asia

The east of civilization

East Asia usually refers to China, Japan and Korea. It is called Northeast Asia as it is located on northeast of Asia, and sometimes called Far East Asia as it is most distant from the Europe. Generally, this region, which developed economical growth within Chinese character culture or the Confucian culture, is generally referred as the East Asia. These countries developed the so-called "oriental" way of thinking and world view through the shared cultural heritage, the Chinese characters. Originally in oriental tradition, there was no such term as "oriental" nor "philosophy". These terms were only an oriental response to the Western civilization. Philosophy showed a new aspect of the idea appeared in this region of Chinese characters. Thus oriental thinking was exposed.

East Asia, gains the wings

"Modern" to the East Asian countries meant the continuation of conflict and tension. It begun with the unilateral acceptance of the Western cultures and values. The oriental mysticism became something that is uneasily exposed, unfamiliar, and counterproductive. Oriental imagination was replaced by an alphabet-oriented, universal worldview. As the emotional and non-linear thinking was overwhelmed by the rational and linear thinking, the East Asia begun to suffer from the impact of civilization. In order to reach the self-examination time to look back on the Western external-oriented culture into the Oriental internal-oriented values, long-term learning process was needed which required the physical changes and sacrifices. The East Asia became an enormous economic spine through the dramatic economical growth. It is finally dreaming of reestablishing its central position beyond the impact of civilization. We begun to focus on the awareness transition of huge cultural earth, i.e., the rediscovery of the oriental values which will lighten up the 21C.

East Asia in 21C

As the East Asian financial rights expanded, China, Japan and Korea has now become one of the world's largest market as well as an economic powerhouse that tow the global economy. If an East Asia economic community of 21C appears in any method in the near future, it will foretell the belching in an affected manner of the new East Asian civilization. It is difficult to visualize how this will appear. It is possible only to guess that the cultural means of the three countries, which each has walked through different path due to the impact of the Modernity, will com-

동아시아의 불꽃

문명의 동쪽

대략 한국, 중국, 일본 3개국을 지칭할 때 쓰이는 동아시아. 아시아의 동북쪽에 위치하여 동북아시아, 유럽을 기준으로 가장 멀리 있다고 해서 극동아시아라고도 한다. 일반적으로 한자문화권 또는 유교 문화권에서 경제 발전을 이룩한 이 지역을 동아시아라고 일컫는다. 이들 국가는 한자라는 공통의 문화유산을 통해서 이른바 동양적 사고방식과 세계관을 그려냈다. 이른바 동양의 신비, 동양적 상상력의 신화는 그렇게 시작되었다. 본래 동양의 전통에는 동양이란 단어도, 철학이란 단어도 없었다. 이 말들은 서양문명에 대한 동양적 대응이었을 뿐, 철학은 한자로 쓰여진 이 지역에서 나타난 사상의 새로운 면모를 보여주는 것이었다. 곧 동양적 사고는 그렇게 실체를 드러내게 된 것이다. 상상력이 그러하듯이, 이들 3개국은 때로는 같으면서도 때로는 다른 방식을 통해 동아시아 문명 전파의 능동적인 주체로서 지구 동쪽에서 세계사에 길이 빛날 문명의 꽃을 피웠다.

동아시아, 날개를 달다

동아시아 국가들에게 근대의 의미는 갈등과 긴장의 연속이었다. 그것은 서구의 문화와 가치를 일방적으로 수용하는 것에서부터 시작되었다. 동양의 신비란 쉽게 드러나지 않는 것, 낯선 것, 비생산적인 것이 되었다. 동양적 상상력은 알파벳으로 대표되는 보편적 세계관으로 대치되었다. 이성을 강조하는 선형적 사고가 감성의 비선형적 세계를 지배하게 되면서 동아시아는 문명의 충격을 겪는다. 서구의 외재 지향형 문화를 동양의 내재적 가치관으로 다시금 되돌아보는 반성의 시간에 이르기까지는 물리적 변화와 희생이 요구되는 장기간의 학습 과정이 필요했다. 비약적인 경제 도약을 발판으로 세계 속의 거대한 경제축이 되면서 비로소 동아시아는 문명의 충격으로부터 벗어나 다시 중심적 위치로의 비상을 꿈꾸게 된다. 이른바 동아시아의 문화전통이 지나간 시대의 위대한 유산이나 구시대적 유물로 치부되고, 동양과 서양이라는 단순이분법적으로 나뉘는 것이 아니라 21세기를 새롭게 빛나게 할 거대한 문화적 토양이라는 인식의 전환, 즉 동양적 가치의 재발견에 주목하게 된 것이다. 이는 그저 문명의 회귀가 아니라 새로운 문명의 도래를 의미하는 것이다.

21세기의 동아시아

동아시아 경제권의 규모가 확대되면서 한국, 중국, 일본은 바야흐로 세계 최대의 시장이자 세계 경제를 견인하는 이른바 경제대국의 지위에 오르게 되었다. 머지않은 미래에 어떤 방식으로든 21세기 동아시아 경제 공동체가 출현한다면 이는 새로운 동아시아 문명의 용틀임을 예고할 것이다. 그러나 그것이 어떤 식으로 나타날 것인가는 쉽게 예측하기 어렵다. 여기에 근대의 충격으로 흩어져 제각기 다른 길을 걸어온 3개국 간의 문화방식은 과거 동일문화권 시기의 양상과는 판이할 것이란 추측이 가능할 뿐이다. 서로 같으면서도 다르고 또한 잘 알 것 같으면서도 그렇지 못함은 그들의 변화무쌍한 상상력에 기인한다. 한류가 바로 그 신호탄이 될 것이다. 누구도 예상 못한 시점에서 등장한 이런 문화현상은 동아시아 문화권의 잠재력이며, 이제 제2, 제3의 예측불허의 형태로 분출할 것으로 본다. 그런 이유에서 21세기 동아시아 문화의 키워드는 다양성이 될 것이며, 3개국은 서로의 소통을 통해서 동아시아 문화의 다양성을 증폭시킬 것이다.

pletely be different from the aspect of era where they used to share the same culture. Their enigmatic imagination results from the similarities and differences, closeness and distance of the countries. The Korean Wave will be the flare. Emergence of such cultural phenomenon at an unexpected time shows the potential of the East Asian culture. The second and third phenomenon will erupt in the form of unpredictability.

East Asian letters

The history of letter is the history of cultural communication itself. The East Asian cultures, ideas and artistic imaginations were created on the basis of Chinese character. Chinese character, with strong characteristics of a letter as well as an image, i.e., the various traditions of Chinese calligraphy. In the 21C where the letter environments of the three countries have changed, the Chinese character still continues to have a profound impact on the aesthetic aspects of letters. For a more efficient letter life, the letter environments of each country is undergoing tremendous changes. The Chinese character of Mainland China has been modified into reduced strokes or simplified formations. Japanese Kana was used as an aid to assist the understanding of Chinese characters for a long period of time, and settled as the current letterforms. Hangeul is a rather significant case. Unlike the ideographic Chinese characters, Hangeul is a phonetic character which consists of both characteristics from the Eastern and the Western letters.

016

Fire Flower of East Asia, meets the typography

How are typographies of China, Japan and Korea different? Under the geographic region of identical culture, what similarities do they have? We need to have a deliberative analysis of these issues. It would also be the challenge of <TYPOJANCHI 2011>. Theme of this feast is the "Fire Flower of East Asia". Sorting through these countries' design footprints and assuring their flower bearings will be the greatest reward of this feast. The Fire Flower may be the representative designers from each country, or the format which each countries aims to express. The filter would be the typography.

Lee Byung-ju
Curating Director

동아시아의 글자

글자의 역사는 문화 소통의 역사 그 자체이다. 애초에 동아시아 문화와 사상 그리고 예술적 상상력은 한자를 기초로 만들어졌다. 글자이면서 동시에 이미지로서의 특성이 강한 한자는 독특한 글자예술, 즉 다양한 서예의 전통을 만들어냈으며, 이는 동아시아 3개국의 글자 환경이 달라진 21세기에 이르러서도 여전히 글자의 조형적 사고에 지대한 영향을 미치고 있다. 달라진 글자 환경이란 무엇인가. 보다 많은 사람들의 수월한 글자 생활을 위해 각국의 글자 환경은 엄청난 변화를 겪고 있다. 중국 본토의 한자는 획을 줄이거나 형태를 간단히 정리한 간자로 바뀌었다. 일본의 가나는 오랜 세월 한자 이해를 돕기 위한 보조수단으로 사용되어 오다 현재의 글자체로 정착하였다. 한글은 보다 획기적인 경우이다. 한자의 뜻글자와 달리 한글은 소리글자이며 동서양 글자의 특성을 한 몸에 지니고 있다. 한편으로 동아시아 글자는 달라진 게 아니고 진화하고 있다는 것이 더 정확한 표현일지 모른다. 이렇게 달라진 각국의 글자들은 오늘날 타이포그래피라는 현대적인 문화형식을 통해서 또 다른 풍경들을 만들어내고 있다.

동아시아의 불꽃, 타이포그래피를 만나다

017

한국, 중국, 일본의 타이포그래피는 어떻게 다른 것인가, 또한 동일문화권이라는 생태적 지형 속에서 그들은 어떤 공통점을 갖고 있는가에 대해 곰곰이 숙고해볼 필요가 있을 것이다. 이것이 〈타이포잔치 2011〉의 과제이다. 이번 잔치의 주제는 '동아시아의 불꽃'이다. 3개국의 디자인을 통해서 각각의 지나온 족적을 살피고 21세기 들어 새롭게 변화하는 모습을 확인하는 것이 이 잔치의 수확이 될 것이다. 불꽃은 각국을 대표하는 작가들이 될 수 있고, 각국이 지향하는 표현형식일 수 있다. 그 거름망은 타이포그래피다. 타이포그래피는 오늘날 시각 문화의 중심에서 문화의 질을 가늠하는 중요한 척도이자 창의적 미디어로서 소통의 역할을 담당한다. 동아시아 소통의 역사와 그 상상력 넘치는 세세한 모습들은 각각의 글자 문화를 통해서 온전히 드러낼 것이다. 그리고 머지않아 우리가 발견할 미래의 새로운 동아시아 문명의 발아는 희망컨대 바로 여기서 시작될 것이며, 또 그렇게 기록될 것이다.

총감독
이병주

main.exhibition

contents

018

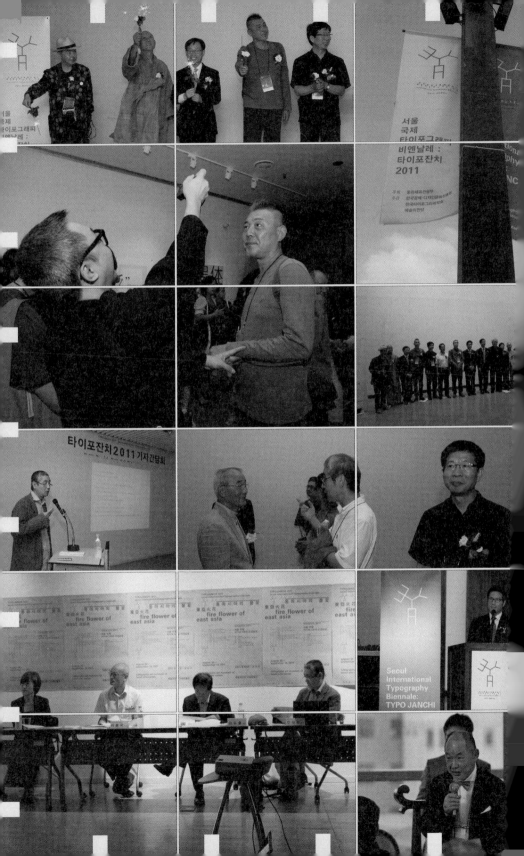

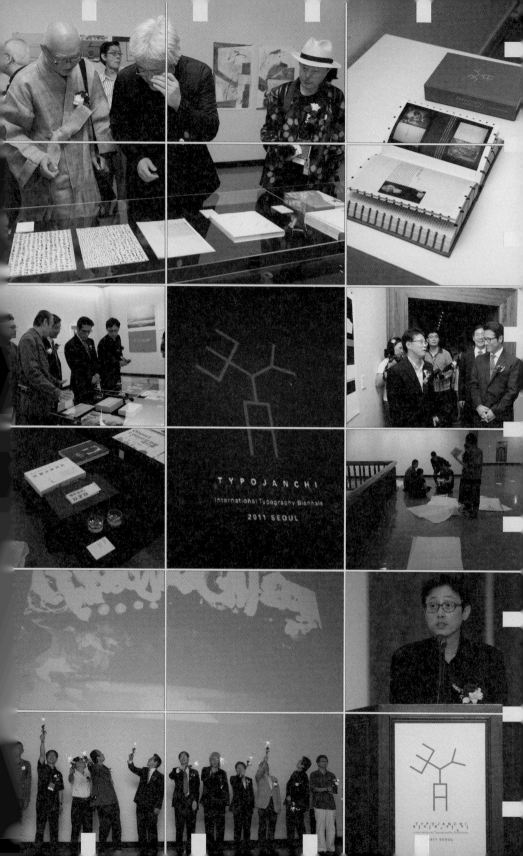

main.exhibition

During his undergraduate study, Ahn Byung-hak spent most of his time designing for The University Press, gaining a range of skills in typography and editorial design. His work through at Ahn Graphics for 2 and half years focused largely on editorial design projects. Ahn participated in the renovation project of Deahanmaeil (now known as Seoul Press) in 1998. Ahn freelanced for 3 years from 1999 seeking out a variety of experiences in cultural, social, and political scopes, as well as in commercial fields. The group exhibition <Active Wire> (2001) was a defining moment where Ahn began to earn a reputation for his experimental attitudes on graphic design. Later in 2002, the exhibition <De_sign Korea: Political Communication> provided the opportunity to show his stance for design as politics. The exhibition <Image Korea> (2003) was another crucial point that exhibited his unique use of the graphic language in dealing with cultural themes. Ahn has run his studio in Seoul since 2002 and has explored diverse borders between graphic design and different areas of study based on typographic experimentation. He was a visiting tutor in Hongik University, Seoul Women's University, Kyunghee University, and others from 2001 to 2007, and currently has focused on graphic design history and new ways of thinking in graphic design.

poster. language play. 420 x 297. 60 pieces. 2002.

ahn.byung-hak. korea

안병학.安秉鶴.

홍익대학교신문사에서 디자인을 담당하면서 신문 디자인에 몰두하며 학창 시절을 보냈다. 이 경험을 통해 타이포그래피와 편집 디자인에 대한 기본적 이해를 얻었고 그래픽 디자이너로 출발하는 계기가 되었다. 졸업 후 안그라픽스에서 풍부한 실무 경험을 쌓은 그는 1998년 대한매일(현 서울신문) 지면 개혁에 참여하기도 했다. 이 프로젝트는 그에게 타이포그래피와 편집 디자인 전반에 대한 상세한 지식을 쌓을 수 있었던 경험으로 남았다. 이후 1999년부터 2001년까지 독자적인 활동을 시작하여 상업적 영역뿐만 아니라 사회·문화·정치적 주제를 다루며 디자인 활동 영역을 넓혀갔다. 아트선재센터에서 열린 <Active Wire>(2001)에 참여하여 디자이너로서 그의 생각을 주변에 알렸고 예술의전당 <De_sign Korea>(2002) 전시는 디자인의 정치 참여에 대한 인식과 입장을 넓히는 기회가 되었다. 이듬해 예술의전당 디자인미술관 <Image Korea>(2003) 전시를 통해 그래픽 디자인이 어떻게 역사·문화 주제를 다루어 내는가에 대한 중요한 실험을 했다. 안병학은 2002년부터 디자인 스튜디오를 열고 타이포그래피적 실험을 바탕으로 한 디자인과 다른 영역이 만나는 다양한 접점을 탐험해왔다. 2001년부터 2007년까지 홍익대학교, 서울여자대학교, 경희대학교 등으로 출강했으며 최근에는 '그래픽 디자인 역사와 디자인으로 생각하는 힘'에 관심을 두고 있다.

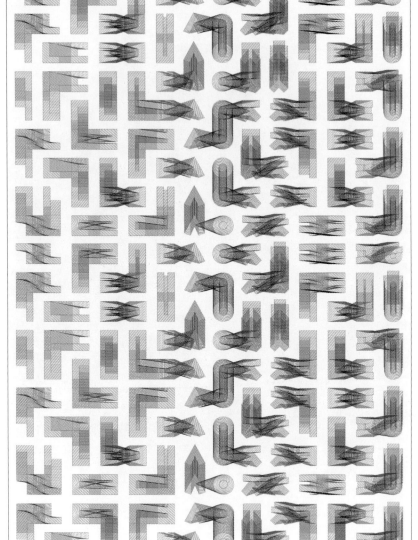

poster. the layers of meaning. 788 x 1,090. 2002.

ahn byung-hak

031

I object any fixation which goes against relative values to others. One of the critical roles of graphic design is to explore alternative ways of looking and interpreting the meaning of social, cultural, and political phenomena in reality, similar to how science creates a solid line along a perforated one drawn by metaphysics. This is because, in terms of culture, graphic design is the process of defining changes in form and structure, and discovering communication routes within a given context. This scope makes graphic design one of the most pervasive mediums within a culture. Graphic design and culture are mutually generative of each other. Culture feeds the graphic design process used to establish creative outcomes that in turn facilitate performances of use and meaning that shape the cultural context. In this sense, graphic design is a practical implementation depending on local participation, and it is acutely

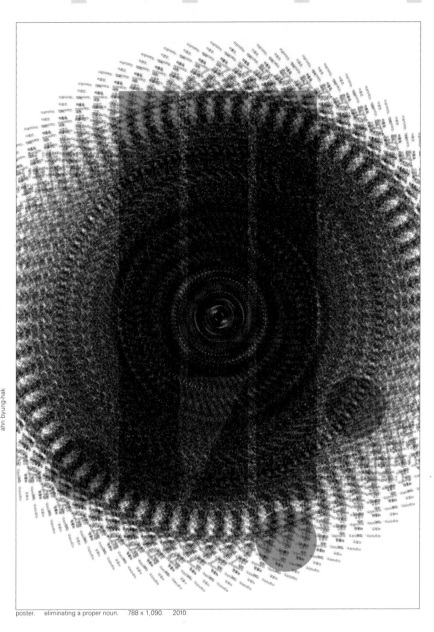

ahn byung-hak

032

poster. eliminating a proper noun. 788 x 1,090. 2010.

responsive to a wider range of graphic design performance demanded by the uniqueness occurring within the cultural context. For the last several decades, the hierarchical way of thinking of graphic design as inherited from the age of mass production has consistently faced challenges from readers' sophisticated visual literacy that has been developed through a computer-aided process. For instance, graphic designers can now control all visual elements without much difficulty and create highly complex information surfaces, while readers are able to decode it using their own knowledge and preference. Producing and reading process-es in graphic design are controlled not only by designers themselves but also by individual audiences to meet their own demands in daily life. Graphic design was a response to the economies of scale and standardization in new mass societies. The design philosophy

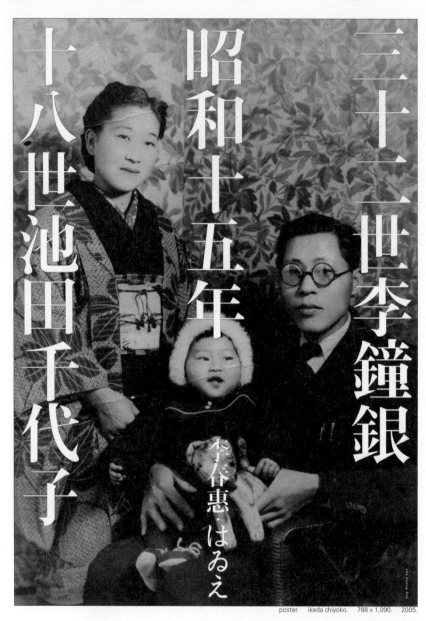

三十二世李鐘銀
昭和十五年
十八世池田千代子
李春惠・はるえ

poster. ikeda chiyoko. 788 x 1,090. 2005.

of "form follows function" is based on standardized processes, modular systems, and machine aesthetics of minimalist form. Universal design solutions were born of the demands of universal needs across cultures as a method to make one design solution appropriate for all users. However, is the universal approach still valid for different cultures? If not, what do we, as visual communicators, need to do next in order to deal with this multi-cultural context? 나는 상대적 가치에 반하는 그 어떤 딱딱함에도 반대한다. 또한 과학이 형이상학에서 그려 놓은 점선을 따라 실선을 그리듯, 현실 속 사회·문화·정치 현상들을 해석하고 그에 대한 시각과 대안을 제시하는 것이 그래픽 디자인의 중요한 역할 중 하나라고 생각한다. 문화라는 측면에서의 그래픽 디자인은 주어진 맥락 속 형식과 구조의 변화를 정의하고 소통의 방법을 찾아내는 과정이기 때문이다. 이러한 생각은 그래픽 디자인이 문화에 가장 파급력이 큰 매개 역할을 하게 한다. 이렇듯 그래픽 디자인과 문화는 서로 상생한다. 문화가 창조적 결과를 만

poster. moca newsletter. 210 x 297. 2004.

들어 내기 위한 그래픽 디자인 과정을 키우고, 창조적 결과물들은 다시 쓰임새로, 또한 문화적 맥락을 형성하는 의미로 사용된다. 과거 수십 년 사이 그래픽 디자인 분야는, 대량 생산 시대로부터 이어온 계층적 사고방식과 기술적 도움을 통해 진보된 디자인 독자들의 수준 높은 시각적 표현 능력에 의해 지속적으로 도전받아 왔다. 예를 들어 그래픽 디자이너는 큰 어려움 없이 모든 시각 요소들을 다룰 수 있고 고도로 복잡화된 정보의 표층들을 창조해내며, 한편 디자인 독자들은 그들 스스로의 지식과 기호에 따라 이를 다시 재구성한다. 디자인 생산과 소비의 과정들이 디자이너 자신에 의해서뿐만 아니라 개별 소비자들 삶 속에서 그들의 수요에 의해 조정되는 것이다. 과거 그래픽 디자인은 새로운 대량 사회 안에서의 규모 경제와 표준화에 따른 부응이었다. 형태는 기능을 따른다라는 디자인 철학은 표준화, 규격화, 미니멀리스트 형식의 기계 미학에 기반을 두었으며, 보편적 디자인 해결책은 다양한 문화를 넘어서는 공통의 수요를 해결하기 위해 하나의 디자인이 모든 사용자를 만족시키는 방법으로 태어났다. 그러나 과연, 보편성에 기반한 디자인 접근법이 서로 다른 문화들을 위해 여전히 유효한 것일까? 만약 그렇지 않다면, 시각 커뮤니케이터로서 우리는 지금의 다문화적 맥락을 다루기 위해 무엇을 해야 할 것인가?

034

poster. contradiction. 788 x 1,090. 2011.

SOMALI FISHERMEN HAVE BEEN FORCED TO BECOME PIRATES BY THE WORLD POWERS IN THEIR COUNTRY NOT TO OVERCOME POVERTY BY THEMSELVES

아키야마.신.秋山伸.

1963년 일본 니가타 출생이다. 1986년 도호쿠대학에서 건축을 전공한 후 도쿄예술대학 대학원에서 미술연구과 건축전공을 수료했다. 1990년부터 개인적인 그래픽 디자인 작업을 하다가 2001년에 스튜디오 Qualia(현 Schtücco)를 설립했다. 또한 2008년부터 Edition Nord 출판사를 운영하며 그래픽 디자이너와 출판인을 겸하고 있다. 2001년과 2002년에 일본 북디자인 콩쿠르에서 심사위원 장려상을 받았으며 다음 해 〈라이프치히 국제 도서전〉(2003)에서 '세계에서 가장 아름다운 책'상을 받았다. 그 밖에도 독일 카셀 포토북 어워드(2008-2009), 아시아퍼시픽 디자인 어워드(2011) 등에서 수상했다. 그의 작품은 독일 국회도서관부속 북앤드타이프박물관, 다케오페이퍼갤러리컬렉션, 카셀포토포럼 등에 소장되어 있다. 도호쿠대학, 도쿄예술대학, 국제교류 심포지엄 등에서 활발한 강연을 하며, 센다이대학교 학생설계 우수작품전, 포스터 공모전 〈부흥을 향한 리디자인〉(2011)의 심사위원을 맡기도 했다. 첫 개인전 〈이사와 장례식〉(2011)을 열었다.

akiyama.shin. japan

Born in Niigata, 1963. Graduated from Architectural Department, Tohoku University and completed the master couse in the study of art at Tokyo National University of Fine Arts and Music. Akiyama founded his studio Qualia Corporation (Schtücco Inc.,) in 2001, and founded publisher Edition Nord. He currently lives and works in Niigata. Akiyama held his exhibition <Moving/Funeral: the Life and Death of Schtücco at Osaka, 2010. He gave lectures at Tohoku University, Tokyo University of the Arts, Shibaura Institute of Technology, Interchange Symposium of East Asia Book in Paju, Korea, and jury member of <The Portfolio Review> in LEMON Exhibition of Students' Works, <Re-design for Recovery> in Sendai School of Design. His works were selected many awards such as Japan Book Design Concours (2001-2002), <Best Book Design from All Over the World> (2003) in Leipzig, Photobook Award in Kassel (2008-2009), Asia-Pacific Design Award, and collected by German Book and Type Museum, Takeo's Paper Work Collection and Kassel Foto Forum.

poster. tadashi kawamata "field sketch". 786 x 537. 2010

"Unexpressionism" in Typography

I make experiments on design under several themes depending on the characteristic of each work. One of them is "unexpression", which I put into practice mainly in publications by my publishing label named "edition nord". In general, a character cannot exist without any content to express. For instance, it will be considered as an error or an accident if one without meaning got mixed in on a page. It is dependent on meaning and exists to "replicate". I think that all operations beyond "replicate", which is the character's basic function, are "expression". It cannot exist without content, but conversely, an existing character by itself can be said to fully functions in meaning. If "expression" is to give greater meaning to a character which functions in "replicate" originally, it is almost "decoration". In that sense, it seems to me that modern typography supposed to avoid decoration to the minimum is highly decorative. So what is a practice not to express, that is, "unexpression" like?

akiyama shin

book. misaki kawai "pencil exercise". 182 x 257. 2011.

My experiments are as follows:

book. buku akiyma "composition no.2". 206 x 297. 2009.

akiyama shin

Not to select fonts: for that you have to use at least one, use only one font per work to eliminate the contrast of different fonts.

In minimal size: minimize characters without significantly affecting readability; although designed font itself is already an expression, you can minimize it.

In the same size: equalize the size of characters to eliminate the contrast of different sizes.

In achromatic color: unify characters basically in black to eliminate the contrast of different letter colors.

In single-column format: have only one block per page basically to eliminate the contrast of character arrangements.

To use linearity: utilize the order, a concentration difference of meaning which occurs at the very least, for character arrangements; a text is linear in principle and a segment by line break is essential for replicating on a page, which grades information inevitably.

To limit the expression of characters: to minimize or to eliminate character information on the cover to avoid it from having the advertising function; characters form a message by appearing on the cover.

Why do I call it "unexpression", not "non-expression"? It is because I expect that the overall practice becomes one expression finally, that is, an inversion of purpose. At the same time, I understand that "unexpressionism" is not "functionalism" at all. To be honest, finished works are far from being functional in terms of language indication. The practice of "unexpression", which seems difficult to persist in real life, has some benefits. One of them is contentism. For instance, in a portfolio, readers can appreciate works themselves without any bias caused by design, which makes the para-text such as an artist's name or a title to its proper subordinate position to works. After a few years of practice, I came to understand that this ultimate attitude of design unexpectedly got accepted naturally by authors who are skeptical of design as formative play, or unconcerned with a commercial result such as sales or attracting many customers, or attaching importance to only present imagination without relying on a symbolic capital such as past own works or reputation, and also readers who can read their attitude from a book.

magazine spread. shin akiyama "site zero / zerosite". 420 x 297. 2008.

poster / dm. invitation for a party "space for your future". 515 x 364. 2007.

타이포그래피에서의 '반표현주의'

나는 작업의 특성에 따라 몇 가지 테마를 가지고 디자인 실험을 하고 있다. 그중 하나가 '반표현'이며 주로 출판물을 통해 실천하고 있다. 일반적으로 문자는 나타내는 내용이 없으면 존재할 수 없다(이를테면 출판물 페이지에 의미 없는 문자가 섞여 있다면 그것은 실수나 사고로 인식될 것이다. 문자는 의미에 종속되고 그것을 재현하기 위해 존재한다. 나는 문자의 기본적인 기능인 재현을 넘은 조작 모두가 표현이라고 생각한다). 문자는 내용이 없으면 존재할 수 없다. 다시 말하면 존재하는 문자는 그것만으로 충분히 그 의미와 기능을 다하고 있다고 할 수 있다. 이미 '재현'을 충분히 하고 있는 문자에 그 이상의 의미를 부여하는 것이 '표현'이라면 표현은 지극히 '장식'에 가까워진다. 장식을 한없이 배척했던 모던 타이포그래피도 이런 뜻에서 현저히 장식적이었다고 생각한다. 그렇다면 표현하지 않기 위한 실천, 즉 '반표현'이란 무엇일까?

내 실험은 이와 같다.

글꼴을 고르지 않는다: 글꼴을 쓰지 않는 것은 불가능하나 여기서는 적어도 글꼴 대비 표현을 없애기 위해 한 작품당 한 글꼴만 쓰도록 한정하고 있다.

최소한의 크기: 디자인된 글꼴 자체가 이미 표현이다. 그러나 그 표현을 최소화할 수는 있다. 여기서는 가독성이 현저히 저하되지 않는 범위 내에서 가장 작은 포인트로 사용한다.

크기의 통일: 크기 대비를 없애기 위해 포인트를 기본적으로 한 종류로 한정한다.

무채색: 문자 색에 의한 대비를 없애기 위해 기본적으로 검정으로 통일한다.

일단(1단) 짜기: 문자 배치에 의한 대비를 없애기 위해 기본적으로 한 페이지 한 블록으로 한정한다.

선형성(線形性)의 이용: 텍스트는 원리적으로 선형적이며 페이지에 재현할 경우 줄바꿈에 의한 분절이 필수다. 그 분절은 필연적으로 정보 서열을 낳는다. 이 서열이라는 어쩔 수 없이 생겨버리는 최소한의 의미 농도 차를 문자 배열에 이용한다.

문자표출의 제한: 문자는 표지에 나타남으로써 메시지가 된다. 이 광고적 기능을 표지가 맡지 않도록 표지에 나타나는 문자정보를 최대한 적게 하거나 없앤다.

내가 이러한 실천을 '비표현(non-expression)'이 아닌 '반표현(unexpression)'이라고 부르는 것은 그 총체가 결국 하나의 표현이 되는, 말하자면 목적의 반전을 예기하고 있기 때문이다. 동시에 '반표현주의'는 결코 '기능주의'가 아니라는 것 또한 이해하고 있다. 솔직히 말해 완성된 작품은 언어 표시라는 점에서 거의 기능적이라고 보기 어려운 것이 사실이다. 현실사회에서 살아남기 힘든 '반표현' 실천에도 몇 가지 효력이 있다. 그중 하나가 내용주의. 이를테면 작품집에 적용할 경우, 독자는 디자인에 의한 선입견 없이 작품만을 감상할 수 있다. 그리고 그것은 작가명이나 타이틀 등의 작품에 대한 텍스트들을 작품에 대하여 본래 있어야 할 종속적인 위치로 되돌리는 것이다. 그리고 이러한 극한적인 디자인 태도가 조형 유희로서의 디자인이라는 것에 회의적인 저자에게 혹은 판매나 모객이라는 상업적인 성과에 무관심한 저자에게 혹은 자신의 과거 작품이나 명성, 자본에 의존하지 않고 현재 창조에만 중점을 두는 저자에게 그리고 이러한 자세를 책으로부터 읽어낼 수 있는 독자에게는 의외로 자연스럽게 받아들여진다는 것을 최근 몇 년 동안의 실천으로 증명하기 시작했다.

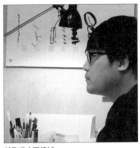

어우베니.区德诚.

au.benny. <small>china</small>

Amazing Angle Design Consultants의 디자인 디렉터이자 Amazing Twins의 공동 크리에이터이다. 1990년대부터 일본 도쿄와 오사
카를 오가며 활발한 전시 활동을 했다. 이를 계기로 그의 작품이 외부에 소개되면서 소니, 히타치와 협업하여 제품과 광고 디자인을 담당
했다. 2003년에는 그의 스튜디오 내에 미니 갤러리를 열었고 그래픽 디자인 작업 이외에도 전시와 세미나 기획, 사진, 출판 활동을 하고
있다. 〈Seven: 일본 최고의 아트 디렉터〉, 〈도쿄 타이프디렉터스클럽(TDC)〉, 〈Love from Hong Kong〉(2007) 등의 전시를 기획했으며.
그래픽 디자인, 종이, 인쇄 과정에 대한 다양한 경험을 바탕으로 디자인 컨설팅을 하고 있다. 국내외 각종 디자인 세미나에 강연자로 초청
되었으며 홍콩 최고 디자이너 10인(2008)에 선정되었고 홍콩디자이너협회(HKDA), 포스터리그, 도쿄 TDC 회원이다. 각종 국제 디자인
공모전의 심사위원을 맡고 있다.

typography works. wordspotting. 400 x 600. 2011.

042

au benny

Design director of Amazing Angle Design Consultants Ltd. and co-creator of Amazing Twins. Works premiered in
Japan in 1990's and toured in exhibitions in Tokyo and Osaka, and at the same time, collaborated with Sony and
Hitachi to develop original products and advertisements. In 2003, Benny founded miniminigallery at his design
studio. Aside from his graphic design work, Benny is devoted to curate exhibitions and seminars on design, pho-
tography and publications. Some of the large-scale design activities include <SEVEN: showcase of top Japanese
art directors> and <Tokyo TDC Exhibition in Hong Kong>, <Love from Hong Kong> (2007) at Tokyo Designers
Week 2007 and 2009 Shenzhen Hong Kong Design Show. Benny is a consultant to various paper companies
with his professional knowledge and experience in graphic design, paper and print production. Also, he's often
been invited to speak for local and overseas design seminars. Benny is currently a full member of Hong Kong
Designer's Association, member of Poster League, overseas member of Tokyo TDC, and jury member of various
international design competitions. He is also an external examiner and course advisor for several design institu-
tions in Hong Kong. Awarded Hong Kong Ten Outstanding Designer in 2008.

typography works.　hello typography.　various.　2004 to present.

When different characters come together, they form words and sentences, which delivers a message.

각기 다른 글자들은 모여서 단어와 문장을 이루며, 그것들은 의미를 전달한다.

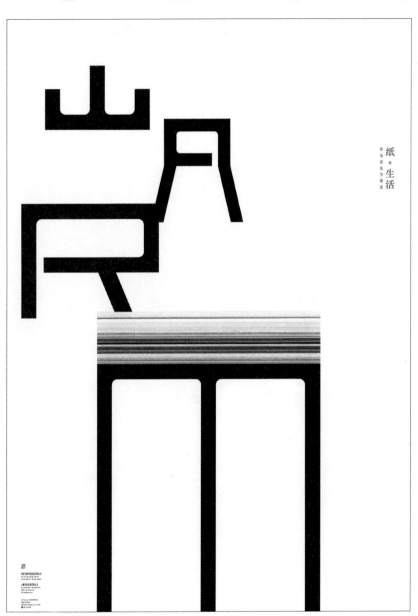

au benny

poster.　turn war into warm.　700 x 1,000.　2003.

　　　　　　　　　　　　　　　In fact, many things we see everyday are also unique
characters, scattered in the city.
사실 우리가 일상에서 매일 보게 되는 대상 역시 도시에 여기저기 흩어져 있는 독특한 문자들이다.

au benny

poster. imprint & imagination #2. 700 x 1,000. 2011.

Anywhere on the street, you may suddenly be attracted to a certain image, sending you a particular message and signal.
거리 어디선가 어떤 특정 이미지에 시선이 멈추게 되는데, 이는 그것이 보내는 특정한 메시지나 신호 때문이다.

au benny

poster.　1/4 typography works from shenzhen, china.　700 x 1,000.　2009.

Design is the discovery, reception and composition of these signals.

디자인이란 이러한 신호들을 발견하고, 수신하고, 그리고 구성하는 것이다.

au benny

poster. hong kong design centre. 700 x 1,000. 2006.

It is also an on-going exploration of possibilities from the established definition of everyday life.

그것은 또한 일상의 삶 속에서 기존에 정의된 것들로부터 가능성을 지속적으로 탐구하는 과정이다.

비쉐펑.毕学锋.

bi.xuefeng. _{china}

IMAGRAM Design, 비쉐펑그래픽디자인컨설턴트의 아트 디렉터이며 선전그래픽디자인협회 (ASGDA) 학술위원, 국제그래픽디자인연맹(AGI) 회원이다. 비쉐펑은 1977년에 IMAGRAM Design을 설립했고 혁신적인 접근과 창조적 상상력으로 고객이 시장에서 선두주자로 성장할 수 있도록 디자인 컨설팅을 하고 있다. 그는 국내외 다양한 디자인 공모전에서 100여 개 상을 수상한 바 있으며 현재 다수의 공모전에서 심사위원을 맡고 있다. 또한 전시 기획자로서 디자인과 예술의 국제 교류를 활발히 추진하고 있다._____

_____Bi Xuefeng is an Art Director in Shenzhen IMAGRAM Design Co., Ltd. and BI XUE FENG Graphic Design Consultant, and also an Academic member of Shenzhen Graphic Designer Association, as well as a Member of Alliance Graphique Internationale (AGI). In 1997, Bi Xuefeng founded IMAGRAM Design Co., Ltd. Mr. Bi with the designers in company have brought tremendous benefits and market influence for clients through works filling with innovation and imagination. The clients have been forerunners in market. Mr. Bi has won numerous design awards home and abroad and participated in design competitions as a jury. In addition, he also positively impels the international design exchanges as a curator.

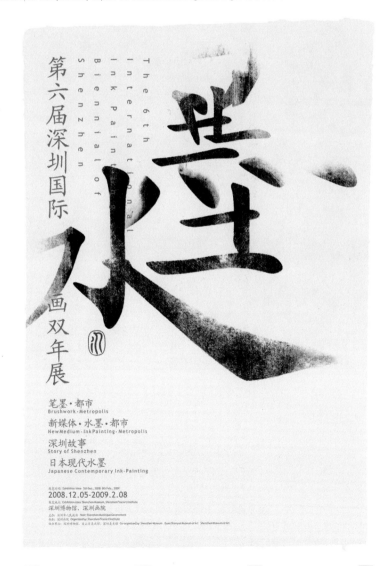

bi xuefeng

poster. the 6th international ink painted biennial of shenzhen. 700 x 1,000. 2008.

Poster of The 6th International Ink Painting Biennial of Shenzhen

Each Chinese character consists of various strokes formed by different dots or lines as the basic components. I make strokes of character "水墨" and other sub-exhibitions abstraction-ized, which brings an effect of light and shade overlap, virtuality and reality intertexture. Applying the methods of interweaving and sharing of strokes, I design the image of Ink Painting Biennial of Shenzhen, which is used in poster and book respectively, to express the artistic conception based on Chinese ink painting.

Binhai Urban Planning Gallery Collection

This set of book is designed for BINHAI District, Shenzhen. The core image is a combination of Chinese character's radical "氵" (which means water, ocean, river, lake, brook, etc.) and English letters "BH" (which are initials of pinyin "BIN HAI"). The arc-shaped cover is featured by coastline stretched along BIN HAI District. In addition, this design makes access to books easily.

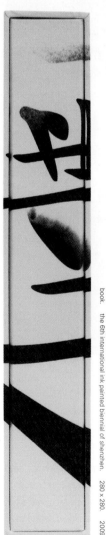

제6회 선전(深圳) 국제 수묵화 비엔날레

한자는 획으로 구성된다. 나는 '수묵'이라는 한자와 각 부분 전시의 주제어의 문자 획을 추상화하였고 여기에 수묵의 농담과 사실적 세부묘사를 더하였다. 획을 교차 시키거나 공통된 획을 이용하는 방법으로 〈선전 수묵화 비엔날레〉의 이미지를 디 자인하였고, 이로써 중국 수묵화의 정취를 전달하고자 하였다.

선전 동부 빈하이신구 도시기획 도록

이 작업은 선전 빈하이신구의 도시기획에 대한 디자인이다. 이 책의 핵심 이미지 는 한자의 삼수변 '氵'과 빈하이의 로마자표기법에 따른 'BIN HAI'에서 이니셜을 따 온 'BH'의 결합으로 만들어졌다. 원호 형태의 표지는 빈하이 지역을 따라 뻗은 해 안선을 형상화한 것으로, 독자가 책에 쉽게 다가가도록 만든다.

049

bi xuefeng

book. the 6th international ink painted biennial of shenzhen. 280 x 280. 2009.

book. binhai urban planning gallery collection. 200 x 250. 2008.

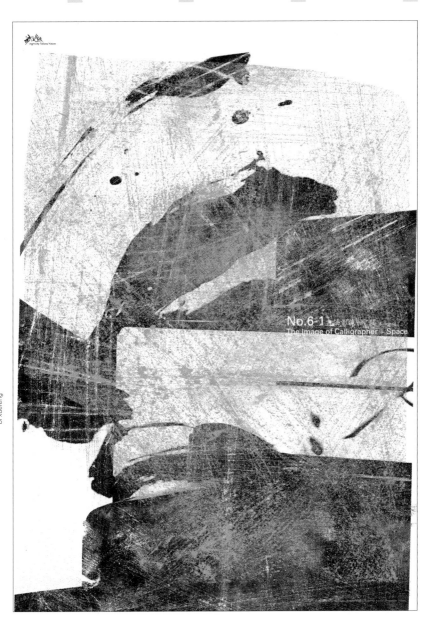

bi xuefeng

poster. ingenuity follows nature. 700 x 1,000. 2011.

Poster of Ingenuity Follows Nature

I'm invited to design this poster by Ms. Dong (Dong Ziyang), a calligrapher of Taiwan. I have Ms. Dong's works projected onto my space. In this way, her calligraphy embraces immense momenta which has beyond the form of paper. Moreover, the beauty of abstract shaped by ink painted lines leap off the paper vividly. By way of projection, I express my understanding of the dialogue of calligraphy and space, space and myself.

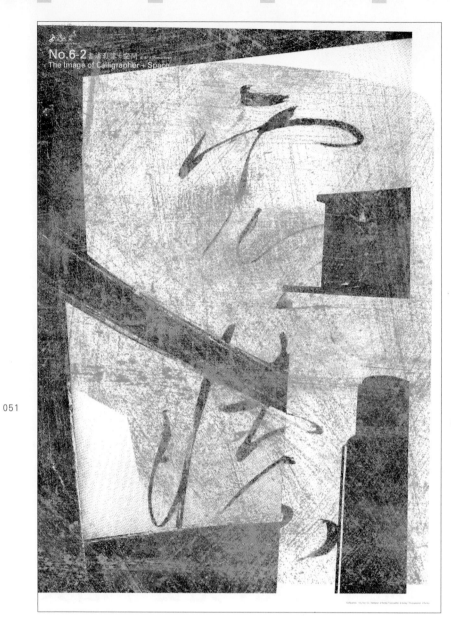

bi xuefeng

poster.　ingenuity follows nature.　700 x 1,000.　2011.

묘법자연 포스터

이 포스터는 타이완의 캘리그래퍼 둥즈양 여사의 요청으로 제작되었고 그녀의 작품은 나의 작업 공간에 투영되었다. 작가의 캘리그래피는 지면을 넘어서는 강력한 기운뿐 아니라 극명하게 구분되는 먹선이 만들어내는 추상적 아름다움을 드러낸다. 결과적으로 투영은 내가 이해하는 캘리그래피와 공간, 그리고 공간과 나의 대화를 표현하는 방식이다.

chen.rong. ^{china}

천룽.陈嵘.

Chen Rong studied in visual communication design at the Shanghai University, and earned Master degree in visual communication design from Musashino Art University with instruction of Prof. Katsui Mitsuo and Niijima Minoru in 2002, in the meantime his graduation work and thesis were voted as the Best Work of the Year. Since 2002 he worked for 'The Design Associates' in Tokyo, taking up branding and packaging design work. Returned to Shanghai in 2005 and joined GK Design Shanghai Branch, served as director of Graphic Design. Now he is Lecturer as well as Director of Visual Communication Design of Shanghai Institute of Visual Arts, Fudan University since 2007; Visiting Lecturer of Zhuhai Branch School, Beijing Normal University; Partner and Chief Creative Director of QinWei Design; Design magazine free writer. Chen Rong is devoting in the typeface design as the core of brand and the packing design research and the education. He participated in the exhibition <Typography Beijing 2009>, won the committee prize of the Founder 5th Chinese Character Typeface Design Competition, and his book design was selected in <the Yearbook 2011 of Japan Typography Association>._____

1996년 상하이대학교 시각전달디자인학과를 졸업하고 일본으로 건너가 무사시노미술대학 대학원에서 카쓰이 미쓰오, 니이지마 미노루의 지도를 받았으며 2002년에 우수졸업상을 받았다. 2002년 도쿄디자인어소시에이츠에 입사, 브랜드 및 패키지 디자인 작업을 한 뒤 2005년에 중국으로 돌아와 GK디자인 상하이분사 디자인부 총감독을 거쳐 2007년부터 푸단대학교 상하이시각예술학원에서 일했다. 현재 친웨이디자인 수석 크리에이티브 디렉터이자 푸단대학교 시각전달디자인 전공 책임교수, 베이징사범대학 주하이분교 객원교수이다. 주로 글꼴 디자인을 중심으로 브랜드와 패키지 디자인 교육 및 연구를 하며, 디자인 잡지에 글을 기고하고 있다. 베이징 국제그래픽디자인협의회(Icograda) <베이징 타이포그래피 2009> 주제전에 초빙되었고, 제5회 방정상 중국 한자 글꼴 디자인 공모전 심사위원상, 일본타이포그래피협회 <올해의 책 2011> 공모전에서 그의 북 디자인 작업 『시각언설』이 입선했다.

052

察身而不敢诬，奉法令不容私，尽心力不敢矜，遭患难不避死，见贤不居其上，受禄不过其量，不以无能居尊显之位。自行若此，可谓方正之士矣。

typeface. sui gothic. 2009.

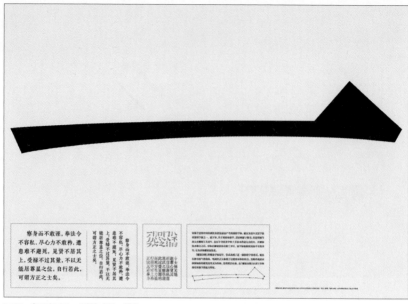

poster. from the one. 1,000 x 707. 2011.

When I was doing my Master graduation work in Musashino Art University Japan, I began to pay attention to typeface design of Chinese characters. The overseas learning experience gave me a chance to look into Chinese design culture from a new angle. Fortunately Japan has similar Chinese character culture, so I learned a lot of their experiences and methodologies. When I was doing my master thesis and creations, I focused on the design of Chinese Typeface Song and horizontal composition that emerged just decades ago.

chen rong

poster. useless is useful – chinese character & legibility 2. 1,189 x 841. 2011.

book. visual narrative. 248 x 258. 2010.

chen rong

At the end of 19th century, with entry of western cultures, Latin words and scientific expressions appeared frequently in books, the single vertical composition lasted for thousands of years was broken. After the New China was established, horizontal composition was fixed as the standard. Almost at the same time, Chinese characters were being simplified. Compared with the long history of China, the change to the composition direction and the simplification is radical indeed. As a result, the design of Chinese characters today has a lot of problems to be solved. Many writers and designers, questioned the simplification of Chinese characters. But I think the change is at least a brave attempt and a revolution in the modern world characters.

Formation of Chinese and Latin characters evolves with some substaintially same rules over the more than three thousand years, although they belong to totally different character systems. Characters is a visual media of culture, and their formation mirrors the development of social economy, politics and culture. Both Chinese and Latin characters develop continuously and swing back and forth like a pendulum between humanism and styling formation in the course of history.

I am confident that humanism will be the most reasonable trend of Chinese typeface design. Design is never a game of styling. Design is one of the most effective tools that improve human life and solve social problem. *Human - oriented* design is the best. My favorite word is "*Acquiring New Knowledge through Reviewing the Old*" by Confucius. It means innovation is impossible without knowing the past. The so-called innovation is based on the creations of predecessors. Wildly fantastic design is difficult to root. Especially Chinese typeface design, strange style without culture of Human will not be longlasting.

일본 무사시노미술대학에서 졸업작품을 준비하고 있을 때 비로소 나는 중국 서체 디자인에 관심을 갖게 되었다. 유학 시절의 경험은 중국 디자인 문화를 새로운 각도로 바라볼 수 있는 계기를 마련해주었다. 다행히도 일본은 중국의 한자 문화와 유사했으므로 나는 많은 경험과 방법론을 배울 수 있었다. 졸업논문과 작품을 하면서 중국 서체 중 '송체' 디자인과 불과 몇 십 년 되지 않은 한자의 가로쓰기 문제에 집중하였다.

19세기 말 서구 문화가 중국에 소개된 후 라틴어와 과학 공식이 책에 빈번히 등장하면서 수천 년간 지속되어왔던 고유한 세로쓰기가 무너졌다. 새로운 중국이 들어선 후 가로쓰기가 표준으로 자리를 잡았다. 그와 거의 동시에 중국 한자는 단순화되었다. 중국의 장구한 역사와 비교할 때 쓰기 방향과 단순화에 따른 변화는 가히 급진적인 것이었다. 결과적으로 오늘날 중국 한자 디자인은 풀어야 될 문제가 산적하다. 많은 작가와 디자이너들은 중국 한자의 단순화에 의문을 제기해왔다. 그러나 나는 그 변화는 용감한 결단이었고 근대 세계의 문자 역사상 하나의 혁명이었다고 생각한다.

비록 철저하게 서로 다른 글자 체계임에도 불구하고 한자와 라틴 글자들은 삼천 년 이상 긴 시간을 거쳐 근본적으로는 같은 규칙을 따르면서 진화하고 있다. 글자는 문화를 보여주는 하나의 시각적 매체이며, 글자의 형성과정은 사회 경제, 정치 그리고 문화의 발전을 반영한다. 중국과 라틴 글자들은 모두 지속적으로 발전하고 있으며 시계의 추처럼 휴머니즘과 조형 양식 사이를 왔다 갔다 하고 있다.

나는 휴머니즘이 중국 타입페이스 디자인의 가장 합당한 트렌드가 될 것이라 확신한다. 디자인은 결코 단순한 조형 놀음이 아니다. 디자인은 인류의 삶을 개선하고 사회 문제를 해결할 수 있는 효과적인 수단 중의 하나이다. 인간 중심의 디자인이 가장 바람직한 디자인이다.

내가 좋아하는 말은 공자의 '온고지신(溫故而知新: 옛것을 통해서 새로운 것을 배우다)'이다. 이것은 혁신은 과거를 모르고는 불가능함을 의미한다. 이른바 혁신이란 이전 사람들이 이룩해놓은 것에 기초한다. 과할 정도로 현란한 디자인은 뿌리내리기가 어렵다. 한자 타입페이스 디자인에 관한 한 인간을 중시하는 문화가 없는 괴상한 스타일은 오래가지 못할 것이다.

055

poster. chinese character — dot, line, plan. 707 x 1,000. 2009.

poster. chinese character — dot, line, plan. 707 x 1,000. 2009.

chen rong

poster. chinese character — dot, line, plan. 707 x 1,000. 2009.

chen rong

056

chinese and arabic figures. 800 x 1,000. 2006.

A Hundred Flowers Blossoming

A Hundred Viewpoints Contending

chen rong

poster. a hundred flowers blossoming and a hundred viewpoints contending. 594 x 841. 2006.

디자이너 조현은 2001년부터 2002년까지 '쓰레기'를 주제로 한 작업에 빠져 지냈으며, 2002년 일상에서 찾은 사물의 규칙을 바탕으로 최성민과 함께 타입페이스 〈FF Tronic〉을 개발했다. 이를 계기로 독일 FSI(Font Shop International) 등록 디자이너로 활동하게 되었다. 2002년 예일대학교에서 그래픽 디자인 석사과정을 졸업하고 2004년에 서울로 돌아와 자신의 스튜디오 S/O Project(Subject and Object Project in everyday life)를 설립했다. S/O Project는 일상과 일상적인 사물에 대한 관점과 타이포그래피적 해석을 접합시켜 표현하는 작업들을 꾸준히 시도하고 있다. 특히 'subject'와 'object'의 관계를 다양한 미디어에 접목하고 확장시키는 데 스튜디오 작업의 방향을 두고 있다. 이런 디자인 방법론을 통해 상업적인 기업과의 협업에서도 독창적이며 실험적인 결과물들을 만들어낼 수 있었으며, 기존의 방식에서 벗어난 다양한 미디어와의 소통방식이라는 평가를 받으며 레드닷디자인 어워드, 뉴욕 및 도쿄 타입디렉터스클럽 (TDC), 아트디렉터스클럽(ADC), 애뉴얼리포트컴페티션(ARC) 등에서 수상했다. 그는 일상 속에서의 'subject', 'object'에 대한 실험을 교육에도 적용하고 있다. 학생들과 일상적인 주제를 바탕으로 작업한 결과물들은 레드닷디자인 어워드에서 수상하며 호평을 받았다. Fendi 10+ 아티스트, 한국의 북 디자이너 19인으로 선정되었으며, 현재 스튜디오 운영과 동시에 서울대학교 대학원과 경원대학교에서 학생들을 가르치고 있다. ARC, ASTRID Award의 심사위원이다.

cho.hyun. korea

조현.曹鉉.

Between 2001 and 2002, the designer Cho Hyun was deeply absorbed with trash. In 2002, he and Choi Sung-min developed the FF Tronic typeface based on the rules of objects encountered in daily life, and this led to his work as a registered font designer with FSI (Font Shop International, Germany). In that same year, he earned a MFA. in graphic design from Yale University, and in 2004 he established his S/O Project studio in Seoul. With a name meaning 'Subject and Object Project in everyday life', this effort sees him making continued attempts at work incorporating perspectives on daily life and everyday objects into typographic expression. In particular, the studio's efforts are focused on combining and expanding the relationship of subject and object into different media. This design methodology has led him to produce unique and experimental results even when cooperating with very commercial enterprises, and his various media and communication approaches, which represent a departure from established methods, have met with considerable praise, including honors from the Red Dot Awards, TDC NY, TDC Tokyo, ADC, and the ARC Awards. Cho's experiments with the subject/object in everyday existence are also realized in the field of education, and the results of his work with students based on everyday themes and areas of interest have been honored by the Red Dot Awards. He has been selected as a Fendi 10+ Artist and one of Korea's Top 19 Book Designers, and his current efforts include running his studio, teaching students at the Seoul National University graduate school and Kyungwon University, and serving as a judge at the ARC Awards and ASTRID Awards.

cho hyun

installation.　garbage collector.　487 x 603 x 950.　2007.

"Strange forms for good reasons"

<u>Designing the Every Day</u>

Designing things means conveying one's thoughts, and there are said to be thousands, even tens of thousands of ways to speak one's mind. Among all these examples, is there any with power enough to communicate with a grounding in actual experience? Is there any with power enough to borrow the voice of the existing objects and phenomena that are constantly producing messages around us? The ordinary—the "every day"—is exceedingly impartial, leading to us ponder at every moment which of them we should choose, and what we should use in communicating. A power and truth that can never be known if one does not locate them, if one does not make the endeavor. Things that always existed in our midst yet were never afforded our gaze or attention. Everyday objects are working to ready reasons for our sympathies, waiting for us to see them. This is the reason for—and the power of—designing the "every day," rather than models with abstract and ideal forms produced on the desk.

bag design.　i can't say in words.　265 x 140 x 50.　2008.

cho hyun

낯선 형식과 적절한 이유　'매일'을 디자인하는 것

디자인을 한다는 것은 생각을 전달하는 것이라 말하고 그 생각을 말하는 방법은 수천 수만 가지가 있다고 한다. 이 많은 경우의 수에서 실질적인 경험을 근거로 전달하는 것만큼 힘을 가진 것이 있을까? 존재하는 주변의 메시지를 끊임없이 발생시키는 사물과 현상의 입을 빌려 말하는 것만큼 큰 힘을 가질 수 있을까? 매일이라는 일상은 너무나 공평하여 우리는 이것들 중에서 무엇을 선택해야 하고 무엇을 통해 전달해야 할지 매 순간 고민하게 만든다. 찾아내지 않으면, 그리고 시도해 보지 않으면 알 수 없는 힘과 진실. 항상 주변에 존재했지만 한 번도 눈길과 관심을 주지 않았던 것. 일상의 사물들은 공감할 수 있는 이유를 준비하고 있으며 우리가 봐주기를 기다리고 있다. 이는 책상 위에서 관념적이고 이상적인 폼으로 생산해 내는 조형이 아닌 매일을 디자인하는 이유이고 힘인 것이다.

In its impartiality, the everyday comes across as quite tedious and ordinary. So tedious are these things that we have failed to hold any interest in them or ask the reasons why. Why do I feel more interested and profoundly moved by such things? After all, there clearly must be things that are somewhat more special, things more peculiar in their origins. It is a devil of a preconception we live with, something not at all unfamiliar that lies hidden within all of our thoughts, or part of a kind of common wisdom everyday experience that we have been educated into and agreed to. Betraying and overturning the things we all trusted in or thought we knew—these things may not glitter or cry out, but they are things that we can sympathize with, media that for all their slightness possess considerable communicative power. These are the things that I focus on.

cho hyun

typeface. ff tronic. 2002.

060

poster. apollo 11/apollo 10. 500 x 700. 2011.

The conveying and communicating of thoughts in real life tends to operate through common wisdom rather than any exceptionally novel methods. But with the standard of "common wisdom," we end up persuading and understanding within the scope of what is known, what has already been seen. Typography serves as an outstanding medium for mediating and connecting the boundaries of common-sense language and common-sense images from the communicator's standpoint. In the relationship of letter and image, the two elements do not always exist together equally. I believe that an approach of eliminating or minimizing the image as much as possible encourages greater imagination, with the effect of leading the viewer to maximally incorporate his or her own experience, and I think that work produced through the equating of image and type represents the greatest appeal and strength of typography.

When I put a thought into design, I try to communicate by way of the everyday, making use of typography that is exceedingly clear, beautiful, and even economical.

typographic drawing. fig.1. 295 x 210. 2009.

061

cho hyun

일상적인 것들에 대해 다시 보려는 노력의 시작 그리고 과정

공평한 일상은 다분히 지루함과 평범함으로 다가온다. 너무나 지루해 지금까지도 아무런 관심도 이유도 묻지 않게 되었던 것들이다. 나는 왜 그런 것들에게서 더 큰 흥미와 감동을 느끼는 것일까? 좀 더 특별한 태생 자체가 더 특별한 것들이 분명히 존재할 텐데 말이다. 그것은 모두의 생각 속에 숨어 있는 전혀 낯설지 않은 고정관념이란 놈과 함께 살고 있는, 또는 교육을 받아 합의한 상식 같은 일상의 일부일 것이다. 믿고 있거나 믿고 있던 것에 대한 배신(?)과 반전. 이것들은 빛을 내거나 소리내지 않지만 공감할 수 있는 존재들이며 소소하지만 큰 전달력을 가진 매개체인 것이다. 나는 이들에 주목한다.

타이포그래피와 일상의 메시지

현실에서의 생각의 전달과 소통은 아주 생소한 방법보다는 상식선에서 통용되기 마련이다. 상식이라는 기준 역시 아는 만큼, 본 만큼의 범위에서 설득하고 이해시키게 되는데, 타이포그래피는 전달자라는 입장에서 상식적 언어와 상식적 이미지의 경계를 조정하고 연결하는 훌륭한 매개체의 역할을 한다. 글자와 이미지의 관계에서 이 두 가지 요소가 항상 평등하게 공존하는 것만은 아니다. 나는 가급적 이미지를 생략하거나 최소한으로 하는 것이야말로 더 큰 상상력을 자극하며 보는 사람으로 하여금 자신의 경험을 최대한 이입시키는 효과를 만든다고 생각한다. 또한 이미지와 타입을 동일시하여 생산해내는 작업이야말로 타이포그래피가 가지는 가장 큰 매력이자 힘이라고 생각한다.

나는 생각을 디자인할 때 일상을 통해 전달하고자 하며 너무나 선명하고 아름다우며 경제적이기까지 한 타이포그래피를 이용한다.

cho hyun

062

poster. reading of the imagery. 535 x 780. 2010.

poster. 100% nylon. 600 x 800. 2009.

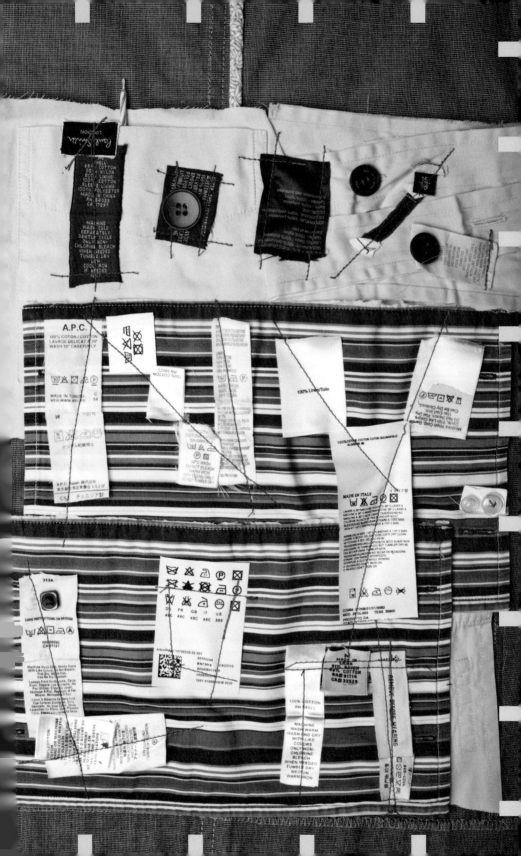

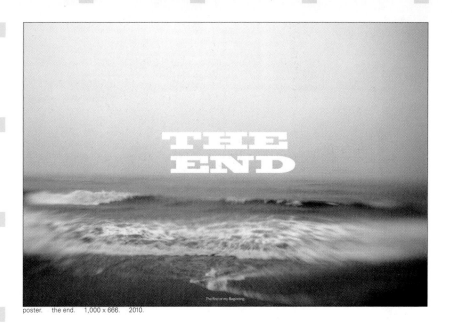

poster. the end. 1,000 x 666. 2010.

I am passionate about graphic design and love doing it.

My design philosophy includes my belief that:

1. The most important element in design is to come up with the idea first.

 I do not permit any one style to dictate my work.

2. Examining each project from different perspectives is essential.

 I favor solutions that are unconventional.

3. Working closely with the Client is important.

 This inevitably leads to superior end products.

In the last two decades or so since graphic designer Choi Sandy returned home to Hong Kong from London with a degree in Graphic Design from Saint Martin's School of Art in 1985, his work has won numerous local and international accolades, including awards from British D&AD, New York Art Directors Club, Cannes festival, Warsaw International Poster Biennale, Le Salon International de l'Affiche Paris, Hong Kong International Poster Triennial, HK4As and HKDA. Prior to founding his own design consultancy Sandy Choi Associates Limited in 1997, Sandy had worked for several years in a number of noted design companies including Steiner&Co as well as in advertising agencies for nine years - first as Art Director and then Creative Director for Euro RSCG Ball Partnership in Hong Kong and later, as the Executive Creative Director for J. Walter Thompson in Shanghai. In recent years, besides serving as an adjudicator for various international design competitions and exhibitions in Hong Kong, Sandy has also served as a lecturer of graphic design at the University of Hong Kong SPACE and Hong Kong Polytechnic University. Sandy is a

choi.sandy. ^{china}

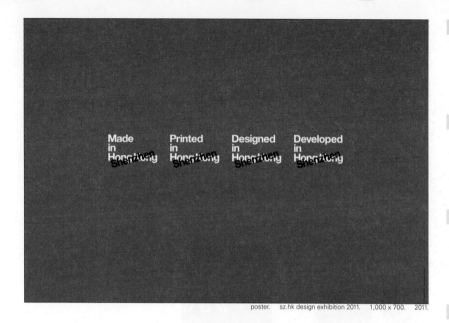

poster.　sz.hk design exhibition 2011.　1,000 x 700.　2011.

나는 그래픽 디자인에 대해 열정적이며, 매우 사랑한다.

나의 디자인 철학은 나의 믿음을 포함한다.

1.　　　가장 중요한 요소는 아이디어를 먼저 생각해내는 것이다.

　　　나의 작업들이 어떠한 한 가지 스타일에 지배당하는 것을 허락하지 않는다.

2.　　　각각의 프로젝트를 다른 시점으로 검토하는 것은 필수적이다.

　　　나는 틀에 얽매이지 않는 방법을 선호한다.

3.　　　클라이언트와의 긴밀한 협력은 중요하다.

　　　이는 우수한 결과물과 필연적으로 연결된다.

member of British D&AD, the New York Art Directors Club.＿＿＿＿＿1985년
런던 세인트마틴스스쿨오브아트에서 그래픽 디자인을 전공한 뒤 홍콩에서 20여 년 동안 꾸
준히 활동하며 D&AD(The Best Advertising and Design in the World), 뉴욕ADC 어워드,
〈칸 페스티벌〉, 〈바르샤바 국제 포스터 비엔날레〉, 〈파리 국제 포스터 전시회〉, 〈홍콩 포스
터 트리엔날레〉, HK4As(The Association of Accredited Advertising Agencies of Hong
Kong) 및 HKDA 어워드 등 수많은 국내외 공모전에서 입상했다. 초창기에는 Steiner&Co를
비롯한 여러 저명한 국제 디자인 회사에서 일했으며, 이후 9년 동안 광고 회사 Euro RSCG
Ball Partnership과 상하이 J. Walter Thompson에서 실무 경력을 쌓았다. 다수의 국제 디자
인 공모전 참가 및 전시의 심사위원 활동 외에도 홍콩 대학위전공진수원 및 홍콩 이공대학 디
자인전공 강사를 겸임하며, 적극적으로 홍콩의 창의적 예술에 공헌하고 다음 세대 디자이너
를 양성하고 있다. British D&AD, 뉴욕 아트디렉터스클럽(ADC)의 회원이다.

초이샌디.蔡楚堅.

My design inspiration comes from daily life, the local environment and the world around us. From a design perspective, it comes from Swiss graphic design of the 50s, in particular, the work of Müller-Brockmann. His thinking, rigour, discipline and clarity established and set the foundations of a design system that essentially is difficult to improve on.

Hong Kong and its local flavour are also the main influence in my design – from the visual stimulus and colours of our culture and environment to our food. I also remember my fascination with old Chinese signs and the different styles of the characters.

In addition, I feel the chaos and confusion of the physical environment in Hong Kong played a part in influencing my design sensibility and my desire to use design to create clarity and in order to improve the environment.

Music has always been a part of my life. I listen to it continuously at work and home.

In literature, the books I read are mainly non-fiction – from historical, biographical, prose, essays, to art, design and music. I remember how excited I was when I first read "Paul Rand: A Designer's Art" in 1985. It's not just visually, his thinking, wit and simplicity has been very influential to me.

Good graphic design is an on going process of learning and experience i.e. it is in the doing itself.

067

choi sandy

나의 디자인 영감은 일상생활, 지역 환경, 그리고 우리 주변 세계로부터 비롯된다. 디자인 관점으로 보면, 1950년대 스위스 그래픽 디자인, 특히 뮐러 브로크만에게서 영감을 얻는다. 그의 생각, 엄격함, 규율, 명료성은 본질적으로 더 이상 개선이 어려울 만큼 훌륭한 디자인 시스템의 기초를 설립하고 설정했다.

홍콩과 지역의 풍미 또한 나의 디자인의 주된 영감이 된다. 우리 문화와 환경의 시각적 자극과 색상에서 음식에 이르기까지. 오래된 한자 간판들과 다양한 스타일의 글자들이 나에게 큰 매력으로 다가왔던 적도 있다. 홍콩의 물리적 환경의 혼돈이 디자인을 통해 명료성과 질서를 창출하여 환경을 개선하려는 나의 디자인 감성과 욕구에 영향을 미쳤다고 생각한다.

음악은 항상 내 삶의 일부였다. 나는 직장과 가정에서 지속적으로 음악을 듣는다. 문학 쪽에서 내가 주로 읽은 책은 논픽션이다. 역사, 전기, 산문, 에세이부터 미술, 디자인, 음악에 이르기까지. 1985년에 『폴란드: 디자이너의 예술』을 처음 읽으면서 내가 얼마나 흥분했었는지 기억 난다. 그의 시각적 취향뿐 아니라 생각, 위트, 단순성 등이 나에게 큰 영향을 끼쳐왔다. 좋은 그래픽 디자인이란 학습과 경험에서의 과정을 즐기는 것이다. 그 속에서 양분을 흡수하고 성장하는 것이다.

wall calendar. antalis calendar 2011. 605 x 825. 2011.

Born in Xi'an,ancient capital of China. In 1989, Du Fengsong graduated from Industrial Design Department of Xi'an University (now Xi'an University of Arts), majored in communication visuelle. He has been working at BATES Advertising Co., Ltd(Shanghai). Until 2001 he founded DuDo DESIGN, Du Fengsong had been working as the design director of Shenzhen Chen Shaohua Design Co., Ltd. from 1997. Du Fengsong is the executive director of Shenzhen Graphic Design Association (SGDA), member of Shanghai Graphic Designers Association._____중국의 옛 수도인 시안에서 태어났다.

1989년 시안대학(현 시안문리학원) 공업디자인계 시각전달전공을 졸업했다. 1997년 광고 회사 BATES 상하이지사를 거쳐 Shenzhen Chen Shaohua Design에서 디자인 디렉터로 일했다. 2001년 DuDo DESIGN 회사를 설립했으며 현재 선전그래픽디자인협회(SGDA) 상무이사, 상하이 그래픽디자이너위원회 회원이다.

du.fengsong

두펑쏭.杜峰松.

du.fengsong.

china

068

poster. mi character series. 850 x 850. 2005.

Mi(米) series

In 2005, I created this set of poster by thinking about pictograms and polysemy of Chinese character at the same.

미(米) 시리즈

2005년 나는 중국 한자의 상형성과 다의성을 함께 생각해보고자 이 포스터 시리즈를 제작했다.

青之爭
即靜如浸
以爲茗
從水染神

cha

poster.　zheng-qing cha.　830 x 700.　2011.

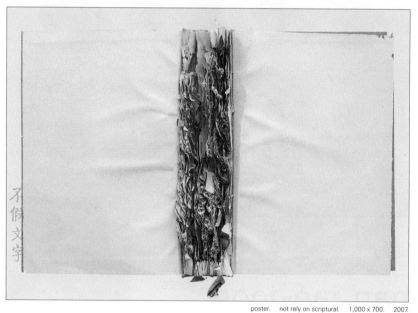

poster.　not rely on scriptural.　1,000 x 700.　2007.

Not rely on scriptural

Prajna is imma-nent in their Essence of Mind, need not rely on scriptural authority,since they can make use of their own wisdom by constant practice of contemplation.

비가문자(不假文字)

프라야나(반야심경의 반야, '지혜'를 뜻함)는 무릇 마음에서 깨닫는 것으로 쓰인 글자에 의지하지 않는다. 이는 끊임없는 명상 수행에 의해서만 그 지혜를 얻을 수 있기 때문이다.

installation. 3d variation. 920 x 1,295. 2011.

한재준.韓在俊.

han.jae-joon. korea

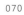

Han Jae-joon is a professor at Seoul Women's University and teaching 'Hangeul Design', 'Typography' and 'Identity Design'. He usually works for design activities through academic associations such as Korean Society of Typography, Korean Society of Design Science, Korean Society of Basic Design & Art, King Sejong Commemoration Committee, and the Korean Language Society.＿＿＿＿＿＿＿＿＿＿＿＿＿＿＿＿＿＿＿＿서울여자대학교에서
한글 디자인, 타이포그래피, 아이덴티티 디자인을 강의하고 있다. 한국타이포그래피학회, 한국디자인학회, 한국기초조형학회(VIDAK),
세종대왕기념사업회, 한글학회 등을 통해 주로 한글과 디자인에 관련된 활동을 펼치고 있다.

han jae-joon

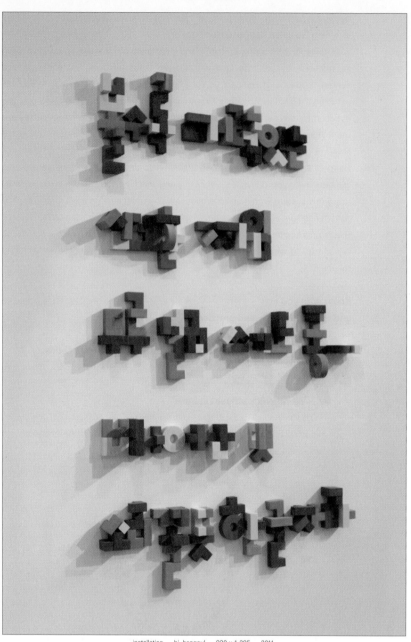

installation. hi, hangeul. 920 x 1,295. 2011.

han jae-joon

It has been 25 years since I started developing typeface as I was attracted by the letter abstract while in college. During the period, I found a fundamental problem of Hangeul and realized that to solve it, it needs to attract part of social agreement and integrate oral and written communication systems. Meeting Dr. Gong Byeong-Woo, a pioneer of mechanization of Hangeul in 1988 was luck in my life and it was a critical event to have me study Hangeul and

develop typeface in earnest. Since then, I have developed innovative typefaces including Gonghan Font and Han Font and after 1990, I announced research results to verify philosophy, principle, and excellence of Hangeul. I published teaching material <Hangeul Design> with the professor Ahn Sang-Soo and expanded serious problems of Hangeul as social problems by planning <Hangul, Teacher> exhibition with the professor Kwon Hyuk-Soo. I suggested the need and the direction for the establishment of Hangeul Culture Center and Hangeul Development Agency and also proposed the fundamental value of Hangeul and excellence of design in <2011 Gwangju Design Biennale> and another problems of Hangeul as a new perspective. In 2008, I also developed 3D module applying Hangeul invention principles. While making teaching tools and playing tools by using this system with high extension, I was getting into Hangeul. I recently had confidence that Hangeul is a new type and content of communication system that is unprecedented in the history of mankind. I value such a fact and a discovery and try to widely spread this value. These days, I live fixing below words in my mind.

'Know who you are,
and think differently and practice.

 Love nature and humans truly,
 and pursue convenience and practicability.
 If so,

 you will spread
 and enjoy affluent culture.'

I got this phrase from Hangeul founder King Sejong's life and the philosophy of <Hunminjeongeum>, design guideline left by him.

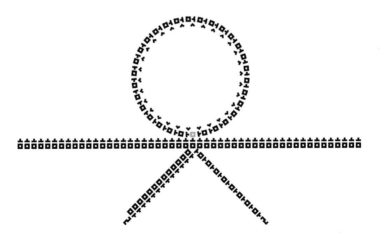

installation. hangeul ideogram. 920 x 1,295. 2011.

visible poetry. mom. 250 x 250. 2010.

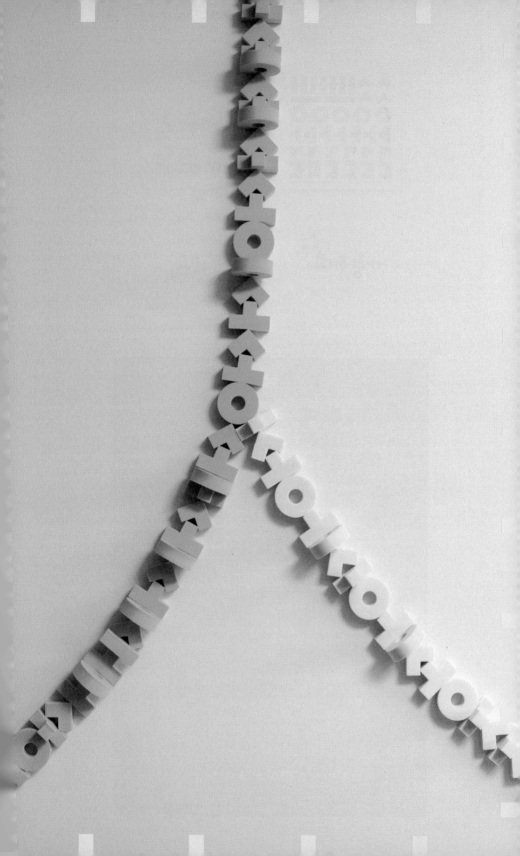

대학 시절에 문자추상 작업에 이끌려 활자꼴 개발에 뛰어든 지 30년
이 되었고 그 기간 동안 한글의 근원적인 문제를 알게 되었다. 이 문제
의 해결을 위해서는 일정 부분의 사회적인 동의를 끌어내야 하며, 또한
말과 글의 소통 체계를 통합시켜야 한다는 것을 깨달았다. 한글에 대
해 더욱 깊이 몰입하게 된 계기는, 1988년에 한글 기계화의 선구자인
공병우 박사를 만나게 된 일이다. 이것은 인생의 행운이었고, 한글 연
구와 활자꼴 개발에 날개를 단 중요한 사건이었다. 그 이후로 공한체와
한체를 비롯한 몇 가지의 활자꼴 개발을 진행해왔고, 1990년 이후에
는 한글의 디자인 철학과 원리, 우수성 등을 입증하기 위해 연구 결과
를 발표하기도 했다. 1999년에는 안상수 교수와 함께 한글 디자인을
안내하는 책『한글디자인』을 발간하였고, 2008년에는 권혁수 교수와
함께 〈한글, 스승〉 전시를 기획하여 한글이 처한 문제의 심각성을 사회
문제로 확산시키기도 하였다. 한글문화관과 한글진흥원의 필요성과 설
립 방향에 대해 제안을 하였고, 〈2009 광주디자인비엔날레〉에서는 한
글의 본질적인 가치와 디자인의 우수성뿐만 아니라, 또 다른 한글의 문
제점들을 드러내었다. 2008년에는 한글 창제 원리를 응용한 입체 모
듈을 개발하였고, 최근에는 이 체계를 활용하여 한글교육 교구와 놀이
도구 등을 만들면서, 점점 더 깊이 한글에 빠져들고 있다. 한글이 소리
와 꼴과 뜻이 통합적으로 작동되는 글자라는 확신을 갖게 된 것도 얼마
되지 않은 일이다. 이 확신은 한글이 인류사에 없던 새로운 형식과 내
용의 의사소통 체계라는 믿음을 더욱 굳건하게 하고 있다. 이러한 사실
과 발견은 매우 소중한 것이므로 이 가치를 널리 나누고 싶다. 요즘에
는 아래의 문장을 마음에 새기면서 살고 있다.

075

'내가 누구인지를 바로 알고,
남다르게 생각하고 실천하라.

　　　　　　　자연과 사람을 진정으로 아껴 사랑하고,
　　　　　　　편리와 실용을 추구하라.

　　　그렇게 하면,
　　　풍요로운 문화를 펼치고
　　　누릴 수 있을 것이다.'

한글을 만든 세종 이도의 삶과 그가 남긴 디자인 지침서『훈민정음』의
철학에서 얻은 내용이다.

han jae-joon

visible poetry.　　sing sing sam sam.　　150 x 840.　　2010.

poster.　bodhi kae.　700 x 1,000.

자상곤괘(字象乾坤)
글자는 우주만물을 형상화한다.

한자잉.韓家英.

Han Jiaying Design & Associates Ltd. 크리에이티브 디렉터이다. 중앙
미술학원 도시디자인학원 객원 교수이며 뉴욕 ADC, 영국 D&AD, 국제 그
래픽디자인 연맹(AGI) 회원이다.

poster. the book of changes. 700 x 1,000.

Word Forms,
so Marvellous!

han.jiaying. china

Han is the General Manager and Creative Director of Han Jiaying Design & Associates Ltd. He is a visiting professor of China Central Academy of Fine Arts, and a member of NY ADC, British D&AD and AGI.

Pay tribute to Chinese characters by artistic design.

Chinese character is one of the most ancient characters in human civilization. From the ancient legend that Cang Jie created characters to oracle, bronze inscription, seal script, official script, regular script, Chinese characters inherit Millennium culture of China, spread eastern civilization by its ancient and mysterious power, going through all the vicissitudes but still fresh and valuable. As the semiotics esthetician Cassirer believes, "art can be defined as a symbolic language", as a symbol of recording language and bearing culture, Chinese characters itself are a superlative art. This art surpasses the visual formal beauty, deposits the wisdom of thinking and becomes mysterious aesthetics like philosophy. We try to use the basic elements of design "point, line, plane" with the essence of the three masterpieces on China's ancient philosophy "Tao Te Ching", "The Book of Changes", "Bodhi hymn" to explore the possibility of design of Chinese character fonts, release aesthetic charm of Chinese characters and pay tribute to Chinese characters and Chinese philosophy by the art of plane design.

"Great Rule" page uses the basic design elements - the "point" to convey the philosophy beauty of fonts.

Lao-tzu is the earliest great philosopher in China or even in the world who has simple dialectics thoughts, writing "Tao Te Ching" by the exploration the research of natural variation rules of universe. "Rule produces one, one produces two, two produces three and three produces everything". Rule is the insight of Lao-tzu on trace to the source of truth of the universe. When rule wisdom derives to design elements, the point is also a rule. Point is the origin of the universe, which can be turn into line, surface and all things on earth. Regarding point as the minimum element and blending it into the font, its endless changes begin. In the grand sight, there are no points but words, while in every detail, no words but points can be seen. Whether they are seen or not seen, they are only points on version. The perception that whether the word exists in your sight creates a sense of beauty of rhythm changes, just as the so-called "existence and nothingness are created together". It also shows a kind of dialectical font aesthetics. This dialectical relationship deduces between black and white, colored and colorless, accomplishs a task with ease between ancient version and modern version and shuttles back and forth freely between outside form beauty and inherent thinking. There is rhythm in changes and connotation in

han jiaying

book. the book of changes. 240 x 360.

simple form, which creates endless visual language for the expression of font design.

"Yuanhenglizhen" page uses the basic design elements - the "line" to convey the philosophy beauty of fonts.

"Book of Changes", which is known as the "leader of Sutura, source of the rules", is the most profound book on ancient wisdom of China. From the earliest king of China Fu His to Zhou Wenwang and from eight trigrams interpretation to trigrams, "Book of Changes" has formed a complete and mysterious philosophy system of "change". "Book of Changes" is essentially derived from "divination" and the liner signs of yin and yang "–" and "-" are its symbolic symbols. Lines are the tracks for the movement, which can most vividly convey the philosophy meaning of "Variation", "simple change" and "no change"in "change" - everything in the universe are moving and changing, but the simplest rule of movement is constant. Therefore, we regard "line" as the basic unit of design and cross and form the relation between lines in the form of "爻" to form a new artistic expression of font. The movement of lines forms surfaces. The combination and changes of lines between bright and dark, deep and shallow, long and short, vertical and horizontal constitute a character form of dynamic and abstract symbols, just like hieroglyphs of divination on the oracle, which is quaint, simple and vivid, as if people can see other people walking, birds flying, fish diving, the hustle and bustle of large crowds, all living things and the vitality of them, which makes people can not help but sigh with emotion, mortal beings, worlds, Vientiane life, it, "Great Kengen!." On the advantage of static energy of "As heaven's movement is ever vigorous, so must a gentleman ceaselessly strive along", in the meantime with tracing to the source of original symbols of Chinese characters, we release internal visual vitality of them by design elements with philosophy meaning.

"Bodhi" page uses the basic design elements - the "plane" to convey the philosophy beauty of fonts.

As the mainstream of Chinese Buddhism, Zen Buddhism insists to understand thoroughly and enlighten the realm of truth under the principle of Zen "direct to heart and form Buddhism from personality". Zen began from Tang Dynasty and has integrated into the millennium culture of China and has become part of Eastern civilization, spreading to overseas. From Bodhidharma to the sixth patriarch of China Huineng, the insight realm of "recognition of mind's nature" has continuously sublimated. "Bodhi hymn" is the crystallization of wisdom of Zen, as well as the philosophy understanding of opposite of subjective idealism and objective idealism. Shenxiu's words "body is the bodhi tree, while the heart is stand of a mirror bright. Always wipe, lest a dust alights" is an objective side; the sixth patriarch Huineng further understand the other side of the Zen: "There is no bodhi tree, nor stand of a mirror bright, Since all is void, Where can the dust alight?", which reaches the Mahayana realm of understanding Buddhism with heart. Bring the understanding of "empty" in "Bodhi hymn" into the technique of design and create more possibilities for font in art of design. A closed line creates a plane and simple and clear lines enclose and combine character with façade, which provides people the perception of visual associations that character itself is a vivid picture, whose shape is like a bright mirror and a monk who studies Zen, which is hollow but having real meaning and profound implication. The shape of font is like the Sanskrit engraved on the platform, which is greatly nurtured by the ancient philosophical wisdom and pass on pureness and permeability of heart illustrated by "Bodhi hymn" with intuitive visual design. It moves people's hearts by making Chinese characters the most vivid expression of the art exists of philosophy connotation.

디자인이라는 예술로 한자에 경의를 표하다

한자는 인류 문명 중에서 가장 오래된 문자 중의 하나이다. 창제가 글자를 만들었다는 오랜 전설에서부터 갑골문, 금문, 전서, 예서, 해서에 이르기까지 한자는 그 유구함과 신비로운 힘으로 중국의 천년 문화를 이어받아 동방의 문명을 전파하고 있다. 이렇게 한자는 온갖 역경에도 불구하고 여전히 새로운 가치를 전달하고 있다. 　　독일의 기호학자 카시러(Cassirer)가 "예술은 하나의 기호학 언어로 정의할 수 있다."라고 말했듯이, 한자는 언어를 기록하고 문화를 지탱하는 하나의 기호이며, 글자 자체가 최상의 예술인 것이다. 이러한 예술은 시각적 형태의 아름다움을 초월하여, 생각의 지혜를 집약하고 철학과 같이 미스터리한 미학이 되기도 한다. 우리는 디자인의 기본 요소인 점, 선, 면과 중국 고대 철학의 3대 저작인 『도덕경(道德)』, 『역경(易经)』, 『보리게(菩提偈)』의 세계관을 결합하여 사용하고자 노력한다. 이는 한자 타이포그래피의 가능성을 탐구하고 한자의 미학적 매력을 드러내는 것이며, 동시에 시각 디자인이라는 예술 행위를 통하여 한자와 중국 철학에 대한 경의를 표하는 것이다.

'비상도(非常道)' 서체의 철학적인 아름다움을 전달하고자 디자인의 기본 요소인 '점'을 사용한다

소박한 변증법적 사고를 갖고 있던, 중국은 물론 세계적으로도 초기의 대철학자로서 노자는 천지만물의 자연 변화 규칙에 대한 연구를 거쳐 『도덕경』을 저작했다. "도는 하나를 만들고, 하나는 둘을 만들고, 둘은 셋을 만들며, 셋은 만물을 만든다." 도는 우주만물의 근원을 찾아가는 노자의 통찰이다. 　　도의 지혜를 디자인의 요소에 귀착시킬 때 점이야말로 하나의 도이다. 점은 우주의 기원이며 점이 모여 선을 이루고 면이 만들어져 만물을 형성한다. 점이 디자인의 가장 작은 원소라고 보고 이를 서체에 결합시킴으로써 끊임없는 변화가 시작된다. 크게 보면 글자에선 점이 보이지 않고 세부적으로 보면 글자는 보이지 않고 점만 보인다. 보이거나 보이지 않거나 그것은 시각적 의미에서 점일 뿐이다. 글자의 감지 여부에 따라 변화무쌍한 리듬의 아름다움을 느낄 수 있다. 이른바 "존재와 아무것도 존재하지 않음(nothingness)이 함께 만들어지는 것이다." 이는 또한 일종의 변증법적 서체 미학을 보여주기도 한다. 이러한 변증법적 관계는 흑과 백 사이에서, 색이 있고 색이 없음에서 도출된다. 그리고 태곳적 시각과 현대 시각 사이, 외적인 형태의 아름다움과 내적인 사유와 철학적 아름다움 사이를 자유롭게 넘나들면서 쉽사리 임무를 수행한다. 변화 속의 리듬과 간결한 형태 속에서의 함축된 의미는 타이포그래피의 표현에 무한한 시각 언어를 창조한다. 　　『도덕경』에는 "모든 아름답다는 가치는 절대적이 아닌 상대적일 수 있다(天下皆知美之为美)."라고 적혀 있다. 따라서 철학적인 관점에서 한자의 상징적 형태들이 보여주는 내적 아름다움의 진수를 포착하고 그 아름다움을 이런 철학과 함께 세계적 가치로 승화시켜야 한다.

'원형리정(元亨利貞)' 디자인 요소인 선으로 글자의 철학적인 아름다움을 전달한다

'모든 경서의 시조이며 대도의 근원'이라고 평가받는 『역경』은 중국의 가장 오래되고 심오한 지혜를 담고 있는 책이다. 중국의 복희(중국 고대의 전설적인 제왕)부터 주문왕에 이르기까지 팔괘연의로부터 육십사괘에 이르기까지 『역경』은 가장 완성도 높고 깊이 있는 '역'의 철학 체계를 갖추었다. 　　『역경』은 본질적으로 '복서(卜筮, 도교에서 길흉을 점치는 점재)'에서 기원하였으며, 선형적 형태인 '— —', '—'의 엇갈림인 '효(爻)'에 상징적인 기호적 의미를 부여한다. 선은 운동의 궤적이며, 가장 생동감 넘치게 '역(易)'의 '변역(变易, 변화)', '간역(简易, 단순한 변화)', 그리고 '불역(不易, 변화 없음)', 즉 우주만물은 항상 운동과 변화를 거듭한다는 철학적

poster. the poster of tao te ching. 700 x 1,000. 2011

의미를 전달할 수 있는 요소이다. 따라서 우리는 '선'을 가장 기본적인 단위 요소로 간주하고, 선과 선 사이의 엇갈림과 교차하는 '爻'의 방식을 통해서 새로운 타이포그래피 표현을 만들고자 한다. 선의 움직임은 면을 만든다. 선의 밝고 어두움, 깊고 얕음, 길고 짧음, 수평과 수직 간의 결합과 변화를 통해 하나의 추상적인 기호와 문자 형태가 만들어지고, 이는 갑골문이나 복서의 상형문자를 보는 듯한 예스럽고 간결하며 생동감 있는 느낌을 준다. 마치 사람이 걸어다니고 새가 날고 물고기가 헤엄치는 듯 만물과 함께 어우러져 생기가 넘치며, 이는 사람들로 하여금, '대재건원(大哉乾元, 『역경』에 나오는 세상 삼라만상을 모두 포함하고 있다는 의미)!'이라 감탄하지 않을 수 없게 만든다.

'보리(菩提)' 디자인의 기본 요소인 '면'을 이용하여 글자의 철학적 아름다움을 표현한다

선종은 중국 불교의 주류로서 '직지인심 견성성불(直指人心 見性成佛, 인간사의 아픔을 알게 되고 마음속의 부처를 알게 되면 성불할 수 있다는 의미)'을 중시한다. 선종은 당나라 시대부터 시작되어 중국 천년 문화의 기초가 되었으며 동아시아 문명의 한 부분으로 널리 전파되었다. 보리달마로부터 중국 육조혜능에 이르는 '명심견성(明心見性, 마음의 본질에 다다름)'의 돈오사상은 부단히 지속되고 있다. 『보리계(菩提偈)』는 선종 지혜의 결정체이자 주관유심론과 관유심론의 대립을 설명하는 철학적 깨우침이다. 신수는 다음과 같이 이른다. "육체는 보리수이고 마음은 명경대이다. 수시로 닦지 않으면 먼지가 쌓인다." 이는 선종의 객관적 측면을 말해주는 반면, 육조혜능은 "보리수란 없을뿐더러 명경대도 없다. 세상엔 사물이 없거늘, 어찌 먼지가 있을 수 있으랴?"라고 이르며 선종의 다른 측면의 이치를 깨닫고 대승(大乘)의 경지에 도달하였다. 『보리계』의 '공(空)' 개념을 디자인 기법에 도입하면 타이포그래피에 있어서 많은 가능성과 마주치게 된다. 폐쇄된 선은 면을 이루고 단순명료한 선들이 둘러싸여 입체적인 글자들이 만들어지면서 보는 이들에게 시각적 연상을 제공한다. 글자는 그 자체가 명경이나 좌선하는 스님의 모습을 보는 듯한 생동감 넘치는 지면을 만들어낸다. 그것은 비어 있되 진정한 의미와 심원한 암시를 담고 있다. 글자의 형태는 마치 경전에 새겨진 산스크리트어처럼 고대 철학사상의 지혜를 담고 있으며 이것은 가장 직관적인 시각 디자인이다. 『보리계』에서 말하는 마음속 깊은 곳의 맑고 투명함을 밝힘으로써 글자는 철학적 의미를 가장 생생하게 전달하는 표현이 되어 사람들에게 감동을 주기에 이른다.

Born in China 1971. After receiving MA degree from China Academy of Art (CAA) in 1997, he became a Professor in CAA. He turned very early into a poster artist and multimedia designer, designed works for many cultural institutions on drama, opera, art show, book etc. And he won many awards in many international poster competitions, such as gold medal of the 1st China International Poster Biennial, silver medal of the 9th Chinese National Art Exhibition; Excellent Award of HKDA Design 2000 Show. He is the director of Graphic Design Department of CAA, director of Multimedia Design Centre of CAA, and the member of Jury of 2nd China International Poster Biennial (CIPB), also the chairman of Art Design Institute of China Academy of Art.

poster. image of istanbul-istanb00000. 900 x 1,280. 2005.

han xu

han.xu. china

082

poster. image of istanbul-golden words. 900 x 1,280. 2005.

한쉬.韩绪.

1971년 출생이다. 1997년 중국미술학원(CAA)에서 석사학위를 받고 동 대학교 교수가 되었다. 그는 일찍이 포스터 아티스트와 멀티미디어 디자이너로 방향을 잡고 활동을 시작했으며, 연극, 오페라, 전시회, 출판과 관련한 여러 문화기관과 작업을 해왔다. 〈제1회 중국 국제 포스터 비엔날레〉 금상, 〈제9회 중국 국립미술전〉 은상, 〈HKDA 디자인 2000 쇼〉 우수상을 비롯하여 수많은 국내외 디자인 관련 상을 받았다. 현재 CAA 그래픽디자인학과 학장, CAA 멀티미디어 디자인센터 책임자, 〈제2회 중국 국제포스터 비엔날레〉 심사위원이다.

083

han xu

poster. image of istanbul-west&east. 900 x 1,280. 2005.

T+: Typeface plus

As we know, Typeface was a kind of tools,
 tools for translation,
 tools for communication,
and tools for make living maybe.

At the same time ,

Typeface was a kind of bridge;
Typeface was a kind of interpretation;
Typeface was a kind of advocate;
Typeface was a kind of release;

 Typeface was a kind of attitude;
 Typeface was a kind of clamor;
 Typeface was a kind of flaunt;

 Typeface was a kind of weapon;
 Typeface was a kind of exploitation;

Typeface was a kind of discrimination;

 Typeface was a kind of privilege;
 Typeface was a kind of magician;

 Typeface was a kind of proud;
 Typeface was a kind of feeling;
 Typeface was a kind of culture;

Typeface was a kind of political;
Typeface was a kind of tradition;
Typeface was a kind of dream;

Typeface is a important part of real life.

After all, are you a typeface designer indeed?

poster. fashion&culture-broken shoes. 700 x 1,000. 1999.

T+: 타입페이스 플러스

우리가 알다시피 타입페이스는 도구의 일종이었다.
번역을 위한 도구,
　　　　소통을 위한 도구,
　　　　　　　　살아가기 위한 도구였다.

동시에,

　　　　타입페이스는 다리의 일종이었다;
　　　　타입페이스는 해석의 일종이었다;
　　　　타입페이스는 옹호의 일종이었다;
　　　　타입페이스는 해방의 일종이었다;

　　타입페이스는 태도의 일종이었다;
　　타입페이스는 외침의 일종이었다;
　　타입페이스는 과시의 일종이었다;

타입페이스는 무기의 일종이었다;
타입페이스는 착취의 일종이었다;

　　　　타입페이스는 차별의 일종이었다;

타입페이스는 특권의 일종이었다;
타입페이스는 마술의 일종이었다;

　　타입페이스는 자부의 일종이었다;
　　타입페이스는 느낌의 일종이었다;
　　타입페이스는 문화의 일종이었다;

　　　　타입페이스는 정치의 일종이었다;
　　　　타입페이스는 전통의 일종이었다;
　　　　타입페이스는 꿈의 일종이었다;

　　　　타입페이스는 실제 삶의 중요한 부분이다.

당신은 진정 타입페이스 디자이너인가?

han xu

poster. fashion&culture-scarlet letter. 700 x 1,000. 1999.

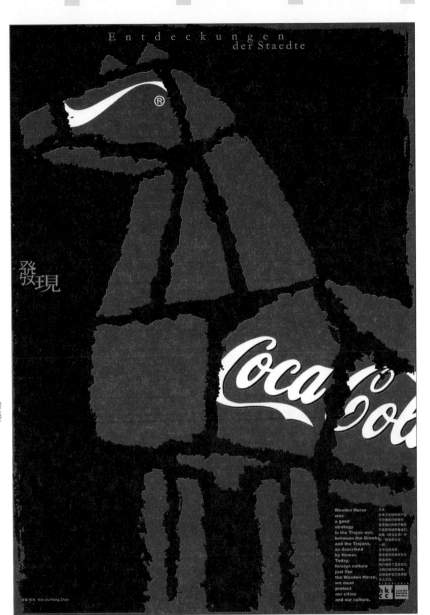

han xu

poster. city discover-woden horse. 900 x 1,280. 2003.

靳埭强设计奖十年庆典

汕头大学长江艺术与设计学院
公元二零零零年十二月十二日

han xu

poster. ktk_10 years. 900 x 1,280. 2010.

Born in 1947, Tokyo, Harata was educated in visual design course in Tokyo University of the Arts. After working in WXY, he founded EDiX in 1989. Harata HeiQuiti is known for his editorial design, book design and typography with use of unique typography and sense of colours, with his motto 'Joyful Editing & Happy Designing'. His early visual works for Japanese underground magazines and musicians have made Harata a cult star in Japanese graphic culture. He has been active in various cultural fields including literature, manga, music and theater. Since the 90's, he has developed his own visual methodology with computers in reference to traditional aesthetics and modernism in Japan. Harata received many awards including Kodansha book design awards for his design of Tarufo Inagaki, <One Thousand One-Second Stories>. He teaches at Joshibi University of Art and Design Junior College.

book. katsue kitasono. "shiro no arubamu" (white album). 130 x 188. 2005.

하라타. 헤이키치. 羽良多平吉.

harata.heiQuiti.japan

1947년 도쿄 무사시노 출생이다. 조시미술대학교 조형학부 디자인과정 정보미디어계연구실 강사이자 그래픽 디자이너로 활동하고 있다. 1970년에 도쿄예술대학 미술학부에서 시각 디자인을 전공한 후, 편집 디자인을 중심으로 북 디자인 작업을 하고 있다. 1979년 설립한 편집 디자인 사무실 더블엑시(WXY)를 거쳐 1989년부터 에딕스(EDiX)의 대표를 맡고 있다. 그는 즐거운 편집과 행복한 디자인을 모토로 보색이나 유니크한 색을 자유자재로 다루는 섬세한 색채 감각과 활자부터 그런지 폰트까지 횡단하는 독특한 타이포그래피 감각을 두루 갖추었다. 최근에는 『백(白)의 소식』에 관한 모더니즘에 심취되어 갓 번짐에 착안한 새로운 기준을 내세우고 있다. 〈제22회 다케오페이퍼쇼〉 포스터 통산장관상, 생산국장상, 나가이 히로시의 책 『머큐리 시티』로 〈제23회 일본 북디자인 콩쿠르〉 심사위원장려상 수상, 이나가키 아시호의 『일천일초 이야기』로 고단샤출판문화상, 굿디자인상을 수상했다. 『기동전사 건담 공식 백과사전』으로 〈제36회 일본 북디자인 콩쿠르〉 일본인쇄산업연합회장상을 수상했다. 현재 〈유리이카〉, 〈건축잡지〉, 〈패치워크 통신〉 등의 편집 디자인 작업을 하고 있다.

Harata developed and practised his own book design methodology "Shoyo-Sekkei". Literally translated, the aggregate parts are: Sho (book) + Yo (vessel) + Sekkei (design). No mere conflation, the Yo element simultaneously means "outlook" - referring not only to modern Western "form and content" philosophies, but a more holistically comprehensive overview of the total architecture of the book as object and how readers will interact with a book project as both object and media. Harata utilizes traditional Japanese aesthetics to help reify both the thought and form of these types of projects.

After the introduction of computers in the late 90s, Harata began researching his own aesthetics based on an ontology of the tools at hand - pixels and digital typefaces, which are conceptualized into his coined terms like "pixel zone", "fontasy" or "fontology". After years of applied research examining the relationship of digital tools, writing and media, Harata's interests have shifted toward an examination of the ambiguity and concreteness of shiro, the Japanese word which represents both white and emptiness.

At the core of Harata's practice is a desire for a unified methodology of total design that dissuades deconstruction or fragmentation. Heavily reliant upon the compound, juxtapositional nature of the Japanese language, Harata's work is worth prolonged examination. MUROGA Kiyonori, IDEA magazine-editor in chief

그는 서적 디자인을 장정이나 북 디자인이 아니라, 용기(容器)인 동시에 모습을 의미하는 '용(容)' 자를 써 '서용설계(書容設計)'라고 부른다. 그리고 소재나 도구의 존재론을 내포한 '덴고쿠(点國, pixelzone)', '폰타지(fontazy)', '폰토로지(fontology)' 등의 조어(造語)를 사용함으로써 서적의 모양과 이치(理)를 조화시킨다. 하라타는 또 1990년대 후반부터 디지털 도구를 사용하여 감각과 공학을 왕복하며 컴퓨팅과 이미징을 연결해나갔다. 그 생성적(生成的)인 사고는 색과 도상의 이미지 광학, 공중에 매달린 타이포그래피, 그리고 픽셀과 폰트에 의한 이미지의 해방계로 이어진다. 그 목적지는 대응·대립하는 개념의 동재(同存), 일거양득적인 해피엔딩 융합이다.

무로가 기요노리(室賀淸德), 〈아이디어〉 지 편집장

magazine.　idea no.346 heiquiti harata: yes, i see.　225 x 297.　2011.

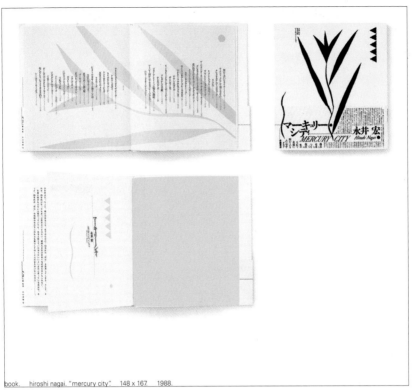

harata heiQuiti

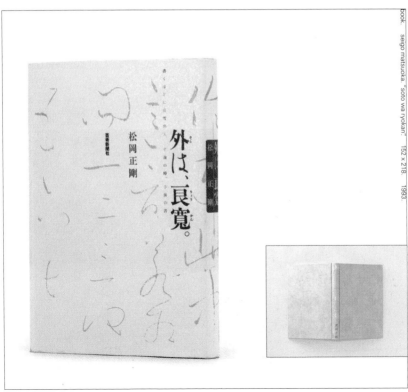

book. gozo yoshimasu. "at the entrance of the house of fireworks". 158 x 220. 1996.

book. masayoshi sukita. "t. rex 1972 sukita". 182 x 257. 2007.

harata heiOuiti

Born in Tokyo in 1964. Graduated from Tokyo National University of Fine Arts and Music (the present-day Tokyo University of the Arts) in 1988 with a degree in Design. In that year, he joined Light Publicity Co. Ltd., Since 2001, he has actively worked as an independent graphic designer and art director. Major works: Advertisement Director for the Kewpie Corporation and East Japan Railway Company. Conducted art direction for magazines <Mayonaka>, <Ryuko Tsushin>, and <Here and There>. Designed logos, symbols, and corporate identities for the Mitsubishi Ichigokan Museum, Tokyo and Utrecht bookshop. Designed exhibition posters and announcements for the Tokyo National Museum of Modern Art, Tokyo, Yokohama Museum of Art, and Tokyo Metropolitan Teien Art Museum. Undertook package designs for the Pocari Sweat 'Earth Bottle', Otsuka Pharmaceutical Co. Ltd. and Queen Bee Garden Co. Ltd. Designed book covers including the <Petit Royal French: Japanese Dictionary> (Obunsha Co. Ltd.) and designed covers for photography books by Takuma Nakahira and Takashi Homma, as well as catalogs and literary books. Major Exhibitions: <Between A and B> (Apel gallery, 2002), <Yusaku Kamekura Design Award Exhibition: Kazunari Hattori> (Creation Gallery G8, 2004), <Kazunari Hattori Exhibition: Visual Communication> (Gallery 5610, 2007), <Nakajo–Hattori's Double Suicide on 8th Avenue> (2 men show with Masayoshi Nakajo, Creation Gallery G8, 2009) and <Kazunari Hattori: November 2010> (GGG, 2010). Major Awards: Tokyo ADC Award, Tokyo ADC Members' Award, Yusaku Kamekura Design Award, Memorial Prize of Hiromu Hara, Tokyo TDC Members' Award and Tokyo TDC Grand Prix.

핫토리.카즈나리.服部一成.

hattori.kazunari. japan

hattori kazunari

094

1964년 도쿄에서 태어났다. 1988년 도쿄예술대학 미술학부 디자인과를 졸업한 뒤 라이트퍼블리시티에 입사했다. 2001년부터 프리랜서 그래픽 디자이너, 아트 디렉터로 활동했다. 주요 작업으로는 큐피하프, JR 등 광고 디자인 디렉션 및 잡지 〈마요나카〉, 〈류코추신〉, 〈Here and There〉의 아트 디렉션을 했다. 그 밖에 미쓰비시일호관미술관, 유토레히토 등의 로고타입, 심벌마크 및 CI 디자인, 도쿄국립근대미술관, 요코하마미술관, 도쿄도정원미술관 등의 전시회 및 홍보물 디자인, 오츠카제약 포카리스웨트와 퀸비가든의 패키지 디자인을 했다. 또한 『프티 로열 불일사전』을 포함한

오분샤사전의 북 디자인, 나카히라 다쿠마, 혼마 다카시 등의 사진집, 화집, 단행본 등이 있으며 〈Between A and B〉(2002,아펠갤러리), 〈핫토리 카즈나리 전〉(2004, 크리에이션 갤러리G8), 〈시각전달〉(2007, 갤러리5610), 나카조 마사요시와 함께한 〈나카조 핫토리 핫초메 신주〉(2009, 크리에이션갤러리G8), 〈핫토리 카즈나리전〉(2010, GGG갤러리) 등 다수의 전시회를 열었다. 도쿄 ADC상, 도쿄 ADC회원상, 제6회 가메쿠라유사쿠상, 하라히로무상, 도쿄 TDC회원상, 도쿄 TDC그랑프리 등을 수상했다.

hattori kazunari

poster. kazunari hattori at ginza graphic gallery november 2010 (no.5). 728 x 1,030. 2010.

poster. flag. 728 x 1,030. 2007.

poster. cake. 728 x 1,030. 2007.

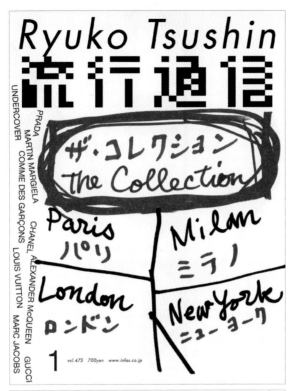

poster. ryuko tsushin. 225 x 297. 2003.

poster. kewpie half mayonnaise. 235 x 297. 2003.

poster. "cream" 5 years old !!. 728 x 1,030. 2007.

poster. kazunari hattori exhibition. 728 x 1,030. 2004.

hattori kazunari

poster. here and there. 420 x 594. 2010.

ドイツ写真の現在
かわりゆく「現実」と向かいあうために

Zwischen Wirklichkeit und Bild
Positionen deutscher Fotografie der Gegenwart ..

Bernd & Hilla Becher
ベルント&ヒラ・ベッヒャー
Michael Schmidt
ミヒャエル・シュミット
Andreas Gursky
アンドレアス・グルスキー
Thomas Demand
トーマス・デマンド
Wolfgang Tillmans
ヴォルフガング・ティルマンス
Hans-Christian Schink
ハンス＝クリスティアン・シンク
Heidi Specker
ハイディ・シュペッカー
Loretta Lux
ロレッタ・ルックス
Beate Gütschow
ベアテ・グーチョウ
Ricarda Roggan
リカルダ・ロッガン

2005年10月25日(火)～12月18日(日)
東京国立近代美術館
The National Museum of Modern Art, Tokyo

MOMAT

アウグスト・ザンダー展
August Sander Face of Our Time

hattori kazunari

099

poster. contemporary positionsin german art photography. 728 x 1,030. 2005.

하야시.노리아키.林規章.

Born in Gifu, 1964. After graduating from Design department of Nagoya University of Art, Hayashi worked as a graphic designer and commercial art director. He is currently teaching at Jyoshi Art University. Hayashi won New Designer Award in JAGDA 2003, Gold Prize in One Show Design Award 2007, Tokyo ADC Award 2010, and many more.————————————————1964년 일본 기후현에서 태어났다. 나고야예술대학 미술학부 디자인과를 졸업한 뒤 광고 아트 디렉터, 그래픽 디자이너로 활동했다. 현재 죠시미술대학 교수이다. 2003년 일본 그래픽디자이너협회(JAGDA) 신인상을 받았으며, 원쇼디자인 어워드(2007) 금상, 도쿄 ADC 어워드(2010) 등에서 수상한 바 있다.

hayashi noriaki

poster. joshibi university of art and design. 728 x 1,030. 2010.

book. munari i libri 1929-1999. 175 x 248. 2010.

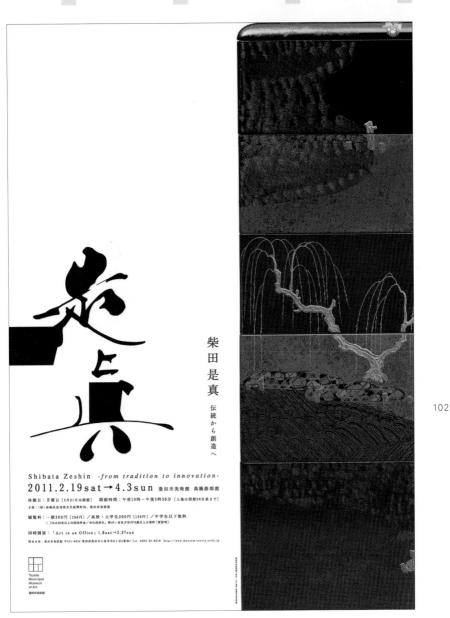

hayashi noriaki

poster. shibata zeshin -from tradition to innovation. 728 x 1,030. 2010.

Typography is wobbling between logic and art.

It is ambiguously and definitely revealing a large chunk of image, bit by bit.

It is similar to carving out stone chunk.

hayashi noriaki

logo.　hanabusa ittyou.　2009.

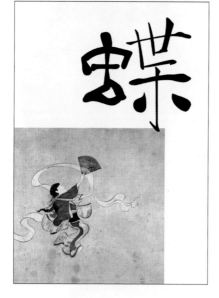

poster.　hanabusa ittyou.　728 x 1,030.　2009.

타이포그래피는 논리와 예술 사이에서 흔들리고 있다.

이미지라는 큰 덩어리 모습을 조금씩 애매하게 그리고 확실히 드러내는 일.

마치 돌덩어리를 깎아나가는 작업과 비슷하다.

He Jianping was born in1973, China. He is now living in Berlin, working as a graphic designer, professor and publisher. He studied graphic design at the China Academy of Art for 3 years from 1991, master of fine arts in Berlin University of Arts in 2001 and had his Ph.D of cultural history in Free University of Berlin in 2011. He had been teaching in Berlin University of the Arts, now employed as guest professor by Hong Kong Polytechnic University, China Academy of Arts in Hangzhou. In 2002 he established his own design studio and publishing house, hesign, based in Berlin with the other branch in Hangzhou since 2008. His works have been globally awarded including Silver medal at the 2nd Ningbo International Poster Biennial; Silver and bronze prize in ADC New York; Silver prize at International Poster Biennial in Warsaw; First Prize at the Lahti International Poster Biennial in Finland; Silver prize in International Poster Triennial Hong Kong; the Golden Bee Awards in Russia; Award for Typographic Excellence TDC New York and TDC Tokyo; Silver medal at the International Poster Biennial in Mexico; Bronze medal of HKDA Hong Kong and German Ruettenscheid Poster Prize in Essen. He held his solo exhibitions in Germany, Hong Kong, Malaysia and Taiwan. He was elected as a member of the professional examination association, school of design ESAG, Paris. He has taken on the judges international committees, including 100 best Germany posters, the International Biennale of Theatre Posters Rzeszow, the International Poster Biennial in Warsaw, the Ningbo International Poster Biennial, the Red dot Design Award, the Design for Asia Award in Hong Kong and so on. He is also a member of the AGI.

he jianping

허젠핑.何见平.

poster. spirited. 841 x 1,189. 2011.

he.jianping. china

poster. peace. 841 x 1,190. 2011.

1973년 중국에서 태어났다. 현재 베를린에 거주하며 그래픽 디자이너, 교수, 출판가로 활동하고 있다. 1991년부터 3년 동안 중국미술학원에서 그래픽 디자인을 공부하고, 2001년 베를린예술대학에서 순수미술 석사과정을 마친 후, 2011년 동 대학원에서 문화사 박사학위를 받았다. 현재 베를린예술대학에서 강의하며 홍콩 폴리테크닉대학교와 중국 항저우예술 아카데미 객원교수를 겸하고 있다. 2002년에 디자인 스튜디오이자 출판사인 hesign을 설립했으며, 2008년부터 항저우에 지사를 두고 있다. 제2회 닝보 국제 포스터 비엔날레 은상, 뉴욕ADC 은상과 동상, 바르샤바 국제 포스터 비엔날레 은상, 핀란드 라티 국제 포스터 비엔날레 우승, 홍콩 국제 포스터 트리엔날레 은상, 러시아 골든비 어워드, 뉴욕TDC와 도쿄TDC의 우수 타이포그래피상, 멕시코 국제 포스터 비엔날레 은상, 홍콩HKDA 동상, 독일 뤼텐샤이트 포스터상 등을 수상했으며 독일, 홍콩, 말레이시아, 타이완 등지에서 개인전을 열었다. 허젠핑은 파리 고등실내건축학교(ESAG)의 시험출제위원으로 선출되었으며, 독일 포스터 100선, 〈제슈푸 국제 영화포스터 비엔날레〉, 〈바르샤바 국제 포스터 비엔날레〉, 〈닝보 국제 포스터 비엔날레〉, 〈레드닷디자인 어워드〉, 〈홍콩 아시아디자인(DFA)〉 등의 심사를 맡았다. 현재 AGI 회원이다.

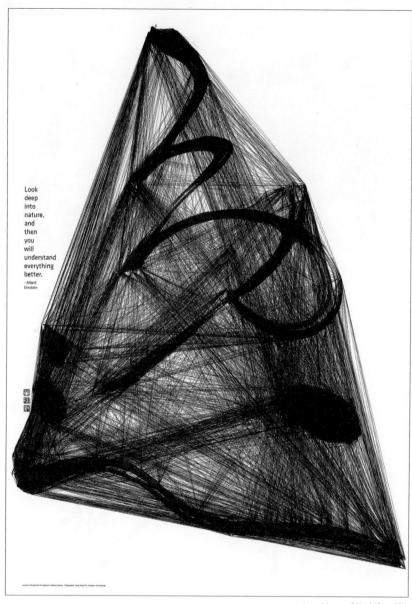

Look
deep
into
nature,
and
then
you
will
understand
everything
better.
- Albert
Einstein

poster. leisure. 841 x 1,191. 2011.

There's a saying in Buddhism that one will not lose anything from the voidness, therefore there is no fear and will not give rise to worries. This idea affects my daily life, and helping myself in problem solving. The living philosophy of Chinese people are more or less under Zhuangzi's "inaction" atmosphere, this "inaction" is embodied in the way we deal with the world and interpersonal relationships. The Zen philosophy helps Chinese people ease their conflicts and self-release before suffering with natural disasters. While in knowledge seeking Chinese people are even more influenced by the "imitating nature". I think I often unconsciously collaborate the idea of "imitating nature" in my creative works or aesthetic trainings. It's certain that it's not persuasive for a graphic designer to explain his work by the

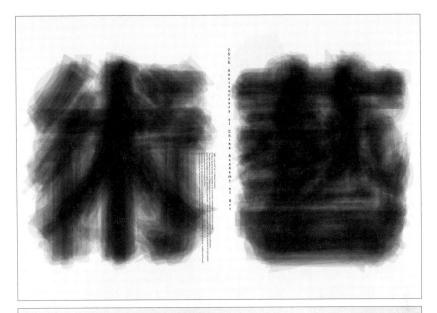

he jianping

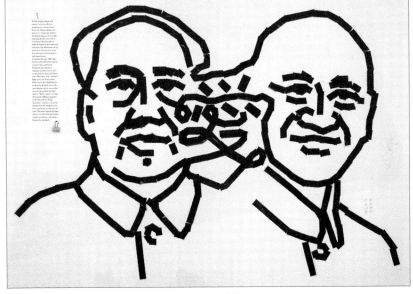

106

poster. 75th anniversary of china academy of art (1/2). 1,682 x 1,189. 2003.

poster. love. 1,189 x 841. 2009.

idea of "imitating nature" but the influence is valid in his thoughts, once the design thinkings
are established there you have design works accordingly. Thinking influences aesthetic ideas
of designers, artists and architects. A few years ago in the Hangzhou Linyin temple, I saw a
sign in the flower bed which said "flowers and trees are both worship offerings, a caring mind
is better than lighting incenses", I think facing this little wooden plaque is really revealing the
Zen of life._____불교에선
비어 있는 것은 잃어버릴 것이 없으니 두려울 것이 없고, 따라서 번뇌와 걱정은 자신이 만들어 내는 것이라고 말
한다. 이 생각은 나의 일상에 영향을 끼치고, 문제 해결에 도움을 준다. 중국 사람들의 생활 철학은 적게, 혹은 많
게는 장자의 '무위사상'의 영향을 받고 있다. 무위사상은 인간 세상과의 소통, 대인관계 안에 녹아들어 있다. 불가

he jianping

poster. agi - to kyo to. 841 x 1,189. 2007.

선종 철학은 중국인들이 자연재해의 고통으로부터 자신의 갈등을 완화시키고 자아를 찾도록 도와준다. 지식 추구에 있어서 중국인들은 더욱 '자연을 본받으라'는 말에 많은 영향을 받는다. 나는 종종 이 자연을 모방한 아이디어를 나의 창작 작품이나 미적 훈련에 무의식적으로 도입하는 경향이 있다. 물론 그래픽 디자이너가 자신의 작품을 '자연 모방'이라는 아이디어로 설명하는 것은 설득력이 부족하겠지만, 이는 분명 사고에 영향을 미치므로, 디자인 사고가 한번 확립되면 그에 따라 디자인 작품이 만들어진다. 사고는 디자이너들, 예술가들, 건축가들의 미적 아이디어들에 영향을 미친다. 몇 년 전 항저우(杭州)의 영은사(靈隱寺)에서 화단에 꽂힌 표지판을 보았다. "꽃 한 송이, 나무 한 그루까지 모두 부처님께 바치는 공물입니다. 보살피는 마음이 향을 피우고 촛불에 불을 붙이는 것보다 낫습니다."라고 쓰인 이 작은 나무판을 보고 있자니 진정한 불교의 뜻을 나타낸다는 생각이 들었다.

poster. niklaus troxler & his students. 841 x 1,189 2010.

108

poster. detour-design show of jianping he in hong kong. 841 x 1,189 2008.

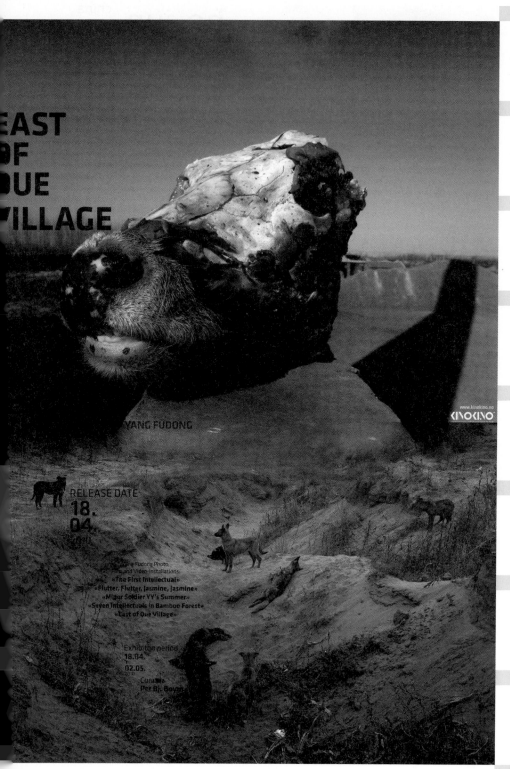

poster. east of que village. 841 x 1,189. 2010.

허쥔.何君. he.jun. china

1977년 칭다오 출생이다. 중앙미술학원에서 그래픽 디자인을 전공했다. 2002년 MEWE디자인얼라이언스를 공동 설립했으며, 2009년 YouAreHere 디자인 사무소를 열었다. 도쿄 TDC, ADC, 영국 D&AD, HKDA 어워드 등 다수의 국제 디자인 공모전에서 수상했으며, 그의 북 디자인은 독일 〈라이프치히 도서전〉에서 '세계에서 가장 아름다운 책', '중국에서 가장 아름다운 책' 부문에 선정되기도 했다. 2008년 국제그래픽디자이너연맹(AGI) 회원으로 가입했으며 현재 베이징예술디자인학원과 중앙미술학원으로 출강하고 있다.

vi. icograda2009 vi. 2009.

he jun

110

Born in Qingdao in 1977, He Jun graduated from School of Design, China Central Academy of Fine Arts, and is teaching at School of Design, China Central Academy of Fine Arts. He is founder of MEWE Design Alliance and YouAreHereDesign, and a member of Alliance Graphique International. He received numerous international awards including Tokyo TDC award, ADC award, British D&AD award, HKDA and etc. The books that He Jun designed were awarded as the Most Beautiful Book Design from all over the World and The Chinese Most Beautiful Book

111

he jun

112

book+poster. little people. 420 x 570 2010

113

1. Solve the problem.

2. Choose the language.

3. Concentrate on details.

4. Control the rhythm.

5. Rely on intuition.

114

poster.　made in china.　570 x 840.　2005.

1. 문제를 해결하라.
　　　　2. 언어를 선택하라.
　　　　　　　3. 세부사항을 중시하라.
　　　　　　　　　　4. 리듬을 장악하라.
　　　　　　　　　　　　　5. 직감에 의존하라.

book.　the books of zhu yeqing.　142 x 210.　2004.

poster. i love chinese charater. 780 x 1,060. 2005.

헤이이양.黑一烊.

hei.yiyang. china

1975년에 태어났다. 디자인 스튜디오 센스팀의 설립자이자 크리에이티브 디렉터로 브랜딩, 전시 기획, 환경 디자인, 출판 분야 등 작업을 하고 있다. 현재 중국에서 문화 교류 활동을 활발히 하는 디자이너 중 한 명으로 그래픽 디자인, 현대 미술, 광고, 건축 공간, 도시, 사회 등의 서로 다른 분야 간의 융합을 통해 흥미로우며 의미와 가치 있는 작업을 하는 데 열중하고 있다. 뉴욕 아트디렉터스클럽(ADC), 칸 국제 광고제, 원쇼디자인 어워드, D&AD(The Best Advertising and Design in the World), ADfest, 홍콩디자이너협회(HKDA) 등에서 다수의 디자인 상을 받았다.

hei yivang

poster. big business 3. 720 x 510. 2010.

Founder & Creative Director of SenseTeam. Born in 1975. Found SenseTeam in 1999. His works are about branding, exhibition planning, environmental design and publishing. He is one of the most active cultural exchange pioneers in China. He devotes himself to putting different mediums like graphic design, contemporary art, advertising, architectural space, city, society together, to make the works interesting, meaningful and valuable. Hei received NY ADC Award, Cannes Lions International Advertising Festival Awards, NY One Show Design Award, D&AD, Adfest Design Lotus,HKDA Awards, and so on.

hei yiyang

poster. x exhibition poster b. 730 x 480. 2007.

I think that all the study and growth derive from work, and the best creation is reasoning.

A good design should form a system, which needs time to think. You should treat it with a research attitude. So I advocate two philosophies of design in the creative world, one is libertinism, and the other is orderliness. Just like a game, the precondition of design should be funny and entertaining, we play it seriously with our ideas.

We devote ourselves to integrated design, using a kind of material as a new communication medium, breaking the traditional design mode. And this medium exists in the whole process of our design. This kind of design is like virus, filling people's sense and consciousness.

나는 작업으로부터 모든 학습과정과 성장이 비롯되고, 최고의 창작은 추론이라고 생각한다.

좋은 디자인은 하나의 시스템을 형성하며, 그러기 위해선 생각할 시간이 필요하다. 우리는 연구하는 자세로 임해야 할 것이다. 그래서 나는 창작의 세계에서 두 가지 디자인 철학을 적극 지지한다. 그 하나는 자유사상이며, 또 하나는 질서정연함이다. 마치 게임처럼 디자인의 전제 조건은 재미있고 즐거워야 하며, 우리의 아이디어로 진지하게 게임을 즐겨야 한다.

우리는 통합된 디자인을 완성하려고 전력을 다한다. 그래서 새로운 소통 매체를 재료로 사용하고, 전통적인 디자인 형태를 탈피하고자 한다. 이 매체는 우리 디자인의 전 과정에 존재한다. 이러한 디자인은 마치 사람들의 감각과 의식을 채우는 바이러스와 같다.

poster. social energy. 780 x 530. 2008.

hei yiyang

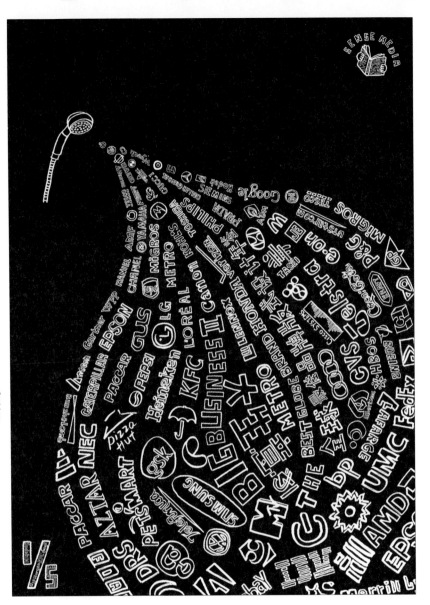

poster. big business 2. 700 x 1,000. 2007.

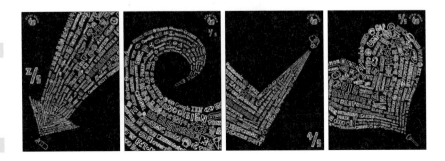

hei yiyang

For the visual identity design of different languages, information transmission is very important, the visual system must play a role in the communication. No matter using the image or text, we believe that good works not only meet the visual identification but also achieve the purpose of information transmission, it should be understood by different countries and cultures. The langue and text are the tools of information identification, great works should across identification.

poster. x exhibition poster a. 540 x 780. 2007.

다른 언어의 시각적 아이덴티티를 디자인할 때는 정보 전달이 매우 중요하며, 시각 시스템은 반드시 소통 과정에서 역할을 수행해야 한다. 이미지를 사용하든 텍스트를 사용하든, 좋은 작업은 시각적으로 훌륭할 뿐만 아니라 정보 전달의 목적을 달성한다고 믿기에, 이는 다른 나라와 문화권에서도 이해되어야 한다. 언어와 텍스트는 정보 식별을 위한 도구이며, 훌륭한 작업은 그 이상을 넘어서야 할 것이다.

1985년 안그라픽스에 입사하면서 사진식자를 이용한 활자 다루는 즐거움에 빠졌다. 그때부터 편집 디자인과 타이포그래피 작업을 주목
했다. 1994년 독립하여 지금까지 17년간 홍디자인을 운영하고 있다. 여전히 타이포그래피가 모든 작업의 기준이 되고 있으며 그런 생
각을 같이하는 스태프들과 함께 일한다. 국민대학교와 SADI 등에서 타이포그래피와 편집 디자인을 강의했고, 한국시각정보디자인협회
(VIDAK) 활자/편집분과 부회장을 역임했다. 현재 한국예술종합학교 미술원 겸임교수이며 출판사 홍시커뮤니케이션을 운영하고 있다.

poster. image korea. 1,040 x 740. 2003.

hong.sung-taek. korea

Hong Sung-taek began his career in 1985 as a designer for Ahn Graphics, a leading Korean design company,
and rapidly became fascinated by photo type setting. At Ahn Graphics, Hong spent most of his time involved in
editorial design and typography. In 1994 Hong established his own firm, Hongdesign Ltd., which he continued
to manage. Hong also continues to center his activities on typography along with his staff. Hong has taught ty-
pography and editorial design at Kookmin University and the Samsung Art & Design Institute, and has served as
department head for Typography/Editorial Design as well as vice-president of VIDAK (Visual Information Design
Association of Korea). Presently Hong is adjunct professor at Korea National University of Arts, and also operate
a publishing firm, Hong Communications.

나는 글자 만지는 일이 즐겁다. 처음에는 오랫동안 가독성 문제에 대해서 고민하고 집중하는 과정이 있었다. 그것은 갈수록 어렵고 혼란스러운 판단이 늘 함께 했다. 결국 기술적인 숙련 위에 정제된 마음과 자세가 개입하게 된다는 것을 느끼면서 타이포그래피의 매력과 재미를 알게 되었다. 글자에 마음이 닿으니 자연스럽게 즐거운 일이 된 것이다.

내가 한글 타이포그래피와 쉽게 가까워진 데는 어려서 잠시 배운 서예 공부의 영향이 있었을 것이라고 믿는다. 서예는 기본이 중요하다고 가르쳤다. 글씨 쓰는 것은 기호를 그리는 것과는 전혀 다른 일이었다. 획과 공간에 감정과 정서가 담긴다는 것을 느끼게 했다. 그 뒤로 붓을 잡을 기회는 거의 없었지만 처음 디자인을 시작하던 시절에 인화지에 새겨진 활자를 대하면 그때의 감정이 살아나곤 했다.

단순하게 압축된 형태는 오히려 풍요로운 상상을 주는 추상의 에너지를 발산한다. 기호의 본질이 그렇듯이 글자도 최대한 압축된 형식이다. 압축은 곧 에너지다. 특히 한글은 시각적으로 가장 간단하고 쉬운 모양이며 태생적으로 독창적인 질서를 갖는 구조다. 게다가 소리를 품은 기호이므로 낱자 하나하나에 울림의 힘을 더한다. 단순함에 울림이 더해진 글자는 형태이기보다 이미지며, 타이포그래피는 이런 이미지를 가지고 노는 하나의 놀이다.

타이포그래피 작업은 공간을 보게 한다. 타이포그래피의 시작은 빈 공간이다. 글자는 양각으로 형태를 만들지만 동시에 다양하고 풍부한 공간을 연출한다. 공간은 글자를 통해서 화려해지기도 하고 엄격해지기도 한다. 작은 책이 넓어지고 커다란 공간이 좁아지기도 한다. 이런 감정의 조율은 어떤 아이디어보다 강한 커뮤니케이션의 힘을 발휘한다는 것을 믿으므로 글자놀이는 언제나 진지하고 즐겁다.

123

poster. image korea 1,040 × 740. 2003

hong sung-taek

My joy in life is working with type. At first I poured myself into the problem of high readability, but the longer I was involved, the more complex and confusing it became. In time I realized that even more important than a high degree of technical refinement was the necessity for a steady, even attitude, and I found greater interest and joy in typography. The joy flowed naturally from the lettering itself.

I believe that this affinity for Korean typography was highly influenced by a short period that I spent learning and practicing calligraphy when young. Calligraphy taught me the great importance of basics. Writing was completely different from merely drawing symbols, and through it I developed the essential sensitivities involved in the use of strokes and space. I never had the opportunity to take up the calligraphy brush again, but when I first began design work, characters on printing paper vividly revived those early sensitivities.

I find that abstract energy that stimulates a rich imagination emanates from simply compressed forms. Symbols represent this, and letters are even more condensed forms. Compression is energy. Korean lettering (hangeul) is visually simple and easy while simultaneously being highly ontogenetic and structurally orderly. Additionally, as phonetic symbols, each letter has the power of sound. And since this is so, each letter is more of an image than merely a phonetic symbol. Therefore Korean typography becomes a fascinating image game.

poster: poster work-1: 1,000 × 1,400: 2011

hong sung-taek

Space is not only an essential ingredient of typography; it is the very beginning of typography. While it is in itself essentially a form of relief work, it also gives birth to a variety of rich spatial forms. Such space both graces and sharply defines the characters. This space has the power to make a small book appear much larger than it actually is, and to make a large space appear smaller. I believe that balancing these sensitivities provides a strong form of communication, and therefore I always find playing with letters a great joy.

125

1983년에 태어났다. 2006년 학교를 졸업한 뒤 Wx-design Studio(광저우)에 입사했다. 3년 뒤 베이징에 Wx-design Studio를 설립하고 크리에이티브 디렉터를 담당했다. 그녀는 정식으로 디자이너로서 일하기 시작했을 때, 왕쉬 교수를 만나게 된 것은 행운이었다고 고백한다. 그의 영향을 받아 2차원과 3차원, 다차원의 경계를 넘어서는 사고와 디자인을 하고 있다. 〈OCT-LOFT 창의전〉(2007-2008), 〈Nakajima Collection〉(2009) Shi Jian이 전시 기획한 〈OCT-LOFT 국제 디자인전〉(2011) 등에 참여했고 시각, 서적, 공간 디자인 등 여러 활동의 기획, 프로젝트를 하고 있다. 〈제1회 베이징 국제 디자인 트리엔날레〉, 〈IGDB6 국제 그래픽 디자인 비엔날레〉(2010) 등의 전시에 초빙되었다. 〈수장-Nakajima〉(2009)는 도쿄 TDC 추천상, 센젠 그래픽 디자인 비엔날레 추천상을 받았고 〈Liu Xiaodong: Painting from Life〉 작품은 2008년 닝보 국제 포스터 비엔날레 은상, 2007년 뉴욕ADC 추천 상을 받았다. 〈Returning to the dreams of Yin and Shang Dynasty〉는 2005년 칸타이콩디자인 동상을 수상했다. 2011년에는 독립 패션 디자이너와 연합하여 실험적인 시각 잡지 〈근호 Radical Sign〉을 창간하여 시각 부호와 형식에 관한 연구를 시작하였다.

hou.ying. ^{china}

허우잉.侯穎.

character. 30 years of chinese comtemporary art. 1,000 x 700. 2010.

126

hou ying

Born in 1983, worked at wx-design studio (Guangzhou) after graduation in 2006, and took the position of creative director at wx-design studio (Beijing) in 2009. As a Chinese designer of the younger generation, I was fortunate to have followed Professor Wang Xu's footsteps in my professional career, reflecting and experimenting ideas on design in two-dimensional, three-dimensional, and even multi-dimensional cross-field and cross-disciplinary projects. My working experience engaged me to participate and curate various professional projects of designing visual material, books and interior spaces. For instance, the 2007 and 2008 OCT-Loft Creative Festival, 2009 Hua Art Museum Nakajima Collection exhibition, and the 2011 OCT-LOFT conceptual design international exhibition, curate by Shi Jian, and etc, just to name a few. Hou Ying's design works were invited to participate in the exhibitions in China and internationally, many of which have received merits. In 2011, Hou participated in the First Beijing International Design Triennale; in 2010, she exhibited at the IGDB6 International Graphic Design Biennale; book design Collection Nakajima received merit award of the Tokyo TDC and nominated for the 2009 Shenzhen Graphic Design Biennale; book design Liu Xiaodong: Painting from Life was received silver award from the 2008 Ningbo International Poster Biennale; graphic design Returning to the dreams of Yin and Shang Dynasty, received the 2005 Bronze Prize in Kan Tai-Keung Design Award. In 2011, Hou Ying and independent fashion designers collaborated on the experimental visual fashion magazine Radical Sign, and embarked on a study of visual signage and forms.

127

poster. ladical sign. 250 x 530. 2011.

The waning of design

In order to discuss art or design, one should first look into different trends and movements in the past. For instance, movements on arts and craft, new art movement, cubism, futurism, dadaism, stylism, structuralism, modernism, post-modernism and etc. A designer is first of all, living in the present time, so his design should also belong to its current era.

The saying of "death in the graphic design" is common in this field in China, current presence will continue to exist at the end of this era of no beliefs. Having lived through the glory in Chinese graphic design of the 1980s and 1990s, as this medium rapidly transformed, graphic design is now only a visual element within spatial design and broadcasting media, thus the claim of entering in the end of its era is logical. At the height of graphic design, it relied on printed medium, posters and books as the most important channels of communication, however in its waning phase, new media era, how could graphic design better communicate its concepts through space and broadcasting media, and how to meet the actual demands of exchange, interface and experience becomes critical.

Traditionally speaking, professional competition usually only focuses on the finished product rather than paying attention to process. In its evaluation process, the final design would be the only standard of judgment. The audience's reception of designed information should not only come from the fixed or linear information, however the judgment on the dynamic, non-linear design language would often create double standards due to geographical and cultural differences in its propagation and evaluation process. The standard of evaluation to a certain degree determines social trends in the style of design. Designers often easily believe in the awarded works, but ignore or fall behind the actual demand due to the rapid change in media technology.

The waning phase of design began with the designers' fear and self-dispersion. While being absorbed in the present, it would be necessary to appropriate from historical examples. One of the origins of modern design, Wurm Design College demands its designers not only to be trained in color and forms, but also to study philosophy, physiology, crafts and other basic fields. Graphic design involves many disciplines, one should keep an open mind in coping with the passive attitude due to changes in the present medium. Furthermore, the decay of the graphic design world is perhaps the beginning of a new era in design in the making.

Note: In religious studies, time can be divided into three phases, the first five hundred, one thousand years is the raising of religion, a phase followers abide to its teachings, and the last ten thousand years would be its waning phase.

hou ying

book. liu xiaodong-painting of life. 375 x 270. 2006;

128

book. liu xiaodong-yanguantown. 215 x 285. 2010.

129

book. collection nakajima. 305 x 400. 2009.

디자인의 말법시대

예술 혹은 디자인을 논할 때 먼저 그 시대를 논하게 된다. 공예
미술운동, 아르누보, 입체파, 미래파, 다다, 구성주의, 모던과 포
스트모던 등, 디자이너는 한 시대에 속할 수밖에 없고 디자인 작
품 역시 그 시대에 귀속된다.

중국 디자인계에는 "시각 디자인은 이미 죽었다"라는 속설이 있
다. 우리는 현재 이러한 디자인의 말법시대에 살고 있으며 앞으
로도 그럴 것이다. 중국 디자인이 1980-90년대의 전성기가 지
나고 각종 매체의 급격한 발전과 더불어 시각 디자인은 단지 시
각적인 요소로서 각종 공간과 영상 매체에 개입하게 되면서 디
자인의 말법시대에 들어서게 되었다. 시각 디자인의 정법시대
는 주로 종이 매체인 포스터, 서적 등에 의존하였다. 그러나 디
자인의 말법시대에 들어서면서 새로운 매체들이 급증하게 되면
서 시각 디자인이 어떻게 공간과 영상 매체를 통해 보다 적극적
으로 상호작용과 인터페이스 기능, 경험을 제공할 것인지가 관
건이다.

전통적으로 디자인 우수작 선정은 과정보다는 그 결과물에만
초점을 맞추었다. 심사과정에서 디자인의 최종 표현만이 유일
한 심사기준이 되었다. 대중은 디자인 정보를 접할 때 단순히 정
적인 선형적 정보만을 받아들이는 것이 아니다. 이러한 비선형
적인 디자인 언어의 심사는 종종 지리적·문화적 차이로 인해 심
사과정에서 양면적인 기준을 만들어낸다. 심사기준은 어떤 의
미에서 보면 사회에서 유행하는 디자인 스타일을 결정하기도
한다. 디자이너들은 수상한 작품들을 쉽게 과신하는 반면, 매체
테크놀로지의 신속한 변화에 대처하는 실질적인 요구에는 소홀
한 경향이 있다.

디자인의 말법시대는 디자이너들의 자아 해방에 대한 공포심으
로부터 시작되었다. 현재 상황에 몰입하기보다는 지나간 역사
를 되볼아보는 것이 바람직할지 모른다. 모던 디자인의 발원지
의 하나인 울름조형대학에선 디자이너는 색채나 형태에 대한
훈련뿐 아니라 철학, 인체공학, 공예나 기타 다양한 분야에 대
한 기초지식을 공부할 것을 요구한다. 시각 디자인은 더욱 다양
한 학문이 개입될 것이므로 개방적인 디자인 사유 과정을 통해
작금의 다양한 매체 변화에 대한 소극적인 정서를 일소해야 할
것이다. 시각 디자인의 소멸은 필시 현재의 변화에 순응하는 또
다른 새로운 디자인 분야의 시작일지 모른다.

Note: 종교학에서 시대를 3부분으로 나눌 수 있다. 부처 열반(nirvana) 후 500년 혹은
1000년을 정법(正法)시대, 그 뒤로부터 상법(像法)시대, 상법이 끝난 뒤 1만 년까지를
말법시대라고 하고 말법시대는 성경에서 말하는 말세와 유사한 의미를 가진다.

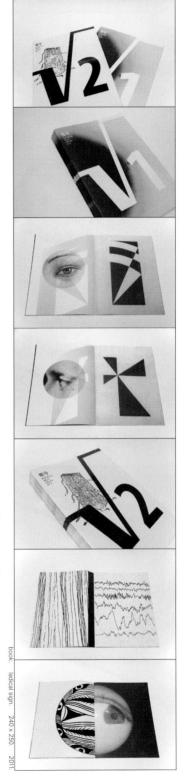

book: radical sign. 240 x 250. 2011.

hou ying

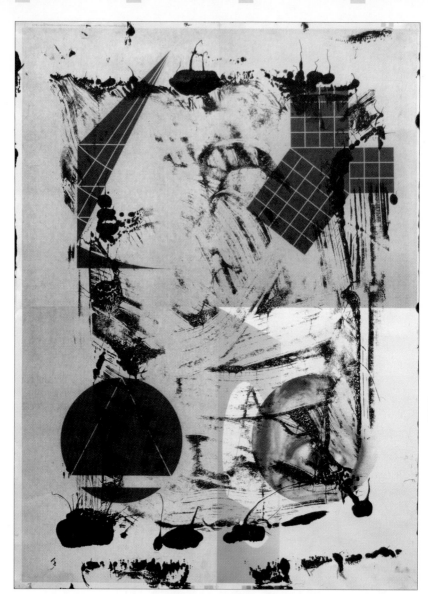

hou ying

poster. ladical sign. 250 x 530. 2011.

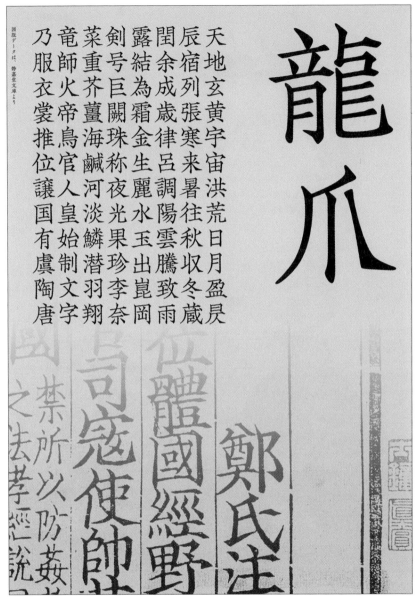

국판データは、静嘉堂文庫より

imada kinichi

typeface. chiense typeface "long zhua". 2008.

이마다.킨이치.今田欣一.

1954년 오카야마현 와케에서 태어났다. 1973년 오카야마 현립시즈타니고등학교 보통과를 졸업하고 1977년 규슈산업대학교 예술학부 디자인학과를 수료했다. 그 후 샤켄에 입사하여 다수의 글꼴 제작에 참여했으며, 〈이시이상 창작 타입페이스〉 공모전에서 수상한 바 있다. 1997년에 독립하여 이마다킨이치 디자인실을 열고 서체 디자이너로 활동하고 있다. 주요 저서로는 『Vignette 05: 도전적 일어 문자의 복각』, 『Vignette 11: 화한구 글꼴 혼식의 제안』, 『Vignette 14: 일어 문자, 끝없는 전진』, 『타입페이스 디자인 시무』, 『타입페이스 디자인 탐방』, 『타입페이스 디자인 만유』 등이 있다.

132

天地玄黄　宇宙洪荒　日月盈昃　辰宿列張　寒来暑往　秋收冬蔵　閏余成歳　律呂調陽　雲騰致雨　露結為霜　金生麗水　玉出崑岡　剣号巨闕　珠称夜光　菜重芥薑　海鹹河淡　鱗潜羽翔　竜師火帝　鳥官人皇　始制文字　乃服衣裳　推位譲国　有虞陶唐

imada kinichi

typeface.　chiense typeface "jin ling".　2004.

imada.kinichi. ^{japan}

Born in Wake, Okayama, 1954. Typeface designer. Imada graduated from Okayama Prefectural Shizutani High School in 1973, and completed Design department of Kyushu Industrial University in 1977. He participated in numerous typeface production in Sha-Ken, and won Ishiisan Creative Typeface Competition. He established Imada Kinichi Design Studio in 1997. Imada wrote many books; <Vignette 05: Dip of Challenging Japanese Letters>, <Vignette 11: Suggestion of Typeface Mix-use in Hwahan>, <Vignette 14: Japanese letters, the Endless Advance>, <Current Affairs of Typeface Design>, <Design Report of Typeface Design>, <Tour of Typeface Design> and many more.

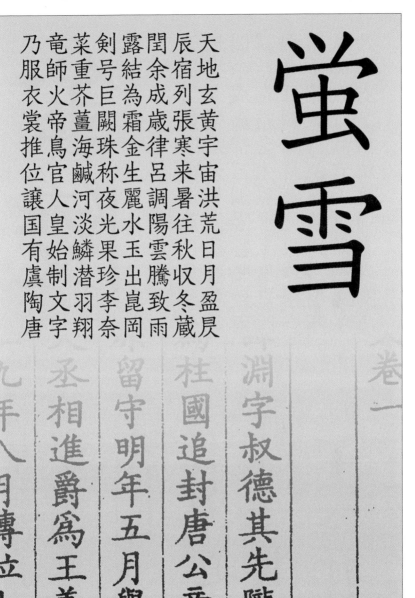

天地玄黄宇宙洪荒
日月盈昃辰宿列張
寒来暑往秋收冬蔵
閏余成歳律呂調陽
雲騰致雨露結為霜
金生麗水玉出崑岡
剣号巨闕珠称夜光
果珍李奈菜重芥薑
海鹹河淡鱗潜羽翔
竜師火帝鳥官人皇
始制文字乃服衣裳
推位讓国有虞陶唐

蛍雪

Source of typeface comes from the history of books. The role of typeface designer may be to succeed the spirit behind it, and sincerely devote in reproduction of the formation. Copy era, Printed Book era, Movable Type era - numerous books were created in each era, and many letters and typefaces are remanent. It is a mission to reproduce them with the breath of new era, make them usable, and succeed them to the next generation. Japanese typeface(Waji) are reproduction of 36 traditional typefaces made by Japanese narrative and printing history from Heian Era to the present day. These were named <Thirty-six Views of Waji (和字書体 三十六景)> from <Thirty-six Views of Mount Fuji (富嶽三十六景)> of Katsushika Hokusai (葛飾北斎). Based on these, many weight variations will be expanded. Chinese characters are reproduction of 24 typefaces from Chinese epitaphs, printed books, printed types from Qin Dynasty to

imada kinichi

typeface. japanese typeface "kamome". 2002.

present day. These were named <Twenty-Four Histories of Chinese Typefaces (漢字書体二十四史)> after the Chinese dynastic affair <Twenty-Four Histories (二十四史)>. But Chinese character typeface production costs a lot of time and effort. Four typefaces are complete so far, more will continue. There are abundant style groups in Roman Alphabet typefaces, but to be composed with Japanese typefaces and Chinese character typefaces similar reproduction is needed. Thus 12 typefaces developed from collection of European books. These were named <12 Ecliptical Constellations of European Typefaces (欧字書体十二宮)> based on the Western astrology <12 Ecliptical Constellations (黄道十二宮)>. The most effective method in intensifying and developing modern Japanese typography is the beautiful harmony composed by the trinity between Chinese characters typefaces, Japanese typefaces, and Roman Alphabet typefaces.

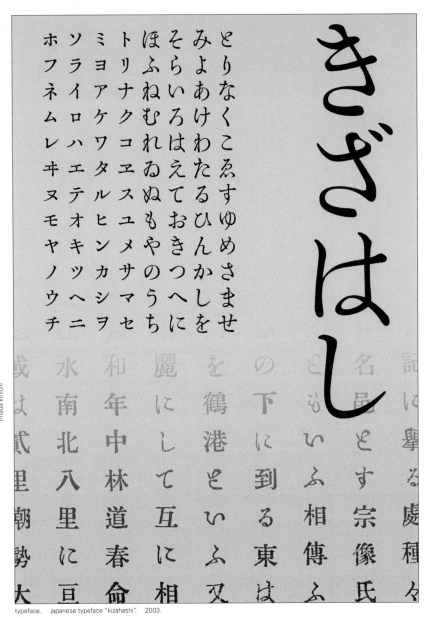

imada kinichi

typeface.　japanese typeface "kizahashi".　2003.

136

활자 글꼴의 원천은 서적의 역사에 있다고 본다. 활자 글꼴 설계자의 역할은 그 배후에 숨겨져 있는 정신계승 및 조형 재생에 성실히 임하는 것이 아닐까. 사본(寫本)의 시대, 간본(刊本)의 시대, 금속활자시대. 각 시대에 수많은 서적이 탄생했고 거기에는 많은 문자와 글꼴이 남겨져 있다. 그것들을 새로운 시대 숨결에 의해 재생시켜 실제로 사용할 수 있게 만들어 다음 세대로 넘겨주는 것이 사명이라고 생각하고 있다. 일본어 글꼴(와지, 和字)은 헤이안(平安)시대부터 현대까지 일본의 서사(書寫)와 인쇄 역사에 의해 만들어진 정통적인 36개 글꼴을 골라 재생했다. 이를 가쓰시카 호쿠사이(葛飾北斎)의 〈후가쿠삼십육경(富嶽三十六景)〉에서 이름을 따 〈와지서체삼십육경(和字書体三十六景)〉이라고 지었다. 이를 바탕으로 하여 다양한 무게감이 있는 베리에이션을 전개해 나갈 생각이다. 한문 글꼴은 진왕조시대부터 현대까지의 중국 비문이나 간본, 활자본에서 재생한 24개 글꼴이다. 중

まどか

とりなくこゑす ゆめさませ
みよあけわたる ひんかしを
そらいろはえて おきつへに
ほふねむれゐぬ もやのうち

トリナクコエス ユメサマセ
ミヨアケワタル ヒンカシチ
ソライロハエテ オキツヘニ
ホフネムレキヌ モヤノウチ

imada kinichi

typeface. japanese typeface "madoka". 2005.

국 역대 왕조의 정사(正史) 『이십사사(二十四史)』에서 이름을 따 〈한자서체이십사사(漢字書体二十四史)〉라고 지었다. 그러나 한문 글꼴 제작은 많은 시간과 노력을 요한다. 현재 완성된 것은 4개의 글꼴이지만 제작을 계속 해 나갈 것이다. 영문 글꼴은 이미 풍부한 활자 글꼴이 있지만 일어 글꼴, 한문 글꼴과 조합하여 사용하기 위해서는 같은 방법으로 재생할 필요가 있다. 그렇기 때문에 역시 유럽 서적을 취재하여 여기서 12개 글꼴을 제작하기로 하였다. 서양점성술의 『황도십이궁(黄道十二宮)』에서 이름을 따 이를 〈구자서체십이궁(欧字書体十二宮)〉이라고 지었다. 현대의 일본 타이포그래피 심화와 발전에 가장 유효한 수단은 한문 글꼴과 일어 글꼴과 영문 글꼴이 삼위일체가 되어 연주하는 아름다운 조화에 있다고 믿는다.

홍익대학교를 졸업한 뒤 정디자인에서 2년간 편집 디자이너로 일했으며, 이후 민음사출판
그룹 내 사이언스북스에서 5년 동안 북 디자이너로 일하며 '과학 책의 대중화'를 위해 노력
했다. 『종교전쟁』, 『메리칸 프로메테우스』 등 선이 굵고 박력 있는 표지 디자인을 선보였으며,
최근의 작업 『시간의 목소리』, 『동적평형』 등 표지 디자인에 글자 작업에 대한 고민의 흔적
을 담았다. 거리에서 글자를 발견, 수집, 관찰하는 작업을 통해 한글 타이포그래피의 의미와
방법을 확장시키려는 시도를 하고 있으며, 이를 바탕으로 세 번의 개인전 〈글자풍경〉을 가
졌다. 현재 영남대학교 시각커뮤니케이션디자인학과 교수로서 타이포그래피, 편집 출판 디
자인을 강의하고 있으며, 학교와 디자인 현장을 오가며 '글자'와 '책'에 대한 연구, 디자인 작
업, 작품 활동 등을 하고 있다.

poster. au magasin de nouveautes written by lee sang. 700 x 1,380. 2010.
poster. sound fragments. 841 x 1,188. 2010.

정재완.鄭在完.

jeong.jae-wan.

jeong-jae-wan

korea

Jeong Jae-wan is a designer of both experimental letter works and commercial publishing book design. After
graduating from Hongik University, Jeong worked as editorial designer at Chung Design for 2 years and as book
designer at Minumsa Publishing Group for five years. He designed science books which he tried to contribute to
popularization of science books. Strong powerful cover designs were launched in books such as <Religion War>
and <American Prometheus>, whereas trace of typographic concern was reflected in books such as <Bocas del
Tiempo> and <Doteki Heiko>. Jeong collects, observes, and works with street letters. Through his three solo
exhibitions, <Letter Scape>, he is attempting to expand the meaning and method of Hangeul typography. He
teaches 'Typography' and 'Editorial/Publication Design' as a professor at department of visual communication
design, Yeungnam University. In between school and design field, he continues to study, work, and design about
letters and books.

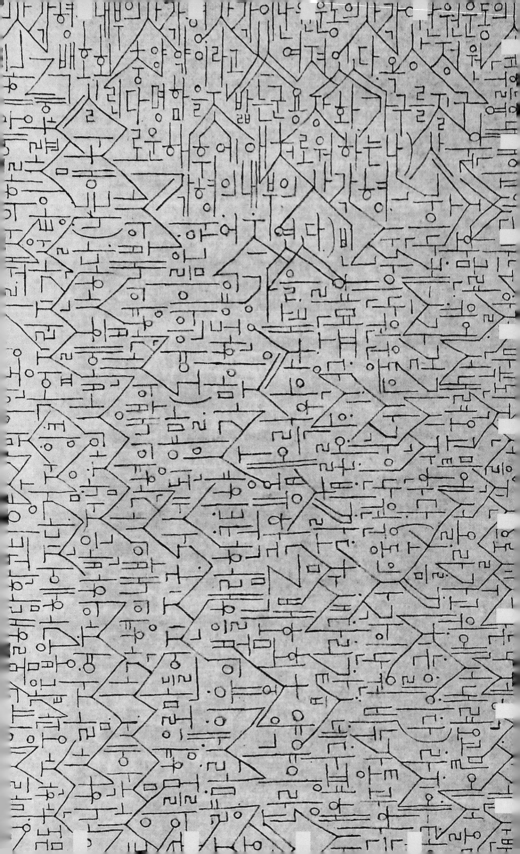

Street Letter

To reason the letters, I first focus on the sound. Sound existed before the letters, people exchanged words. The eyes that see letters can be closed, yet the ears that listen to sounds can not be closed. The hearing takes precedence over sight. Sound leisurely floats around in the space like fish under the sea. Invisible substance quickly and slowly exists in space from top to bottom, narrow space to larger space with ever-changing expression.

Sound consists of materialities such as size, intensity, texture(rough and smooth), pitch, rhythm, tone, and more. Communicating in sound is an active and dynamic behavior with richness of materials. Having dull vision, we assume sound does not have color, yet listening to sounds makes us sense their colors. Furious laborer roaring at a rally scene would not be felt as white, coo and gurgle of a three-year-old baby would not be sensed as black. Sound carries weight. Truth is delivered through heavy sounds, joke through light sounds. Weight of father's voice on his deathbed is different from weight of business partner's voice accidently bumped on the road. To understand the materiality of sound we mix senses and expand them.

poster.　letterscape - chilseong market.　841 x 1,188.　2010.

Letters are visualization of sounds. Letters reduce numerous sounds into a few forms. Letters convey representativeness for the convenience of learning and exchanging. Thus letters can not contain all elegant attributes of sound. Letters guide sound to our vision, yet seem to have a scheme of making it simple.

Wandering sounds temporarily sit down on rocks, sands, clothes, papers, trees, and animal skins. Letters are born from fingertip of the writer. Interestingly, and luckily, various sizes and weights are expressed depending on the touch of hand and characteristics of tools used, and these manage to reflect the color, weight, and other attributes of sounds. Letters sometimes sit, sometimes become wealthy, and live active lives welded to men. Previously to the printing only.

Unfortunately, intended or not, men degenerate the wild 'sounds' into pets using the technology of 'typography'. The wandering sounds of wild now has become 'enlightened'. It is irony that unlike its name, movable type lies inexpressively, printed on the paper. Printing is the funeral of letters, books are the tomb. Letters can not survive on its own, barely manage to make ends meet by human hand manipulation.

Without doubt, many designers seem to believe that "typography is [dealing with type]". Is it because of the flow of era that once believed men's involvement made things better? We cut the values of letter, and ruled over them until the balance between letters and men finally collapsed,

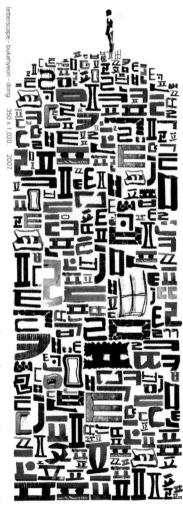

poster. letterscape - bukahyeon - dong. 350 x 1,020. 2007.

jeong jae-wan

140

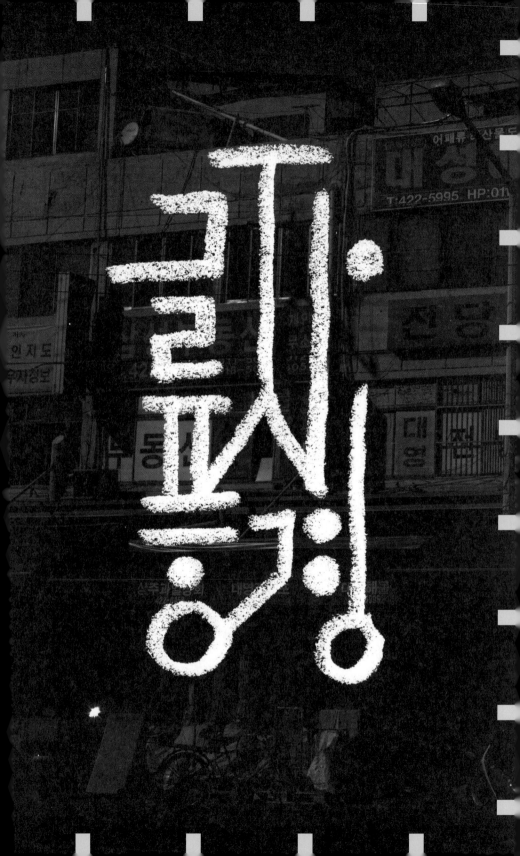

and asymmetric relationship was formed.

The world of sounds, however, still exists on its own. Sounds knew they could not be fully expressed in letters from the beginning. It is reckless and unwise to believe that all sounds can be written in letters.

Looking at letters on streets, I felt other aspects compare to printed types. Men initially created Street Letters, yet they have been breathing with the environments, and gaining lives of their own for some time. They are improvising and multi-layered. The flat lying letters stand up and make eye contacts with me. Some of them even violently attach me. Instead of myself observing the letters, I am observed by the letters. When I step into a street packed with letters, I feel excitement and tension as if I am in a lush jungle. Through the door of Street Letters, I could access to the ecosystem of sounds previous to letters, and the materialities of sounds. The series of my work is achievement of pulling out the potential of letters.

거리글자 생각

글자를 사유하기 위해 나는 우선 소리에 주목한다. 글자 이전에 소리가 있었고, 인간은 말을 주고받았다. 사물을 보는 눈은 감으면 볼 수 없지만, 소리를 듣는 귀는 닫을 수가 없다. 인간의 청각은 시각에 우선한다. 소리는 글자에 우선한다. 소리는 마치 바닷속 물고기처럼 공간을 유유히 헤엄쳐 다닌다. 눈에 보이지 않는 어떤 물질이 위에서 아래로 좁은 곳에서 넓은 곳으로 빠르게 또 느리게 변화무쌍한 표정으로 공간 속에 존재한다.

소리는 크기, 세기, 질감(거칠고 부드러움), 높낮이, 리듬, 음색 등 다양한 물질성을 띠고 있다. 소리로 의사소통을 한다는 것은 풍부한 재료를 가진 적극적이고 역동적인 행위였다. 둔한 시각을 가진 우리는 소리에는 색이 없다고 생각하지만, 소리를 들으면 색을 떠올릴 수 있다. 분노에 찬 노동자가 궐기대회 현장에서 부르짖는 격양된 고함 소리가 흰색으로 보이지는 않을 것이고, 세 살 아기의 옹알이가 검정색으로 다가오지는 않을 것이다. 소리는 무게를 품고 있다. 진실은 묵직한 소리를 통해 전달되고, 농담은 가벼운 소리를 통해 전달된다. 임종 직전의 아버지로부터 듣는 소리의 무게와 길에서 우연히 마주친 거래처 직원과의 목인사 소리의 무게는 다르다. 소리의 물질성을 이해하기 위해서 우리는 감각과 감각을 섞고, 확장하게 된다.

글자는 소리를 가시화(可視化)한 것이다. 글자는 많은 소리를 많은 형태로 만들지 않고, 적은 수의 형태로 만들었다. 익힘과 교환의 편리를 위해서 글자는 대표성을 지닌다. 그래서 글자는 소리의 미려한 특성을 모두 담아낼 수 없다. 글자는 소리를 우리의 시각으로 안내했으나, 소리를 오히려 단순화하려는 계획을 품은 듯하다.

떠돌던 소리는 바위, 모래, 천, 종이, 나무 위에, 동물의 껍질 위에 잠시 내려와 앉는다. 글자는 쓰는 사람의 손끝에서 태어난다. 재미있는 것은, 또 다행인 것은 글자를 쓰는 손길과 도구의 성질에 따라 다양한 크기, 굵기 등이 연출되며 그것이 곧 글자의 색과 무게 등 소리의 성질을 어느 정도 반영한다는 것이다. 글자는 앉기도 하고, 다시 부유하기도 하며, 인간과 좀 더 밀착한 역동적인 삶을 살고 있었다. 인쇄 이전까지는 말이다.

불행하게도(우리가 의도했던 그렇지 않던) 인간은 야생의 '소리'를 '타이포그래피'라는 기술을 동원해서 애완동물로 전락시켰다. 야생에서 떠돌던 소리는 이제 '문명화' 되었다. 활자(活字, movable type)가 그 이름과 달리 종이 위에 찍혀서 아무런 자기 표현을 하지 못하고 누워 있는 것은 아이러니하다. 인쇄는 글자를 장례 치르는 행위요, 책은 글자의 무덤이다. 활자는 스스로 살아갈 수 없고, 인간의 손 조작에 의해서만 겨우겨우 삶을 연명한다.

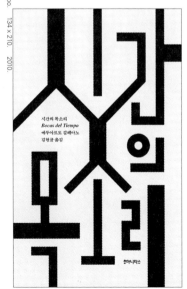

book. bocas del tiempo. 134×210. 2010.

많은 디자이너는 별다른 의심 없이 '타이포그래피는 활자를 (다루는) 일'이라고 믿는 듯하다. 인간이 손을 대면 모든 것이 좋아지리라 믿었던 시대의 흐름 탓일까. 글자와 인간의 균형이 무너지고, 비대칭 관계가 만들어지기까지 우리는 글자가 지닌 가치를 재단했고, 글자 위에 군림해왔다.

하지만 소리의 세계는 여전히 스스로 존재한다. 소리는 자신들이 글자에 모두 담길 수 없다는 것을 처음부터 알고 있었다. 모든 소리를 글자로 기록할 수 있다고 믿는 것은 무모한 어리석음이다.

나는 거리에서 만난 글자들을 보면서 인쇄된 활자와는 다른 면모를 느낄 수 있었다. 거리글자를 처음 만들어 놓은 것은 인간이지만, 언제부터 글자는 주변 풍경과 호흡하며 스스로의 생명력을 가진다. 즉흥적이고 다층적이다. 누워 있던 글자들은 모두 일어서서 나와 눈을 맞추고 있고, 나를 강하게 공격하는 폭력적인 글자들도 있다. '내가 관찰하는 글자'가 아닌, '글자가 관찰하는 나'가 되어버린다. 글자가 빼곡한 어떤 거리에 들어서면 마치 무성한 밀림 속에 선 듯한 흥분과 긴장감도 느껴진다. 거리글자라는 문을 통해서 글자 이전의 소리, 소리의 물질성이라는 생태계에 접근할 수 있었다. 내가 하는 일련의 작업은 글자의 잠재성을 끄집어 내는 사유의 기록이다.

poster. letterscape - samdeok-dong. 841 x 1,188. 2010.

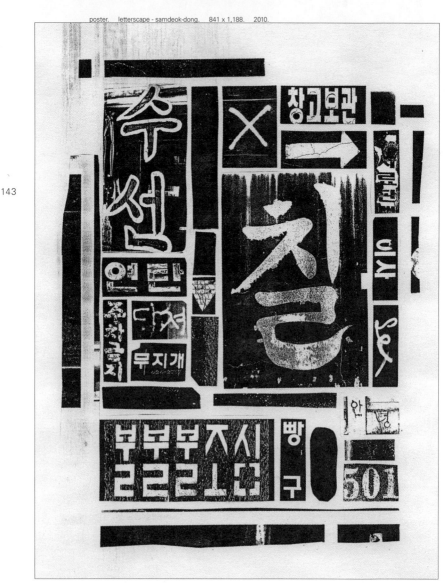

joe.hyoun-youl. korea

Joe Hyoun-youl is a graphic designer based in Seoul, Korea. He received a BFA degree in visual communication design from Dankook University in 2004 and MFA in graphic design from Yale University in 2009. His work focuses mainly on experiment in various visual relationships between images and texts in the context of society and culture. He has been working as a graphic designer at studio Hey Joe since 2009, and is teaching a graphic design at Dankook University and Kookmin University.

joe hyoun-youl

144

poster.　campaign 1.　594 x 841.　2010.

조현열.趙顯烈.

조현열은 서울을 기반으로 활동하는 그래픽 디자이너이다. 2004년 단국대학교에서 시각 디
자인을 전공한 뒤 2009년 미국 예일대학교에서 그래픽 디자인 석사학위를 받았다. 2009년
스튜디오 헤이조를 열고 주로 사회적·문화적 맥락에서 이미지와 텍스트가 갖는 다양한 시각
적 관계를 탐구하고 실험하는 작업을 하고 있다. 단국대학교와 국민대학교에서 그래픽 디자
인을 가르치고 있다.

145

poster. campaign 2. 594 x 841. 2010.

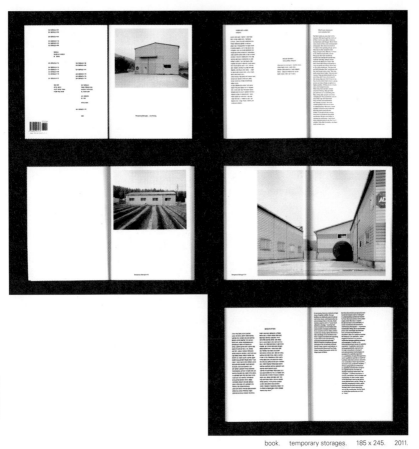

book.　temporary storages.　185 x 245.　2011.

Design note of hyoun youl joe

01. Communicate with dry and new language.
02. Capture and document accidents.
03. Be easy and simple.
04. Ornament is just a product of desire to avoid ambiguousness.
05. Obsess.
06. Think clients as partners.
07. Translate what clients want into my visual language.
08. Do not forget the fact that clients give money.
09. Steal other's ideas.
10. Translate stolen idea to mine.
11. Get used to failure and mistake.
12. There is no word "perfect"
13. Break down the myth of universal language.
14. Research similarities of existing language and images.
15. Beware of satisfaction making the public's eye happy.

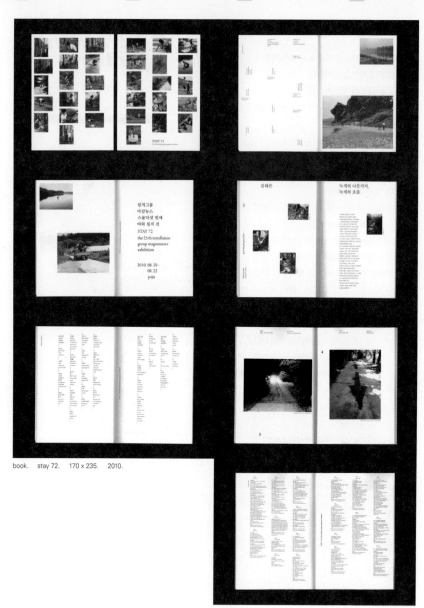

book. stay 72. 170 x 235. 2010.

joe hyoun-you

16. Keep asking "why" and "how".

17. Collect and edit.

18. Research similarities of kitschy.

19. Visualize cause of kitschy.

20. Pay attention to language from mass media.

21. Understand misunderstanding.

22. Look for sense from nonsense.

23. Report.

24. Do not expect compensation.

25. Do not spend much time for choice.

조현열의 디자인 노트

01. 건조하지만 새로운 언어로 이야기한다.
02. 우연을 포착하고 기록한다.
03. 쉽고 간결하게 제안한다.
04. 장식은 모호함을 회피하고 싶은 욕구의 산물일 뿐이다.
05. 집착한다.
06. 클라이언트를 파트너로 생각한다.
07. 클라이언트의 요구를 자신의 스타일로 반영한다.
08. 클라이언트가 돈을 준다는 사실을 잊지 않는다.
09. 남의 아이디어를 훔친다.
10. 훔친 아이디어를 나만의 스타일로 바꾼다.
11. 실수와 실패에 익숙해진다.
12. '완벽'이라는 단어는 존재하지 않는다.
13. 보편적 언어의 신화를 허문다.
14. 존재하는 언어와 이미지의 유사성을 찾아본다.
15. 많은 사람들의 눈을 즐겁게 해주는 자신의 만족을 경계한다.
16. '왜'와 '어떻게'라는 질문을 던져본다.
17. 수집하고 편집한다.
18. 키치의 유사성을 찾아본다.
19. 키치의 이유를 시각화한다.
20. 미디어에서 흘러나오는 언어를 주목한다.
21. 소통에서 오해를 이해한다.
22. 비논리에서 논리를 찾는다.
23. 보도한다.
24. 보상에 집착하지 않는다.
25. 선택을 하기 위해 많은 시간을 소비하지 않는다.

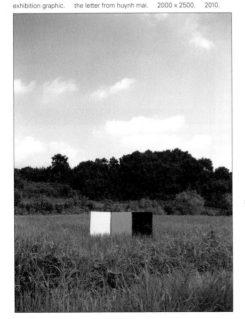

exhibition graphic. the letter from huynh mai. 2000 x 2500. 2010.

post card. durian pie factory. 150 x 100. 2010.

post card. the letter from huynh mai. 150 x 100. 2010.

JOYN: VISCOM is an independent, multidisciplinary design studio and communication consultancy based in Beijing, China. The studio aims to create experiences, whether they are commissioned client work or self-initiated projects. By working across diverse disciplines, the studio consistently delivers exclusive, creative and easy-going solutions. In addition, JOYN: VISCOM produces a wide range of independent projects, including exhibitions, lectures, publications, and events. All efforts the collective has been made to devote it to exploring all facets of contemporary visual culture and communications.

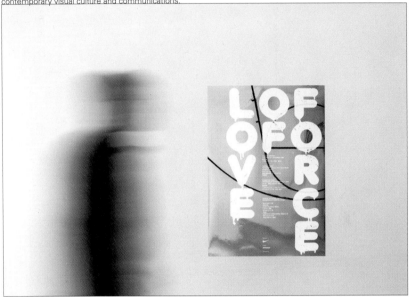

joyn:viscom

mixxid midia. force of love. 270 x 190 x 60. 2007.

150

joyn:viscom. _{china}
조인:비스캄

'조인:비스캄'은 베이징에 위치한 독립 디자인 스튜디오이자 시각 디자인 관련 자문 기관이다. 2003년 여름, 오스트레일리아 시드니에서 만난 3명의 젊은이들로 구성되었으며 2005년 초에 베이징에 정착했다. 상업적인 일이든 자발적 프로젝트이든 조인:비스캄의 목표는 경험을 창조하는 것이다. 창작 영역의 경계를 넘어선 합작을 통하여 조인:비스캄은 끊임없이 독특하고 창의적이며 상대로 하여금 부담스럽지 않은 솔루션을 찾는다. 그 밖에도 전시, 강연, 출판, 이벤트를 통해 다양한 독립 프로젝트를 진행하고 있으며, 예술과 디자인, 기술, 생활의 관계에 대한 진일보한 탐색을 통해 현재 시각 문화의 다양한 면을 탐색하고 있다.

poster. past on. 700 x 1,000. 2011.

poster. past on. 700 x 1,000. 2011. 152

The loss of natural resources

Among the family of hieroglyphs, Chinese characters used to vividly "picture" the material and spiritual environment of Chinese people. The rapid economic development has brought along rich fruits of civilization; however, a variety of problems also have been exposed: environmental destruction, moral deterioration, and the lost of values etc. Then, how might these "picture"-like characters response to this era and record it?

The overflow of counterfeit culture

Counterfeit culture, often interpreted on the surface as an attack on intellectual property, is not only a perplexing legal matter, but also a socially reflective one. Given the unique structural nature of Chinese characters, opportunists can play with and move around strokes to mistake one character for another, changing the meaning of logos altogether. As what is real is no longer so, as one is raised in an environment where "coca cola" might as well be "cola coca", what is the value of authenticity? Who is to say what is real and what is fake?

The penetration of collective concept

Chinese characters, due to their unique constructive methods, have a distinctive nature— an infinite flexibility in structure. During the constant use of Chinese characters, some users try to take their individual consciousness about the culture of character to alter the collective unconsciousness. They pick out some characters which represent certain social types, events, objects and insert them into other individual characters, to make an integration of characters. These new character forms still follow the basic structural logic. We try to record and spread these new character forms. Maybe in the future, via such creations, individual consciousness will turn into collective consciousness about the culture of character.

153

유전(流轉)

자연 자원의 유실

한자는 상형문자로서 중국인의 물질적·정신적 환경을 생동감 있게 묘사해냈다. 그러나 경제발전이 이뤄지면서 풍요로운 문명의 성과로 인해 환경 파괴, 도덕성 문란, 가치관 결핍 등 각종 문제점들이 점차 노출되기 시작했다. 그렇다면 이런 '그림'과 같은 문자는 어떤 방식으로 이 시대와 반응하고 기록해야 하는 걸까?

산자이 문화의 범람

'산자이(山寨)'란 광둥어에서 온 것으로 산업화 시대에서 복제, 즉 '짝퉁'을 이르는 중국식 표현이다. 산자이 문화는 표면적으로 볼 때 통상 저작권에 대한 침해로 비춰진다. 이는 단지 복잡한 법률 문제뿐 아니라 사회적 문제점도 반영한다. 한자 특유의 구조적 특성으로 인해 기회주의자들은 한자의 획을 자유롭게 변형하여 비슷하면서도 다른 로고나 브랜드 명을 만들 수 있다. 진실이 더 존재하지 않고, 'coca cola'가 'cola coca'로 표기되는 환경 속에서 성장한다면 진실한 가치란 무엇인가? 누가 어느 것이 진짜이고 가짜라고 말할 수 있을까?

집합개념의 침투

한자는 특유의 구조적 방법으로 인해 형태의 구조적 변형의 무한한 가능성이 내재한다. 한자를 계속 사용하면서 어떤 사용자들은 한자 문화에 대한 개인적인 의식을 집합적인 무의식으로 전환시키고자 시도한다. 그들은 특정 사회적 형식, 행사, 대상을 표현하기 위해 몇몇 글자들을 선택해서 그것들을 다른 개별적인 글자와 결합시킴으로써 글자의 의미를 보다 더 강화시킨다. 이런 새로운 글자 형태들은 여전히 기본적 글자의 구조적 논리를 따른다. 우리는 이러한 새로운 글자 조합을 기록하고 널리 알리려고 노력한다. 아마도 미래에는 이런 개별적인 의식은 그런 창작 방식을 통해서 글자 문화의 집합적인 무의식으로 바뀔 것이다.

book. mad dinner. 190 x 240. 2008.

magazine. eins. 370 x 260. 2005.

joyn:viscom

packaging. un mask. 1,000 x 1,000. 2009. 154

artfolio. nostalgia. 235 x 320. 2008.

정진열은 철학을 공부하고 국민대학교에서 시각 디자인을 전공했다. 졸업 후 The-d 스튜디오에서 디자이너로 근무하고 국민대학교 제로원디자인센터의 아트 디렉터로 있으면서 〈스테판 사그마이스터〉, 〈조니 하드스태프〉, 〈루에디 바우어〉 등의 전시 기획과 디자인을 주관했으며 〈루에디 바우어 전〉의 도록과 포스터가 아트디렉터스클럽(ADC)에 선정되기도 했다. 2006년에는 한국디자인진흥원에서 주관하는 차세대 디자인 리더에 선정되었다. 2008년 예일대학교에서 그래픽 디자인 석사학위를 받고 뉴욕 MTWTF에서 디자이너로 근무했다. 2009년 귀국하여 디자인 스튜디오 TEXT를 설립, 〈플랫폼 2009〉, 〈광주비엔날레 2010〉, 백남준아트센터, 국립극단 등과 관련된 다양한 프로젝트를 진행해왔다. 서울대학교, 홍익대학교, 경원대학교에서 강의했으며 현재는 국민대학교 시각디자인학과 전임강사이다. 〈부재〉(2002), 〈이미지와의 대화〉(2003), 〈어떤 것들의 목록〉(2005), 〈창천동: 기억, 대화, 풍경〉(2008), 〈The Sign: The hidden place of the city〉(2009) 등의 전시회와 프로젝트를 통해서 개인과 공동체의 정체성이 어떻게 형성되며 어떤 요인들에 의해서 변화되는지에 관심을 가지고 있으며 다양한 개인 작업을 발표하고 있다. 도시 문화 현상에 대한 관심을 토대로 박은선과 함께 '리슨투더시티'라는 프로젝트팀 활동을 하고 있으며 최근에는 김형재와 공동으로 도시의 공간과 사회 현상들을 정보 디자인적 측면에서 다룬 『이면의 도시』를 출간했다.

정진열.鄭鎭烈.

<div style="text-align:right">

jung.jin-yeol.

korea

</div>

156

jung jin-yeol

Jung Jin-yeoul (known as Jin Jung) studied philosophy and majored in visual communication design at Kookmin University. After graduation, he worked as a designer at The-d Studio and oversaw exhibition planning and design for Stefan Sagmeister, Johnny Hardstaff, Ruedi Baur, and others while working as art director for the Zeroone Design Center. He received an award from ADC NY for his <Ruedi Baur> exhibition catalogue and poster. In 2006, he was selected as a Next Generation Design Leader in a program organized by the Korean Institute of Design Promotion. After receiving an MFA in graphic design from Yale University in 2008, he worked as a senior designer at MTWTF in New York. He opened the TEXT design studio upon his return to Korea in 2009, and has worked on a wide range of projects for Platform 2009, Gwangju Biennale 2010, the NJP Art Center, the National Theater Company of Korea, and others. He has lectured at Seoul National University, Hongik University and Kyungwon University, and he currently works as a full-time lecturer at Kookmin University. He also has an interest in the ways in which individual and community identities form and the factors behind their changes, and he has done a variety of personal work in this area, which he has presented through exhibitions and projects such as <Absent>, <Imagelogue>, <List of Something>, <Chang-chun Dong: Memory, Dialogue, Scape>, and <The Sign: The hidden place of the city>. Based on interest in the phenomena of urban culture, he has worked with Park Eun-seon on the project team 'Listen to the City'. Recently, he and Kim Hyeong-jae co-published <The Hidden City>, which focuses on the spaces and social phenomena of the city from the standpoint of information design.

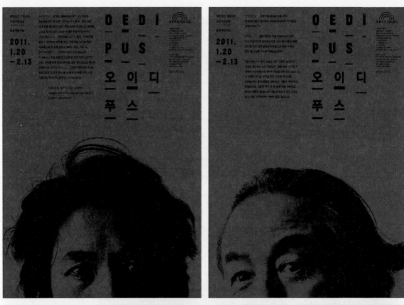

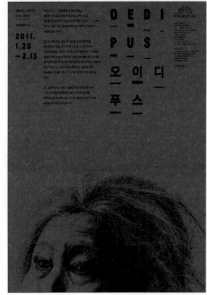

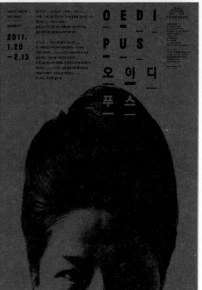

poster. oedipus. 700 x 1,000. 2011.

interactive. urban noise. installation. 2011.

book. hae gue yang. 170 x 230. 2009.

book. ham yang ah. 210 x 240. 2011.

book. nam june paik art center prize 2009. 190 x 260. 2010.

book. 10000 lives gwangju biennale. 200 x 270. 2010.

The accumulation of memories brings out desire,

and that desire gives a name to its objects.

As a graphic designer, I am interested in the process whereby certain objects—an item, multiple items, a person, many people, a place, places, or ideas that encompass them—obtain and come to be called by names. I try to start my work carefully but enjoyably asking the questions that spring up from all around—questions about how the objects I need to address came to be created, or how they grew. These kinds of questions, posed as though in rumination, serve to distinguish the things I can do, the things I have to do, and things I am not able to do. Beyond that, they function to sketch out the "identity" of the action's object. My functional role as a designer involves drawing out an object's "identity" in visual terms, and the "conditions for how things should be" that I encounter or discover in the process have often turned into the principal objects of my personal attention. By naming and referring to some object with the "word," we bring its "identity" to the surface. Graphic design—and particularly typography—is, I believe, an act of representing an invisible identity in reality and giving it substance. Much of the work I have done—whether commercial or noncommercial, or somewhere in between—has occupied just such a position. Rather than assigning a single representativeness in the process of showing this "identity," I prefer methods that allow individual differences to reveal themselves completely within a single flow. I believe that the act of closely observing objects and the stubborn questioning of this are capable of leading those objects to reveal their own identities. As a designer, I seek to play the part of someone who waits somewhere on the street for the moments when they are manifested, snatching them up as they come. Of course, it is too much to expect that to be the totality of the object I am addressing. "Identity" can be something general that emerges within an accretion of experiences and self-declarations, but the moments when I touch upon identity as a designer are fated to be not "the perfect point," but rather "some point" within a continued revelation. Within these limited circumstances, I aim to shed light on a relationship between the individual and the totality. How do I bring an individual voice alive within design as an overall process of coordination? In what ways do such individual qualities communicate within a

"기억들의 집적은 욕망을 낳고

그 욕망은 그 욕망의 대상들에게 이름을 부여한다"

159 그래픽 디자이너로서 나는 어떤 대상물들–사물, 사물들, 사람, 사람들, 장소, 장소들, 혹은 이를 포괄하는 어떤 생각들–이 이름을 얻고 불리는 과정들에 대해서 관심을 가지고 있다. 나는 내가 다루어야 할 대상들이 어떻게 만들어져 왔는지, 혹은 자라났는지에 대해서 캐묻는 것, 여기저기서 불쑥불쑥 튀어나오는 질문들을 신중하지만 즐겁게 던지는 것에서부터 일들을 시작하려고 한다. 되새김질하듯이 던지는 이런 종류의 질문들은 내가 할 수 있는 것과 해야 하는 것, 할 수 없는 것들을 구분하는 기능을 하고, 나아가 그 행위 대상의 '정체성'을 그려내는 역할을 한다. 기능적인 역할을 수행하는 디자이너로서 내 역할은 대상의 정체성을 시각적으로 끌어내는 것이고 그 과정 속에서 부딪히는, 혹은 발견하는 '그것이어야 할 조건들'이 내 개인적인 관심의 주된 대상이 되곤 한다. 우리는 '말'로써 어떤 대상을 이름 짓고 그것을 부름으로써 그것의 정체성을 표면화한다. 그래픽 디자인, 그중에서 특히 타이포그래피는 비가시적인 정체성을 현실에 재현하고 실체화시키는 행위라고 나는 생각한다. 내가 해왔던 많은 작업들–그것이 상업적인 것이든 비상업적인 것이든, 혹은 그 양자 사이에 있든지–은 그 지점에 위치하고 있다. 나는 이 '정체성'을 드러내는 과정에서 하나의 단일한 대표성을 부여하는 것보다 개별적인 차이들이 하나의 흐름 속에서 온전히 드러날 수 있게 하는 방법을 선호한다. 나는 대상을 세심히 관찰하는 행위와 거기에 대한 집요한 질문들이 그 대상들로 하여금 스스로 자신의 정체성을 드러낼 수 있게 만들 수 있다고 생각한다. 디자이너로서 나는 그것이

book. with nam june paik 2009-2010. 210 x 297. 2011.

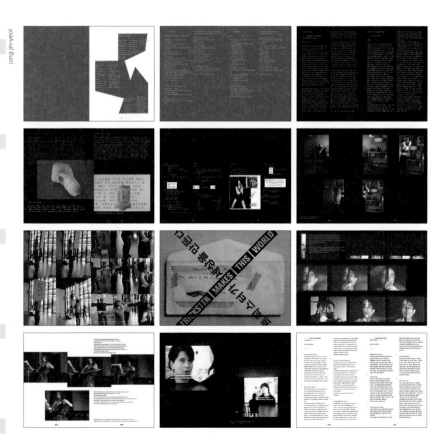

group and transform accordingly? And how am I to show that in visual terms? Typography is the act of showing that object in the most direct and final of ways. This may be a "context" or a "tone" with micro-typography, and it may be an act of visually fixing the name by which it is called in a manner "befitting" that thing. The moments when "language" is fixed through type are points of contact characterized by a subtle transaction between the other and the self, and between others. And in the process of those points of contact escaping the temporary to persist in a continuous flow, there arises an identity as a "flow in which there is a natural reason and necessity for that thing being that way." For the designer, it is a pleasure to be able to participate in that process.

poster. 10000lives gwangju biennale. 700 x 1,000. 2010.

발현되는 순간을 골목의 어디쯤에서 기다리고 있다가 낚아채는 역할을 수행하고자 한다. 물론 그것이 내가 다루는 대상의 온전한 모습이기를 기대하기는 어렵다. 정체성은 경험과 자기 선언의 누적 속에서 나타나는 총체적인 것이기도 하지만 디자이너로서 정체성을 건드리는 순간은 완전한 지점이 아니라 연속적인 드러남 중에 어떤 한 지점일 수밖에 없다. 이 제한적인 상황 속에서 나는 개별적인 것과 전체적인 것 사이의 관계를 조망하고자 한다. 어떻게 전체적인 조율로서의 디자인 속에서 개별적인 목소리를 살아 있게 만들 것인가, 혹은 그 개별성이 집단 속에서 어떤 식으로 서로 소통하고, 거기에 따라서 변해가고 있는가, 그리고 그것을 어떻게 시각적으로 드러낼 것인가. 타이포그래피는 가장 직접적이자 최종적으로 그 대상을 드러내는 행위이다. 그것이 마이크로 타이포그래피로 문맥이 되거나 어조가 될 수도 있고, 불리는 이름을 그것답게 시각적으로 정착시키는 행위가 될 수도 있다. 언어를 활자를 통해서 고착화시키는 그 순간은 타자와 나, 타자와 타자 사이에 은밀하게 거래가 오가는 접점이며 그 접점이 일시적인 한 점을 벗어나 일련의 흐름으로 지속되는 과정 속에서 그것이 그렇게 되어야 할 당연한 이유, 당위성을 갖춘 흐름으로서의 정체성이 생겨난다. 그 과정에 동참할 수 있다는 것은 디자이너로서 즐거운 일이다.

kasai.kaoru. ^{japan}

poster. seven. 723 x 1,030. 2005.

162

Born in Sapporo, Hokkaido, in 1949. After working for Bunka Printing from 1968 to 1970, and for Ohtani Design from 1970 to 1973, he has been working for Sun-Ad to date. His best-known works are long-term advertisements for Suntory Oolong Tea, United Arrows, and CI planning spatial designs and package designs for Toraya. His activities range from CI and signage for Suntory, the Suntory Museum of Art and the Toranomon Towers, to advertisements for cinema and theater, and designs for photo collections and so on. His works were awarded Asahi Advertising Award, Tokyo ADC Grand Prix, Mainichi Design Award, Kodansha Syuppan-Bunka Award, and Japan Advertising Fumio Yamana Award and etc. He held solo exhibitions such as <Kaoru Kasai and SONY> (1984), <Kasai Kaoru Exhibition, AERO> (1992), <Kasai Kaoru 1968> (2007). Kasai published *Kaoru Kasai's Work and the Surroundings, World Graphic Design 35, Kaoru Kasai, KASAI Kaoru 1968*. Currently he is a member of the Tokyo ADC, Tokyo TDC, JAGDA, and AGI.

"The first steps in planning printed work take place in the imagination."

poster. letters and design 2010. 723 x 1,030. 2010.

1949년 홋카이도 삿포로에서 태어났다. 1968년 분카인쇄, 1970년 오타니디자인연구소를 거쳐 1973년부터 선애드에서 일하고 있다. 대표작으로 산토리 우롱차, 유나이티드애로우즈의 광고 캠페인, 토라야의 CI, 공간 디자인, 패키지 디자인, 산토리, 산토리미술관, 토라노몬타워즈의 CI, 사이니지 계획 등이 있으며 영화·연극 광고, 사진집 장정 분야의 활동도 하고 있다. 아사히광고상, 도쿄ADC 그랑프리, 마이니치디자인상, 고단샤출판문화상 북디자인상, 일본광고상, 야마나야오상 등을 수상했다. 〈카사이 카오루와 SONY〉(1984), 〈AERO 카사이 카오루 전〉(1992), 〈카사이 카오루 1968〉(2007) 등의 전시회를 열었으며, 저서로 『카사이 카오루의 일과 주변』, 『세계의 그래픽 디자인 35』, 『카사이 카오루 1968 도록』 등이 있다. 현재 도쿄 아트디렉터스클럽(ADC), 도쿄타이프디렉터스클럽(TDC), 일본그래픽디자이너협회(JAGDA), 국제그래픽디자이너연맹(AGI) 회원이다. 카사이.카오루.葛西薫.

164

book.　kasai kaoru1968.　2010.

Asian chaos of letters

Well, why do I regard letters as my last resort? Maybe it's because my starting point was a correspondence course in calligraphy, where I repeated writing Ming type letters thousands of times. In such practice, you first draw lines to divide a square, then build a framework of a letter with curves and arrange the shape by fleshing out. You need to improve legibility by enhancing your physical senses and controlling writing pressure according to each part of the letter, in addition to the mechanical skills such as correction of errors and optical illusions. I also think my space perception and layout abilities have been benefited greatly through learning lettering. To me a letter looked rather like a building than a design, because it might collapse by only one mistake. I'd like to strongly recommend people who want to be a designer to undergo basic lettering training.

Letters typeset in Ming have beauty in their own forms. They are legible even if their thin horizontal lines disappear. Indeed, It is a great design in itself, so I dislike fonts whose horizontal lines were made bold for further legibility. On the other hand, letters typeset in Gothic feel mechanical and easy for eyes to follow at a steady speed. Most of the letters used by Internet and cell phone users are Gothic, and I suspect this is not only because they are simply easy to read but also because nowadays people tend to distance themselves from sentiment. Since I was a little child, whenever I looked at types in a newspaper, I always felt that vertical typesetting of Ming was cool, while horizontal typesetting of Gothic was crude. However, I've become to use Gothic type on more occasions, while I was not aware of it. The Japanese language can be typeset vertically or horizontally. Moreover, it is the mixture of several kinds of letters—kanji, hiragana, katakana (hiragana and katakana are syllabaries peculiar to the Japanese writing system, derived from kanji) as well as the Arabic numerals. These are nightmarishly complicated conditions for typography, but I think this chaos, which is very Asian, is not necessarily bad, or rather attractive.

(adapted from *KASAI Kaoru 1968*)

165

kasai kaoru

문자의 아시아적 혼돈

내가 마지막으로 기댈 곳이 늘 '문자'인 까닭은 통신교육을 받으며 수없이 많은 명조체 연습을 했던 것이 나의 원점이기 때문일 것이다. 정방형 안에 구분 선을 그은 후 곡선으로 골격을 만들고 살을 붙이면서 모양을 다듬어나간다. 어디서 붓을 강하게 누를지 힘을 뺄지 등의 신체 감각에 더해 오차 수정이나 착시 교정 등의 기교적인 부분을 다듬어 가독성을 높인다. 공간 감각과 레이아웃도 문자로부터 배웠다. 내게 문자는 디자인이라기보다 건축물처럼 느껴졌다. 하나가 잘못되면 전체가 무너진다. 디자인에 뜻을 품은 사람이라면 꼭 레터링 기초훈련을 체험했으면 한다.

명조체는 조형적으로 아름답다. 가령 가는 가로선이 사라져도 가독성이 있다. 이는 대단한 설계가 아닐 수 없다. 그렇기 때문에 나는 가독성을 위해서라는 이유로 가로 획을 굵게 한 서체는 별로 좋아하지 않는다. 그에 비해 고딕체는 눈으로 쫓는 데 안정적인 속도를 지닌 기계적인 문자라는 느낌이다. 그리고 현재 인터넷이나 휴대전화에서 주로 고딕체가 사용되는 것은 읽기 쉽다는 이유 때문만이 아니라 정서를 꺼리는 시대적 추세와 관계가 있다고 본다. 어릴 적부터 신문 활자를 보고 세로쓰기 명조체는 멋지다, 가로쓰기 고딕체는 촌스럽다고 생각했으나 나도 어느새 고딕체로 조판하는 일이 많아졌다. 일본 말은 세로쓰기와 가로쓰기를 모두 한다. 뿐만 아니라 한자에 히라가나, 가타카나, 게다가 영문 숫자까지 혼입한다. 타이포그래피적으로 아주 나쁜 조건이라고 말할 수도 있다. 그러나 나는 이 아시아적 혼돈이 제법 멋지다고 생각한다.

(『카사이 카오루 1968 도록』 중에서)

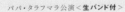

poster.　　letters between tokyo-buenos aires.　　723 x 1,030.　　2007.

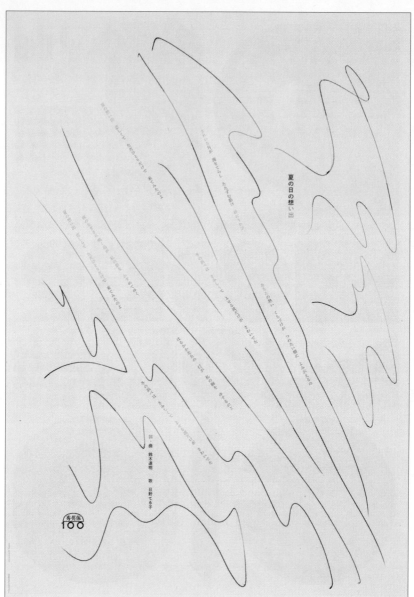

167

kasai kaoru

poster.　shueitai 100.　723 x 1,030.　2011.

poster. re-modernologio. 728 x 1,020. 2011.

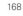

kato.

kensaku. ^{japan}

poster.　super high tension.　728 x 1,020.　2011.

kato kensaku

169

카토.켄사쿠.加藤賢策.

1975년에 태어났다. 무사시노미술대학 대학원 시각전달디자
인과정을 수료한 뒤 동 대학 시각전달디자인과 조교를 거쳐
강사로 근무하고 있다. 2006년 편집 디자인 회사 도쿄피스톨
을 설립했으며 주로 예술 분야 관련 그래픽 디자인이나 서적,
잡지 등의 편집 디자인, 웹 디자인 등의 작업을 하고 있다.

Art Director and Graphic Designer. Born in 1975. Graduated from Musashino Art University
and earned his M.A. of Visual Communication Design. After participating as a part-time lec-
turer of Musashino Art University, Kato established 'Tokyo Pistol Inc.,' the design and editorial
firm in 2006. As the lead Art Director, Kato is committed in various artistic and intellective
design including book and magazine as well as the firm's web consultation.

神奈川県民ホール開館35周年記念展

日常／場違い

Everyday life Another space

2009.12.16wed.-2010.1.23sat. 10:00-18:00

12月19日（土）、1月16日（土）19:00まで ※入場は閉場の30分前まで ※12月30日（水）から1月4日（月）は閉場

神奈川県民ホールギャラリー

神奈川県横浜市中区山下町3-1

雨宮庸介	泉太郎	木村太陽	久保田弘成	佐藤恵子	藤堂良門
Yosuke Amemiya	Taro Izumi	Taiyo Kimura	Hironari Kubota	Keiko Sato	Ramon Todo

アーティストトーク 12月20日（日）13:00泉太郎、15:00木村太陽／12月26日（土）14:00雨宮庸介／12月27日（日）14:00久保田弘成／1月9日（土）14:00佐藤恵子／1月10日（日）14:00藤堂良門
久保田弘成（Berlin Hitoritabi）パフォーマンス　会場＝神奈川県民ホール前庭　スケジュール＝12月27日（日）、1月10日（日）、11日（月・祝）、16日（土）、17日（日）　各16:00開始予定
※天候やその他の事情により日時が変更または中止になることがございます。あらかじめ、ホームページや お電話にてご確認ください。

入場料＝一般700円　学生・65歳以上500円　高校生以下無料　※本展の関連パフォーマンス「アート・コンプレックス2009」　各公演チケットの提示により100円引き
※障害者手帳をお持ちの方その介護の方1名は無料　※かながわアーツ倶楽部会員・10名以上の団体は100円引き
主催＝神奈川県民ホール〔指定管理者＝財団法人神奈川芸術文化財団〕　お問い合わせ＝神奈川県民ホール TEL 045-662-5901（代）　http://www.kanakengallery.com/
助成＝アサヒビール芸術文化財団　財団法人花王芸術・科学財団　後援＝オランダ王国大使館　協賛＝EPSON　協力＝Nonkredis SAKEI WAGAKU FINE ARTS　Yuka Sasahara Gallery 日本オランダ年 2008-2009認定事業 www.nihonjaranda.jp

poster.　everyday life another space.　514 x 728.　2009.

One of designer's unique occupational hazards is "immersion into the form". Without exception, I am suffering from it. When I think of design, how I should compromise with such visual fetishism basically becomes an important point. I would like to intensionally call the tool to compromise a "logic", though how obscure it may be. Of course, visual fetishism in design can not be totally excluded. In my opinion, design is an operation of moving back and forth between fetishism and society via logic. I am interested in the process of anonymous or collective creation. For example, "sample image" is an image for image. Such tautological "pure image", which do not refer to anything, basically may be worthless. It seem to be at the totally opposite pole of "difference in value" concept, made by the designers so far. Because it is anonymous and ordinary, it is related to our unconsciousness. It may look smooth at glance, yet it draws multiple meanings. It can be referred as a collective creation. In the sample image for camera performance, for instance, why is the subject always "female" or clean "nature"? What makes them valid? The images resulted from absence of decision makers are somewhat suggestive. Model of 'fetish-logic-society' was introduced in above. The keyword "society" used in design is clear, yet "society" in this sense may not be the optimistic clear target as in "drive society with design". Rather, it may be nothing more than a passive, group-unconscious "oddness". In the premises of this, the presence of internet is large. Neither of perspective distance nor order of size is valid in this environment. Explosive quantity of images are created while I am writing this text. Bulks of images, which are inadequate. "Composition" solution, which has been accumulated in design field so far, may not be valid before the potentially overflown of amount of images. Composition may be valid locally, but it can no longer be an "image" as a simple subject. In that sense, we need to double check our excessive reliance upon the validation of "visual communication" or "visual language".

kato kensaku

anonymous / odd / overproduction / tin god / bulk / neutral / historical / futility / meta / fiction / intention motivation / happening / database / architecture / temporary / superficial / congregative / fragmentary / do not select by oneself / cautious / unconscious / noisy / chat not dialog /accident and its claim / general-purposed / salvation by faith / Matrix concept / translation / writing style / denial of writing style / Twitter / speed / explosive compression / inadequate / sum / positive production / CAMP / lousy / easy / excessive method / cheap / surplus of inflation / excess diet / extreme populism / as parallel as sound and video / surrealism / characterism / USA / Godard / Cambrian Period / The Tower of Babel / imitation / no immersion / rejection of inference / Sontag *Against Interpretation* / maintaining apathetic relationship / sexy / transitional object / substitution / dexterity / foolproof / research / CMYK / Pieter Bruegel / new fundamentalism / beastly / partial best / revert meaning into image / animal / absolute innocence / RPG / meaning and meaningless / Internet / decoration(excess) / default / the order of instant / totally consumed / used / similar / scale / joke / the oddness of "This sentence is a seventeen letters" / cryptographic / artificial environment / nesting status of meaning and meaningless

book. document mau m&u. 2010.

kato kensaku

poster.　reflection.　514 x 728　2010.

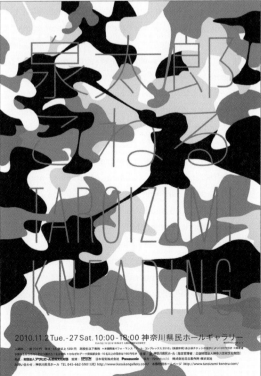

poster.　taro izumi/kneading　514 x 728　2010.

디자이너 특유의 직업병 중에 '형태로의 몰입'이라는 것이 있다. 나도 예외 없이 그 병을 앓고 있는 한 사람이므로 디자인을 생각할 때 기본적으로 그러한 시각적 페티시즘에 대해 어떻게 타협을 볼 것인가를 중요한 포인트로 삼고 있다. 그것이 아무리 애매한 것이라 할지라도 타협을 보기 위한 툴을 일부러 '논리'라 부르기로 했다. 물론 디자인에 있어서 시각적 페티시즘을 완전히 배제할 수는 없지만 요컨대 내가 생각하는 디자인은 논리를 매개로 하여 페티시즘과 사회를 왕복하는 작업이라 말하고 싶다. 익명적인 것이거나 집합적인 창작물이 만들어지는 과정에 관심이 있다. 이를테면 '샘플 이미지' 같은 것은 이미지를 위한 이미지이다. 그 무엇도 지칭하지 않는 동어반복적인 '순수 이미지'는 기본적으로 보잘것없는 것일지도 모르지만 여태껏 디자이너들이 만들어온 '가치의 차이'라는 것의 대극(對極)에 있는 것처럼 보인다. 단지 그것은 익명적이고 평범하기 때문에 우리의 무의식과 관련돼 있고 언뜻 보기에 매끄러운 것처럼 보여도 다양한 의미를 끌어들인다. 집합적인 창작물이라고도 할 수 있다. 가령 카메라 성능을 소개하는 샘플 이미지 피사체는 왜 늘 '여성'이나 깔끔한 '자연'일까, 또 그것을 성립하게 하는 것은 무엇일까. 누가 정한 것도 아닌 결정자 부재 속에서 나오는 이미지들은 어딘지 시사적이다. 서두에 '페티시-논리-사회'라는 모델을 내걸었다. 디자인에서 사회라는 키워드는 자명하지만 여기서 말하는 사회란 디자인으로 사회를 구동시킨다는 등 명확히 대상화되는 낙관적인 것이 아니라, 더 수동적이고 집합무의식적인 '기묘한 것' 정도에 지나지 않을지도 모른다.

또한 이 말의 전제로서 인터넷의 존재는 크다. 원근법적 거리감도 질서였던 규모감도 통용되지 않는 환경이고, 이 글을 쓰고 있는 지금도 어딘가에서 폭발적인 양의 이미지들이 생산되고 있다. 감당할 수 없을 정도의 대량의 이미지들, 그리고 일정량을 잠재적으로 넘어버린 것을 앞에 두고 지금까지의 디자인 영역에서 축적되어 온 '컴포지션'이라는 해결법이 통하지 않을 수 있다고도 생각한다. 물론 국소적으로는 컴포지션이 성립되겠지만 이제는 단지 소재로서의 이미지일 수는 없다. 그러한 의미에서는 지금까지의 비주얼 커뮤니케이션이나 시각 언어를 성립하도록 하는 것에 대한 과도한 신뢰를 재점검해볼 필요가 있다고 생각한다.

poster+dvdbox.　ensembles.　2011.

kato kensaku

익명적인 것 / 기묘한 것 / 생산과잉 / 허울 좋은 하눌타리 / 대량의 / 중성적 / 역사적 / 허무적 / 메타 / 픽션 / 의사동기(疑似同期) / 해프닝 / 데이터베이스 / 아키텍처 / 일시적인 / 표면적인 / 집합적인 / 단편적 / 스스로 선택하지 않는다 / 경계적 / 무의식적 / noisy한 / 대화가 아닌 수다 / 사고(accident)와 그 원용(援用) / 범용함 / 타력본원(他力本願) / 매트릭스의 발상 / 번역 / 문체 / 문체의 거부 / Twitter / 스피드 / 폭발적인 압축 / 감당할 수 없음 / 수(數) / 긍정적인 제작 / CAMP / 후진 것 / 손쉬운 / 과도한 방법 / 값싼 / 인플레이션의 잉여 / 과도한 다이어트 / 극단적인 포퓰리즘 / 소리와 영상처럼 평행적일 것 / 초현실주의 / 문자주의 / 미국 / 고다르 / 캄브리아기 / 바벨탑 / 모방 / 몰입하지 않기 / 유추 거부하기 / 손택『반해석』/ 냉담한 관계 유지하기 / 섹시함 / 이행대상(移行對象) / 대용품 / 손재주 있음 / 절대안전 / 연구적 / CMYK적인 것 / 피테르 브뤼헐 / 새로운 원리주의 / 동물적 / 부분 최적(最適) / 의미를 이미지로 되돌리다 / 동물 / 절대적 무구(無垢) / RPG / 의미와 무의미 / 인터넷 / 장식(과도한) / 디폴트 / 생각난 순서대로 / 모조리 소비되어진 것 / 써진 것 / 서로 닮은 것 / 스케일 / 농설(弄舌)일 것 / '이 문장은 열곱 글자입니다'라는 기묘함 / 암호적 / 인공환경 / 의미와 무의미의 내포화 상태

Born in 1974, Korea. BA from College of Fine Arts, Hongik University, majored in print making and visual communication design.

1974년에 태어났다. 홍익대학교에서 판화와 시각 디자인을 전공했다.

김도형.金度亨.

kim.do-hyung. korea

poster. beyond president park. 2,100 x 1,500. 2008.

poster. the troxlers & do-hyung kim poster exhibition. 1,530 x 1,091. 2010.

We always had an answer sheet to model ourselves after.

Japan, for one, and the United States.

We were taught to follow that sheet closely.

And when we got close to it, we were pleased with the similarity and praised for it.

poster.　cy unspecific language.　788 x 1,090.　2011.

우리에게는 항상 모방해야 할 모범 답안이 있었다.

그것은 일본이었고, 그것은 미국이었다.

　　　　우리는 그 모범 답안에 가까이 가는 교육을 받았다.

　　　　그리고 그것에 가까이 가면 근사하다고 즐거워했고 칭찬도 받았다.

kim do-hyung

Printemps Été 2012
Cy Choi

poster. cy choi 2012 ss. 788 x 1,090. 2011.

We could not conceive of anything but the answer sheet.
We were naive. We didn't doubt.
Imagination has disappeared.

poster.　doh+vier5.　788 x 1,090.　2011.

poster.　yunisang 16th.　788 x 1,090.　2010.

poster.　you are under cctv.　788 x 1,090.　2008.

모범 답안 외에 다른 것은 생각할 수도 없었다.
우리는 순진했고 우리는 의심하지 않았다.
상상력은 없어졌다.

kim do-hyung

178

poster. one one root2_01. 788 x 1,090. 2010.

After fifty years of this, we have become quite similar indeed.
We even brag about it to other people, telling them how close we are to the answer sheet…
I wanted to study fine art.
But by coincidence I became a designer.

poster.　one one root2_02.　788 x 1,090.　2010.

그렇게 50년, 이제 우리는 제법 근사해졌다.
모범 답안과 비슷해졌다고 자랑할 수 있을 정도로…….
　　　　　나는 순수미술을 하고 싶었다.
　　　　　하지만 우연한 계기로 디자이너가 되었다.

김두섭.金枓燮.

kim.doo-sup. ^{korea}

Graduated both bachelor and Master in Visual Communication Design, Hongik University. Kim is currently the Creative Director of Noon Design, and is teaching typography and graphic design at Hongik University and many others. Kim participated in several domestic and international exhibitions including <TYPOJANCHI 2001> and <Active Wire: Flow of Design in Japan and Korea>. Since 1994, he has been an active member of graphic designer club <Jindalrae>, introducing fun and meaningful formative arts. He is particularly concentrating at the cross point of rationality and emotionality, digital and analog, design and art.

poster. heaven. earth. human. 728 x 1,030. 1996 ~ 2006.

kim doo-sup

홍익대학교 시각디자인과, 동 대학원을 졸업했다. 현재 눈디자인 대표이며 홍익대학교를 비롯한 여러 대학에서 타이포그래피, 그래픽 디자인을 강의하고 있다. 〈타이포잔치 2001〉, 〈Active Wire: 한일디자인의 흐름〉전 등 다수의 국내외 전시회에 참여했으며, 1994년부터 그래픽 디자이너 클럽 '진달래' 회원으로 활동하면서 재미있고 의미 있는 조형예술을 선보이고 있다. 특히 이성과 감성, 디지털과 아날로그, 디자인과 미술이 만나는 지점에 주목하고 있다.

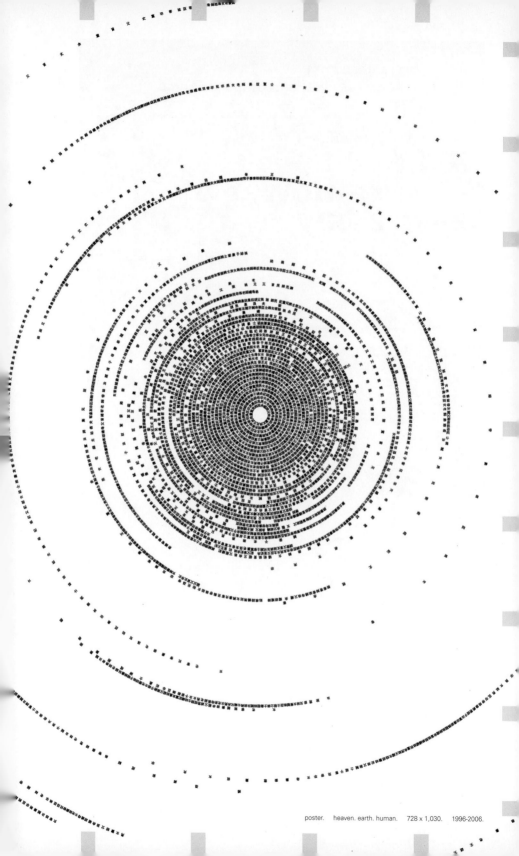

poster. heaven. earth. human. 728 x 1,030. 1996-2006.

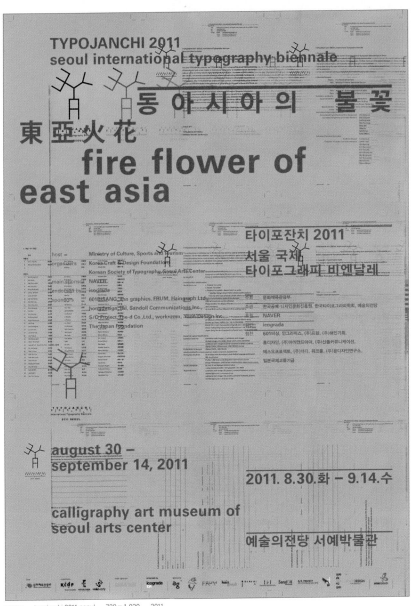

poster.　typojanchi 2011 seoul.　728 x 1,030.　2011.

typography is..with type...
.........in text......................the reader..................than colloquial language......................the
legitimacy.........................conventional..............non-specialists also..........using justified....
...legibility.............sight............texture and..........even words..................
.........the interlectual...linguistic......................clarity............
.....linear............the white space...................in grid..recording
..transcribers...the phonemic
letters........block letters......................of reading................readability and.................visual...........

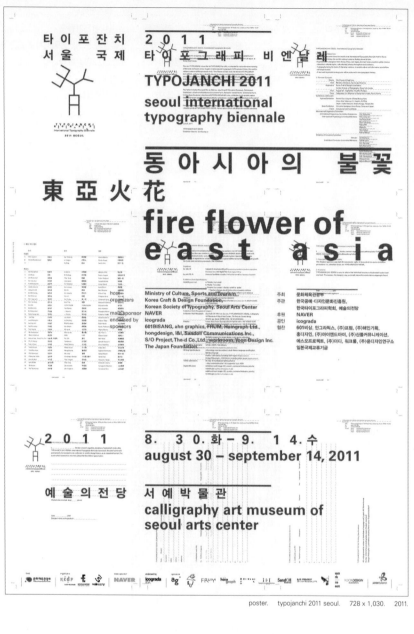

poster. typojanchi 2011 seoul. 728 x 1,030. 2011.

....fonts...leading................attractiveness...............................
........punctuation mark....................books and.......experimental........the golden ratio..............
......contrastive...........in calligraphy.............photo-letter composition...................................
...................kerning.................in serif.......................................typesetting.................notation
..............the clues.........legitimacy...........press.................arrangement...................headline..
..asymmetrical.......information and...........misreading..........................
..........form..........general..........rythmical...........meaning and.......................artisctic............
...............................it is..is how I think.

타이포그래피는..............................활자로.............................텍스트에는.........................

독자가...........구어보다..............정통성을.........................관례에.............비전문가들도....................

양끝맞추기로.................................판독성을.............시력의............질감과.........낱말조차도.........

..............지적인....................................언어학적....................명료함과......................

선형...........여백이............그리드를.................................기록하는........................

.......................필사의.............................음소글자가............활자체들을........................

독서의...............가독성과..............시각적.........폰트를...글줄사이를

poster. leesangleesangleesang. 450 x 620. 2010.

주목성이............ 구두점과............. 서적이나......... 실험적........

...황금비율을............. .대조되는............ 캘리그래피로............. 사진식자의............

..............커닝이........ 세리프체로................ 조판을........표기하는

.............단서들이....... .정통적....... 인쇄기를............ 배열방식으로........... 제목용은...........

..............................비대칭...... 정보와........ 오독의.........

형태를........ 일반적인........ .리듬감과........... .의미와.................... .예술적.........

..............것이다...나는 그렇게 생각한다.

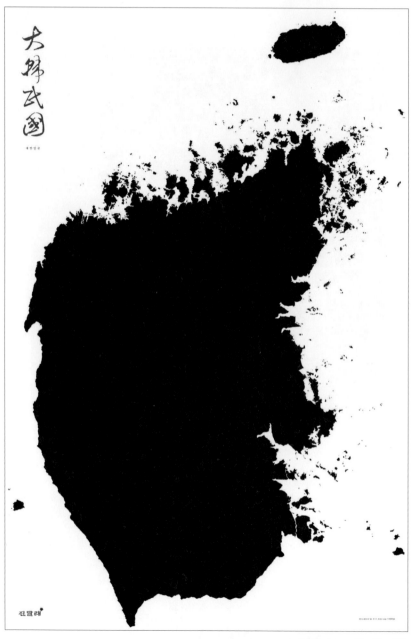

185

kim doo-sup

poster. korea. 594 x 841. 1998.

Kim Jangwoo graduated from the Visual Design department at Dankook University in 2000. He started working as designer at Ahn Graphics to pursue interest in typography and graphic design, and managed Graphics team at Vinyl in 2003. He launched personal studio Strike Design in 2005 and worked as art director for the World Peace Festival, Daekwanryung International Music Festival, among others, and collaborated with various cultural organizations to focus on brand and graphic design. His studio developed to Strike Communications. Inc., to create integrated, systematic graphic identities for corporations regarding spatial and cultural design. He exhibited a personally created Korean typeface as part of a special graphic exhibit at the Seoul Design Festival in 2006 and 2009, and participated in Hangul Dada Exhibition. He is a lecturer at Seoul Women's University, and is an active member of the Korean Society of Typography.

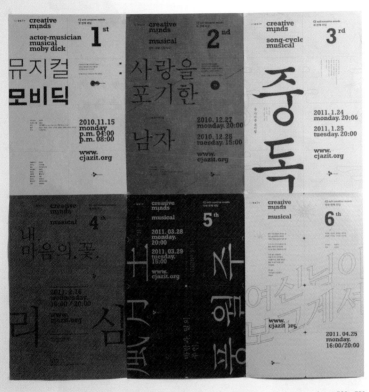

poster. musical poster series. 500 x 750. 2011.

2000년 단국대학교 시각디자인학과를 졸업하고 안그라픽스와 바이널에서 근무한 뒤 2005년 개인 스튜디오 스트라이크디자인을 열었다. 세계평화축전, 대관령국제음악제 등의 아트 디렉션을 맡으며 문화 관련 행사나 단체들의 브랜딩과 그래픽 디자인 작업에 전념했다. 2007년부터 스트라이크커뮤니케이션즈로 명칭을 변경하며 기업의 통합적이고 체계적인 아이덴티티를 구축하는 그래픽 디자인, 공간 및 문화 디자인을 다루고 있다. 2006, 2009년 〈서울 디자인페스티벌〉 특별전에 참여하여 자신의 한글 글꼴을 전시했으며, 2006년 〈한글다다〉 전시에 참여했다. 서울여자대학교에서 타이포그래피 강의를 하며, 현재 한국타이포그라피학회 회원으로 활동하고 있다.

kim.jang-woo.

korea

김장우.金章禹.

1.

When I was in elementary school my grandfather, every night, wrote his diary in ink and showed me all the ways calligraphy could be beautiful. I also remember observing movie posters and their fancy titles and practicing my lettering skills. I ended up winning the grand prize for a poster I made in middle school and started preparing for a design education in art school. In my high school art class I looked at mirrors and drew self-portraits which I then exhibited every year.

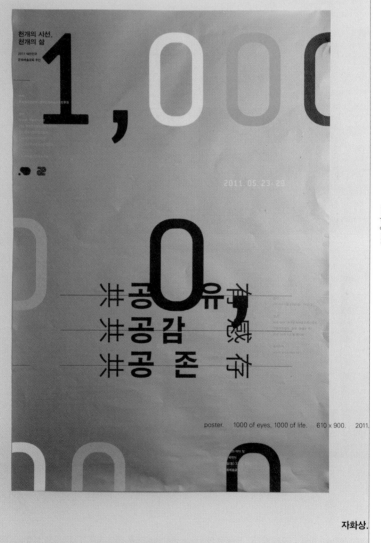

poster. 1000 of eyes, 1000 of life. 610 x 900. 2011.

자화상.

1.

초등학교 때 할아버지가 매일 밤. 물을 벼루로 갈아서 먹으로 일기를 쓰시며 서예가 아름다울 수 있는 표현들을 알려주셨다. 그리고 영화 포스터를 보면서 멋진 타이틀을 따라 레터링하던 기억이 난다. 결국 포스터로 중학교 때 대상을 받고 미대입시에서 디자인을 준비했다. 이후 고등학교 미술반에서 자화상을 거울 보고 그려 매년 전시를 했다.

2.

At university I made a Korean alphabet design club that exhibited on Hangeul Day. I was also exposed to formative arts and graphics around then. By coincidence, I saw a program on TV that introduced Eum-sik-di-mi-bang (the first Korean cookbook, written in 1670), written by a Mrs. Jang in the Andong region. My eyes only saw the powerful brushstrokes of Mrs. Jang and I called the TV station. I visited the museum that kept the original book and obtained a copy, from which I geometrically interpreted traditional handwriting to design a digital font.

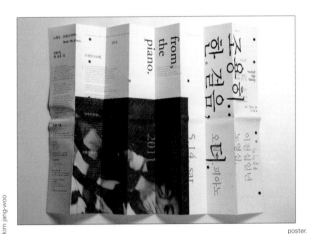

kim jang-woo

poster. from the piano. 520 x 740. 2011.

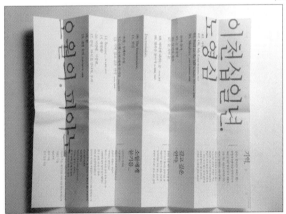

2.

대학교에서는 한글 디자인 클럽을 만들어 한글날에 전시와 발표를 하고 조형과 그래픽을 접했다. 우연히 TV를 보다가, 안동 지역의 장씨 부인이 쓴 『음식디미방』(최초로 한글로 쓰인 1670년 요리책)을 재조명해서 소개한 방송을 봤다. 난 그중에서 장씨 부인의 강한 붓글씨만 보였고 방송국으로 전화를 해서 원본을 소장한 박물관을 찾아가 복사본을 얻고 하나의 옛멋글씨를 바탕으로 기하학적으로 해석한 디지털 폰트를 디자인했다.

3.

That was how I began typography. Like my self-portraits in graphic design that strived to improve various aspects, I was working to add, fill in, and improve. I see the designer not as someone who only embraces the beautiful, but as someone who finds answers from typography experience and the history of design so that issues may be resolved. The moment a mirror reflects, I look clearly and accurately at the reflection. I find internal structures and envision an image based purely on that reflection. I want to draw crystal clear images that are - although maybe a little different - more or less definitive self-portraits of a person.

album. ode to snow. 120 x 120. 2010.

kim jang-woo

3.

그리고 시작한 타이포그래피. 그래픽 디자인 활동에서 많은 부분을 더 멋있게만 그리려던 자화상처럼, 그렇게 보태고 채워 넣고 있었다. 올바른 타이포그래피 경험과 디자인의 역사에서 답을 찾아 아름다운 것만이 아닌, 감싸 안고 해결해야 될 디자이너의 역할을 그려본다. 거울에 비친 그 순간, 그 내용을 정확히 바라본다. 그것이 가지고 있는 체계를 찾아내고 그 내용만으로 얼굴을 그려본다. 많이 닮진 않았지만…… 누가 봐도 그 사람의 자화상인 걸 알 수 있게 기분 좋아지는 명쾌한 그림을 그리고 싶다.

kim jang-woo

post card. celebration. 100 x 150. 2010.

book. leesang book 1+2+3+▼. 400 x 140. 2010.

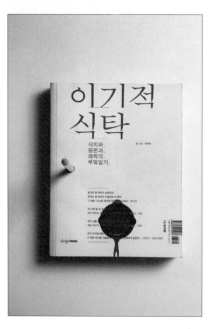

book. selfish dinner table. 145 x 185. 2009.

kim.joo-sung. korea

김주성.金柱成.

Majored in visual communication design at Hongik University, and graduated from advertising design department at a graduate school. He worked as designer at 'Seoul graphic center', 'Typohouse', and participated establishing 'I&I', and ran design studio 'Intergraphic' for a long time. He also established 'Pureun Gamsung Co. Ltd.', a design joint office and served as a producing director. He has been lecturer on typography at Myongji College since 1991. He served director and vice president at Visual Information Design Association of Korea. His works were exhibited at <Typojanchi 2001>, <Art of Typography in East Asia(1999)> and at many other international exhibitions. Currently he conducts activities at Korean Society of Basic Design & Art, Visual Information Design Association of Korea, and Korean Society of Typography._____ 홍익대학교에서 시각 디자인을 전공한 뒤 동 대학원 산업디자인과에서 착시 현상을 이용한 그래픽 디자인에 관한 논문으로 석사학위를 받았다. 서울그래픽센터, 타이포하우스에서 일했으며 아이앤드아이를 공동 설립했고 오랜 기간 디자인 스튜디오 인터그래픽을 운영했다. 그 후 디자인 연합 사무실 푸른감성을 결성, 제작이사를 맡았다. 1991년부터 명지전문대학에서 타이포그래피를 강의하고 있으며 한국시각정보디자인협회(VIDAK)에서 홍보담당 부회장과 한글꼴특별위원장을 맡기도 했다. 그의 작업은 <타이포잔치 2001>과 <동아시아 문자예술전>(1999) 등 여러 국제전시에서 전시되었다. 현재 한국기초조형학회, 한국타이포그라피학회, 한국시각정보디자인협회 회원이다.

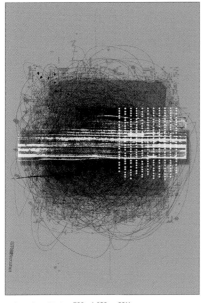

kim joo-sung

poster.　typostract.　700 x 1,030.　2011.

poster.　typostract.　700 x 1,030.　2011.

poster.　typostract.　700 x 1,030.　2011.

Luciano Pavarotti, a world-renowned tenor, said that he completed music in the head by picturing the music with sound while looking at a musical score when he first became aware of music. The music, which is completed by being pictured in the head, is very similar to typography. A composer needs musical scales and musical notes to express the image of synesthesia which is pictured in the head and a musical score is made of the musical scales and musical notes. Those who listen through the musical score associate them in the image of synesthesia and become moved. Performance, which exists between them, is regarded as

typography and it is very similar to the work of dealing with types.

Music is about playing instruments to express music through what are considered noises in daily life and a dissonance occurs because there is no length of time between musical notes or spatial depth between them, which means there is not rhythm. Appropriate and intentional distribution of empty time and empty space and 'rhythm', which is made from it, are created by counter parts hidden between them and it is deeply related with the method of reading types.

kim joo-sung

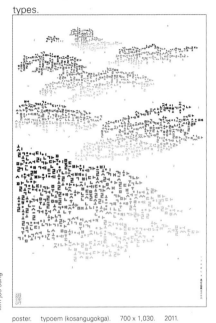 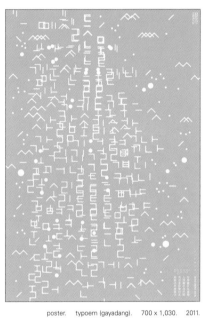

194

poster. typoem (kosangugokga). 700 x 1,030. 2011. poster. typoem (gayadang). 700 x 1,030. 2011.

As performers and conductors, who deal with musical scores, have different interpretations of music pieces, performing through types requires intuitive interpretation of a designer regarding type and space. The reason is that image should be interpreted through five senses and conveyed in completely different methods. It is not types' pictorial form, but types' visual form and the method conveyed through abstract form. The pictorial image of letter, which started from pictogram in the early days of human beings, has long disappeared from types, and in the process of hand-writing for a long time, abstract form took its place. Abstract form in fine art does not exclude association with what exists in the world, but types are pure symbols that are not modelled after anything in nature. Since types are visual, rather than relation with sound, the meaning of abstractness of visual image is overwhelming and it is associated with verbal, tactile and image of synesthesia through the 'visible' process. Intuitive performance of types can be free when it is sometimes opposed to typography principle and consciously cuts association of meaning conveyance. Type arrangement with the intention of conveying image through multifaceted imaginations leads to focus on pleasure interpretation floating in types' abstract form and space which are somewhat unfamiliar, rather than on directive meaning, and a type becomes not a dead type, but a 'living type'.

Hangeul is made of symbols, which are already possessed by the pictorial objects such as form of the vocal organs, heaven, earth, man or yin-yang. Accordingly, Hangeul has abstract forms which are remarkably geometrical and simple than other languages regarding pictorial forms about objects. Hangeul's visual poetry focuses on abstract form of types of Hangeul

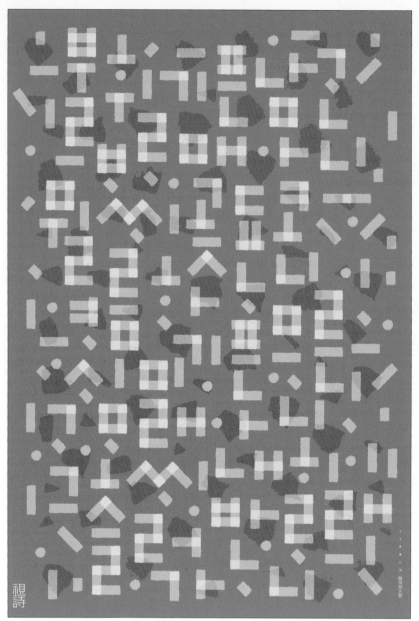

195

kim joo-sung

poster. typoem (yongbieocheonga). 700 x 1,030. 2011.

and consciously breaks away from connection of language meaning, which indicates that Hangeul is the experiment of expanding freedom and the feeling of movement as a living type, and the work of trying to do synesthesia change literature's context compressed in a poetry and image completed in the head into type's pictorial image. Performance of types, which blurs the boundary between meaning structure constraining words and unfamiliar image shown by types' abstract form, is very attractive typography. Sometimes, impromptu and splendid performance which does not put in time to hold fast to or look into musical scores, is significantly beautiful.

觀詩-살아 있는 활자

세계적인 테너 성악가 루치아노 파바로티는 처음 곡을 대할 때 악보를 보면서 음악을 머릿속에서 소리로 그리며 완성한다고 이야기한 적이 있다. 그런 과정은 타이포그래피와 비슷하다. 작곡가가 머릿속에 떠올린 공감각적 이미지를 표현하기 위해 음계와 음표가 필요하고 이를 기록한 것이 악보라면 그 악보를 통해서 듣는 이는 다시 공감각적 이미지로 연상하며 감동을 받는 것. 그 사이에 있는 연주라는 것이 바로 타이포그래피라고 생각하며 실제로 활자를 다루는 일과 많이 일치한다. 일상생활 속에서의 소음이 각기 다른 악기로 연주되는 음이지만 전체가 불협화음인 것은 그 음들 사이의 시간과 공간의 길이나 깊이가 그 사이에 없기 때문이며 이것은 즉 리듬이 없다는 것을 의미한다. 빈 시간, 빈 공간의 적절하고도 의도적인 배분, 그로 인해 생기는 '리듬'은 활자 그 자체보다도 그 사이에 숨어 있는 공간들로 만들어지는 것이며 동시에 활자를 읽는 방식과 깊게 연관되어 있다. 악보를 대하는 연주자나 지휘자마다 곡에 관한 해석이 다르듯, 활자로 연주한다는 것은 활자와 공간에 관한 디자이너의 직관적 해석을 필요로 한다. 오감각을 통한 이미지를 해석하고 다른 방식으로 전달하여야 하기 때문이다. 그것은 활자의 상형이 아니라 시각적 형태이며 추상적 형태성이 도구가 된다. 인류 초기에 상형문자로 시작된 활자의 상형성은 이미 글자에서 사라진 지 오래이며, 오랜 세월을 손으로 쓰는 과정에서 추상적 형태성이 그 자리를 대신하였다. 추상적 형태성…… 회화에서의 추상적 형태성은 이 세상에 존재하는 그 어떤 것과의 연관성을 배제하지 못하지만 활자는 자연 그 어디에서도 본뜨지 않은 순수 심벌이다. 소리와의 관련성도 있지만 그보다 활자가 시각적이므로 시각적 형태의 추상성이 갖는 의미가 압도적이며 '보여지는' 과정을 통해 음성적, 촉각적, 공감각적인 이미지로 연결되는 것이다. 직관적 활자 연주는 때로 타이포그래피 원칙과 배치되기도 하면서 의미전달이라는 연결고리를 의식적으로 끊어내기도 하여야 자유로울 수 있다. 이미지를 다각도로 상상하여 전달하려는 의도의 활자 배열은 그것이 지시하는 의미들보다는 다소 낯선 활자의 추상적 형태와 공간에 부유하는 유희적 해석에 집중하게 하며 이로써 죽어버린 활자가 아닌 그 자체로 '살아 있는 활자'가 되는 것이다. 한글은 시각적으로는 발음 기관의 형상이나 천지인과 음양오행 등 상형의 대상이 이미 가지고 있는 상징성을 바탕으로 만들어져 있어 그 어느 나라 문자보다도 사물에 대한 직접적인 상형성보다 추상적 형태성이 강력하며 놀라울 정도로 기하학적이고 간결한 특징을 가지고 있다. 한글 시각시는 한글 활자의 추상적 형태성에 집중하고 언어적 의미성의 고리를 의식적으로 탈피하여 살아 있는 활자로서의 자유로움과 생동감을 확장시키고자 하는 실험이며, 시가 가지고 있는 압축된 문학적 문맥(context)과 머릿속에서 완성되는 이미지를 활자 회화 이미지로 공감각 전이를 시도하는 작업이다. 낱말을 구속하는 의미 구조와 활자의 추상 형태성이 보여주는 낯선 이미지의 경계를 모호하게 하며 자유롭게 이를 넘나드는 활자 연주는 매우 매혹적인 타이포그래피가 아닐 수 없다. 때로 악보에 집착하거나 들여다보는 데 시간을 들이지 않는 즉흥적이고 현란한 연주가 주는 느낌이 더할 나위 없이 아름답기도 하다.

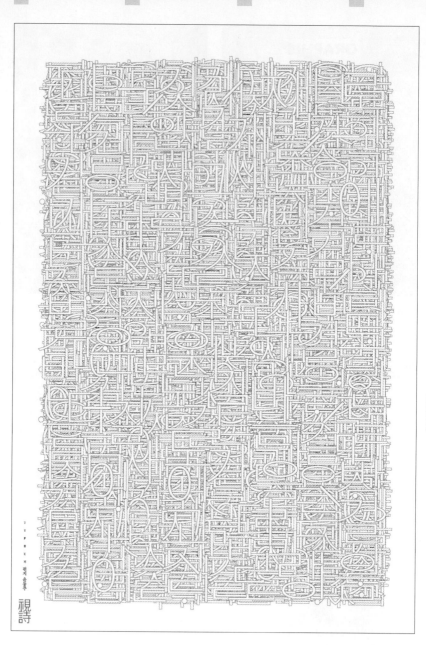

kim joo-sung

magazine. graphic #9. 230 x 300. 2009.

Na Kim studied in Product Design in KAIST and Graphic design in Hongik University, in Korea. After finishing her study in Korea, she participated in the Werkplaats Typografie, in Arnhem, Netherlands between 2006 and 2008. Now she lives and works in Amsterdam, in collaboration with many cultural projects. She was selected as 'the Young Korean Design Leader' in 2008 and organized several exhibitions <WT at Neon>, Lyon in 2007 and <Starting from Zero>, Seoul in 2008. Since 2009 she has been art-directing <GRAPHIC> magazine. On occasion she is working on self-initiated projects such as <Blow-up> series and independent magazine <umool umool>. Recently her works were featured in Wallpaper*, Grafik, AXIS, Items, Novum and etc. She was invited for various exhibitions, including Milan Triennale Design Mueseum, Design Beijing Typo '09, Graphic Design Festival Breda and she also invited for lectures and workshops in the Gerrit Rietveld Academie, ÉCAL, Hongik University, Kaywon School of Art & Design.

kim na

198

kim.na.

김영나.金영나.

korea

KAIST에서 제품 디자인을 공부했으며 홍익대학교 대학원에서 그 래픽 디자인을 전공했다. 이후 네덜란드 베르크플라츠티포흐라피 (Werkplaats Typografie)를 졸업하고 현재 암스테르담을 근거지 로 활동하고 있다. 2008년 차세대 디자인 리더로 선정되었고, 전 시 〈WT at Neon〉, 〈Starting from Zero〉를 기획하였다. 2009년부터 계간 〈GRAPHIC〉의 아트 디렉터이자 편집자로 활동하고 있으며, 그 밖에 'Blow-up series' 시리즈와 'umool umool' 등의 개인 프로젝트를 수행하고 있다. 최근 그의 작업은 〈Wallpaper*〉, 〈Grafik〉, 〈AXIS〉, 〈Items〉, 〈Novum〉 등의 매체에 소개되었으며, 〈밀라노 트리엔날레〉, 〈베이징 타이포그래피 2009〉, 〈그래픽 디자인 페스티벌 브레다〉 등의 다양한 국제전에 초대되었다. 네덜란드 헤릿리트벨트아카데미, 스위스 에칼, 홍익대학교, 계원조형예술대학에서 초빙 강연 을 했다.

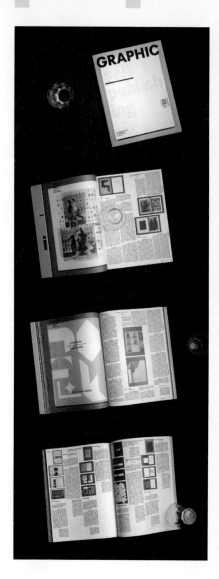

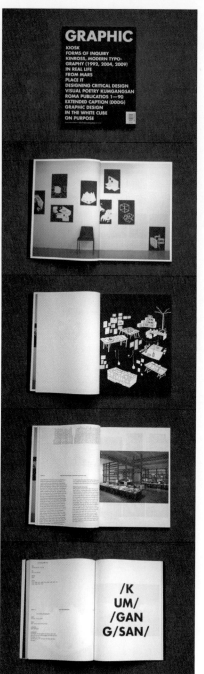

kim na

magazine.　graphic #10.　230 x 300.　2009.

magazine.　graphic #11.　230 x 300.　2009.

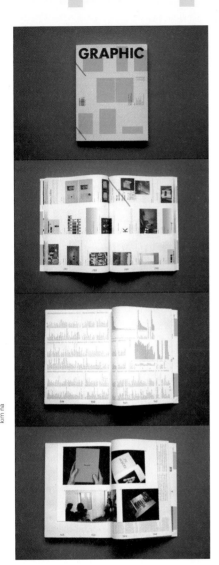

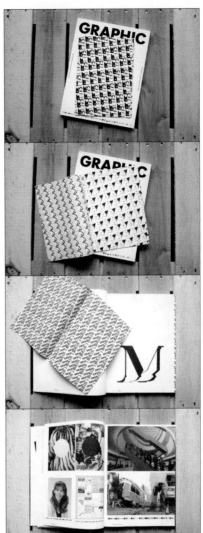

In the end,
it is "convincing" myself.

결국에는
자신을 '설득하는' 것.

magazine.　graphic #12.　230 x 300.　2009.

magazine.　graphic #13.　230 x 300.　2010.

kim na

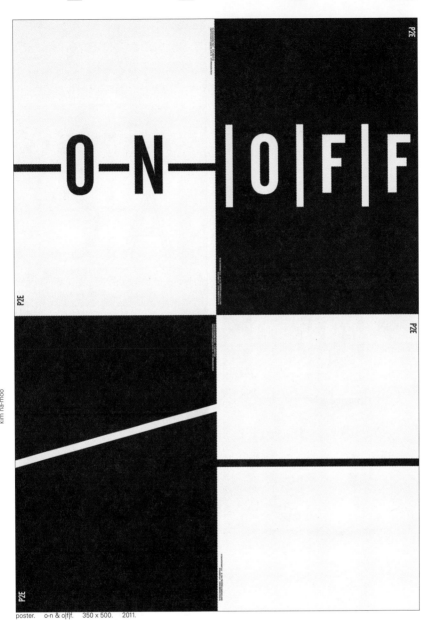

kim na-moo

202

poster.　o-n & o|f|f.　350 x 500.　2011.

Kim Namoo, who is currently working as a graphic designer and design educator, initially studied user experience design and visual communication design in Korea. He later went on to earn an MFA degree with honors in the graphic design program at the Rhode Island School of Design in U.S. In the summer of 2008, he worked at Lust, a cross-disciplinary design studio in the Netherlands. While working there, he worked on multi-disciplinary projects such as the TodaysArt Festival, De Vrije Academie, Stedelijk Museum Amsterdam. He came back to Korea in 2009 and set up his own design practice and press named Golden Tree which is the English translation of his Korean name. Along with working on design projects and teaching graphic design and typography, he is currently doing lectures, workshops, seminars, exhibitions, research, translation, and publishing as well. Golden Tree's projects have been awarded by AIGA, ADC, Tokyo TDC, TDC NY, iF, Red Dot, I.D., Creative Review, Goldenbee, Graphis, Creative Quarterly, IDA, Summit with outstanding excellence. He is recently working on a typography research project entitled <Typescape> which explores the relationship between forms of type and the experience of it.

poster. il/literate. 700 x 1,000. 2011.

한국에서 사용자 경험 디자인과 시각 디자인을 공부하고 미국 로드아일랜드 스쿨오브디자인
의 그래픽 디자인 석사과정을 마쳤다. 2008년 여름, 네덜란드에 있는 디자인 스튜디오 러스
트에서 일하며 프라이아카데미, 암스테르담 시립미술관, 〈투데이아트 페스티벌〉 관련 프로젝
트에 참여했다. 2009년 귀국하여 그의 이름을 내건 디자인 스튜디오 골든트리를 운영했다.
스튜디오 운영과 교육 활동 외에도 강연, 워크숍, 세미나, 전시, 연구, 통역, 번역과 출판 분야
에서 활동하고 있다. 골든트리의 작업은 미국그래픽디자인협회(AIGA), 아트디렉터스클럽
(ADC), 도쿄 타이프디렉터스클럽(TDC), 뉴욕TDC, iF, 레드닷디자인 어워드, I.D., 크리에이
티브리뷰, 골든비 어워드, 그래피스, 크리에이티브쿼털리, IDA, 서미트 등에서 수상하였다.
최근에는 글자의 형태와 경험을 주제로 하는 타이포그래피 리서치 작업 〈활자풍경〉을 진행하
고 있다.

kim.na-moo.

korea

김나무.숲나무.

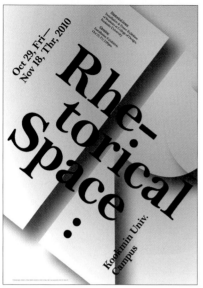 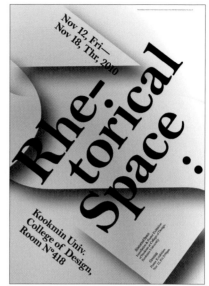

poster. rhetorical space. 700 x 1,000. 2010.

For me, graphic design and typography is a puzzle. As the trio at Lust once mentioned, the moment when the last piece of a puzzle is missing is "thousand times more interesting than the moment when the puzzle is finished because when that happens, there is nothing more. Since I have worked at Lust, my design has been heavily influenced by this notion. In response to this, my design has always been based on the process and the system rather than the eventual design itself. I think this process and system, helps in my own design, and in automatically producing or generating my very own design output—a called Golden Tree unique puzzle.

To give you a sense of such a Golden Tree puzzle, I will provide you with a list of words which consists of terms and names of tools that help me design and think. It also contains people that I admire. This list is ordered, somehow, based on a key, the term in database theory, but is always open to be re-ordered. A newly ordered list would give you a different meaning and experience. I hope these words help you to grasp my design philosophy: 80/20 rule, affordance, alternative alphabets, archetypes, archiving, bottom-up approach, cartography, categorize, chaos, Chris Marker, chunking, code, coincidence, context, contribution, curve, data-

book. impossible type. 195 x 260. 2010.

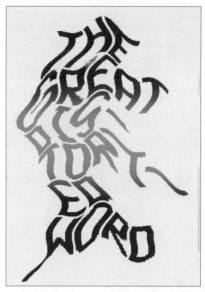

poster. the great distorted word. 700 x 1,000. 2010.

205 visualization, database, David Reinfurt, dimension, distortion, distribution, dot, El Lissitzky, encyclopedia, essence, experience, face, feedback, generation, Georges Perec, graph, Hammett Nurosi, hi-fi, incompleteness, indeterminacy, intertitle (or title card), Italo Calvino, iteration, Jean-Luc Godard, Jorge Luis Borges, László Moholy-Nagy, layers, letraset, line, list, lo-fi, Lust, mapping, marking, matrix, mental model, mimicry, mistake-ism, modularity, narrative, non-hierarchy, notation, open-ended, order, overlap, pattern, personas, perspective, Peter Greenaway, process, projection, prototyping, Rainer Maria Rilke, random, re-contextualization, rhizome, Robert Bresson, routing, scale, searching, sorting, special printing, stacking, Stanley Kubrick, subtitle, Sulki & Min, Susan Sontag, system, table, tiling, timeline, translation, tree, uncanny, virus, Wyndham Lewis, zoom in/out.

Finally, I will insert this quotation here from Jean-Luc Godard's thoughts about story.
"A story should have a beginning, a middle, and an end... but not necessarily in that order."
Jean-Luc Godard

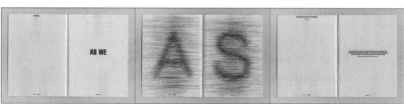

book. rush type. 195 x 260. 2010.

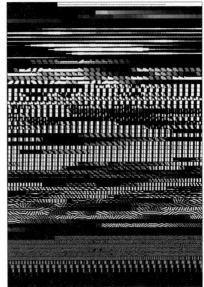

poster.　a visual dialogue with john cage.　700 x 1,000.　2010.

나에게 그래픽 디자인과 타이포그래피는 퍼즐이다. 네덜란드의 디자인 스튜디오 러스트는 퍼즐이 완성되는 그 순간보다 마지막 퍼즐 조각이 맞춰지기 직전, 또는 마지막 퍼즐 조각이 사라진 그 순간이 훨씬 더 흥미롭다고 했다. 퍼즐이 완성되는 순간 거기에는 다른 어떠한 가능성도 남지 않기 때문이다. 러스트의 디자인을 경험한 뒤로, 이 개념은 나의 디자인에 큰 영향을 끼쳤다. 이 영향 때문에, 나는 완성된 결과물보다 과정과 체계에 기반을 두고 항상 작업을 진행한다. 이 과정과 체계는 스스로 디자인을 해내거나, 적어도 내가 디자인하는 것을 수월하게 하여 골든트리만의 디자인을 자동으로 생산 또는 생성해 낸다. 이른바 골든트리 퍼즐이다.

골든트리 퍼즐에 대한 맛보기로 용어들, 디자인 사고와 실천을 돕는 도구들, 그리고 내가 존경하는 인물들로 구성된 단어의 목록을 여기에 싣는다. 이 목록은 데이터베이스 이론에서 사용되는 어떤 하나의 '기준'에 의해 순서가 매겨져 있다. 그러나 이 단어들의 목록은 누구나 새롭게 재구성할 수 있도록 열려 있다. 새롭게 재구성된 목록은 또 다른 의미와 경험을 만들어 낼 것이다. 이 단어들의 목록이 나의 디자인 철학을 이해하는 데 조금이나마 도움을 줄 수 있기를 바란다. 80/20법칙, 겹치기, 경험, 고성능, 곡선, 과정, 기여, 나무, 낯선 두려움, 대응, 대체 문자, 덩어리로 나누기, 데이비드 라인퍼트, 데이터 시각화, 데이터베이스, 도표, 라슬로 모호이-너지, 라이너 마리아 릴케, 러스트, 레트라세트, 로베르 브레송, 맥락, 면, 모듈 방식, 목록, 무작위, 묶음화, 바이러스, 반복, 백과사전, 번역, 보관, 본질, 분류, 분배, 불완전성, 불확정성, 뿌리줄기, 삽입 자막(또는 자막 카드), 상향식 접근, 생성, 서사, 선, 수전 손택, 순서, 스탠리 큐브릭, 슬기와 민, 심성 모형, 엘 리시츠키, 연대표, 열린 결말, 왜곡, 우연의 일치, 원근법, 원형, 원형 제작, 위계 소거, 윈드햄 루이스, 의도적으로 실수하기, 의태, 이탈로 칼비노, 자막, 장뤼크 고다르, 재맥락화, 저성능, 절차 결정, 점, 정렬, 조르주 페렉, 지도 제작술, 차원, 체계, 층위, 코드, 크기, 크리스 마르케, 타일 깔기, 탐색, 투사, 특수 인쇄, 패턴, 페르소나, 표, 표기법, 표시, 피드백, 피터 그리너웨이, 하멧 누로시, 행동 유도성, 행렬, 호르헤 루이스 보르헤스, 혼돈, 확대/축소.

마지막으로, 장뤼크 고다르의 '이야기'에 관한 그의 견해를 인용하며 글을 마친다.
"이야기는 시작, 중간과 끝이 있어야 한다. 그러나 꼭 그 순서일 필요는 없다."
　　　장뤼크 고다르

207

poster. brilliant sorrow. 700 x 1,000. 2011.

Born 1947 in Hokkaido, Japan. Art director and designer. After graduating from Musashino Art University, Kimura entered the Kei Mori and Associates and then spent 10 years working in Tamotsu Ejima's design studio. In 1982, he went solo and founded the Kimura Design Office. In 1987, <Esquire Japan>, with Kimura on board from day one as art director, burst on the scene marking an epoch in the history of Japanese editorial and design work. While providing works of design for scores of magazines, PR publications and books, including <Mrs.>, <Waraku>, <High Fashion>, <Mr.>, <Marie Claire>, <Martha Stewart Living>, <Kurashi no Techo>, <Tokyo-jin>, <Tsubasa no Okoku (ANA in-flight magazine)>, and 13-volume set of books <Ushinawareta Toki wo Motomete (In Search of Lost Time)>, Kimura also worked in the book design field, and received the Kodansha Publications Cultural Award. Kimura was chosen by the Tokyo ADC as recipient of 2009 ADC Award. His exhibition <The Making of Yuji Kimura: Margins and Memories> was held at Japan Creative Centre in Singapore in 2010.

키무라.유지.木村裕治.

kimura.yuji. japan

News paper.　the asahi shimbun globe (2008 no.1).　280 x 407.　2008.

kimura.yuji

208

news paper.　the asahi shimbun globe (2008 no.4).　280 x 407.　2008.

1947년 홋카이도에서 태어났다. 무사시노미술대학 조형학부를 졸업하고 모리케이디자인연구실을 거쳐 에지마디자인사무소에서 10년 간 근무한 뒤 1982년 키무라디자인사무소를 열었다. 〈에스콰이어〉 일본판 창간호부터 10년 동안 아트 디렉터를 담당했고 〈ANA 기내지〉, 〈날개의 왕국〉, 〈미세스〉, 〈와라쿠〉, 〈하이패션〉, 〈미스터〉, 〈마리끌레르〉, 〈마사 스튜어트 리빙〉, 『삶의 수첩』, 『도쿄진』, 『잃어버린 시간을 찾아서』(전 13권) 등의 기업 홍보물과 잡지 디자인, 북 디자인과 서적 장정 등의 작업을 병행했다. 고단샤출판문화상 북디자인상, 아트디렉터스클럽(ADC)상을 수상했으며 2010년에는 싱가포르 JCC에서 전시 〈The Making of Yuji Kimura 전〉을 열었다.

209

Kimura Yuji

As concerning the situation Japan is facing now, I am bewildered how I can deal with writing this statement. It has been so long. We Japanese left much behind to step forward for half a century. Never thought to pay back in such a cruel way for what we did and did not...

New daily life which is different from yesterday. Words to link people to people. Reality to be aware of. Thoughts to be inherited by next generation. "Now" which we are groping for in a dense fog.... I understand this is not a place to look for those here, but they have never released me out of deep thought. It may be good to go back to square one to find out where I am now. Whatever coming up to my mind, I mutter for now. ● I am working on a compilation book of an art director who ran through the '60s and the '70s. It probably will not be just a book like his portfolio. I don't think all his works would be fit comfortably enough in that form. His major battlefield was "magazines." He struggled to pursue something we had never seen on earth. As flipping pages of those magazines, the audience who knows his bitter struggle would hear his cry. Here is an e-mail from the editor who took on my escort runner throughout this book creation. "I have been felt a lack of vitality of Japanese people these days, but now is the time we must hang in strongly to revive Japan with innovative imagination, and also a wonderful chance for Japanese people to be tough. I am sure young people involving in modern design and publications would see full of inspiring and thought-provoking

book. rokujyou-no-miyasudokoro genji-gatari 1,2. 137 x 193. 2010.

book. in search of lost time marcel proust abridged translation 2 vloumes. 160 x 217. 1992.

kimura yuji

contents in this book, including the implication that any creation started originally with "by hand." ● 1960 was the year of the World Design Conference in Tokyo. I wonder what the participants, especially Japanese designers, in the conference thought of at that time. Though 15 years had passed since the defeat of World War II, it was considered that nothing was sufficient in Japan. How were they conscious of renascence of Japan by using the tool called "design" in the future under such severe conditions? Several years later, when I was 15 years old, I encountered a magazine created on the basis of the conference at a book store. I remember myself at that time having felt very special about what was called design. Japanese design since then has been greatly attributed to those senior designers who were present in the conference. Keeping pace with the rapid economic growth after the war in Japan, it seemed to work effectively to provide good influences on the society with a momentum, while adjusting its way to go sometimes. ● Bauhaus was established in 1919. Though I knew its name, it was not until I joined a study group after entering the art university that I understood its true figure. Contrary to its romantic spirit of initial school motto, or maybe, as a consequence of the spirit, Bauhaus repeatedly faced its fate being tossed about by violent changes of the times. Design is often assumed as a matter of shape and its practical application. I became aware of that it was a new trend of thoughts derived from various transmigra-

book. the little prince antonie de saint-exupery. 113 x 193. 2005.

book. nigatsu wintertale (february) yuji obata. 198 x 251. 2007.

kimura yuji

tion by way of Bauhaus, maybe owing to the fact that I was just a young student at a design school as well as its time background in the late '60s. With the design philosophy from those days in one hand, I have walked along the pavement of blessing constructed by great design-ers before us.　●　Time has passed since then. Japanese have reached the summit of a small mountain, and lost sight of the signpost in front of us.　●　Now, what will I do? I'm thinking over, but just get nowhere.＿＿＿＿＿＿현재 일본이 놓인 상황을 생각하며 이 글을 어떻게 써야 할지 고민한다. 어제오늘 시작된 것이 아니다. 일본인들은 큰 것을 놓친 채 이 반 세기 남짓을 지내왔다. 지금까지 지내온 나날들이 이러한 형태로 고스란히 돌아오다니. 어제까지와 다른, 앞으로의 일상 / 사람과 사람을 잇는, 말 / 안다, 분수 / 다음 세대로 이어지는, 뜻 / 안개 속에서 더듬어보는, 현재……. 여기에서 그것을 찾을 수 있는 것은 아니지만, 생각이 그것에 매여 끝없이 이어진다. 자신이 선 곳을 알고 싶으면 시발점에 돌아가 보아야 하는 걸까. 일단 생각나는 대로 중얼거려본다.　●　현재 1960~1970년대를 질주한 아트 디렉터에 대한 책을 만들고 있다. 아마도 작품집을 만들지는 않을 것이다. 그러한 형태로는 이 사람을 충분히 담아낼 수가 없다. 그 사람들의 주된 싸움터는 잡지였고 그는 세상에 없는 것을 찾으려 고투했다. 잡지의 페이지를 넘기면 그것을 아는 사람들에게는 그 우렁찬 부르짖음이 들려온다. 아래는 자진해서 이 책을 만드는 데 함께했던 편집자의 메일이다. "현대 일본인들은 '살아가는 힘'이 약하다고 느끼고 있었는데, 이런 때야말로 강인하게 새로운 발상으로 그 힘을 재생시켜 나가야겠습니다. 그리고 강해질 수 있는 좋은 기회라는 생각이 듭니다. 물건을 만드는 일의 원점은 사람

magazine.

esquire japan.　227 x 280.

kimura ryuta.

1987 ~ 1995.

book.

one, two, three.　342 x 400.

1996.

의 '손'이라는 것을 알리고 디자인, 출판에 종사하는 젊은이들에게 시사하는 바가 많은 책이 되리라 확신하고 있습니다." ● 1960년대라고 하면 세계디자인회의가 도쿄에서 열린 해이다. 참가자 중에 일본 디자이너들은 어떤 마음으로 이 회의에 임했을까. 패전으로부터 15년이 지난 시기였지만 지금 돌이켜보면 모든 것이 충분치 못한 상황이었다. 앞으로 일본을 디자인이라는 도구로 재생시키겠다는 의지가 가득 차 있었던 것일까. 그 수년간의 회의를 바탕으로 묶은 잡지를 서점에서 발견했던 15살의 나는, 디자인이라는 것에 무언가 특별함을 느꼈던 것을 기억한다. 그 이후 일본의 디자인은 그 회의에 참석했던 디자이너들이 짊어져 갔다. 그것은 제2차 세계대전 후 일본 고도성장기와 보조를 맞추어, 때로는 그 길을 바로잡으면서 어떤 세력을 동반하여 사회에서 자리 잡으며 유효하게 기능한 것처럼 보였다. ● 1919년에 창립된 바우하우스. 이름은 알고 있었지만 그것이 무엇인지를 알게 된 것은 학생이 되고 그 연구회에서였다. 당초의 로맨틱한 건축 정신과는 달리, 혹은 그것 때문이라고 해야 할지, 그 이후 시대에 의해 줄곧 농락당하게 된다. 단순히 조형적인 것이라고 사람들이 흔히 생각하는 디자인이라는 것. 그것이 바우하우스를 통해 실은 다양한 변화를 통해 흐르는 하나의 사상으로 일어나기 시작한 것은 1960년대 말이라는 시대적 배경도 물론 크지만 내가 단지 젊은 디자인전공 학생이었기 때문인지도 모른다. 그러한 디자인에 대한 생각을 한쪽 팔로 부여안고 그들이 남겨준 포장된 은혜 속에서 줄곧 헤엄쳐왔던 것이다. ● 그로부터 시간이 흘렀다. 일본은 작은 언덕 정수리에 이르렀고 눈앞의 이정표를 놓치게 된다. ● 이제 어떻게 할 것인가. 생각이 멈추지 않는다.

213

book. the documentary of visconti. 196 x 308. 2007.

kimura yuji

Issay Kitagawa is the head designer at GRAPH Co., Ltd. He was born in Kasai, Hyogo Prefecture, in 1965 and graduated from Tsukuba University. In the book *NEW BLOOD: Art, Architecture and Design in Japan* (2001), Kitagawa is introduced as one of the 20 people who influence Japan's present-day architecture, art, design and fashion. The overwhelming quality of his works featured in design magazine <Idea> caused ripples in the global design industry. He was also selected as one of the juries for D&AD awards in United Kingdom and ADC awards in New York. He has also been selected as a member of AGI. A number of his works are housed in a permanent collection in the Bibliothèque nationale de France in recognition of their <outstanding book design and print techniques in recent years>. At the present time is continuing to bring forth new creations. In 2008 he exhibited some of his works at the Frieze Art Fair in London. He has received several awards, including the JAGDA New Designer Award and the Tokyo TDC Award. He published a book <Kawarukachi (Changing Values)>.

214

poster. chinkiwa poster. 720 x 987. 2011.

kitagawa.issay.japan

키타가와.잇세이.北川一成.

1965년 효고현 간사이에서 태어났다. 쓰쿠바대학을 졸업했고 현재 GRAPH의 책임 디자이너이다. 2001년 발행된 책『뉴블러드: 일본의 예술, 건축 그리고 디자인』에서 일본의 영향력 있는 디자이너 20인 중 한 명으로 소개되었으며 <아이디어>지에 소개된 그의 작품들은 세계 디자인계에 큰 인상을 남겼다. 영국 D&AD상과 뉴욕 ADC상의 심사위원을 지냈고 국제그래픽디자이너연맹(AGI)의 회원이기도 하다. 그의 다수 작품이 프랑스 국립도서관의 '지난 몇 년간의 뛰어난 북 디자인과 인쇄 기법' 부분에 영구 소장되어 있다. 현재는 새로운 창조물을 만들어내는 데 집중하고 있으며 2008년 작품 일부를 런던 <프리즈아트페어>에 전시했다. JAGDA 신인디자이너상, 도쿄TDC상 등을 수상했으며 저서『카와루카치(가치의 변화)』를 출판하였다.

215

kitagawa issay

poster. kanpai. 594 x 841. 2010.

When I design, I consider white space to be of the greatest importance. In the design context, white space invariably exists as one half of a pair with the typeface, logomark, etc. – like an object and its nest. White space corresponds to the chippings left when a sculptor creates a work of art from a piece of stone. The object takes shape, I believe, precisely because one can see its 'white space.' What I pay attention to in particular is the flow of ki, i.e. energy. For example, when deciding how much space should be placed between two objects, I create sufficient white space to create a path for ki to 'flow'. This is entirely a perceptual way of expressing what I mean, but the image here is one of a breeze blowing freely through a space without obstruction. When determining a white space, another thing I believe is important is the 'weight' of the design. Basically, I feel there is something wrong about design that is based on computer-generated numbers alone. Objects can be positioned perfectly using mathematics and machines, but do appear optically wrong. In the natural world, straight lines and perfect symmetries don't exist. I believe the source of creativity lies hidden in things which are consciously overlooked or white spaces or perceptions in the interstices of my conscience. For example, why do we feel at ease seeing a wine glass placed in the centre of a table but feel anxious when the same glass is placed close to the table's edge? The wine glass itself is unchanged, but I think we feel differently as a result of the change in the white space (or our perception of it) of the table resulting from the glass's shift in position. Anyone who can see only the wine glass undergoes no change whatsoever. The passage of human consciousness is something that fascinates me. In the confrontation between the formation and breakdown of a common awareness within that passage I believe lies the source that leads to creative discovery. With the passage of perceived awareness through words, it is very difficult to encompass the differences in perception felt by each individual. I believe that the gap between individual perceptions and concepts that 'seem' identical is the source of creativity. I think with human powers such as the unconscious mind, intuition and individual sensibilities, it is important for them, along with conceptualization, to have an impact on our physical being, and I worry about relying too much on one direction or the other.

216

Translated by Rei Muroji
Excerpt from Issay Kitagawa "The Role of White Space in Design" which was first appeared in TypoGraphic 68. TypoGraphic is the journal of International Society of Typographic Designers:
www.istd.org.uk

디자인을 할 때 나는 백색 공간을 매우 중요하게 고려한다. 디자인 맥락에서 백색 공간은 글꼴, 로고 등과 한 쌍을 이루는 절반으로 예외 없이 존재한다. 마치 개체와 그 둥지처럼. 백색 공간은 조각가가 돌로 예술품을 창조할 때 버려지는 부스러기와 비슷하다. 개체가 형태를 갖춰가는 명백한 이유는 그것의 백색 공간을 볼 수 있기 때문이라고 생각한다.

내가 특별히 더 많은 관심을 기울이는 것은 기의 흐름, 즉 에너지의 흐름이다. 예를 들어 두 개의 개체 사이에 어느 정도의 공간을 지정할지 결정할 때, 나는 기의 '흐름' 경로를 위해 충분한 백색 공간을 만든다. 이것은 내 뜻을 표현하는 전적으로 지각적 방식이지만, 이곳에서 나타나는 이미지는 장애물 없는 공간을 통해 자유롭게 부는 미풍이다.

218

poster.　issay kitagawa poster.　720 x 1,000.　2010.

백색 공간을 결정할 때 중요한 또 한 가지는 디자인의 '무게'이다. 기본적으로 나는 컴퓨터로 생성된 숫자들에만 기반을 두어 만들어진 디자인에는 뭔가 문제가 있다고 생각한다. 개체들은 수학과 기계를 사용하여 완벽한 위치에 놓일 수 있지만, 시각적으로 잘못되어 보이기도 한다. 자연적인 환경에서 직선과 완벽한 대칭은 존재하지 않는다.

창조성의 원천은 내 양심의 틈에 있는 의식적인 간나나, 백색 공간이나, 지각에 숨겨져 있다고 믿는다. 예를 들어, 와인 잔이 테이블 정중앙에 놓여 있을 때 편안함을 느끼지만, 같은 와인 잔이 테이블 모서리 가까이에 위치할 때 불편함을 느끼는가? 와인 잔 그 자체는 변함이 없으나, 우리는 와인 잔의 위치가 바뀜으로써 테이블 위의 백색 공간의 변화가 만든 결과(혹은 우리가 지각

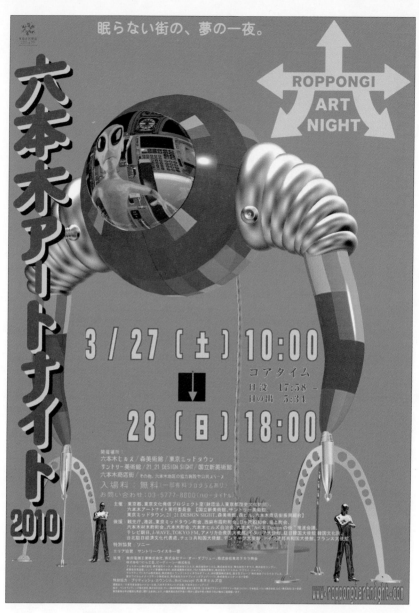

poster.　roppongi art night 2010 poster.　728 x 1,030.　2010.

한 것)에 대해 다르게 느끼는 것이다. 와인 잔을 볼 수 있는 누구나 동일하게 반응한다.

인간 의식의 통로는 나에게 매력이다. 그 통로 안의 일반적인 의식 형성과 붕괴 사이의 대립에 창조적 발견으로 이끄는 근원이 자리 잡고 있다고 믿는다. 단어들을 통해 지각된 의식의 통로를 가지고, 개인이 느끼는 차이의 지각을 아우르는 것은 매우 어렵다. 나는 개인의 지각과 동일하게 보이는 콘셉트의 차이가 창조적 근원이라고 생각한다.

나는 무의식적인 마음, 직관, 그리고 개별 감각들과 같은 인간의 힘으로 사고하며, 그것들은 개념적 해석과 더불어 우리 신체적 존재에 영향을 끼치는 것이 중요하다. 그리고 나는 그중 한쪽 방향에만 치우치지 않도록 주의한다.

ko.kang-cheol. korea

고강철.高康喆.

1967년에 태어났다. 1992년 홍익대학교 시각디자인과를 졸업했다. 〈예술을 위한 디자인전 1〉(2003, 아티누스), 〈기원형상 playgram 1〉(2006, 세종문화회관), 〈기원형상 playgram 2 talisman〉(2007, 베이징 눈갤러리) 등 국내외 개인전을 가졌으며, 〈bookArt 전〉(2004, 국립현대박물관), 〈물티쿨티 크로스오버〉(2006, 헤이리 판페스티벌), 〈전심전력전〉(2009, 베이징 KU아트센터), 〈온고지신〉(2009, 서울 가나아트센터), 〈핑야오 사진비엔날레〉(2011, 중국 산시성), 〈Korea Tomorrow〉(2011, 예술의전당) 등의 기획전에 참여했다. 2007년 부산국제영화제 개관 홍보탑 설치 및 부천 디지털컨텐츠진흥원 리노베이션 작업, 2010년 새문안길 미술의 거리 조성 등 공공미술 프로젝트에 참여했으며, 프랑스만화 특별전, 이란 건축전, 부산 비엔날레의 전시 및 공간 디자인, 인천여성비엔날레 전시 그래픽 디자인과 인천세계도시축전 세계의 문화거리 조성 작업을 맡기도 했다.＿＿＿＿＿＿＿＿＿＿＿Born in 1967. Graduated in visual communication design from Hongik University. Ko held solo exhibitions including <Design for Art 1st> (Gallery Artinus), <Original form playgram 1st> (Sejong Center), <Original form playgram 2nd talisman> (Space Noon, Dashanzi 798 Beijing), and participated various planned exhibitions including <BookArt> (2004, the National Museum of Modern Art, Gwacheon), <MultiCulti Crossover> (2006, Pan Festival, Heyri), <JeonsimJeonlyuk> (2009, KU Art center, Beijing), <Ongojisin> (2009, Gana Art Center), <Pingyao Photo Biennale>(2011, China), <Korea Tomorrow> (2011, Seoul Art Center), and so on. Ko also involved in many public art projects including making Saemunan road Art Streets, renovation of Bucheon digital contents agency, installation of opening promotional tower in Pusan international movie festival, etc. He also executed space and exhibition designs such as Global Fair & Festival 2009 Incheon (Culture Streets of World), Busan Biennale, Iranian architecture exhibition, French Cartoon Special exhibition, and exhibition graphic of Incheon Female Biennale, and so on.

220

poster. national human right commission of korea 1. 520 x 760. 2005.

poster. national human right commission of korea 2. 520 x 760. 2005.

221

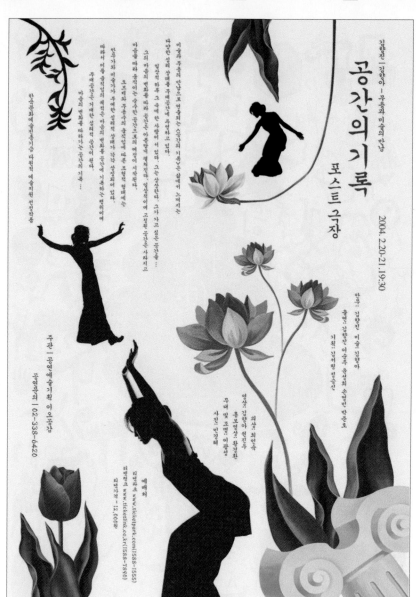

ko kang-cheol

poster. the performance "space recording". 510 x 760. 2004.

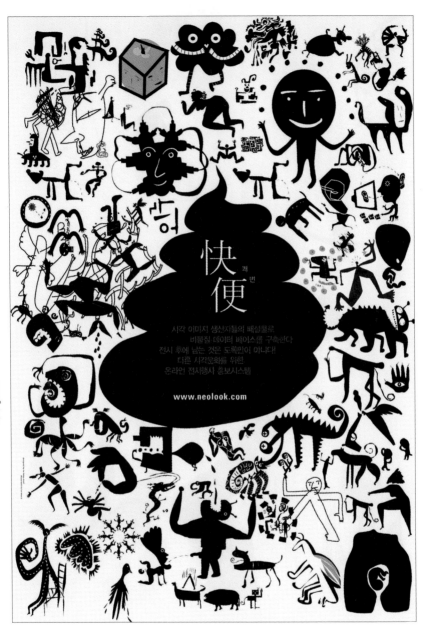

快便
쾌변

시각 이미지 생산자들의 배설물로
비물질 데이터 베이스를 구축한다
전시 후에 남는 것은 도록만이 아니다!
다른 시각문화를 위한
온라인 전시행사 홍보시스템

www.neolook.com

poster. poster for the art website neolook.com. 520 x 760. 2000.

223

ko kang-cheol

poster. moving poster for mime performance. 520 x 760. 2000.

poster. 2006 asia now. 520 x 765. 2006.

ko kang-cheol

224

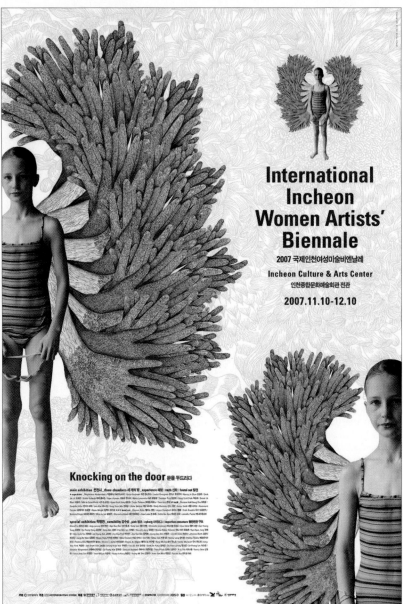

ko kang-cheol

무사시노미술대학 시각전달디자인과를 졸업하고 1989년부터 약 1년 반 동안 영국 런던에서 캘리그래피를 공부했다. 1983년부터 1989년까지 주식회사 샤켄에서 글꼴 디자인을 담당했으며 1990년부터 유한회사 자유공방에서 〈히라기노 명조〉, 〈히라기노 고딕〉 글꼴 제작에 참여했다. 그 후 1993년부터 1997년까지 주식회사 타입뱅크에서 일본어 글꼴 영문 서체 부분을 디자인했다. 1997년 이후 프리랜서로 활동했으며. 타입프로젝트와 함께 글꼴 〈악시스〉의 영문 서체를 제작했다. 2001년부터 독일에서 라이노타입 회사의 타입 디렉터로 일하면서 글꼴 디자이너 헤르만 차프나 아드리안 프루티거와 함께 글꼴 개발 및 글꼴 패밀리 개선, 그리고 기업 전용 글꼴 개발을 담당하고 있다. 본문용 영문 서체 〈클리포드〉로 미국 U&lc(글꼴 공모전)에서 본문 부문 1위와 최우수상, 2000년 독일 라이노타입 글꼴 공모전에서 글꼴 〈콘라드〉로 본문 부문 1위, 〈ITC 우드랜드〉, 〈ITC 저패니스가든〉, 〈ITC 실버문〉, 〈FF 클리포드〉, 〈LT 콘라드〉, 〈팔라티노 산스〉 (헤르만 차프와 공동제작)로 뉴욕 TDC '최우수 글꼴 선정' 공모전 등에서 수상했다.

코바야시.아키라.小林章.

Studied at the Musashino Art University in Tokyo, and later followed this up with a calligraphy course at the London College of Printing. His first work experience in type design was at Sha-Ken, a manufacturer of phototype-setting machines, where he was employed from 1983 to 1989. This was followed by 3 years at Jiyu-Kobo, where he participated designing and digitizing the Japanese font Hiragino Mincho and Hiragino Gothic. From 1993 to 1997 he worked at TypeBank where he designed Latin alphabets to accompany TypeBank's digital Japanese fonts. Since mid-1997 he has worked as a freelanced type designer. In 2001, right after completing Latin alphabets to accompany Type Project's Axis Japanese font, Kobayashi joined Linotype as the company's type director. At Linotype in Germany, he collaborates with Adrian Frutiger and Hermann Zapf in modernizing their earlier typeface designs; he creates digital interpretations of typeface families in need of renovation; and, he draws custom typefaces for corporate clients. His fonts were awarded Best of Category and Best of Show for the Clifford typeface in the 1998 U&lc magazine type design competition, 1st prize of text category for the Conrad typeface in Linotype Library's 3rd International Digital Type Design Contest, TDC type design competitions for ITC Woodland, ITC Japanese Garden and ITC Silvermoon, FF Clifford, Linotype Conrad and Palatino Sans (with Hermann Zapf) respectively.

kobayashi.akira

226

kobayashi.akira. japan

brochure. neue frutiger type specimen. 420 x 280. 2009.

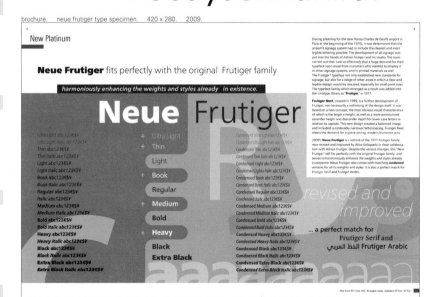

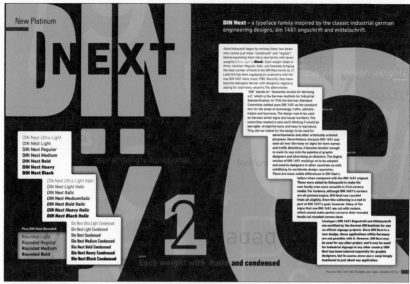

I remember very clearly when I first used a digital font. I had never touched a computer until I worked for a type design studio in Tokyo in 1991, right after I came back from London where I learned calligraphy, read books on typography and studied the English language.

One of my favorite typefaces by that time, Bembo, was the first digital font I wanted to look at on my computer screen. After typing a couple of letters, I got into a slight panic. None of the letters looked like the beautiful, extremely readable text typeface that I had become familiar with! That was the moment I decided to design my own Latin typeface suitable for body texts. I studied historical type specimens and prints, and learned from my predecessors through their type designs. I also implemented their ideas to my digital type when necessary.

brochure. din next type specimen. 420 x 280. 2009.

brochure. palatino nova / palatino sans type specimen. 420 x 280. 2006.

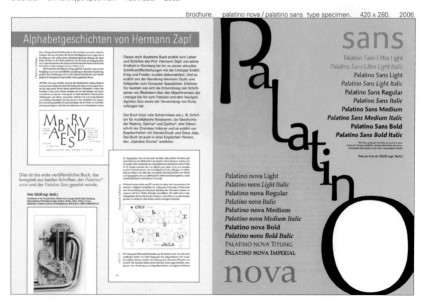

kobayashi akira

After I joined Linotype, my collaborations with Hermann Zapf and Adrian Frutiger, the masters of modern typeface design, instilled a depth of understanding of letterforms that took my type designs to new levels.

There is an old Chinese saying: looking into the old, learning something new. It is also stimulating to look into the old type specimens and rediscover how clever the designs in the past were. Sometimes they help me create traditional-looking types, and sometimes the types that are fresh and lively.

228

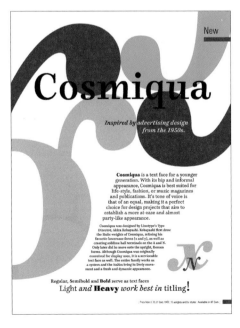

처음으로 디지털 폰트를 썼을 때를 선명하게 기억하고 있다. 캘리그래피나 타이포그래피를 배우던 영국에서 일본으로 돌아와 글꼴 디자인 회사에서 일하기 시작한 1991년에 처음으로 컴퓨터를 써본 것이다.

당시 내가 좋아하는 글꼴 중에 〈Bembo〉가 있었고 그것을 스크린에서 보고 싶어 몇 자 입력해 보고는 깜짝 놀랐다. 어느 글자를 봐도 내가 알던 그 아름답고 읽기 쉬운 글꼴이 아니었다. 그때 나는 스스로 본문에 적합한 디지털 글꼴을 만들겠다고 마음먹었다. 과거 글꼴 견본이나 인쇄물을 보고 그 디자인에서 많은 것을 배우며 스스로의 글꼴에도 활용했다.

229

Akko &
Akko rounded
cozy and tender but definite

Thin	**Medium**	Thin	**Medium**
Thin Italic	***Medium Italic***	*Thin Italic*	***Medium Italic***
Light	**Bold**	Light	**Bold**
Light Italic	***Bold Italic***	*Light Italic*	***Bold Italic***
Regular	**Black**	Regular	**Black**
Italic	***Black Italic***	*Italic*	***Black Italic***

New

A new typeface
by Akira Kobayashi

12 weights
between Thin and **Black**

New *adjustable levels* of
spherical abberations

THE PRINCIPLE OF
BLURRING THE EDGES

The Source of the Originals
www.linotype.com

LinotYPE
by Monotype Imaging

kobayashi akira

akko type specimen.

라이노타이프사에서 근대 거장인 헤르만 차프나 아드리안 프루티거와의 공동작업을 통해 문자 모양에 대한 이해를 더욱 심화시킴으로써 나의 디자인은 새로운 경지에 달했다.

중국에 온고지신(溫故知新)이라는 말이 있다. 옛 글꼴 디자인을 보고 당시 디자인이 얼마나 수많은 검토를 거친 것인지 깨닫게 될 때는 마음이 설렌다. 그것이 있을 때는 전통에 뿌리를 둔 글꼴 디자인에 도움이 되고 때로는 신선하고 현대적인 디자인에 살릴 수도 있다.

김경선은 어린 시절부터 한자와 서예를 배웠고 브리태니커코리아에서 일을 하던 아버지의 영향으로 접한 많은 책들과 잡지 덕에 꽤나 '그래픽적'인 경험이 많았다. 건국대학교에서 시각 디자인을 공부할 당시, 북 디자인〈한글 고딕체에 관한 연구〉로 문화체육관광부 장관상을 받았다. 첫 직장인 광고회사 제일기획에서 브랜딩, 프로모션 디자인, 포스터, 북 디자인등의 다양한 경험을 했다. 그 당시 티보 칼맨을 동경해 티보가 교편을 잡고 있던 뉴욕으로의 유학을 생각하고 있었지만, 그가 암투병으로 사망한 소식을 듣고, 영국으로 방향을 돌렸다. 런던 센트럴세인트마틴스컬리지에서 커뮤니케이션 디자인을 공부하던 중 피카디리서커스의 광고판에서 도심 속 문자, 브랜드, 문화에 대한 관심이 생겼다. 그는 '거리 표지로 도시읽기'라는 주제로 석사논문을 쓰게 되었고, 유럽 도시들을 각기 다르게 지배하고 있는 글자들과 조크 키니어의 영국도로표지판시스템, 거리에 흩어진 구체시와 같은 문자들, 공간 속의 타이포그래피 등에 관심을 가지게 되었다. 한국으로 돌아와 홍디자인에서 북 디자인, 브랜드 디자인을 했고, 그래픽 디자이너 모임 '진달래'에 합류했다. 진달래에서 디자이너들과 2006년 시각 시집 '금강산 프로젝트'를 기획하여, 남한의 디자이너들이 북한의 금강산을 방문하여 보고 느낀 것을 그래픽적으로 해석해 전시했고, 그 결과를 도큐먼트 형태로 묶어 발간했다.〈565돌 한글날〉(2011)의 프로젝트, 책축제〈파주북소리〉(2011)의 포스터 작업을 했으며 2010년부터 경상북도와 '한국의 종가' 아이덴티티 디자인 작업을 하며 전통의 가치를 현대화하는 데 관심을 가지고 있다. 그 밖에 한국전쟁 이후 열강들의 흔적과 산업화 근대화 과정 속에서 남겨진 다양한 시각문화에 대해 기록하고 있다. 현재 서울대학교에서 그래픽 디자인과 타이포그래피를 가르치고 있다.

poster. pajubooksori 2011. 700 x 990. 2011.

poster. nikkan sports. 700 x 990. 2004.
poster. ilgan sports. 700 x 990. 2004.

kymn Kyung-sun

With his father working at Britannica Korea, Kyungsun Kymn was exposed to visual contents since his early childhood. He played with numerous books and took calligraphy lesson which stimulated his interest in the visual world. He received a Grand Prize by Korean Ministry of Culture for Kkodik - a book on typeface, Hangeul Gothic while studying at Konkuk University. Then he pursued his career at Cheil Communications Inc., experiencing various aspects of design including CI, posters, and book design. Fascinated by the works of Tibor Kalman, who was then teaching at a college in New York, which inspired Kyungsun to plan to study abroad. However, with the news of Tibor Kalman's death, Kyungsun changed his plan and decided to study Communication Design at Central Saint Martins College of Art and Design in London. Kyungsun's interest extended to the letters in the cities, brands, and culture, which he explored further during his study; Reading a City through Street Signs, and then went further on numerous letters in different European cities, Jock Kinnier's UK Road sign system, concrete poetry-esque letters scattered on streets and typography in space.

After returning to Seoul, he worked on book design and brand identity design at Hong Design Inc. and joined a graphic designer club, Jindalrae, whose members are from different visual communication design. He planned a project called 2006 Visual Poetry – Kumgang Mountain, graphic interpretation of what designers from South

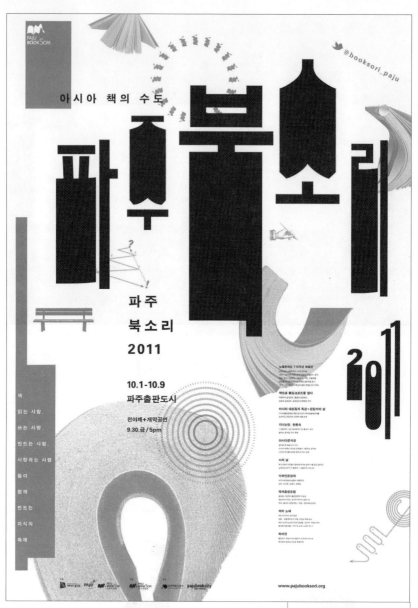

Korea, the last divided nation on earth, saw and felt during the trip to Kumgang Mountain in North Korea - which was exhibited and later published as a document.

He began teaching Visual Communication Design and Typography at Seoul National University in 2008. He participated in graphic design project for the 564th Hangeul Day in 2010 and designed a poster of 2011 Paju Booksori, the book festival held in the city of Asian books, Paju, Gyeonggi Province. Kyung-sun is also an art director for the Korean Novel Family (Jong-ga) identity design project with Kyungsangbukdo Province. He is currently interested in modernizing traditional values which led him to research on the Korean visual vernacular influences of industrialization on modernism.

김경선.金京瑄.

kymn.kyung-sun.

korea

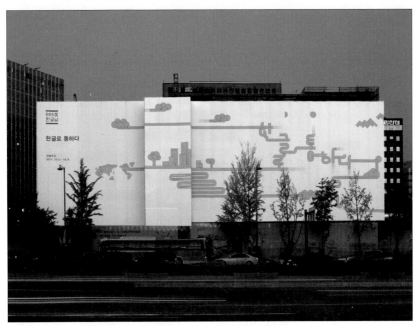

construction hoarding. hangeul, communicating with the world. 57,400 x 23,400. 2011.

232

poster. creativity through convergence. 597 x 841. 2008.

poster. the korea int'l poster biennale. 597 x 841. 2008.

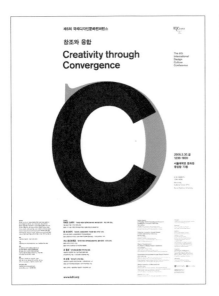

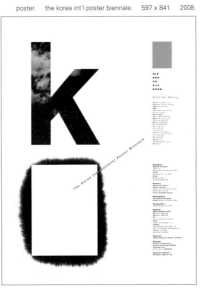

Play Design, to me, is not a breathtaking art, a grandiose architecture, a solemn classical music, or a sophisticated technique, but just a fun play. Design has always been a pleasure and a curiosity like the hanging Christmas cards from the childhood, drawing offbeat caricatures of famous people after reading biographies or flipping through the pages of National Geography whose contents were well beyond my understanding. It has not been long since I have come to realize it is design that can connect tradition and modernity to bloom a cultural flower. It is also design that allows the creation of ergonomical technology and the translation of profound knowledge into an understandable content. However, design must be fun and happy.

Relationship The love letter that connected me to her, the clues that let me know the soldier next to me had been from the same unit when I served, the signs that guided me at an unfamiliar airport during my first voyage to abroad, and the voices heard over my own first cell phone are all the joyous moments that were made possible by design. Through design, I believe I can talk straight to the manager, speak of the world with heartwarming stories and take a babbling baby to an unknown world. With my design, I wish people would get to know each other, longing and desire with passion, and that eventually those marvelous feelings would blossom

233

poster. giyeok e anna. 4,000 x 7,000. 2006.

kymn kyung-sun

놀이 나에게 디자인은 숨막히는 예술도, 웅장한 건물도, 엄숙한 고전음악도, 정교한 기술도 아닌 그저 심심풀이 땅콩이었다. 어린 시절 여러 나라에서 온 크리스마스 카드를 벽에 가득 매달아 놓고 보는 것처럼, 친구들과 위인전을 보며 위인들의 초상을 엉뚱하게 그려대는 놀이처럼, 혹은 〈내셔널 지오그래피〉와 같은 알 수 없는 내용의 잡지를 넘겨보는 것처럼, 나에게 디자인은 놀이이며 즐거움이며 호기심이었다. 그런 디자인은 요즘 들어 이 사회에서 중요한 역할을 많이 한다. 전통을 현대에 소개하여 문화의 꽃을 피우기도 하고, 낯선 첨단 기술을 손쉽게 사용하게 하기도 하며, 난해한 지식을 쉽고 재미있게 전하기도 하는데, 여전히 디자인은 즐거운 것이어야 한다는 것이 나의 생각이다.

관계 나와 그녀를 이어주었던 편지도, 군대 시절 내 옆의 동료가 나와 같은 부대 소속임을 알게 해준 것도, 처음 해외여행을 떠나 낯선 공항에서 길을 찾을 수 있게 해준 것도, 첫 월급으로 처음 구입한 휴대전화 너머 들린 목소리들도 모두 디자인을 통해 만났던 기쁜 순간들이었다. 또한 디자인을 통해 나는 분명히 경영자에게 옳은 소리를 할 수 있다 믿으며, 때론 따뜻한 이야기와 함께 세상을 노래할 수도 있으며, 옹알대는 아기에게 미지의 세계를 소개해 줄 수도 있다고 믿는다. 내가 하는 디자인으로 서로가 알게 되고, 보고 또 보고 싶게 하며, 알 수 없는 묘한 감정이 싹트게 되었으면 한다.

poster. minhwa. 594 × 841. 2005.

poster. typography workshop 10-1. 700 × 1,000. 2008.

kymn kyung-sun

City The focus should be on the traditional values, cultural heritage and peripheral stories. Characters visualizing the forms and sounds of the images passed down from the ancient times are the important media which have recorded and conveyed the values of the past. I learn a lot observing the streets of the cities where history and values of ancestors are experienced, priding themselves without any extra decorations or formality. Street signs and languages expressed in modern cities have now been planned and groomed, slowly losing their charm and making us miss the old modernistic cityscapes that resembled innocent teenagers; it was very sincere that it felt almost awkward around. Just like building a repertoire of my own memories after straying through a city, somebody once called it a gigantic book, a city as an environment is burdensome, yet is still a subject of interest.

Responsibility Although I am neither the UN Secretary General, nor a member of the national soccer team, I feel obligated to make a contribution to the society I am in with what I do every day, design. British designers have already been insisting that this skill be of service to the margins of society(First things first manifesto, 1964, by Ken Garland), but the society still neglects to see the importance of design and utilize design for ostentatious displays and egocentric motivations. I feel that it is my duty and dream to listen to a small voice and help to make this world better by designing things the way it is, designing for contents, and designing less.

235

poster. typography workshop 08-1. 210 × 297. 2008.

typography workshop 08-1

talk 1: sulki & min 080417 thu. 1800

talk 2: yun sumil 080423 wed. 1800

talk 3: kim doo-sup 080507 wed. 1800

talk 4: sung jae-hyouk 080523 fri. 1800

40-309 open seminar

kymn kyung-sun

도시 고유한 가치, 전해오는 문화, 변방의 이야기에도 주목해야 함을 느낀다. 선사로부터 내려오는 이미지의 형태와 소리를 시각화한 문자는 그것들을 기록하고 전해왔던 중요한 매체이고, 그것들이 격식 없이 꾸미지 않고, 서로를 뽐내듯 자리를 차지하고 앉은 도시의 거리를 보며 많은 것을 배운다. 현대의 도시에 표출된 거리 언어도 이제는 많이 다듬어지고 계획되어 약아빠진 어른 같아 재미없고, 어색한 듯 진지했던 순진한 중학생 같았던 모더니즘 때의 도시 풍경을 그립게 한다. 누군가 거대한 책이라고 일컬었던 도시 속에서 길을 잃고 헤매고 나면, 그만큼의 고유한 기억을 갖게 되는 것처럼 지금 내 앞에 주어진 환경으로서의 도시는 여전히 부담스럽지만 흥미로운 공부거리이다.

책임 또한 나는 유엔사무총장도, 국가대표 축구선수도 아니지만, 내가 매일 하는 일로 내가 속한 사회에 이바지해야겠다는 생각을 한다. 이미 반세기 전부터 영국의 디자이너들은 이 기술을 그간 소외되었던 분야에 우선적으로 쓰이게 하자는 주장을 소리 높여 왔지만, 여전히 세상은 들은 척 만 척, 번듯한 과시와 이기적 목적을 위해 디자인을 고용한다. 그것답게 만드는 디자인, 내용이 주인인 디자인, 덜 하는 디자인으로 작은 소리에 귀 기울이며, 건강한 지구를 만드는 데 기여하고자 하는 마음은 아직 실천하지 못하고 있지만, 꼭 실현하고자 하는 나의 책임이자 바람이다.

lee.chae. ^{korea}

poster. practice 1-writing poetry. 594 x 841. 2010.

lee chae

이재원.李在苑.

poster. practice 2-writing music. 600 x 840. 2010.

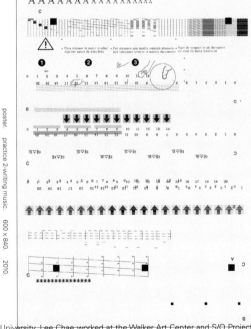

²³⁶

After completing her M.F.A. study at Yale University, Lee Chae worked at the Walker Art Center and S/O Project. She works as a professor in the Department of Visual Design at the Seoul Women's University College of Fine Arts. She is currently working to develop a broader scope of application from graphic design research into information design.

예일대학교에서 석사과정을 마친 후, 워커아트센터와 S/O Project에서 일했다. 현재 서울여자대학교 미술대학 시각디자인학과 교수로 재직 중이며, 그래픽 디자인 연구부터 정보 디자인까지 디자인의 응용 범위를 넓히는 데 관심이 많다.

poster. graphical print. 841 x 1,189. 2010.

Visual experiment: practice of forms

'Practice of Forms', a consistent area of interest for Chae Lee, refers to both the external form of the visual objects we frequently see around us, as well as their language and system. It involves producing new forms and the new contents that emerge from them, out of everyday visual objects discovered on the street, which are made to float loosely according to flows of time and space or placed into heterogeneous combinations in consideration of the mutual relationship of 'content' and 'form' in graphic/information design. On the top of that her working in a 'method of visual experiment that uses these forms as a pure graphic material', is not to lend support to the design ideal of clear communication; rather, the goal is to focus on experimenting with the transformations of graphic form that can be attained through objectively separating out those visual elements and excluding their original purpose.

Instead of the healthy goal of conveying information on the basis of 'quantitative' and 'objectivity', Lee's work is focused on experimenting with the transformations of graphic form that can be achieved through the appropriate deconstruction and constellation of those visual elements. While this attempt may be judged inappropriate from the general standpoint of information design, which dictates that 'ambiguity and confusion are indications of design failure', it places value on pure graphic experimentation realized through altering the conventional meaning systems of established visual languages, or through using only their shapes and forms. Through this sort of researching of form, her work presents possibilities for the discovery of transformed aesthetic values or the production of new meaning as information is reinterpreted within a new combination of codes and contexts.

시각 실험: 형식으로서의 그래픽 디자인

꾸준히 관심을 가져온 '형식으로서의 그래픽 디자인' 은 우리 주변에서 흔히 볼 수 있는 시각물들이 갖는 외 적인 형식이며 그것들의 언어이자 체계이다. 거리에서 발견한 일상의 시각물을, 그래픽·정보 디자인의 '내용 (content)'과 '형식(form)'이라는 서로의 관계를 고려 하여, 시간과 장소의 흐름에 따라 서로 느슨하게 부유 하게 만들거나 이질적으로 결합시켜 새로운 형식과 그 로부터 비롯된 새로운 내용을 만들어낸다. 그 형식들 을 순수한 그래픽 재료로 활용하려는 시각 실험 프로 젝트를 설정하는 데 명확한 소통이라는 디자인의 이상 에 힘을 보태려는 것이 아니라, 오히려 그 시각적 요소 들을 냉정하게 분리하고 원래의 목적을 배제함으로써 얻을 수 있는 그래픽 형태의 변형 실험에 집중하려는 목적을 가진다.

'정량성'과 '객관성'에 기반하는 정보의 전달이라는 건 전한 목적보다는, 오히려 그 시각적 요소들을 적절히 해체하고 재배열(constellation)함으로써 얻을 수 있 는 그래픽 형태의 변형 실험에 집중한다. 어쩌면 이것 은 '애매모호함과 혼동은 디자인의 실패를 의미한다' 는 정보 디자인의 보편적 관점에서 적절치 않은 시도 일 수 있지만, 이미 구축되어 있는 시각 언어들의 관습 적 의미체계를 바꾸거나 그 형태·형식만을 이용해 순 수한 그래픽 실험을 하는 것에 가치를 둔다. 이러한 형 식연구를 통해 정보들은, 여러 기호와 문맥의 새로운 조합으로 재해석되어 변형된 미적 가치를 발견하거나 새로운 의미를 생산할 수 있는 가능성을 제기한다.

lee chae

exhibition catalog. 2007 design made. 210 x 297. 2007.

(6) (7)

239

(8) (9)

lee chae

book. diagonal writing. 840 x 594. 2010.

poster / invitation. chae lee's 1st solo exhibiton. 182 x 257. 2008. 240

241 poster. design ¡olé!. 841 x 1,189. 2006.

Lee Choong-ho is an art director and graphic designer graduated from Central Saint Martins College of Art and Design in London with a BA (Hons) degree in graphic design. After graduation, he founded his own studio SW20 where he has produced both commercial and cultural projects for various clients. He intends to work without boundaries and his works are based on typography. He was appointed as an adjunct professor at Kyungwon University and Daejeon University and taught at Seoul Women's University and Kaywon School of Art and Design. His works were awarded by multiple awards including ADC, TDC, TDC Tokyo and etc. His work has been exhibited and published in magazines and books across the world. He is currently staying in London to focus on self-initiated project and pursuing research project.

아트 디렉터이자 그래픽 디자이너인 이충호는 런던 센트럴세인트마틴스컬리지에서 그래픽 디자인을 전공했다. 졸업 후 자신의 그래픽 디자인 스튜디오인 SW20을 운영하면서 상업적 디자인 작업과 문화 관련 작업 등 경계를 넘나드는 디자인 작업을 하고 있다. 경원대학교와 대전대학교 겸임교수를 역임했고 서울여자대학교, 계원디자인예술대학 등에서 강의했다. 그의 작업은 뉴욕 ADC·TDC, 도쿄 TDC 등 국제 디자인 공모전에서 여러 차례 입상하였으며 국내외 잡지를 비롯한 여러 매체에 소개 되었다. 현재는 런던에 머물고 있다.

lee choong-ho

lee.choong-ho.

korea

이충호 李忠昊.

242

poster. sw20. 540 x 750. 2005.

lee choong-ho

poster. a count. 700 × 1,000. 2006.

As a graphic designer, my subject of interest is trivial details in everyday life. This interest becomes the starting point to look at our world from various angles and it makes me to approach in a more comprehensive environment. Through design, I want to show that there are various eyes watching our world and different ways of communicating with people. Eventually I hope that these efforts can expand my way to see the world. Most of my self-initiated projects start as my personal interest and how I feel and the experience leads me to be inspired and to have ideas. I am also interested in the methods of delivering messages and I want to discuss the essential problems of the subject by using different approach depending on the characteristics of the subject and I like to express in my own way the values of the objects, phenomenon and thoughts that I have in my daily life through self-initiated project.

I like to use the word 'interpretation' for graphic design because I am interested in how I visually interpret a subject matter in a critical point of view. For a unique interpretation, it is essential to deeply understand a subject matter through comprehensive research. Research is an important part of design process and its role is especially influential for idea-led design. My approach to graphic design is idea and concept driven and if a project is decided, I start the research that can help me to understand the subject extensively and this will provide me with important evidences to make concepts and ideas for the project. I spend much time generating ideas that the project requires and then I express them in a visual form. As a graphic designer, I treat form however I am more focused on the idea and concept rather than form itself. The form naturally comes from idea and it is used to support my ideas to speak effectively.

poster. 10x15_front. 700 x 1,000. 2007.

poster. uk travel photo competition. 520 x 750. 2004.

poster. 10x15_back. 700 x 1,000. 2007.

244

lee choong-ho

Especially I am interested in the visualization through typography because typography is closely related to language and it shows how well the meaning of written words can be expressed visually by using type. The reason why I like graphic design is to convey the message of content using visual language and typography is an effective tool to systematise and create hierarchy in text. Personally I like simplicity and clarity rather than complication and ambiguity. How every element is systematically structured is important in my design. Typography provides me with an effective solution to solve a problem using the minimum of means.

그래픽 디자이너로서 나는 일상과 관련된 사소한 일들에 관심이 많다. 이러한 관심은 우리가 살고 있는 세상을 다양한 관점에서 바라보는 출발점이 되어 이것을 통해 더욱 폭넓은 환경을 생각하고 이해할 수 있게 한다. 디자인을 통해 세상을 보는 다양한 시선이 존재하고 있음을 보여주고 또한 다양한 방법으로 사람들과 교감하길 원한다. 이런 생각들이 궁극적으로는 세상을 보는 나의 눈을 확장시켜주길 바라기도 한다. 내가 진행하는 자발적인 프로젝트의 대부분은 보통 개인적인 관심에서 출발하며 일상에서 느끼고 경험하는 것들로부터 영감과 새로운 아이디어를 얻는다. 나는 메시지의 전달 방식에 많은 관심을 가지고 있는데 각 주제마다 다양한 방법을 가지고 접근하여 주제가 내포하는 본질적인 문제를 이야기하고자 하며 사물, 생각, 현상이 담고 있는 가치를 깊이 연구하여 이를 나만의 방법으로 표현하고 싶다.

그래픽 디자인을 언급할 때 난 해석이란 말을 쓰길 좋아하는데 그래픽 디자이너로서 주어진 내용을 어떻게 비평적인 관점에서 바라보고 이를 시각적으로 해석하는가에 관심이 많기 때문이다. 자신만의 독특한 해석을 위해서는 프로젝트에 대한 이해가 무엇보다도 중요하다. 그러기 위해서는 디자인에 앞서 폭넓은 리서치를 통해 프로젝트와 관련된 사회적이고 문화적인 맥락을 깊이 있게 이해하는 것이 필요하다. 리서치는 디자인 과정 중 중요한 일부로서 아이디어가 주도하는 디자인에서는 그 영향력이 크다. 보통 프로젝트가 시작되면 전체 과정의 많은 부분을 리서치에 할애한다. 그래야 프로젝트가 무엇을 요구하는지 명확히 이해하게 되고 그럼으로써 자연스럽게 문제해결 방법을 찾아간다. 디자인을 하는 데 형태를 다루기는 하지만 형태 자체보다는 아이디어와 리서치에 더욱 중점을 두고 아이디어가 스스로 말을 할 수 있도록 하기 위해 형태를 사용한다고 볼 수 있고 생각이 정리되면 자연스럽게 어떻게 표현해야 할지 정해지기에 그에 따라 디자인을 한다.

246

poster. jam.˚ 450 x 635. 2011.

내가 특별히 타이포그래피에 관심을 가지는 이유는 타이포그래피가 언어와 밀접한 관련이 있으며 글이 담고 있는 의미를 타입을 사용하여 시각적으로 적절하게 표현할 수 있기 때문이다. 디자이너가 가지고 있는 시각적인 언어로 메시지를 전달한다는 점이 내가 그래픽 디자인을 좋아하는 이유인데 특히 타이포그래피는 텍스트에 담겨 있는 정보를 체계화하고 계층을 만들어 가기에 효과적인 수단이라고 생각한다. 개인적으로 복잡함보다는 단순함을, 모호함보다는 명료함을 좋아하고 모든 요소가 체계적으로 구조를 이루는 디자인을 중요하게 여긴다. 그런 점에서 타이포그래피는 최소의 수단으로 내용을 전달하는 데 좋은 해결책을 제공한다.

lee choong-ho

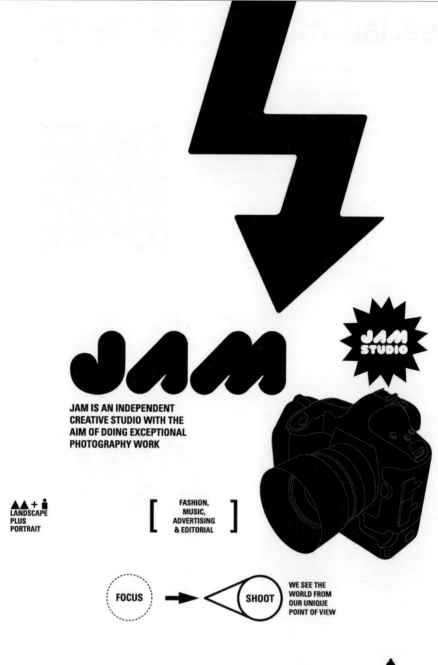

JAM IS AN INDEPENDENT
CREATIVE STUDIO WITH THE
AIM OF DOING EXCEPTIONAL
PHOTOGRAPHY WORK

▲▲ + 👤
LANDSCAPE
PLUS
PORTRAIT

[FASHION,
MUSIC,
ADVERTISING
& EDITORIAL]

FOCUS ➡ SHOOT

WE SEE THE
WORLD FROM
OUR UNIQUE
POINT OF VIEW

 SINCE 1993 ›››

T.	F.	A.
82 2	82 2	30-5, NONHYUN-DONG,
517	517	GANGNAM-GU, 135-815,
8159	8195	SEOUL, KOREA

 www.
agencyteo.
com

lee.jae-min.

After earning BFA degree in Visual Communication Design at Seoul National University, Lee Jaemin has been the art director of studio fnt where he founded in 2006. He is the lecturer of Seoul Women's University and Kaywon School of Art & Design, and had special lectures at the University of Seoul, Seoul Womens University, Hongik University and Seoul National University. He also had a lecture and talk in CA conference and Sangsangmadang forum in Seoul. Lee Jaemin participated in many exhibitions such as <Design Korea 2010>, <Weird book>, <Connected project> in Graphic design festival Breda, <Uncertainty composition>, <Work in progress> and etc. He was the winner of 2010 Reddot Design Award and Web Award Korea. His works and interviews were featured in variety of presses and publications such as <Typography Workshop 06>, <g:>, <CA>, <Design magazine> and so on._____

_____서울대학교에서 시각 디자인을 공부했다. 2006년부터 스튜디오 fnt의 아트 디렉터를 맡고 있으며 서울여자대학교와 계원디자인예술대학에 출강하고 있다. CA 콘퍼런스 〈매체와 타이포그래피〉, 상상마당 열린포럼 〈소규모 디자인 스튜디오의 이상과 현실〉에서 강연을 했다. 디자인코리아의 〈영 디자인 스튜디오〉(2010), 한국타이포그라피학회 두 번째 전시 〈이상한 책〉(2010), 〈그래픽디자인 페스티벌 브레다-Connected project〉(2010), 그라우 갤러리 〈Uncertainty composition 전〉(2007), 갤러리 아침의 〈Work in progress 전〉(2006) 등의 전시회를 열었다. 2010년 레드닷디자인 어워드 2개 부문을 수상했으며, 2008년 웹 어워드 코리아 정부·공공부문 최우수상을 받았다. 그의 작품과 인터뷰는 〈타이포그래피 워크숍〉(2006), 〈지콜론〉, 〈CA〉, 〈월간디자인〉 등의 매체에 소개되었다.

이재민.李在敏.

lee jae-min

248

poster. flower of salt. 594 x 840. 2011

poster. weird party, crying while dancing. 594 x 840. 2010.

249

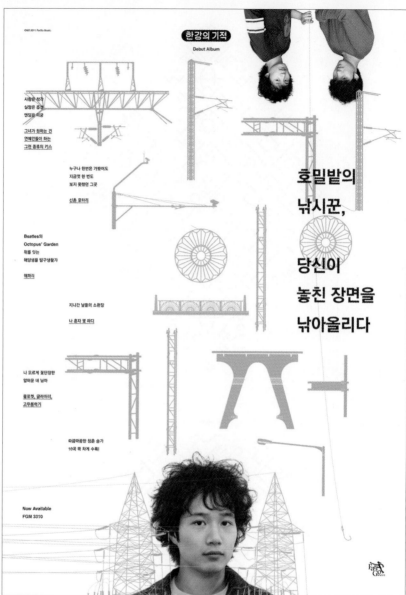

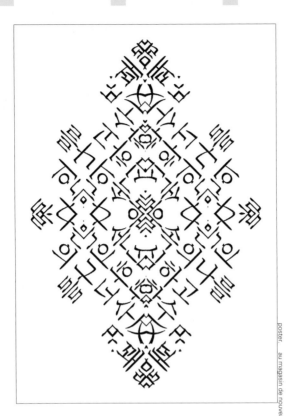

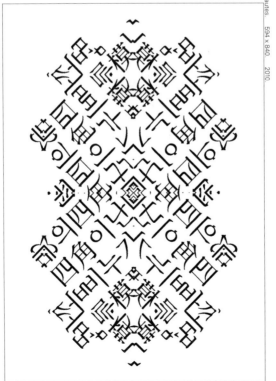

lee jae-min

poster. au magasin de nouveautés. 594 x 840. 2010.

In some projects conducted at earlier stage of work, I have found charms of images and patterns which have been produced through repeating, enlarging, reducing, or reversing shapes. I have been captivated by unexpected shapes of continuity and discontinuity reproduced through the process which, I thought, seemed to be a magical and powerful tool to me.

At first, I depended on the visual intuition, but I gradually developed the methodology until it has consistent principles or algorithm. Most of works based on mathematical and logical principles often generate totally different shapes to predicted images from the start. I like this unpredictable aspect of the process which let us free from all the strict rules of functional typography. Also once I build up the algorithm of the process for a project, I can apply it to the project without being obsessed about every visual details. Therefore I could enjoy my working process more.

251

poster: graphic method. 594 x 840. 2010.

lee jae-min

작업 초기에 진행한 몇 번의 프로젝트에서 조형을 반복하여 배치하거나, 확대와 축소, 혹은 반전의 과정을 거쳐 만들어지는 이미지, 그리고 그 이미지들로 만들어지는 패턴의 매력을 발견하게 되었다. 그리고 반복과 변화를 통해 복제된 형태들이 갖는 연속성과 불연속성, 그것을 통해 발견되는 의외성, 반복이라는 행위 자체가 갖고 있는 주술성, 그리고 그렇게 모이고 응집된 이미지들이 만들어내는 강한 힘에 점차 매료되었다.

형태를 복제하거나 반복 배치할 때, 시지각적 감각에 의존하는 것이 초기 방식이었다면, 점차 일관된 조형 원칙 혹은 알고리즘을 수립하고 적용하는 방식으로 발전해갔다. 수리적, 논리적 원칙에 근거한 작업물 대부분은 시작할 때 막연하게 예측하던 이미지와는 사뭇 다른 형태로 완성되곤 한다. 이런 의외성 덕분에 세밀하고 엄격한 마이크로 타이포그래피의 영역이 주는 부담감에서 어느 정도 벗어나 좀 더 '즐겁게' 작업을 진행할 수 있다. 또한 이러한 작업 방식은 형태에 당위성을 부여해주므로, 세밀한 부분에 심혈을 기울이는 의무감에서부터 어느 정도 해방감을 느끼게 해주며, 과정의 고단함을 덜어주기도 한다.

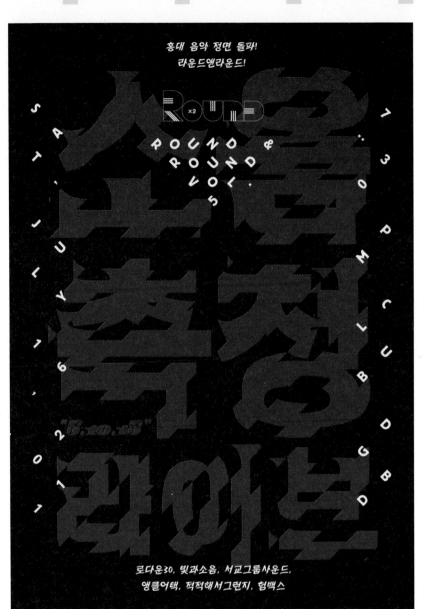

252

poster. measuring noise concert. 594 × 840. 2011.

Designing typefaces is one of my favourite types of work. It allows me to experiment new algorithm to 26 contours. Furthermore, I have been making my efforts to create and develop these principles and algorithms of attaching, cutting, twisting, mixing and reversing titles and typefaces.

253

lee jae-min

poster. 'truss' typeface specimen. 594 x 840. 2007.

'활자를 도안하는 작업'이야말로 이러한 알고리즘을 26가지 베리에이션을 통해 실험하고 점검해
보기에 가장 효과적인 기회이다. 이에 착안하여 많은 작업의 제호나 문안의 활자들을 특정한 원
칙에 따라 덧대고 자르고 돌리고 뒤섞고 반전시키는 작업을 진행하고 있으며, 또 그러한 원칙들을
고안해내기 위해 노력하고 있다.

lee.kentsai. taiwan

리켄차이.李根在.

poster. chinese character art festivel. 702 x 1,000. 2011.

리켄차이는 타이완 출생으로 현재 뉴욕에서 활동하고 있다. 1996년 켄차이리 디자인 스튜디오를 열었으며 타이완의 스튜디오는 파트너 처우사우펑이 맡고 있다. 뉴욕에서 리켄차이는 다양한 매체를 다루는 시도를 하고 있으며, 사진가, 애니메이터와 같은 다른 분야 전문가와의 협업을 통해 디자인의 새로운 방법론을 모색하고 있다. 1996년 이후 D&AD 어워드, 커뮤니케이션디자인 어워드, 뉴욕 타이프디렉터스클럽(TDC), 원쇼디자인 어워드, 레드닷디자인 어워드, 하우매거진 어워드, 도쿄 TDC, 홍콩디자이너협회상, IDN 매거진 어워드, 타이완디자인 어워드, 타임즈광고 어워드 등에서 수상했다.

poster. fonso paper. 701 x 1,000. 2007.

lee kentsai

254

Lee Kentsai was born in Taipei, currently living in New York. He established Ken-tsai Lee Design Studio in Taiwan, 1996. Since 2002, he has moved to New York to continue his career, and his partner Chou Yaofong is keeping the studio still working in Taipei. After moving to New York, Lee has tried different media and cooperated with other fields of professionals, such as photographer, animator to explore new methods of design. Since 1996 he has won numerous design awards and participated many design exhibitions in worldwide, such as D&AD (The Best Advertising and Design in the World) Award, Communication Arts Design Annual Award, New York TDC Annual Award, One Shoe Design Award, Red Dot Award, How magazine- International Design Competition, Self-Promotion Design Competition, Step inside 100 Awards, Tokyo TDC Annual Award, Hong Kong Designers Association Award, IDN Magazine award, Taiwan National Design Award, Times Advertising Award and so on.

2 0 1 1
兩 岸 漢 字
藝 術 節

Knowing the rules is for breaking the rules.

Starting from 1983 when I was still studying in the department of design and technology in a senior vocational school, the school teachers not only taught me technical skills, they also frequently urge me to enhance my basic capabilities in the field of design, frame composition and aesthetics. Later in 1988, I studied in the Applied Art department in Shih-Chien College; I started to have more understanding about design besides pure technical skills. I got to know that Design is to solve problem and design is not like arts, so "out of nowhere". Starting from the training on technical graphical design, then to the training on the styling art; finally, I got to understand the problem solving characteristics of design which makes me slowly enter the core of designing. Graphical design is using color, styling and calligraphy to express thoughts and I have very deep feeling on this after I entered KUOHUA Inc. Advertising emphasizes on the searching of target group and utilizes market, consumption behavior and marketing creativity to achieve the purpose of advertising. Designing is not a core in advertising actions. With Clear target group, consumption actions of advertising could easily touch the hearts of the target group. But designing is using graphics; language and calligraphy to get convey messages which make me very interested in designing. Having been worked on the field of design for nearly 20 years, I have more and more doubts and questions about design as the time goes by. Especially, when I quitted my job and went to the United States in 2002, I had the chances to get in touch with the designers from all over the world, my increasing English capability also gave me a boarder and diverse view of design. I have always believed that design is communication and art is self-expression; these two extremely different disciplines are regarded as a golden rule under the guidance of the teachers when I was in schools. In particular, Taiwan's design is based on the framework of society as a whole arising from business transactions, the mission of designers is to promote business prosperity, this kind of concept is deeply rooted in the heart of every Taiwanese designers.

Summarizing the directions of my creation in the past ten years.

My creations in the past few years could be generally categorized into three aspects:

1. Overlapping identity of exhibition planner and designer—planning exhibitions and creating exhibition image.
2. Walking on the boundary between design and art—design which has the function of communication and self-expression.
3. Design on social issues—voice for AIDS prevention and political issues.

These three issues are all surrounding designers and they are not a single designer's role in design behavior. I participated in Taiwan Designers Week event and played the role of event planner and overall image planning designer. From Taiwan region representative appointed by New York Arts Director Club to Greater China representative appointed by New York Type Directors Club, I introduce two largest annual competition exhibitions in the world to Taiwan; in the meantime, since I am also a designer so I am also in charge of designing of the overall exhibition image. The self-promotion of "I am Ken-Tsai Lee" was at the age of 35 when I quitted my job and went to New York to develop my own designing career. In the biggest city in the world where

poster. celebrating 50 years of helvetica 700 x 1,000. 2006.

Celebrating 50 years of Helvetica

lee kentsai

I had no background and support, I suddenly feel the sense of doubt on myself. So I design poster with my name in different languages and then post those posters on the streets of New York, I would also use holding those posters high and taking pictures with New York Landmarks to express the idea of "Ken-Tsai Lee is here", these two distinct ways of exhibition make me suddenly realize that design is not only expressed in any particular aspect or face. This kind of creation is purely expressing the personal feelings of the new environment, and such creation which is blur between design, advertisement and performance art has inspired myself to explore more possibility in designing. The diversity to the identity of designer also makes me not confined to the original understanding on the identity of a designer. The idea to voice for social, AIDS and political issues with design started many years ago during my four year designing job for Hope Workshop—a Taiwan AIDS control unit, I found that the scope of work that a designer does is mostly in the framework of the capitalist business practices, it is undeniable that many of Taiwan's design is based on commercial activities. This kind of knowledge makes me firmly believe that designing actions are engaged with commercial activities. However, I believe, a designer, besides being hired thugs of commercial activities, should play a more diverse role in the society. Designers should voice their opinions and should not be absent from the issues arose from the process of society development. Designing only for commercial activities seems to narrow the true nature of design. In 2007, I was invited by Department of Commerce of the Ministry of Economic Affairs to fly to Havana, Cuba from New York to participate in the year's World Conference of Icograda, I remember meeting the former chairman of Icograda in Havana airport when I left Cuba, I asked the former chairman why Icograda chose Cuba, the economically underdeveloped country, to be the host of the General Assembly of Icograda. The former chairman pointed at the airport environment and said why there should be a relationship between design and economic prosperity, if the decision of General Assembly to be held in Cuba could make Cuban designers to have more profound ideas about design, it would also make some progress in beautifying the environment.

257

book: fame. 290 x 400. 2005.

lee kentsai

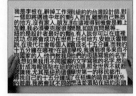

poster. my name is ken-tsai lee. 700 x 1,000. 2006.

258

lee kentsai

규칙을 터득하는 것은 규칙을 깨기 위함이다

1983년 전문학원에서 디자인기술학과를 공부할 때 디자인의 기술적 기능 외에도 디자인의 기본, 화면 구성, 미학 등 기본 능력을 키웠다. 1988년 선진대학 응용미술학과에 입학하고 나서야, 테크닉 외에 디자인에 대해 이해하기 시작했다. 나는 디자인은 예술과 다르다고 생각한다. 디자인의 핵심 본질에 점차 다가서기 위해서는 테크니컬한 평면 설계와 스타일링 훈련, 조형 미학 능력을 배양하는 것에서 시작해 디자인의 문제 해결점을 인식하는 것이 중요하다고 생각한다. 그래픽 디자인은 색채, 스타일, 서체로 생각을 표현하고 메시지를 전달할 수 있다는 것을 KUOHUA 광고 회사에 들어간 이후에 깊이 깨우쳤다. 광고는 정확한 타깃, 시장 분석, 소비 행위 등에 창의력을 입혀 광고의 목적을 이뤘다. 디자인은 광고 행위 중 핵심이 아니었다. 보통은 명확한 타깃의 소비 행위의 분석만으로도 쉽게 타깃의 마음을 움직일 수 있었다. 하지만 디자인은 그래픽 언어와 문자 조형 등으로 메시지를 전달해야 하는 점에서 디자인에 대한 회의감을 느끼게 되었다. 디자인 분야에 종사한 20년간 시간이 지남에 따라 디자인에 대해 더 많은 의심과 질문이 생겼다. 특히 2002년에 직장을 그만두고 미국으로 향했을 때 더욱 그러하였다. 세계의 많은 디자이너들과 만나고, 영어로 소통하는 실력이 늘면서, 디자인에 대한 인식이 더욱 넓어졌다. 나는 지금까지 디자인은 커뮤니케이션 예술이고 자아의 표현이라고 믿고 있다. 이 두 가지의 매우 다른 지점은 학교 다닐 때 담당 교수님의 지도 아래 황금 규칙이라고 배웠다. 또 타이완 디자인은 전체 사회의 상업 비즈니스 거래를 기반으로 생성되며, 디자이너의 숙명은 상업성을 목적으로 하고, 이런 관념은 거의 모든 타이완 디자이너의 관념에 깊숙이 뿌리 박혀 있다.

십 년간의 창작방향을 종합하다

이 몇 년간의 창작은 대략 세 가지로 나뉜다.
　　　1. 전시 플래너와 디자이너의 중복 – 전시의 정체성과 전시 형상의 규화.
　　　2. 디자인과 예술 – 커뮤니케이션과 자기표현의 경계에서 산책.
　　　3. 사회 문제 제기 – 에이즈 예방 및 정치 문제에 대한 사회적 이슈에 디자인을 담다.

이 세 가지 문제는 디자이너의 주위를 맴돌며, 디자인 작업에서 어느 한 사람의 역할만이 아니다. 나는
타이완의 디자인 행사에 참여하면서 이벤트 기획과 전체 이미지 디렉팅 역할을 수행했다. 뉴욕 유형이사클럽에
서 타이완 대표 겸 뉴욕 타이포그래피 및 아트디렉터스 클럽 중국 대표로 임명되었다. 타이완 최대의 연례 콘테스
트를 소개하고, 세계적인 행사를 치르면서 동시에 디자이너의 신분으로 전체 전시 형상의 디자인을 담당하였다.
〈나는 Leekentsai이다〉라는 셀프 프로모션을 했을 때는 35세의 나이에 직장을 그만두고 처음부터 다시 디자인
인생을 시작하였을 때이다. 그때 아무런 배경과 지원이 없는 상태에서 전
세계 가장 큰 도시라는 뉴욕에서 자아에 대한 의심을 느꼈다. 그리하여
자신의 이름을 다른 언어로 인쇄한 포스터를 뉴욕의 거리에 붙였다. 여러
번에 걸쳐 거리에 붙이고 또 뉴욕 명소나 랜드마크에서 포스터를 든 모습
을 사진 찍어 이곳에 내가 다녀갔다는 것을 표현하였다. 이런 두 가지의
다른 실행 방식을 통해, 디자인은 일종의 이미지만을 보여주는 작업이 아
니라는 것을 깨달았다. 이러한 창작은 새로운 환경에서의
개인 감정표현이다. 이러한 불분명한 경계는 디자인, 광고, 행위예술 간
의 창작에서 자신의 디자인에 대해 더 많은 가능성을 탐험하게 한다. 디
자이너의 다양성은 또한 한 곳에만 국한되어 있지 않다는 것을 인식하기
시작한다. 하지만 디자인이 에이즈나 사회 및
정치적 문제에 의견을 제시하는 것은 몇 년 전까지만 해도 희망사항이었다.
지난 4년간 에이즈방지단체와 워크숍을 하면서 디자이너의 작업은 자본
주의의 구조 아래의 상업 행위라는 것을 발견하였다. 타이완의 디자인은
상업에서 출발하여 기초가 되었고, 상업 행위를 갖춘 디자인이라는 것은
부인할 수 없는 부분이다. 하지만 나는 디자인은 상업성 이외에도 사회에
서 여러 가지 역할을 해야 한다는 생각을 믿고, 그렇게 변하리라 생각한다.
사회 문제, 공공 문제, 정치 문제에서 디자이너는 전체 사회 발전의 과정

259 중 목소리를 내야 한다. 상업 활동에 대해서만 한정 짓는 것은
타이완 디자인의 본질 범위를 좁힐 것으로 보인다. 2007년에 경제부 상
업사의 초청으로 쿠바의 하바나에서 열린 국제그래픽디자인협의회(Ico-
grada)에 참여했다. 쿠바를 떠날 때 하바나공항에서 협회 전 회장을 만
나 질문을 한 적 있다. 왜 이번 행사를 경제적으로 낙후한 쿠바에서 열었
는지를. 그때 전임 회장은 공항의 환경을 가리키며 말했다. '왜 디자인은
꼭 경제 번영과 관련되어야 하는가? 대회가 쿠바에서 열리면 더 많은 쿠
바의 디자이너들에게 디자인에 대한 깊은 생각을 안겨주지 않겠는가? 그
것은 환경의 미화에 필연적으로 발전을 일으킬 것이다'라고.

lee kentsai

Korean Face

American Face

Turkish Face

Thai Face

Japanese Face

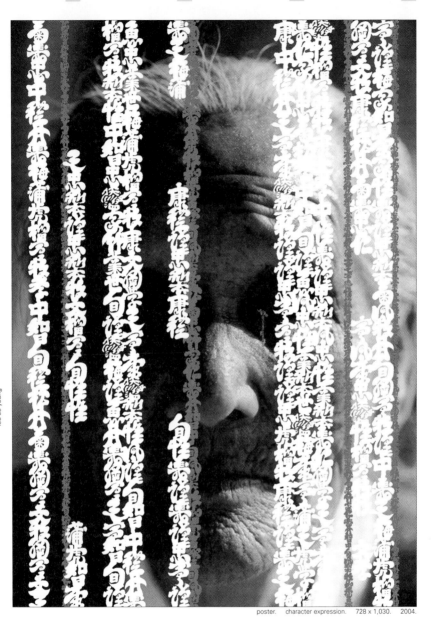

poster. character expression. 728 x 1,030. 2004.

lee.se-young. korea

Born in 1963 at Hwaseong city of Kyounggi province. Master of Arts, Hongik University Graduate School. He worked at ahn graphics since 1988 for 20 years, experiencing the excessive change of the design world in Korea. In 2006, Lee established the Design Studio Nabi for more vigorous activities in his creative works—idiom of Korea image and cherishing Korean traditional cultures. Since his first private exhibition in 1998, he participated in many shows such as <Hangul> at GGG and DDD gallery (2001), <Seoul Typography Biennale> (2001), <East Asia Illustration Poster> (2007). Lecturer at Kyonggi University, Dankook University, Sangmyung University, and Korea National University of Arts. Currently a member of AGI.

lee se-young

poster.　character expression.　728 x 1,030.　2004.

이세영.李世英.

1963년 경기도 화성에서 태어났다. 홍익대학교 대학원에서 석사과정을 마쳤다. 1988년 안그라픽스에 입사해 20년간 몸담았으며 국내 디자인계가 내용과 기술, 규모 면에서 커다란 변화를 맞는 과정을 경험했고 2006년에 독립하여 디자인 스튜디오 나비를 설립했다. 한국 전통문화에 대한 오랜 관심으로 한국 이미지에 천착하며 작품활동을 해왔으며 현재 국제그래픽디자이너연맹(AGI) 회원이다. 1998년 첫 개인전 이후 2001년 DDD갤러리와 GGG갤러리에서 열린 〈한글〉전, 2001년 〈제1회 타이포잔치〉, 2007년 〈동아시아 일러스트레이션 포스터〉전 등 다수의 전시에 참여했다. 경기대학교, 단국대학교, 상명대학교, 한국종합예술학교 등에 출강해 학생들을 지도하고 있다.

上 下 報 萬
腐 提 以 壽
萬 白 介 無
壽 福 福 彊

福
緝
祿

character tree (blessing)

BLESSING

262

poster. character tree (blessing). 728 x 1,030. 2005.

When I was a beginner of the design world in the late of nineteen eighties, my major job was to set up photographic lettering, font of printing type, mounting photograph which is so-called, 'paste-up', checking every letter, every word, every phrase. At that time, I had optical illusion to see 'Black is Letter'. It took me long time to see the 'blank' surrounding the 'letters' and recognize the connection of each leaf of a book. Paying attention to so many different factors, I could build up a sort of map to organize each leaf of a book. Whenever I am immersed in my work for a birth of new book, I feel much strain, heart-beating, even seized with fear, because all the process and outcome are on my shoulders. After all, I shall not cease from exploration, and the end of all my exploring will be to arrive where I started.

lee se-young

poster. character tree (longevity). 728 x 1,030. 2005.

사진식자를 위한 활자명세를 매기고 소위 대지 작업이란 것이 주 업무이던 1980년대 말 신입 디자이너 시절 한 글자 한 글자, 글자 사이, 글줄 사이를 칼질로 오가며 검은 것은 온통 글자로 보이더니 한참 후에야 글자를 에워싼 주변 공간이 보이기 시작했다. 그것이 한 낱장의 공간에 관계로 이루어져 있음을 인식한 건 한참 후의 일이다. 그 낱장이 이어져 펼침면이 되면 또 다른 고민거리와 세상이 다가왔고, 거기에 이미지를 붙이고 이야기를 담으며 그것들 하나하나가 각기 맡은 역할을 적절하게 해내도록 배려해야 하는 일련의 과정 속에서 한동안을 보냈다. 태어나서 처음으로 어떤 일에 몰입했을 때의 긴장과 설렘, 두려움, 그리고 기쁨이 함께 어우러진 특별한 경험을 했다. 그 낱장 낱장이 모여 한 권의 책으로 완성될 때는 식은땀이 나며 다가오는 일말의 책임감…… 그 책임감으로부터 자유롭고자 늘 새로운 도전을 하지만 아직도 그러하지 못하다. 그 자유로움을 위해 성실함으로, 마음을 다하는 지극 정성으로 일과 삶을 섬긴다. 진정성으로 사람과 관계를 하고 균형감각을 잃지 않으려 노력한다. 그것으로 부족한 나를 모든 것을 내려놓고 하늘의 뜻과 의를 구한다.

lee-a-e-young

264

poster.　character evolution.　800 x 1,456.　2005.

poster.　character evolution.　728 x 1,030.　2004.

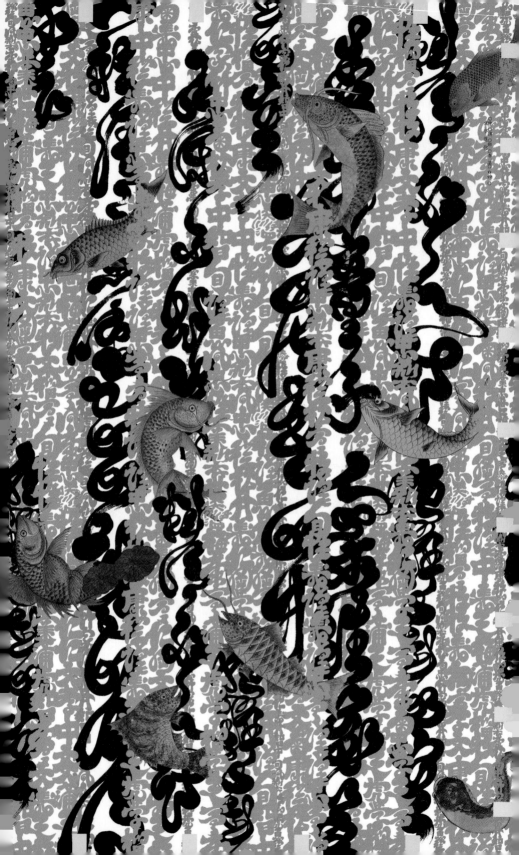

한글을 디자인하고 한글로 디자인하면서 배우고 경험한 내용을 후배들에게 가르치는 일을 한다. 1999년부터 2003년까지 한글디자인연구소에서 근무하며 미래 지향적인 본문용 한글 활자에 대해 연구하고 디자인했다. 2004년 활자공간을 설립하여 세로쓰기 전용 글꼴 〈꽃길〉 등 인쇄출판용 한글 글꼴, 아모레퍼시픽의 기업 전용 서체 〈아리따〉, 홈쇼핑 방송 전용 서체 〈GS블루〉 등을 디자인했다. 공공 디자인과 환경에 대한 관심의 작은 결실로 2007년 〈(잉크를)아끼는 글자〉를 만들었고, 2008년부터 2011년까지 한글과 타이포그래피를 삶에서 즐길 수 있도록 '타이포그래피 공간 ㅎ'을 열고 한글과 타이포그래피 관련 전시와 세미나를 지속적으로 진행했다. 2010년부터 디자인 잡지 〈지콜론〉의 디렉터를 맡고 있으며, 현재 계원디자인예술대학에서 한글 타이포그래피를 강의하고 있다. 저서로 『한글+한글디자인+디자이너』, 『한글디자인 교과서』(안상수, 한재준 공저)가 있다.

이용제.李庸齊.

lee.yong-je. korea

poster. dada. 4,205 x 2,377. 2004.

266

lee.yong-je

A Hangeul designer. Majored in Graphic Design. He designs Hangeul and uses Hangeul in his designs and teaches what he has experienced and learned. From 1999 to 2003 he worked at the 'Hangul Design Research Center' conducting research and designing forward thinking body text fonts. In 2004, he started 'Type Space', developing print-based fonts such as <Ccotgil> (2006) a vertically set font, <Aritta> (2007) developed as the corporate font for Amore Pacific, <GSBlue> (2008) the corporate font for GS Home Shopping among others. With his interest in public design and the environment he developed <Ink-Saving Typeface>. To enjoy typography in our daily lives he opened 'Hiut' in 2008, a cafe that doubles as a gallery and seminar space. It closed in July of 2011.

From 2010 he has been the creative director for 'G colon' a local design magazine. He is professor of the Hangeul track at Kaywon University. He has written <Hangul + Hangul Design + Designer> as well as co-authored <Hangul Design Textbook> with his teachers Ahn Sang-soo, and Han Jae-jun.

lee yong-je

poster. song for all living things. 260 x 1,520. 2007

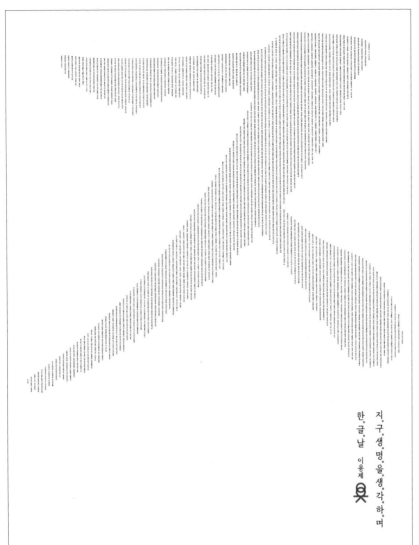

poster.　terrestrial life.　788 x 1,090.　2010.

Need: I design things that the world or people need. There are things that many people need and things that a small number of people need. We all need.

Publicness: Design has many definitions. I consider this as the core of design. Simply put publicness is 'used by many' or a public space. However, the point of public is not on number or space but consideration for others.

Noble: I pursue noble beauty. When someone is in need of design, I design for them. Design that exists for man does not mean it is only for man alone. Design should help man to co-exist with nature in happiness.

Hangeul: Letters are noble. It is the most beautiful creation for man. Hangeul is especially beautiful in that it was made by a king for his people.

Identity: Man has a cultural foundation. I was born in Korea, East Asia and naturally grew up influenced by Korean culture and it's history. I want to express my emotions or sentiments about Korea and East Asia using Hangeul.

Essence of Existence: All existence has a purpose. I look for my purpose in existing. In as much, I find my purpose in my family, Hangeul and design. It's what I can do and what I should do.

lee yongje

typeface. a meandering river. 2,330 x 1,440. 2010.

필요: 나는 세상에 필요하거나 사람들에게 필요한 것을 디자인한다. 다수의 사람들에게 필요한 것이 있고, 소수의 사람들에게만 필요한 것이 있다. 모두 필요한 것이다.

공공성: 우리는 디자인을 다양하게 정의할 수 있다. 나는 디자인의 본질이 공공성이라고 말한다. 공공성을 단순하게 판단하면 많은 사람들이 쓰는 것 또는 공공적인 장소에 있는 것이다. 그러나 공공성의 핵심은 쓰는 사람의 수와 장소가 아닌 사람에 대한 세심한 배려다.

숭고: 나는 숭고한 아름다움을 추구한다. 누군가에게 디자인이 절실히 필요할 때, 나는 디자인한다. 인간을 위해 존재하는 디자인은 단순히 인간만을 위한 디자인이 아니다. 인간을 위한 디자인은 인간이 다른 자연물들과 함께 행복하게 살 수 있도록 만드는 일이다.

한글: 문자는 숭고하다. 인간을 위해 만들어진 가장 아름다운 창조물이다. 특히 임금이 백성을 위해 만든 한글은 아름답다.

정체성: 인간은 모두 문화적 기반을 가지고 있다. 나는 동아시아의 한국에서 태어나서 자랐고, 자연스럽게 한국 사회의 역사와 문화의 영향을 받았다. 나는 내가 받은 한국의, 동아시아의 정서를 한글로 표현하고 싶다.

존재의 본질: 세상에 존재하는 것에는 이유가 있다. 나는 나의 존재 이유를 찾는다. 지금까지 찾은 나의 존재 이유는 가족과 한글과 디자인이다. 그것이 내가 할 일이고 내가 할 수 있는 일이다.

물— 흙— 바람이
생명 낳아 기르고,
아름다운 희망 사람—사람이
희망 키워 나눈다.
생명이 아름답다.
희망이

270

typeface. type family. 788 x 1,090. 2011.

홀로

강철에 핀 소금꽃이

인간을 깨우고

생명도 살리고

lee yong-je

typeface. ink-saving type face. 788 x 1,090. 2007.

디자인은
예술이 아니며,
기술이 아니며,
장식이 아니며, 환각제가 아니며,
상품의 숭배도 아니며,
상업적 도구도 아니다.　　　　　디자인은　　　삶을 바꾸고
정신을 정제하고,
사회를 개조한다.

나에게
디자인은 고귀하고 겸손한 행위이다.

리사오보 李少波.

li shaobo

li.shaobo. ^{china}

poster.　oral examination 2007.　700 x 1,000.　2007.

Li Shaobo started his teaching career in Fine Arts Academy of Hunan Normal University in 1994. During the period of 2003-2004, he was invited to Denmarks Designskole as visiting scholar with government scholarship. In 2004, he worked in Mervyn Kurlansky Design Studio as designer. He owned the doctoral degree from Central Academy of Fine Arts (CAFA) in 2008. Now, Li is the Dean of Design Department of Fine Arts Academy of Hunan Normal University and Visiting Professor in Hunan Radio and Television University. Besides, he also works as design consultant of the 2 largest Chinese font foundry 'Foundertype' and 'Sinotype', member of the academic committee of Center for Chinese Font Design and Research, evaluation expert of doctoral and master thesis of CAFA. In recent years, he has been invited to numerous international conferences including Design in China (V&A, Beijing), International Calligraphy Design Conference (Seoul), Pecha-kucha Night (Beijing), Typotomorrow International Type Design Forum (Beijing), and IGDB 6 (Ningbo). Meanwhile, he has also served as judge for China Trademark Design Competition, FounderType Chinese Type Design Competition, Identity: Best of the Best 2010, and various design contests. In 2009, he presided over Typeface Design Forum of ICOGRADA 2009 and 10 CITIES' Design Forum. Li's works have awarded numerous international design awards such as The 1st China Exhibition of Design Grand Award, Morisawa Awards 2002 International Typeface Design Competition Judge's Award, '2008 Sailing Qingdao' Poster Competition, and so on.＿＿＿＿＿＿＿＿＿＿＿＿＿＿＿1994년부터 후난사범대학교 미술학원에서 근무했다. 2003년부터 2004년까지 국비장학생으로 덴마크디자인스쿨에 방문연구원으로 초대되었으며 2004년에는 머빈 쿨란스키 디자인 스튜디오에서 디자이너로 일했다. 2008년 중앙미술학원에서 디자인 박사학위를 받았으며, 현재 후 난사범대학교 디자인계 주임, 후난 방송텔레비전대학교 초빙교수, 중앙미술학원 석·박사 논문심사위원, 중국 서체디자인연 구센터 학술위원, 중국의 양대 글꼴회사인 Foundertype과 Sinotype의 디자인 고문을 맡고 있다. 〈Design in China〉(런던, 베이징), 〈Pecha-kucha Night〉(베이징), 〈국제서예디자인콘퍼런스〉(서울), 〈Typotomorrow〉(베이징), 〈IGDB6〉(닝보) 등의 국제 콘퍼런스에 서 강연을 했다. Foundertype 서체 디자인 공모전, 중국 상표 디자인 공모전, 국제 아이덴티티 디자인 공모전 〈Best of the Best〉 등의 심사위원을 맡았으며, 국제그래픽디자인협의회(Icograda) 베이징회의와 '10도시 디자인포럼'의 사회와 진행을 맡기도 했다. 중국 디자 인예술대전 대상, 모리사와 국제 서체디자인 공모전 심사위원상 및 2008 칭다오 범선대회 포스터 은상 등을 수상했으며, 그의 작업은 〈NOVUM〉, 〈Idpure〉, 〈Art and Design〉, 〈Package and Design〉, 〈New Graphic〉, 〈360〉 등의 간행물을 통해 소개되었다.

Design
is not art, not technology,
not decoration,
not illusion,
nor is it commodity worship
or commercial tool.

Design **changes life,**
refines spirit,
reshapes society.

To me,
design is a noble and humble practice.

li shaobo

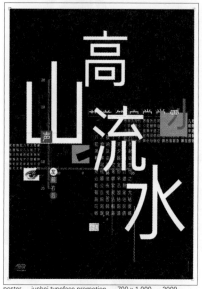

poster. junhei typeface promotion. 700 x 1,000. 2009.

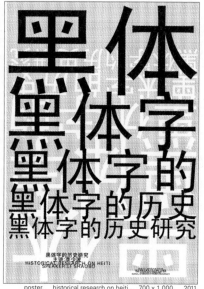

poster. historical research on heiti. 700 x 1,000. 2011.

Design manifesto

Recent post-modern thinking has equated the role of the intellectual with that of the gardener (Bauman), seen as the exploiter of nature in two senses - as the exploiter of external nature and as the dominator of other men and their internal natures as though they were domestic animals to be tamed. But I would rather see the garden as the attempt to carve out a small patch of civilization, of light and of moral action, within the surrounding indifference, darkness, even absurdity, of potentially destructive nature.

Nicholas Garnham

디자인 선언

최근의 포스트모던적 사고는 지식인의 역할과 정원사(바우만)의 역할을 동일하게 만들어버렸다. 이는 두 가지 의미에서 자연의 이용자로 볼 수 있다. 하나는 외부적 자연을 다루는 자, 또 하나는 마치 애완동물 길들이듯 타인 또는 그들의 내부적 본성을 장악하는 자이다. 반면에 나는 오히려 그 정원이 우리를 둘러싼 무관심과 어두움과 심지어 부조리, 그리고 잠재적인 파괴 본성으로부터 문명, 빛, 그리고 도덕적 행동의 작은 조각을 다듬어보고자 하는 시도로 보고자 한다.

니콜라스 간햄

Design is not art

An artist creates things to evoke emotion. Such emotional expression is frequently imprinted with personalities of the artist and derived from his inner spiritual world. Thus, art is subjective – the artist is free to give the 'feel' regardless of the surroundings and others. In contrast to artists, designers are creators with limitations. During the designing process, 'others' become the central concern instead of "self". To me, great design is rational – it is very objective-driven, and that's what makes it interesting.

As Clive Bell argues, it is "significant form" that makes an object a work of art. However, unlike the artist primarily concerned with form, style, and manner, the designer must have content foremost and make their job functional. Design functions sharply to resolve problems, not to decorate things. The social function in particular, I would stress, is the destiny of any serious design.

Design is not technology

Nowadays people tend to believe that technology is the creator of the world and the most powerful driving force of modern civilization. We worship and glorify technology like a demiurge, since it penetrates into every level of our life, changes our world, and creates various miracles. Though it is an age of technology, I do insist that design is not technology. In fact, technology is not equivalent to knowledge, to culture and civilization. It stands by itself and serves only as one of important components in the design process. It may run contrary to the trend of design which largely relies on new science and technology. However, one must not ignore the profound creator of the science and technology – man. Man has limitations, so does technology, particularly when it is connected to design. Technology, in terms of design, goes beyond nature and even contradicts nature as it is driven by manpower. It also goes against human nature, because it covers history by creating it.

A battle in the career of a designer is to witness how technology both illuminates and kidnaps design. Technology propels design in countless ways, but it becomes brutal when design is too much dependent on it. In my view, technology is just one of the most significant forces to achieve perfect designs. So my choice is, do not depend on technology, depend on MAN, because man designs, not technology.

li shaobo

poster: keep your city clean. 700 × 1,000. 2006.

hold din by ren

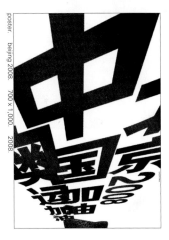

poster: beijing 2008. 700 × 1,000. 2008.

274

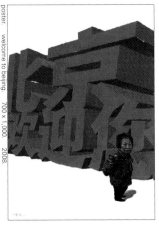

poster: welcome to beijing. 700 × 1,000. 2008.

디자인은 예술이 아니다

예술가는 감성을 자극하기 위해 작품을 창조한다. 이 같은 감성적 표현엔 종종 작가 내면의 성격이 각인되어 있으며, 이는 작가의 내면 정신세계로부터 비롯된다. 따라서 예술은 주관적이다. 예술가는 주변 환경과 타인들에 개의치 않고 '느낌'을 전달할 자유가 있다. 예술가와는 반대로, 디자이너는 제한이 있는 창조자이다. 디자인 과정에서 '자신'이 아닌 '타인'이 핵심 관심사가 된다. 나에게 훌륭한 디자이너란(아주 객관적인 것이어서) 이성중심적이고, 그래서 바로 디자인을 흥미롭게 만드는 것이다.

클리브 벨(Clive Bell)이 주장하듯, 대상을 예술로 만드는 것은 '뚜렷한 형식'이다. 그러나 유형, 스타일, 매너에만 주로 관심을 두는 예술가들과 달리, 디자이너는 그 내용을 최우선시하며, 기능을 온전히 수행하도록 만들어야 한다. 디자인은 물건을 장식하기 위함이 아닌, 문제를 해결하기 위해 집요하게 기능을 수행한다. 특별히 사회적 기능은 어떤 심각한 디자인이라도 피할 수 없는 운명임을 나는 강조하고자 한다.

디자인은 기술이 아니다

요즘 사람들은 기술이 세상의 창조자이며 현대 문명의 가장 강력한 추진력이라고 믿는 경향이 있다. 기술은 우리 삶의 모든 부분에 침투되어 있고, 세계를 바꾸며, 다양한 기적을 만들어내기에 우리는 기술을 마치 조물주처럼 경배하고 찬양한다. 물론 지금은 기술의 시대이지만 나는 디자인은 기술이 아니라고 주장한다. 사실 기술은 지식, 문화, 문명과 동등하지 않다. 이는 홀로 존재하며 디자인 과정의 중요한 구성요소로서 역할을 할 뿐이다. 새로운 과학과 기술에 의존하는 현대 디자인의 추세와 역행하는 생각일지도 모른다. 그러나 우리는 과학과 기술의 심오한 창조자, 즉 인간을 간과해서는 안 된다. 인간은 한계를 가지고 있기에 기술도 한계를 갖는다. 특히 디자인과 연결되었을 때 그렇다. 디자인에 있어서 기술은 인력에 의해 구동되므로 자연을 넘어서며, 때로는 자연과 맞서기도 한다. 이는 또한 창조를 통해 역사를 다루기에 인간의 본능을 거스른다.

디자이너로 살아가면서 치르는 전쟁은 기술이 어떻게 디자인에 빛을 비추기도 하고 또 숨겨버리는지를 목격하는 일이다. 기술은 무수한 방법으로 디자인을 이끌어 가지만 디자인이 기술에 너무 의지하면 이는 무참한 상황이 된다. 내 관점으론 기술은 완벽한 디자인을 달성하기 위해 필요한 중요한 요소 중 하나일 뿐이다. 그래서 나의 선택은, 기술에 의지하지 말고 인간에게 의지하자는 것이다. 왜냐하면 사람이 디자인하는 것이지 기술이 하는 것은 아니기 때문이다.

275

poster. design manifesto. 700 x 1,000. 2011.

poster. design & research about typeface. 700 x 1,000. 2010.

li shaobo

Design is not decoration or illusion.

Design is not tool for political purposes, not means to realize power, nor is it ornament to beautify imperfections. Design is the important media to reveal the nature of humanity and the radical criticism on nowadays social reality. So, designers should maintain independent dignity and morality in front of politics and powers, since what they are doing is responsible for the whole human beings and the future. If designers could not be their independent selves, their work will be tricked, twisted, and become subservient and dependent.

Design is not commodity worship or commercial tool.

Industrialists chase money endlessly at the cost of exploitation of the social and natural resources. The result is not only a huge waste of labor and material but also a morbid consumer society based on modern chain of production. The role of design, under such circumstances, is undoubtedly overshadowed in the vast commercialization. It goes further and further away from the aura of social norms and could no longer duly shoulder its responsibility. Therefore to avoid the traps of moral corruption and commercialization, it is high time that designers returned to the basis of humanity and reconstructed their man-centered but not money-chasing ethics.

Design changes life.

Life is imperfect and needs constant refinement. Design is exactly an effective approach to improve our life. It is wisdom with high practicality to fulfill people's dreams for the better life, both material and spiritual.

Design refines spirit and reshapes society.

Ideality is the prime motivity of design. Nearly 100 years ago, designers from Bauhaus aimed to establish a new design culture for the masses. Driven by such a great ideal, abundant stunning designs were created. Now, we pay close attention to various method and techniques of these Bauhaus masters but tend to ignore the ideal of utopianism that initially motivated their great designs. As contemporary designers, we should hold noble belief and consider seriously people's material and spiritual demands during the design process. In this light, I believe a good design in real sense has incredible power and extraordinary influences. It restructures objects, reshapes people's personalities, and even reforms the society. By this way, it may be proper to say that design creates civilization.

Design is a noble and humble practice.

Design can be grand and ambitious, it can also be small and composed. Design can be both avant-garde and profound. It can also be geared towards the interests of the mass or individual. The ideal combination of its world vision and humble practicality determines design as a profession of wisdom, resolution and a noble and humble obligation.

li shaobo

디자인은 장식도, 일루전도 아니다

디자인은 정치적 목적을 위한 도구도, 권력을 실현하기 위한 방법도, 결점을 가리기 위한 장식도 아니다. 디자인은 인간의 본능과 현대 사회 현실에 대한 철저한 비판을 드러내는 중요한 매체이다. 그래서 디자이너들은 정치와 권력 앞에 독립적인 위엄과 도덕을 지켜야 한다. 이는 그들이 하는 행동이 모든 인류와 미래에 대한 책임을 지기 때문이다. 만약 디자이너들이 독립된 자아가 될 수 없다면 그들의 작업은 속임수이고 꼬이게 될 것이며, 나중에는 순종적이고 의존적이 될 것이다.

디자인은 상품의 숭배도 아니며, 상업적 도구도 아니다

자본가들은 사회와 자연의 자원을 착취하면서까지 끝없이 돈을 좇는다. 결과는 노동력과 물자의 막심한 낭비이자 현대의 제품생산 속성에서 비롯된 병적인 소비 사회일 뿐이다. 이러한 조건에서 디자인의 역할이란 의심의 여지 없이 어마어마한 상업화의 그늘 아래 가려져 있다. 디자인은 사회적 규범의 아우라로부터 멀리 더 멀리 벗어나고, 더 이상 그 책임을 온전히 짊어질 수 없게 되었다. 그러므로 도덕적 부패와 상업화의 함정을 피하기 위해서, 바로 지금이 디자이너들이 휴머니티의 기본으로 되돌아가, 황금만능이 아닌 사람 중심의 윤리를 복구해야 할 적기인 것이다.

디자인은 삶을 바꾼다

삶은 불완전하며 지속적인 개선을 필요로 한다. 디자인은 우리 삶을 향상시키기 위한 매우 적절하며 효과적인 접근법이다. 물질과 정신에 있어서 보다 나은 삶을 살고자 하는 사람들의 꿈을 성취하게 해주는 실용성이 좋은 지혜이다.

디자인은 정신을 정제하고, 사회를 개조한다

이상은 디자인의 주요 원동력이다. 약 100년 전, 바우하우스의 디자이너들은 대중을 위한 새로운 디자인 문화를 확립하고자 했다. 그와 같은 훌륭한 이상에 힘입어, 풍부하며 아름다운 디자인들이 창조되었다. 오늘날 우리는 이러한 바우하우스 장인들의 방법과 기법에 많은 관심을 기울이지만, 정작 애초에 그들의 훌륭한 디자인들에 원동력이 되었던 유토피아적 이상은 간과하는 경향이 있다. 현대 디자이너로서 우리는 디자인 과정 안에서 고귀한 신념을 가지고 사람들의 물질적, 정신적 요구들을 진지하게 고려해야 한다. 이러한 관점에서 보면, 나는 진정한 의미의 좋은 디자인이란 놀라운 능력과 비범한 영향력을 행사한다고 생각한다. 디자인은 대상을 재구성하고, 사람의 개성을 다듬어주며, 심지어 사회를 개혁하기도 한다. 이렇게 된다면, 디자인이 문명을 만든다는 것이 가히 틀리지 않은 말일 것이다.

디자인은 고귀하고 겸손한 행위이다

디자인은 크고 웅대하고 야심적일 수 있으며, 또한 작고 사소할 수도 있다. 디자인은 전위적인 동시에 심오할 수 있다. 또한 대중과 개인의 취향에 맞춰질 수도 있다. 세계적 비전과 겸손한 현실성이 이상적으로 조합된다면 디자인은 확실히 지혜와 해법, 고귀함과 겸손한 의무감을 갖춘 직종일 것이다.

li shaobo

art work. qin yuan chun. changsha. 3,000 x 1,800. 2010.

리토미는 신세대를 대표하는 브랜딩 디자이너이자 컨설턴트로서 블랙 유머와 대담한 비주얼 디자인으로 유명하다. 홍콩, 중국, 일본, 마카오, 이탈리아를 연결하는 그는 국제 시장을 관통하는 몇 안 되는 디자이너 중 한 명이다. 홍콩 폴리테크닉대학교 디자인학과를 졸업한 그는 550개가 넘는 상을 수상했으며, 토미리 디자인 워크숍은 chinabico.com 선정 중국 10대 브랜딩 회사 중 하나로 뽑혔다. 2008년 최초의 창의 지향 인터넷 라디오 방송국 '라디오 다다'를 설립했다. 일본 베스트셀러 디자인 잡지 〈Agosto〉에서는 향후 10년 동안 홍콩에 지대한 염향력을 끼칠 잠재력 있는 그래픽 디자이너로 뽑았다.

li.tommy. china

리토미.李永銓.

brand. the vietnam woods. 2010.

li tommy

Li Tommy is the branding designer/consultant for the generation renowned for his 'Black Humor' and 'Audacious Visual' designs. Spanning Hong Kong, China, Japan, Macau and Italy, he is one of the few designers to have penetrated to the international market. Graduated from the School of Design in the Hong Kong Polytechnic University, Tommy was received over 550 awards. Tommy Li Design Workshop was selected by 'chinabico.com' to be one of the best top 10 Branding Company in China. In 2008, he was established the first creative oriented web radio station 'Radio dada' the same year. <Agosto>, a best-selling design magazine in Japan, has cited Tommy as the only graphic designer with potential to have an influential impact on Hong Kong in the next decade.

279

li tommy

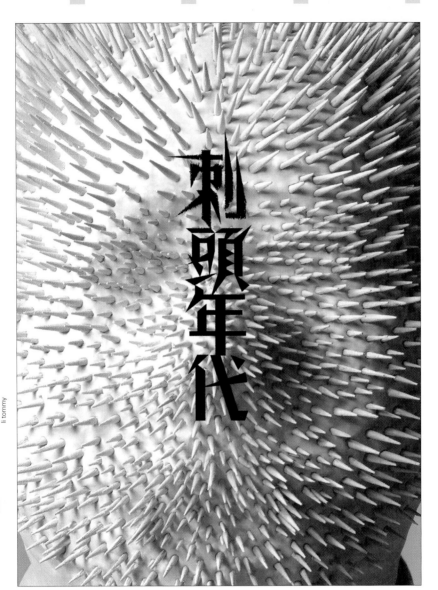

li tommy

280

poster. times of thorn. 711 x 970. 2011.

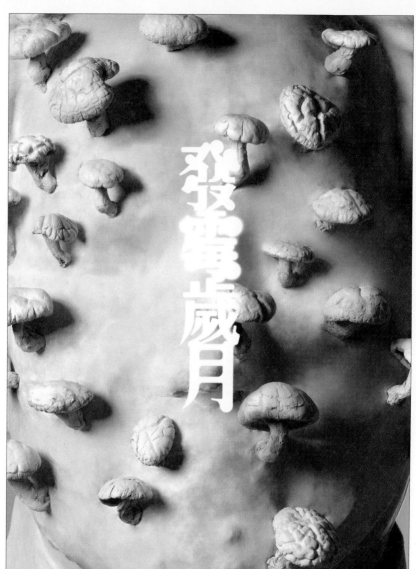

281

li tommy

poster. years of mold. 711 x 970. 2011.

Liu Esther is an associate professor at the School of Design, The Hong Kong Polytechnic University. Liu received an MA from New York University and practiced as art director and designer in the US and in Hong Kong. Liu has participated in solo and group shows in Hong Kong and many other countries. She was awarded the President's Award for Achievement in Research and Scholarly Activities by the Hong Kong Polytechnic University. She is a recipient of numerous international design awards. Her work was selected and published by Idea magazine, Tokyo TDC, ADC and the Hong Kong Designers Association and collected by the Hong Kong Heritage Museum and Osaka City Museum. Since 2000, Liu has been invited to be on jury panels for graphic design and book design competitions in Japan, Taiwan, China and Germany. Liu has published 2 books on Chinese typography, one being Chinese Typographers since 1949 and has been researching on the topic of Hong Kong magazine design since 1970 in the past few years.

cover poster. chinese typographers in china since 1949. 610 x 690. 2009.

liu esther

282

liu.esther. china

류에스더.廖潔連.

류에스더는 현재 홍콩 폴리테크닉대학교 디자인대학의 부교수이다. 뉴욕대학교에서 석사학위를 받은 뒤 미국과 홍콩에서 아트 디렉터와 디자이너로 활동했다. 홍콩 및 해외에서 다수의 개인전, 그룹전을 가졌으며 홍콩 폴리테크닉대학교에서 총장상을 받기도 했다. 그 밖에도 많은 디자인 관련 상을 수상했다. 류에스더의 작업은 〈아이디어〉, 도쿄 타이프디렉터스클럽(TDC), 아트디렉터스클럽(ADC), 홍콩디자이너협회(HKDA) 등을 통해 소개되었으며, 홍콩 헤리티지뮤지엄과 오사카 시립박물관 등에 소장되어 있다. 2000년부터 일본, 타이완, 중국, 독일 등지에서 열리는 그래픽 디자인과 북 디자인 관련 공모전의 심사위원을 맡았다. 중국 타이포그래피에 관한 책을 다수 출간했으며, 최근 몇 년 동안 '1970년대 이후의 홍콩 잡지 디자인 역사'에 관한 연구를 진행하고 있다.

liu esther

book. chinese typographers in china since 1949. 170 x 230. 2009.

Designing is not that important?

Designing lives in our daily life, our daily life nourishes designing.

Living lives in our daily life, our daily life nourishes living.

Loving lives in our daily life, our daily life nourishes loving.

newsletter. very - antalis co,ltd.. 210 x 295. 2003.

journal. the journal of designing in china. 180 x 285. 2006.

The spirit of designing is a living experience, and the experience of the social and cultural living. From observation, knowledge and experience of our daily life, a self and the global civilization can be reflected.

A sheet of paper, a word, an image, an idea. Material beings on paper. Interaction of thinking and material beings on paper. Union and expression of creativity and 'us' on paper. Sensing of things and beings are inborn, but awakening might not be taken as. Awakening of design – loving lives in our life.

디자인은 결코 중요한 것이 아니다?

우리의 일상생활에 있는 디자인 생활, 우리의 일상생활은 디자인을 기른다.

우리의 일상생활에 있는 살아 있는 생활, 우리의 일상생활은 생존을 기른다.

우리는 생활 속에서 살아가는 것을 사랑한다, 우리의 일상생활은 사랑을 기른다.

liu esther

book. 100 years of hong kong architecture. 190 x 285. 2005.

디자인의 기본정신은 자신의 생활체험 및 사회문화 생활체험에서 온다. 생활에서 관찰, 인지하고 체험하며 자신
과 세계 생활문화에 대하여 반성한다.

한 장 종이, 한 개 글자, 한 개 이미지, 한 가지 의념. 한 가지 사색은 종이에 있고 한 가지 뜻은 종
이 안에 있고 한 가지 생각은 종이 밖에 있다. 감각은 타고난 능력이지만 각성은 그렇지 않다. 디
자인의 각성-우리는 생활에서 살아가기를 좋아한다.

Born in Hong Kong, Lu Zhichang graduated from School of Design, Hong Kong Polytechnic University. He worked as a book designer in Hong Kong for more than a decade, during which studied in France for 2 years. Since 2000, Lu has worked as book designer and publication planner in Beijing. He co-founded ISreading Culture Studio with Mrs. Dong Xiuyu (renowned senior publisher in PR China) and friends in 2003. In 2008, Lu zhichang became the art director of the Heritage and Creative Design Program, which is hosted by the Forbidden City Publishing House, and cooperated with Prof. Zhao Guangchao, in the Design and Cultural Studies Workshop, to make practical experiments on traditional and modern Chinese ideas of its culture, art and design. Lu has been awarded more than 60 book-designing prizes. Selected titles as below: <Design for Asia Grand Award 2009> & <Design for Asia Award 2009 Special Award for Culture> by Hong Kong Design Center, <Excellence Prize in Magazine Design> by Society of Publishers in Asia (SOPA), <Prize for the Best Book Design> by the 3rd National Exhibition for Architecture Books, <Prize for the Best Book Design Prize> by the 2nd National Publication Exhibition.

루즈창.陆智昌.

lu.zhichang.

china

lu zhichang

book. '85 new wave-the birth of chinese contemporary art. 340 x 320. 2007.

홍콩에서 태어났다. 홍콩이공대학교에서 그래픽 디자인을 전공했다. 졸업 이후 10여 년간 북 디자인 작업을 했으며 프랑스에서 2년 동안 유학했다. 2000년부터 베이징에서 북 디자인 및 출판 기획을 하고 있으며 2003년 출판인 동슈위를 비롯한 지인들과 함께 ISreading 컬처스튜디오를 설립했다. 2008년에 베이징 자금성출판사의 주최로 열린 고궁 예술문화 추진기획 및 아트 디렉터를 맡게 되었다. 디자인·문화연구공작실에서 자오광차오와 함께 중국 전통 및 현대의 문화, 예술과 디자인 이념에 대해 구체적인 탐구와 실천을 하고 있다. 홍콩디자인센터 선정 Design for Asia 대상 및 특별상, 아시아출판업협회(SOPA) 선정 잡지디자인 부문 대상, 제3회 중국 건축도서상 최고북디자인상, 제2회 중국 출판정부상 북디자인상 등 60여 종의 상을 받았다.

book. skindeep, hardcore. 130 x 190. 2011.

book. chinese architecture: a suite inspired by nature/book. 162 x 230. 2010.

book. xixia hotel. 130 x 185. 2011.

book. beijing parkour – roadway observations on 18 city areas. 60 x 232. 2009.

Reading with mobile phone in subway - this is a kind of activity that I have long been interested in. I believe that mobile-reading will become one of the most convenient ways of reading for human beings in the coming future.

Being similar to other e-devices, mobile phones enable readers to promptly and easily find out better contents and arrangements according to their specific needs. Such overwhelming autonomy of readers, diminishing the immature media's other disadvantages, will definitely become a keynote for future human reading habits.

I have long been feeling puzzled on book designing.

lu zhichang

Book designers are constantly enslaved by endless arrangements of texts and photos in a given page, hoping to structuralize a more reasonable and safer layout for the readers. However, given pages always fail to satisfy every individual need. For the established form of book, there is a destined limitation for their function of exhibiting various contents.

The rising of e-media has easily solved the problem.

The traditional reading habits of human beings will change soon, as the increasing emergence of more and more refined e-media. Somehow, books will vanish and disappear, eventually.

In the distant future, if there are still the existences of books at that moment, I believe, it must because there are still some readers, who cherish the unique emotional value released from books. All supposed on the premise, that there are still such kind of people, who are willing to instill their emotion into every word, every sentence, and every page of a book.

And that, is one of the most precious values for the existence of book and book-designing.

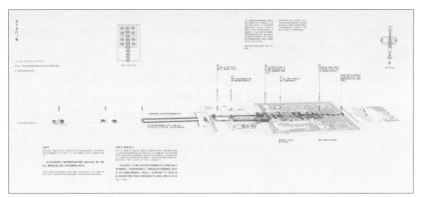

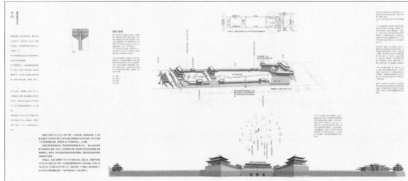

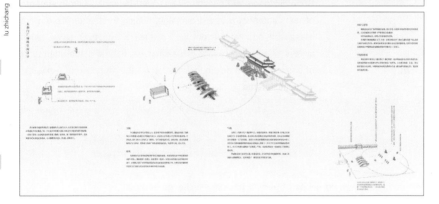

book. the grand forbidden city-the imperial axis. 174 x 228. 2008.

book.　simple life.　148 x 210.　2006.

'지하철에서 휴대전화로 독서하기'는 내가 오래도록 관심을 가져온 활동이다. 나는 휴대전화로 읽는 활동이 미래에 인간의 독서에 가장 편리한 방법 중 하나가 될 것이라고 믿는다.

다른 전자 기계들과 비슷하게 휴대전화는 독자들이 그들의 구체적인 필요에 따른 내용과 구성을 신속하고 쉽게 찾을 수 있도록 해준다. 독자들의 이러한 압도적인 자율성은 미숙한 매체의 단점을 절감하며, 분명 미래 인간의 독서 습관에 주안점이 될 것이다.

나는 오래도록 북 디자인에 어리둥절해왔다.

북 디자이너들은 주어진 공간 안에 텍스트와 사진들을 끝없이 배치하는 것에 지속적으로 노예가 되어왔다. 독자들을 위해 보다 합리적이고 안전한 레이아웃을 구축하길 바라면서. 그러나, 주어진 공간은 항상 모든 개인의 필요를 만족시키는 데 실패한다. 책의 서식은 다양한 내용을 보여주는 기능에 운명적 한계를 가지고 있다.

전자 매체의 등장은 이러한 문제들을 쉽게 해결했다.

점점 더 정교한 전자 매체 출현이 증가할수록 인간의 전통적 독서 습관은 곧 바뀔 것이다. 어떻게든 책은 결국 사라지고 그 모습을 감추게 될 것이다.

먼 미래에 만약 아직도 책이 존재한다면 내 생각에는 책이 선사하는 특별한 감성적 가치를 소중히 여기는 일부 독자들이 여전히 있기 때문일 것이다. 모든 단어, 모든 문장, 모든 책의 페이지에 그들의 감성을 주입시키는 사람들이 있다는 전제 하에 말이다.

그리고 그것은, 책과 북 디자인의 가장 소중한 가치 중 하나이다.

2006년 홍콩 청년디자인대상 장학금을 받으며 런던 센트럴세인트마틴스컬리지 석사학위를 마쳤다. 홍콩 브랜드 Chocolate Rain은 맥프루든스가 2000년에 창시한 브랜드이다. Chocolate Rain은 상상력과 초심, 꿈 같은 아름다운 이야기들의 전시이고, 젊은이들이 환경을 사랑하도록 격려하고, 에너지와 창작력을 발산하는 데 노력하고 있다. 2003년부터 영국, 홍콩의 아트숍에 입점했다. 유일무이한 핸드메이드 상품이라는 점과 어린 시절의 꿈과 기묘한 여행 속에서 찾아낸 디자인 영감을 콘셉트에 담았다. D.I.WHY공방을 만들어 사람들이 핸드메이드의 재미와 낡고 조각난 천을 재활용하여 잊혀진 어린 시절을 추억하는 공간이다. Chocolate Rain은 세계 유명 브랜드 전시에 참가하였고.e.g. London Paris, New York, Tokyo 전시에 참여했다. 전시하는 동안에도 그는 사람들과 자신의 디자인 이념을 공유하는 강좌를 진행한다.

www.chocolaterain.com
A Childhood ...etc.

맥프루든스.麦雅端.

mak.prudence. china

<div style="transform: rotate(0deg)">mak prudence</div>

Chocolate Rain ...
Love is all around.

292

book. why throw away your memory?. 135 x 185. 2009.

Chocolate Rain Design is inspired by childhood dream and wonderland adventure. Each piece is unique and handcrafted with mix medium and special artistic elements. Prudence is the founder and designer and graduated in Fine Art. In 2008, Prudence was granted the Design Smart scholarship to Central Saint Martins London for MA Degree in Design Studies. Chocolate Rain design has been exhibited and distributed internationally, including the MoMA, Tate Modern and Guggenheim Museum. Chocolate Rain design collection and illustration were commissioned projects for global brands such as Clinique, Luella, Stella McCartney's Care and Swarovski. In 2009, "WHY THROW AWAY YOUR MEMORY" art exhibition was unveiled at Times Square. In 2010, BRITISH MUSEUM X Chocolate Rain Collection launch in London. Chocolate Rain created the DIY workshop in 2003 to share the enjoyment of the 100% handmade accessories in our flagship shop, Sogo Club, YMCA, Hong Kong Art Museum London Craft Central, Yorkshire Sculpture Park, Design 100% in London and V & A Childhood ...etc.

book. tour de' i halloween. 240 x 140. 2010.

The design is inspired by childhood dream and wonderland adventure. Each piece is unique and handcrafted with mix medium and special artistic elements.

Chocolate Rain의 디자인은 아이들의 낯선 세계로의 모험에서 영감을 얻는다. 독특한 디자인과 수작업으로 제작했다는 것이 큰 특징이다.

book. love is all around. 240 x 140. 2010.

Chocolate Rain uses imagination and heart, creating dream like wonderful story and ex-
hibition bit by bit, encourages youngsters to be passionate for the environment, release
positive energy and creativity and join the dream team of Chocolate Rain DIWHY.



matsuda.yukimasa. japan

마쓰다.유키마사.松田行正.

1948년 시즈오카현 출생이다. 북 디자인을 중심으로 단순하고 힘찬 디자인을 지향한다. 문자나 기호를 포함한 모든 형태의 기원이나 그것이 생성되는 현장, 형태를 발상하는 순간 등에 관심이 많으며 그 궤적을 찾는 것을 좋아한다. 센다이 미디어테크, 다이샤문화플레이스, 모토마치 중화가역 플랫폼, 마쓰모토 시민 예술관, 도미히로미술관 등의 사이니지 디자인을 했다. 『Lines』, 『원과 사각형』, 『Zerro』, 『앰프라맹스』, 『×바쓰』, 『et』, 『1000억분의 1 인 태양계』, 『속도 내기 좋은 날』 등을 편저했다. 『디자이너스, 컬러, 차트』, 『디자이너스, 컬러링, 북』, 『눈의 모험』, 『눈의 황홀』, 『화력』, 『선 의 모험』, 『도지반전』에서는 북 디자인과 편집을 맡았다. 『눈의 모험』으로 제27회 고단샤출판문화상 북디자인상, 『얼마 안 있어 멸망한다 는 종이 서적에 대해서』로 제45회 일본 북디자인 콩쿠르 문화과학장관상을 수상했다. 『Lines』, 『눈의 모험』, 『눈의 황홀』은 한국에서, 『원 과 사각형』, 『Zerro』는 타이완, 한국, 중국에서 출간되었다.

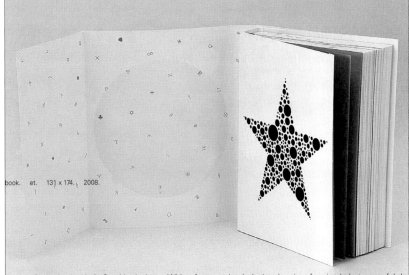

book. et. 131 x 174. 2008.

296

Born in Shizuoka, in 1948. Graphic designer. With a focus on book design, he aims for simple but powerful designs. He is interested in the origins of characters, symbols and other shapes, where they are created, and the moment 'shapes' are conceived, and tries to trace their paths. He has also worked on signs and designs for architectural projects such as the Sendai Mediatheque, the Taisha Cultural Place, and the platforms of the Motomachi Chukagai Station in Yokohama, the Matsumoto Performing Arts Centre, and Tomihiro Art Museum. His books include <Lines>, <Circles and Squares>, <Zerro>, <Inframince>, <xBATZ>, <et>, <One Hundred-Billionth of the Solar System>, <Rolling Velocity>, <The Designer's Color Chart and The Designer's Coloring Book>, <The Adventure of the Eye>, <The Story of the Beginning>, <For warming japan>, <Adventures with Lines>, and <Vantage Point>. In addition to the text of all these titles, Matsuda is also responsible for their design. Matsuda has received the 37th Kodansha Publishing Culture Prize for Book Design, for <The Adventure of the Eye>, and the 45th Japanese Book Design Award from the Minister of Education, Culture, Sports, Science and Technology for <This is not the End of the Book>. <Lines, The Adventure of the Eye> and <The Story of the Beginning> have been published in Korea; while <Circles and Squares> and <Zerro> have been published in Taiwan and China as well as in Korea.

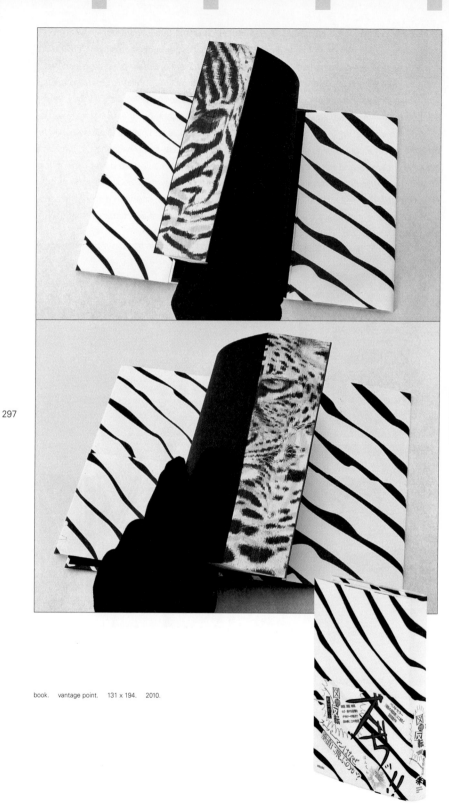

matsuda yukimasa

book. vantage point. 131 x 194. 2010.

I run a tiny publishing company called Ushiwaka-maru, that publishes a book a year of my own writings. With this kind of pace, I once declared that every book should be an *objet d'art*, and that has always been my aim. To me, a book should have a certain presence, something that you keep around and are reminded of from time to time. A book basically consists of a series of thin, flat sheets of paper that have been stacked together so that they form a solid body. In this sense, any book is a three-dimensional object, but that is not quite what I mean by an *objet d'art*. For some people, a book is a miniature universe, while for others it is just a container to stuff information into. In the past, if you happened to step on a book, your parents and teachers would get angry, saying you should take better care of your books. These days, however, many people not only throw away their books as soon as they have read them, some even scan the pages before reading them and then discard the actual book. I suppose that if you treat a book as just another information container, that sort of treatment is inevitable.

matsuda yukimasa

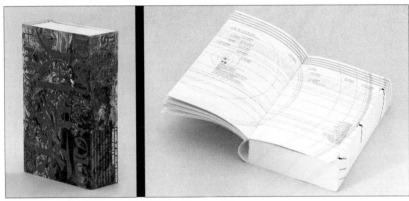

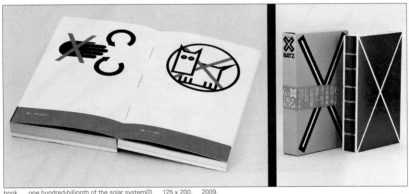

book. one hundred-billionth of the solar system01. 125 x 200. 2009.

book. xbatz. 115 x 185. 2007.

우시와카마루출판사를 주재하며 일 년에 한 권꼴로 책을 출판해오고 있다. 그 과정에서 책이란 '오브제'여야 한다고 믿으며 공언해왔다. 물론 내가 노력하고자 하는 목표이기도 하다. 책은 존재감이 있고 손이 닿을 곳에 늘 있으며 다른 일을 하다가도 가끔 떠올려보게 되는 그런 존재였으면 좋겠다는 생각을 한다. 책이란 얇은 종이라는 평면이 여러 장 겹쳐져 입체가 된 것이다. 따라서 책이라고 불리는 것은 모두 입체물이지만 여기서 말하는 '오브제'는 조금 다른 의미이다. 책을 우주의 축소판이라고 생각하는 사람이 있는가 하면 정보를 담은 그릇에 불과하다고 생각하는 사람도 있다. 옛날에는 책을 밟으면 '책은 귀하게 다뤄야 한다'라며 혼나곤 했지만 요즘은 한 번 읽고 버리는 책이 많아졌다. 뿐만 아니라 내용을 스캔하고 책 자체는 처분해버리는 일도 자주 일어나곤 한다. 책을 정보의 그릇이라고만 인식한다면 책을 이렇게 다루는 것이 이상하지 않다.

But a book contains many kinds of information. The font of the text, the size , the spacing, the way illustrations and captions are inserted, the way the pages are numbered, the margins, the paper quality, the smell, the size, the thickness, the weight. These are like the book's DNA, and I think it's safe to say that no two books are exactly alike. On top of this, the cover and the binding are designed as the face of the book, fixing its expression. I call all these details of a book as a whole its "material feel," and books that have the right kind of material feel are "books as *objets d'art*." For the books I publish at Ushiwaka-maru, I always strive to improve this feel. When I published my first book, which was about diagrams, the person who wrote the foreword mentioned that "the most miraculous under-taking of art is making visible what cannot be seen." He was talking about diagrams, but I believe it is true of book design as well.

Perhaps "what cannot be seen" is the "material feel," and when it is rendered visible, it is called a "book."

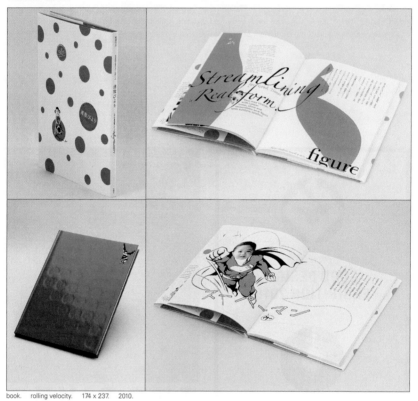

299

matsuda yukimasa

book. rolling velocity. 174 x 237. 2010.

그러나 모든 책에는 다양한 표정이 있다. 본문 글꼴, 글자 크기, 글줄 사이, 도판 및 캡션을 넣는 방법, 페이지 번호를 넣는 방법, 여백, 종이 질감, 냄새, 크기, 두께, 무게. 이것들은 책의 DNA와도 같아서 완전히 똑같은 책은 없다고 해도 과언이 아닐 것이다. 커버나 표지 등 책의 얼굴에 해당되는 부분이 디자인되면 책의 표정이 확고히 드러난다. 나는 이러한 책 전반에 걸친 디테일을 '질감'이라 부르며 이 질감이 느껴지는 책을 '오브제로서의 책'이라고 부른다. 우시와카마루가 출판하는 책은 늘 질감 향상을 위해 노력하고 있다. 처음 다이어그램에 관한 책을 출판했을 때 서문을 써주신 분이 "미술에 있어 가장 기적적인 시도는 '보이지 않는 것'을 보이게 만드는 것"이라고 기술했다. 이 말은 다이어그램에 대해 쓴 것이지만 책을 만드는 일에도 해당되는 것 같다. '보이지 않는 것'이 '질감'이고 시각화된 것이 '책'이라고 말할 수 있을 것 같다.

마쓰시타.케이.松下計.

matsushita.kei. ^{japan}

Born in Yokohama in 1961, Matsushita graduated from Tokyo University of the Arts, Design Course, where he currently serves as an associate professor. After completing the postgraduate study at the school, he established Kei Matsushita Design Room in 1990. Major works include symbol and logo for the Japan pavilion, Expo 2002 in Hannover, Germany; sign, pamphlets and website direction for Benesse Art Site Naoshima; branding for 'YUICHI', the oil paint co-developed by Holbein Works and Tokyo University of the Arts; direction of exhibition catalogues for 21_21 Design Sight; and art direction for Takeo Paper Show 2009. His awards to date include the JAGDA New Designer Award; the ADC Award; the Minister of Education, Culture, Sports, Science and Technology Prize; and the Good Design Award. He is member of Alliance Graphic Internationale (AGI).

<div style="writing-mode: vertical">matsushita kei</div>

poster. good design exhibition 2010. 728 x 1,030. 2010.

poster. hideki noda tokyo metropolitan art pace artistic director assumption. 728 x 1,030. 2009.

GOOD DESIGN
EXHIBITION 2010

THE DIVER
ザ・ダイバー

1961년 요코하마에서 태어났다. 도쿄예술대학 미술학부 디자인과를 졸업하고, 동 대학원 수료 후 마쓰시타케이디자인을 설립했다. 현재 도쿄예술대학교 디자인과 부교수이며 국제그래픽디자이너연맹(AGI) 회원이다. 주요 작업으로 〈하노버 국제 만국박람회〉 일본관 심벌마크 및 로고 디자인, 나오시마의 베네세아트 팸플릿·웹사이트 아트 디렉션, 홀바인공업과 도쿄예술대학교가 공동 개발한 유화물감 유이치(油一) 브랜딩, '21_21 디자인' 사이트, 전시회 카탈로그 디렉션, 〈다케오 페이퍼쇼 2009〉 아트 디렉션 등이 있다. 일본그래픽디자이너협회(JAGDA) 신인상, ADC상, 문부과학장관상, 굿 디자인상 등을 수상했다.

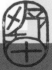

301

matsushita kei

2009年夏、野田秀樹、
池袋、東京芸術劇場、芸術監督就任。

2009年7月、池袋「東京芸術劇場」に満を持して野田秀樹が芸術監督に就任。
通称『ゲイゲキ』は新しい東京の芸術拠点となり得るのか、乞うご期待。

東京芸術劇場

Tokyo Midtown Design Hub 21st Exhibition:

Design in Japan 2010

東京ミッドタウン・デザインハブ第21回企画展

日本のデザイン 2010 トゥエンティ・テン

5人のキュレーターが考えるデザインのこれから 黒崎輝男 / 柴田文江 / 曽我部昌史 / 八谷和彦 / 廣村正彰

2010.4.8 [thu] → 5.9 [sun] 11:00 — 19:00

東京ミッドタウン・デザインハブ[ミッドタウン・タワー5F] 入場無料 Tokyo Midtown Design Hub [Midtown Tower 5F] Admission Free

主催:東京ミッドタウン・デザインハブ [(社)日本産業デザイン振興会 / (社)日本グラフィックデザイナー協会 / 九州大学-芸術工学研究サイト] アートディレクション:松下 計 各協力デザイン:川崎貴久

Tokyo Midtown
DESIGN
HUB

Exposition

WA : L'HARMONIE
AU QUOTIDIEN
DESIGN JAPONAIS D'AUJOURD'HUI

22 OCTOBRE 2008 – 31 JANVIER 2009
Maison de la culture du Japon à Paris

101bis, quai Branly 75015 Paris M° Bir-Hakeim / RER Champ de Mars www.mcjp.asso.fr

poster.

wa: l'harmonie au quotidien. 728 x 1,030. 2008

303

matsushita kei

http://www.tnm.jp/

TOKYO
NATIONAL
MUSEUM [Ueno Park]

Information service 03-5405-8686 [English]

Hours 9:30 - 17:00 (last admission at 16:30)
Closed Mondays (except National Holidays; closed on Tuesdays following National Holidays)
Year-end holidays (December 27 - January 1)

Admissions Adults: 600yen
University Students: 400yen
Persons under 18 and over 70: free
*Separate admission required for special exhibitions.

東京国立博物館

matsushita kei

305

Sumidagawa – The Beloved River of Edo

特別展

江戸が愛した風景

栄之・広重・国貞・・・
隅田川を愛した絵師による160余点を公開

隅田川

江戸東京博物館
EDO-TOKYO MUSEUM 1階展示室
平成22年9月22日[水]−11月14日[日]

休館日：毎週月曜日 ただし10月11日(月)は開館、12日(火)は休館
開館時間：午前9時30分〜午後5時30分（土曜日は午後7時30分まで）＊入館は閉館の30分前まで
観覧料：一般1100円（880円／1000円）、大学・専門学校生880円（700円／780円）、小・中・高校生・65歳
以上550円（440円／450円）＊（）内は20名以上の団体料金／前売料金。※次の場合は観覧料が無料。未就
学児童、身体障害者手帳・愛の手帳・療育手帳・精神障害者保健福祉手帳・被爆者健康手帳をお持ちの方と、
その付き添いの方（2名まで）。＊前売券販売期間：6月22日〜9月21日、会期中は当日料金で販売。
チケット取扱：江戸東京博物館、チケットぴあ、ローソンチケットほか主要プレイガイド
〒130-0015 東京都墨田区横網1-4-1 Tel.03-3626-9974（代表）http://www.edo-tokyo-museum.or.jp
交通：JR総武線両国駅西口徒歩3分、都営地下鉄大江戸線両国駅A4出口徒歩1分、都バス錦27・両28・門
33・lb38系統、夢の下町観光循環バス「都営両国駅前」徒歩3分
主催：公益財団法人東京都歴史文化財団 東京都江戸東京博物館、読売新聞社
協賛：光村印刷、キヤノンマーケティングジャパン

橋本貞秀「東都両国ばし夏景色」安政6年（1859）江戸東京博物館所蔵

Born in Wenzhou, 1983. Mei worked as designer at MEWE in Beijing from 2006 to 2007, as art director at wx-design in Beijing /Guangzhou from 2008 to 2010. He has been a freelanced designer since 2010._____

_____1983년 중국 원저우에서 출생했다. 2006년부터 2007년까지 베이징 MEWE에서 디자이너로 일했으며 2008년부터 2010년까지 베이징과 광저우 WX디자인에서 아트 디렉터를 지냈다. 현재 프리랜서 디자이너로 활동하고 있다.

메이수즈.梅数植.

mei.shuzhi. china

poster. synchronous object. 580 x 850. 2010.

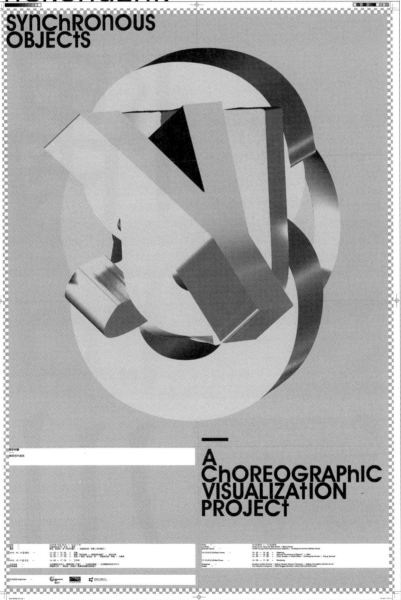

mei shuzhi

poster. d day. 545 x 675. 2010.

mei shuzhi

mei shuzhi

exhibition visual.　"21-dc" oct_loft cf08.　290 x 225.　2008.

book. ttf jewelry brand brochure . 230 x 305. 2009.

mei shuzhi

book. qiu xiaofei. 240 x 315. 2010.

magazine. 0zz0 no.2. 210 x 285. 2008.

min.byung-geol. _{korea}

민병걸.閔炳杰.

1968년 청주에서 태어났다. 홍익대학교에서 시각 디자인을 전공한 후, 1994년부터 4년 동안 안그라픽스에서 디자이너로 일하며 달력, 애뉴얼 리포트, 잡지 등 주로 기업을 위한 그래픽 디자인 작업을 진행했다. 1998년 일본으로 건너가 무사시노미술대학에서 논문 〈그래픽 디자인에 있어서 수학적 이성의 활용〉으로 석사학위를 받았으며, 다니무라디자인실에서 일했다. 논문을 쓰면서 관심을 갖기 시작한 '한 글 창제원리와 글자 디자인에서 활용되는 규칙적 형태변화'에 대한 작업을 하고 있다. 글자처럼 도구적 성격을 지닌 디자인 결과물을 만드는 것을 지향하며 원형의 조합과 구성을 통해 다양한 결과물을 만들어내려고 노력한다. 대표적인 작업으로 10개의 선과 원의 기초적인 형태를 조합해 즉흥적으로 다양한 문장을 만드는 디지털 캘리그래피 방식의 글꼴 〈이니그마〉가 있다. 그 밖에 디자이너그룹 '진달래'의 전시 및 출판물을 통해 매년 작업을 발표하고 있으며 2003년부터 서울여자대학교 교수로 재직 중이다.

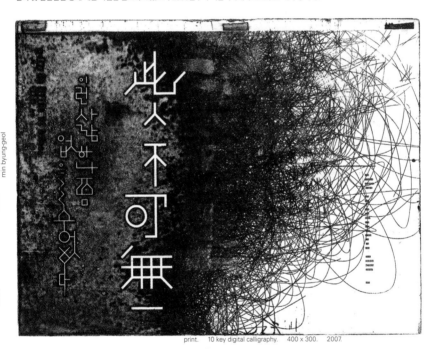

print. 10 key digital calligraphy. 400 x 300. 2007.

310

Min Byung-geol is a graphic designer and a professor, whose work explores the visual resonance of mathematical structures and types. He was born in 1968, Cheongju, Korea and studied visual communication design at Hongik University. His career as a graphic designer commenced from 1994 at Ahn Graphics where he experienced various design works such as calendar, annual report, magazine that mostly assigned by major Korean corporations. In 1998, Min moved to Tokyo and worked at Tanimura Design Office, and also studied at Musashino Art University where he earned master degree for his thesis 「Applying Mathematical Algorithm to Graphic Design Process」. This thesis project marked his persist interest on the foundation of forming types and the regularity of advancing the form of letter, such as in Hangeul and type design in general. Min defines the type design as the result of inter-conversion between forms and its structure. Initial work of Min is <Enigma>, a font that utilizes his method 'digital calligraphy', consists of 10 different straight and curved lines as minimum meta-form of Hangeul and makes it possible to instantly draw various letter forms. As a member of 'Jindalrae', a group of Korean designers, Min has his work exhibited and published annually. He has been professor at Seoul Women's University since 2003.

logo design.　logo design for barom 100th anversary.　2009.

poster.　3x3 wooden typeface promotion poster.　728 x 1,030.　2008.

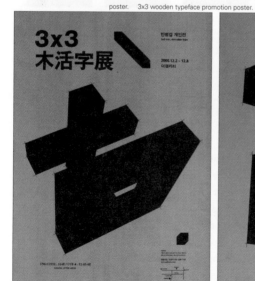

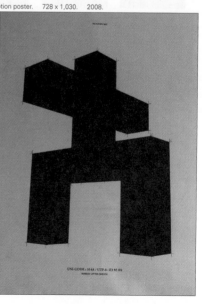

Enigma Bold

poster.　10 key digital calligraphy.　728 x 1,030.　2006.

Letters perform their role to deliver a message. Therefore, creating letters can be compared to creating a tool. The physical form of a tool, or a letter, is a moving letter.

I pursue the process of design, not the result, as a tool which the audience experiences in various way, like type as a module. I have tried to create three-dimensional letter with wood, a new lettering tool, beyond the two-dimensional forms shown in my digital calligraphy work which could be transformed into various compositions by using the modulated morphemes. I planned to create a new lettering tool with geometrical plastic letters, by fitting hexahedral shapes of wooden forms together, and also tried to create a new tool by putting new functions and meanings to the letter.

poster.　10 key digital calligraphy.　728 x 1,030.　2006.

글자는 메시지를 전달하는 도구로서 그 역할을 한다. 그러므로 글자를 만드는 것은 도구를 만드는 작업이기도 하다. 그 도구의 물리적 형식인 활자는 결국 움직이는 글자이다. 모듈화된 몇 개의 형태소를 활용하여 나무활자 등을 만듦으로써 글자가 가진 평면성을 벗어나 보려 노력한다.

최종의 디자인 결과물을 지향하기보다는 서체와 같이 모듈화된 형태로 사용자가 다양한 변화를 체험할 수 있는 디자인 도구로서의 의미를 갖는 작업을 지향하고 있다. 모듈화된 몇 개의 형태소를 활용하여 다양한 글자로 변형시키는 방식인 디지털 캘리그래피의 기존의 작업을 벗어나 나무활자 등을 만들어 평면을 넘어서 보려 한다. 육면체 나무를 서로 조합해가며 기하학적인 조형글자를 만들고 그 글자에 또 다른 기능을 부여하여 새로운 도구로 변화시키는 작업을 계획하고 있다.

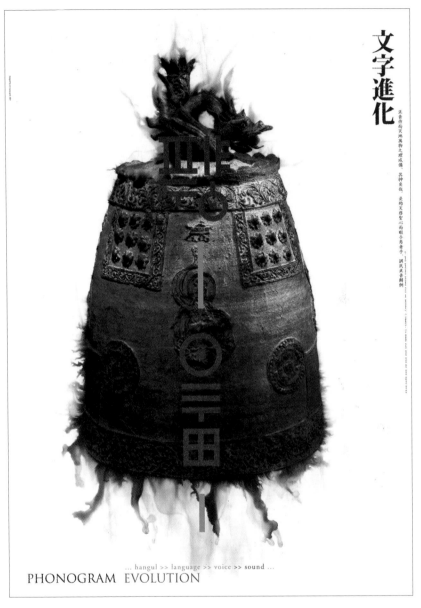

文字進化

正音作而天地萬物之理咸備，其神矣哉，是殆天啓聖心而假手焉者乎，訓民正音解例

min byung-geol

314

... hangul >> language >> voice >> sound ...

PHONOGRAM EVOLUTION

poster. phonogram evolution. 728 x 1,030. 2001.

pattern design. hangeul pattern for textile. 2008.

mito.hidetoshi. ^{japan}

미토.히데토시.美登英利.

Born in Ehime Prefecture, Japan in 1955. He founded his company, mitografico in 1985. In 1990 he published a book of his calligraphy works <Sho by mito>. He held a solo exhibition of calligraphic works at various places across Japan in 1991. He was awarded a grand prix of International Typography Almanac for calligraphy posters <HANA (Flowers)>, <MIZU (Water)> and <UGUISU (A Japanese Bush Warbler)>. He is a winner of International Typography Almanac for CD cover design <Japanese Traditional Music>. Mito was awarded a prize of Kanagawa poster exhibition for <The World of Pop Art> and <Poetic of Hue> in 1992. He exhibited a poster for Nuclear Free Symposium hosted by world medical association in 1998, and participated in the exhibition <Blooming Typefaces from Ryobi>. He held a joint exhibition <Pottery and Calligraphy> and a solo exhibition <Impressions of Sho> in 1999. In 2009 he held an exhibition <Poetry and Sho> at shop HABA Ginza and published a book of <Sho by mito>, <Shorin>.

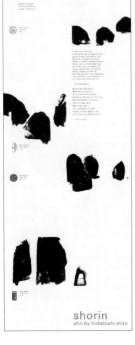

poster. shorin poster. 408 x 1,030. 2011.

1955년 에히메에서 태어났다. 1985년 미토그래피코(Mitografico)를 설립했다. 서예를 모티프로 한 포스터 〈꽃(花)〉, 〈물(水)〉, 〈메까치(鶯)〉로 국제 타이포그래피연감 그랑프리를 수상했으며, 〈일본 전통음악〉 CD 커버 디자인으로 국제 타이포그래피연감에 입상했다. 1992년 포스터 〈색상의 시학 전〉, 〈팝아트 전〉으로 가나가와포스터전에서 우수상을 수상했다. 1998년 세계의사학회 주최 핵 폐절운동 심포지엄에 포스터를 출품했으며, 〈료비 글꼴 포스터 백화전〉에 참가했다. 1991년 서예 개인전을 일본 각지에서 열었고 1999년 〈도기와 서예 2인전〉, 〈서예의 인상: 미토 히데토시 개인전〉, 〈시와 서예 2인전〉 등을 도쿄에서 가졌다. 작품집으로 『sho by mito』, 『쇼린』을 출간했다.

The art of Japanese calligraphy is fragile. Every stroke, such as the upward flip and a complete stop with the bleeding or dry brushing of the ink, is masterly intertwined and these strokes shape a form of letter. When you draw calligraphy, you put the black ink, Sumi, drawn with one stroke, on the clean white paper. If you displace a dot position a little or draw a pull-out stroke too long, we will get a different taste from the appearance of a letter.

What matters is a letterform but its form has already been predetermined. What is left to drawers are details such as the bleeding or dry brushing, and these details are a result from chance that god only knows. If you try to control them, then superficial techniques and artificiality come up to the surface of letters, and will incur a lack of style. So after a succession of failures, I always face up to a white paper without any artificiality. If I tried to draw a hundred times, I hardly saw anything to my liking.

I have never learnt the formal way of Japanese calligraphy called "Shodo." It seemed it was unapproachable and unsuitable for me from the start, to the way to adjust posture and hold a brush. I was not interested in tracing the great examples of predecessors. From my viewpoint as a graphic designer, I was attracted to calligraphy as a visual image or logotypes and always drawing letters in this way. I didn't mean to find innovative value in an act of calligraphy but kept the value of "drawing" in my mind. From the first days, it seemed to me that I had attached my mind to the act of "drawing." I thought the act of "drawing" and typography which were a way to make my living were closely overlapping disciplines.

One day, I met with someone who led me to change my attitude to calligraphy. When Mr. and Mrs. Baumann, who were running a multi-disciplinary design office in Germany, came to Japan, I had the opportunity to talk with them at the party. After talking over many issues like each other's viewpoints of design, they asked me the following question.

"Mr. Mito, where do Chinese characters originally come from?"

Chinese characters originate from pictures. Chinese characters are created from pictures each with different meanings that are called hieroglyphs. These hieroglyphs had been symbolized and simplified over time and every character has deep meaning in its refined symbolic forms... Although I explained it to them in this way, a kind of small question arose in my mind. At that time, I spent the days trying to deal with the Chinese characters "Hikari (Light)" and "Yama (Mountain)" from various approaches but was not happy with the results. Meanwhile, the following conversation with them gave me some sort of a clue.

Why don't you find out the original meaning of the letters, in other words, restore letters to their origin as pictures, instead of bound by the rules and conventional forms. Taking "Hikari (light)" as an example, the letter Hikari itself is a compound of ideographs. If we resolve this letter into its elements, it was made by combining pictures of "Hi (Fire)" and "Hito (human)." So it means a picture of holding something shining up to a human's head. There was a Chinese bronze inscription in the Yin Dynasty which engraved a variant version of the letter Hikari that substituted Hito (human) with woman. Interestingly, this replacement symbolized the ancient matriarchal society. With such an idea of a letter as a picture, a picture as a letter, I tried to eliminate distraction from my mind as the next step.

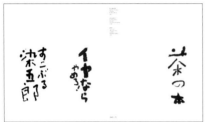 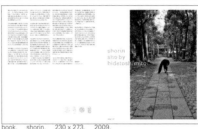

shorin
sho by
hidetoshi mito

book. shorin. 230 x 273. 2009.

318

mito hidetoshi

There are various aspects of the light such as the strong sunlight of summer and soft sunbeams streaming through leaves in autumn. I imagined these various lights and focused attention on expressing that as a hieroglyph. The calligraphic work of Hikari through this process became the letter that had the characteristics like the light from the center in all directions. It expressed the serene light in spring, so the bleeding brushing of the ink on Japanese paper became a part of the interpretation as a pictorial letter.

In case of the letter "Yama (Mountain)," I sped up progress on the act of drawing. I could concentrate on drawing calligraphy with an innocent child's heart. This letter has a bare form with three vertical strokes directly expressing the metaphor of the head of mountains, so I expressed a mountain's four seasons of spring, summer, autumn and winter and drew with pictorial bold strokes. It might not be able to be recognized as the letter Yama from the eye of Japanese people. The mountain in spring has a serene look. The mountain in winter is isolated in the bitter cold. It was a delightful work that tried to express various aspects of such landscapes.

Then I took one step further from just drawing letters. I am exploring ways of drawing letters such as scenery image. The letter will be in harmony with the scene. It is only because the message in the letter as a picture overlapped with my attitude on life and my view of nature. It will invite the result of attaching the scenery image to the letters. In addition to the level of pictorial drawing of the letter which is attributable to the nature meaning of its letter, I would like to add aspects of spirit and make progress to the next stage. Beyond this approach, I have a high degree of expectation for the new form of Japanese calligraphy.

서예는 위태로운 예술이다. 번짐, 스침, 삐침, 누름…… 모든 것이 교묘하게 서로 엮이면서 문자를 형성해 나간다. 서예에서는 붓으로 하얗고 청초한 종이 위에 새까만 먹으로 표현한다. 점의 위치가 조금 비뚤어지거나 획이 너무 길어져도 문자는 그 풍정(風情)을 바꾼다.

문자는 골격이 중요하여 쓰기 전에 이미 그 모습이 결정돼 있다. 쓴다는 작업에 의해 좌우되는 것은 번짐이나 스침 등의 디테일이며 이는 우연성에 의존한다. 이를 컨트롤하려고 하면 기교나 작위가 들어와 서예의 품격을 저해하게 되는 것이다. 늘 작위 없이 종이와 대치하며 실패를 반복하고 있다. 백 번을 써봐도 납득할 수 있는 작품은 하나 있을까 말까 한다.

나는 '서예'라는 것을 배운 적이 없다. 자세를 바르게 잡거나 붓을 쥐는 법부터 배우는 것은 어쩐지 멀리하게 되고 스스로에게 어울리지 않는다고 생각해 왔다. 또 선인들의 명필을 따라해보아도 큰 흥미를 느끼지 못했다. 나는 그래픽 디자이너의 눈으로 로고타입이나 소위 말하는 비주얼로서의 매력을 느끼며 줄곧 제작을 했다. 서예라는 행위에서 특별히 혁신적인 의의를 찾으려고 하는 것도 아니며 늘 의식하는 것은 '그린다'는 것이었다. 초기에는 '쓴다'는 행위에 더 가까웠던 것 같다.

서예에 대한 태도가 바뀐 것은 우연한 만남 때문이었다. 독일에서 디자이너로 활동하고 있는 바우만 부부가 일본을 방문했을 때 파티 석상에서 그들과 회담할 기회가 있었다. 서로의 디자인 철학 등에 대해 이야기를 나눴는데 그때

'미토, 한자라는 문자는 어디서 왔는가?'라는 질문을 받았다.

나는 한자는 그림에 뿌리를 두고 있다. 한자는 상형문자라 불리는 하나하나가 의미를 지닌 그림으로부터 생겨난 것으로 서서히 기호화 혹은 간소화되며 현대까지 전해져 왔으며 모든 한자는 교묘한 상형성에 깊은 의미를 내포하고 있다고 설명했다. 그러한 대답을 하면서 마음속에 작은 무언가가 걸리는 기분이었다. 당시 나는 '빛(光)'과 '산(山)'이라는 문자를 테마로 여러 디자인적 접근을 시도하고 있었지만 좀처럼 풀리지 않는 나날을 보내고 있었기 때문이다. 나는 그것들을 '쓰려고' 했다는 걸 깨달았다. 그들과의 대화가 나에게 하나의 힌트가 되었던 것이다. 그 이후 한자가 상형문자라면, 즉 원래 그림이라면…… 규칙이나 모양새를 중요시하는 것이 아니라 문자 본래 의미를 찾아내는 소위 문자를 그림으로 되돌리는 작업을 해보면 어떨까 하는 생각을 하게 되었다. 이를테면 빛 자체는 회의문자(會意文字)이지만 그 조성을 분해하면 불(火)과 사람(人)이라는 그림으로 이루어져 있다. 마치 사람 머리 위에 빛나는 것이 있는 것 같은 모양이다. 은(殷)나라 금문에는 사람 부분이 여성을 본뜬 '빛'이 있다는 것도 과거의 모계 사회를 상징하는 것 같아 흥미롭다. 이러한 회화로서의 문자, 문자로서의 회화를 염두에 두면서 작업할 때는 사념(思念)이라는 필터를 빼고 바라보는 시선을 갖게 되었다.

'빛(光)'에는 한여름의 강한 햇볕, 가을에 부드럽게 나뭇잎 사이로 새어드는 햇빛 등 여러 가지가 있다. 나는 여러 빛을 상상하면서 그것들을 상형문자로 표현하는 데 집중했다. 그렇게 하여 만들어진 〈빛〉이라는 작업은 중심으로부터 사방으로 방사되는 듯한 문자가 되었다. 따스하고 온화한 봄빛을 표현한 것으로, 화지(和紙)에 스며드는 먹 번짐도 그 회화성 연출에 일조하게 되었다. '산(山)'이라는 문자의 경우는 '그리는' 작업이 아주 순조롭게 잘되었다. 동심으로 돌아가 온전히 서예만을 마주할 수 있었다. 중심이 높은 3개의 세로선이 각각 정수리를 나타내는 이 골격을 그대로 두고, 드러나는 문자에 살을 붙여 회화적인 표정을 부여하고 산의 춘하추동을 표현해 보았다. 그것들은 '산'으로 읽히지 않을지도 모른다. 봄의 온화한 표정을 닮은 산, 겨울의 극심한 추위 속에서 고결하게 치솟은 산…… 그러한 풍경을 표현하면 작업이 즐겁기만 하다.

문자를 그린다는 행위에서 한 걸음 더 나아가 문자의 풍경화를 모색하고 있다. 문자가 장면(scene)이 된다. 그것은 회화로서의 문자에 담긴 메시지가 인생관이나 자연관과 겹쳐져 문자에 풍경을 부여하는 작업이다. 문자 본래 뜻에 기인하면서도 문자를 회화화한다는 단계에서 더욱 정신성을 가하여 전개해 나가고자 한다. 이 접근 너머에 있는 또 다른 서예 모습을 기대해본다.

모자빈.毛灼然.

mo.javin. ^{china}

1998년 홍콩침회대학교 커뮤니케이션학과를 졸업하고 5년간 그래픽 디자인 작업을 하다가 2004년 파브리카에 초청되어 1년 동안 세계 각국의 젊은 디자이너들과 다양한 시각 커뮤니케이션 프로젝트들을 경험했다. 2006년에 홍콩으로 돌아와 밀크셰이크(Milkxhake)를 시작했다. 밀크셰이크는 젊은 그래픽 디자이너 그룹으로, 상업 및 문화 프로젝트를 다양한 분야와 협업하면서 효과적인 커뮤니케이션을 추구하며 홍콩에서 가장 활기찬 디자인 작업을 선보인다는 평을 받고 있다. 2008년부터 온라인 채널 '라디오다다(Radiodada)'의 프로그램 〈디자인-인-하우스〉 진행에 참여해 홍콩의 젊은 예술가들, 디자이너들과의 대화에 초점을 맞췄다. 2009년에 RTHK와 홍콩 디자인센터가 공동 제작한 TV 다큐멘터리 〈디자인 시티〉의 객원 아트 디렉터로 초청되어 세계 8대 디자인 도시를 소개했으며 〈선전〉 편의 진행을 맡기도 했다. 그는 2008년부터 중국 디자인 현장에 적극적으로 참여하고 있다. 그의 첫 번째 저서 『3030: 중국의 새로운 그래픽 디자인』을 편집했으며, 2009년부터 2011년까지 중국 유일의 영문 병기 디자인 잡지 〈디자인 360°〉의 제작에 참여했다. 2008년에 홍콩침회대학교에서 수여하는 '커뮤니케이션 교육의 개척자'와 '존경받는 커뮤니케이터 졸업자 40인' 상을 받았으며, 2006년에는 뉴욕 ADC 'the Young Guns 5 Honoree'에 선정되기도 했다.

book.　asia art archive ten tears.　70 x 220.　2011.

mo javin

320

Mo Javin is a Hong Kong based graphic designer and founder of Milkxhake, a young graphic design practice focuses on diversified collaborations with commercial and cultural projects through effective visual communications. Graduated from the School of Communication at the Hong Kong Baptist University in 1998, he practiced as a graphic designer for 5 years. In 2004, he was invited to join Fabrica in Italy for 1 year, where he worked on diversified visual communication projects with young designers from different parts of the world. In 2006, he initiated Milkxhake as one of the most energetic design practice in Hong Kong. Since 2008, he has involved in the local creative online channel 'Radiodada' as host for <Design-in-House>, a weekly on-air program. In 2009, he was invited as the guest art director of <Design Cities>, a co-produced TV documentary by RTHK and Hong Kong Design Centre, featured 8 design cities around the world. He was also the host of 'Shenzhen' episode. Mo has been actively involved in the mainland design scenes since 2008, he edited his first title, <3030: New Graphic Design in China>. Since 2009, he has involved in the creative and design direction for <Design 360°>, the only bilingual design magazine published in China. Over the years, his works have been widely published in design magazines and journals internationally. He has also received important achievements such as the honor of the Pioneers in Communication Education and 40 Distinguished Alumni Communicators, presented by Hong Kong Baptist University in 2008 and the Young Guns 5 Honoree presented by the NY ADC in 2006.

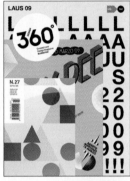
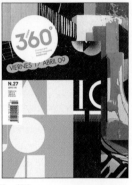

book. design 360°-concept and design magazine. 185 x 250. 2010.

mo javin

My aspiration on design is to simply believe the power of visual communication. I believe all my design works have a common principle, by bring up creative ideas and powerful visual languages, together with typographic treatment on both Chinese and English. My intension is to reinforce the image and identity particularly in Hong Kong's art and cultural activities. Not solely applying graphic design, I focus on the creative process while delivering messages to my collaborators as well as public community.

Since the early formation of my design practice Milkxhake in 2006, I have been actively involved in the visual communication projects for many local art and cultural events and festivals through the collaboration with local artists, new media groups, design organizations, non-profit organizations, education units and NGOs.

In my works, typography has been one of the most important visual elements with the combination of simple abstract graphics, generating a new form of visual languages appeared in local public community. In Hong Kong, Traditional Chinese always accompanied by English nearly in all circumstances, the perfect use of bilingual typography has been a great challenge for many local designers. I enjoy accomplishing this task as a form of design challenge. Sometimes, either English comes first or

lenge. Sometimes, either English comes first or Chinese the second, or even using Simplified or Traditional Chinese in different aspects would affect different outcome.

Typography to me means a linguistic form of visual communication; typography is part of design context; typography is sometimes rational as well as emotional. My works have been regarded as functional, geometric and simple. This may be influenced from our living surroundings. Hong Kong is a very small city full of visual chaos from streets to subway to any public space. Messages could be easily delivered to public audience without clear hierarchy, which easily become visual "noise". When I was asked to design a poster, I always pay much attention to the information hierarchy and details on typography in any language. It is very interesting to see how a graphic designer response his work from his living surroundings.

mo javin

book. 'nature transformer'. 297 x 420. 2009.

book. screenarcadia. 260 x 190. 2010.

324

book. think · carbon free. 127 x 180. 2010.

나의 디자인 열망은 단순히 시각 커뮤니케이션의 힘을 믿는
것이다. 나의 모든 디자인 작업들이 공통된 원칙을 가지고 있
다고 생각하는데, 이는 창의적인 아이디어와 힘 있는 시각적
언어를 사용한다. 주로 중국어와 영어를 같이 사용하여 타이
포그래피 작업을 하고 있다. 나의 의도는 구체적으로 홍콩의
예술과 문화 활동의 이미지와 정체성을 강화하는 것이다. 그
래픽 디자인에만 국한된 것이 아니라, 나의 동료들과 대중 사
회에 어떤 메시지를 전달할 때도 항상 창의적인 과정에 중점
을 둔다.

2006년 Milkxhake의 초기 형성 이후에, 나는 현지 예술가들,
뉴미디어 그룹, 디자인 기관, 비영리 단체, 교육 기관, NGO
등 이들과 함께하여 많은 지역 예술과 문화 행사 및 축제를 위
한 시각 커뮤니케이션 프로젝트들에 적극적으로 참여했다.

나의 작업 안에서 타이포그래피는 단순한 추상적 그래픽들과
조합된 가장 중요한 시각 요소이며, 이는 지역 사회에 나타난
시각 언어들의 새로운 형태를 만들어냈다. 홍콩에서는 전통적
한자가 거의 모든 상황에서 언제나 영어와 함께 동반되기 때
문에 이중 언어를 사용한 타이포그래피 작업은 현지 많은 디
자이너들에게 큰 도전이 되어왔다. 나는 도전의 형태로 이 디
자인 작업을 완수하는 것을 즐긴다. 때로는 영어가 먼저 쓰이
고 한자가 쓰이거나, 간체를 사용하거나 전통 한자를 사용하
는데, 각기 다른 결과로 영향을 미친다.

325

나에게 타이포그래피는 시각 커뮤니케이션의 언어적 형태이
다. 타이포그래피는 디자인 맥락의 일부이다. 타이포그래피
는 때로는 이성적이기도, 감성적이기도 하다. 나의 작업들은
기능적이고, 기하학적이며, 단순하다고 여겨왔다. 이는 나의
생활 환경으로부터 영향일 수 있다. 홍콩은 작지만 거리에서
지하철까지 모든 공공 장소에 시각적 혼란이 가득한 도시이
다. 메시지들은 명백한 위계질서 없이 일반 청중들에게 전달
될 수 있으며, 이는 곧 시각적 소음이 된다. 나는 포스터 디자
인을 의뢰받으면 어떠한 언어이든 먼저 정보의 위계질서와 타
이포그래피의 디테일에 많은 신경을 쓴다. 그래픽 디자이너의
작품이 그의 생활 환경에 의해 어떻게 반응하는지를 보는 것
은 매우 흥미롭다.

Moon Jang-hyun majored in visual design and earned a master's degree with a thesis titled <A Study on Euigwe of Joseon Dynasty from the Perspectives of Information Design>. After graduation, he has worked as a designer in the design laboratory for 2 years. He entered Ahngraphics and worked as a designer for 10 years and assumed the position of art director. He founded Generalgraphics in 2011, and currently he is pursuing the direction of new design. He has participated in numerous exhibitions such as <Personal Relationships> and <Hangul Dada>, etc. He has lectured in Korea National University of Arts and Hongik University. He has performed numerous projects in 'Admission illustration of Crown Prince,' 'Seoul Palace Signage,' and 'Exhibition Design, House of Park Gyeong-ri Literature.'

문장현.文璋炫.

moon.jang-hyun. korea

홍익대학교에서 시각 디자인을 전공하고 논문 〈정보 디자인의 관점에서 본 조선시대 의궤 연구〉로 석사학위를 받았다. 졸업 후 홍익대학교 디자인연구실에서 디자이너로 2년간 일한 뒤 안그라픽스에 입사하여 10년 동안 아트 디렉터로 일했다. 2011년 현재 제너럴그래픽스를 설립해 새로운 디자인 방향을 모색 중이다. 〈인간관계로〉, 〈한글다다〉 등의 전시에 참여했으며 한국예술종합학교와 홍익대학교에서 강의했다. 왕세자입학도, 서울궁궐 사이니지, 박경리 문학의 집 등 다수의 프로젝트에 참여했다.

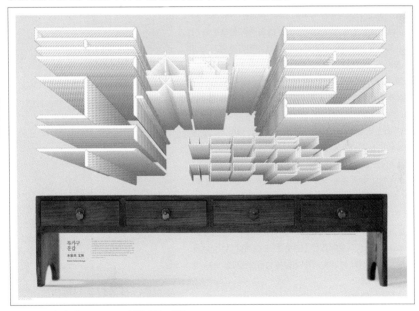

moon jang-hyun

poster. wooden furniture moongap. 1,080 x 766. 2011.

A few years ago, I had a chance to write my own view on design like this essay. I premised that my thinking would be liable to change in the preface of my writing before giving my opinion. It might have been true that I intended to defense myself because I was ashamed of not establishing myself with my own view. Today, I also write this essay under the premise that my way of thinking would be subject to change. While being engaged in the realm of design over the last ten years, I threw questions to myself so many times. Each time, my answers with regard to the repeated same questions have undergone a change little by little.

poster. wooden furniture. 776 x 1,080. 2011.

However, due to my dullness my design has always been preponderated on work in prog-
ress, and I could not reflect the change of my thinking in my work. I do not have any idea or
strength to strive for something else on my own initiative, except for solving tasks given to
me. Since I have dealt with things requested by my clients for a long time, I spent
almost all of time in resolving the matters, commissioned by my clients and I could not afford
to seek for my work. In particular, I was not satisfied with a climate that underestimates and
disregards commercial design. Therefore, my concern turned to upgrade commercial design

to the high level, which gains recognition by people. Most of all, I have paid attention to satisfy the greatest number of requests. My idea remains unchanged, but recently a little bit different idea rose to my mind. It is regarding expertise. The expertise I mean is the expertise of knowledge rather than the expertise of technology and experience. While dealing with contents related design, thirsty for knowledge has always provoked my inferiority complex. Now, I try to find profound knowledge in the field I take an interest in. Based on it, I will embody my design world. My design world will become affluent as far as my knowledge is deepened. Currently, my concern is tradition. Tradition might be a breaking field from new perspectives, although people think that it is outdated. Tradition was the future in the time when it was created. The best values of their own age have been survived and they have been solidified as tradition. On account that it captures the mind of people only with its surface, I'd like to peek into the inside by penetrating outward appearance. I'd like to connect the time of tradition into the present going beyond it. On the basis of it, I am dreaming of making my future. A lot of designs at a certain age are created and perished. Nonetheless, the things that have attracted people's concern are not vanished, maintained and represented. Even, they are expanded and reproduced. What else things are attractive like this? What kind of current design will live and breathe as tradition in future? I will try to make my efforts. Design is not an easy work.

poster. sijo. 500 x 200. 2011.

book. picture book on crown prince entering school. 244 x 372. 2005.

몇 년 전 오늘 쓰는 이 글처럼 자신의 디자인관을 적어 볼 기회가 있었는데, 글머리에 내 생각의 변화를 전제하고 어설프게 의견을 피력했던 기억이 있다. 아마도 디자인에 대한 확고한 '관'이 서지 않았음을 부끄러워하며 스스로 보호막을 친 것이었으리라. 오늘 또다시 내 생각의 변화를 전제로 이 글을 적는다. 나는 지난 10여 년간 디자이너로 일해오면서 디자인은 어떤 것인가 수없이 스스로에게 질문을 던졌다. 반복되는 질문만큼이나 그 답은 언제나 조금씩 변해왔다. 생각이 변해 왔다고는 하나 명석하지 못한 머리 탓인지 내가 생각하는 디자인은 언제나 현재 진행하고 있는 일에 중심을 두고 있었다. 나에게 주어진 일을 해결하는 것 외에 스스로 또 다른 무엇을 찾아 디자인할 생각도 여력도 없었다. 오랫동안 클라이언트가 의뢰한 일을 주로 다루어 왔기에 철저하게 그것을 해결하는 데 골몰

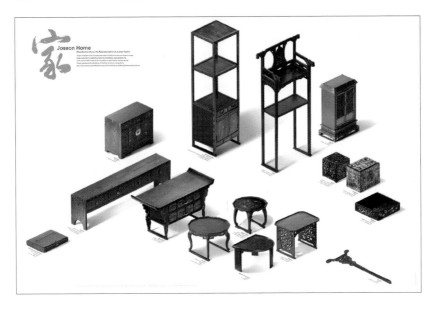

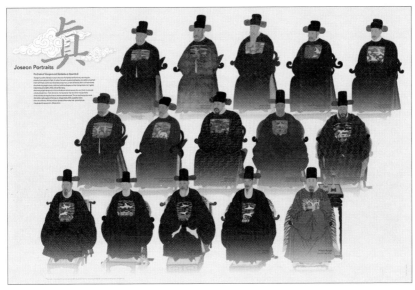

moon jang-hyun

poster. joseon home. 840 x 560. 2010.

poster. joseon portraits. 840 x 560. 2010.

했고 스스로에게 다른 여유를 주지 않았다. 특히 클라이언트가 의뢰한 상업적 디자인을 하는 것을 부끄러워하고 경시하는 듯한 일부의 풍조를 못마땅히 여겼고, 어떻게 하면 그런 일들을 많은 사람들이 인정하는 높은 수준으로 끌어올릴 수 있을까 고민해 왔다. 즉 여태 내가 생각하고 진행한 디자인은 '의뢰받은 일을(가능하면 많은 이가) 만족할 만한 수준으로 해결하는 것'이었다. 여전히 이 생각을 품고 있지만 최근 들어 조금 다른 생각이 싹트기 시 작했다. 그것은 '전문성'이다. 기술과 경험의 전문성이 아니라 '지식의 전문성' 말이다. 콘텐츠 를 다루는 디자인을 진행하면서 항상 느꼈던 지식에 대한 열등감이 나를 자극했다. 이제 내가 관심을 갖고 있는 것에 대해 즐거운 마음으로 지식을 쌓고, 그것을 토대로 디자인을 구현하고자 한다. 관심이 있으므로 즐겁고 알

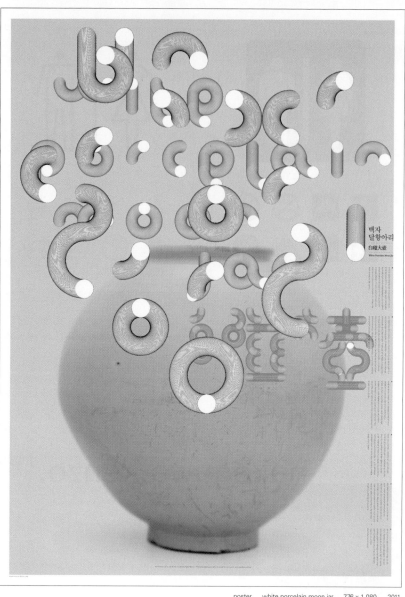

poster. white porcelain moon jar. 776 x 1,080. 2011.

아가는 만큼 풍부해질 것이다. 현재 나의 관심사는 전통이다. 고루하다고 여길 수 있겠지만 관점에 따라서는 아주 새로운 분야일 수 있다. 전통은 항상 그 당시의 '미래'이기도 하다. 당대 최고의 가치를 지닌 것들이 살아남아 '전통'이 되었으나 그 표피만으로도 충분히 마음을 사로잡기에 '현대'에 박제된 것들. 그 겉모습을 파고들어 속살을 들여다보고 싶다. 전통을 재현하는 것을 넘어 현재와 연결하고 싶고, 그것이 토대가 되어 미래를 만들어가는 꿈을 꾼다. 당대의 많은 디자인들이 생성되고 소멸된다. 그러나 사람들로부터 관심을 받은 것들은 결코 사라지지 않고 보관되고 재현되며, 다시 확대 재생산된다. 무엇이 그토록 매력적이었을까. 현재의 어떤 디자인이 미래에 전통이 되어 살아 숨쉴 수 있을까. 애써 보려 한다. 디자인은 결코 쉽지 않다.

pictogram. public information symbols. 594 x 841. 2000.

pictogram. nagoya university noyori memorial hall sign. 594 x 841. 2004.

나카가와.켄조.中川憲造.

nakagawa.kenzo. ^{japan}

nakagawa kenzo

1947년 오사카 출생으로 1966년 오사카시립공예고등학교 도안과를 졸업했다. 다카시마야 광고부를 거쳐 1975년 일본디자인센터에 입
사했다. 1994년 일본디자인센터와 공동으로 NDC그래픽스를 설립해 CI나 정보 디자인, 패키지 디자인, 프로모션, 환경 디자인 등 종합
디자인 회사를 운영하고 있다. 〈브르노 국제 그래픽 비엔날레〉에서 특별상을 받았으며, 도쿄 ADC상, 우정성 DM대상 등을 수상했다. 일
본그래픽디자이너협회(JAGDA), 일본타이포그래피협회 회원이다._____Head
of NDC Graphics Inc. Born in Osaka in 1947. Graduated from the design
course of the Osaka City Polytechnic High School in 1966. After working for
the advertisement division at Takashimaya Department Store, Nakagawa
joined Nippon Design Center in 1975. In 1994 he co-founded with Nippon
Design Center, NDC Graphics to handle total design including corporate
identity, information design, package, promotion, and environmental design.
His awards include the Tokyo ADC award, Special Mention at the Biennial of
Graphic Design in Brno, Ministry of Postal Services' DM Grand Prix, and so
on. He is a member of JAGDA and the Japan Typography Society.

333

pictogram. import furniture company work place sign. 594 x 841. 2005.

pictogram. public information symbols. 2000.

pictogram. nagoya university noyori memorial hall sign. 2004.

pictogram. import furniture company work place sign. 2005.

okuzawakenzo

Design which navigates unknown world

Pictures depicted in caves of Altamira or Lascaux are the primary graphic information. Cows or goats observed in the wilderness and drawn on walls of the caves as "community's memory" acted as the community members' own common records across time and space, and also act as communication tools which send specific visual messages for instructing others. In today's human society where different languages crisscross, pictogram (picture language) plays the same role as this "community's memory".

•

In urban spaces, a variety of signals or marks are used as visualized messages. Maps or traffic signs of towns are designed as visualized "language system" with ingenious attempt in colors and shapes to offer quick reading out while moving. Newly obtained useful tool is useless if you do not know how to use it. So, it is desired that anyone can use the tool easily directed by the pictogram illustrated in the guidebook.

•

The modern computerized "information sharing society" is far too vast. Hence, pictogram with comprehensible illustrated information is expected to narrow the range and navigate unknown world as the new world language which transcends existing languages.

미지의 세계로 인도하는 디자인

알타미라나 라스코 동굴에 그려진 동물 그림은 가장 원초적인 정보도(情報図)이다. 들판에서 목격한 소나 산양의 실제 모습을 벽에 옮겨 그린 '공동체의 기억'은 시공을 초월한 자신들을 위한 공통의 기록으로서 혹은 타자로의 교시(教示)로서 고유의 시각 메시지를 발신하는 커뮤니케이션 도구로 기능한다. 다른 언어세계를 왕래하는 오늘날의 인간 사회에서 픽토그램이 하는 역할은 이 '공동체의 기억'과도 같다.

•

도시 공간은 다양한 메시지가 신호나 표시로 시각화되어 있다. 낯선 도시의 거리를 가이드하는 지도나 교통표지판은 이동 도중에라도 재빨리 그 의미를 읽어낼 수 있도록 배색이나 모양이 고안되었고 '보는 언어체계'로 디자인되었다. 또 다른 예로는 도구 매뉴얼을 들 수 있다. 아무리 편리해도 그 사용법을 모르면 소용이 없다. 설명서나 전기기구 매뉴얼에 표시된 픽토그램에 인도되어 누구나 쉽게 사용할 수 있는 것이 바람직하다.

•

컴퓨터화된 현대 '정보 공동체 사회'는 너무나 방대하다. 서로 간의 거리를 단축하고 정보를 우리 체형에 맞도록 친절하게 또는 다른 언어를 초월하는 새로운 세계언어로서 미지의 세계로 인도하는 것이 픽토그램의 역할이다.

nakajima.hideki. ^{japan}



나카지마.히데키.中島英樹.

1995년 나카지마디자인을 설립했다. 현재 국제그래픽디자이너연맹(AGI), 뉴욕 아트디렉터스클럽(ADC), 도쿄 ADC, 도쿄 타이프디렉터스클럽(TDC) 회원이다. 뉴욕 ADC 금상, 은상, 도쿄 ADC상 및 하라히로무상, 시카고 애서니엄 굿디자인상, 고단샤출판문화상 북디자인상, 뉴욕 TDC상, 도쿄 TDC상, 〈닝보 국제 포스터 비엔날레〉에서 심사위원상을 받는 등 다수의 국제 디자인상을 받았다. 〈나카지마 디자인전〉(2004, 광저우), 〈Clear in the Fog〉(2006, GGG갤러리), 〈Infinite Libraries & Re-CitF〉(2008, G/P Gallry 에비스), 〈나카지마 히데키 컬렉션 전〉(2009, The OCT Art & Design Gallery), 〈re-street view/line〉(2010, G/P Gallry 에비스) 등의 개인전을 열었으며 그의 작업은 현대 그래픽아트센터(CCGA), 광둥미술관, Musee de l'Ilmprimerie, 프랑스 국립도서관, 보스턴대학교, 오슬로대학교, 취리히미술관에 소장되어 있다. 저서로 작품집 『REVIVAL』, 『나카지마 히데키의 일과 주변』, 사카모토 류이치와 협업한 『S/N』, 『CLEAR in the FOG』, 『ggg 북스 78: 히데키 나카지마』, 『나카지마 히데키 디자인』, 『문자와 디자인』 등이 있다.

book. clear in the fog. 232 x 316. 2006.

book. ryuichi sakamoto tour 2005. 210 x 297. 2005.

336

Art Director and Graphic Designer. Nakajima established his own studio Nakajima Design in 1995. He is member of AGI (Alliance Graphique Internationale), ADC New York, Tokyo ADC, Tokyo TDC. Nakajima received many international design awards including ADC Awards (5 Golds, 7 Silvers), Tokyo ADC Award, The Chicago Athenaeum's Good Design Award, Kodansha Prize for Book Design, International Jury Prize at The 3rd International Poster biennial, Ningbo, The Tokyo TDC Awards (Grand Prix), Tokyo ADC Award (Memorial Prize of Hiromu Hara), Tokyo TDC Awards, and so on. He held solo exhibitions such as <NAKAJIMA DESIGN Exhibition> (Guangdong Museum of Art, China), <CLEAR in the FOG: Hideki Nakajima Exhibition> (GGG), <Infinite Libraries & Re-CitF> (G/P Gallary, Tokyo), <Collection: Hideki Nakajima Exhibition> (The OCT Art & Design Gallery, China), <re-street view/line Hideki Nakajima Exhibition> (G/P Gallary, Tokyo). His works are collected at Center for Contemporary Graphic Art; Guangdong Museum of Art China; MUSEE DE L'ILMPRIMERIE France; the Bibliotheque nationale de France; Boston University; The Oslo Academy of the Arts, Museum fuer Gestaltung Zurich. He published many books including <Revival>, <Artist, Designer and Director SCAN #13>, <S/N> (collaboration work with Ryuichi Sakamoto), <CLEAR in the FOG>, <ggg Books 78: HIDEKI NAKAJIMA>, <HIDEKI NAKAJIMA DESIGN> and <TYPO-GRAPHICS>.

book. revival. 215 x 303. 1999.

poster. the library of sacred texts & library of fragrances. 728 x 1,030. 2008.

I wish to create a new design on my own, a design which has never been seen before. I have always been facing design with such attitude. And I repeatedly told myself, "It is finally done." But how ever confident I may be, the thoughts do not last for more than ten days. Soon I conclude that it has not reached my ideal point. I probably will be repeating same thoughts and attempts ten years later.

nakajima hideki

poster.　instrumental music library.　728 x 1,030.　2008.

아직 본 적이 없는 새로운 디자인을 스스로의 힘으로 만들고 싶다. 늘 그러한 자세로 디자인과 마주하고 있다. 그리고 '드디어 됐다'고 생각하는 일을 몇 차례 반복해왔다. 그러나 확실하게 그런 생각이 들어도 늘 열흘 정도밖에 못 간다. 이윽고 전혀 내 이상에 도달하지 않았다고 느끼게 된다. 아마 십 년 후에도 같은 것을 거듭 생각하며 시도하고 있을 것이다.

Art Director, Graphic Designer, Planner. Born in Kawasaki City, 1967. Nakamura graduated from Nihon University College of Art and Joined Sony Music Entertainment Inc. He established his own office in 1997. Now Nakamura lives in Tokyo. His representative works include: Play Station Video Game <I.Q(KURUSHI)> and Graphic Design of Maywa Denki and others._____

1967년 가와사키시에서 출생했다.

일본대학교 예술학부 졸업 후 소니뮤직엔터테인먼트를 거쳐 1997년에 독립했다. 플레이스테이션용 게임 'I.Q'의 기획 및 아트 디렉션을 맡았으며 '메이와덴키' 그래픽 디자인 등을 작업했다.

나카무라.노리오.中村至男.

nakamura.norio. japan

nakamura norio

poster. tdc bccks / twin universe. 1,030 x 728. 2007.

In year 2011, where anything can be searched due to the internet development, both good and bad designs, treated as information with same value, are flooding like trash. If designers copy or recompose with such existing images, the profession 'designer' will gradually become extinct. As long as I call myself a designer, I aim for the unseen and new image, white space, or communication.

book. tdc bccks. 182 x 257. 2007.

book. tdc bccks / twin universe. 182 x 257. 2007.

2011년, 인터넷이 발달해 뭐든지 찾아볼 수 있는 지금, 좋은 디자인도 그렇지 않은 디자인도 같은 가치로서 정보로 다뤄지며 쓰레기처럼 범람하고 있다고 생각한다. 만일 디자이너들이 그러한 기존 이미지의 복사나 조합으로 디자인한다면 디자이너라는 직업은 곧 없어질 것이다. 스스로를 디자이너라고 부르는 한, 아직 본 적이 없는 새로운 그림이나 여백, 커뮤니케이션을 지향하고 싶다.

nakamura norio

7:14 norio nakamura

342

poster. 7:14. 728 x 1,030. 2011.

book.　7:14.　182 x 257.　2011.

poster. art artist audition. 728 x 1,030. 2011.

nakamura norio

344

book. frogs. 148 x 210. 2007.

card. house-moving. 105 x 148. 1992.

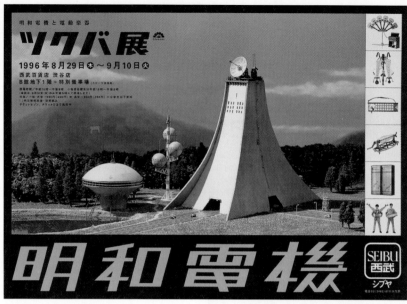

poster. maywa denki. 364 x 515. 1996.

poster. close-up of japan são paulo. 1,456 x 1,030. 1995.

나카노.타케오.中野豪雄.

nakano.takeo. ^{japan}

Born in 1977. Nakano studied book theories and techniques, such as bookbinding, printing, and typography, in Visual Communication Design, Musashino Art University. He joined Katsui Design Studio after graduating, then established Nakano Design Studio in 2007. He won Grand Prize in Japan Typography Annual, Print Industry Association President Award in Japan Catalog/Poster Fair, and was selected in Toyama International Poster Triennale, Lahti International Poster Biennale, China International Poster Biennale, JAGDA Annual, Japan Typography Annual, TDC Annual and more.

poster.　hiroaki umeda "holistic strata".　728 x 1,030.　2010.

poster.　prototype 04 "new action".　728 x 1,030.　2010.

1977년에 태어났다. 무사시노미술대학 시각전달디자인학과에서 제본, 인쇄, 타이포그래피에 관한 이론과 테크닉을 배웠다. 졸업 후 가쓰이디자인사무소를 거쳐 2007년 나카노디자인사무소를 설립했다. 일본 타이포그래피연감 최우수상, 〈일본 카탈로그&포스터 페어〉 인쇄산업연합회 회장상 등을 수상했으며, 〈도야마 국제 포스터 트리엔날레〉, 〈라티 국제 포스터 비엔날레〉, 〈중국 국제 포스터 비엔날레〉, 일본그래픽디자이너협회(JAGDA), 일본타이포그래피연감, 타이프디렉터스클럽(TDC)연감 등에서 입선한 바 있다.

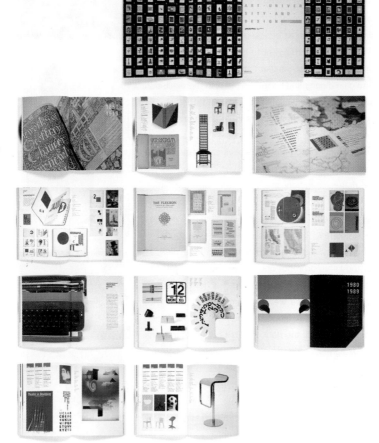

In 2010, an exhibition, "Design to Change the World", was held at the Tokyo Midtown DESIGN HUB and AXIS GALLERY. The exhibition was a response to the current social situation in which 90% of the world's population is living in developing countries; the exhibition fundamentally asked how Design can play a role in providing solutions to social problems faced by the poor. Various products and design projects from all over the world were displayed in this exhibition. They were specifically designed to tackle issues,

to propose solutions, and eventually to "Change the World".
Being in charge of all the graphical works, including posters and
information panels, at the beginning I faced great difficulty in
visualizing the message of the exhibition. I thought it would be
hard for ordinary Japanese to instantly imagine life on an aver-
age income of less than 2 dollars per day. Besides, in Japan it
is often thought that the major role of Design is "to add value".
This is not quite compatible with the basic principle of these
products: locally adaptable (low cost, appropriate technology, lo-
cally produced), creating jobs for locals, and appropriate for local
culture. Therefore, accepting these principles could question the
meaning and value of Design itself. As a result of active
discussion among staff, the poster became very simple. It
showed just one product–a low cost and low technology artificial
foot, which had been used by nearly 1 million people in 22 coun-
tries. The poster also showed 8 icons classifying typical social
issues causing poverty, such as education, housing, and energy.
The artificial foot in the poster was to inspire imagination and
call for action. The visual also implies "the first step" for those
without legs to gain dignity and hope. In the exhibition,
various graphical methods were used, including posters, dia-
grams, and pictograms,. All these items were designed to stim-
ulate the interest and imagination of audiences. With a piece of
information or a simple pictogram, audiences can begin to face,
in their own way, a wide range of social issues in the world. At
the entrance of the exhibition, the 12 meter-long information
boar was displayed. It showed various comparative data related
to the above-mentioned 8 social issues, as well as the average
income of each country. This data directly shows the degree of
seriousness of poverty and social problems. For the audiences,
by viewing at the same time not only the products designed to
provide solutions, but also this comparative overview of poverty,
they can acquire an objective viewpoint and understanding of
those issues. Ultimately, the theme of this exhibition
was to "imagine" the life of the poor. When it comes to imagina-
tion, I believe Design has a role to play. Historically, Design has
been developed in relation to economic activities, but its essen-
tial function has been to propose a way to make people imagine.
Meantime, the conflicts and economic gaps observed in the
current world are partly caused by a lack of imagination toward
others. Since the catastrophic earthquake on
11 March in Japan, many graphic designers have sought ways to
contribute to improving this disastrous situation. Some of them
feel very helpless, saying there is nothing they can do. I believe,
however, if the essence of Design is to "imagine others" and
to "make the audience imagine others", there are many things
graphic designers can do in this society.

nakano takeo

book. view of an Indigo house. 168 x 257. 2011.

348

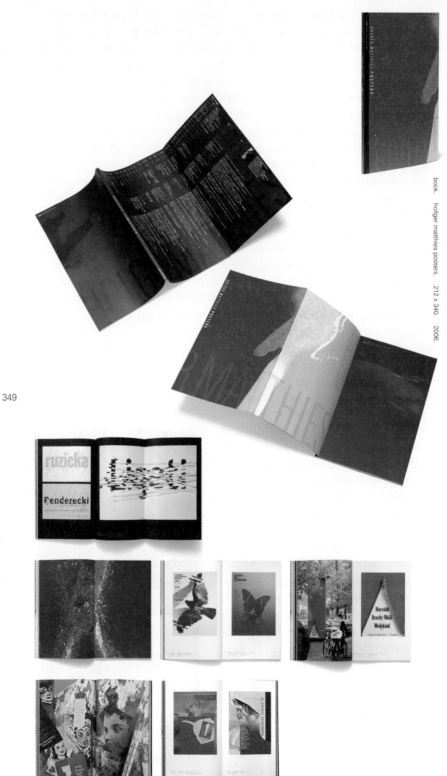

349

book. hollger matthies posters. 212 x 340. 2006.

nakano takeo

2010년 5월 15일부터 6월 13일까지 도쿄 미드타운 디자인허브와 엑시스갤러리 두 곳에서 〈세계를 바꾸는 디자인 전〉이 개최되었다. 세계 인구의 90%를 발전도상국 사람들이 차지하는 현재, 빈곤층에 사는 사람들이 직면하는 사회 과제에 대해 디자인이 어떻게 기능해야 할지를 묻는 전시회였다. 세계를 바꾸는 과제를 해결하기 위한 제품 디자인이나 각종 디자인 프로젝트가 모아져 전시되었다. 나는 이 전시회 포스터를 비롯한 그래픽 전반을 담당하게 되었지만 이들을 어떻게 정착시킬지 상당히 고민했다. 왜냐하면 일본은 선진국이자 풍요로운 나라 중 하나로 하루 평균 수입이 2달러밖에 안 되는 사람들의 생활을 상상하는 것 자체가 일본인들에게 어렵기 때문이었다. 또 '디자인은 부가가치'라는 인식이 많이 자리 잡은 일본에서 '비용을 최소화하여 생산할 수 있는, 현지에서 생산할 수 있는, 현지 사람들이 생산할 수 있는, 직업 창출의 기회가 주어지는, 현지 문화에 뿌리를 둔 것'이라는 개발도상국을 위한 디자인 기본 원칙은 기존 일본인들의 가치관을 크게 뒤엎을 가능성이 있었다. 팀 내에서 다양한 논의가 이루어졌고 결과적으로 포스터는 지극히 심플한 것이 되었다.

22개국 96만 명이 사용하고 있고 그들에게 살아갈 희망을 줬던 의족(義足)을 심플하게 보여주며 사회 과제를 여덟 가지로 분류한 아이콘을 나열했다. 의족은 사람을 연상시키고 개발도상국에 사는 사람들이 자존심을 획득하는 것을 의미하며 일본인의 행동을 일으키는 첫걸음을 의미한다.

도쿄 미드타운 디자인허브 입구에는 세계 수백 개국의 데이터를 분석하여 8개의 사회 문제마다 그 심각도와 평균 연봉을 열람할 수 있는 인포메이션 그래픽을 제시했다. 사회 문제를 직접적으로 보여주는 전시 작품과 전 세계 사회 문제를 부감(俯瞰)할 수 있는 인포메이션 그래픽 모두를 마련하여 관람자가 객관적인 시선으로 테마와 마주할 수 있다. 더 나아가 사회 과제란 한 테마로 완결되는 것이 아니라 타 사회 과제와도 밀접한 관계성을 가진다는 것도 알 수 있으며 전시작품에 대한 고찰이 한층 깊어진다. 또 개개의 전시작품에는 〈Cause〉, 〈Design〉, 〈Solution〉을 간결하게 표현한 픽토그램을 마련했다. 이 픽토그램은 모두 100개가 넘는다.

이 전시회 테마는 '제품을 통해 사회 문제에 직면한 사람들의 생활을 상상할 것'이다. 디자인이란 경제활동과 더불어 발전해온 경위가 있으나 상대방에 대해 상상하고 문제를 가지고 있다면 해결책을 제시한다는 본질적인 기능은 변함이 없다. 전 세계에서 일어나는 분쟁이나 경제격차 등의 문제는 상대방의 상황이나 심리를 상상하는 일을 게을리했던 결과이다. 디자인이 사회에 기여할 수 있는 것은 바로 이런 상상력이 아닐까 생각한다.

그래픽 디자이너로서 자립하기 위해서는 다양한 능력을 습득할 필요가 있다. 색이나 모양의 컨트롤, 타이포그래피 식견도 물론 요구된다. 그것들을 모두 집결하여 난립하는 정보를 하나의 문맥으로 묶어나가는 편집 능력도 필요하다. 이러한 능력들이 상호관계에 있어야만 그래픽 디자이너의 표현으로서 결실을 맺을 수 있다. 〈세계를 바꾸는 디자인 전〉에서는 포스터나 다이어그램, 픽토그램 등 그래픽 디자인의 기초라고도 할 수 있는 다양한 방법을 사용했지만 이 모든 것들은 관람자가 한 정보에 흥미를 갖는다면, 그것을 계기로 광대하게 펼쳐지는 사회 문제와 진지하게 마주하길 바라는 시도였다. 일본에서는 3.11대지진을 계기로 디자이너가 스스로 할 수 있는 것이 무엇인지 생각하게 되거나 혹은 아무것도 할 수 있는 것이 없다고 절망하기도 했다. 그러나 디자인의 본질이 자신 외의 누군가를 상상하는 일 혹은 누군가를 상상케 하는 일이 출발점인 이상, 디자인에는 아직까지 많은 역할이 있다고 생각한다.

book.
danese
237 x 200
2007

350

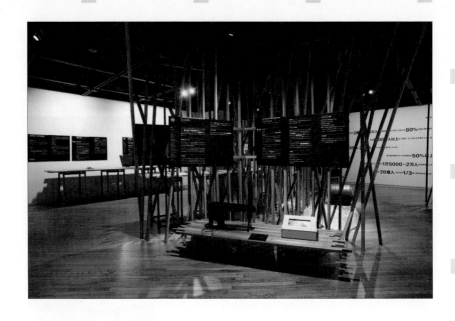

exhibition design. design to change the world. 2010.

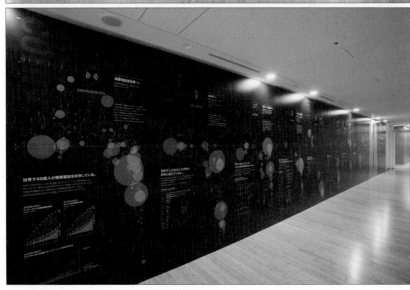

Born in Iwate, 1976. After graduating from Musashino Art University in 1997, Nakui joined an advertising agency. She stood on her own feet as a freelancer in 2005 and since then she has been actively participating in print media focusing on book design._____1976년 이와테현에서 출생했다. 1997년 무사시노미술대학을 졸업한 뒤 광고대행사에 입사했다. 2005년 프리랜서로 독립했으며 북 디자인을 중심으로 인쇄 매체와 관련된 작업을 하고 있다.

나쿠이.나오코.名久井直子.

I do not work with a grand philosophy, but I make my books with love,

so that more people would hold them in hands. Doing so could be called my philosophy.

평소에 거창한 철학을 가지고 작업하지는 않지만,

내가 만든 책이 많은 사람들의 손에 닿도록 애정을 가지고 만든다는 것이 철학이라면 철학이다.

nakui naoko

book. nyokki. 131 x 194. 2006.

nakui.naoko. japan

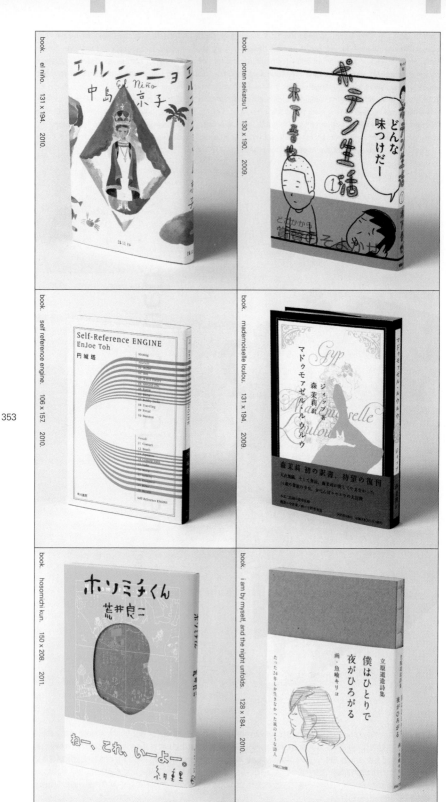

book. el niño. 131 x 194. 2010.

book. poten seikatsu1. 130 x 190. 2009.

book. self reference engine. 106 x 157. 2010.

book. mademoiselle loulou. 131 x 194. 2009.

353

nakui naoko

book. hosomichi kun. 150 x 208. 2011.

book. i am by myself, and the night unfolds. 128 x 184. 2010.

Born in Osaka in 1951. Nanbu learned Bauhaus design philosophy and the craft at the Osaka Municipal High School. After graduation he worked in graphic design firm for several years, and established a design firm in 1988. He has worked as an art director for branding and lots of projects with companies based on graphic design. Nanbu held seminars around the world such as China, Hong Kong, Japan and etc. He also involved in educational activities at the Colleges of Art in Asia. He participated in design lecture of Design Symposium for 2010 Shanghai World Expo. Individual features are web design and typography in the international design magazine. Nanbu has received many awards including gold award of 7th Tokyo TDC, gold award of Hong Kong Design Awards, distinctive merit awards of New York ADC annual Awards, best work awards of Japan Typography Association, judge's prize of International Typeface Design Competition/Morisawa Awards, gold award of Conqueror Design Contest, Achievement award of ADI Design Award.

난부.토시야스.南部俊安.

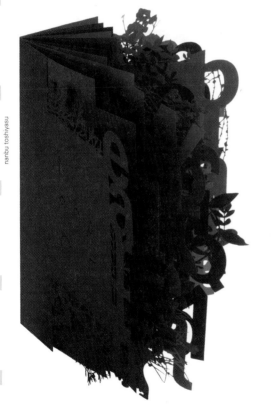

nanbu toshiyasu

nanbu.toshiyasu.
japan

book. paper sample of eco rasha. 257 x 364. 2010.

1951년 오사카에서 태어났다. 오사카시립공예고등학교에서 바우하우스 이념과 디자인을 배웠다. 졸업 후 AIDMA 그래픽 디자인 회사에서 근무했고 1988년에 디자인 사무실 Taste를 설립했다. 그래픽 디자인을 중심으로 기업 디자인 프로젝트나 브랜딩 디자인의 아트 디렉터로 일했다. 중국, 홍콩, 일본 등 세계 각지에서 디자인 세미나를 가졌으며 미술대학을 중심으로 교육 활동을 하고 있다. 2010년에 중국 상하이 엑스포 디자인 심포지엄에서 강연한 바 있다. 도쿄 TDC 금상, 홍콩디자인 어워드 금상, 뉴욕 ADC 특별우수상, 일본 타이포그래피연감 최우수상, 모리사와 국제 타입페이스 공모전 심사위원상, CONQUEROR DESIGN CONTEST 금상, ADI디자인 어워드 최고상을 수상했다.

355

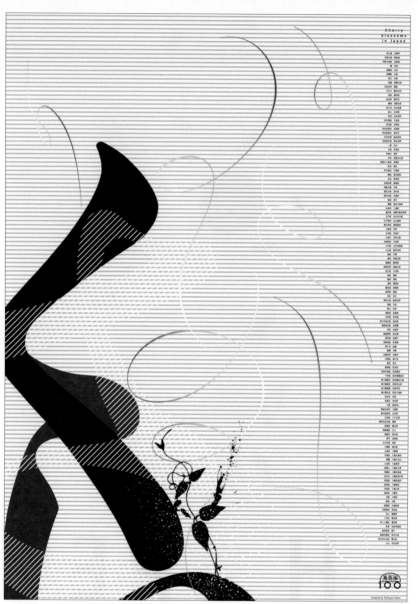

nanbu toshiyasu

poster. shueitai 100. 728 x 1,030. 2011.

nanbu toshiyasu

356

poster. 11·3·11 hope. 728 x 1,030. 2011.

1. Design perspective

The human eye seems to look into a material yet does not. It is a vague perspective of an eye indeed. The material exists only after it has been perceived, and others do not exist. The material itself changes over time while the eye perceives only the current state. The eye is capable of verifying many things when perceived properly. Likewise, a fresh impression can be inspired from a changed or replaced perspective in typography and graphic design. A new design perspective must continue to doubt the natural perception, penetrate through the essence, and establish the concepts. In order to prevent design from turning into a mindless task, the perception must be expanded, and the essence must be rediscovered and established. Without such attempt, we will all be blinds in future design.

2. Character communication

I often visit China and Hong Kong for design review or seminar. Here I came to a new understanding of Kanji as a great communication tool. Communication between China and Japan is possible through the common use of Kanji. I had experiences of solving several miscommunication situations using hand written Kanji. Simplified Chinese characters are a good sample for Japanese designers' ellipsis. The most amusing aspect of Kanji is that it is capable of instantly conveying several meanings in a single letter. Graphic design cannot be established without typography. Thus, Asian typography, such as Chinese character, Japanese Kanji, by extension Korean Hangeul, is likely to fuse through design.

3. Beauty of moderation

Graphic design and typography today seem to be aiming for the beauty of decoration rather than moderation. It reminds us of the early Art Nouveau by William Morris. Young designers of Japan often practice detailed and intricate designs, constraining themselves with decorations. This era will verify if these decorations are capable of fulfilling their initial function, the resistance against the Modernism. Unlike the West, moderation-oriented ink painting traditions exists in Japan and Asia. Within the continuation of this tradition in Japanese graphic design, the trend is changing from decoration to moderation, and moderation to decoration again. I believe the beauty of moderation such as simple design or white space has the timeless universality.

book. message from the earth. 257 x 364. 2007.

nanbu toshiyasu

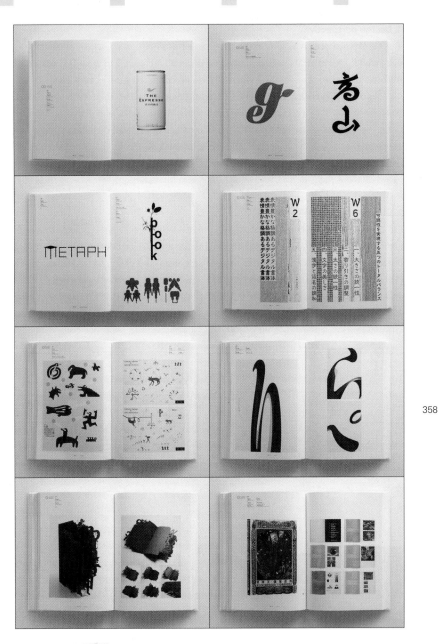

nanbu toshiyasu

book. applied typography 19. 210 x 297. 2009.

1. 디자인의 시점

사람의 눈은 물질을 보는 듯하면서도 보지 않는, 실로 애매한 인식의 눈이다. 물건은 인식되고 나서야 비로소 거기에 존재하며 그 외 물질은 아예 존재하지 않는 듯하다. 물질 자체도 시간에 따라 변화하기 때문에 눈은 현재 상태밖에는 보지 못한다. 그러나 의식만 한다면 눈으로 많은 것을 확인할 수 있다. 타이포그래피나 그래픽 디자인도 보는 각도를 바꾸거나 시점을 옮겨봄으로써 전에 보지 못했던 감동을 불러일으키는 행위일 것이다. 새로운 디자인 시점은 당연시되는 인식에 의문을 던지며 각도를 바꾸어 본질을 꿰뚫어보고 개념을 확립하는 것이 중요하다. 디자인이 단순작업으로 전락하지 않으려면 디자인 인식을 확대하고 본질을 재발견하여 구축하여야 한다. 이러한 행위야말로 미래의 디자인을 향한 맹아일 것이다.

2. 문자 커뮤니케이션

나는 디자인 심사나 세미나를 위해 중국이나 홍콩을 자주 방문한다. 의사소통 도구로서 한자의 훌륭함을 재인식하게 되었다. 중국과 일본에서 공통으로 쓰는 한자를 씀으로써 의사소통할 수 있다. 손글씨로 의사소통이 해결된 일이 여러 번 있었다. 디자인에 있어 중국 한자인 간체문자(簡体文字)는 일본 디자이너에게 생략법 추가의 견본이다. 무엇보다 한자는 한 글자로 여러 의미를 순식간에 이해시킨다는 점이 훌륭하다. 그래픽 디자인에 있어서 타이포그래피 없이는 디자인이 성립되지 않는다는 점을 감안한다면 앞으로는 중국 한자나 일본 한자, 더 나아가 한글 등 아시아 타이포그래피가 디자인에 의해 융합되는 것이 아닐까.

3. 절제의 미

현재 그래픽 디자인이나 타이포그래피는 절제된 미가 아닌 장식적인 미를 지향하는 듯하다. 마치 일찍이 윌리엄 모리스 등이 제창한 아르누보가 부활한 것만 같다. 요즘 일본의 젊은 디자이너들도 디테일이나 복잡한 디자인을 스스로 실천하여 장식에 구애받고 있는 사람이 많다. 그것들이 본래 역할 즉 모던 디자인에 대한 대항마로서 기능할지는 시대가 증명할 것이다. 일본이나 아시아에는 서양에 없는 절제미를 추구한 수묵화 전통이 있다. 이는 일본 그래픽 디자인에서도 맥맥히 계승되고 있으나, 장식에서 심플한 모던 디자인으로 그리고 다시 모던 디자인에서 장식으로 변천해가고 있다. 그러나 나는 절제된 아름다움인 심플한 디자인이나 여백미에는 시대를 초월한 보편성이 있다고 확신한다.

book. forest of typographic. 257 x 364. 2008.

nanbu toshiyasu

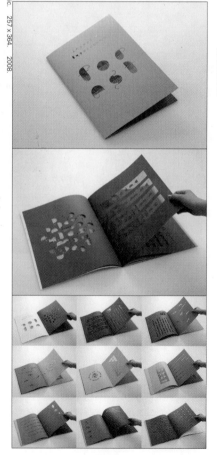

nanum.font. ^{korea}

NHN은 네이버를 통해서 '정보의 평등화'라는 취지를 가지고 사용자들이 양질의 한글 기반 정보를 쉽게 접하고 생활에 도움이 될 수 있도록 했다. 네이버는 한글 콘텐츠를 바탕으로 성장하고 있으며 그 연장선에서 한글이라는 소중한 문화를 많은 국민들이 다양하게 접할 수 있도록 나눔글꼴 프로젝트를 시작하게 되었다. 한글은 다른 나라 문자에 비해 짧은 역사를 갖고 있지만, 과학적이고 아름답다고 한다. 하지만 영문 폰트에 비해 질적·양적으로 부족한 것이 사실이다. 대부분의 컴퓨터 사용자들이 한글로 문서작업을 하는 데 실질적으로 사용할 수 있는 한글서체는 몇 종 되지 않는다. 컴퓨터 OS에 기본적으로 설치되어 있는 서체들이 거의 다라고 할 수 있다. 대부분 만들어진 지 오래되어 미감이 떨어지기 때문에 조형적으로 아름답고 읽기에도 쉬운 서체를 만들어 배포하고자 노력하고 있다. 네이버는 한 글자 한 글자에 정성을 들여 2008년 〈나눔고딕〉, 〈나눔명조〉를 배포했다. 지속적으로 한글의 특성과 아름다움을 살린 '나눔글꼴'을 꾸준하게 만들고 나누어 더 나은 한글 문서 사용 환경과 한글 디지털 자산화가 그 목표이다.

<div style="text-align: right">nanum font</div>

poster. root of information & knowledge through letters. 700 x 1,000. 2011.

360

NHN has aimed at providing equal information to all and has enriched the users' daily lives through Naver (www.naver.com) by providing them with easy access to *Hangeul* (Korean alphabet) based quality information. Naver's *Hangeul* contents has acted as the driving force behind Naver's continuous growth, and we at NHN initiated the *Nanum* Font Project so that more people can experience *Hangeul*, which is a precious part of the Korean culture. *Hangeul* does not date as far back as the alphabets of other countries, but it is said to be extremely scientific and beautiful. However, there is a lack of *Hangeul* fonts compared to English fonts, both in quality and quantity. Most Korean users use *Hangeul* when creating documents on the computer, but there are not many *Hangeul* fonts available. The only choices they have are the basic fonts installed in the computer's OS. These fonts were created a long time ago, and lack aesthetic appeal. Therefore we plan to create and distribute fonts that are not only beautiful, but also are easily readable. In 2008, Naver devoted our efforts into each character to create the *Nanum Gothic* and *Nanum Myeongjo* fonts, which was distributed to the public. Naver will contribute to creating an environment that makes it possible to make better Korean documents, and also contribute to turning *Hangeul* into digital assets by continuously developing Nanum fonts, which embodies Hangeul's characteristics and beauty.

nanum font

multimedia. realtimekeyword-typeplay. 1,366 x 768 (px). 2011.

한국적이고
부드러운

한글을 나누다,
나눔고딕

친근한
글꼴

한국적 유려함을 현대적으로
적용한 새로운 고딕체입니다.
부드러운 고딕을 기본으로,
한국적 조형미와 현대적 굴림의
느낌을 살렸습니다. 따뜻하고
친근한 획의 형태는 실용성을
추구하고, 감성적이며 모던함을
컨셉으로 하는 글꼴입니다

나눔고딕 Regular

한국적 유려함을 현대적으로
적용한 새로운 고딕체입니다.
부드러운 고딕을 기본으로,
한국적 조형미와 현대적 굴림의
느낌을 살렸습니다. 따뜻하고
친근한 획의 형태는 실용성을
추구하고, 감성적이며 모던함을
컨셉으로 하는 글꼴입니다

나눔고딕 Bold

한국적 유려함을 현대적으로
적용한 새로운 고딕체입니다.
부드러운 고딕을 기본으로,
한국적 조형미와 현대적 굴림의
느낌을 살렸습니다. 따뜻하고
친근한 획의 형태는 실용성을
추구하고, 감성적이며 모던함을
컨셉으로 하는 글꼴입니다

나눔고딕 ExtraBold

네이버
한글한글아름답게

nanum font

typeface. nanumgothic. 2008.

Nanum Gothic

Korea's traditional elegance and a modern artistic touch were applied to the existing *Gulrim* font to create *Nanum Gothic*, a new version of Gothic typeface.(Which is a term normally represents 'san serif' in Korea) Korea's traditional shape is combined with modern curves to create *Nanum Gothic*. *Nanum Gothic* is an emotional and modern typeface and has warm and friendly lines can be used for all occasions.

나눔고딕

나눔고딕은 기존 〈굴림체〉를 계승 발전하여 한국적인 유려함과 현대적 미감을 적용한 새로운 고딕체이다. 부드러운 고딕을 기본으로 하며, 한국적인 조형미와 현대적 굴림의 느낌을 살렸으며 따뜻하면서도 친근한 획의 형태는 다양한 곳에 활용할 수 있는 실용성을 추구한다. 또한 감성적이며 모던함을 콘셉트로 하고 있다.

현대적이고
직선적인

한글을 나누다,
나눔명조

명쾌한
글꼴

현대적이고 직선적인 느낌을
바탕으로 명쾌함과 남성적인
느낌을 살렸습니다.
단순하면서도 차별화되는
획의 형태로 본문과 제목에
모두 사용할 수 있는
기능성을 갖추었습니다

나눔명조 Regular

현대적이고 직선적인 느낌을
바탕으로 명쾌함과 남성적인
느낌을 살렸습니다.
단순하면서도 차별화되는
획의 형태로 본문과 제목에
모두 사용할 수 있는
기능성을 갖추었습니다

나눔명조 Bold

현대적이고 직선적인 느낌을
바탕으로 명쾌함과 남성적인
느낌을 살렸습니다.
단순하면서도 차별화되는
획의 형태로 본문과 제목에
모두 사용할 수 있는
기능성을 갖추었습니다

나눔명조 ExtraBold

네이버
한글한글아름답게

typeface. nanummyeongjo. 2008.

Nanum Myeongjo

The lines of the existing Myeongjo have been simplified and a modern appeal was adopted to create *Nanum Myeongjo*, a new *Myeongjo* typeface. The lines are more modern and straight, thus giving the font a more clear and masculine feel. *Nanum Myeongjo's* simple but unique strokes can be used throughout the documents, in titles and the body of the text.

나눔명조

나눔명조는 기존 〈명조체〉를 계승 발전시키며 획의 단순화 과정을 거치고 현대적 미감에 맞게 제작한 새로운 명조체이다. 현대적이고 직선적인 느낌을 바탕으로 명쾌함과 남성적인 느낌을 살렸다. 단순하면서도 차별화되는 획의 형태로 본문과 제목에 모두 사용할 수 있는 기능성을 갖추며 이성적 모던함을 기본 콘셉트로 한다.

poster. nanumgothic11,172. 700 x 1,000. 2011.

nanum font

poster.　nanummyeongjo11,172.　700 x 1,000.　2011.

1977년에 태어났다. 국립 타이완과기대학교에서 상업 디자인을 전공하고 아전국가기술대학의 기술미디어 미술대학원을 졸업했다. 대학교 2학년 때 '성품서점 카피라이팅상'을 수상하면서 성품서점의 편집 카피라이터가 되었다. 졸업작품이었던『현실 속의 섬키딩』책이 출판되면서 대중의 관심을 한 몸에 받게 되었다. 최근 성품서점 독자들의 연간 리포트에서 여러 차례 '최고 관심 대상'과 '최고 그래픽 디자이너'로 선정되기도 했다. 또한 금나비상의 최고 표지미술상을 수상하고 국제적인 디자인 전문지〈Musikraphics〉의 '최고 음악 아트워크와 디자이너 100선'에 선정되었다. 그의 스튜디오 에어런너워크숍은 권위 있는 예술 출판사 Hesign에 의해 '소규모 스튜디오 50'에 선정되었다. 2009년에는 LA아트센터의 레지던스 아티스트를 지냈으며, 레드닷디자인 어워드 커뮤니케이션디자인상, 골든멜로디 최고 앨범패키지상, APD디자인연감, IF커뮤니케이션디자인상 등을 수상했다.

니에어런.聶永真.

nieh.aaron. taiwan

poster / flyer.

hsu yen-ling x sylvia plath.

600 x 600.

2009.

366

poster / flyer.

quartett von heiner müller.

600 x 600.

2010.

Born in 1977. Received BA degree in Commercial Design at NTUST, and studied in Graduate School of Applied Media Srts, NTUA. Nieh became the contributing copywriter of Eslite Bookstore after he won the copywriting award of Eslite Bookstore in his sophomore year. He got exclusive public attention since his graduate works, the book <Somekidding in Reality>, was published. In recent years, he was awarded 'Best Attention' and 'Best Art Designer' several times in the annual report of Eslite readers. He was also awarded the 'Best Cover Art Award' of the Golden Butterfly Award and the 'Best 100 Music Artworks and Designers' of the International design book <Musikraphics>. His workshop 'Aaron Nieh Workshop' was in one of the <50 Small Studios> which was published by Hesign, an authoritative artistic publishing company. Nieh was a resident artist in Art Center L.A. in 2009, and an awards winner at Red-dot Communication Design Award, Best Album Package of Golden Melody Award, APD Design Annual in 2010 and IF Communication Design Award in 2011.

nieh aaron

poster.　i see languages.　700 x 1,000.　2011.

From writing by myself to watching others write, my obsession for characters expanded along with my design career and cast onto languages and characters that are completely different to mine. Hebrew, Korean, Thai, Tibetan and Vietnamese, characters with different forms spread before our eyes, so foreign it makes them "look" insanely fascinating. Because we do not understand the characters so different to ours, when observing symbols of such language without understanding its meaning, it became a pure form of superficial "admiration of beauty", hence "inexplicable language objects" such as newspaper articles, billboards, images and magazines continue to stack up in my camera, my flickr, and my hard drive, such distance

book cover.

miyamoto tero - kinshu.

150 x 210.

2009.

aaron yiu

drives my cravings. The prototype of aesthetics is distance, we come together because we do not understand, and part our ways when we finish exploring. I once saw a Chinese character "de" (of) tattooed on an Englishman's arm, I'm not sure if he understood what it meant, but he must have found the form of "de" attractive... "Choose a character you like from the Chinese dictionary!" I'm sure that is probably what the tattoo artist said to him. It may seem silly to us, but to him, it is a form of beauty which cries out "who cares". Thus began infatuation, no? You are not me, how would you know that I don't know if you know that I don't know that you know whether I am a willing indulger or a worshipper of the unknown? The process of "observation" and "realization" is always the most alluring._____혼자

글을 쓰는 것부터 남들의 글 쓰는 것을 바라보는 것까지, 글자에 대한 나의 집착은 나의 디자인 경력과 더불어 우리의 것과 전혀 다른 언어와 글자에까지 드리워져 확장되었다. 히브리어, 한국어, 태국어, 티베트어, 베트남어. 우리 눈앞에 놓인 다양한 형태의 글자들은 너무나 이국적인 나머지 미치도록 환상적으로 보여진다. 우리의 글자

book cover.

kyogoku natsuhiko - mouryou's case.

150 x 210.

2009.

notebook. irregular notebook. 170 x 230. 2010.

와 전혀 다른 이 글자들을 읽을 수 없기에 이러한 언어들의 의미를 이해하지 못한 채 관찰해보면, 그 순수한 형태의 피상적인 아름다움에 감탄하게 된다. 따라서 신문 기사, 게시판, 이미지들과 매거진 같은 '불가해한 언어 개체들'은 내 카메라, 플리커, 하드 드라이브에 지속적으로 쌓여가며, 이러한 거리감은 나의 열망을 자극한다. 미학의 원형은 거리감이다. 우리는 이해할 수 없을 때 함께하며, 탐험을 마무리했을 때 헤어진다. 나는 한번은 한자 '的'가 영국인의 팔에 문신된 것을 본 적이 있다. 그가 그 의미를 이해했는지 알 수 없었지만 그는 분명 형태를 매력적으로 느꼈을 것이다. "한자 사전에서 좋아하는 글자를 고르시오", 아마도 문신 예술가가 그에게 그렇게 말했을 것이다. 우리에겐 어리석어 보일지 몰라도 그에게는 "뭐 어때"라고 소리치는 아름다움의 형태인 것이다. 당신도 열병이 시작되었다. 아닌가? 당신은 내가 아니므로, 내가 미지의 것들에 대한 열렬한 탐닉자 혹은 숭배자인 것을 당신이 알고 있음을 내가 알지 못함을 당신이 어떻게 알겠는가? 관찰과 실현의 과정은 언제나 매혹적이다.

ticket card. hsu yen-ling x sylvia plath. 60 x 210. 2009.

nieh aaron

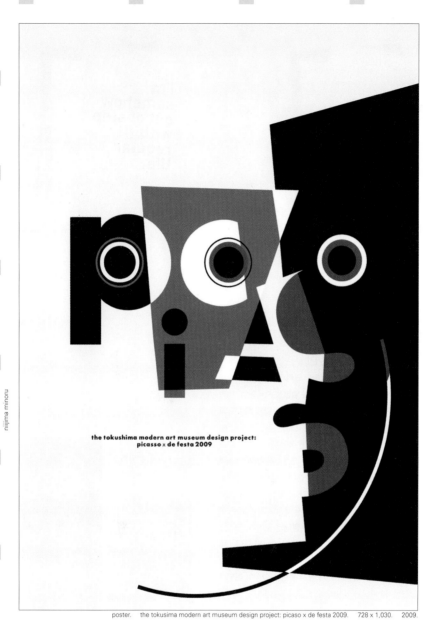

the tokushima modern art museum design project:
picasso x de festa 2009

poster. the tokusima modern art museum design project: picaso x de festa 2009. 728 x 1,030. 2009.

niijima.minoru. ^{japan}

Born in Tokyo, 1948. Niijima established Niijima Minoru Design in 1977. After three years of working, he moved to U.S., graduated master's in Yale University, and returned to his company. He served as both the Executive Committee and Standing Member of Committee in the Society of Japanese Typography in 1988. He also worked as the judge of Japan Industrial Design Association Good Design Award. Niijima is currently a member of JAGDA, Japanese Secretary General of AGI, professor of Visual Communication Design in Musashino Art University. Invited by Tokyo GGG, he held <Niijima Minoru: Interaction of Color and Font> Exhibition in 2003. He also took charge of art direction and official poster design of <22th National Cultural Festival, Tokushima> in 2006.

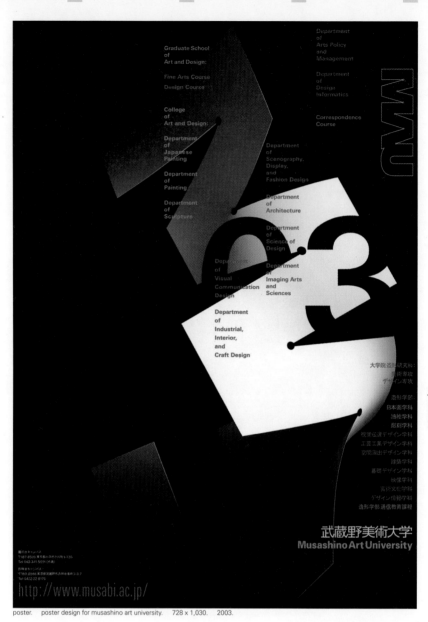

niijima minoru

poster.　poster design for musashino art university.　728 x 1,030.　2003.

니이지마.미노루.新島実.

1948년 도쿄에서 태어났다. 1977년 니이지마미노루디자인을 설립하고 3년 후 미국으로 건너가 예일대학교 미술학 석사학위를 마치고, 회사로 복귀했다. 1988년 일본타이포그래피협회 대표 상임위원을 역임했으며 2003년 일본산업디자인진흥회 굿디자인상 심사위원으로 활동했다. 현재 일본그래픽디자이너협회 회원이자 국제그래픽디자이너연맹(AGI) 일본 사무국장, 무사시노미술대학 시각전달디자인과 주임교수를 맡고 있다. 도쿄 GGG갤러리에 초대되어 〈니이지마 미노루: 색채와 폰트의 상호작용〉(2003) 전시를 했으며 〈제22회 도쿠시마 국민문화제〉(2006) 공식 포스터 디자인 및 아트 디렉팅을 담당했다.

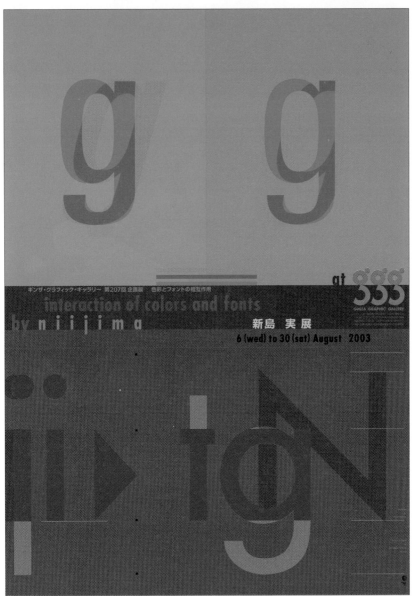

niijima minoru

poster. minoru niijima: interaction of colors and fonts, ginza graphic gallery 2003. 728 x 1,030. 2003.

There is an appeal of Visual Communication Design that pursue for a better communication, from conveyance to dialogue. On the other hand, there is an obsession of "individuality" that seek for self-contained expression. I have been wandering for many years between these two opposite pursuits. In order to express as one wishes, physical permissible amount exists on one side. This heads to the completion of "individuality" but physical extension leads to the society on the other side. This may indicate placing result in between the boundaries of "individuality" and society in the context of Visual Communication, yet it is not as easy as it sounds. Language, in other words symbol, is the point which connects this "individuality" with the society. It is the visual symbol called visual language by the people of Visual Communication Design. Visual language, disseminating around us, includes letters as written

nijima minoru

poster. the 22nd national cultural festival tokusima 2007. 728 x 1,030. 2007.

language, typeface, font, form, color, shape, diagram, icon, pictogram, illustration, photograph, video, and more. Methods of treating visual language have become very diverse, due to the digital technology development. The boundary between professionals and amateurs in the visual expression field, which previously had been known as a special area, can now only be perceived as an ambiguous relation. But it is hard to come across successful cases of visual language syntax. Development of visual perception is required in order to express as the thoughts. Even the professionals have now set their senses to the monitor resolution of their tables. Solving problems by controlling the visual language, which is cumbersome yet very interesting symbol world, with visual perceptions, this is the foundation of my design. In my design activity, I attempt Visual Communication Design as not only treating image in the brain,

poster. agi-japan exhibition. 728 x 1,030. 2006.

374

nijima minoru

but also understanding it from the correlation of continuous process, the action and thinking to formation. If the result could give an aesthetic impression to the viewers, it would be most wonderful._____전달에서 대화로, 커뮤니케이션의 나은 모습을 찾으려 하는 비주얼 커뮤니케이션 디자인 영역에 매력을 느끼는 한편 표현자로서의 자기완결을 구하는 '개(個)'에 대한 집착이 다른 한편에 존재한다. 이 상반되는 지향 사이에서 벌써 오랜 세월을 나는 방황해 왔다. 자신이 원하는 대로 표현을 하기 위해 신체성 허용량의 확대라는 것이 한편에 있고 이는 '개(個)'의 완결로 향하지만 한편으로 신체성의 연장선상에 사회가 있다. 비주얼 커뮤니케이션 문맥에서 생각하면 이상적으로는 이 '개(個)'와 사회의 경계선상에 결과를 올려놓는 일이라고 생각하지만 말처럼 쉽지 않다. 이 '개(個)'와 사회를 연결하는 접점으로 기능하는 것이 말 즉 기호인데, 비주얼 커뮤니케이션 디자인에 종사하는 자에게 그것들은 시각언어라 불리는 시각기호이다. 시각언어는 말을 표기하는 문자를 비롯하여 서체, 폰트, 모양, 색채, 도

poster.　　poster design for musashino art university.　　728 x 1,030.　　2008.

형, 다이어그램, 도상, 픽토그램, 일러스트레이션, 사진, 영상 등 우리를 둘러싸듯 확산해가고 있다. 디지털 기술 발달에 의해 시각언어를 취급하는 방법이 아주 다양해졌다. 지금까지 특수한 세계라고 생각되어온 시각표현 영역에서의 전문가와 비전문가 경계 같은 것은 이미 애매한 관계로 인식할 수밖에 없는 상황이 되었다. 그러나 시각언어 신택스(syntax) 성공 사례는 찾아보기 힘들다. 그것과 동시에 생각한 대로의 표현을 하기 위해서는 시지각(視知覺) 개발도 요구되는데 전문가까지도 책상 위 모니터 해상도에 자신의 감각을 맞춰버린 현실이다. 시각언어라는 번거롭지만 대단히 재미있는 기호 세계를 시지각으로 컨트롤하여 문제를 해결하는 일. 이것을 내 디자인의 바탕으로 삼으면서, 비주얼 커뮤니케이션 디자인을 단지 뇌 안의 이미지 다루기가 아닌 행동과 사고로부터 조형(造形)에 이르는 연속된 과정의 상관관계 속에서 파악하려 애쓰며 디자인 활동을 하고 있다. 그리고 그 결과가 그것을 보는 사람들에게 미적 감동을 줄 수 있을 정도까지 승화될 수 있다면 이토록 멋진 일은 없을 것이다.

oh.jin-kyung.

korea

Oh Jin-Kyung is a freelanced book designer in Seoul, Korea. She previously worked in-house at Munhakdongnae publishing company before leaving to set up her own studio in 2002. She won the 'book designer of the year' award by Korean Publishers Society in 2008. She studied graphic design and typography and received master's degree at Hongik University in Korea.

오진경.鳴眞京.

홍익대학교 시각디자인학과와 동 대학원을 졸업했다. 문학동네출판그룹에서 디자이너로 일한 뒤 2002년부터 프리랜서 북 디자이너로 활동하고 있다. 2008년 한국출판인회의 선정 올해의 북 디자이너상을 수상했다.

oh jin-kyung

book. bibliographic novel. 140 x 205. 2010.

376

book. 7 years night. 150 x 210. 2011.

book. last fan club of sammisuperstars. 153 x 224. 2003.

377

Doing my book design work, I most likely enjoy the time, which complete the prelude part of connecting book cover with the body text. This introduction area is generally called 'frontmatter', and that is an important part of 'paratext' in a broad sense. Book designers notice and suggest of forthcoming books through typography and image in various ways, furthermore, they can create new experiences for readers. Most of the interest and research about Book design are generally divided into two parts - book cover and body text. It goes without saying that there is an interest in the whole design work without a compartment. Book cover and body text are completely different space not only visual and physical way but also the expression aspect can be totally different. This spatial experience goes for readers same as book designers. Some of designers usually begin his/her work with body text first and after that the cover image follows, but some others firstly get an idea of the cover image and finally complete the body text. And also they seem to have a particular stressing point within the book cover and body text. I am interested, though, in the connecting relationship with the book cover and body text, not in the special one of the two design area.

Cover is located in the center of book and leads readers to the early experience before reading the body text. Readers guess the meaning of a word from the cover image and look forward to reading the text. Meeting with the cover, and just thought of it can make readers mind flutter. In that meaning, it can be said that readers experience starts from the book cover. After bumping into the cover image, readers open the book cover, meet with the flap of the book, turn over the end paper as likely discover a stage curtain, go through the 'title', look over the 'half title', and after pass over the 'second half title', they can finally find the first sentence of the book writer.

My interest always is being here these connecting process. Book covers are generally composed of limited number of letters as compared with body text. The body text is certainly the other way round. Study and research about the 'frontmatter' of books, therefore, necessarily have to done to make harmony the symbolic system of the book cover with the body text that is made up of relatively thicker and longer letters than the covers. And this 'frontmatter' is accomplished in the end of the book design process. Such as it is mentioned above, I think, how to design the 'paratext' of books can make or break the quality of the whole book design process._____북 디자인의 전 과정을 통틀어 내가 가장 즐거운 순간은 표지와 본문을 이어주는 공간을 완성하는 시간이다. 이 영역을 가리켜 흔히 '도입부'라 부르기도 하고, 넓은 의미에서는 '파라텍스트(paratext)'의 대표적 공간이기도 하다. 북 디자이너는 타이포그래피와 이미지를 통해서 다양한 방식으로 책의 내용을 예고하고 암시하고 더 나아가 새로운 경험을 창조해낸다. 일반적으로 북 디자인에 대한 관심이나 연구는 본문 디자인에 관한 것과 표지에 관한 것으로 나누어져 있다. 물론 둘을 굳이 나누지 않고 전체적인 북 디자인에 대해 관심을 갖기도 한다. 표지와 본문은 시각적으로나 물리적으로 혹은 표현의 양상조차 완전히 다른 공간이다. 이것은 독자들뿐만 아니라 디자이너에게도 마찬가지이다. 디자이너에 따라 본문을 먼저 작업하면서 표지 이미지를 구축하는 이도 있을 것이고, 혹자는 표지 이미지 구상이 먼저 떠오르고 본문을 완성하기도 할 것이다. 그리고 표지와 본문 디자인 가운데 굳이 꼽으라면 둘 중 어떤 것이 조금 더 중요하다고 여기는 이도 있을 것이다. 그러나 나의 관심은 표지도 아니고 본문도 아닌, 이 둘의 연결성에 있다. 표지는 독자에게 책의 내용을 읽지 않은 상태에서 앞서 경험되는 장소에 위치한다. 독자는 표지 디자인을 통해 책이 담고 있는 내용을 추측하고 기대한다. 독자는 책의 첫 문장을 아직 읽지 않았으나, 미지의 세계를 향한 설렘은 벌써 시작되었다. 그런 의미에서 독서의 경험은 표지에서 시작된다고 할 수 있을 것이다. 그렇게 촉발된 독서의 시작이 책을 열고 책의 날개를 만나고, 무대의 막이 열리듯 면지를 넘기고, 속표제를 지나 반표지를 넘겨, 차례를 찾고, 장표지를 넘긴 후에야 우리는 비로소 저자의 첫 문장을 만나게 된다. 나의 관심은 바로 여기에 있다. 일반적으로 표지는 본문에 비해 상대적으로 적은 수의 활자요소로 구성된다. 본문은 그 반대이다. 그렇기 때문에 표지의 상징적 체계가 상대적으로 긴 호흡과 많은 분량의 활자 더미로 구성된 본문의 세계와 어울리기 위해서는 책의 도입부의 역할을 고민하지 않을 수 없다. 그리고 북 디자인 전체 작업의 과정에서도 이 도입부 디자인은 제일 마지막 단계에 이루어진다. 그런 면에서 책의 완결성 혹은 북 디자인의 완결성은 잘 만들어진 도입부 디자인을 통해서 완성되는 것이 아닐까 생각한다.

book.
l'hotel du nord.
132 x 190.
2009.

book.
modern girl.
144 x 224.
2005.

book.
secular film, secular criticism.
150 x 210.
2010.

book.
n the meantime, only for me.
133 x 190.
2007.

book.
the hitchhiker's guide to the galaxy.
153 x 224.
2005.

book.
the portrait.
250 x 300.
2008.

oh jin-kyung

li degeng

jiang hua

As a teacher, designer and curator, Jiang Hua teaching in Design School of CAFA, and co-founded OMD (2007, Beijing) with Li Degeng, approaches design research and art practice with Multimedia. His research project of "Mei Shu Zi" (Chinese Modern Typography) explores design methodology under the context of Chinese characters. He is the curator of "Social Energy: Contemporary Communication Design from the Netherlands", Ningbo International Design Biennial, "POST__", "NOPAPER", "TYPOSTER100", "Designing in China", "Critical Graphic Design", "Meishuzi Project". Jiang Hua received the Ph.D. in design, he is a member of AGI.

Li Degeng, Co-founder of OMD. As an editor-in-chief, Li Degeng has edited and designed two sets of book series: "The European Design Now" and "Contemporary Communication Design from the Netherlands". He has been teaching at Tsinghua University. He is the Magazine Art Director of "Design Management", "FRAME" (Chinese Edition) and "MARK" (Chinese Edition) and the Academic Director of Design House of Today Art Museum (Today Design Museum). He is the curator of "Social Energy", "Design in China", "Taking a Stance" and "the 1st Beijing International Design Triennial".

omd.

china

오엠디.

omd

OMD 장화는 CAFA 디자인 학교에서 학생들을 가르치며, 큐레이터이자 디자이너로서 멀티미디어를 통해 디자인 연구 와 예술 작업에 접근한다. 2007년에 베이징에 OMD를 리더경과 함께 공동 설립했다. 그의 연구 프로젝트 메이슈지(중 국 현대 타이포그래피)는 한자 맥락 안에서 디자인 방법론을 탐구한다. 그는 〈사회 에너지: 네덜란드로부터의 현대 커 뮤니케이션 디자인〉, 〈닝보 국제 디자인 비엔날레〉, 〈포스트〉, 〈노페이퍼〉, 〈타이포스터100〉, 〈메이슈지 프로젝트〉 등 다수의 전시에서 큐레이터를 담당했다. 국제그래픽디자이너연맹(AGI) 회원이다.

리더경은 OMD의 공동 설립자이며 칭화대학으로 출강하고 있다. 그는 편집자로서 『오늘날의 유럽 디자인』과 『네덜란드로부터의 현대 커 뮤니케이션 디자인』을 편집 및 디자인하였다. 그는 〈디자인 매니지먼트〉, 〈프레임〉(중국판), 〈마크〉(중국판) 잡지의 아트 디렉터이며, 현 대예술박물관 디자인하우스의 학술이사이다. 그는 〈제1회 베이징 국제 디자인 트라이엔날레〉의 큐레이터이다.

book. igdb book. 210 x 285. 2004.

poster. ting tai lou ge. 450 x 750. 2011.

Typeface is a lifestyle.
Chinese character is a form of consciousness.

Typeface is a method.Chinese character is an attitude.
Designers build the matrix of character design.

omd

And then the characters come and go on their own, wander freely and elect. Character design
grows naturally in the human world.

I slowly fall asleep on typeface on a spring day.

book. igdb book. 210 x 285. 2006.

book. design now book. 210 x 285. 2006.

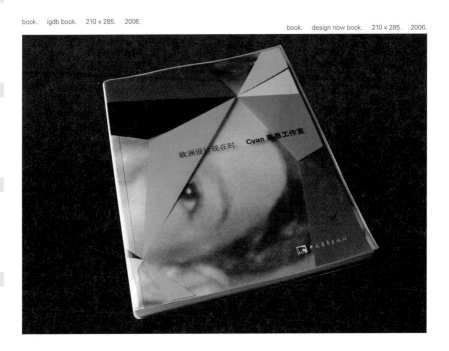

글자체는 한 가지 생활방식이다.
한자는 한 가지 의식형태이다.

글자체는 한 가지 방법이다.
한자는 한 가지 태도이다.

디자이너는 문자 디자인의 행렬을 구축하고 그 다음 그들이 스스로 왕래하고 자유롭게 돌아다니며 선택한다.
문자 디자인은 인류세계에서 자연스럽게 성장한다.

봄날에 나는 글자체를 베고 천천히 잠든다.

book. design now book. 210 x 285. 2009.

book. design now book. 210 x 285. 2009.

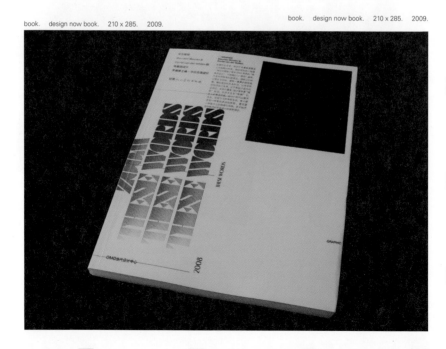

ota.tetsuya. ^{japan}

Born in Miyazaki, 1941. Active in various fields including book design, graphic
design, editorial design, and CI. Ota graduated from Kuwasawa Design Re-
search Lab, and joined Tanaka Ikko Design Studio in 1963. He established
Ota Tetsua Design Studio in 1975. He participated in numerous exhibitions;
<Japanese Corporate Identity Exhibition>, <S.I Map and International Mea-
surement Exhibition>(TDS), <Diagram Exhibition>(MOTS), <Harahiromu
Creator Exhibition>, <Book Inside-Out Exhibition>. Ota won Minister Award
in National Catalog/Poster Exhibition, National Manual Competition, Member
and Bronze Award of Tokyo TDC, Grand Price in Society of Japanese Typogra-
phy, Harahiromu Award in Tokyo ADC, and more. He wrote <CI: The Change
in Mark and Logo>(1989) and <PIE BOOKS>(2009). Ota is currently a mem-
ber of JAGDA and Society of Japanese Typography.

오타.테쓰야.太田徹也.

ota tetsuya

384

book.　casa barragan.　190 x 250.　2002.

1941년 미야자키현에서 태어났다. 북 디자인, 그래픽 디자인, 편집 디자인, CI 등 폭넓은 작업을 하고 있다. 1963년
구와사와디자인연구소를 졸업한 뒤 타나카잇코디자인실에 입사, 1975년 오타테쓰야디자인을 설립했다. 〈일본기업
의 CI전〉, 〈S.I map과 국제단위전〉(TDS), 〈다이어그램전〉(MOTS), 〈하라히로무상 크리에이터전〉, 〈책의 Inside-
Out전〉 등 다수의 전시를 가졌으며, 1991년 전국 카탈로그포스터전 통산장관상, 일본 북디자인 콩쿠르, 도쿄 TDC
회원상 및 동상, 일본타이포그래피협회 최우수상, 도쿄 ADC어워드 하라히로무상 등을 수상했다. 저서로 『CI: 마크,
로고의 변천』(1989), 『PIE BOOKS』(2009)가 있다. 현재 일본그래픽디자이너협회(JAGDA), 일본타이포그래피협회
회원이다.

poster.
japan.
1,030 x 728.
1989.

ota tetsuya

Digitalization is taking over the design field like a blowing wind. It seems as digitalization is swallowing the whole 21st century society, culture, and human life like a tsunami. I honestly confess that I am struggling in between analog and digital every day. I am an analog generation designer who grew up in the times where design studios had no copy machine nor fax. On the desk there were manual labour necessities such as desk mat, pencil, eraser, compass, divider, ruler, and knife. I remember my initial step to the job was to nicely cut and paste types of blue print or photocomposer with paper cement, or draw straight lines at regular intervals. But how about now. Computers like Mac takes care of manual labour quickly and clearly. As a result, simply loading software programs installed in the devices makes plausible design production possible (for anyone). Young designers of today dream of 21st century professional designer. They all walk around with a Power Book and a digital camera. But they have no experience of manually drawing a line nor studying color coloration with poster colors or color chips. It is an irony that creative expression is difficult to reach when these designers are unexpectedly designing. In other words, the simplicity of digital expression is excluding personality and lowering levels of the design quality. Typing and clicking on the keyboard prior to learning basic skills and knowledges as a graphic designer will obviously not lead to a good design. How could a designer, who does not know typesetting specifications, manuscript instructions for printing house, registration marks nor knock out, be given the job of creating a digital data? I daily pray that the generation of designers, who does not remember even the typeface, point, typesetting rules he is using, or whose everything is digitalized and processed in numerical informations, will not come. Furthermore, perspective of the world on viewing the problem of highly bright digital color becomes even more important. In my generation, we mixed water colors or poster colors with brush to learn the three elements of color in physical senses. Even the scales of Munsell and Ostwalt, who created classifications and theories of color, are subtly different from the colors of nature or

the actual products. Our generation learned to understand such differences and to apply them to the designs by cultivating the senses on our own. Colors of photographs or films, colors printed on paper, colors displayed on computer, colors of LCD TV, the appearances of color are truly various. The color representation is also having a great hesitation. Most of my works are book designs. Book binding(body) and body text(mind) may seem separate, but it is more desirable to have their oneness. The body(appearance, format, binding technique) must be expressed in contemporary senses and design. The mind(body text, contents) is concept therefore the design must be easy to understand and persuasive. In other words, content-oriented appearance would be the right way. In my point of view, highlighting only the book cover, which is separated from the content, would be an astray way. During my daily routine, I repeatedly tell myself that the question of "for whom, for what is this book design" should be asked from the root. I wish book is something beautiful and pleasing for anyone reading or touching it. I often come across dull design in body text typesetting as a result of computer wave. I want to make "spacious body text typesetting" that follows typesetting rules. I think it becomes an important part of a designer as long as this work is continued. "Recovering analog sense prior to digital expression is required for growing creativity", "As long as the ability of understanding and identifying letters and colors both physiologically and psychologically, design quality can be maintained even in the direction of digitalization", "Design is the sense and skill required to create something beautiful. In order to learn it, learning from beautiful things of the past (including anonymous things) instead of predicting the future (which can not be assured) is important." Thinking these things in a corner of my head, I consciously try to meet people constantly, observe with my own eyes, experience the fields, and learn design on daily basis. Design is enjoyable indeed.

ota tetsuya

poster. kyosyou. 728 x 1,030. 1997

poster. animal farm. 728 x 1,030. 1999

386

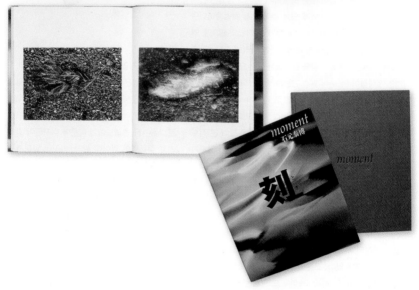

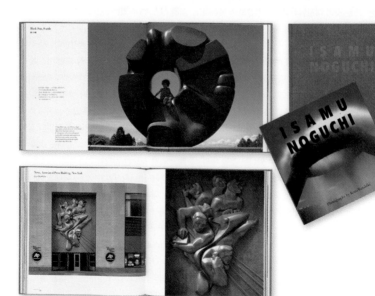

book. moment. 255 x 300. 2004.

ota tetsuya

book. isamu noguchi. 300 x 300. 1998.

디자인계에도 디지털화 바람이 불고 있다. 디지털화는 21세기 사회와 문화 그리고 생활 전반에 걸쳐 마치 쓰나미의 소용돌이처럼 통째로 삼켜버리려는 현상을 보이고 있다. 지금 나는 솔직히 고백하건대 아날로그와 디지털 사이에서 매일 몸부림치고 있다.

나는 디자인 사무실에 복사기도 팩스도 없는 시대에 자란 소위 아날로그 세대 디자이너다. 책상 위에는 작업용 매트와 연필, 지우개, 컴퍼스, 디바이더, 자, 칼 등 수작업 필수품들이 널려 있었다. 페이퍼 시멘트(접착제)로 활자청쇄나 식자문자의 기리바리(자르고 붙이기)를 능숙하게 해내고 동일한 간격(等間隔) 직선을 그을 수 있게 되는 것이 수행 첫걸음이었던 것을 기억한다. 그러나 지금은 어떠한가. 수작업의 일체를 맥킨토시 등의 컴퓨터가 신속하고 깔끔하게 처리해 준다. 그 결과 기기에 내장된 프로그램을 불러오는 것만으로 그럴 듯한 디자인 제작물이 (누구에게나) 가능하게 되었다.

현재 젊은 디자이너들은 21세기 프로 디자이너를 꿈꾸며 모두(?)가 Power Book과 디지털 카메라를 들고 다니며 다룬다. 그러나 그들은 자기 손으로 실제로 주어진 선을 그어 본 적도 포스터컬러나 색채 칩으로 배색 공부를 한 적도 없이 갑자기 디자인 결과물을 얻을 수 있기 때문에 물건을 만들 창조적인 표현에 도달하기 어렵다는 모순을 품고 있다. 말하자면 디지털 표현의 간편함이 디자인의 질(質)에서 개성을 배제하고 레벨을 저하시키고 있는 것이다.

그도 그럴 것이 그래픽 디자이너로서의 기본적인 기술도 지식도 알기 전부터 키보드를 두들기고 클릭만 한다고 좋은 디자인이 탄생될 리가 없다. 조판의 지정, 인쇄소에 넘기기 위한 원고 지시, '돔보(재단선)'도 '녹아웃'도 모르는 사람에게 디지털 데이터 만드는 일을 맡길 수 있을까?

자신이 쓰고 있는 문자 글꼴이나 포인트, 조판 규칙조차 기억해 내지 못하는, 모든 것이 디지털화되어 수치정보로 움직여지는 디자이너가 세상으로 배출되는, 그러한 시대가 오지 않기를 나날이 기도할 뿐이다.

더 나아가 저 휘도(輝度) 높은 디지털 색채 문제를 세간에서는 어떻게 파악하고 있는지 그 시점도 더욱 중요해진다. 내 세대에서는 물감이나 포스터컬러를 붓으로 혼색하여 육체적 감각으로 색의 3요소 등을 익혔다. 색채를 분류하고 이론화한 먼셀이나 오스트발트 스케일도 자연계에 있는 색이나 상품 실제 색과는 미묘하게 달라서 스스로의 감각을 연마하는 것으로만 그 차이를 이해하고 디자인에 적용할 수 있다는 것을 우리 세대는 배웠다. 사진이나 필름 색, 종이에 인쇄된 색, 컴퓨터 화면에 보이는 색, 액정 TV 색 등 색의 모습은 실로 다종다양하다. 지금 색의 표현에서도 많은 고민을 가지고 있다.

book ohtsuka sueko. 248 × 310. 2003

ota tetsuya

나의 주된 작업은 북 디자인 분야이다. 책의 장정(몸)과 본문(마음)은 별개처럼 보여도 일체인 것이 바람직하다. 몸(외견, 형태, 제본기술)은 동시대 감각과 디자인으로 표현되며 마음(본문, 내용)은 콘셉트이기 때문에 디자인이 알기 쉽고 설득력이 있어야 한다. 바꾸어 말하자면 책 내용을 중심으로 외관에 힘을 쏟는 것이 북 디자인의 정도(正道)가 아닐까. 내용에서 분리되어 책 표지만을 부각시키려 하는 것은 내 시점에선 도리에 어긋나는 일이다. 책 작업은 '누구를 위한, 무엇을 위한 북 디자인인가' 하는 근본 문제부터 물어야 한다고 생각한다. 책이라는 것은 누가 읽어도 누가 만져도 아름답고 기분 좋은 것이었으면 좋겠다. 본문 조판에도 컴퓨터라는 파도가 밀려와 무미건조한 디자인에 그친 것이 자주 보인다. 나는 지금 활자 조판 규칙을 살린 '여유 있는 본문 조판'을 하고 싶다고 생각하는데, 작업을 계속해 나가는 한 그것도 디자이너의 중요한 일이라 생각한다. 지금 내가 생각하는 것 중에 '디지털적 표현 이전에 다시금 아날로그적 감각을 되찾는 것이 창조력을 기르는 데 필요하다', '문자나 색을 생리적·심리적으로 이해하고 파악할 수 있는 능력을 키워 나가면 디지털화 방향으로 가도 디자인의 질을 유지할 수는 있다', '디자인은 아름다운 것을 만들기 위해 필요한 감각과 기술이다. 그것을 배우기 위해서는 (확신할 수 없는) 미래를 예측하기보다 과거의 아름다운 것(익명의 것도 포함하여)에서 배우는 것도 중요하다', 이런 것들을 머리 한 구석에서 생각하며 끊임없이 사람과 만나고 스스로의 눈으로 관찰하고 현장에 나가 그 환경을 경험하고 디자인을 배우는 일이 일과가 되도록 의식하고 있다. 디자인 작업은 실로 즐거운 것이다.

388

book.　ohtsuka sueko　248 x 310.　2003.

ota tetsuya

판친.潘沁.

Take history as a mirror.

과거 역사를 거울로 삼는다

pan.qin. china

Graphic designer, Professor, Dean of the School of Arts, Ningbo City College of Vocational Technology. Chairman of Ningbo Graphic Designers Association. Deputy President of Zhejiang Association of Creative Design. Founder and Curator of Ningbo International Poster Biennial. Pan Qin graduated from China Academy of Arts in 1993. He founded his studio in 1993. His jobs range from edition, poster, typeface, brand identity and corporate identity. He has been engaged in the study of professional creation and design education for sixteen years. Under his leadership, the school has explored new ways of teaching methods and established a series of effective reforms in teaching, which gained good effects. Under his guidance, his students won many important design awards both in the country and abroad. Pan Qin is the Founder and Curator of Ningbo International Poster Biennial. It has been held five with great success since 1999. Ningbo International Poster Biennial has become the symbol of internationalization in graphic design of China. He received many design awards, including: The Grand Prix of "WATER FOR HUMAN KIND" International Poster Design Competition 2000 in France; Mayor Award in the 9th International Triennale of Environment Posters in Zilina Slovakia; Gold prize of The Huadong Design Award, China 2003; Bronze prize in the Chinese International Graphic Design Competition. Silver Award of GDC (Graphic Design in China) His works have been selected in the design biennials and competitions in the cities as follows: Beijing, Shanghai, Ningbo, Shenzhen, Hangzhou, Hong Kong, Taipei, Tokyo, Toyama, Ogaki, Seoul, Warsaw, Rzeszow, Trnava, Kharkov, Moscow, Zurich, Paris, Chaumont, Berlin, Essen, Mexico, New York, etc. He has been invited to participate in exhibitions such as the "Cities, Discoveries" Poster Exhibition in the Festival of Vision - Hong Kong in Berlin; "Chinese Poster 1920 – 2000" exhibition in Canada; "Chinese Contemporary Poster" exhibition in Japan, 2001; "Chinese Contemporary Poster Art" exhibition in Berlin, 2001; "Chinese Poster" exhibition in Philadelphia; "Children are the rhyme of the world" International Poster Invitational Exhibition; "In China – 20 Graphic Designers" Invitational Exhibition, 2005. He has edited and published some international design books, including "Uwe Loesch", "Mieczyslaw Wasilewski", "Michael Bierut", "Mechior Imboden", "The Third Ningbo International Poster Biennial" and "The 8 Graphic Designers Poster Exhibition, Ningbo 2001". Panqin's works have been featured and published by "Poster Collection", "Etapes", "Graphis "(Chinese version), "Arts & Design", "Art Panorama", "Ad world" and "China Art News".

pan qin

poster. design ink. 640 x 900. 2006

1993년 저장미술학원을 졸업하고 1994년 개인 작업실 설립, 1999년 닝보 좌우디자인유한회사를 설립했다. 현재 닝보 그래픽디자인협회 주석, 저장성 창의디자인협회 부이사장, 닝보성시직업기술학원 집행원장이자 부교수이다. 1999년부터 〈제5회 닝보 국제 포스터 비엔날레〉를 공동으로 창시, 조직하였다. 프랑스 WATER FOR HUMAN KIND 국제 포스터대회 대상, 국제 상표상징 비엔날레 우수상, 슬로바키아 국제 환경 포스터 트리엔날레 시장상, 전국 체육대회 길향물 금상, 중국의 별우수상징 디자인상, 홍콩 디자인 우수상, 화인그래픽디자인 대회 동상, 중국 그래픽디자인 은상, 화동디자인 대상, 도쿄 TDC 우수상 등을 받으며 국내외 20여 곳에서 전시되었다.

book. revelation design before "design". 210 x 285. 2011.

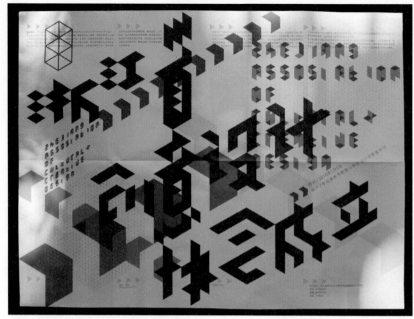

poster. zhejiang assosiation of creative design. 640 x 900. 2009.

book. zhejiang assosiation of creative design. 210 x 285. 2009.

Park Ji-hoon was born in Seoul, 1977. He graduated from Musashino Art University, Visual Communication Design, and completed master's degree of same school. Park is currently working as research lab assistant in Musashino Art University Visual Communication Design department. He is a member of Japanese Society of Design, and Korean Society of Typography. Park participated in exhibitions such as <RA10 Assistant Exhibition> in Tokyo(2009), and <Musashino Art University Alumni Exhibition> in Seoul. He was awarded with Musashino Art University Best Design Award and Best Thesis Award, Mitsubishi Chemical Junior Designer Award, and many more._____1977년 서울에서 태어났다. 무사시노미술대학 시각전달디자인과를 졸업한 후 동 대학교 석사과정을 수료했다. 현재 무사시노미술대학 시각전달디자인과 연구실 조교이며, 일본 디자인학회, 한국 타이포그라피학회 회원이다. 2009년 도쿄에서 <RA10 조수 전>, 서울에서 <무사시노미술대학 동문회 전>을 열었다. 무사시노미술대학 우수작품상과 우수논문상, 미쓰비시케미컬 주니어디자이너 어워드 등을 수상했다.

박지훈.朴志勳.

park.ji-hoon.

korea

394

book.　printing and letter form of east asia.　297 x 420.　2007.

A letter does not exist by itself.

There is one memory from my freshman days at college that still makes me blush with embarrassment. As I entered the college of fine arts, I was an excellent student, working hard and completing all of my assignment faithfully. One day when I was working with homework that required using Hangeul font lettering, my younger brother said to me.

"You can use a computer to print those letters bigger. Why are you using a ruler to write them?"
'...That's right' I thought, 'why am I writing these letters one by one almost as if I were just copying them?'

The fact that I couldn't answer at the time makes me sad. I wasn't able to grasp the understanding of designing a letter's expressions. In those days, my perception was that the fundamental form of letters had always been natural, and I had a strong sense that this basic style applied to all situations.. The letters in newspapers, textbooks, and novels had aways existed, even before I learned to read and write them, and their existence, as normal and obvious as the surrounding environment, I couldn't think of any reasons to start thinking about the basis for the shapes of the characters. When I saw characters that had been engraved on a seal, I thought that the shape of the character, which had been crumpled up to fit on the small, narrow stamp, was one that was written to correspond to the flavor of the medicine dispensed by the Korean herb medicine shop... On the other hand, the shapes and forms of the letters printed in newspapers or textbooks were so ideal that their shapes shouldn't be changed. Even after my interest in the typographic field had grown, it took me some time to realize the fact that these characterized shapes are based on the images experienced by a lot of cultures through their long histories..

book. characters, printing, and letter form of east asia. 210 x 297. 2011.

park ji-hoon

A letter is like water.

Letters have been constantly changing their shapes and forms to fit the molds of society. The ancient letters of Eastern Asia served as a record of communications with a god, and in the Middle Ages, was only commonly used among the privileged classes and in modern society, it is used as a tool for men with power to spread their ideologies. The factors that influence changes in the use of letters or characters are so varied that I can't easily note all of them here. Letters were used in ancient times and during the Middle Ages for the purposes of record keeping and was purposely kept difficult to maintain the elite status of those who could use them, in modern times however, characters have been simplified and useable by everyone, and importance was placed on the information they conveyed. In particular, the introduction of print media has eliminated the idea of letters and characters being only for authoritative figures, and resulted in various different types of character shapes to better suit mass production of printed text as well as to better convey information. Letters and characters in modern times have changed into a style that fits perfectly with the current flow of media and its use has spread among the general public even through the efforts of limited number of persons.

At this point I want to introduce the word "font."

If, as I mentioned earlier, that a letter is like water, or in other words, it is mobile and fluid and can alter its style and appearance depending on social circumstances, then from a typographical perspective, fonts are clear, flavorless and odorless, just like water. We neither read nor write characters in daily life, we only read and interpret messages. In cases like these, the central figure is not the letters or characters, but the information itself. Fonts are a visual element that exists between letters and information. It is a medium that exists to convert letters to information, but its effectiveness decreases as a medium the more we see it. Typography that is transparent like water, will never be able to establish itself solely through the ability of a designer. Above all, it has to consider the reader as well as the larger framework of society itself. In addition, the correct understanding of the shapes of letters can be obtained by focusing on the medium, the roots of the letters. When I was younger, my hands became used to writing the shapes of the various characters by writing lines along printed dotted lines in my "Disciplined Life" lessons. In calligraphy class the letters that we practiced were written by paying attention to the line guides and in the order presented in the textbook, and a manual-based style of writing was created. the shapes of the characters that I had memorized when I was younger were for personal reasons such as to become a future member of society, then the topics and fonts that I had repeatedly copied during my freshman years in college was training towards understanding the standards of media. I repeatedly wrote the most common Batang and Dotum fonts without rest, using the tip of my pen over and over until the letters were resetted into Zeroes, flavorless and transparent like water and odorless like water. A letter is the result of a relationship with a society, and gains life through media shared within that society. In addition, just as a person's senses adapt to the surrounding environment, the previously mentioned Zero standard will constantly change its axis depending on social framework.

The works that I have submitted to this exhibition is to realistically convey traditional media that has established the forms and shapes of the Chinese characters while introducing the use of letters and print media in East Asia. I hope that you will be able to understand that this is academic research for the understanding of letters, printing, and fonts in the culture of Chinese characters. It is also a message in order to understand the relationship between design and the environment that goes beyond a logical understanding of fonts, and the directionality of design, through the creation of an awareness of the relationship between print media, a waterway for information, and letters.

poster. characters, printing, and letter form of east asia. 278 × 456. 2011.

park ji-hoon

396

문자는 스스로 존재하지 않는다

가끔 떠오르는 신입생 시절 창피한 생각에 얼굴을 붉히고 만다. 미대에 입학한 나는 어떠한 과제도 충실히 열심히 하는 우수한 학생이었다. 어느 날 집에서 타이포그래피 수업의 과제로 한글 글꼴의 레터링 작업을 하고 있을 때 옆에 있던 동생에게 한소릴 들었다.

> "그런 글자들 컴퓨터 자판 치면 크게 해서 뽑을 수 있어. 그걸 뭐하러 자 대고 그리고 있냐?"
> '……그러게 나는 왜 이 글자들을 카피라도 하듯 하나하나 따라 그리고 있을까……'

슬프게도 당시의 난 아무 답변도 하지 못했다. 문자의 표정을 디자인한다는 의식이 좀처럼 이해가 안 됐던 것 같다. 당시 나의 의식 속에 문자란 아주 오래전부터 당연한 듯 본질적 형태를 갖추고 있으며, 어떠한 조건에서도 그 기본 모습은 고유하다는 인식이 강했다. 내가 글을 배우기 이전부터 존재했던 신문, 교과서, 소설 속의 글자들은 마치 자연환경과 같이 오래전부터 있었던 당연한 존재물로 그 형태의 근거에 대해서는 생각해야 할 이유조차 느끼지 못했다. 전서체를 보곤 좁은 인감(印鑑) 안에 구겨 넣기 위한 형태라 생각했고, 한약방 간판의 예서체는 한방 느낌에 걸맞게 하기 위함이란 정도로 생각했던 것 같다. 반면 신문, 교과서 등에 인쇄된 본문용 활자들은 그 형태를 의심해선 안 되는 가장 바람직한 모습이란 인상을 갖고 있었다. 이러한 자형들이 장구한 인간사회의 여러 문화와 접하며 정립된 모습들이란 사실을 알기까지는 타이포그래피 분야에 흥미를 갖고 난 이후로도 어느 정도의 시간이 필요했다.

문자는 마치 물과 같다

문자는 사회란 그릇에 적응하며 자신의 모습을 끊임없이 바꾸어왔다. 동아시아 고대의 문자는 신(神)과의 소통을 담은 기록이었고, 중세에 들어 신분사회의 특권으로 통용되었으며, 근대에 와서는 이데올로기의 전파를 위한 권력자의 목소리로 활용되었다. 목적의 변화가 문자의 쓰임에 끼친 영향은 이루 말할 수 없을 정도다. 고대, 중세 사회의 기록목적 문자가 특권유지를 위해 어느 정도의 난이도를 유지한 엘리트형 문자였다면, 정보로서의 가능성을 중시한 근대 이후의 문자는 누구에게도 알기 쉬운 자형을 요구받았다. 특히 인쇄매체의 등장 이후 문자는 더 이상 그 권위적 형태에 구애를 받지 않아도 되었고, 대량생산과 정보로서의 양질화를 목적으로 자형에 많은 양식화를 이루었다. 근대 이후의 문자는 매체라는 물길에 적합한 형태로 완벽히 모습을 탈바꿈했으며, 이 시기부터 문자는 일부 인간의 수고만으로도 그 모습이 사회 내에 공유되기 시작한다.

이쯤에서 글꼴이란 단어를 사용하고 싶다

앞서 언급한 물의 의미가 사회환경에 따라 모습을 바꿀 수 있는 유동성이라 설명한다면, 글꼴·타이포그래피의 측면에서는 물과 같이 맑은, 무미, 무취한이란 표현을 쓰고 싶다. 우리는 일상생활에서 문자를 읽지 않으며 문자를 쓰지도 않는다. 사고(思考)를 쓰고 메시지를 읽을 뿐이다. 이 경우 주인공은 문자가 아닌 정보이다. 글꼴은 문자와 정보 사이에 위치한 시각적 요소로, 문자를 정보화시키는 매개체이지만 그 존재감이 눈에 띌수록 매개체로서의 효율성은 마이너스가 된다. 물과 같이 투명한 타이포그래피란 결코 디자이너의 기량만으로 성립되지 않는다. 무엇보다 독자를 의식해야 하고, 사회라는 커다란 틀을 이해해야 한다. 또한 문자의 루트인 매체를 주시함으로써 바른 형태의 이해를 얻을 수 있을 것이다.

park ji-hoon

poster. characters, printing, and letter form of east asia. 278 x 456. 2011.

나는 어린 시절 바른생활 수업시간에 점선을 따라 쓰며 글의 형태를 손에 익혔고, 서예시간에 연습하던 해서체는 교과서에 실린 운필 순서의 안내선에 주목하며 붓을 움직이는 매뉴얼 작업으로 완성되었다. 이렇듯 어린 시절 사회의 한 인간으로서 자립하기 위한 개인적 이유로 문자의 모습을 암기했다면, 대학 신입생 때 반복했던 카피와 같은 과제는 글꼴이란 사회 공용 매개체의 표준을 이해하기 위한 훈련이었다 생각된다. 가장 일반적이었던 바탕체, 돋움체를 펜 끝으로 따르며, 물과 같이 무미하고 투명하며 공기와 같이 무취한 '0'으로의 리셋을 쉼 없이 반복했다. 문자란 사회와의 관계성에 의해서 빚어지는 결과물이며, 그 사회 내에서 공유라는 매개체에 의해 생명력을 얻는

park ji-hoon

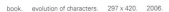

book. evolution of characters. 297 x 420. 2006.

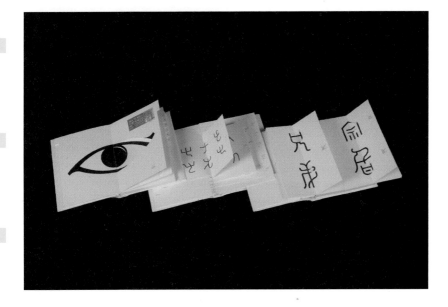

존재이다. 또한, 주변 환경에 인간의 감각이 적응하듯, 앞서 말한 0의 기준 역시 사회라는 틀에 따라 끊임없이 중심점을 바꿀 것이다. 이번 전시에 출품된 나의 작품은 동아시아의 문자사용 및 인쇄매체를 소개하는 과정에서 한자문화권의 자형을 정립시킨 전통매체를 사실적으로 어필하려 했다. 한자문화권에서의 문자, 인쇄, 글꼴의 이해를 위한 학술적 연구인 동시에, 정보의 물길이 되었던 인쇄매체와 문자의 관계성을 인식시킴으로써 문자형태의 논리적 이해, 디자인의 방향성, 이상을 넘어 디자인과 환경의 관계성을 재검토하고자 한 메시지로 이해해주길 바란다.

book. study of character policy in modern east asia. 210 x 297. 2008.

park.kum-jun.

korea

박금준.朴金準.

홍익대학교에서 시각 디자인을 전공했고, 동 대학원에서 광고홍보를 공부했으며 제일기획 아트디렉터, 홍익대학교 시각디자인학과 겸임교수를 역임했다. 현재 601비상 대표로 있다. 『캘린더는 문화다』, 『2note:시간.공간』, 『601 SPACE PROJECT』, 『둘,어우름』 등을 기획 출판했고, 2003년부터 8년 동안 '601아트북프로젝트'를 개최했다. 뉴욕 아트디렉터스클럽(ADC) 금상, 독일 레드닷디자인 어워드 Best of the best 4회, I.D. 애뉴얼 디자인 리뷰 그래픽부문 최고상(Best of Category), 타이완 국제 포스터어워드 금상(2009), 트르나바 국제 포스터트리엔날레 특별상(2009), DFA Award 2010 그랜드어워드(Grand Awards) 등 많은 국제디자인상을 수상했으며 여러 전시에 참여해왔다. 현재 국제그래픽연맹(AGI) 회원이다.

park kum-jun

400

calendar poster. 365&36.5 communication. 520 x 710. 2011.

Park Kum-jun graduated from Hongik University, Department of Communication Design, and received his Master's degree in advertising and public relations from the same university. He lectured on visual communication design at Hongik University from 1999 to 2005, and worked as an art director at an advertising agency, Cheil Communications. He is now the president and creative director of 601Bisang. He has planned and designed a variety of art books, including "Calendars are Culture", "2note:time.space", "601 SPACE PROJECT", and "Eoureum-the uniting of two". Between 2003 - 2010 he has organized and hosted the '601 ARTBOOK PROJECT.' He participated in various exhibitions both domestic and international, and has won many awards in international design competitions, including New York Art Director's Club - Gold Medal (2002), Silver Medal (2009); Red dot Award - Best of the Best (2007, 2009, 2011); I.D. Annual Design Review - Best of Category: Graphics (2009); Taiwan International Poster Design Award - Gold Medal (2009); Design for Asia Award - Grand Award (2010); Trnava International Poster Triennial - Special Award (2009). He is also a member of AGI since 2008.

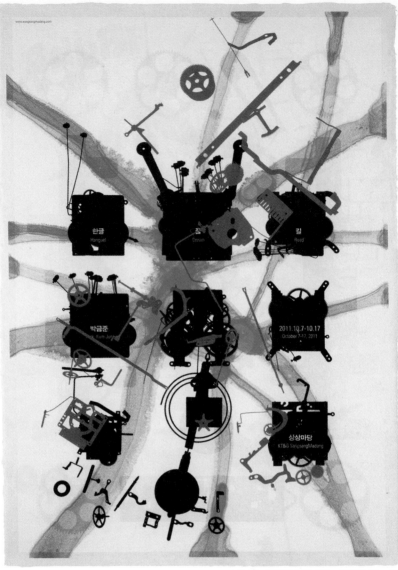

한글
Hanguel

꿈
Dream

길
Road

박금준
Park Kum Jun

2011.10.7-10.17
October 7-17, 2011

상상마당
KT&G SangsangMadang

poster. hangeul. dream. path. 1,001 x 1,450. 2011.

park kum-jun

I cannot say exactly when and how my work begins or ends. Sometimes I become inspired by discarded objects I pick up from the street or by long forgotten articles I had shoved into a drawer. Sometimes I return to square one after struggling through a series of experiments, instead of arriving at a conclusion. However, I am always prepared to embrace the new. I take pleasure in overcoming the challenges that arise through different steps of design development and relish the excitement of the creation site. I prefer designs that give off a spontaneous, non-calculated feel. Water, earth, rocks and other elements of nature that build up layer after layer with the passing of time captivate me. It is a painstaking but rewarding job to fathom the depth of nature, explore the harmony of yin and yang in nature,

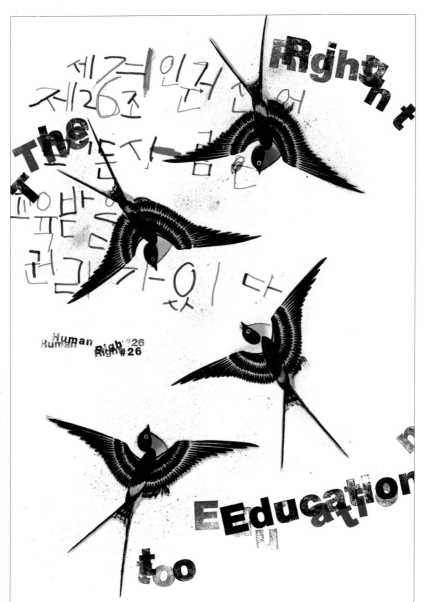

402

poster.　human rights.　1,050 x 1,500.　2011.

and re-create its subtle sentiment.　　　　　　　　　　　　　　　I make sure
to stay focused on the concept that served as my starting point while trying to adopt different
approaches and employ different techniques. I believe design is about executing the solid ba-
sic concept and delivering messages of truth, not just putting up a good front. Typography is a
centrifugal force of my work that serves as an important symbol. It embodies the aesthetics
of interactive relationships. I dismantle or reassemble them as I please and strive to convey
who I am – sometimes like an architect and sometimes like a painter.＿＿＿＿＿＿＿＿
＿＿＿＿＿＿＿＿＿＿＿＿＿＿＿＿＿＿＿＿＿＿＿＿＿＿나의 작업은 늘 시작과 끝이
분명치 않다. 언젠가 주워온 길거리 쓰레기에서 시작되기도 하고 케케묵은 서랍 속 여러 도구들에서 또 다른 시

제17회 인천아시아경기대회 ┃ 2014.9.19-10.4

INCHEON 2014

poster. the asian games incheon 2014. 594 x 841. 2011.

작을 보기도 한다. 다양한 실험을 하면서 완성인 줄 알았던 작업이 다시 원점으로 돌아오는 경우도 있지만, 언제
든지 새로움을 받아들일 준비가 되어 있다. 내게는 그 모든 과정과 현장이 즐겁고 또한 여유롭다. 나는
손맛 나는 작업이 좋다. 물이나 흙, 오랜 세월의 퇴적처럼 켜켜이 쌓인 자연의 형상에는 마력이 있다. 내면 깊숙이
감춰진 깊이와 사색, 자연과 맞닿아 있는 음양의 조화. 여기에 깃든 미묘한 감정을 살려내는 일은 쉽진 않지만 즐
거운 탐색이다. 매번 다른 방법과
접근을 시도하면서도 '왜'라는 물음을 통해 초점이 흐트러지지 않도록 경계한다. 예쁘게 잘 꾸민 껍데기가 아닌
콘셉트의 힘, 메시지의 진정성을 믿기 때문이다. 타이포그래피는 작업의 중요한 조형이자 상징이고 소통하는 관
계의 미학이다. 내 방식대로 해체하고 조합하면서 때론 건축처럼 때론 회화처럼 나다움을 표현할 수 있는 가능성
을 찾고자 한다.

park kum-jun

poster. bless china. 760 x 1,118. 2008.

poster. vidak 10th anniversary. 930 x 1,310. 2004.

poster. ballerina who loves b-boyz. 700 x 1,000. 2008.

poster. 601artbook project. 700 x 1,000. 2008.

poster. 601artbook project. 700 x 1,000. 2006.

park woo-hyuk

Design: Jin Dallae · Park Woohyuk - 2011

종 김수영 풀이 눕는다 비를 몰아오는 동풍에 나부껴 풀은 눕고 드디어 울었다 날이 흐려서 더 울다가 다시 누웠다
풀이 눕는다 바람보다도 더 빨리 눕는다 바람보다도 더 빨리 울고 바람보다 먼저 일어난다
날이 흐리고 풀이 눕는다 발목까지 발밑까지 눕는다 바람보다 늦게 누워도 바람보다 먼저 일어나고 바람보다 늦게 울어도 바람보다 먼저 웃는다 날이 흐리고 풀뿌리가 눕는다

poster.　manifesto.　728 x 1,030.　2011.

나의 디자인엔 언제나 사람이 있었다

박우혁.朴遇赫.

홍익대학교와 스위스 바젤디자인대학교에서 그래픽 디자인과 타이포그래피를 공부했고, 최근 홍익대학교에서 〈한글 타이포그래피〉로 박사학위를 받았다. 디자이너 진달래와 함께 디자인 스튜디오 타입페이지를 운영하고 있으며, 국가인권위원회, 인권정책연구소, 아르코미술관 등의 여러 단체와 함께 사회·문화와 관련된 다양한 디자인과 작업을 하고 있다. 이외에도 미대에서 타이포그래피를 강의하고 있으며, 『A Diary』, 『스위스 디자인 여행』 등의 책을 펴냈다.

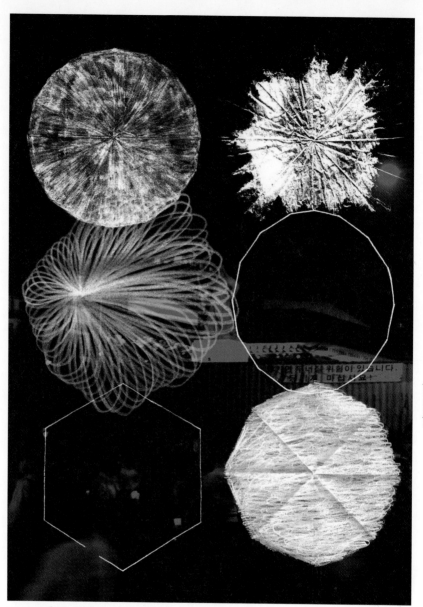

park woo-hyuk

poster.　manifesto.　728 x 1,030.　2011.

There was always a human being in my design works.

park.woo-hyuk. korea

Studied graphic design and typography at Hongik university. Seoul, Korea and Hochschule fuer Gestaltung und Kunst Basel, Switzerland. Recently, he earned a Ph.D. in Hangeul typography at Hongik university. Park is working in design studio, TypePage with his partner, Jin Dallae and participating in variable kinds of social and cultural events with National Human Rights Commission, Korea Human Rights Policy Institute, Arko Art Center, etc. He is teaching typography at several schools and has written the books such as <A Diary> <Switzerland, design and travel>.

book.　　p1 dark hole.　　220 x 295.　　2010.

park woo-hyuk

408

인터뷰	Y	mixrice
A	Z	nahyun
B	1	o
C	2011	p
D	3.22 TUE.-	q
E	4.20 WED.	r
F	5	sooyoung lee
G	6	tacy iohc
H	7	u
INTERVIEW & ARTISTS AS AN INTERVIEWER		
J	8	v
K	9	w
L	0	x
M	a	yeondoo jung, youngho lee
N	b	z
O	c	
P	d	
Q	e	
R	flyingcity	
S	gimhongsok	
T	heungsoon im, hyejeong cho	
U	i	
V	jinjoon lee	
W	kyongju park, kyungwoo chun	
X	l	

book.　　interview & artists as an interviewer.　　210 x 297.　　2011.

newspaper. takeout drawing newspaper. 297 x 420. 2008 - 2011.

대학로 1 0 0 번지

2009
아르코
미술관
기획전

100 Daehangro

한국문화예술위원회
아르코미술관
제 1, 2 전시실

2009.
5. 22-
7. 5

Arko Art Center
Arts Council Korea

Opening

2009

5. 21

목 Thur.

6:00 pm

410

관람시간
11:00 am - 8:00 pm
매주 월요일 휴관
Closed on Mondays

관람실명
전시기간 중
 · 오전
2:00 pm
4:00 pm
 · 오후
2:00 pm
4:00 pm
6:00 pm

교육프로그램 및
다양한 부대 행사
관련 일정 등
자세한 내용은
아르코 홈페이지를
통해
확인하시기
바랍니다.
www.arkoartcenter.or.kr
02 760 4602

구동희 김구림 김승영 김수범 김을 김장섭 김호득 민성기 박기원 박불똥 박용석 박주연 박현기 Sasa[44] 슬기와민 성능경 윤사비 윤영석 이건용
이미경 이미혜 이승택 임동식 장진영 주재환 책읽는홍 홍경택 made-community(성기완 ps 부추라마)

한국문화예술위원회
아르코미술관
서울시 종로구 대학로 100
(110-706)

Arko Art Center
Arts Council Korea
100 Daehangro
Jongno-gu
Seoul, Korea
110-706

Tel. +82-(0)2 760-4850~2
Fax. +82-(0)2 760-4758

www.
arkoartcenter.or.kr

design
Typo Page /
park
woo
hyuk



park woo-hyuk

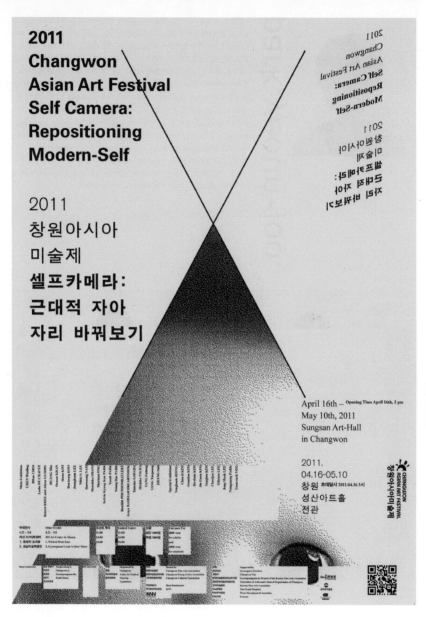

park woo-hyuk

박연주.朴蓮珠.

park.yeoun-joo.
korea

박연주는 서울을 기반으로 활동하는 그래픽 디자이너다. 홍익대학교와 런던 왕립미술대학에서 공부했으며, 이후 다양한 디자인 작업을 해오고 있다. 특히 여러 디자이너, 작가들과 함께하는 작업을 즐기며 베반패밀리, 헤적프레스 등을 조직했고 최근에는 노멀타입, 가게오게 워크숍 등과 협업하고 있다. 그녀는 불확실성/불완전, 부조리, 모순과 유머 등에 관심이 많으며, 현재 홍익대학교, 건국대학교 등에서 강의하고 있다._____Park Yeoun-joo is a Seoul based graphic designer. She studied at Hongik University, Seoul and the Royal College of Art, London. Since she graduated from the RCA in 2006, she has worked various design projects. She founded Vaeban Family in 2008 and Hezuk Press in 2010. Her main interest is 'uncertainty/incompleteness', 'the absurd', 'paradox' and 'humour'. Working in Hezuk Press, she currently collaborates with Normal Type and Come & Go Workshop and teaches at Hongik and Konkuk University.

park.yeoun-joo

412

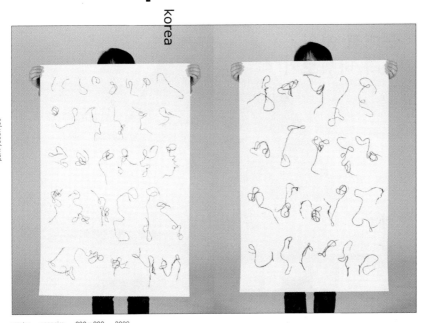

poster. yangsim. 600 x 900. 2008.

413

poster. untitled. 760 x 1,030. 2011.

414

poster. untitled. 760 x 1,030. 2011.

park yeoun-joo

poster. untitled. 760 x 1,030. 2011.

416

installation.　nal tteuda.　2008.

poster.　the adventure of mr, kim and mr, lee.　600 x 900.　2010.

Representative of Welle Design corporation. Born in Kobe City, Hyogo, 1970. Graduated from Visual Communication Course in Kobe Design University. Employee of Sony Corporation 1993-1996. His first job was to design operation manuals for Sony products. In 1996, Sakano began working in Sugiura Kohei's design office so that he could work on book design. He got a job to direct the production of textbook in 2003, which became the trigger to start his own office. Soon after that Sakano got the opportunity to design a book written by Natsuhiko Kyogoku and shifted more to book design. Currently he designs about 150 books per year.

sakano.koichi. japan

사카노.코이치.坂野公一.

418

book. asia honkaku league. 128 x 188. 2009 ~ 2010.

1970년 효고현 고베시에서 태어났다. 고베예술공과대학 시각정보디자인학과를 졸업한 후 1993년부터 소니에서 제품 취급설명서 디자인을 담당, 플레이스테이션, 워크맨, 비디오레코더 등의 매뉴얼 포맷 개발 및 레이아웃을 맡았다. 1996년부터 그래픽 디자이너 스기우라 코헤이에게 사사받으며 동경했던 북 디자인 세계에 입문했다. 2003년 『과학 교과서』 디렉션 의뢰를 받아 독립, 그 후 작가 교고쿠 나쓰히코의 작업을 하며 북 디자인을 주축으로 활동하기 시작했다. 문예서, 문고, 소설집, 만화 커버 등 현재 연간 150권의 북 디자인을 하고 있으며 Welle Design 대표이다.

sakano koichi

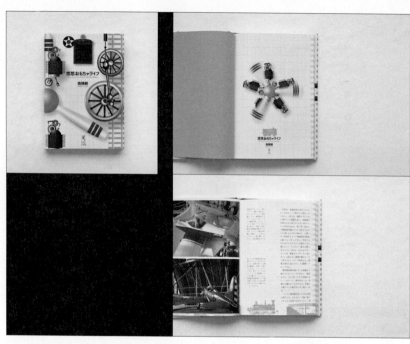

book. the leisurely life with toys models. 135 x 195. 2006.

419 Welle Design covers book design, editorial design, illustrations, and diagrams. "Welle" is a German word that means wave and represents my will to harmonize with people, to have a strong and sturdy German craftsman spirit, and to be a universal existence like waves. To design at ease like being floating on the sea is ideal and I would be able to work more frankly that way. Both society and design are not simple enough to make me believe that "simple is the best." Is grid so important? I want to find wonderful photos and illustrations. My brain works in different ways depending on what I deal with. My left and right brains are crossing over with each other? Using favorite fonts makes me feel comfortable and is the driving force of my design. How big is the power of letters! Stuck and buried under the pile of drafts. Am I enjoying it too much? Can I read the space between the sentences even if it is just a space? Am I creating works of art? Can I dare say, "I am creating?" Do I care about the sales of the books I designed? Does the book design have effect on sales? Should I use big letters for title to increase sales? How many people would buy books by jacket design? The only person I can ask opinions for is myself who is still up in the midnight. Client is waiting, writer is expecting. Soon morning comes. I am well aware of inconsistency and have already passed the age to be indecisive. I got techniques through experiences. I have my own experiences and the words from my teacher, "Do not do what is not necessary," "Think simply." They will solve my problems. To continue is a power. Coincidence is not impure. Remember the handwriting by Mr. Helmut Schmidt, the logo mark of Welle design. It gives me power, doesn't it? Rin, the black cat, brings me peace. The last thing that would help me is my own techniques. Days pass like this....

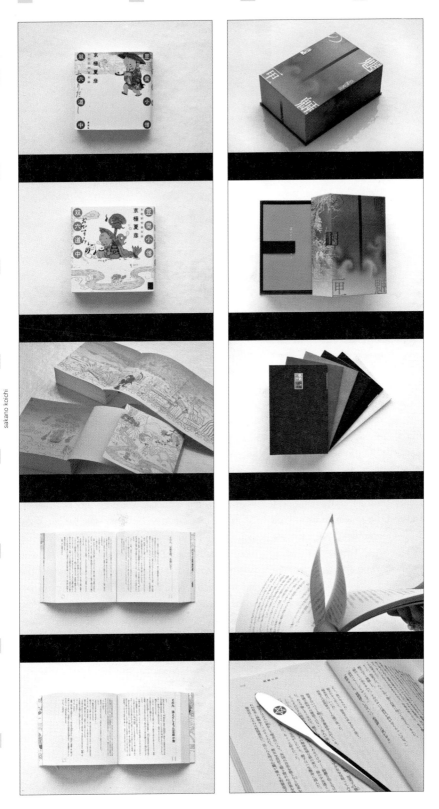

420

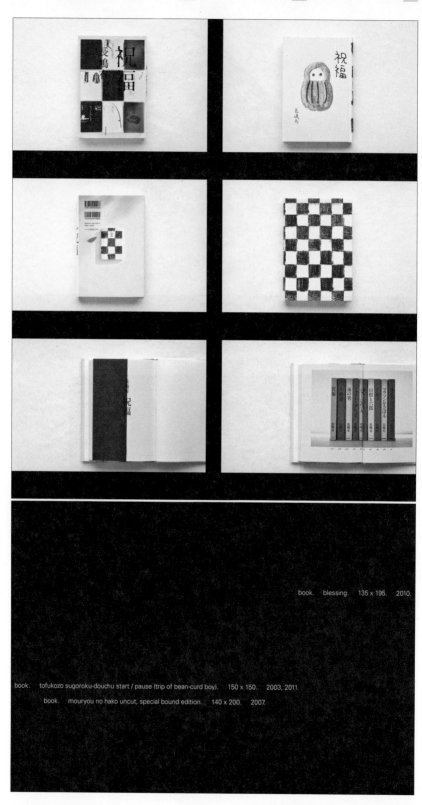

421

book. blessing. 135 x 195. 2010.

book. tofukozo sugoroku-douchu start / pause (trip of bean-curd boy). 150 x 150. 2003, 2011.

book. mouryou no hako uncut, special bound edition. 140 x 200. 2007.

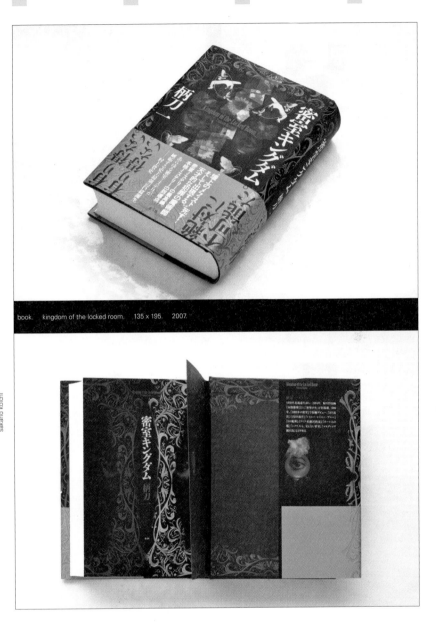

book. kingdom of the locked room. 135 x 195. 2007.

Welle Design은 장정, 북 디자인, 편집 디자인 및 그와 관련된 일러스트나 다이어그램 작업을 중심으로 활동하는 디자인 사무실이다. 'Welle'란 독일어로 '파도'란 뜻으로 커뮤니케이션에 관한 내 입장은 사람과의 조화를 중히 여기는 것이며, 창작에 대한 입장은 독일 사람들의 질실강건(質實剛健)한 장인정신을 동경한다. 끝없이 밀려오는 파도처럼 보편적인 존재이고 싶다. 그러한 마음을 담아 회사 이름을 'Welle Design'이라 지었다. 둥실둥실 파도에 떠다니는 것처럼 마음 편히 디자인하는 것이 Welle Design 이념이다. 그러는 편이 주문을 솔직하게 받아들일 수 있을 것이다. 늘 거기서부터 시작할 수 있도록 이렇게 이름을 지었다. 세상도, 디자인도 당연히 그렇게 단순하지 않다. 때문에 'Simple the Best'에 동의하지 않는 편이다. 이제 그리드를 고집하던 시기를 벗어난 것 같다. 과연 그렇게까지 연연해야 하는 것일까? 멋진 사진을, 일러스트레이션을 만나고 싶다. 타이포그래피와 비주얼을 다룰 때 서로 다른 뇌를 쓰는 것 같다. 우뇌와 좌뇌를 왕래하듯. 좋아하는 글꼴을 쓰면 그것만으로도 기분이 좋다. 그 좋은 기분이 내 디자인 추진력이 된다. 문자가 가지는 힘이 얼마나 큰 것인가. 의미적으로도 시각적으로도. 매일 도착하

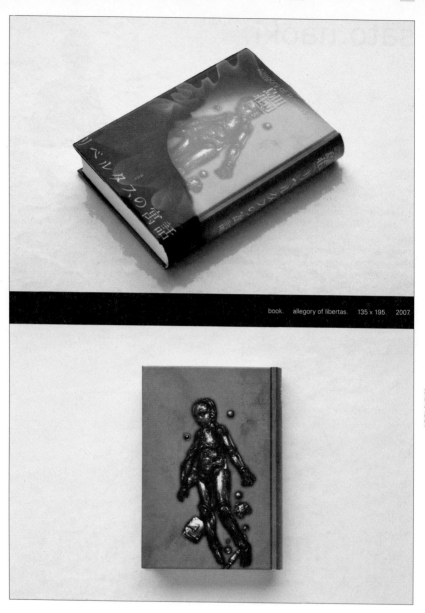

book. allegory of libertas. 135 x 195. 2007.

sakano koichi

는 교정지 산더미에 묻혀 스토리를 좇다 보니 수렁에 빠진다. 내용을 너무 즐기는 걸까? 사실은 몰입하지 못한 것일까? 행간이나 읽을 수 있는 것일까? 단지 공백일 뿐인데. 내가 만들고 있는 것은 작품일까? 만들고 있다니 주제넘은 표현인가? 장정한 책이 팔릴지를 걱정하는가? 장정이 책 매출에 영향을 줄까? 팔리기 위해서는 타이틀을 키워야 하나? '책 표지를 보고 사는 사람'은 총인구의 몇 퍼센트에도 미치지 않을 터. 상의할 수 있는 것은 한밤중에 깨어 있는 나뿐. 클라이언트가 기다리고 있다. 작가가 기대를 걸고 있다. 곧 동이 튼다. 모순이라는 것은 알고 있다. 게다가 방황할 나이는 지났다. 경험의 집적이 기술을 축적하고 날카롭게 갈고 닦는다. 지금까지 쌓은 경험과 스승이 자주 하던 말이 있지 않은가. "쓸데없는 일은 하지 마라", "단순하게 생각하라". 보라, 역시나 쓸데없는 일을 하고 있다. 그것을 모조리 싹 잘라버리면 문제는 해결될 것이다. 계속은 힘이다. 우연은 불순한 것이 아니다. 헬무트 슈미트가 써준 Welle Design 로고를 떠올리자. 힘이 솟아오르지 않는가? 검은 고양이 린이 위안을 준다. 그리고 역시 최후에 자신을 구하는 것은 기술뿐이다. 그러한 잡생각을 반복하면서 세월이 지나간다.

sato.naoki. ^{japan}

사토.나오키.佐藤直樹.

Majoring in the Sociology of Education and the Sociology of Language at Hokkaido University of Education and Shinshu University, Sato undertook research into education in remote rural areas. He went on to study painting under the artist Kikuhata Mokuma, as well as undertaking the self-study of graphic design. In 1994 as the art director of <WIRED JAPAN> he developed unique experiments previously unseen in Japan in the full desktop publishing of the magazine. In 1997 he founded the design company ASYL design inc. (now ASYL inc.) and while providing the editorial design for composite, ART iT, DAZED&CONFUSED JAPAN, undertook work in graphic design in many fields including music, fashion and architecture (including work for Ken Ishii, Kosuke Tsumura, Final Home, Atelier Hitoshi Abe). In 2001 he founded the broadsheet graphic paper 'NEUT'. In 2003 he initiated the project Central East Tokyo, taking East Tokyo as its stage and utilizing unoccupied buildings for various creative events, leading to the establishment of artist studios, design offices, cafes etc, and gaining much media attention. Sato is associate Professor of Tama Art University, art director of Tokyo 'FESTIVAL/TOKYO', design director of independent art centre 3331 Arts Chiyoda, art director of 'Little Tokyo Design Week', art director of 'Japan Media Arts Festival'.

sato naoki

424

poster. 3331 arts chiyoda. 594 x 841. 2010.

홋카이도교육대학 및 신슈대학에서 언어사회학을 전공, 주로 벽지교육(僻地教育)을 연구했다. 그 후 미술가인 기쿠하타 모쿠마에게 회화를 배웠으며, 그래픽 디자인은 독학했다. 1994년 〈WIRED JAPAN〉의 아트 디렉터로서 일본에서 전례가 없던 상업지의 전면적인 DTP 인쇄를 시도하여 실험적인 지면을 선보였다. 1997년부터 디자인 회사 ASYL을 열었고 〈Composite〉, 〈ART iT〉, 〈DAZED&CONFUSED JAPAN〉 등의 편집 디자인을 맡아 음악, 패션, 건축 등 다양한 장르와 관련된 그래픽 디자인 작업을 추진해왔다. 2001년 그래픽 잡지 〈NEUT〉를 창간하여 스스로 기획·편집을 진행했다. 2003년부터 산업 구조 변화로 공동화된 도쿄 동부 지역의 빈 빌딩이나 공터를 이용해 이벤트를 마련하는 〈센트럴 이스트 도쿄〉 프로젝트를 시작했다. 2005년부터 다마미술대학 부교수직을 맡고 있으며, 〈페스티벌 / 도쿄〉 아트 디렉터, 민간 아트센터 3331 Arts Chiyoda의 디자인 디렉터, 〈리틀 도쿄 디자인 위크〉나 〈문화청 미디어예술제〉 등의 아트 디렉터를 역임하고 있다.

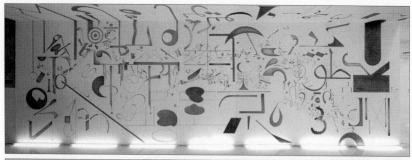

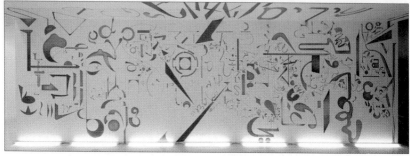

佐藤直樹 大原大次郎

文字と即興

IMPROVISED TEXT

425

book. improvised text. 180 x 180. 2010.

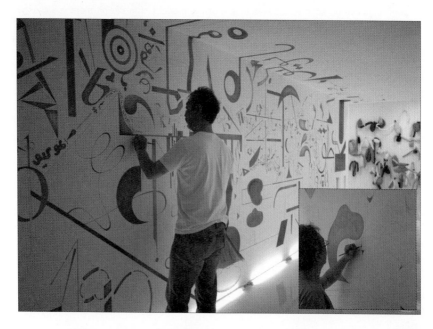

The old and new of graphic design

Graphic design is a field which is always in transition. There is never a condition of perfection when everything is complete. There is always something which is lacking, or something in excess. It is a difficult territory to tread. Whatever the design it soon becomes dated. However there is some design which survives through history, a design which still shines despite being past the fashion. Many designers must aspire towards such, wanting to be linked with the great designers of the past. Yet I believe we should question the very concept of the history which gives rise to such thinking, history being something which comes into being only after its contextualization. There are numerous designs which have not and will not leave their name in history but have an important meaning in everyday life. It is this which I have most interest in. The dilemma, persisted by capitalism, in which the pursuit of the new soon becomes old, is something we cannot escape from.

Japan graphic design today

Recently in Japan there has been a significant increase in graphic design which seems to have a message of holding no interest in the new, and it is here that one can really sense the present age, yet the reproduction of this message in print and on screen is limited to the current fashion, limited to a design which is simplified and given the taste of the retro. In one sense this is a good thing but also it is problem. It can create a situation whereby designers and their associates have a great enthusiasm for something, but this fails to reach the general public. From now on we have to imagine Japan where the population of people of all different backgrounds will continue to increase and lead to further frictions and crossovers.

The next stage

There is no form of graphic design which is appreciated by everyone throughout the world, and while I have no wish to return to pre-imperialist times, I have no wish to make such design. Fundamentally culture is a vernacular. But modernism has rejected this and contemporary graphic design is an extension of this line. Rather than being a vernacular my current undertakings can be seen as a displacement of the modern. If in design there is a change from the modern to the contemporary then perhaps we face the problem of awareness towards such a shift. But we must also face the next stage. The wave of globalization continues to grow through the internet and information age. Amongst this the important values of each region are reassessed, they do not stagnate but are reformed and call upon a form of chaos that lies above borders, taking on a different energy, and it is possible to imagine such a design which reflects this.

sato naoki

book. nomadism. 128 x 182. 2007.

book. the next media. 128 x 188. 2009.

A new form of public

As designers we must question the meaning of our existence from its very foundations and make every effort towards regeneration. Graphic design is a field which has gained much strength through its popularization, but many designers still think that the public are simply the receivers of information. We must rethink such an attitude. We have to consider communication, the vernacular of regional cultures and small communities, which make up the layers of contemporary society, here lies an opportunity for design, graphic design and of course typography. We must search for the next form after the mass production of consumer capitalism.

sato naoki

t-shirt. ensembles. 1,080 x 780. 2009.

그래픽 디자인의 새로움과 낡음

그래픽 디자인은 늘 과도기에 있는 장르라고 생각한다. 완벽하게 완성되어 '이것이 최상'이라고 말할 수 있는 일은 결코 없다. 언제나 무언가 부족하거나 무언가 과도하므로 대단히 고민스러울 수밖에 없다. 어떠한 디자인도 곧바로 옛것이 되어 버린다. 물론 역사에 남는 디자인은 존재한다. 아무리 제철이 지나도 찬란히 빛나는 디자인. 그런 디자인을 하고 싶다고 많은 디자이너들이 생각하는지도 모른다. 과거의 위대한 디자이너 무리에 나도 끼고 싶다고. 그러나 나는 여기서 상정된 역사 개념 자체에 의구심을 품어야 한다고 생각한다. 역사란 모두 후대에 맥락화된 것으로 역사가 되는 것이다. 역사에 이름을 남기지 않더라도 생활 속에서 의미가 있는 디자인은 무수히 많다. 나는 오히려 그런 것들에 관심이 많다. 자본주의에 종지부가 찍히지 않는 한 '새로운 것을 추구하기 때문에 옛것이 되는' 딜레마에서 헤어 나올 수는 없을 것이다.

현재의 일본 그래픽 디자인

요즘 일본에서는 '새로운 것에 관심이 없다'는 것 자체가 메시지가 된 듯한 그래픽 디자인이 많아졌다. 인쇄되거나 모니터에 표시되어 있는 시점에서 그것도 이미 일종의 유행이라고 봐야 할 것이다. 그저 심플하게 해봤을 뿐. 그저 레트로 분위기를 풍길 뿐. 그것은 어찌 보면 행복한 일이지만 다른 의미에서 보면 문제라고 생각한다. 디자이너나 지망생들이 열광하고 일반 사람들에게는 와 닿지 않는, 그런 세계가 분명히 있다. 앞으로는 일본에도 다양한 문화적 배경을 가진 사람들이 많아질 것이기에 더욱 마찰이 일어나고 섞여나가는 그 말로 또한 상상해야 하지 않을까.

다음 스테이지

애초에 전 세계 사람들이 모두 '좋다'고 느끼는 그래픽 디자인 같은 것은 존재하지 않고 존재하지 말아야 한다고 나는 생각한다. 다만 그렇다고 해도 제국주의가 석권한 19세기 전으로 세계가 돌아갈 수는 없는 일이다. 본래 문화라는 것은 토착적이다. 그러나 모더니즘은 그것을 배제해왔다. 현재 그래픽 디자인은 아직 그 연장선에 있다. 지금 내가 하는 것은 토착적인 것보다 모던한 것을 뒤트는 행위라고 할 수 있다. 디자인에 모던에서 컨템포러리로의 변화가 있다면 그 의식(意識)의 문제가 아닐까. 그러나 우리는 거기서 멈춰 있을 수 없다. 다음 스테이지로 가야만 한다. 정보 처리 능력의 비약적인 향상이나 인터넷 보급에 의해 세계화의 기운은 더욱더 가속화될 것이다. 그 속에서 지역마다 존중되어 온 가치를 재평가하고 동시에 그것들을 거침없이 혁신적으로 다루며, 더 나아가 경계 선상의 혼돈을 끌어들여 또 다른 활력을 낳는 그런 디자인을 상상하는 것은 가능할까.

magazine

design no hikidashi.

182 x 257

2010

sato naoki

새로운 '공공(Public)'의 형태

우리의 존재 의의를 근본부터 의심하면서도 재생할 수 있는 힘을 길러야 한다. 그래픽 디자인은 본래 대중화 흐름 속에서 힘을 키워온 분야지만 많은 디자이너들은 아직도 대중을 그저 정보의 수신자로만 바라보고 있다. 거기서부터 다시 생각해야 한다. 즉 교신(交信) 부분이다. 세계 각지의 토착적 예술에는 그것이 갖춰져 있었다고 생각한다. 사람에게 꼭 맞는 작은 커뮤니티였기에 가능했을 것이다. 지금은 단순히 그 상태로 돌아갈 수는 없다. 그러나 작은 커뮤니티라는 의미에서는 지금도 그렇게 불러야 할 계층이 현 사회에 다수 존재한다. 세분화라고 부정적으로 표현되기도 하지만 디자인 및 그래픽 디자인의 활로는 거기에 있을 것이다. 물론 타이포그래피도 그 안에 포함된다. 어찌됐든 대량 생산 대량 소비적인 자본주의의 '다음' 모습을 그리며 살펴가는 수밖에 없다.

commercial complex brochure.　the curated mag.　210 x 297.　2007.

sato naoki

사와다.야스히로.澤田泰廣.

sawada.yasuhiro.

japan

Sawada Yasuhiro was born in Tokyo in 1961. He graduated in Design Course from the Faculty of Fine Arts at Tokyo University of the Arts in 1985. After working in the advertising department at Suntory, he has run the Yasuhiro Sawada Design Studio since 1989. He plays active roles in the fields of graphics, advertising, book design, packaging, and textile as art director and graphic designer. Alongside this, Sawada is also a professor at Tama Art University. Among his numerous awards won to date are New York ADC Silver Prize, International Poster Triennial in Toyama Bronze Prize, Tokyo ADC Grand Prize, ACC Producers' Prize, Tokyo ADC Award, Japan Magazine Advertising Awards Gold Prize, Tokyo TDC Silver Prize, JAGDA and New Designer Award. He had many solo and group exhibitions in Tokyo, Kuala Lumpur, São Paulo, Hong Kong, Munich and so on including <P2>, <Close-up of Japan Kuala Lumpur 1991>, <Amnesty International Poster Exhibition>, <LIFE>, <Close-up of Japan São Paulo>, <Today's Japan-Design Sampling '95>, <100 Japan Plakat 20 Tevezotol>, <4 from Tokyo Poster Exhibition>, <The Scene of Design>, <Graphic Wave 2002>, <SEVEN>, <Japanische Plakatdesign>, <Graphic Trial vol. 1>. His publications include <Design by Yasuhiro Sawada>, <Graphic Wave 7>. Sawada is a member of AGI, JAGDA and Tokyo TDC._____1961년 도쿄에서 태어났다.
1985년 도쿄예술대학 미술학부 디자인과를 졸업한 후 주식회사 산토리 광고제작부를 거쳐 1989년 사와다야스히로 디자인실을 열었다. 그래픽, 광고, 책, 패키지, 텍스타일 등의 영역에서 아트 디렉터 및 그래픽 디자이너로 활동하고 있으며, 다마미술대학 교수다. 그의 작업은 1988년 뉴욕 아트디렉터스클럽(ADC), 2003년 세계 포스터 트리엔날레, 1989년 도쿄 ADC상, 일본잡지광고상, 도쿄 타이프디렉터스클럽(TDC), 1993년 일본그래픽디자이너협회(JAGDA) 등에서 수상했다. 도쿄, 쿠알라룸푸르, 홍콩, 부다페스트, 뮌헨 등지에서 전시회를 가졌으며, 주요 전시로는 〈P2〉(1991), 〈클로즈업오브저팬 쿠알라룸푸르〉(1991), 〈클로즈업오브저팬 상파울루〉(1995), 〈앰네스티 인터내셔널 포스터전〉, 〈라이프〉(1984), 〈투데이저팬 디자인샘플링〉(1995), 〈100 Japan Plakat 20 Tevezotol〉(1997), 〈4 프롬도쿄 포스터디자인〉(1997), 〈디자인의 풍경〉(2001), 〈그래픽웨이브 2002〉, 〈세븐〉(2005), 〈Japanische Plakat Design〉(2005), 〈그래픽트라이얼 vol. 1〉(2006), 〈DNP 그래픽디자인 아카이브 소장품전〉(2009)이 있다. 저서로 『사와다 야스히로의 디자인』, 『그래픽 웨이브 7』이 있으며, 현재 국제그래픽디자이너연맹(AGI), 일본그래픽디자이너협회(JAGDA), 도쿄 TDC 회원이다.

sawada yasuhiro

430

poster.

kosaka giken co.,ltd.. 728 x 1,030. 2007.

poster. graphic wave 2002. 1,030 x 1,456. 2002.

poster. the design spirit of japan. 1,030 x 1,456. 2001.

sawada yasuhiro

poster. gallery sugie. 728 x 1,030. 2005.

GALLERY SUGIE
6-11-14 Ginza, Chuo-ku Tokyo
104-0061 Japan
Tel.03-5537-3731
Fax.03-5537-5112
sugie@gallerysugie.com

GALLERY SUGIE
6-11-14 Ginza, Chuo-ku Tokyo
104-0061 Japan
Tel.03-5537-3731 Fax.03-5537-5112
sugie@gallerysugie.com

sawada yasuhiro

432

poster. graphic trial vol.1(black). 728 x 1,030. 2006.

Even though its value may be disagreed on from time to time, I believe that there is an important social responsibility as a designer to present people with hope.

433

poster. graphic trial vol.1(white). 728 x 1,030. 2006.

We have lost where to go in the face of an uncertain future and are threatened by the shadow of anxiety. That's why, even more so today, design – is the act of hope – which should bear fruit on a strongly rooted tree of its will.

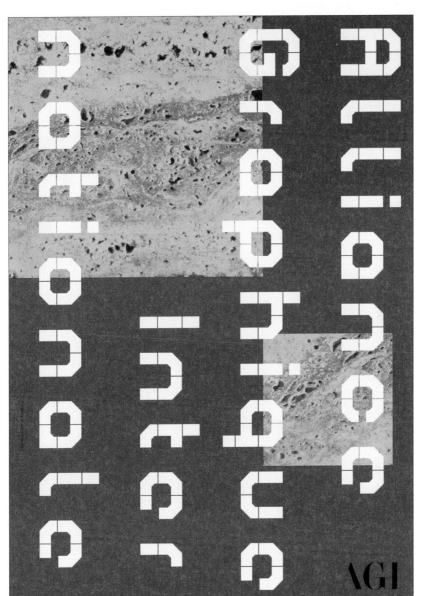

sawada yasuhiro

434

poster. agi. 728 x 1,030. 2006.

시대에 따라 그 가치가 어떻게 논해지든 디자인은 사람들에게 희망을 보여주는 사회적으로 소중
한 측면이 있다고 생각한다.

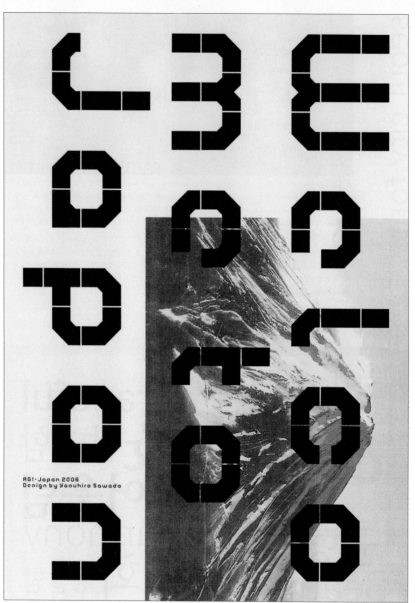

435

sawada yasuhiro

poster. welcome to japan / agi. 728 x 1,030. 2006.

지금 인간의 미래는 방향성을 잃고 불안이라는 큰 그림자로부터 위협받고 있다. 그래서 더욱 디자
인이라는 희망의 행위는 뿌리를 잘 내린 의지 있는 나무에 많은 신선한 열매를 맺어야 한다.

seoul.city.font.

korea

서울체

In September 2008, Seoul metropolitan city developed and unveiled the original typefaces named "Seoul Nan-San-che" and "Seoul Han-Kang-che" to build up the brand of Seoul city. In 2007, Seoul was selected as world design capital of 2010 by International Centre for Settlement of Investment Dispute (ICSID). There started the projects around designing the nature of Seoul city, the original typeface was made in such context._____2007년에 '2010 세계 디자인 수도'로 선정된 서울시는 디자인 도시로서 서울의 아이덴티티를 확립하고, 친절하고 깔끔한 도시 이미지를 형성, 유지하기 위하여 서울 서체 프로젝트를 시작하였다. 이어 2008년 8월 서울시청이 공개한 '서울 남산체' 와 '서울 한강체'는 누구나 편리하고 쉽게 활용할 수 있는 새로운 서체 디자인 시스템으로 서울의 거리나 공공장소, 공문서나 홍보물 등의 매체에 통일되고 일관되게 적용할 수 있는 새로운 개념의 전용 서체다.

seoul city font

436

typeface.　seoul city font.　2008.

'전통적', '현대적' 그리고 '미래지향적'이라는 디자인 콘셉트로 개발된 서울서체는 서울이 가진 역사성·전통성·문화성·사회성 등의 심층적 고찰을 바탕으로 하여 세련되고 소프트한 현대적 감성을 담고 있다. 단순한 구조와 간결한 형태는 여유로운 멋과 편안함을 보여주며, 위쪽으로 정리된 무게중심은 가로쓰기 환경에서의 가독성을 높였다. 한국 고유의 아름다움을 의미하는 '전통성'은 강직한 선비정신과 단아한 여백, 한

옥구조의 열림과 기와의 곡선미를 의미하며 세련된 서체 효율성을 의미하는 '현대성'은 단순하고 간결한 형태, 그리고 영문과 한글의 조화를 의미한다. '미래지향적'은 다양한 미디어 환경에 적합한 확장성을 의미한다. 서울체는 한강체(L, M), 남산체(L, M, B, EB), 세로쓰기 총 7종으로 구성된다. 한글은 유니코드(Unicode) 기반의 11,172자를 지원하며, 영문(Basic Latin) 94자, KS심볼, KS한자로 이루어지며, 총 개발 자수는

The Design concept is that "traditional", "modern" and "future-oriented" which means they have polished soft modern emotion. "Traditional" is beauty of traditional architecture which expresses spirit of Korean scholar and beauty of space. Also we are made with the characteristic of the history and culture of Seoul. They have a motif of a traditional house "Hanok" and a curve of roof tile in the detail. "Modern" is chic toward type efficiency through simple and concise form and composition of Korean alphabet and English Alphabet. "Future-oriented" means future-oriented expansibility for various media environment. It has in-depth examination of history, traditional, culture and sociality of Seoul. Seoul Nam-San-che is a gothic typeface and Seoul Han-Kang-che is a myung-jo typeface. Nam-San-che family consists of 4 weights: L, M, B, EB, and vertical typographical feature is included. Han-Kang-che family consists of 2 weights: L, M. These 7 typefaces are differ from other normal gothic and myung-jo typeface in detail and development process. In the development process the questionnaire was performed to adopt the opinion of the citizen, and there was over a hundred thousands of opinion at both online and offline. Seoul typeface was made with the participation of citizens. They are going to be used all the way in the documents of the city, sign system, uniforms of public institutions, taxi. They would be popular gradually in long-term use, and would be recognized the nature of Seoul in them. Seoul typefaces can be downloaded by the web site of the Seoul city and the use of persons and companies are permitted. Seoul city and Microsoft Korea is in cooperation, so the typefaces are also downloadable from the web site of Microsoft.

typeface. seoul city font. 2008.

119,980자이다. 문헌 조사 및 현장 조사를 통한 학술 연구와 디자인 기획을 통해 서울체의 콘셉트를 도출하였으며, 개발사인 윤디자인연구소는 서울시와의 긴밀한 협조와 학계 전문가, 현장 디자이너의 자문을 바탕으로 디자인 방향을 결정하였다. 대표 글자의 개발로 서울체의 기본 구조를 확립하고 파생과정을 거쳐 Beta 버전 폰트를 생성한 이후 개발된 서체에 대한 시민 의견 및 충분한 테스트를 거쳐 발생 가능한 모든 문제를

최소화한 완성도 높은 서체로 완성할 수 있었다. 서울 서체는 서울시 웹 사이트를 통해 내려 받을 수 있으며, 개인 또는 기업에서 무료로 사용할 수 있다. 한국 마이크로소프트 웹 사이트에서도 내려받을 수 있다.

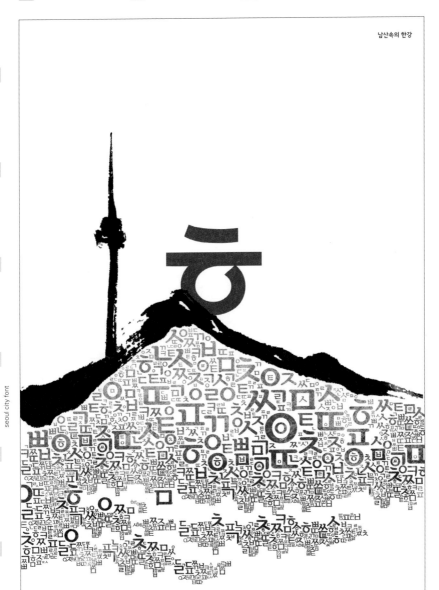

seoul city font

438

poster. seoul nam-san-che. 420 x 594. 2008.

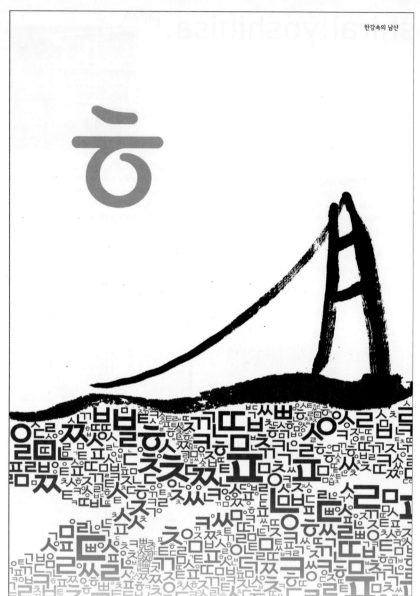

seoul city font

poster. seoul han-kang-che. 420 x 594. 2008.

shirai.yoshihisa. japan

시라이.요시히사.白井.敬尚.

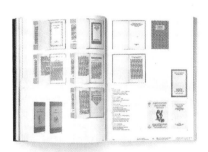

Graphic designer. He was born in Aichi Prefecture, Japan in 1961. After working for Seihokei Co., Ltd. (founded by Etsushi Kiyohara), he founded Shirai design studio in 1998. He has been involved in works in the field of graphic design mainly focused on typography. He has been a lecturer at various educational institutions such as Musashino Art University and Kyoto University of Art and Design. His best book design works include the Japanese translation of <Meisterbuch der Schrift>, <Encyclopedia of Typefaces>, <EXHIBITIONS> and <Tokyo TDC Vol.20>. Since 2005 he has been the art director/designer of the international graphic design magazine <Idea>.

1961년 아이치에서 출생했다. 기요히라 에쓰시의 '정방형'을 거친 뒤 1998년 시라이요시히사 형성사 무실을 설립하고 타이포그래피를 중심으로 하는 그 래픽 디자인 작업을 진행해 왔다. 무사시노미술대 학교, 교토조형예술대학교를 비롯한 각종 교육 기 관에서 학생들을 가르치고 있다. 주된 작업으로『서 적과 활자』(1998), 『구문서체 백과사전』(2003), 『EXHIBITIONS』(2007), 『도쿄 TDC Vol. 20』 등이 있으며 2005년부터 그래픽 디자인 전문잡지 〈아이 디어〉의 아트 디렉션 및 디자인을 맡고 있다.

magazine. idea no.321. 225 x 297. 2007.

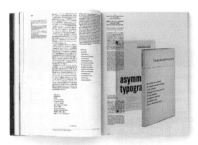

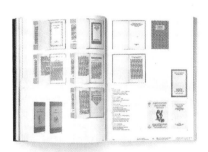

440

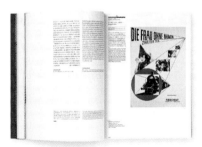

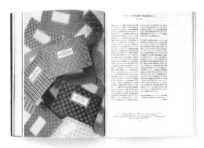

magazine. idea no.310. 225 x 297. 2005.

magazine. idea no.337. 225 x 297. 2009.

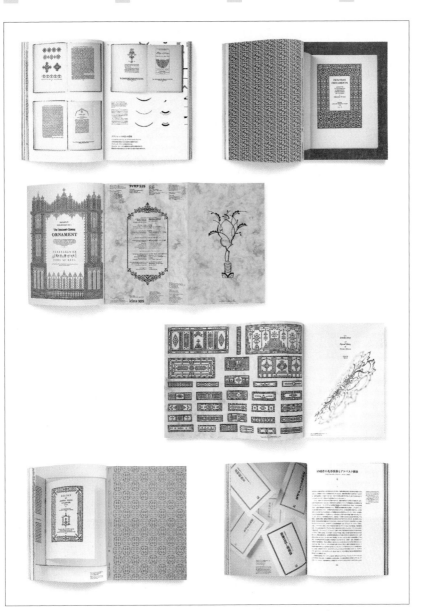

shirai yoshihisa

magazine.　idea no.325.　225 × 297.　2007.

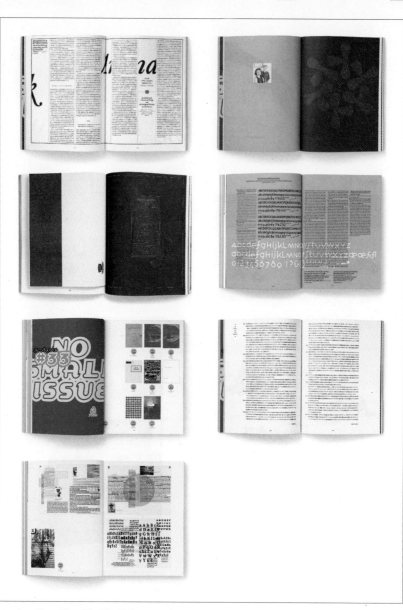

shirai yoshihisa

magazine.　idea no.314.　225 x 297.　2006.

book. first light. 210 x 257. 2010.

'From the aspect of the nature of linguistic activity as a verbal communication, you may find wasteful things in a series of processes from printing types on papers to binding of a book, or in most typographic elements. You have to make decisions about forms of typefaces, type-size, spacing between the lines, length of the lines, format for typesetting, margin settings, ink, paper, printing and binding methods and finally a book will come out... But these waste-ful things include a sign of the times, our historical memory and an immense amount of nonverbal information perceived by the bodily senses. In other words, written language is an integration of nonverbal cognitions, that is the field that I would call typography, and our writ-ten language communication can exist on this basis of typography. In the middle of the 15th century Johannes Gutenberg invented the printing press in Mainz, Germany. Since then, our ancestral typographers' act of printing with types has been continuing year by year for more than five hundred and fifty years. Even if they felt these acts were a useless and exhaustive effort for the nature of verbal communication. An act of setting and composing types are in line with this same traditional and conventional way, whenever the times and whatever

445

shirai, yoshihisa

book.　line style.　210 x 297.　2009.

machines you use. My master, Etsushi Kiyohara said, "Printing types have a beauty. Just like flowers are beautiful for people, I find printing types beautiful." Beauty might also be a waste from the viewpoint of the nature of a written language communication. But I feel immensely attracted to this "waste."＿＿＿＿＿＿＿＿＿＿＿ '말을 전달한다'라는 언어 전달의 본질에서 본다면 종이에 활자를 새기고 묶는 일련의 행위와 그것을 구성하는 요소들의 대부분은 쓸모없는 것일지도 모른다. 글꼴의 모양, 크기, 글줄 사이, 글줄 길이, 단락 스타일, 여백 설정, 잉크, 종이, 인쇄, 제본 그리고 그 결과물로서의 서적……. 그러나 쓸데없는 것 중에는 시대의 감성 그리고 역사의 기억과 몸이 감지하는 압도적인 양의 비언어 정보가 있다. 다시 말해 기술 언어란 비언어의 집적 즉 타이포그래피 그 자체이며, 타이포그래피에 의해 기술 언어 전달은 지지되고 존재한다. 15세기 중엽 독일 마인츠에서 요한 구텐베르크가 활자판 인쇄술을 창시한 이래 타이포그래퍼들은 550년이 넘는 세월에 걸쳐 이 행위를 반복해 왔다. 가령 그 행위가 언어 전달의 본질에 무익하고 소모적인 노력이었다 해도 말이다. 그리고 활자를 조판하는 일은 어떤 시대에 어떤 기계를 사용하든 모두 똑같이 이 연장선에 있다. "활자는 아름답습니다. 사람이 꽃을 아름답다고 느끼듯이 저는 활자가 아름답다고 느낍니다." 라고 스승 기요하라 노에쓰시(清原悦志)가 말했다. '아름다움' 또한 기술 언어 전달의 본질에 쓸데없는 것일 수도 있다. 그러나 나는 이 '쓸모없는 것'에 무한한 매력을 느낀다.

Shur received BFA. at Department of Visual Communication Design, Hongik University in 1979, and MFA. at Graduate School of Industrial Art, Hongik University in 1983. He has been a professor at Department of Visual Communication Design, Kyungwon University since 1988, and was the Dean of School of Art and Design, Kyungwon University for 2 years since 2009. Shur was the president of VIDAK (2006-2007), and nominated as next president of Korea Society of Basic Design and Art. He is the President Invitational Designer Korea Design Exhibition since 1987. Shur has been the creative director of I & I (Image & Imagination) where he founded in 1991. He awarded 'President Prize in Art, Art & Culture Awards of Korea, 2008', 'Recommended Artist Prize of Korea Design Exhibition (2004)' 'Jury Prize of VIDAK Awards (2003)'. 'Gold Prize of 1st Korea International Poster Biennale (2002)', and participated in many exhibitions including <VIDAK Invitational Exhibition Hosted by AIGA NY>, <30th Anniversary of Design House>, <Typojanchi 2001>, <Hangul Exhibition> (GGG/DDD Gallery), <Contemporary Letter Arts of East Asia>. He has designed and directed more than 2000 Books and Covers since 1979, and participated in newspaper design study on horizontal layout for Chosun Ilbo. He wrote and published many books including <Design Aphorism: Thoughts>.

shur.ki-heun. ^{korea}

서기흔.徐其欣.

1979년 홍익대학교와 1986년 동 대학원을 졸업한 뒤 1988년부터 현재까지 경원대학교 시각디자인과 교수직을 맡고 있다. 2009, 2010년 경원대 미술디자인대학 학장, 2006, 2007년 한국시각정보디자인협회(VIDAK) 회장을 역임했으며, 한국기초조형학회 차기 회장이다. 〈대한민국 디자인 전람회〉 초대 디자이너이며 1991년 아이앤드아이(Image & Imagination)를 설립하고 현재까지 크리에이티브 디렉터를 맡고 있다. 2008년 대한민국 문화예술상(미술부문), 2004년 대한민국 디자인 전람회 추천작가

상, 2003년 VIDAK 어워드 심사위원상, 2002년 코리아 국제 포스터 비엔날레 금상을 수상했다. 〈AIGA, VIDAK 뉴욕초대전〉, 〈디자인하우스 30주년 기념 초대전〉, 〈타이포잔치 2001〉, 〈한글전〉(GGG/DDD갤러리), 〈동아시아 문자예술의 현재전〉 등의 전시에 참여했다. 1979년부터 현재까지 2000여 종의 단행본 표지 및 디자인을 디렉션했으며, 조선일보 가로쓰기 신문 디자인 작업을 진행했다. 저서로 『디자인 아포리즘, 사유』 등이 있다.

446

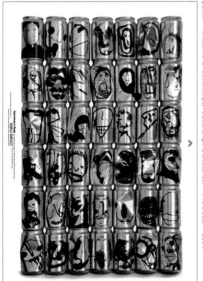

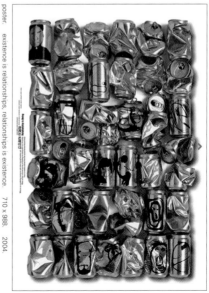

poster. existence is relationships, relationships is existence. 710 x 988. 2004.

In a way of Yeon-Am(1737-1805) Park Ji-won's reading, having coveted his call of truthful reading and his piety towards the book, I imagine typography. He says, "The ultimate purpose of reading a book is to read what can't be read." Chirping birds flying in the sky are vivid and refreshing. I wonder how to make the way of it looks and sounds using only the word 'bird(鳥)' printed on the book. He says that it can never be possible. He sees the flock of birds chirping warmly in a leafy yard. Finally, he shouts as he becomes aware of a meaning. "This is exactly what it means to be the letters of scenery describing the birds flying in and out. Ornamenting a sentence couldn't be any better than this scenery I've been watching. I, today, did well trustful reading."

 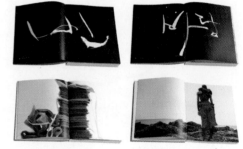

book. jinte ok. 250 x 320. 2005.

shur ki-heun

447 One critic says, "The reason why the poetry exists is there's something that can't be expressed by the language." The way of Yeon-Am's shouting can be understood in the same context. The reason of typography's existence is not that different as well. Languages and letters have been driving forces that threw open the door to human civilization. Languages can be disappeared, but letters transcend the limit of space-time. Immortal vitality of letters expands more throughout typography. Typography is the domain of playing letters. In other words, it is the activities of vision and mind, which praise the value of letters, as its physical properties. If the letters are the medium that records a subject, typography is the activities of observing, relating, and imagining a subject. Therefore, the core issue of typography is not the delivery method by letters, but the communication by languages and letters, and beyond. In other words, by the role and process of 'personification of letters,' it has led to creative communication and thoughts. In this context, like Yeon-Am's shouting on truthful reading, authenticity of typography is certainly completed outside the letters. Compromising its sounds and meanings, Hangeul supports the thoughts outside the letters enhancing semantic figures by adding the picturesque of Hangeul and physical form with the sense of hands and the mark of body efforts. Hence, postulating 'Yeon-Am's Typography Logic' - the ultimate purpose of typography is to read by languages and letters what can't be read, I imagine the exit to typography that combines either typography as an art or both images and messages.

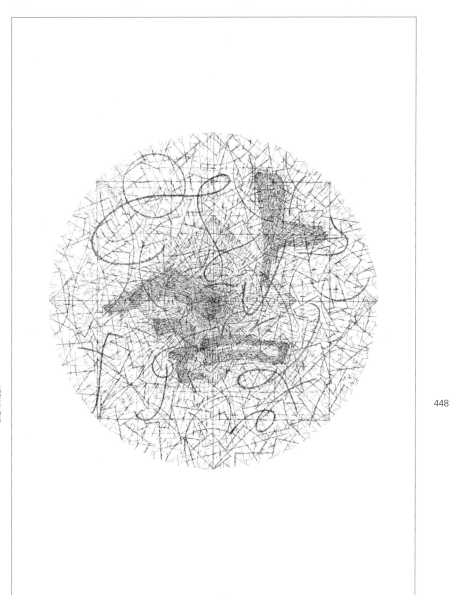

poster. the script of sce nery_knowing. 1,000 x 1,400. 2011.

My project had started from the background of this kind of thinking. I wanted to draw the letters of scenery that contain the scenery of thoughts, and arrange chance to meet them in certain point by engraving the mark of experience on the letters. My hope's destination was the letters 'knowing' and 'living.' Interestingly, they have something in common. In the course of a number of life's ordeal and debris, both have penetrated the light and dark, excluding any tricks or jokes. Eventually, I couldn't help weeping on this with awe. In the end, Hangeul is implied by each character piercing deeply into its being. And also, a close interlinking between

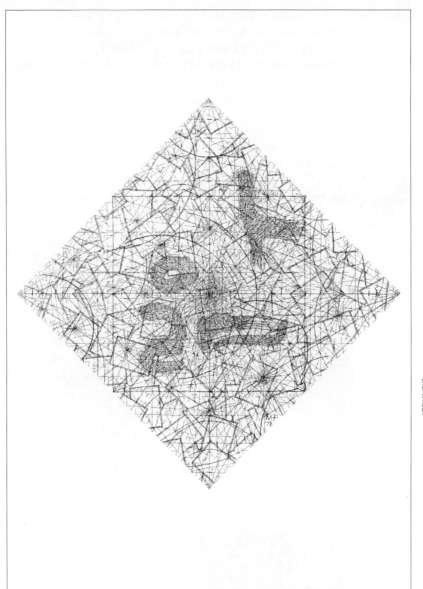

shur ki-heun

poster. the script of sce nery_living. 1,000 x 1,400. 2011.

these letters has conceived the disharmony even if they become to be the sustainable power that maintains social relationship in life consistently. Accordingly, they quite have similar letterforms, structurally and morphologically. The 'knowing' and 'living' always exist as a flutter on the borders between abundance and deficiency, daily life and the universe.

Project <The Letters of Scenery _ Knowing & Living> could be defined as an art or design. It may be as the beauty of the letterforms in Hangul or the sense of freedom of tools and expression. You may read the meaning in the painting or you may see the image as a meaning.

You may say, "Living is knowing, and vice versa." Or if you may say it's not... It may be good if one says, "Never try to find the 'living' in the 'knowing,' try to seek the 'knowing' in the 'living'." You may look around yourself or console yourself. Or, what if it's just the appreciation of non-thought(無想)? Whether or not people would interpret or think about, it depends on the viewers, and everything will become to be its own flare eventually. It may be just good if it's related to one thing or another or if you may deeply think.

연암 박지원(1737-1805)의 참된 독서의 부르짖음과 책에 대한 경건함을 넘보며, 타이포그래피를 상상한다. 그는 "책 읽기의 궁극은 책으로 읽을 수 없는 것을 읽는 데 있다"라고 말한다. 하늘을 날며 지저귀는 새는 생기발랄하다. 책에 적힌 새 '조(鳥)'자 하나로 모습과 소리를 살릴 수 있겠는가. 연암은 어림없다고 말한다. 그리고 녹음 우거진 마당에 새들이 날아와 정답게 우짖는 광경을 본다. 마침내 깨달은 듯 부르짖는다. "이것이야말로 새들이 날아가고 날아오는 풍경의 문자다. 글로 문장을 꾸민

book. kwon myung kwang. 240 x 300. 2002.

들 이 풍경보다 나을 것인가. 나는 오늘 참다운 독서를 했도다", "시가 존재하는 이유는 언어로
다 표현할 수 없는 것들이 있기 때문이다"라는 어느 평론의 지적도 연암의 부르짖음과 같은 맥
락에 있다.

타이포그래피의 존재도 이와 다르지 않다. 언어와 문자는 인간의 문명을 가능케 한 원동력이다. 언어는 사라지지만,
문자는 시공간의 한계를 초월한다. 문자가 지닌 이런 불멸의 생명력은 타이포그래피를 통해 더
욱 확장된다. 타이포그래피는 글자를 가지고 노는 영역이다. 즉 물성으로서 글자의 가치를 한껏
추어올리는 시각과 정신의 활동이다. 글자가 대상을 기록하는 매개체라면 타이포그래피는 대상
을 보고 관계 짓고 상상하는 행위다. 따라서 타이포그래피의 핵심은 글자를 통한 전달이 아니라
언어와 이미지를 통한 의사소통과 그 너머다. 즉, '문자의 인격화'라는 과정과 역할을 통해 창조
적 소통과 사유를 이끄는 데 있다. 그런 맥락으로 보면 참된 독서에 대한 연암의 부르짖음처럼
타이포그래피의 진정성은 언제나, 반드시 글자 밖에서 완성된다고 할 수 있다. 소리와 의미를
아우르는 독특한 한글은 글꼴의 예술성에 물질적 형식이 더해지고 손의 감각, 몸의 흔적이 덧붙
여져 의미적 상형성을 더욱 확장하면서 글자 밖에서의 사유를 뒷받침한다. 이에 타이포그래피
의 궁극은 언어와 문자로 읽을 수 없는 것을 읽고 글자 밖에서 완성하는 데 있다는 '연암 타이포
그래피론'을 상정하며, 예술로서의 타이포그래피 이미지와 메시지가 결합된 타이포그래피의 비
상구를 상상한다.

나의 작업은 이러한 생각에서 출발했다. 사유의 풍경이 있는 풍경의 문자를 그리고 싶었고, 글자에 경험의 자국
을 아로새김으로써 자신과의 만남을 주선하고 싶었다. 그 바람의 종착지가 '앎'자와 그리고 '삶'
자였다. 이 두 글자는 묘한 공통점이 있다. 수많은 질곡의 과정과 파편이 내재된 이 둘은 잔꾀나
농담을 거부하며 빛과 어둠을 관통하고 있다. 결국 눈물을 흘릴 수밖에 없는 대상이다. 존재의
사무침이 하나의 낱자들에 함축된 한글이다. 또한 이 둘의 긴밀한 맞물림은 생활과 사회적 관계
를 일관성 있게 지속시키는 힘이 되면서도 한편으로 부조화를 잉태하고 있다. 그래선지 흥미롭
게도 이 둘은 구조적으로 형태적으로 매우 유사한 글꼴을 갖추고 있다. '삶'자와 '앎'자는 언제나
풍요와 결핍, 일상과 우주의 경계에서 설렘으로 존재한다.

　　　작업 〈풍경의 문자_앎, 삶〉은 미술로 보아도 좋고 디자인으로 보아도 좋다. 한글
꼴의 아름다움을 보아도 좋고 도구와 표현의 자유로움으로 보아도 좋다. 그림에서 뜻을 읽어도
좋고 뜻으로 이미지를 보아도 좋다. '삶이 앎이고 앎이 삶이다'라 생각해도 좋고, 아니라는 역설
도 좋다. '앎에서 삶을 찾지 말고 삶에서 앎을 얻어라'라는 메시지도 좋다. 아니 무상(無想)의 감
상이면 어떠냐. 무엇으로 해석하든, 생각이 어디에 있든 그것은 보는 사람의 몫으로 모두 자기
다움의 불꽃이 되리라. 그저 이것저것 많이 관계되고 사유하면 좋을 따름이다.

poster. imagination. 710 x 988. 2004.

shur ki-heun

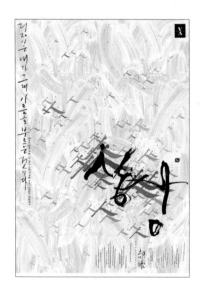

Born in Aichi Prefecture in 1959. Graduated from the Art Department of Aichi Asahigaoka Prefectural High School, albeit unmotivated. While he was in the Graphic Design Department of Tama Art University, he started to work at the Kosakusha publishing house and dropped out of university. After he worked as an art director for Kosakusha and For Sale, he went freelanced in 1988. Realizing in 1990 that his studio did not have a name, he named it 'Cozfish'. By then he had dealt with more than a thousand book designs. At present, capitalizing on his 'extraordinary power to enchat' every kind of printed matter, he is active across a broad range of projects.

sobue shin

poster.　scar print.　728 x 1,030.　2011.

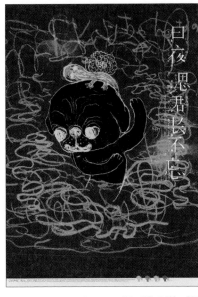

poster.　curry print.　728 x 1,030.　2011.

452

sobue.shin. ^{japan}

소부에.신.祖父江慎.

1959년 아이치현 출생인 소부에 신은 다마미술대학 그래픽디자인학과 재학 중 고사쿠샤출판사에서 일하며 학교를 중퇴했다. 이후 고샤쿠샤와 포세일의 아트 디렉터를 지냈으며, 1988년 독립하여 개인 스튜디오를 열었다. 1990년 스튜디오의 이름을 'Cozfish'라고 짓고 지금까지 1000여 종의 북 디자인 작업을 해왔다. 인쇄된 모든 사물에 매료된 그는 일본 그래픽 디자인계의 최전선에서 소설·만화·그림책·사진집 등 다양한 분야에서 작업하고 있다.

poster.　water trouble.　728 x 1,030.　2011.

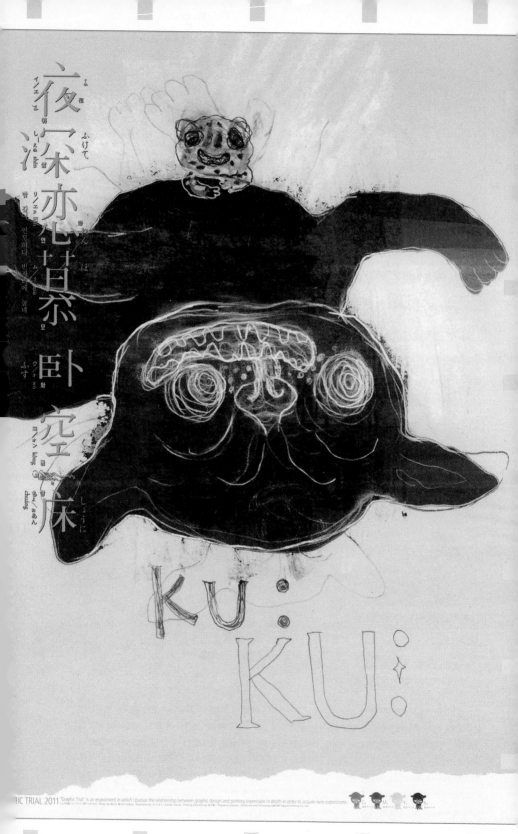

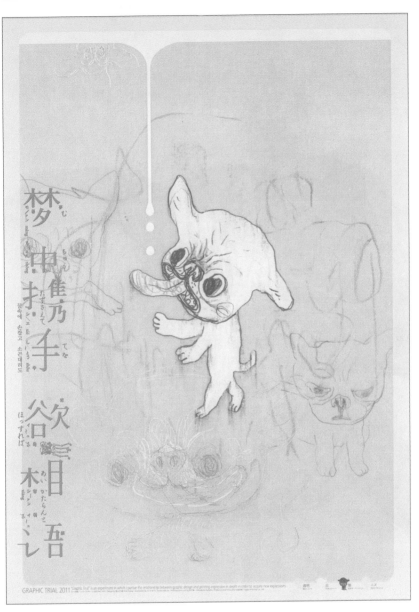

poster.　transparent print.　728 x 1,030.　2011.

'소부에 신 문자(祖父江慎文字)'는 그림과 같은 모양에서 시작되었다. 그리고 그 모양이나 음은 지금도 계속 변화하고 있다. 마치 생물체가 환경에 맞춰 진화해가는 것처럼. 넓은 중국에서는 '보통화(普通話)'도 생겨났지만 지금도 지역마다의 모양과 음이 활발히 쓰이고 있다. 한국에서는 한자음을 축으로 한 이해하기 쉬운 문자 '한글'을 사용하고 있다. 또 일본에서는 한자 모양을 간략화한 두 가지 가나문자(히라가나와 가타카나)를 한자와 함께 표기하고 있다. 이 '카라(空)'시리즈 작품은 약 600년 전에 잇큐(一休)라는 일본 스님이 만든 한시(漢詩)다. 시공을 넘어 아시아의 모두가 공통으로 음미할 수 있는 표기법이 있으면 좋겠다.＿＿＿＿＿＿＿＿Sobue Shin letters begun as a drawing. Its form and sound is still changing depending on the country

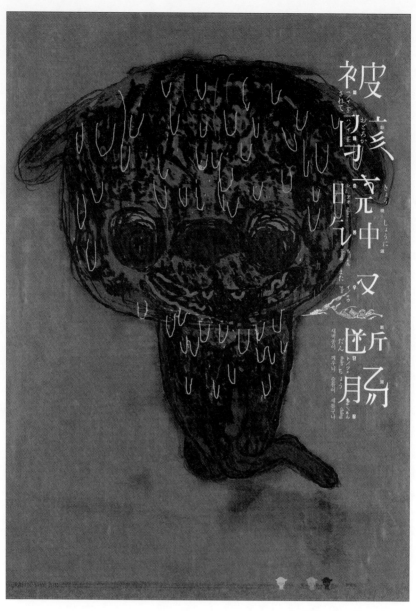

sobue shin

455

poster. deterioration print. 728 x 1,030. 2011.

or region. It is like observing evolution of an organism to fit its environments. In big China, "Mandarin(general language)" was formed, but still each region is actively using its own forms and sounds. In Korea, it was changed to the easily understood letter "Hangeul", using the sound of Chinese character. In Japan, two simplified Chinese characters "Kana(Hiragana and Katakana)" are used together with Kanji. This "Kara" series works is an Chinese Character poem composed by Japanese monk Itkyu 600 years ago. I wish there was a writing system that all Asia could mutually appreciate beyond the time and space.

sugisaki.shinnoske. ^{japan}

Born in Nara, Japan. Sugisaki sees design as a process of constructing information to create impressions. His goal is clear and effective communication. Through his consistent design principle he has worked on a wide range of projects from cultural sectors to corporate branding, information design and space design. His works have been showcased in exhibitions and has given many lecture both domestically and internationally, actively presenting his experimental challenge. During his career, Sugisaki has received a number of prestigious design awards such as: Distinctive Merit Award, ADC, NY; Typography Excellence, TDC, NY; Good Design Award; Red Dot Design Award; HKDA Asia Design Awards; International Triennials and Biennials: Toyama, Taipei, Trnava, Brno, Warsaw and Lahti. Sugisaki is a member of the AGI(Alliance Graphique Internationale); a steering committee member of the JAGDA(Japan Graphic Designers Association); Professor of Osaka University of Arts; and Creative Director of Shinnoske Design.

book. yoshio hayakawa exhibition. 185 x 240. 2002.

스기사키.신노스케.杉崎真之助.

스기사키 신노스케는 나라현 출생으로 디자인을 '정보의 구축과 인상의 설계'라고 정의하며 명쾌하고 효과적인 커뮤니케이션의 실현을 지향한다. 그는 일관된 디자인 이념을 바탕으로 문화 관련 기업 브랜딩부터 정보 디자인, 공간 계획까지 다방면에서 활동하고 있다. 새로운 시도의 디자인을 열정적으로 발표하며 국내외에서 다수의 전시회 및 강연을 진행하고 있다. 뉴욕 ADC 특별상, 뉴욕 TDC 우수상, 굿디자인상, 레드닷디자인 어워드, HKDA 아시아디자인을 수상했으며 도야마, 타이베이, 트르나바, 브르노, 바르샤바, 라티 등 국제 공모전에서 다수의 상을 받았다. 작품은 함부르크미술공예박물관, 홍콩문화박물관 등에 다수 소장되어 있다. 현재 국제그래픽디자이너연맹(AGI) 회원, 일본그래픽디자이너협회(JAGDA) 운영위원이며, 오사카예술대학교 객원교수, 신노스케디자인의 대표 겸 크리에이티브 디렉터를 맡고 있다.

From communication design to explorations of pure form in experimental works, logical expression is my intention. Possessing no emotion, lines, circles, and other geometrical shapes are neat and beautiful. In themselves they have no heat to sway the heart. Even so, in the process of working up a design, there is focus and stimulation.

————My encounter with computers enabled me to understand the true nature of communication design. The personal computer liberated me from the physical limitations I had felt when working by hand. Unlimited manipulations could now be done in a single instant, as if paper had been extended. In real time, I could interact with the computer screen and see what was in my mind's eye.

poster. shueitai 100. 728 x 1,030. 2010.

457

sugisaki shinnoske

————This probably had a big influence on the directions I took in design. You could say that there are some works in which proliferation, repetition, and multilayering seem overdone. The concise structures of the forms, however, were based on embodied principles. My works are rational constructs that eliminate personality and emotion.

————In twenty years since I started using computers, I have carried out a huge number of experiments, including works with superimposed characters and works with superimposed images, and represented by pixels, other works comprising form and structure. The computer leaves no brush marks, and it is the form and structure of the works that records the traces of my feelings and thoughts.

poster.　typography 2001.　728 x 1,030.　2001.

sugisaki shinnoske

————Rather than using shape and color for decoration and expression, the essence of design is to structure impression and information. In my design practice, without regard to the particular field of application, from my experimental works to corporate branding and space design, I have applied the same thinking. Even so, feelings, not reason, are the source of creation. You could say that all my varied graphic design experiments are a dialogue I have been having with my inner feelings.

poster.　morisawa font.　728 x 1,030.　2002.

459

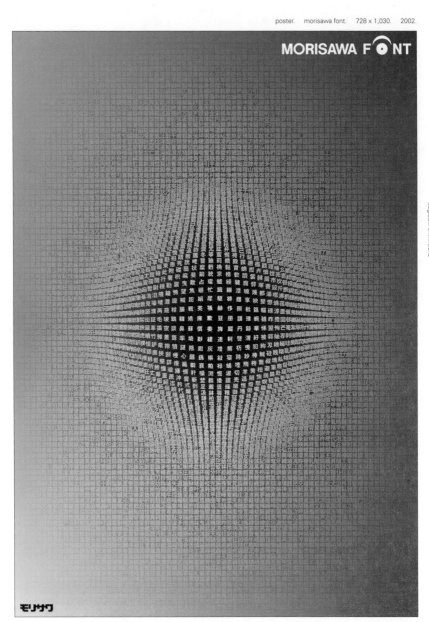

sugisaki shinnoske

커뮤니케이션 디자인에서 순수하게 형상을 탐구하는 실험 작품에 이르기까지 논리적인 표현을 지향해 왔다. 선과 원이라는 감정을 갖지 않는 기하학 형상은 단정하고 아름답다. 그것 자체에는 마음을 흔드는 온도(溫度)는 없다. 하지만 디자인을 만들어내는 과정에는 집중과 흥분이 있다.

————컴퓨터를 쓰면서 커뮤니케이션 디자인의 본질을 이해하게 되었다. 컴퓨터는 지금까지의 수작업에 의한 물리적인 제한으로부터 해방시켰다. 무한한 작업을 순식간으로 변화시킨 소위 확장된 종이다. 컴퓨터 화면에 비친 도상과 나의 상상력이 실시간으로 대화할 수 있게 되었다.

————이러한 것들이 나의 디자인 경향에 큰 영향을 주는지도 모른다. 증식, 반복, 집적된 작품군은 과도해 보이기도 하지만 법칙성을 바탕으로 형상을 구조화한 간결한 구조를 내포하고 있다. 개성이나 감정을 배제한 이성적(理性的)인 구성체다.

poster.　virtue, truth, beauty.　728 x 1,030.　2008.

───컴퓨터를 쓰기 시작한 후 20년 사이에, 문자를 겹치고 집적하는 작품, 이미지를 겹치는 작품, 픽셀에 의한 표현, 모양과 구조에 의한 작품 등 방대한 양의 실험 작품을 제작해 왔다. 컴퓨터는 붓 자국을 남기지 않지만 작품의 형상이나 구조 속에 감성과 사고 흔적이 기록되어 있다.

───디자인의 본질은 모양이나 색에 의한 장식이나 표현이 아니라 감동이나 정보의 구조를 설계하는 일이라 생각한다. 그래서 실험 작품에서 기업의 브랜딩, 공간 계획까지 분야에 상관없이 같은 생각으로 디자인을 실천하고 있다. 그러나 창조의 원점은 이성이 아닌 감성이다. 고로 나는 다양한 그래픽 디자인 실험을 통해 자신의 마음과의 대화를 즐기고 있는 것인지도 모르겠다.

poster.　to kyo to.　728 x 1,030.　2006.

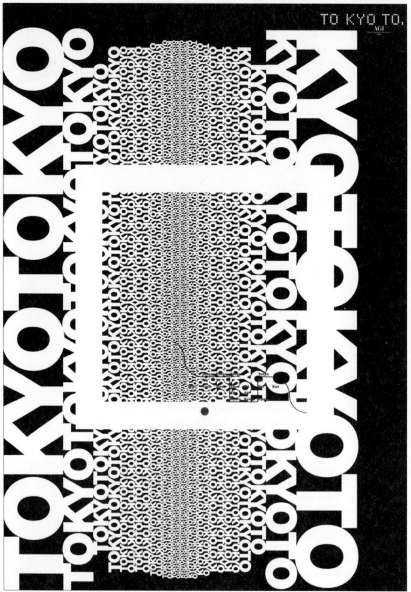

461

sugisaki shinnoske

Sulki & Min is a collaboration between the Seoul-based graphic designers Sulki Choi and Min Choi. Sulki Choi studied communication design at Chungang University, and Min Choi at Seoul National University. Both earned their MFA degrees in graphic design at Yale University in US. They worked as researchers in design at the Jan van Eyck Academie in the Netherlands, from 2003 until 2005. Since they came back to Seoul, Sulki & Min have worked mainly in cultural area, collaborating with such institutions as Arko Art Center, Insa Art Space, Gyeonggi Museum of Modern Art, Festival Bo:m, and Hyunsil Culture Studies, on the design of graphic identities, marketing materials and publications. In 2006, they held their first exclusive exhibition at the Gallery Factory in Seoul, for which they received the Art Award of the Year from the Arts Council Korea. They had their second exhibition in 2008 at Kimjinhye Gallery in Seoul. They have participated in many group exhibitions in Korea and abroad, including the ones at the Frankfurter Kunstverein, Moravian Gallery in Brno, Ningbo Graphic Design Biennale, Anyang Public Art Project, Arko Art Center, Platform Seoul, Graphic Design Festival in Breda, Gyeonggi Museum of Modern Art and CCA Wattis Institute for Contemporary Arts. Sulki & Min were appointed as graphic designers of the BMW Guggenheim Lab., a collaborative project initiated by the Guggenheim Foundation and BMW, for which they have created an interactive identity system based on on-line participation. Both Sulki Choi and Min Choi teach graphic design and typography, at Kaywon School of Art & Design and the University of Seoul, respectively.

identity. bmw guggenheim lab. variable. 2011.

poster. festival bo:m 2011. 460 x 740. 2011.

sulki & min

| Mature street trees / 龍興次葛與故龍 / Having at least 800 square foot to myself / Accoglienti aree pedonalia a misura d'uomo con posti a sedere / ไม่ใด้ถึน เสียงนกาฯฯ / การวางวฏง ทั้งสั้น ในระดะ ที่มีเกา่ส่งอนเสน / Being able to wander the streets, regardless of whether it's | Japanese sake / Savoir night dans quelle or day direction marcher sans lire / Sie- les panneaux dzạc na moim trâw- niku / Una cama grande con muchas sábanas lim- pias y almo- hadas grandes 使いやすい公共交通 / Гуляя по улицам уса- женьми красивыми высокими деревьями / | 平日信步到熟 識店家的水果 攤, 熱食店, 以及乾洗店 / 친한 친구들 과 스스럼 없이 어울릴 수 있는 것 / Saubere Strassen / I find comfort in just being busy and be- ing in a city where there is always things happening / سلاسلاماپا صیم گرم ین این بان کرم و شارختمن من תקלה / תקלה עלה עליה / שع ועלה עליה / بسيوو / اوجد الشابات بين مدينتي أو مدن / Traffic lights turning all green at once in sync | / Aire acon- dicionado / ledereen wordt een deel van hun buurt, een deel van de sociale om- geving / ni ayi- ka ogbon ati oye / Knowing I can escape / Or- dered chaos / Está sem- pre movi- mentada / Sushi lunchbox special / Empty seat on the subway / |

462

sulki.&.min. korea

슬기와 민은 서울에서 활동하는 그래픽 디자이너 최슬기와 최성민의 협업체이다. 최슬기는 중앙대학교에서, 최성민은 서울대학교에서 각각 시각 디자인을 공부했고, 미국 예일대학교 미술대학원에서 그래픽 디자인을 전공했다. 2003년부터 2년간 네덜란드 얀판에이크아카데미에서 디자인 리서처로 일했다. 2005년 한국에 돌아온 이후 주로 문화 영역에서 디자인 작업을 하면서, 아르코미술관, 인사미술공간, 경기도미술관, 페스티벌 봄, 현실문화연구 등을 위해 아이덴티티와 홍보물, 웹 사이트, 출판물을 디자인했다. 아울러 독자적인 출판사 스펙터프레스를 통해 Sasa[44], 박미나, 홍승혜, 이형구, 잭슨홍, 이재이, 이득영, 임근준 등 작가들과 협업으로 책을 펴내기도 했다. 2006년 서울 갤러리팩토리에서 연 첫 단독전으로 한국문화예술위원회에서 올해의 예술상을 받았고, 2008년에는 서울 김진혜 갤러리에서 두 번째 단독전을 열었다. 프랑크푸르트 쿤스트페어라인갤러리, 브르노 모라비안갤러리, 〈닝보 그래픽디자인 비엔날레〉, 안양 공공예술 프로젝트, 아르코미술관, 플랫폼 서울, 〈그래픽디자인 페스티벌 브레다〉, 경기도미술관, 샌프란시스코 CCA워티스현대미술연구소 등에서 열린 전시회에 참가했다. 2010년 구겐하임미술관과 BMW가 공동으로 조직한 실험적 문화공간 'BMW 구겐하임연구소'의 그래픽 디자이너로 선정되어 대중의 참여로 만들어지는 쌍방향 아이덴티티 시스템을 개발했다. 현재 최슬기는 계원디자인예술대학에서, 최성민은 서울시립대학교에서 시각 디자인과 타이포그래피를 가르치고 있다.

슬기와.민.瑟杞和旻.

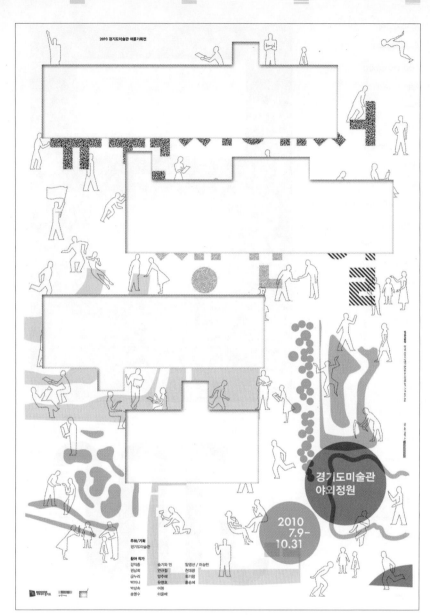

poster. our korean typography, 1. 594 x 840. 2011.

sulki & min

poster. our korean typography, 2. 594 x 840. 2011.

464

poster. our korean typography, 3. 594 x 840. 2011

poster. our korean typography, 4. 594 x 840. 2011.

제6회 서울 국제 미디어아트 비엔날레

poster. our korean typography, 5. 594 x 840. 2011.

sulki & min

카십
카짜
캐입
겹쳐커
크럼 안녕히 계십서오
꾸며낸
타이어크램
도서
두 도서 이야거
래코
로타러
무작위적인
반 해일런
받은
병쳐
보이지 않는
볼드
블랙
서월
시차증
산
에스오에스
에술
우연
원더우먼
익숙한
익스터마네이터
자외선
장치 미학
적합한
전처
정말?
조아 디버전
좀비
주운
중력
지도
차용
채게
춤

sulki & min

466

poster. cabbage thoughts. 594 x 840. 2009.

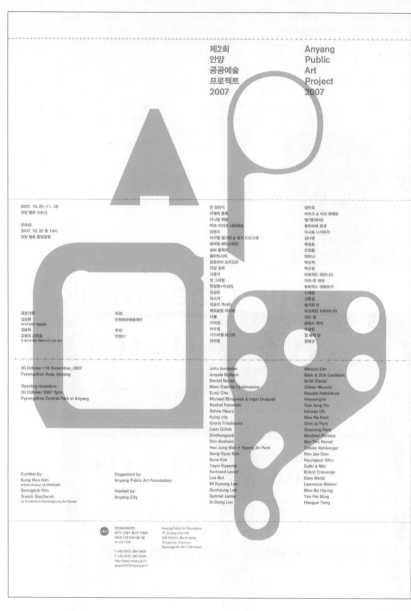

제2회
안양
공공예술
프로젝트
2007

Anyang
Public
Art
Project
2007

2007. 10. 20~11. 18
안양 평촌 신도시

오프닝:
2007. 10. 20 토 14시
안양 평촌 중앙공원

공동기획:
김성원
APAP2007 예술감독
김승덕
프랑크 고트로
Le 블소르 컨템포러리 아트 센터

주관:
안양공공예술재단

주최:
안양시

존 암리더
안젤라 불록
다니엘 뷔랭
마크-카미유 샤르모비츠
조르지
미카엘 엘름그린 & 잉거 드라그셋
레이첼 페인스타인
실비 플뢰리
플라잉시티
글로리아 프리드만
리암 길릭
김홍석
댄 그레엄
한정완+박경진
김상균
김소라
야요이 쿠사마
베르트랑 라비에
이불
이미경
이수경
가브리엘 레스터
임인동

일민욱
마이크 & 더크 뢰베르트
엠/엠(파리)
올리비에 모세
마사토 나카무라
곽정호
오인환
박미나
박신자
박소영
만프레드 페르니스
마이-투 페레
토비아스 레베르거
노재온
신양섭
슬기와 민
리크리트 티라바니자
게리 웹
로렌스 위너
우보형
얀 페이 밍
양혜규

20 October~18 November, 2007
Pyeongchon Area, Anyang

Opening reception:
20 October 2007 2pm
Pyeongchon Central Park in Anyang

Curated by:
Sung Won Kim
artistic director of APAP2007,
Seungduk Kim
Franck Gautherot
Le Consortium Contemporary Art Center

Organized by:
Anyang Public Art Foundation

Hosted by:
Anyang City

John Armleder
Angela Bulloch
Daniel Buren
Marc-Camille Chaimowicz
Eunji Cho
Michael Elmgreen & Inger Dragset
Rachel Feinstein
Sylvie Fleury
flying city
Gloria Friedmann
Liam Gillick
Gimhongsok
Dan Graham
Han Jung Wan + Kyung Jin Park
Sang Gyun Kim
Sora Kim
Yayoi Kusama
Bertrand Lavier
Lee Bul
Mi Kyeong Lee
Sookyung Lee
Gabriel Lester
In-Dong Lim

Minouk Lim
Maik & Dirk Loebbert
M/M (Paris)
Olivier Mosset
Masato Nakamura
Nayoungim
Oak Jung Ho
Inhwan Oh
Mee Na Park
Shin Ja Park
Soyoung Park
Manfred Pernice
Mai-Thu Perret
Tobias Rehberger
Rho Jae Oon
Hyungsub Shin
Sulki & Min
Rirkrit Tiravanija
Gary Webb
Lawrence Weiner
Woo Bo Hyung
Yan Pei Ming
Haegue Yang

안양공공예술재단
경기도 안양시 동안구 부림동
시민로 205 안양사랑 7층
우 431-735

T +82 (0)31 389 5400
F +82 (0)31 389 5406
http://apap.anyang.go.kr
apap2007@anyang.go.kr

Anyang Public Art Foundation
7F, Anyang City Hall
205 Bimim, Burim-dong
Dongan-gu, Anyang-si
Gyeonggi-do 431-726 Korea

poster. anyang public art project 2007. 841 x 1,189. 2007.

캐시, 자니
퀴즈쇼
킹크스
탈현대주의
패턴 만들기
퍼포먼스
필터
현대주의
효과적

Sung Jae-hyouk earned his MFA from CalArts in 2003. While at CalArts, he focused on exploring areas where graphic design could play a more integral role in everyday life. After his graduation, he worked as a graphic designer at CalArts Office of Public Affairs, and designed promotional materials for CalArts and REDCAT (Roy and Edna Disney/CalArts Theater). Currently, he teaches visual communication design at Kookmin University in Seoul while maintaining his own studio, IMJ where he experiments with graphic language and explores typographic systems based on linguistics. Since 2006 he co-curated the exhibitions: <Brand New School>, <Yokoo Tadanori Poster Exhibition>, <Out of Print—Mevis & Van Deursen>, <Starting from Zero: 10 years of exhibition, Werkplaats Typografie> at Zero-One Design Center in Seoul. He has won awards from the Type Directors Club, the Art Directors Club, Adobe and I.D. magazine.

성재혁.成在爀.

sung.jae-hyouk. korea

sung jae-hyouk

book.　code (type) 3.　150 x 225.　2010.

국민대학교에서 시각 디자인, 미국 클리블랜드인스티튜트오브아트에서 그래픽 디자인을 전공하고 칼아츠에서 그래픽 디자인 석사학위를 받았다. 대학원 졸업 후 칼아츠 홍보처에서 칼아츠와 칼아츠 극장 REDCAT의 다양한 인쇄물과 웹 사이트를 디자인했으며, 개인 스튜디오 IMJ를 열고 타이포그래피와 그래픽 언어에 대한 개인적인 실험을 해오고 있다. 성재혁의 작품은 아트디렉터스클럽(ADC) 금상을 받은 것을 비롯해 타이프디렉터스클럽(TDC), ID, Adobe 등의 공모 전에 입상했고, 프랑스 <샤몽 국제 포스터-그래픽아트 페스티벌>을 비롯한 다수의 국제 전시회에 초대되었다. 2006 년부터 국민대학교 시각디자인학과에서 그래픽 디자인의 새로운 패러다임을 이끌어갈 젊은 디자이너를 양성하고 있다. 국민대학교 제로원디자인센터에서 열린 <브랜드 뉴 스쿨 전>, <요코오 타다노리 포스터 전>, <아웃 오브 프린트: 메비 스&판되르센의 그래픽 디자인 전>, <타이포그래피 공방 10주년 전 Starting from Zero> 등의 전시회를 공동 기획했다.

sung jae-hyouk

I am happy as a rouleur!

*Rouleur means a type of racing cyclist considered a good all-rounder and often work as a domestique in support of their team leader.

poster.　fire flower of east asia.　615 x 870.　2011.

나는 rouleur로 행복하다.

*Rouleur는 숙달된 경기를 펼치는 사이클리스트를 부르는 말로서 레이싱팀 리더의 역할을 맡곤 한다.

poster. samwon paper gallery. 615 x 870. 2010.

오감도 — 성재혁

poster. k-sad workshop 27. 594 × 841. 2009.

poster. 2009=31536001 sec. 594 × 841. 2009.

sung jae-hyouk

워크숍
Workshop
27 **TOC** 사업
창의장학생
워크숍 **K·SAD**
계원디자인예술대학

2009. 9. 7–11.
갤러리 **Gallery**
27. **www.
workshop006.
com**

001 무용
Useless. 박경미,
송누리, 이대웅, 이
태석, 최고은, 한재
현, 한혜미

002 버려진 것들
을 가지고 놀기.
권오준, 김덕민,
박진실, 신지원

003 **GGOI @** 계
원. 김꽃봄, 안세
현, 유지연, 이정
은, 장수영, 정혜
리, 홍희정

004 **Meeting
with Vibrations**
곽아영, 김창령, 심
규인, 이승희

005 **Rosetta Stone
2009: How to become
immortal by designing
something.** 권오현, 김
대훈, 김미현, 김하늘, 박유
정, 유길튼, 이재룡, 임철
민, 조승우, 차윤수, 최진경

006 **Manifesto
Zine-Making
Workshop.** 강문식,
김지혜, 박슬기, 양상
미, 윤은경, 최귀연

2009
=315
3600
Isec.

스즈키 히토시는 1950년 도쿄 다치카와시에서 태어났다. 도쿄 조케이대학을 졸업한 후 12년 동안 그래픽 디자이너 스기우라 코헤이의 조수로 일했다. 그 후 1985년에 독립하여 개인 스튜디오를 설립해 북 디자이너로 활동하고 있다. 예술제본에서 영감을 받아 북 디자인의 기초부터 전 과정에 관여하고 있다. 2001년부터 그는 토다 츠토무와 함께 디자인 리뷰 잡지 〈d/SIGN〉의 편집을 시작했으며 영화와 사진 작품에 대한 리뷰도 쓰고 있다. 집필한 저서로『스크린의 탄생』(2002), 『페이지와 힘』(2002), 『중력의 디자인』(2007) 등이 있으며, 『치에조 재판의 완전한 기록』(2001), 『영화의 열망, 감독의 매너, 시니치로 사와이』(2006) 등을 공동 집필했다.

스즈키.히토시.鈴木一誌.

suzuki.hitoshi. japan

newspaper. do not kill. 405 x 545. 2011

Book designer. Born in 1950, Tachikawa-city, Tokyo, Japan. Suzuki was an assistant to graphic designer Sugiura Kohei, after graduating from Tokyo Zokei University. After working there for 12 years, he set up his own office in 1985. Inspired by bookbinding, he is now involved in the entire process of designing books from scratch. From 2001, he started editing a design review magazine <d/SIGN>, with Toda Tsutomu. He also writes movie and photo reviews. He has written books such as *Birth of screen*, *Page and power* and *Design of gravity*. His co-authored books are *Complete record of 'Chiezo' trial* and *Aspiration of movie, manner of a movie director, Shinichiro Sawai*.

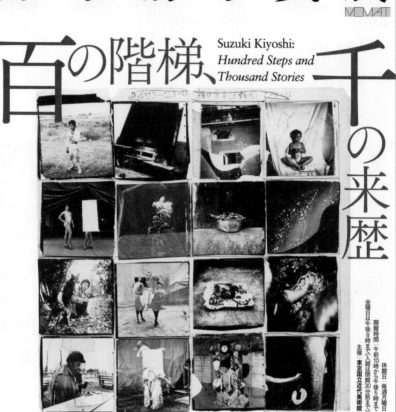

suzuki hitoshi

poster.　hundred steps and thousand stories.　515 x 727.　2010.

I consider 'Typography' as a measure to inform meaning of words to people. Words can be printed on papers, displayed on monitors, or can even be hand written. What happens if a designer's intention is expressed in those words? The meaning of words in the dictionary and how they are perceived are not always the same, and there is often a gap in between them. 'Typography' can intensify this gap bigger or smaller.

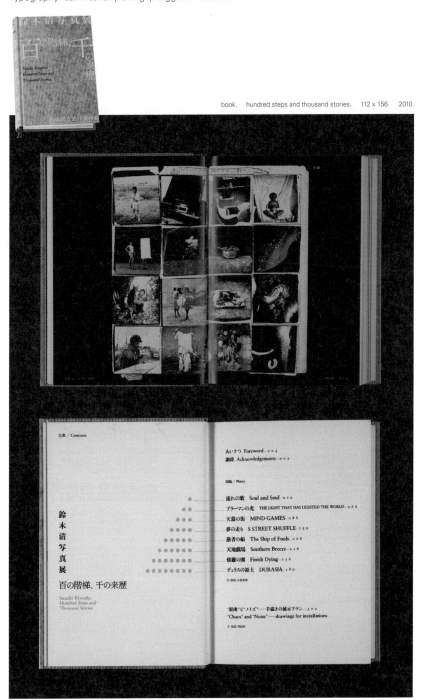

book. hundred steps and thousand stories. 112 x 156. 2010.

suzuki hitoshi

This gap can be expressed in many ways, such as spacing, blur or changing of fonts. An awareness of this gap gives freedom of expression for designers and interpretation for readers. If designers want to convey the meaning of words effectively to the readers, we need to pay special attention to the power behind words. 'Typography' can be creative but it also raises questions about our day-to-day methods of communication.

book. dictionary of calligraphy. 195 x 265. 2010.

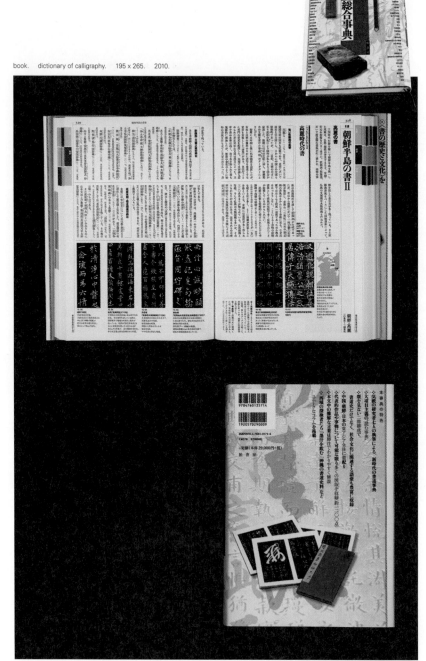

477

타이포그래피는 사람들에게 단어들의 의미를 전달하는 단위라고 생각한다. 단어들은 종이에 인쇄될 수도 있고, 모니터에 디스플레이될 수도 있고, 손으로 쓰일 수도 있다. 만약 이러한 단어들에 디자이너의 의도가 표현된다면 어떻게 되겠는가. 단어의 사전적 의미와 그들이 어떻게 인지되는지가 항상 동일한 것은 아니며, 종종 그들 간에 차이가 있다. '타이포그래피'는 그러한 차이를 더 크거나 작게 심화할 수 있다.

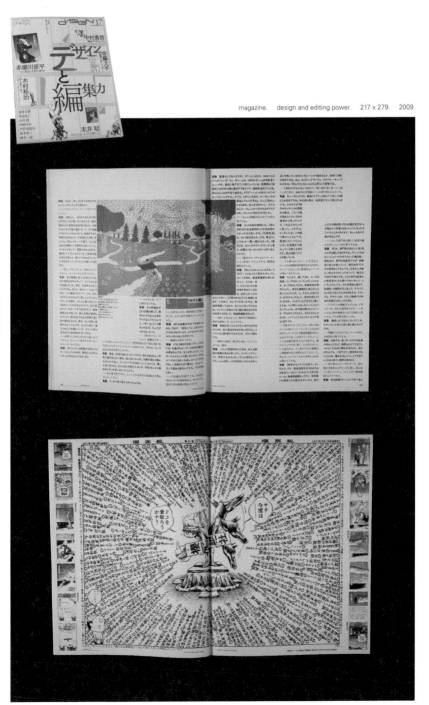

magazine.　design and editing power.　217 x 279.　2009.

suzuki hitoshi

이 차이는 다양한 방법으로 표현될 수 있는데, 예를 들어 공간, 흐릿함, 폰트의 변경 등이 있다. 이러한 차이의 인식이 디자이너의 표현과 독자의 해석에 자유를 제공한다. 만약 디자이너가 독자에게 단어들의 의미를 효과적으로 전달하고 싶다면, 우리는 단어 뒤의 힘에 특별한 주의를 기울여야 한다. 타이포그래피는 창의적일 수 있지만, 우리의 일상적인 소통 방법으로서 의문들을 제기하기도 한다.

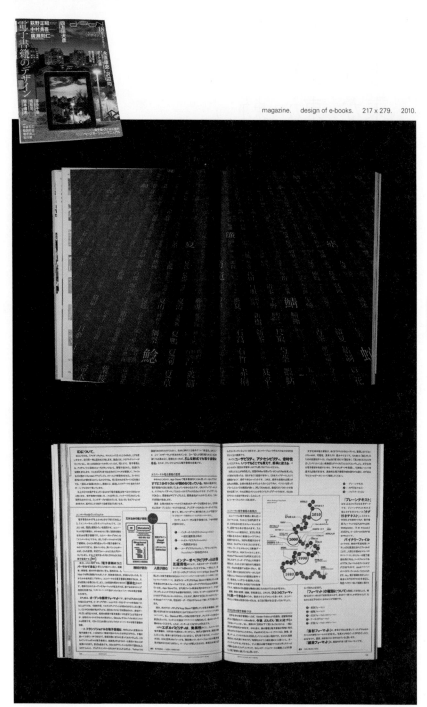

magazine.　design of e-books.　217 x 279.　2010.

479

suzuki hitoshi

Born in Nagoya in 1967, and graduated from Aichi Prefectural University of Fine Arts and Music. He worked at Adobe Systems Inc. from 1993 for 7 years, taught as part-time lecturer at Tama Art University from 2003 for 2 years, has been teaching at Aichi Prefectural University of Fine Arts and Music since 2004 until today. Isao is currently the representative of Type Project Inc., which he founded in April, 2001. He announced AXIS Font for renewal of <AXIS> the design magazine in 2001. He opened cityfont.com, announced Hama-mincho. Many of his fonts were awarded with Good Design, Frontier Design and etc. He held Kinshachi Font Exhibition in Nagoya in 2010.

specimen.　axis font family chart.　148 x 210.　2007.

specimen.　axis font hiragana specimen.　148 x 210.　2001.

스즈키.이사오.鈴木功.

suzuki.isao. japan

1967년 나고야 출생이다. 아이치현립예술대학을 졸업하고 1993년부터 2000년까지 어도비시스템에서 근무했다. 2001년 타입프로젝트를 설립하고 디자인 잡지 〈악시스〉의 리뉴얼을 위해 제작한 글꼴 〈악시스〉를 발표했다. 2009년에는 도시폰트 웹 사이트(www.cityfont.com)를 오픈했으며 〈하마명조〉를 발표했다. 2010년에 나고야에서 〈킨샤치 글꼴〉 전시회를 열었다. 굿디자인상, 프런티어 디자인상 등을 수상했으며, 2003년부터 2년간 다마미술대학 강사로 활동했다. 현재는 아이치현립예술대학에서 학생들을 가르치고 있다.

suzuki isao

cityfont.com voice of a city.

Nagoya City Font "Gold Brush" Designed by Type Project Inc.

poster. nagoya city font "gold brush". 728 x 1,030. 2011.

High Contrast Middle Contrast Low Contrast

EL 東か 東か 東か
L 東か 東か 東か
R 東か 東か 東か
M 東か 東か 東か
B 東か 東か 東か
H 東か 東か 東か

specimen.　axis mincho hiragana specimen.　148 x 210.　2010.

specimen.　axis mincho family chart.　148 x 210.　2010.

AXIS明朝 High Contrast
あいうえお
かきくけこ
さしすせそ
たちつてと
なにぬねの
はひふへほ

AXIS明朝 Middle Contrast
あいうえお
かきくけこ
さしすせそ
たちつてと
なにぬねの
はひふへほ

AXIS明朝 Low Contrast
あいうえお
かきくけこ
さしすせそ
たちつてと
なにぬねの
はひふへほ

か
か
か

suzuki isao

The first job I got, at the age of 25, was font designer. This fortuitous chance went well along with my personality. Thinking that this was a rare lucky chance, I have had this job for over twenty years. Font design is a repetition of simple, tedious tasks. Extra composure and endurance is required in Kanji production. Not many people are adequate for these tasks, yet even less people enjoy or volunteer for this job. People, who would quit leave right away, people who would continue go on for a long time.

When development of a new font initiates, I bear awe and anticipation as if I am hiking up an unexplored mountain. Across the river, through the valley, I examine the trails, determine walking speed, sometimes wander and sometimes enjoy the flowers of roadsides. The scenery, gained solely by oneself, is special that surprisingly, or naturally, makes us think about the next mountain to challenge. It has not been long since I realized that having mountains that I may not be able to challenge could be my happiness. The trail of font production itself is life. It is good to go alone, and better with a companion.

As mentioned above font design is based on affiliated personality, but once it is launched into the society, the font gradually gains publicity. Furthermore, letters, the sources of fonts, are social and cultural that it becomes difficult to claim for creativ-

482

내가 스물다섯 살 때 가진 첫 직업이 글꼴 디자인이었다. 우연히 얻은 직업이 내 성격과 잘 맞았다. 이런 행운은 드물다고 느끼며 글꼴 디자인을 생업으로 삼은 지 이십 년 가까이 지났다. 글꼴 디자인은 단순하고 지루한 작업의 반복에 의해 이루어진다. 특히 한자 제작에는 평상심과 지구력이 요구된다. 이를 감당할 수 있는 사람은 그리 많지 않지만, 이러한 작업을 좋아하며 자원하는 사람 또한 적다. 그만둘 사람은 바로 그만두고 계속할 사람은 오래 한다.

새 글꼴 개발을 시작할 때 나는 미답의 산에 도전하는 것과 같은 경외와 기대를 품는다. 강을 건너 계곡을 지나 길을 검토하면서 걷는 속도를 확인하며 때로는 헤매고 때로는 길가의 꽃을 즐긴다. 자신의 힘으로 오른 산의 경치는 각별하여서 신기하게도 혹은 당연하다고 해야 할까, 다음 산에 대해 생각하게 된다. 답파하지 못할 산이 있다는 것이 행복하다고 느끼기 시작한 것은 최근 일이다. 글꼴 제작이라는 산길은 그것 자체가 인생길이기도 하다. 혼자 가도 좋고 동행자가 있으면 더욱 즐겁다.

상술했듯이 글꼴 디자인은 속인성(屬人性)에 바탕을 둔 일이지만 글꼴이 완성되어 일단 사회에 내보내지면 그 글꼴은 차차 공적인 성격을 띠게 된다. 게다가 글꼴의 근원이 되는 문자는 사회적·문화적인 존재이기 때문에 글꼴의 창작성·저작성을 주장하는 일은 더욱 어려워진다. 한편 반가운 일은 글꼴이 보급될수록 자신이 만든 글꼴을 볼 기회가 많아진다는 사실이다.

あいうえおかきくけこ
さしすせそたちつてと
なにぬねのはひふへほ
まみむめもやゐゆゑよ
らりるれろわをんがぎ
ぐげごぱぴぷぺぽ、。

483

suzuki isao

cityfont.com voice of a city.

Nagoya City Font "Gold Brush" Designed by Type Project Inc.

poster. "gold brush" hiaragana font. 728 x 1,030. 2011.

specimen. gold mincho specimen. 148 x 210. 2010.

specimen. gold mincho family. 148 x 210. 2010.

Heavy　Extra Bold　Bold　Medium　Regular　Light　Extra Light

味噌煮込みが食べてや～なぁ。

金シャチ明朝 ひらがな
あいうえお
かきくけこ
さしすせそ
たちってと
なにぬねの
はひふへほ

金シャチ明朝 カタカナ
アイウエオ
カキクケコ
サシスセソ
タチツテト
ナニヌネノ
ハヒフヘホ

金シャチ明朝 漢字
金鯱味噌飲
屋嫁菓課肝
館丸級去句
形慶言古御
好校行込最
財子紙煮車

あア金

ity or rights of the fonts. One the other hand, it is good to have more chances to see fonts designed by myself as they disseminate. It is a preferential treatment for the font designers to experience the fonts being used widely for a long time, regardless its slow penetration speed. Thus vitality of the fonts is desired.

It is significant that it is "movable type" not "moving type". It is like an instrument waiting for an outstanding performer. Feature of outline font is "scaleable", and concept of family is "selectable". A requirement for basic font is "readablity/legiblity", and the true quality of basic font is "sustainability". It is true pleasure of font design to imbue various "abilities" into movable types.

Letters have role of inheriting history, fonts are mirrors that reflect the times. Font designers are definitely responsible for a section of culture, and exporter for next generation. Japanese fonts which require years of development sometimes need to precede the era. Force to imagine the future and heart to hope for certain future and required for this reason. The future of full of possibilities and a portion of this hope is undertaken by font designers.

글꼴이 침투 속도는 느려도 오래 쓰이면서 널리 쓰이는 것을 볼 수 있다면 그것은 글꼴 디자이너만의 특혜라 할 수 있을 것이다. 때문에 글꼴의 생명력을 바라게 된다.

활자가 'moving'이 아니라 'movable'인 것은 의미심장하다. 마치 뛰어난 연주자를 기다리는 악기와도 같다. 아웃라인폰트의 특성은 'scalable'이며 자족(字族) 개념은 'selectable'이다. 기본 글꼴에 요구되는 조건은 'readable, legible'이며 기본 글꼴의 진면목은 'sustainable'에 있다. 활자에 다양한 'ability'를 붙어넣는 것이 글꼴 디자인의 참다운 즐거움일 것이다.

문자에는 역사를 계승할 역할이 있고 글꼴은 시대를 반영하는 거울이다. 그러한 점에서 글꼴 디자이너는 틀림없이 문화의 한 영역을 담당하는 자이며 다음 세대로 내보내는 자이다. 개발에 수년을 요하는 일본어 글꼴의 경우 때로는 시대를 앞서가야 할 때도 있다. 미래가 이럴 것이라고 상상할 힘과 미래가 이러했으면 하고 바라는 마음이 요구되는 까닭이다. 미래는 가능성에 가득 차 있고 그 희망의 일단(一端)을 글꼴 디자이너가 맡고 있다.

484

アイウエオカキクケコ
サシスセソタチツテト
ナニヌネノハヒフヘホ
マミムメモヤユヨ
ラリルレロワヲンガギ
グゲゴパピプペポ、。

cityfont.com voice of a city.

Nagoya City Font "Gold Brush" Designed by Type Project Inc.

suzuki isao

485

poster. "gold brush" katakana font. 728 x 1,030. 2011.

테라야마 유사쿠의 전문 분야는 시각 전달 디자인, 그래픽 디자인이며 시각 정보 디자인, 시각기호론, 타이포그래피, 디자인 근대사, 라이팅 스페이스 디자인(Writing Space Design)에 관한 연구를 하고 있다. 『박물도감과 디지털 아카이브』, 『세계의 표상 오토 노이라트와 그 시대』, 『엘 리시츠키 구성자의 비전』, 『그래픽 디자인 시각 전달 디자인 기초』, 『A Study of Visual Communication Design』 등을 집필했다. 세계 각국에서 '라이팅 스페이스 디자인 교육에 대하여', '지각의 기술로서의 지도', '디자인 교육의 입구와 출구', '그래픽 디자인의 원류' 등의 주제로 심포지엄과 강연을 했으며, 한·중·일 미술대학의 합동으로 진행된 '세 도시 이야기'와 '새 지각의 발견 /커뮤니케이션의 발견' 등의 워크숍에도 참여했다. 전시회 〈문화유산으로서의 모더니즘 건축 100선 전〉, 〈미술교육의 선구자 프란츠 치젝 전〉, 〈아시아 민속조형 전〉 등의 아트 디렉션과 디자인을 맡았다.

테라야마.유사쿠.寺山祐策.

book. el lissitzky the vsion of cnstructor. 191 x 264. 2005.

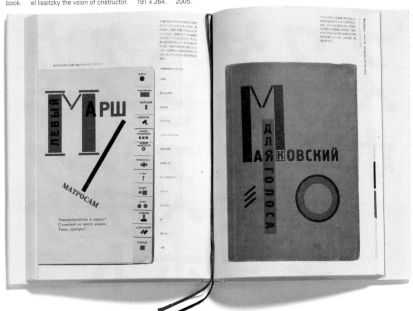

terayama yusaku

486

terayama.yusaku. japan

Born in Nagasaki Prefecture 1957. Specialized in visual communication design and graphic design, Terayama has various themes of research such as visual information design, visible semiotics, typography, history of modern design, and study of writing space design. His publications include *Rare books and Digital Archive of Natural History* (edit and co-author), *Representation of the World: Otto Neurath and his Era, El Lissitzky: The Vision of Constructor, Graphic Design: basic of visual communication, A Study of Visual Communication Design*, etc. He had speeches at many symposiums and lectures titled 'Education of Writing Space Design', 'Map as Description of Perception Space', 'Entrance and Exit of Design Education', and 'Ancestor of Graphic Design'. He held workshops 'A Tale of Three Cities (Japan, Korea China 3 Countries)' Combination Workshop)' and 'Finding New Perception/ Finding New Communications'. His art directions and design works include exhibition of <The Documentation and Conservation of Buildings, Sites and Neighborhoods of the Modern Movement>, exhibition of <Franz Cizek: Pioneer of Art Education>, exhibition of <Asian Form Ethnology>, etc.

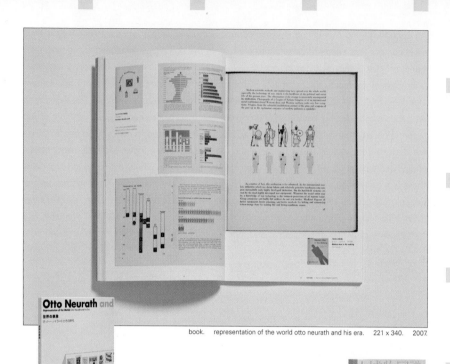

book.　representation of the world otto neurath and his era.　221 x 340.　2007.

book.　rare books and digital archive of natural history.　219 x 294.　2011.

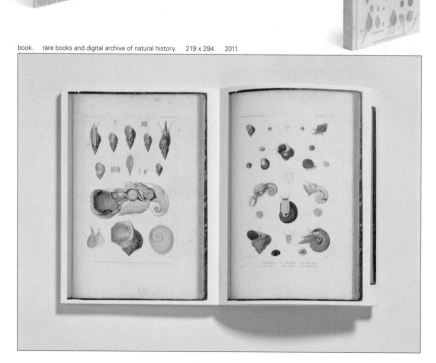

An important thing considered in visual communication is simple of how to convey the message content that needs to be told into a visual. In the process of visualization we perform a transformation, which without exception, involves our conscious and subconscious. However, it is not easy to decide the optimality of the process of deriving the final form from content. Needless to say, in semiotics words themselves are categorized as symbols. The expressionist traces a considerably complicated process when it comes to deciding the medium of representation whether it be in written characters, voice or printed matter and so on. Solutions are derived from various related factors such as images (icon), index semantic relationships (index) and arbitrary rules and cultural customs (symbol). Even when restricting to typography, there is a dimension where the individual character's "Form" have meaning, another for the "Space" that occurs when characters congregate, and "Structure" which is the result of heavily stratified space. Furthermore, when the synchronic and diachronic qualities of shape, and the disparity between phonogramic and ideographic scripts are added into consideration, it

terayama yusaku

488

book.　the documentation and conservation of buildings, sites and neighborhoods of the modern movement japan.　228 x 298.　2005.

book.　metabolism nexus.　149 x 210.　2011.

becomes complex. This process, and the principles which form visual language, is where my keen interest lies. Therefore, I think that theory, practice and historical study are necessary.___

_____시각 커뮤니케이션에서 중요한 것은 전달할 내용을 어떻게 시각화할 것인가 하는 부분이다. 시각화하는 과정에서 우리는 반드시 의식적, 무의식적인 변형(transformation)을 한다. 그러나 내용에서 최종 형태를 이끌어내는 과정에서 최적성을 염두에 두고 결정을 내리는 일은 결코 쉬운 일이 아니다. 기호론적으로 본다면 문자 자체는 두말할 것 없이 심벌에 속한다. 그러나 그것이 글자나 목소리, 또는 인쇄물로 표상된다고 할 때 표현자가 그 형태를 결정하는 과정은 꽤나 복잡하다. 거기에는 유상적 이미지(아이콘), 지표적인 의미 관계(인덱스), 자의적인 규칙이나 습관(심벌) 등 다양한 요인이 있다. 타이포그래피의 경우를 봐도 글꼴 하나의 '모양새'가 의미하는 차원, 글자가 집합하여 생기는 '공간'의 차원, 공간이 중층화된 결과 생기는 '구조'적인 차원이 있다. 거기에 형태가 가지는 공시성(共時性)과 통시성(通時性), 표음문자와 표의문자 차이가 더해지면 더욱 복잡해진다. 나는 그 프로세스 즉 시각 언어에 큰 관심이 있다. 임시방편적인 도구로서 기호론을 기초로 사고할 수밖에 없다. 그리고 거기에는 늘 실천이 함께 따라가야 한다. 결과적으로 내가 해온 일들은 시각 언어의 본질이란 무엇인지 추구하고 연구한 내용이 책이나 전시회라는 결과로 나타난 것이다.

book. shinchi kazu book design ii: 155 x 216. 2011.

book. experiences of reading and writing. 133 x 194. 2005

Tomeetyou is a graphic design studio in Beijing founded by Liu Zhizhi and Guang yu in 2008. Liu was born in 1975 Beijing, China and graduated from Central Academy of Fine Arts (CAFA) in 2003, and he was a guest lecturer of CAFA for 6 years since 2004. He became the member of AGi since 2010, and awarded Tokyo TDC award, GDC (Graphic Design in China), New York ADC award, Ningbo International Poser Biennale, and so on. Guang Yu was born in 1975, Beijing, China, and graduated from CAFA. He was the co-founder of MEWE Design Alliance, and awarded various prizes including HKDA award, D&AD award, Tokyo TDA, New York ADC, GDC and etc. The studio's Chinese name and English name are not related at all. In Chinese, it is called 'Tu Mao Qiu', a similar pronunciation to 'To Meet You'; it means '(cats) vomit hairball'. This strange name comes from a very particular homeless cat, which makes the design studio his home and behaves like an owner. He is not healthy for he never vomits up any hairball. The English name "To Meet You" probably indicates that after meeting you, nobody knows what happens next. We hope our work can bring more interesting stuff to everyone.

liu zhizhi.

tomeetyou.

투미츄.吐毛球.

china

Guang yu.

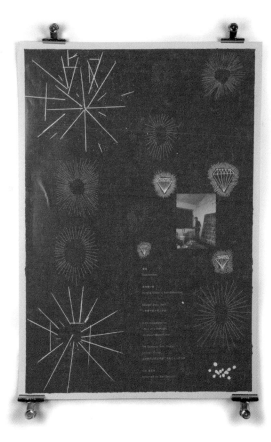

490

poster. luminescent. 700 x 1,000. 2007.

투미츄는 류즈즈와 광위가 2008년 베이징에서 설립한 그래픽 디자인 스튜디오다. 류즈즈는 2003년 중앙미술학원을 졸업하고 2004년부터 6년간 모교에서 학생들을 가르쳤다. 2010년 국제그래픽디자인연맹(AGI) 회원이 되었으며, 그의 작업은 도쿄 타이프디렉터스클럽상(TDC, 2008), GDC 동상(Graphic Design in China, 2007), 뉴욕 아트디렉터스클럽상(ADC, 2006), 〈닝보 국제 포스터 비엔날레〉 등에서 수상했다. 광위는 중앙미술학원을 졸업했으며, MEWE 디자인연합의 설립 멤버이기도 하다. HKDA 어워드(2009) 은상과 동상, D&AD, 도쿄 TDC상(2008), 뉴욕 ADC상(2007) 등을 수상했다. 이들은 작업 공간에 주인처럼 드나들던 길고양이를 보고 스튜디오의 이름을 '투마오치우(吐毛球)'라고 지었으며, 이와 유사한 발음의 영어 'To Meet You'로 스튜디오의 이름을 쓰게 되었다. 이는 만남 이후에 어떤 일이 일어날지 알 수 없듯이 그들의 작업이 다른 이들에게 흥미로움을 불러일으키길 바란다는 의미를 담고 있다.

491

tomeetyou

catalogue. sleek serise-adidas originals foot wear catalogue. 270 x 350. 2007.

exhibition. boundless, 2010 a/w collection fashion exhibition. 2010.

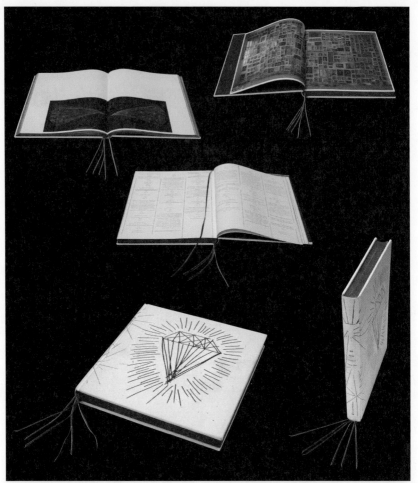

tomeetyou

book.　luminescent.　285 x 285.　2007.

book.　village by the sez.　150 x 225.　2010.

1955년 출생한 토리노우미 오사무는 다마미술대학 그래픽 디자인을 전공했으며, 1979년 주식회사 샤켄에 입사했다. 이후 1989년에 스즈키 쓰토무, 가타다 게이치와 함께 설립한 유한회사 '자유공방'의 대표이자 글꼴 디자이너다. (주)다이니폰스크린제조의 〈히라기노〉 시리즈, 〈코부리나 고딕〉 등을 수탁 제작했으며, 고유 브랜드 '유서체 라이브러리'의 〈유명조체〉와 〈유고딕체〉 패밀리, 〈유쓰키미다치 명조체〉, 〈유교과서체M〉 등 본문 글꼴을 중심으로 40종 이상의 글꼴을 개발했다. 자유공방은 2002년에 제1회 사토게이노스케현창을 수상했으며, 히라기노 시리즈로 2005년 굿디자인상, 2008년 도쿄 타이프디렉터스클럽(TDC) 타입디자인상을 수상했다. 현재 그는 교토세이카대학 그래픽 디자인 과정 교원이다.

torinoumi osamu

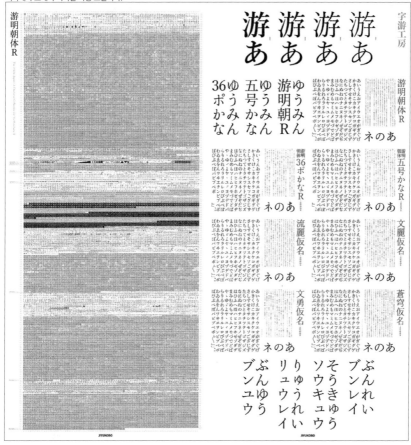

poster. [yuminchoitai pr6n-r] + [yuminchotai family, bunrei-kana, sokyu-kana, ryurei-kana, bunyu-kana]. 2,060 x 2,184. 2011.

494

torinoumi.osamu. japan

토리노우미.오사무.鳥海修.

Born in 1955. Graduated from Graphic Design Course of Tama Art University. In 1989 Torinoumi founded Jiyu Kobo with Tsutomu Suzuki and Keiichi Katada where he now works as both the CEO and type designer. Trinoumi has designed typefaces like Hiragino series (for Dainipon Screen Mfg., Ltd.) and the commissioned Koburina Gothic. He also designed more than 40 typefaces, focusing on text type designs, as well as producing his own house brand <The Yu-shotai Library> whose releases include the Yu-Mincho family, the Yu-Gothic family, Yu-tsuki Midachi Mincho, and Yu-Kyokashotai M. Jiyu-Kobo received the first Keinosuke Satou award for its activities, the Good Design Award in 2005 for their Hiragino family and the Tokyo TDC Type Design Award in 2008. Torinoumi teaches in the graphic design course at Kyoto Seika Univerasity.

Jiyu Kobo is a typeface design company engaged in the production and distribution of so-called "basic" typefaces for the setting of Japanese texts. A "basic" typeface can be defined as one that is universal- as elemental as water and air, and therefore can be used regularly and without worry. Of *Jiyu Kobo's* works, one full Japanese typeface (*Yu Mincho-tai* R), and four kana typefaces (*Bunrei Kana*, *Soukyu Kana*, *Bunyu Kana* and *Ryurei Kana*) are presented here. *Yu Mincho-tai* R is a full typeface including the full set of *kana* (Japanese syllabic character sets) and *kanji* (characters derived from Chinese) indispensable for proper Japanese text composition. It was the first original typeface designed and released in 2002 by *Jiyu Kobo*, a work symbolic of the company's creative endeavors. The stylistic univer-sality inherent within the typeface, free of intentional idiosyncrasies, is just one of the remarkable features of this typeface. The typeface's design is intended for longer text settings such as novels. Some noted features of the typeface include the wider bodies of the Chinese-derived *kanji* characters, stylistically or-thodox smaller-sized Japanese *kana*, and heavier Latin letterforms based on Old Style characters (but being original designs developed by *Jiyu Kobo*). The mix of different character types is intended for unified text-setting to increase the ease of reading longer texts through optimal legibility and readability, reducing eye strain to an absolute minimum. *Yu Mincho-tai* R Pro6 comprises the complete Adobe Japan 1-6 Character Set (23,058 glyphs), an extended version of the Adobe Japan 1-3 Character Set (9,640 glyphs). This revised version released in October 2011 was far beyond a mere extension due to the addition of a number of in-dividual characters. The typeface was further improved by re-designing a wide variety of the original family's characters; adjusting the scale and elements of *kanji* glyphs, editing the width of *kana* characters' terminals, recalculating the entire font's side-bearings, recasting punctuation marks and a number of other refinements on not a minute and grand scale. The completeness of *Yu Mincho-tai R Pro6* owes to multiple investigations into the physical form and space of the Japanese vi-sual language and a lengthy iterative process to arrive at detailed adjustments. *Yu Mincho-tai Go-go Kana* and *Yu Mincho-tai 36 point Kana* are also exhibited for refer-ence.

495

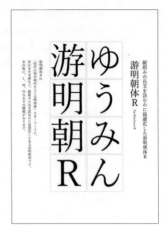

adobe japan 1-6 character set.　yu minchotai-r.　2011.

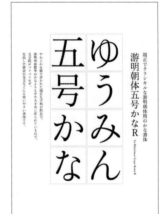

kana typeface.　yu mincho-tai go-go kana.　2006.

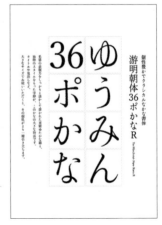

kana typeface.　yu mincho-tai 36 point kana.　2006.

While *Yu Mincho-tai R Pro6* is a revised version of an earlier work, in contrast, the four aforementioned *kana* fonts, *Bunrei Kana*, *Soukyu Kana*, *Bunyu Kana* and *Ryurei Kana*, are all original typefaces designed by Jiyu Kobo from 2009 to 2010 for the typesetting company, *CAPS Co. Ltd*. These *kana* character sets are all designed to be combined with similarly-weighted *Mincho* typefaces for text-setting. Their features: *Bunrei Kana* is a kana typeface specifically designed for text-setting of Modern Japanese literature. The design is inspired by the novel *Kokoro*, a story written by Soseki Natsume, one of the Japanese masters from Meiji-era. *Bunrei-Kana's* feminine-feeling strokes deliberately evoke the graceful strokes of Japanese handwriting from that era. *Soukyu Kana* is designed for setting texts from foreign literature translated into Japanese. The contemporary tendency of increased katakana usage in translated texts is well-considered in the typeface's design. When used in text composition, this typeface's katakana glyphs assist readability and make for better typographic consistency, as well-formed katakana body sizes should be slightly proportionally larger for optical balance. The design of the hiragana glyph characters are cheerful and robust, being well-suited to the katakana and further promoting readability. *Bunyu Kana* is designed for the specific purpose of setting texts from proletarian literature. The unique formation of each glyph's strokes is an important, clearly visualized part of the design. This typeface's individual glyphs are based on the calligraphic quality of Japanese characters influenced by the traditional form of the Chinese visual language. There is nothing unessential in the design- the slim body of the type has a classic appearance and the masculine tone of the design is appropriate for acquiring visual tension in the setting of appropriate texts. *Ryurei Kana* is designed for setting texts of haiku and waka, handwritten forms of literature from the Heian Period (784 to 1185/1192 AD). Thus, the key influencing formal factor is the fluid stroke of a brush or pen, akin to the example of how a Japanese woman in Kimono is suitable for the expression of innate Japanese-ness, or "Wa".

496

kana typeface.　bunrei kana.　2009.　　　　　　　　kana typeface.　soukyu kana.　2009.

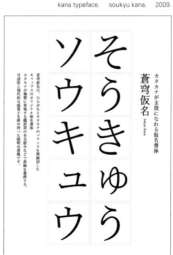

자유공방(字游工房)은 일본어 판짜기를 위한 베이식 글꼴을 제작하는 회사다. '물이나 공기와 같이'라고 형용되는 보편적이고 오래 쓰일 수 있는 글꼴을 목표로 나날이 모색하며 제작에 임하고 있다. 이번에 전시한 글꼴은 한자를 포함한 풀세트 폰트인 '유명조체(游明朝体)R'와 '분레이가나(文麗仮名)', '소큐가나(蒼穹仮名)', '분유가나(文勇仮名)', '류레이가나(流麗仮名)'의 네 가지 가나 폰트이다. '유명조체(游明朝体)R'는 2002년에 처음으로 독자적으로 개발하여 판매한 서체로 자유공방의 상징이라 할 수 있는 글꼴이다. 수수하고 보편적인 스타일이 특징이며 소설 등의 긴 글을 읽을 때 적합하다. 큰 자면(字面)을 가진 한자와 약간 작고 정통파 스타일의 가나, 독자적으로 개발한 약간 굵은 올드 스타일 영문의 조합은 장문을 읽을 때 피곤하지 않도록 배려한 결과다. 이번에 전시한 '유명조체(游明朝体)R Pr6'은 종래 Adobe Japan1-3(9640자)의 세트였던 것을 2011년 8월에 Adobe Japan1-6(2만 3058자)으로 자종(字種)을 확장한 것이다. 그때 한자의 크기나 요소, 가나 획 끝의 굵기, 알파벳 사이드베어링, 약물 등 모든 자종의 디자인을 다시 살펴보고 미세한 조정을 가해 완성도를 높였다. 이번에는 '유명조체 5호(游明朝体五号) 가나'와 '유명조체(游明朝体) 36포인트 가나'도 전시했다.

한편, '분레이가나' 등 네 가지 가나 폰트는 조판회사인 주식회사 캡스를 위해 자유공방에서 2009년부터 2010년까지 개발한 것이다. 비슷한 굵기의 한자와 조합하여 사용할 것을 전제로 하고 있으며 각각 다음과 같은 특징이 있다. '분레이가나(文麗仮名)'는 일본 근대문학을 조판하기 위한 목적으로 만든 가나 글꼴로 메이지(明治)시대 작가 나쓰메 소세키(夏目漱石)의 『마음』을 읽고 그것에 자극을 받아 제작하게 되었다. 여성적이고 느긋한 운필이 특징이다. '소큐가나(蒼穹仮名)'는 일본어로 번역된 외국 문학을 짜기 위한 목적으로 제작한 것인데, 디자인 특징은 가타카나가 크게 디자인되어 있다는 점과 히라가나가 밝은 스타일이라는 것이다. 특히 가타카나를 키움으로써 자주 나오는 가타카나 부분의 조판이 눈에 거슬리지 않게 되었다. '분유가나(文勇仮名)'는 프롤레타리아 문학을 위해 제작했다. 필맥(筆脈)을 살리고 군살을 제거해 늘씬하고 클래식하며 남성적인 스타일이 특징이며 긴장감 있는 조판이 가능하다. '류레이가나(流麗仮名)'는 일본 헤이안 시대 하이쿠나 와카(和歌)를 조판할 것을 상정하여 제작했다. 기모노를 입은 여성을 방불케 하는 흐르는 듯한 운필이 특징으로 '와(和)'를 표현하는 데 적합하다.

497

왕즈홍은 1975년 타이베이에서 출생했으며, 1995년 복흥고급상공직학교 광고디자인학과를 졸업했다. 2000년에 개인 스튜디오를 열고 다양한 주제의 책과 건축, 영화, 연극 관련 순수 미술 프로젝트 및 이벤트를 위한 그래픽 디자인에 주력해왔다. 2008년부터는 해외도서 전문 출판업을 시작해, 카시와 사토, 아라키 노부요시, 켄야 하라, 야요이 쿠사마, 오틀 아이허 등의 작업을 소개하는 원서의 번역본을 제작하였다. 타이완의 가장 권위적인 북디자인상 금나비상을 5회 수상하였고, HKDA 아시아 디자인 어워드, 도쿄 TDC 우수상 수상 및 홍콩 IDN 디자인 101인에 선정되는 등 다수의 수상 경력으로 국제적인 명성을 얻고 있다.

poster. naze design nano-ka. 520 x 740. 2009.

wang.zhihong.

wang zhihong

taiwan

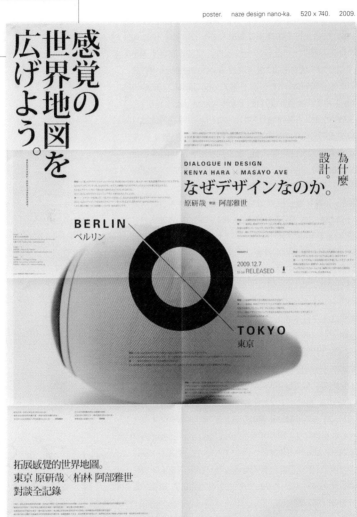

왕즈홍.王志弘.

Born in 1975 in Taipei, Wang Zhihong is an award-winning graphic designer based in Taiwan. He graduated from Department of Advertisement Design at Fu-Hsin Trade and Arts School in 1995. He opened his studio in 2000 and has been specialized in graphic design for books on various subjects and for fine art projects and events, ranging from architecture, film to performing arts. In 2008 launched his book publishing program insight with a trade publisher, featuring translated titles on art and design, such as the works by Kashiwa Sato, Araki Nobuyo-shi, Kenya Hara, Yayoi Kusama, Otl Aicher. A five-time winner of Golden Butterfly Awards, Taiwan's highest honor for excellence in book design, Wang has received many international awards and recognitions, including Kaoru Kasai choice winner and bronze awards from HKDA Asia Design Awards, excellent work from Tokyo TDC Annual Awards and one of the Best 101 from Hong Kong IDN Design Awards.

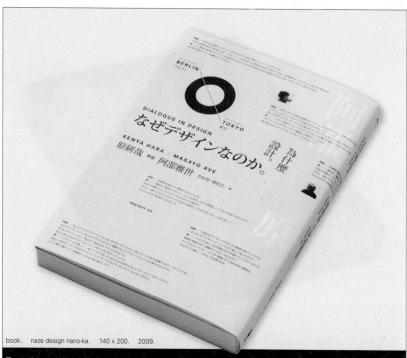

book.　naze design nano-ka.　140 x 200.　2009.

To strike a delicate balance between market demands and artistic values, knowing where to draw the line while responding to the market.

'시장의 요구와 예술적 가치' 사이의 섬세한 균형을 찾기 위해. 시장에 대응하면서도 선을 그을 시점을 아는 것.

poster.　the traveling photo studio.　595 x 420.　2010.

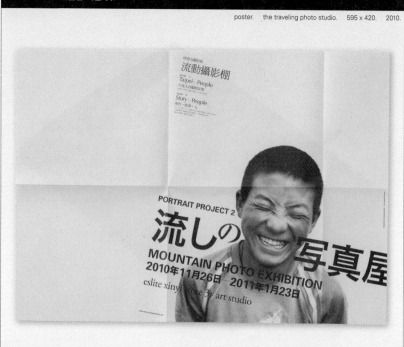

book.　a silver moon.　148 x 210.　2008.

To make "words" stand out among other elements of visual design, and to grow audience's appreciation towards the impact that words can make.

여러 시각 디자인 요소들 사이에서 '단어들'이 부각되도록 만들기 위해. 그리고 단어들이 만들어내는 영향력의 가치를 관객들이 알도록.

wang zhihong

book.　in' ei raisan.　148 x 210.　2009.

book.　until the end of the road.　148 x 213.　2010.

501

To take my design beyond its form and make it complement one's life, in the way fine accessories better express one's identity.

나의 디자인이 그 형태를 넘어서서 개인의 삶을 보완하게 만들기 위해. 작은 액세서리들이 개인의 정체성을 더 잘 표현하듯이.

book.　shashin no hanashi.　130 x 190.　2009.

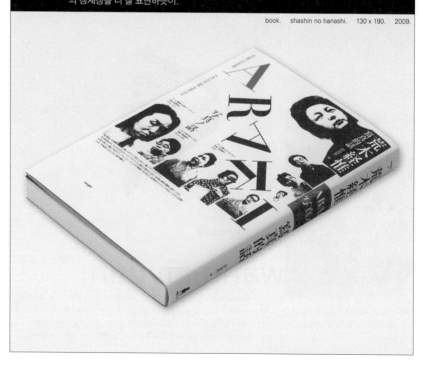

Upon graduation with a Master of Design in 1999, Wang Ziyuan started his career as a lecturer at the Design Department, China Central Academy of Fine Arts (CAFA). Since 2003, he has chaired the Visual Communication Department, School of Design under CAFA. Wang has received a number of important design awards including the Gold Award on the 6th nationwide book design competition of China in 2004 and 'The Most Beautiful Book of The Year' in China in 2004 and 2006. He joined the Image design team as a core member for 2008 Beijing Olympic Game and engaged in designing the color system, pictogram and other basic design elements of imaging for 2008 Beijing Olympic Game. In 2009 when ICOGRADA Congress was held in Beijing, Wang curated the show <Beijing Typography 2009>, one of the major academic events in relation to typography in China.

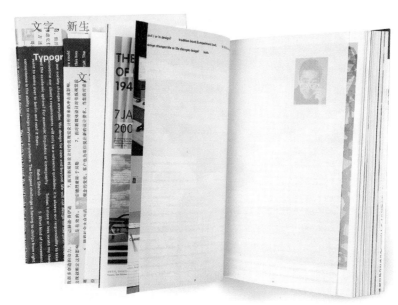

wang.ziyuan

book. typography, unity with new life (2 copies). 170 x 240. 2009.

왕쯔위안.王子源.

wang.ziyuan. china

왕쯔위안은 1999년 석사 과정 졸업 후 중앙미술학원 디자인학원에서 강의를 시작했으며, 2003년부터 그래픽디자인전공 학장을 맡고 있다. 2004년 제6회 중국 북디자인상 금상 수상 및 2004년과 2007년 '중국에서 가장 아름다운 책' 상에 선정되는 등 다수의 중요한 디자인상을 받았다. 2008년 <제29회 베이징올림픽> 이미지 디자인 팀의 핵심 멤버로 참여해 컬러 시스템, 픽토그램, 기본 이미지 요소 디자인 등을 맡았다. 2009년 베이징 <Icograda 국제 그래픽디자인 대회> 기간에 열린 중국 타이포그래피에 관한 주요 학술 행사 중 하나인 <베이징 타이포그래피 2009> 전시의 총감독을 맡았다.

wang ziyuan

book.　diary of Shanghai EXPO.　170 x 240.　2010.

Just like the rapid and rough growth of economy in mainland China, design as an accessory of this economic development has been passively engaged into China's societal discourse for an overall modernization. What is the modernity for design in mainland China? How do we cognize the so-called "visual pollution" from the so-called "avant-garde thought" in the discourse as such? And how do we distinguish them?

A quiet attitude towards design in my regard is the most needed. Quietness might let you walk slowly in the process of design, whilst you take the walk, you do have the time to see; whilst to see, you do have the time to think about, to contemplate calmly and to experience slowly; in addition, designing with a cautious attitude is also a necessity to contemplate on what facial expressions of Chinese Typography are, just like feelings not being placed into void. Chinese Typography is related with all kinds of experiences out of acts such as reading and looking, touching and daily living, sometimes those acts showcasing a scientifically neutral nature; sometimes showcasing artistically emotional just like a game; out of this we will be set free. All the work we have done are destined to make typography magic. Placing them in front of your eyes and starting to read: "Sesame, open the door…"

중국 본토의 가파른 경제 성장처럼 이런 경제 발전의 부수적 요소로서 디자인 역시 중국 현대화 과정에 대한 사회적 담론에 소극적으로 관여해왔다. 중국 본토에서 디자인의 모더니티란 무엇인가? 우리는 이른바 '시각적 공해'와 '전위적 사고'와 같은 담론에 대해 어떻게 인식하는가? 그리고 이들은 어떤 차이가 있는가?

디자인에 대한 신중한 태도도 중요하지만 그보다는 안정적인 태도가 가장 중요하다는 게 나의 생각이다. 안정적 태도는 나로 하여금 디자인 영역을 산책하듯 걸으면서 관찰하고 관찰하면서 생각하게 만든다. 이런 태도는 침착하게 생각하고 서서히 경험하도록 해주기 때문이다. 그렇다면 중국 타이포그래피는 어떤 것인지 생각해보자. 중국의 타이포그래피는 읽고 보고 만지고 일상생활에서 경험하는 모든 것과 연관되어 있다. 때로 그런 행동은 과학적으로 중립적인 태도로, 때로는 예술을 대하는 감성적 태도로 드러나기도 한다. 이러한 유희적, 과학적, 그리고 예술적 본질은 우리를 자유롭게 할 것이다. 우리가 해오고 있는 모든 디자인의 최종 목적은 타이포그래피를 마술로 만드는 것이다. 글자들을 눈앞에 두고 묵념하라. "열려라, 참깨……."

book. art and design literature books (4 copies). 150 x 210. 2007.

book. the world as design. 170 x 240. 2009.

wong.stanley. ^{china}

왕스탠리.黃炳培.

Born in 1960, Stanley Wong ping-pui, better known as anothermountainman on the local art scene, is a homegrown artist who received his education and professional training in Hong Kong. Following his graduation from the Hong Kong Technical Teachers' college (design & technology) in 1980, Stanley worked as a graphic designer for 5 years before embarking on what was to become a productive and rewarding career in advertising. Over the next 10 years, he was on the creative teams of some of the most distinguished advertising agencies in town. In 1996, Stanley was the first Chinese to undertake an overseas position in the asian advertising industry when he became the regional creative director at bartle bogle hegarty [asia pacific] in Singapore. He returned to Hong Kong in 1999 as chief executive officer and executive creative director at tbwa (Hong Kong) advertising. in 2000, Stanley joined centro digital as chief creative officer/ film director. There, he experienced, for the first time, the joy of directing. Two years later, Stanley set up threetwoone film production limited, specializing in advertising film production. Since then, Stanley has produced over 100 TV commercials. In 2007, he established 84000communications. A part from his commitment to advertising, Stanley has a passion for fine arts and photography, often focusing his subjects on social issues. His affection for his birthplace is strongly reflected in his art. In recent years, his works on 'redwhiteblue', depicting the positive spirit of Hong Kong using the ubiquitous tricolour canvas, have won critical acclaim both locally and internationally. a selected of the works are permanent collections at Hong Kong museums. The Victoria & Albert Museum in england and other oversea museums such as Holland and china... He presents as guest lecturer through numerous colleges and universities in local & oversea, eternally contribute to design education is major segment in the rest of his life. In 2005, redwhiteblue travelled to venice as one of the two art works from Hong Kong presented at the 51st Venice biennale. Stanley's excellence in photography and fine arts have been recognized in numerous exhibitions and awards. Throughout his career, he has won more than 400 awards in graphic design, advertising and fine art at home and abroad. In 2004, Stanley was inducted into alliance graphique internationale, a prestigious institution whose membership comprises the most elite graphic designers from around the world.

506

poster. heaven on earth. 800 x 1,000. 2007, 2009.

1960년 홍콩에서 태어났다. 1980년 홍콩공상사법학원(Hong Kong Technical Teachers' College, design & technology) 디자인응용 학과를 졸업하고 그래픽 디자이너로 5년 동안 활동하다 광고업계에 입문했다. 현대광고회사, 엘리트광고회사, JWT에서 일했다. 1996년에 싱가포르로 이주한 후 Bartle Bogle Hegarty에서 크리에이티브 디렉터로 일했다. 1999년에 홍콩으로 돌아와 홍콩 TBWA 대표 및 총감독을 역임했다. 15년간 광고계에 몸담았으며 2000년부터 Centro Digital 크리에이티브 디렉터로 활동했다. 2002년에 Threetwoone Film Production을 설립했다. 왕스탠리는 교육사업을 중요시하여 홍콩 및 세계 각 지역에서 강연을 했다. 사회 문제에 대한 작품에 관심이 많으며, 그의 작품 역시 영국 빅토리아앨버트박물관을 포함, 세계 여러 미술관에 보관되고 있다.

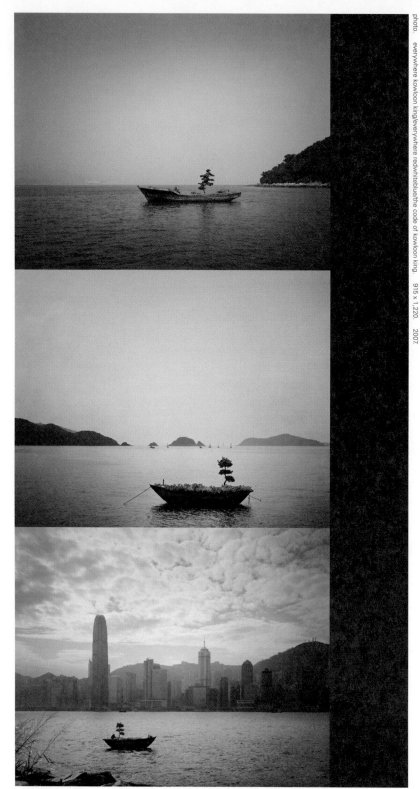

photo. everywhere kowloon king/everywhere redwhiteblue/the code of kowloon king. 915 x 1,220. 2007.

wong stanley

form / emptiness

색/공

anothermountainman

우일산인(又一山人)*

fire burns. fire stops.

불이 타다. 불이 꺼지다.

flowers bloom. flowers die.

꽃이 피다. 꽃이 지다.

water calligraphy.

수서법

on and off

켜지고 꺼지다.

it has been in my mind

몇 년 전 광저우 공원에서 처음 본 그 광경은

ever since I experienced the touching feat firsthand

항상 머릿속에 맴돌았다.

in a park of Guangzhou many years ago.

이것이야말로 불법에서 말하는 색과 공의

not just because its cultural history and humanity,

가장 미묘한 관계이다.

not just because its composition and environmental sensitive.

모든 것은 무에서 유로, 다시 유에서 무로 비롯된다.

not just because its zen meditation-like practice.

색즉시공　　508

it is the most meaningful response to

공즉시색

the form and emptiness of the Buddhist.

역사와 인문학

everything from absence to presence,

경제와 환경보호

and from presence to absence.

이러한 관계의 헤아림은

form itself is emptiness.

선수행의 훈련과 같다.

emptiness itself is form.

색/공/6:34

form / emptiness / 6:34

공/8:58

emptiness / 8:58

심경/62:48

heart sutra / 62:48

개념/우일산인

concept / anothermountainman

서법/정후이핑(鄭輝平)

calligraphy / zheng hui-ping

음악/궁즈청(龔志成)

music / kung chi-shing

wong stanley

우일산인(又一山人)은 융신탕가 작품에 의해 종종 사용하는 별명

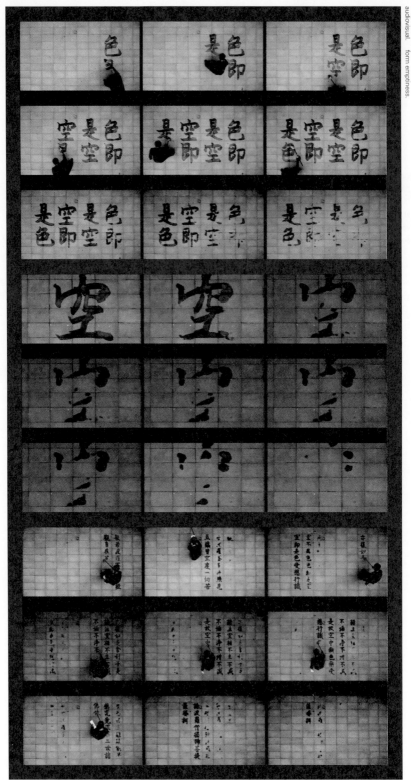

509

workroom.^{korea}

워크룸.

Workroom is a graphic design studio and publisher located in Seoul, Korea. In December 2006, photographer Park Junghun, designers Kim Hyungjin and Lee Kyeongsoo, and editor Park Hwalsung jointly launched the studio. Since then, Workroom has been working with clients mainly in the fields of arts and culture including galleries and museums as well as art biennales and film festivals. The studio has participated in exhibitions such as <Beyond Art Festival 2008> and <Beijing Typography 2009> while continuing to publish the <Lájka> series which documents works of contemporary artists._____서울 창성동에 위치한 그래픽 디자인 스튜디오이자 출판사다. 2006년 12월 사진가 박정훈, 디자이너 김형진, 이경수, 편집자 박활성이 모여 문을 열었으며 갤러리와 박물관을 비롯해 미술 비엔날레, 필름 페스티벌 등 주로 문화예술 분야의 클라이언트와 작업해오고 있다. 〈비욘드아트 페스티벌 2008〉, 〈베이징 타이포그래피 2009〉 등의 전시회에 참여했으며, 동시대 작가들의 작업을 기록하는 『라이카』 시리즈를 출간하고 있다.

installation.　takeoutdrawing hannam.　2,800 x 3,120.　2010.
leaflet.　temporary landing.　310 x 490.　2009.

510

workroom

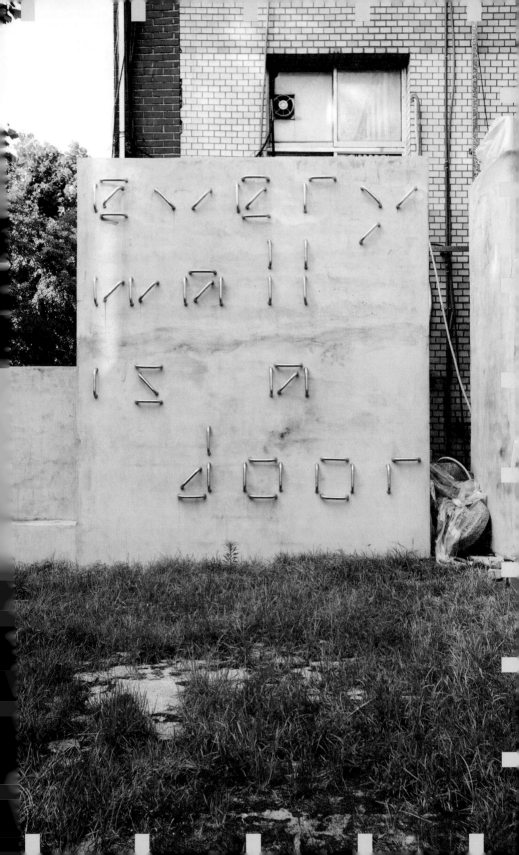

self-portrait; 9. november 2007 22. january 2008 2008 6. 23–30

박용석
귀국
보고전

poster. self-portrait. 600 x 840. 2008.

We think typography itself is like an "empty chair." We cannot say that a certain person suits the chair well or not. A chair is a tool to sit on but sometimes it is not. The same applies to typography. It is about language & image but sometimes it is not. What is certain is that typography is a tool to be used for something good as far as possible. Like a chair, the usage of the tool of typography was completed long time ago. Efforts made since then have been kind of surplus efforts._____

512

poster. utopia, the evolution of an idea. 700 x 1,000. 2009.

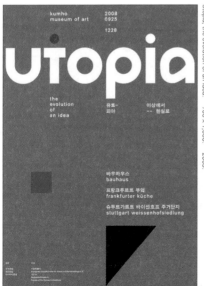

kumho museum of art 2008 0925 - 1228

UTopia

the
evolution
of
an idea

유토-
피아

이상에서
-- 현실로

바우하우스
bauhaus
프랑크푸르트 부엌
frankfurter küche
슈투트가르트 바이센호프 주거단지
stuttgart weissenhofsiedlung

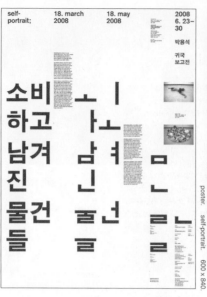

poster. self-portrait. 600 x 840. 2008.

타이포그래피 자체는

513 '텅 빈 의자' 같은 것으로 생각한다. 어느 누가 와서 앉는다고 해서 '어울린다' 혹은 '어울리지 않는다'고 단정 지을
수 없다. 의자는 앉는 도구이기도 하지만 그렇지 않기도 하기 때문이다. 타이포그래피도 마찬가지다. 타이포그래
피는 말과 이미지에 관한 것이기도 하지만 그렇지 않기도 하다. 한 가지 명확한 점은 그것이 가능한 한 선한 일에
쓰여야 할 도구라는 점이다. 의자와 마찬가지로 그 도구의 기본적인 사용법은 이미 오래전에 완성되었다. 그 이
후의 노력은 일종의 잉여 노력이다.

poster. utopia. the evolution of an idea. 700 x 1,000. 2009.

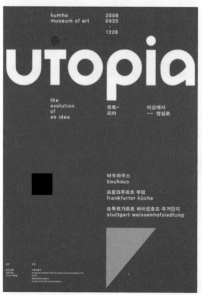

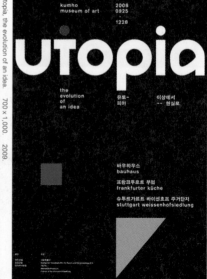

book. suh yong-sun. 220 x 270. 2009.

book. the trickster. 225 x 280. 2010.

book. realism in asian art. 225 x 280. 2010.

515

workroom

poster. beginning of new era. 600 x 900. 2009.

Graduated from The Academy of Arts & Design of Tsinghua University (the old Central Academy of Craft Art), Department of Art books, holding a bachelor degree and graduated from the academy of Arts & Design of Tsinghua University, Department of Visual Communication, holding a master degree; used to be vice-director of art department at China Youth Press, and the art consultant of UNICEF (China district). He has taken on the judges including 'Kan Tai-keung Global Chinese Students Design Award', 'Platinum Creative Award' and so on. Now a member of Chinese Artists Association Art Committee of Graphic Design, director, Professor, master tutor of Cheung Kong School of Art & Design Department of Graphic Design; employed as a guest professor of China Central Academy of Fine Arts, The Academy of Arts & Design of Tsinghua University, Beijing Institute of Fashion Technology, Department of the Design and Decoration. He has been globally awarded for design: the gold and bronze medal of Hong Kong Designers Association Biennial of APAC area, National Book Awards, gold medal of Hong Kong International Poster Triennial 2001, the most beautiful books in China, the silver medal of the 7th exhibition of Graphic Design in China, the silver and gold medal of the 6th National Book Design Art Exhibition, and so on. He published his own album <+- 2000 Wu Yong Graphic Design>, issued stamps for 'Centennial celebration of Fudan University', 'Mark the centennial of Chinese Movie' and 'commemorating the centennial of modern Chinese Drama'. He was invited to join the 'Design 300% Design Forum' in Spain, and made keynote speech in 2007 and the 'East Asia Book Design Forum' in Korea.

book. abcdefg~. 2011.

wu.yong. china

우용.못勇.

1988년 중앙공예미술학원(현 칭화대학미술학원)에서 북 디자인을 전공하고 2008년 칭화대
학미술학원에서 그래픽 디자인 석사학위를 받았다. 중국청년출판사 미술편집실 부주임 및 유
니세프 중국 지역 예술고문을 역임했다. 칸타이킁 디자인 어워드, 플래티넘 크리에이티브 어
워드 등의 심사위원을 맡았으며 1998년 베이징에서 우용디자인실을 열었다. 현재 중국미술
가협회 그래픽디자인위원회 회원이며 청콩미술대학 그래픽디자인학과의 학장 겸 교수이며,
중앙미술학원, 칭화대학미술학원, 베이징복장학원 및 한국 ACA의 객원 교수로도 활동하고
있다. 홍콩 디자이너협회 비엔날레 아태지역 대상 및 동상(2001), 중국 북디자인상(2002),
홍콩 국제 포스터 트리엔날레 금상(2001) 등 국제적인 상을 다수 수상했으며, 2002년에 개
인 작품집 『+-2000 우용 그래픽 디자인』을 냈다. '푸단대학교 개교 100주년 기념 우표', '중
국 영화탄생 100주년 기념 우표' 및 '중국 화극 탄생 100주년 기념 우표'를 디자인했으며, 스
페인 〈디자인300% 디자인포럼〉(2007), 한국 〈동북아 북디자인포럼〉(2008), 〈타이베이 국
제도서전〉(2009) 등에서 초청 강연을 했다.

poster. ingenuity follows nature-1. 2011.

poster. ingenuity follows nature-2. 2011.

This Pictorial quotes from Mr's Dong's calligraphy: 'true' & 'honesty', 'love' & 'happiness', 'beauty' & 'Elegance', just as these simple words imply the people's basic morality. At the same time, mimic the corresponding calligraphy by crumpled newspaper, with the concise and shortly newspaper printing fonts, this pictorial show out the art in calligraphy with powerful and cultural, and the convey information between each words form to a philosophy in Chinese character, as a thought-provoking philosophy. In the layout, using the dialog mode as a guide, and let every arrow points to the news headline on the newspaper. All of the words are shown out both as the calligraphy character and Newspaper character (Oral language words), to reflect the art abstract beauty and cultural richness, not only the meaning on the surface of the text.

As similar to newspaper's language,oral language is in everywhere of our life. At the same, with the influence of informationization, cause unconsciously us to attention on the handwriting just like calligraphy and daily writing more less. The existence of this phenomenon is real. What shall we lose? It has no correct answer, This is still a object which need us to solve._____이번 시리즈의 포스터에서는 신문지를 구기고 뒤틀어 서예글씨를 모방하였고, 동 선생님의 서예글씨인 '진(眞)'과 '성(誠)', '애(愛)'와 '낙(樂)', '미(美)'와 '아(雅)'자를 나타내었다. 그 이유는 글자에 함유된 은유가 인간의 기본 품성을 나타내고 짧고 빠른 속도로 인쇄된 글자와 역량 있는 문화유산인 서예글씨가 서로 호응하며 나타난다. 신문에 인쇄된 문자가 전달하고자 하는 각종 뉴스를 한자의 형태로 함축하면서 철학적으로 비교하고자 하였다. 포스터에서 보이는 통속적인 말풍선 모양은 시각적 부호로 사용하고, 이 말풍선 꼬리 부분은 신문의 타이틀로 숨겨진 어두운 의미를 담으려고 했다. 문자는 서예의 형식과 신문에 나타나는 언어의 형식(구어체)을 동시에 보여줌으로써 추상미와 문화의 풍요로움을 느끼고 문자의 의미 이상을 담아내고자 했다.

신문에 쓰이는 언어와 유사한 구어체 문자는 우리 생활을 충만하게 하지만 정보화 시대의 환경과 영향은 우리도 모르는 사이에 책에서 보이는 서면체와 서예체 그리고 손글씨를 가볍게 여기고 있다. 이러한 현상은 실제로 존재하고 있으며 이런 현상에서 우리는 무엇인가를 잃고 있는 건 아닌가? 생각해 보아야 할 것이다. 아직은 정확한 답안은 없지만 우리는 지속적으로 고민하고 관찰하며 찾아가야 할 것이다.

poster. future. 2011.

518

poster. the protection of children. 2011.

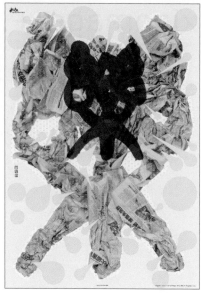

poster. ingenuity follows nature-3. 2011.

poster. ingenuity follows nature-4. 2011.

poster. ingenuity follows nature-5. 2011.

poster. ingenuity follows nature-6. 2011.

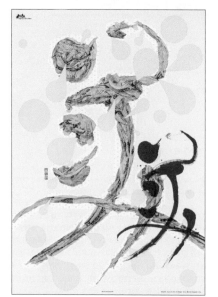

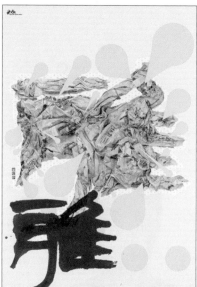

xiaomage.+.chengzi.

china

Xiaomage+Chengzi studied in Graphic Design Department, College of Fine Arts Tsinghua University from 1996 to 2000. Their works received prizes in domestic and foreign design competitions include: ADC New York Annual Awards, the Most Beautiful Book Prize, Shenzhen GDC Biennial, The National Book Design Prizes, Hong Kong Designer Association award, D&AD prizes, The Most Beautiful Books in China, and so on. They participated in group exhibitions such as <Beijing Typography 09>, <Get It

xiaomage.

xiaomage + chengzi

520

book. hard-boiled wonderland and the end of the world. 230 x 235. 2010.

chengzi.

샤오마거.+.청쯔.小马哥.+.橙子.

Louder>, <X>, <70/80 Design Exhibition> and <40 Contemporary Chinese Book Designers>, etc._____ _____
 샤오마거와 청쯔는
1996년부터 2000년까지 칭화대학미술학원에서 그래픽 디자인을 전공했다. 그들의 작업은 뉴욕 아트디렉터스클럽(ADC) 은상 및 동상, 라이프치히 국제도서전 '세계에서 가장 아름다운 책상', 선전 그래픽디자인(GDC) 비엔날레 대상, 제6회 중국 북디자인 금상, 홍콩디자이너협회(HKDA) 은상, D&AD에서 두 번의 상을 받았다. 또한 '중국에서 가장 아름다운 책'으로 5회 뽑힌 바 있다. 〈베이징 타이포그래피 2009〉, 〈Get It Louder 2007〉, 〈X 전〉, 〈70/80 디자인 전〉, 〈북디자인 40인 전〉 등의 전시회에 참여했다.

Take paradox and entanglement as the starting point. Different kinds of unicolor illustrations are taken from the recreation of artist's installation works. Design the Chinese character styles in a way of contradiction space and design the space of literal titles with the method of space frame, showing that the artist's work takes installation as the main tool.

The Method of Paradox 2011

521

book. the method of paradox. 285 x 285. 2011.

xiaomage + chengzi.

book. odyssey: architecture & literature. 165 x 235. 2009.

역설은 디자인의 출발점이다. 각종 단색 일러스트는 예술가들의 설치작품을 재창조함으로써 이루어진다. 모순된 공간에서의 중문 폰트를 디자인하는 방법, 프레임 공간 안에서 문자 텍스트를 디자인하는 방법, 이처럼 어떻게 배치할 것인가는 예술가의 작품을 반영하는 중요한 수단이 되고 있다.

『역설의 방식』(2011)

Graphic Designer. Born in 1948 in Chiba Prefecture. Entered the Kuwasawa Design School in 1972, specializing in living design. Started his own design firm after leaving Cosmo Public Relations Corporation. Currently Yamaguchi is the head of Yamaguchi Design Office. In 2000 he began contemporary paper-folding based on traditional designs as head of the Origata Design Institute. Major projects include the complete 100 book designs of the series <Sumaigaku Taikei (Survey of the Science of Living)>. He served as art director of the architectural journal <SD>, and was also responsible for the redesign of the series SD Sensho. Author of <Wax-White Wane>, Co-author of <Rei no Katachi>, <Oru, Okuru (Fold, Offer)>, <Hanshi de oru Origata Saijiki>, <Nihon Mingeikan e Ikou (Japan Folkcrafts Museum)>, and other works. Since 2004 he has worked as art director and planner for exhibitions at the Matsumoto City Museum of Art and at gallery AXIS in Tokyo. His recent exhibitions include <Su to Katachi (Material and Form)> and Takeo Paper Show (2010).＿＿＿＿＿＿＿＿＿＿＿＿1948년 지바현에서 태어났다. 1972년 구와사와디자인연구소 리빙디자인과에 입학했다. 학교를 졸업한 후 (주)코스모피알을 거친 뒤 야마구치디자인사무소를 설립했다. 2000년부터 전통적인 '오리가타(折形, 접기)'를 현대 생활에 접목시키는 오리가타디자인연구소를 설립했다. 대표적인 작업으로 『삶의 백과사전』, 가고시마출판회의 잡지 <SD>의 아트 디렉션, <SD>총서의 리뉴얼 디자인 등이 있다. 저서로는 『백의 소식』, 공저 『예의의 형태』, 『접어, 보내다』, 『전통 종이로 종이접기 세시기』, 『일본 민예관에 가자』, 『오리가타 디자인연구소의 신, 포결도설』 등이 있다. 또 2004년 마쓰모토시 미술관과 악시스갤러리에서 개최된 <재료와 모양 전>, <다케오 페이퍼쇼 2010>의 아트 디렉터로 활약했다.

yamaguchi nobuhiro

poster: deuxsieme exposition de la poesie visuel a paris. 728 x 1,030. 1998.

book: grandfather's envelopes. 148 x 210. 2007.

yamaguchi.nobuhiro. japan

야마구치.노부히로.일본(信博).

'심심하다(simsimhada/boring)' in Korean is used negatively, to mean 'boring, no fun, insipid'; losing among winning and losing, weak among strong and weak, slow among fast and slow. Likewise, among '正(sei/positive)' and '負(hu/negative)' we have been seeking for '正' and denying '負' to be unworthy. We have been seeking for success and avoiding failure, seeking for fitness and avoiding illness. The world is composed of two opposite terms, as '正' has been believed to be valuable and '負' to be unworthy. But is it really true? The two terms may not be confrontations but rather one and equivalent being. I begun so think so after an incident of failing typesetting.

I acquired British Anada 8x5 and tried studying typesetting. I bought four letters of my name in 40 point size Iwata Myungjo type. However, I had totally forgotten about filling up the white space with leads, quadrat, justifier, furniture, etc. I was so concerned with the visible letters, '正', that I had not thought about the rest white spaces. To place 40 point types in a space, multiples of 8 point or 10 point leads are needed. 7 point or 9 point multiples result remainders, thus 40 point types can not be fastened. Multiples of 8 point lead fragments fill up to create white space, which fasten and support 40 point types. The visible portions are supported by invisible portions, and invisible portions become valid by the visible portions. It is a mutual help. When typesetting, both letter and white space are one and equivalent being.

Since then, I have been conscious about '負'. In '図(zu/figure)' and '地(chi/ground)', I became aware of '地' portion as well as '図' portion. This is my design principles, my world perspective, and even my way of living. Among the overflowing 'strong', 'bright', 'heavy' designs, I aim for '심심한' designs which can become one and equivalent being.

524

poster. kitasono katsue. 728 x 1,030. 2006.
poster. the concrete poetry of niikuni seiichi. 728 x 1,030. 2008.

く1＝2 二人の仕事

澄 敬一×松澤紀美子
解説／山口信博　写真／大沢シーゲ

レ Rutles

한국말로 '심심하다'는 '지루하다' 혹은 '재미없다', '싱겁다' 등 부정적으로 쓰이는 말이다. 이기고 지는 것 중 지는 것. 강하고 약한 것 중 약한 것. 빠르고 느린 것 중 느린 것. '정(正)'과 '부(負)'에서 말하자면 '정'을 구하고 '부'는 가치 없는 것으로 부정됐다. 성공을 좇고 실패를 피하며, 건강을 바라고 병을 두려워해 왔다. 세상은 두 항의 대립으로 이루어져 있으며 '정(正)'이야말로 가치가 있고 '부(負)'는 가치가 없는 것으로 믿어왔다. 그것은 사실일까? 오히려 두 항은 대립하는 것이 아니라 두 항은 일체이며 동체(同體)인 것은 아닐까? 그렇게 생각하기 시작한 것은 활판 조판에 실패한 사건 후부터다.

영국제 아다나8×5를 입수하고 활판 조판을 공부하려고 했다. 내 이름 '山口信博'의 네 글자 활자를 이와타명조체(岩田明朝体) 첫 호 40포인트로 각 한 글자씩 구입했으나 인테르, 쿼드, 조스(ジョス, 저스티파이어), 포맷스테그 등 여백에 채울 것들은 까맣게 잊어버리고 있었다. '정(正)' 즉 눈에 보이는 문자에만 신경 쓰는 나머지 여백에 대해 떠올려보지도 않았던 것이다. 40포인트의 문자를 공간 안에 고정하기 위해서는 여백 부분에 8포인트 혹은 10포인트 배수의 채울 것이 필요하다. 7포인트나 9포인트 배수로는 끝수가 생겨 40포인트 문자는 공간 안에 고정되지 않는다. 8포인트 배수의 납 조각이 채워져 여백이 되면서 40포인트 문자를 고정·지지하고 있다. 보이는 부분은 보이지 않는 부분에 의해 지지되고, 반대로 보이지 않는 부분은 보이는 부분에 의해 성립된다. 상부상조하는 것이다. 문자와 여백은 조판으로서는 일체이며 동체였다.

거기서부터 여백이라는 '부(負)' 부분, 도(図)와 지(地)로 말하면 '지(地)' 부분 또한 '도(図)' 부분과 더불어 동시에 의식하게 되었다. 이는 디자인의 원리이며 동시에 세상을 바라보는 관점이자 내가 사는 방식이기까지 하는 것 같다. 세상에 넘쳐나는 '강하고', '밝고', '짙은' 디자인에 맞서, 일체이며 동체인 '심심한' 디자인을 지향하고 있다.

yamaguchi nobuhiro

裸形のデザイン

大西静二／著　大友洋祐／写真

К
Rutles

自然物には、無駄な形は無く、名前も無く、着色もない。
この本に登場するアルミニウム製品は、
古美術では手沢や歴史、味と呼ばれ重宝とされる汚れは洗われ、
銘板は外され、塗装は落とされ、アルマイトは剥がされて、
アルミニウムという素材そのものの素顔となって登場する。………本文より

야마모토 타로는 무사시노미술대학에서 타이포그래피와 역사를 연구하고 1983년에 졸업했다. 모리사와에 취직하여 글꼴개발 및 광고 등의 업무를 맡았다. 1992년에 일어 타이포그래피 매니저로서 어도비시스템에 입사, 글꼴 관련 기술 개발·기획·관리 업무에 종사하며 〈고즈카명조(小塚明朝*)〉 및 〈고즈카고딕(小塚ゴシック*)〉을 포함한 어도비 오리지널(アドビ*オリジナル) 일어 글꼴을 고즈카 마사히코(小塚昌彦) 지도 하에 개발했다. 야마모토가 최근 관여한 일 중 하나로 Nishizuka Ryoko(西塚涼子)가 디자인한 〈가즈라키(かづらき*)〉 글꼴이 있다. 이 글꼴은 문자마다 폭을 다르게 한 일본어 서체란 의미에서 혁신적이다. 한편 개인 작업으로는 『구문서체백화사전(欧文書体百花事典)』에 P. S. 푸르니에에 관한 기사를 기고. 또 타이포그래피학회 회원으로 〈타이포그래피 학회지〉에 2007년부터 논문을 기고하고 있다. 2008년에는 활자 몸체 사이즈 표준화 역사에 관한 논문으로 모토기쇼조상(本木昌造賞)(타이포그래피학회)을 수상. 2010년에는 필 베인즈 저 〈펭귄북스 디자인〉-일어판, 사이토노리코(齋藤慎子) 역, 시라이요시히사(白井敬尚) 디자인-을 감수했다. 또 1980년대에는 헬무트 슈미트와 볼프강 바인가르트의 TM No. 5, 1986년 잡지 기사 「일본 타이포그래피 연감으로부터 시작된 왕복서간(往復書簡)」 조판을 담당했다. 『타이포그래피 학회지』에 기재된 야마모토 타로 논문은 아래와 같다.

「타이포그래피에서의 문자 크기에 관한 고찰」, 『타이포그래피 학회지』, 타이포그래피학회, 2007년
「Morison의 타이포그래피 정의에 관한 고찰」, 『타이포그래피 학회지』, 타이포그래피학회, 2008년
「상용한자표(常用漢字表) 머릿말에 대한 고찰」, 『타이포그래피학회지』, 타이포그래피학회, 2009년
「소위 전자책에 관한 단편적 고찰」, 『타이포그래피 학회지』, 타이포그래피학회, 2010년

yamamoto taro

yamamoto taro. ^japan

야마모토.타로.山本太郎.

Taro Yamamoto received a BFA from Musashino Art University in 1983, where he studied the history and art of typography. After a stint doing type development at Morisawa, he joined Adobe in 1992 as Manager of Japanese Typography. In addition to management and engineering tasks, he led the design team that produced Adobe's original Japanese typefaces, including Kozuka Mincho and Kozuka Gothic, under the artistic direction of Masahiko Kozuka. One of the recent projects in which he was involved was the Kazuraki typeface designed by Ryoko Nishizuka. It is an innovative true-proportional Japanese font. He has written an article on P. S. Fournier that appeared *in An Encyclopaedic Collection of Typefaces*. As a member of the Society of Typography, Japan, he has also written papers on typography for *The Journal of the Society of Typography, Japan* since 2007. Taro Yamamoto is also the ATypI country delegate for Japan. In 2008, he was awarded the 1st Motogi Shozo Prize by the Society of Typography for his paper on the standardization of type body sizes. In 2010, he supervised the Japanese version of *Penguin by Design* written by Phil Baines and translated by Noriko Saito, and designed by Yoshihisa Shirai. Also, Taro Yamamoto was involved in the typesetting work for Helmut Schmidt and Wolfgang Weingart's article "a correspondence prompted by the japan typography annual" on TM No. 5 in 1986. His main papers written for *The Journal of The Society of Typography, Japan* are as follows:

"Considerations on the Size of a Character in Typography",
The Journal of The Society of Typography, Japan. (Tokyo: The Society of Typography, 2007)
"Considerations on the Definition of Typography by Stanley Morison",
The Journal of The Society of Typography, Japan. (Tokyo: The Society of Typography, 2008)
"Considerations on the Preface of the Joyo Kanji List",
The Journal of The Society of Typography, Japan. (Tokyo: The Society of Typography, 2009)
"Fragmental Notes on 'Electronic Books'",
The Journal of The Society of Typography, Japan. (Tokyo: The Society of Typography, 2010)

What is typography?

Do you think it is changing today? I don't think the definition of typography that Stanley Morison mentioned in his First Principles of Typography in the 1920s is no longer valid at all. But the world of typography has been expanded. When he was active, there was not a mobile phone on which digital fonts are used. There were no pupular music magazines featuring hip hop musicans or heavy metal rock and roll bands. Today, typography is not only for printed matters, but also for new media including electronic books and the world wide web. What do you think about this change? Wait, wait. I completely agree that more and more new electronic books and magazines will be created, distributed and read in the near future. However, I don't think that books will be replaced with something else. The change of media that we are now experiencing is needed in the expansion of the notion of book itself. If the new media had been unrelated to traditional books, it would have not been called an "electronic book" or "e-book". It seems that we want to call it a "book", even if it is not a printed book. It's a new form of book, but it's nothing but a book. But, electronic books and printed books are very different. Isn't it necessary for any typographers or book designers to learn many new things : skills and technologies for the new form of book, etc.? No doubt, yes. But, I told you to wait. Before jumping into the new technology of "e-books" or "e-publishing", I think we first need to re-examine and re-evaluate what experiences we have had with printed books, and what values printed books have provided to us all. A finely printed book can have a good texture that you can touch. The smooth surface printed typically with offset printing has its own beauty, while letterpress printing can also provide its unique texture.It can have a well-harmonized rhythm of characters composed and printed on pages. After quires are made from folded printed leaves, they are bound, and a book is born. Like a sculpture, a book is a three-dimensional object, composed of different materials, which can be seen at different angles, and examined by your own hands directly. Okay, let's now talk about digital typography. What is the most important benefit of digital technologies in the field of typography? With the advent of digital technologies, it became possible to control spaces between characters very finely. Also, it gave us the freedom of arranging and composing type, with which we can freely mix and overlay different printing elements including not only type but also images, colors, textures, graphic shapes, etc. But we should not forget that every process in digital typography needs combinations of binary bits. For example, even a small character you see on screen is composed of bits, and if you are using digital outline fonts, such a bit map is created by using a software component called a rasterizer or a scan-converter. At Adobe, everyday, engineers are working hard to improve the quality of their rasterizer software, so that our characters displayed on different types of display devices will look fine and readable. Scan conversion is a very important, infrastructural field of today's typographic technology. In a sense, digital typography may be a simple process of converting inputcoded characters into bitmap patterns on display screens. It's not a simple process. But it's a rational and logical process, on the one hand. If you type "f" and "i", the two character codes representing the abstract Latin alphabet characters are converted into their corresponding glyph ID numbers by using a mapping table in the font currently used. The two glyph IDs for "f" and "i" may be converted again into a single glyph ID number, which represents one "fi" ligature. The glyph ID of the "fi" ligature glyph is then converted into an address information that shows where the glyph's outlines are stored in the font file. Then, the information of the outlines will be processed by the above-mentioned "rasterizer" software, and finally, you will get a bitmap of the ligature

529

yamamoto taro

"fi" displayed on your screen. On the other hand, digital typography needs to handle human factors and visual perception. In the age of hot metal type, a matrix for a glyph (such as "a") needed to be designed and produced for each size in many cases. But this enabled the character to have a design more or less optimized for the target size. For example, a character designed for the body size of 8 pt should have relatively thicker serifs, and it should have a wider width, and wider side-bearings (spaces between characters), than those for the 12 pt body, so that the character looks better in the smaller type size. After type foundries began using an automatic scaling method, mechanical, photographic or electronic, the optical optimization made in the age of hot metal type was forgotten. And what serious typographers could do for the optical adjustment was limited to only spacing or tracking the characters evenly, to loosen or tighten the spacing for the adjustment. To avoid this "modern" problem, some typeface families today have multiple fonts designed for multiple type size ranges. One such example is shown in the next page. Today, interculturalization is becoming an important issue, as digital communication technologies have been advanced and used by billions of people in the world who have different nationalities and cultures. How will this affect the form of typography in the future? It is clear that typographers today need to understand how different scripts can coexist and interrelated in typography, although this doesn't mean that they need to be experts of writing systems in the world. For example, when we need to compose text including both Latin alphabet and Japanese characters, and if the main language is Japanese, Latin alphabet characters should be positioned well relative to the main line of Japanese characters. Today, we can do this semi-automatically with OpenType fonts on some software tools such as InDesign, because a Latin alphabet OpenType font can contain the information about the position of the Japanese EM body. With the information, applications can do some adjustments. In most cases, the Latin alphabet baseline is shifted, so that the mean height of their capital letters is aligned to

530

the mean height of the EMbox of the Japanese line, as shown in the next page. But this works only for the positioning of the Latin alphabet baseline in Japanese lines. Mismatching of sizes or stroke widths between Latin alphabet and Japanese characters may require manual adjustments. Some people think that electronic publishing will weaken the role of graphic designers and typographers, because programmers will play important roles in the production and publishing processes. What do you think about this kind of pessimism? Most mark-up languages such as HTML used for web pages on the Internet as well as electronic books are based on the principle of the separation of content and style. The recipient side of web documents can control the style and its typographic, visual appearance. Each user can set the stylistic specifications by him/herself, but usually, the default preset style has already been set by the developer of the reader or viewer soft-

poster.

mincho@ poster.

1,030 x 1,456

2011.

Rationality in typography

The Kozuka Mincho® typeface family, one of the Adobe® Originals Japanese typefaces designed by Masahiko Kozuka, has six different weights (Extra Light, Light, Regular, Medium, Bold and Heavy), and was designed using a revolutionary typeface design process and technology with which consistent and well-balanced glyph shapes can be produced. Each weight is carefully designed to achieve excellent typographic quality and printability. Each glyph for kanji is designed by composing multiple stroke elements. The sample above shows that the average bounding box size of the Extra Light weight is smaller than that of the Heavy weight, and that the standard stroke width of the Extra Light weight is heavier than that of the Heavy weight.

The typeface family is designed with rational principles. It embodies a crisp and original touch, reflecting the modern era while retaining the tradition and spirit of the Mincho style.

ware. Today, in communication or social network services, content information is dynamically recieved and updated on the reader software, and the recipient side determines in what style the content should be visualized. But are you satisfied with the typography made for such new media today? If you are not satisfied with the typography you see on such new media today, it means that the new media really need serious typographers and graphic designers, because no one else has the competence in improving it. In conclusion, again, what is typography? Typography is a tool with which one can communicate with authors beyond space and time. Also, typography can be something that gives you an unforgettable aesthetic experience. Nothing cannot change these two principles forever.

타이포그래피는 무엇인가

오늘날 변화했다고 생각하는가. 스탠리 모리슨이 1920년대에 '타이포그래피의 첫 번째 원칙'에서 언급한 타이포그래피 정의가 더 이상 전혀 유효하지 않다고 생각한다. 그러나 타이포그래피의 세계는 확장되었다. 그가 활동하던 때는 디지털 폰트들이 사용되는 휴대전화가 없었다. 힙합 음악가들이나 헤비메탈 로큰롤 밴드들을 소개하는 유명한 음악 잡지도 없었다.

오늘날, 타이포그래피는 더 이상 인쇄물만을 위한 것이 아닌, 전자책이나 인터넷을 포함한 뉴미디어를 위한 것이다. 이러한 변화에 대해 어떻게 생각하는가. 잠깐, 잠깐만 기다려라. 가까운 미래에 더 많고 많은 새로운 전자책이나 잡지들이 만들어지고, 배포되고, 읽힐 것이라는 것에는 전적으로 동의한다. 그러나, 책이 다른 뭔가로 대체될 것이라고 생각하진 않는다. 지금 우리가 경험 중인 매체의 변화는 책 자체의 개념 확장에 필요한 것이다. 만약 뉴미디어가 전통적인 책과 무관했다면 이는 '전자책' 혹은 'e-북'이라 불리지 않았을 것이다. 인쇄된 책이 아닐지라도 우리는 '책'이라 부르고 싶어 하는 것 같다.

그러나 전자책과 인쇄된 책은 매우 다르다. 타이포그래퍼들과 북 디자이너들은 새로운 형태의 책을 위한 방법과 기술 등 새로운 많은 것들을 배우는 것이 필수적이지 않을까. 의심할 여지 없이 그렇다. 그러나 기다리라 했다. 전자책 혹은 전자출판의 새로운 기술로 들어가기 앞서, 우리는 먼저 인쇄된 책으로부터의 경험을 재검토하고 재평가해야 할 필요가 있다고 생각한다. 인쇄된 책들이 우리에게 어떤 가치들을 제공했었는지도. 훌륭하게 인쇄된 책은 우리가 만질 수 있는 좋은 질감을 갖는다. 옵셋으로 인쇄가 된 부드러운 표면은 자체적인 아름다움을 가지고 있으며, 활판인쇄된 것 또한 그 독특한 질감을 제공한다. 페이지들 위에는 글자들의 조화로운 리듬이 구성되고 인쇄된다. 인쇄물들이 접지를 통해 여러 첩으로 만들어지고 제본되고 책이 탄생한다. 조각과 마찬가지로 책은 다양한 물질들로 구성된 입체적인 물건이며, 다양한 각도에서 볼 수 있고 직접 손으로 살펴볼 수 있다. 좋아, 이제 디지털 타이포그래피에 대해 이야기해보자.

531

yamamoto taro

poster. kazuraki® poster. 1,030 x 1,456. 2011.

Spontaneity in typography

Adobe® has created a ground-breaking new typeface that is visually rich and free from the rigid design protocols that have constrained Japanese fonts for decades. Called Kazuraki®, this new typeface design serves as an inspiration and model for other CJK type designers and type foundries. The Kazuraki typeface design was inspired by the calligraphy of 12th century artist and writer Fujiwara-no-Teika, who is considered to be one of the greatest poets in Japan's history. Inspired by Teika's calligraphy, Adobe Senior Designer, Ryoko Nishizuka began creating a new typeface years ago. Most Japanese fonts are monospaced, meaning that their glyphs are designed to fit within an imaginary box known as the em-square. Kazuraki, on the other hand, is an example of genuinely proportional typeface that can faithfully represent the calligraphic quality of the typeface inspired by an ancient master.

타이포그래피 분야에서 디지털 기술의 가장 큰 혜택은 무엇인가. 디지털 기술의 도래 덕에 글자 사이 공간을 아주 세밀하게 제어할 수 있게 되었다. 또한, 글자를 배치하고 구성하는 자유를 주었다. 글자 외에 이미지, 색, 질감, 그래픽 도형 등 다양한 인쇄 요소들을 자유롭게 혼합하거나 겹칠 수 있다. 그러나 디지털 타이포그래피의 모든 과정은 바이너리 비트 조합을 필요로 한다는 것을 잊어서는 안 된다. 예를 들어, 스크린에 보이는 작은 글자조차도 비트로 구성된 것이다. 만약 디지털 아웃라인 폰트일 경우의 비트맵은 '레스터라이저' 혹은 '스캔컨버터'라는 소프트웨어로 만들어진 것이다. 어도비의 엔지니어들은 레스터라이저 소프트웨어 품질을 향상시키기 위해 매일 열심히 일하고 있다. 이는 다양한 디스플레이 기기들 상에서 우리의 글자들이 좋아 보이고 가독성 있게 하기 위함이다. 스캔컨버터는 오늘날 타이포그래피 기술 분야에 있어서 아주 중요한 기반시설이다.

어찌 보면, 디지털 타이포그래피는 코딩된 글자 인풋을 디스플레이 스크린상의 비트맵 패턴으로 변환하는 간단한 과정이다. 그러나 한편으로는 합리적이고 논리적인 과정이다. 'f'와 'i'를 입력하면 추상적인 라틴 알파벳 문자들을 상징하는 두 글자의 코드들은 폰트가 현재 사용하는 테이블 맵의 해당 글리프 아이디 번호로 변환된다. 'f'와 'i'의 두 글리프 아이디는 연자 'fi'를 상징하는 단일 글리프 아이디 번호로 다시 변환될 수 있다. 연자 'fi'의 글리프 아이디는 폰트 파일 안의 아웃라인 저장 위치를 안내하는 주소 정보로 다시 변환된다. 그 후, 아웃라인 정보는 위에 명시한 '레스터라이저' 소프트웨어를 통해 처리되며, 비로소 스크린에 연자 'fi'의 비트맵을 얻게 되는 것이다. 한편, 디지털 타이포그래피는 인간 요소들과 시각적 인지를 다루어야 할 필요가 있다. 금속활자 시대에 대부분의 경우 글라프 매트릭스는 (예를 들어 'a') 모든 크기로 디자인되고 생산되어야 했다. 그러나 덕분에 대상 크기에 최적화된 글자로 디자인될 수 있었다. 예를 들어, 8pt로 디자인된 글자는 12pt 글자에 비해 비교적 두꺼운 세리프, 넓은 장평, 넓은 사이드베어링(글자 사이 공간)을 가져야 한다. 그래야 작은 크기에서 글자가 더 나아 보이기 때문이다. 기계식이든 사진식이든 전자식이든 폰트 회사들이 자동 크기조절 기법을 사용하기 시작한 후에 금속활자 시대에 만들어진 시각적 최적화는 잊혀져 버렸다. 진지한 타이포그래퍼가 시각보정을 위해 할 수 있는 것은 고작 글자 사이 공간을 고르게 하기 위해 간격을 느슨하게 풀거나 조여주는 조정에 제한되었다. 이러한 '현대' 문제를 피하기 위해 폰트 자족 안에는 다수의 글자 크기 종류를 위해 다수의 폰트들이 디자인되어 있는 경우도 있다. 그러한 예제 중 하나는 다음 페이지에서 볼 수 있다. 디지털 커뮤니케이션 기술이 국가도 문화도 다른 수십억 세계 인구에 의해 사용되면서 오늘날 상호문화습득은 중요한 이슈가 되고 있다. 미래 타이포그래피의 형태에 어떤 영향을 줄 것인가. 다양한 스크립트들이 타이포그래피와 공존하거나 밀접한 관계를 가질 수 있다. 오늘날의 타이포그래퍼들이 이를 이해해야 한다는 것은 명백하지만, 세계의 문자에 대해 전문가여야 한다는 뜻은 아니다. 예를 들어, 라틴 문자와 일본어를 사용하여 글을 작성할 때, 기본 언어가 일본어라면 라틴 문자들은 일본 문자들의 무게중심선에 맞춰 상대적으로 배치되어야 할 것이다. 오늘날 우리는 인디자인 같은 소프트웨어 상에서 오픈 타입 폰트들을 통해 이를 반자동으로 조절할 수 있다. 라틴 알파벳 오픈 타입 폰트는 일본 글자 높이(EM body)의 위치 정보를 포함하기 때문이다. 그 정보를 가지고 응용 프로그램은 약간의 조절이 가능해진다. 대부분의 경우 다음 페이지에서 보이는 것과 같이, 알파벳 대문자의 평균 높이가 일본어 문자 글줄의 평균 높이에 정렬되기 위해 그 하단 기준선을 이동한다. 그러나 이것은 라틴 알파벳 하단 기준선을 일본어 문자 글줄에 맞추어 위치하게 하는 경우에만 가능하다. 라틴 문자와 일본 문자 간의 글자 크기 혹은 획 굵기의 부조화는 수동 조절을 필요로 할 수 있다.

532

어떤 이들은 전자출판은 그래픽 디자이너들과 타이포그래퍼들의 역할을 약화시킬 것이라고 생각한다. 생산과 출판 과정에서 프로그래머들이 중요한 역할을 하게 될 것이기 때문이다. 이러한 비관적 입장에 대해 어떻게 생각하는가. 인터넷 웹페이지와 전자책에 모두 사용되는 HTML과 같은 마크업 언어들은 내용과 스타일의 분리 원칙에 근거한다. 웹 도큐먼트들의 수신자 입장은 스타일과 타이포그래피, 시각적 모습을 제어할 수 있다. 모든 사용자는 스스로 스타일 사양을 설정할 수 있다. 그러나 대개는 소프트웨어의 리더 혹은 뷰어 개발자에 의해 기본 프리셋 스타일로 설정되어 있다. 오늘날, 커뮤니케이션과 소셜 네트워크 서비스에서는 콘텐츠 정보가 드라마틱하게 수신되고 독자의 소프트웨어에 업데이트된다. 그리고 수신자 측은 그 콘텐츠가 어떤 스타일로 보여져야 할지를 결정한다. 그러나 당신은 오늘날의 뉴미디어 타이포그래피에 만족하는가? 만약 현재 뉴미디어에서 보여지는 타이포그래피에 만족하지 않는다면, 이는 그 뉴미디어는 진지한 타이포그래퍼들과 그래픽 디자이너들을 시급히 필요로 한다는 것을 말한다. 왜냐하면 그 외에는 누구도 더 이상 개선할 능력이 없기 때문이다.

결론으로, 다시 말해 타이포그래피란 무엇인가? 타이포그래피는 작가들과의 시공을 초월한 소통을 가능케 하는 도구이다. 또한, 타이포그래피는 잊을 수 없는 심미적 경험을 제공하는 무언가이다. 영원히 그 어떤 것도 이 두 가지 원칙을 바꿀 수 없다.

533

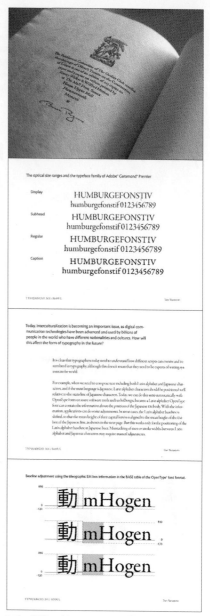

typojianchi2011seoul_taroyamamotonew.pdf (presentation) 2011 1
taro yamamoto's presentation for the typojianchi 2011.

yamamoto taro

book. 210 x 297.
the journal of the society of typography, japan, 01. (tokyo: the society of typography, 2007) designed by joji sugishita. 2007.
the journal of the society of typography, japan, 02. (tokyo: the society of typography, 2008) designed by joji sugishita. 2008.
the journal of the society of typography, japan, 03. (tokyo: the society of typography, 2009) designed by joji sugishita. 2009.
the journal of the society of typography, japan, 04. (tokyo: the society of typography, 2010) designed by suguru watanabe. 2010.

book. the japanese version translated by noriko saito, designed by yoshihisa shirai, and published by bruce interactions, inc. of the book:
phil baines. penguin by design: a cover story 1935–2005. (london: penguin books, 2005). 148 x 210. 2010.

서예가인 여태명은 국립현대미술관에서 열린 〈한·중·일 수묵의 향기 초대전〉, 중국미술관에서 열린 〈제1회 베이징 비엔날레〉(2003) 등의 국제전에 참여했으며 전주·서울·베이징·선양·파리·베를린 등지에서 14회의 개인전을 열었다. 또 『여태명 예술실천』, 『한글서예』 등 10종의 책을 냈다. 그의 작품은 국립현대미술관, 중국미술관, 독일교통역사박물관, 칠레대사관 외무성, 러시아 모스크바 동양미술관, 모스크바대학, LA UCLA, 하와이대학교, 예술의전당, 서울서예박물관, 국립전주박물관, 중국노신미술대학 미술관 등에 소장되어 있다. 현재 원광대학교 미술대학 서예, 문자예술학과 교수이고 중국 노신미술대학 객원 교수직을 맡고 있으며 한국 캘리그래피디자인협회 회장직을 맡고 있다.

여태명.余泰明.

yeo.tae-myung. korea

<div style="writing-mode: vertical-rl">yeo tae-myung</div>

534

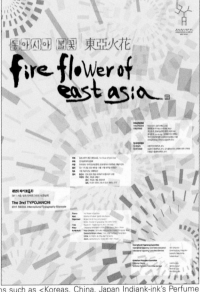

Korean calligrapher. Participated in international exhibitions such as <Koreas, China, Japan Indiank-ink's Perfume Invitation Exhibition> in Seoul and <2003 The 1st Beijing Biennale> in Beijing. He held 14 solo exhibitions in Jeonju, Seoul, Beijing, Shenyang, Paris, Berlin and published 10 books including *Yeo Tae-myong Art Practice*, *Hangul Calligraphy* and etc. His works are collected by various of museums such as Germany Transportation History Museum, Ministry of Foreign Affairs in Chile Embassy, Moscow Oriental Art Museum in Russia, Moscow University, L.A UCLA University, Hawaii University, Seoul Calligraphy Museum in Hall of Art, Chungwadae, National Jeonju Museum, National Traditional Music Hall, Chinese Art Museum, He is professor at Fine Art Division, Wonkwang University and also emeritus professor at Luxun Academy of Fine Arts, China. He is the president of Korea Calligraphy Design Association.

yeo tae-myung

poster.　flame.　700 x 990.　2011.

poster.　fire flower.　700 x 990.　2011.

poster.　fire flower of east asia.　700 x 990.　2011.

a work of art. deep-rooted tree deep-springed water. 900 x 300. 2001.

I am a Korean calligraphy artist as well as a calligraphist.

As a figure to have maintained a job as artist for a long time, I personally think that any artist, at least any person regarded art as a job, cannot find out some pleasure from repeated working. With an evolved working through an endlessly repeated change, I do express myself. In the past I had been astray owing to being tired with repeated imitating working. At that time when I aspired for 'novelty', I discovered a calligraphy book freely written by any grandmother and grandfather at an antique shop in which I casually dropped.

Although that it was really a chance and bond was always beside of us, we did not know its true value unintentionally because that it was used as a kindling or a cigarette or toilet paper as I saw when I was young.

For example, there was hosted Korea·China·Japan Calligraphy Invitational Exhibition memorizing the 600th anniversary of paper invention, which was sponsored by German Transportation History Museum in 1990. At that time, the curator who saw Korean artworks asked me, "Why do you display Chinese artworks? Isn't there your native calligraphy?" As soon as I respond to this question with Hangeul artworks that I carried from Korea, he astonished and admired with a saying, 'Respectful! Good feeling!' That curator who saw Hangeul for the first time was surprised by the fact that it is Korean native character and culture, and marvelled an excellent character of Hangeul from the standpoint of plasticity. From that occurrence, even now I feel pride in that Hangeul is ours, so that I became to pay more attention to Hangeul artworks.

To speak more about character of Hangeul, it is divided into Kwanbang and Mingan patterns as six or seven patterns as for Chinese character. Kwanbang pattern implies the used one in public office, which seems orderly as if gauged by a measure, and most of modern people are accustomed by this pattern and apply to their artworks. Expressed under maximum suppression of myself, thus it seems that this pattern cannot reveal self-identity. On the contrary, as used for daily living, Mingan pattern can various forms of personality. Owing to maintaining order in disorder, originality, and delight, it is a pattern which I can find myself.

The personalities of "I" result in a group, and it results in a culture. Language or character is the face of its times. It is circulated and read in that period, and continues to be developed more and more. Therefore even now I write and read the world, and pursue myself by Minche of Hangeul.

yeo tae-myung

나는 한국의 서예가이며, 캘리그래피스트다

반복적인 작업에서 즐거움을 찾기 힘들다고 생각한다. 수없이 반복되는 변화를 통해 진화된 작업으로써 나 자신을 표현한다고 생각한다. 반복적인 임서 작업에 지쳐 고민하던 때가 있었다. '새로움'이 간절하던 그때, 우연히 들렀던 골동품가게에서 할머니, 할아버지들이 자유스럽게 쓴 글씨 책을 발견했다.

참으로 우연이고 인연이었던 게 늘 우리의 곁에 있었던 것이지만 어릴 적 불쏘시개나 담배말이용 종이 또는 화장실에서 화장지 대용으로 쓰여 왔기 때문에 무심결에 그 글씨의 진정한 가치를 몰라봤던 것이다.

일례로 1990년도 독일 교통역사박물관에서 주관하여 종이 생산 600주년 기념으로 〈한·중·일 서예초대전〉이 열렸다. 당시 한국 작품을 본 큐레이터가 "당신들은 왜 중국 작품을 전시합니까? 자국의 고유체는 없습니까?"라며 질문해 왔다. 이에 한국에서 준비해 온 한글 작품을 꺼내서 보여주자 그는 몹시 놀라워하며 '존경스럽다! 느낌이 너무 멋지다!'라고 극찬을 해왔다. 한글을 처음 접하게 된 그 큐레이터는 한국 고유의 문자와 문화라는 것에 놀라워했으며, 조형적인 측면에서 우수한 한글에 감탄했다. 그 일을 계기로 지금도 우리의 것이라는 자부심과 예술성을 더해 한글 작품에 더 심혈을 기울여 작업하고 있는 것 같다.

한글의 서체에 대해 더 말하자면, 한문이 6체, 7체로 나뉘는 것처럼 한글은 관방서체와 민간서체로 나뉜다. 관방서체란 관에서 주도하는 서체로 자로 잰 듯한 질서정연한 서체인데, 현대 사람들은 대부분 관방서체에 익숙해져 작품 활동을 한다. '나'를 최대한 억제하며 표현하는 관체이기 때문에 자기 독자성을 찾을 수 없다고 볼 수 있다. 반대로 민간서체는 실생활에 사용되었던 서체로 개성이 표현되어 다양한 표정을 구현시킬 수 있다. 무질서 속에 질서가 있고 독창성과 유쾌함이 있기에, 나를 찾을 수 있는 서체이다.

세상에 나라는 개성이 모여 집단이 되고, 또한 그것이 모여 문화로 이어지는 것이다.

언어나 문자는 그 시대의 얼굴이다. 그 시대에 통용되고 읽혀지며 발전에 발전을 거듭하여 진화한다. 그래서 오늘도 나 여태명은 한글의 민체를 통해 세상을 써내려가고 읽어나가며 또한 나 자신을 찾아가고 있다.

poster. love hungry. 530 x 460. 2006.

poster. heaven,land,man. 1,480 x 3,100. 1999.

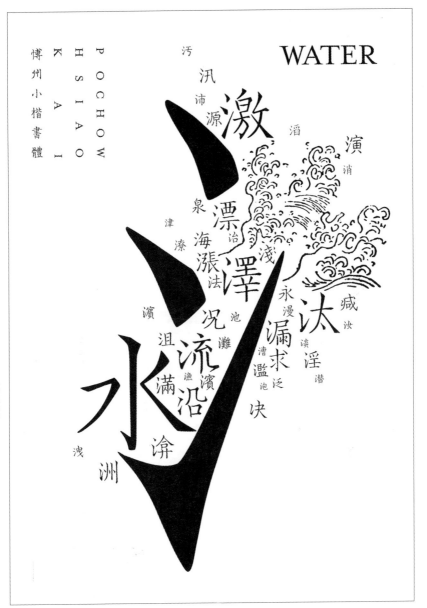

poster. chekiang shu ke sung (chinese font). 700 x 1,000. 2011.

ying yonghui

잉융후이.应永会.

그래픽 디자이너,
 일러스트레이터,
 글꼴 디자이너로 다양한 분야에서 자신만의 작업을 이어가고 있다.

1979년 저장성 향산현에서 출생했다.

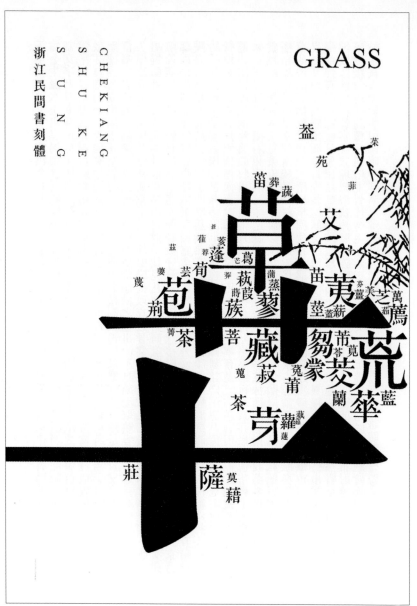

GRASS

poster. chekiang shu ke sung (chinese font). 700 x 1,000. 2011.

Ying yonghui

ying.yonghui. china

Graphic Designer

Illustrator,

Typeface Designer.

Born in 1979, Xiangshan County, Zhejiang Province of China.

浙江民間書刻體

CHEKIANG SHUKE SUNG

千字文

天地玄黃，宇宙洪荒。日月盈昃，辰宿列張。寒來暑往，秋收冬藏。閏餘成歲，律呂調陽。雲騰致雨，露結為霜。金生麗水，玉出崑岡。劍號巨闕，珠稱夜光。果珍李柰，菜重芥薑。海鹹河淡，鱗潛羽翔。龍師火帝，鳥官人皇。始制文字，乃服衣裳。推位讓國，有虞陶唐。弔民伐罪，周發殷湯。坐朝問道，垂拱平章。愛育黎首，臣伏戎羌。遐邇壹體，率賓歸王。鳴鳳在樹，白駒食場。化被草木，賴及萬方。蓋此身髮，四大五常。恭惟鞠養，豈敢毀傷。女慕貞絜，男效才良。知過必改，得能莫忘。罔談彼短，靡恃己長。信使可覆，器欲難量。墨悲絲染，詩讚羔羊。景行維賢，克念作聖。德建名立，形端表正。空谷傳聲，虛堂習聽。禍因惡積，福緣善慶。尺璧非寶，寸陰是競。資父事君，曰嚴與敬。孝當竭力，忠則盡命。臨深履薄，夙興溫凊。似蘭斯馨，如松之盛。川流不息，淵澄取映。容止若思，言辭安定。篤初誠美，慎終宜令。榮業所基，籍甚無竟。學優登仕，攝職從政。存以甘棠，去而益詠。樂殊貴賤，禮別尊卑。上和下睦，夫唱婦隨。外受傅訓，入奉母儀。諸姑伯叔，猶子比兒。孔懷兄弟，同氣連枝。交友投分，切磨箴規。仁慈隱惻，造次弗離。節義廉退，顛沛匪虧。性靜情逸，心動神疲。守真志滿，逐物意移。堅持雅操，好爵自縻。都邑華夏，東西二京。背邙面洛，浮渭據涇。宮殿盤鬱，樓觀飛驚。圖寫禽獸，畫綵仙靈。丙舍傍啟，甲帳對楹。肆筵設席，鼓瑟吹笙。升階納陛，弁轉疑星。右通廣內，左達承明。既集墳典，亦聚群英。杜稿鍾隸，漆書壁經。府羅將相，路俠槐卿。戶封八縣，家給千兵。高冠陪輦，驅轂振纓。世祿侈富，車駕肥輕。策功茂實，勒碑刻銘。磻溪伊尹，佐時阿衡。奄宅曲阜，微旦孰營。桓公匡合，濟弱扶傾。綺迴漢惠，說感武丁。俊乂密勿，多士寔寧。晉楚更霸，趙魏困橫。假途滅虢，踐土會盟。何遵約法，韓弊煩刑。起翦頗牧，用軍最精。宣威沙漠，馳譽丹青。九州禹跡，百郡秦并。嶽宗恆岱，禪主云亭。雁門紫塞，雞田赤城。昆池碣石，鉅野洞庭。曠遠綿邈，巖岫杳冥。治本於農，務茲稼穡。俶載南畝，我藝黍稷。稅熟貢新，勸賞黜陟。孟軻敦素，史魚秉直。庶幾中庸，勞謙謹敕。聆音察理，鑑貌辨色。貽厥嘉猷，勉其祗植。省躬譏誡，寵增抗極。殆辱近恥，林皋幸即。兩疏見機，解組誰逼。索居閑處，沉默寂寥。求古尋論，散慮逍遙。欣奏累遣，慼謝歡招。渠荷的歷，園莽抽條。枇杷晚翠，梧桐早凋。陳根委翳，落葉飄颻。遊鵾獨運，凌摩絳霄。耽讀翫市，寓目囊箱。易輶攸畏，屬耳垣牆。具膳餐飯，適口充腸。飽飫烹宰，飢厭糟糠。親戚故舊，老少異糧。妾御績紡，侍巾帷房。紈扇圓潔，銀燭煒煌。晝眠夕寐，藍筍象床。弦歌酒讌，接杯舉觴。矯手頓足，悅豫且康。嫡後嗣續，祭祀烝嘗。稽顙再拜，悚懼恐惶。箋牒簡要，顧答審詳。骸垢想浴，執熱願涼。驢騾犢特，駭躍超驤。誅斬賊盜，捕獲叛亡。布射遼丸，嵇琴阮嘯。恬筆倫紙，鈞巧任釣。釋紛利俗，並皆佳妙。毛施淑姿，工顰妍笑。年矢每催，曦暉朗曜。璇璣懸斡，晦魄環照。指薪修祜，永綏吉劭。矩步引領，俯仰廊廟。束帶矜莊，徘徊瞻眺。孤陋寡聞，愚蒙等誚。謂語助者，焉哉乎也。

poster. chekiang shu ke sung (chinese font). 700 x 1,000. 2011.

This exhibition is to show the font of Chekiang Shu Ke Sung which is designed by me. The idea comes from the structures of Traditional Chinese characters. Based on the radicals, also a part of structures in Chinese characters, I designed the posters in that the original Chinese characters were from nature and life. Here, I chose two radicals which are Straw(草) and Bam-

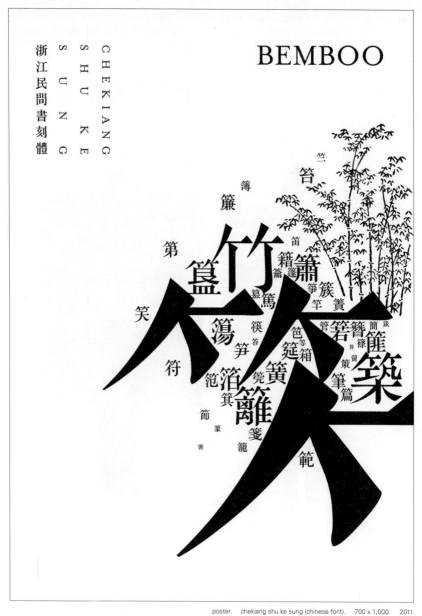

浙江民間書刻體

CHEKIANG
SHU
KE
SUNG

BEMBOO

yihng Yonghui

poster.　chekiang shu ke sung (chinese font).　700 x 1,000.　2011.

boo(竹) to show the origin of the Chinese Characters._____ 본 전시는 내가 디자인한 〈Chekiang Shu Ke Sung〉 폰트를 소개한다. 전통 한자의 구조에서 아이디어를 얻었다. 한자 구조의 일부인 근본에 기반하여 본래 한자가 자연과 삶으로부터 비롯되었음을 포스터로 디자인하였다. 초(草)와 죽(竹)의 근본을 선택하여 한자의 근원을 보여주었다.

1988년 난징예술학원 디자인학과를 졸업했다. 1996년 디자인 작업실 'Fan(梵)'을 열었고 2000년 '한칭탕디자인'의 디자인 디렉터를 지 냈다. 2007년 개인 포스터전 〈07/70〉을 열었고 2010년 〈ADC 다이얼로그 난징 디자인〉 전시회를 조직했다. 〈제9회 백금 크리에이티 브대회〉의 심사위원을 맡았으며 현재 국제그래픽디자이너연맹(AGI), 중국출판업종사자협회 서적예술연구회, 선전그래픽디자이너협회 (GDC) 회원이며 장쑤성그래픽디자이너협회와 난징문화크리에이티브산업협회 이사회원이다. 그의 작업은 원쇼디자인 어워드, 레드닷디 자인 어워드, D&AD, 골든비 어워드, 홍콩 아시아디자인상, 도쿄 타이프디렉터스클럽(TDC) 어워드 등을 수상했다.

zhao.qing. ^{china}

zhao qing

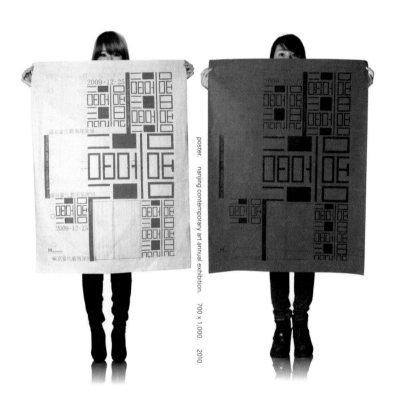

poster. nanjing contemporary art annual exhibition. 700 × 1,000. 2010.

542

자오칭.赵清.

Born in 1965 in Nanjing, Zhao graduated from Design Specialty, Nanjing Arts Institute in 1988. He found the Fan Design Studio in 1996, and established Han Qingtang Design Co., Ltd. and worked as design director of the company. In 2000, he started his practice and exploration in graphic design, holding individual Poster Session of <07/70> in 2007. Zhao was the Judge of The 9th Platinum Originality Graphic Design Competition, and organized ADC dialogue Nanjing Design Exhibition in 2010. He is member of AGI, Shenzhen Graphic Designers Association, the Art Design of Books Committee of Publishers Association of China, Council of Culture Originality Industrial Association and director/member of Jiangsu Graphic Designers Association. Many of Zhao Qing's works have been accepted to show on various international design competitions including: One Show Design, Red dot award, D&AD Awards, Design for Asia (DFA) Award, Golden Bee Awards, TDC Tokyo Annual Award, and so on.

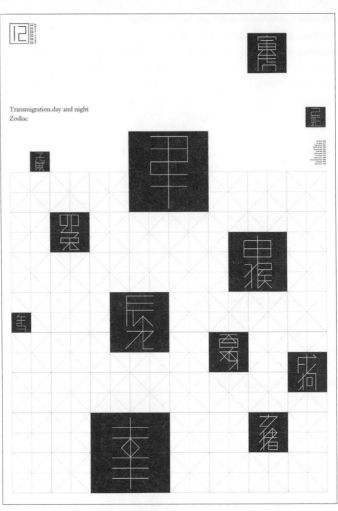

Transmigration.day and night
Zodiac

543

zhao qing

poster. transmigration. day and night. 700 x 1,000. 2009.

Nanjing Contemporary Art annual Exhibition Chinese
symbols are not directly used in this design work, while contrast colors of white-red and
red-black are presenting the contemporary art of China in it. Red paper used for couplet—cal-
ligraphy in folk China are alternately interspersed. With overflowing ink—darkness of block
printing and casual traces of paper—dyeing—sense of casuality are shown to our minds.
Non—spine bookbinding makes the cover page elegant and floating, and shows the rythmic
feelings on reading Chinese books.

Mix Design The Beauty of Chinese Characters,
a collection of selected works by brand image designer Hong Wei, was raising difficulties
in new variety of book design which could represent Hong's Mixing—Designing Philosophy
and his works. After many attempts, re—deconstruction of his logos and overview of red
and black colors became the final decisions on designing this book. Traditional page—folding
method had made deconstructed logos printed inside and outside of any page, explaining the
essence of Hong's works. Title charaters in the image of childish scribblings bring along with
sprung rhymes on reading such book.

Transmigration. Day and Night Deformation of Chinese characters
which are constructed in traditional squad for calligraphy training represent 12 traditional Chi-
nese years that are under animals'names. Linking strokes are melted into the design, reflect-
ing the philosophy of 12 years' Cirlce.

Knowledge Essence Perfection This is the post
for 09' Graduation Exhibition of Nanjing University of the Arts. The Chinese character "Mei" 544
which means beauty is entirely used to form the image, with fusion materials of 09, badge of
university and so on. Long history of the university is shown in the form of pictures. The post
reflects the history of the university and predicts the future.

book.　knowledge essence perfection.　600 x 900.　2010.

545



zhao qing

동양적 맥락으로서의 디자인　　　　　　　　　　　　　　　동양 디자이너들의 작품들은 명백히
동양적 매력과 리듬이 깊이 포함되어 있다. 국제 무대에서 뛰어나고 빛나는 디자인 작품들은 항상 동양적 맥락을
가지고 있다. 동양 디자이너들은 한자와 함께 태어나고 호흡하며, 그들의 디자인 여정은 그 글자들의 생명이다.

한자로부터 시작된 디자인　　　　　　　　　　　　　　　　　　　　　　디자이너들은
자신의 여정을 특성과 개성 가득한 한자로부터 시작할 수 있다. 디자이너들은 한자의 철저한 탐구와 이해로부터
시작하므로, 시각 영역 안에서 다양한 디자인을 접하게 될 때 그들의 사고는 넓고 생산적이며, 자연스럽게 그들의
디자인 작품은 풍부한 동양적 스타일과 감성으로 가득하게 된다.

형태와 콘셉트를 가진 디자인　　　　　　　　　　　　　　　형태와 콘셉트를 둘 다 가지고 있는
디자인은 완벽할 것이다. 형태는 디자인의 방법이며, 콘셉트는 디자인의 정신이다. 최고와 최신 콘셉트는 유토피
아에 있을 것이며 풍부한 형태들로부터 해석할 필요도 없다. 반면 속이 빈 콘셉트의 결함들은 다양한 종류의 디자
인 방법을 통해서도 감소될 수 없다. 콘셉트는 형태를 완성시키며, 형태는 콘셉트를 진전시킨다.

전통적 관례의 해체로부터의 디자인　　　　　　　　　　　　　　　　　각 국가의
광범위하고 깊은 전통적 관례는 동양 디자이너들이 연구하고 흡수할 수 있는 최고의 원천이다. 그러나 디자인에
있어 그들은 자신의 작품을 비전통적으로 만들어야 하며, 전통적인 관행으로부터 벗어나야 한다. 디자이너들의
재료들은 수년에 걸친 전통적 이해로부터 온 것일지라도, 디자인의 구조는 전통을 해체한 현대 콘셉트의 형태에
기반해야 한다.

zhao qiup

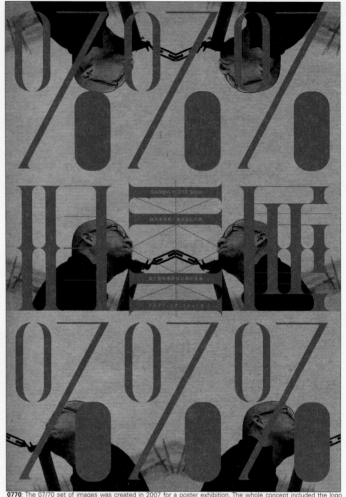

zhao qing

0770: The 07/70 set of images was created in 2007 for a poster exhibition. The whole concept included the logo 07/70, the invitation for the exhibition and the 07/70 poster album. The exhibition showed altogether 70 poster , which is the meaning of this set of images. The invitation is a foaled one; for the thread-stitched 07/70 poster album, the spine of the album is exposed to reveal a sense of clumsiness.

poster. 770. 600 x 900. 2009.

热烈祝贺法国
肖蒙海报节创
办二十周年！

Ville de Chaumont. Avec le soutien du Conseil général de la Haute-Marne, du Conseil régional Champagne-Ardenne et de la Direction Régionale des Affaires Culturelles / Ministère de la Culture et de la Communication.

20ᵉ Festival International de l'Affiche et
du Graphisme de Chaumont

du 16 mai au 14 juin 2009

548

zhu.haichen. china

Zhu Haichen, born in 1976 is an independent graphic designer and the teacher of the Chinese Academy of Art. His works won the prizes and displayed at Warsaw, Chaumont, Toyama, Tehran, Hong Kong and so on. He was the jury member of the 17th International Poster and Graphic Arts Festival of Chaumont, and the 2th International Poster Biennial of Islam._____

주하이천.朱海辰.

_____1976년 생인 주하이천은 독립 그래픽 디자이너이자 중국미술학원 교수로 재직 중이다. 그의 디자인 작업은 바르샤바, 샤몽, 도야마, 테헤란, 홍콩 등지에서 열린 국제 공모전에서 입상하였으며, 세계 각국의 도시에서 전시되고 있다. 또 〈제17회 샤몽 국제 포스터 페스티벌〉, 〈제2회 이슬람 국제 포스터 비엔날레〉의 심사위원으로 활약하기도 했다.

zhu haichen

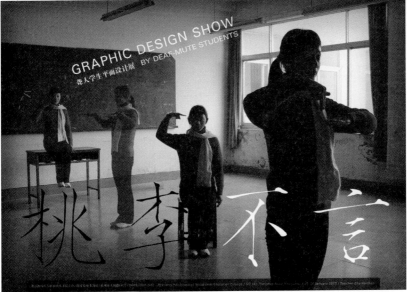

poster. the 10th anniversary of visual communication design dept in china academy of art. 900 x 1,280. 2006.

poster. graphic design show by deaf-mute students. 900 x 1,280. 2005.

Graphic designer: the observer of the social culture

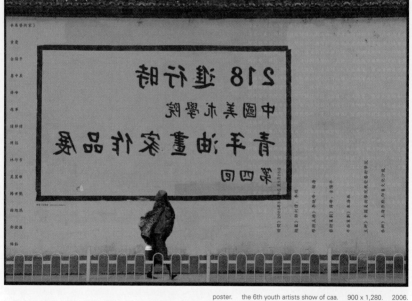

zhu haichen

poster.　the 4th youth artists show of caa.　900 x 1,280.　2005.

poster.　the 6th youth artists show of caa.　900 x 1,280.　2006.

그래픽 디자이너:　　　　　　　　　　　　　　　　　　사회문화의 관찰자

Zhu Yingchun is a book designer and acquisition editor. Many of his works have been selected in the National Book Design Exhibition and won awards. In 2007, <Stitching Up> was named as 'the Most Beautiful Book in the world' in Leipzig, Germany, and was stored by the National Library of Germany. In 2008, written and designed by him, <Ant>, received the special award of 'the Most Beautiful Book in the world' given by UNESCO and German Book Art Foundation and its copyright was bought by many countries. In the same year, he attended the Forum of Book Design in Korea on invitation, and he was also invited to attend the <Amazing Asia: Design Forum> in Taipei International Book Exhibition in 2009. In the same year, his <Ant>, <Weep No More>, and <Envelope> won the Best Book Design Award in the 7th National Book Design Exhibition.  was awarded the Nomination Prize of Designing in the 10th National Artworks Exhibition in 2009, and it received the Book Design Award of Chinese Government Award for publishing in 2010. In the same year, Zhu gave a speech titled <Passionate Paper, Tender Book: Searching the Beauty of Book> on invitation in 798 Art District of UCCA. Also in this year, he was invited by Goethe Institute to make a lecture tour with the title <The Paper with Affection>, and <the Book with Soul> in the provincial libraries of Hubei, Chongqing, Shanxi and Shanghai. In September 2010, he successfully planned and organized <the Most Beautiful Book in German> and <East China Book Design Biennale> in Nanjing. And in 2011, he planned the exhibition of <the Most Beautiful Book in Germany> in Nanjing.

book. just line . 143 x 203. 2011.

주잉춘 朱贏椿.

주잉춘은 주로 북 디자인과 편집기획 활동을 하고 있으며, 그의 작업 중 다수가 중국 북 디자인 전시회에 전시되었고 많은 상을 받았다. 2007년 『부재(Stitching Up)』는 라이프치히에서 '세상에서 가장 아름다운 책'으로 선정되어 독일 국가도서관에 수장되었다. 2008년 그가 저술 및 디자인을 맡은 책 『개미』로 유네스코와 독일 도서예술기금회가 수여한 '세상에서 가장 아름다운 책' 특별상을 받았으며 판권이 여러 국가에 수출되었다. 2008년 한국에서 열린 북 디자인 포럼과 2009년 타이베이 국제 도서전 〈어메이징 아시아: 디자인 포럼〉에 초청받았다. 2009년 『개미』, 『불곡』, 『신봉』 등으로 제7회 중국 북디자인전 '최고 북디자인상'을, 2009년 『사적인 생각을 하다』로 '중국 출판정부상 북디자인상'을 받았다. 2010년 다산초 798 내 UCCA에서 '정이 많은 종이, 부드러운 책: 책의 아름다움을 탐구하다' 강연을 하였다. 2010년 독일문화원의 요청으로 후베이성 도서관, 충칭 도서관, 산시성 도서관, 상하이 도서관에서 순회강연 '종이에는 정이 있고, 책에는 영혼이 있다'를 열었다. 2010년 9월 난징에서 열린 〈독일에서 가장 아름다운 책〉, 〈화동 북디자인 비엔날레〉를 기획하였다. 2011년 현재 난징에서 〈독일에서 가장 아름다운 책〉 전시회를 기획 중이다. 난징사범대학교출판사 아트 디렉터이자 난징 서의방작업실 디자인 디렉터이며, 장쑤성의 촉망받는 에디터로 선정되었다. 장쑤성 출판협회 장식예술위원회 주임, 난징사범대학 편집출판전공 겸임 교수, 2009년 〈제7회 중국 북디자인 전〉 심사위원, 2009년 〈칸타이킹 디자인 전〉 초청 심사위원, 2010년 〈중국에서 가장 아름다운 책〉 심사위원을 맡았다.

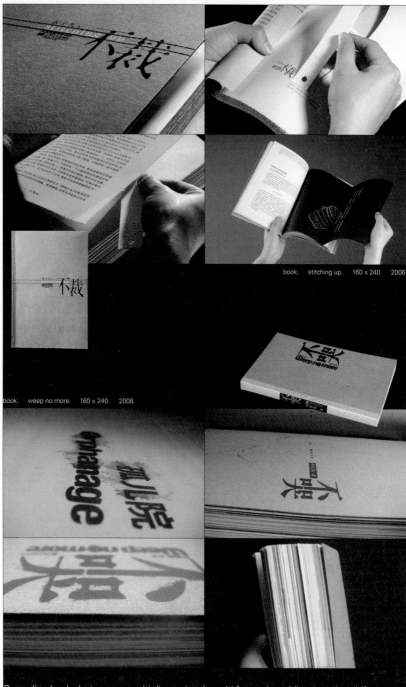

book. stitching up. 160 x 240. 2006.

book. weep no more. 160 x 240. 2008.

zhu yingchun

Regarding book design as a multi-dimensional, multi-faceted, multilayer, and multifactor sys tematic project, Book Garment Workshop is committed to bring the ideas of design ahead into the process of editing in hope of accurately expressing the temperament of a book. Var ied design techniques are applied to reveal the charm of the texture that is uniquely rooted in paper books, so that paper books become works of art with high collection value, which reflect the irreplaceable quality that electronic medias could never compare to.

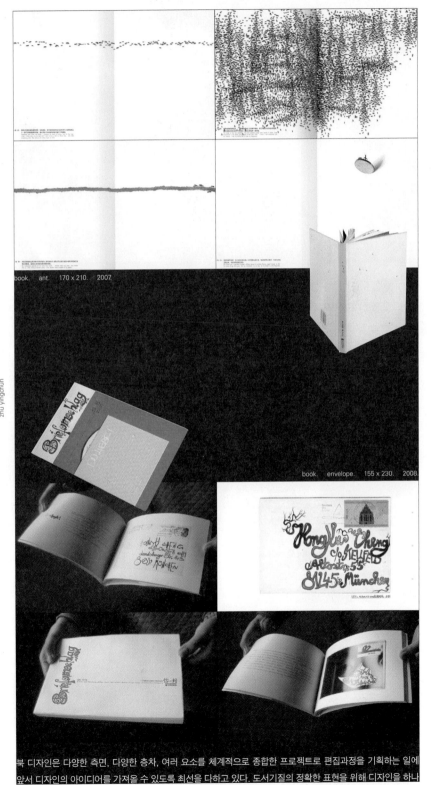

book. ant. 170 x 210. 2007

zhu yingchun

554

book. envelope. 155 x 230. 2008.

북 디자인은 다양한 측면, 다양한 층차, 여러 요소를 체계적으로 종합한 프로젝트로 편집과정을 기획하는 일에
앞서 디자인의 아이디어를 가져올 수 있도록 최선을 다하고 있다. 도서기질의 정확한 표현을 위해 디자인을 하나

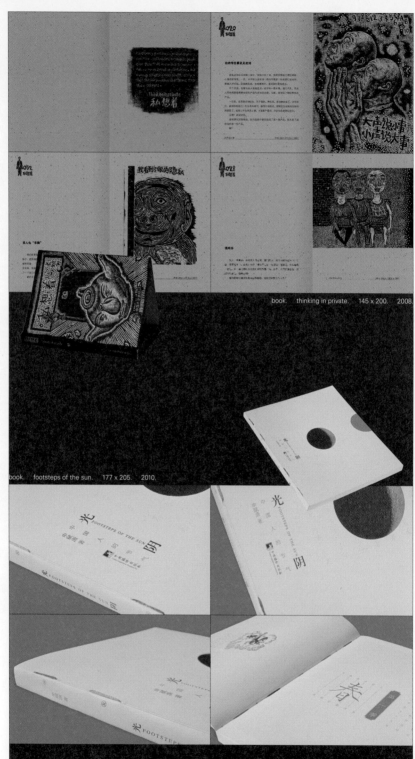

book. thinking in private. 145 x 200. 2008.

book. footsteps of the sun. 177 x 205. 2010.

zhu yingchun

의 수단으로 사용하고 종이도서가 가지고 있는 독특한 매력을 충분히 발휘하여 예술적 효과를 강조했다. 이는 종이도서가 전자매체로 대신할 수 없는 소장품의 가치를 가지게 되고 나아가 고급품으로의 역할을 하고 있다.

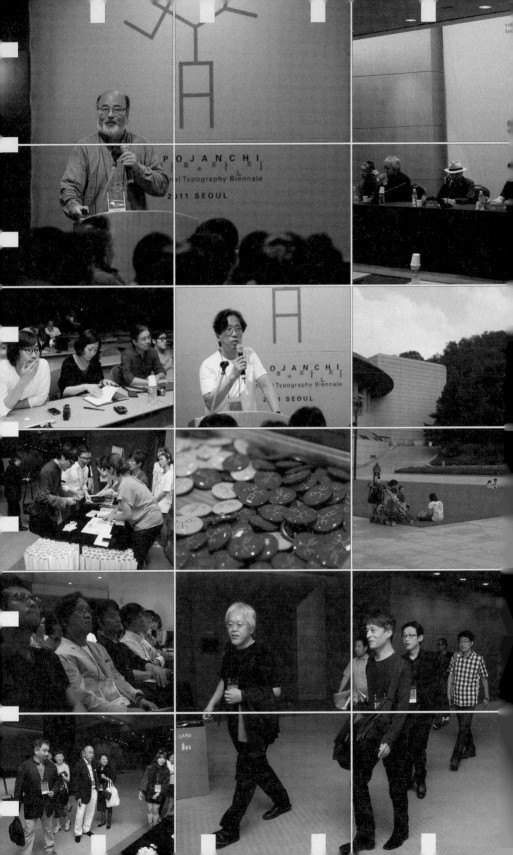

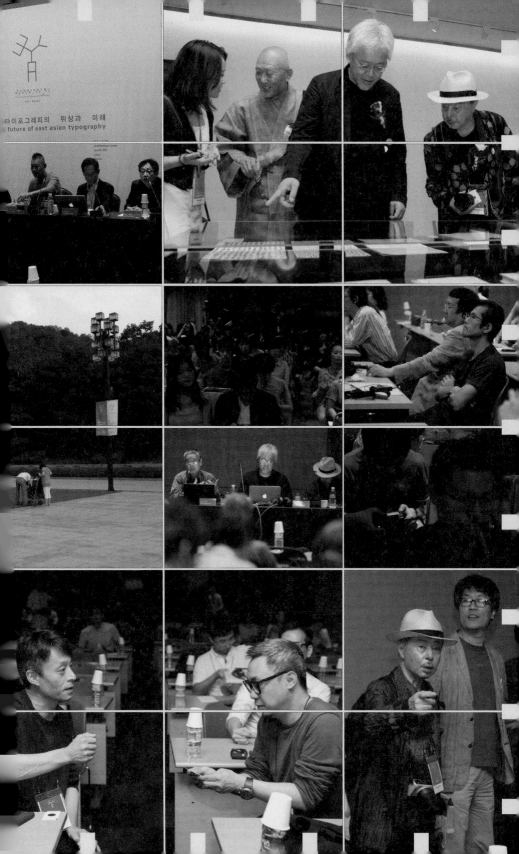

future of east asian typography

Born in 1940. Founded the Asaba Katsumi Design Studio in 1975, Asaba has designed many memorable works in the history of Japanese advertising design. His major works include the Nagano Winter Olympics poster design, the logo mark for the Democratic Party of Japan and etc. Asaba explores the relationships between written and visual expression, and has a particular interest in the rich cultural heritage of writing in Asia. His principal area of expertise lies in the pictographic Dongba script used in rituals by the Naxi tribe in China. He has received numerous awards, including the Tokyo ADC Grand Prix, the Medal with purple ribbon, among others. He is the chairman of the Tokyo TDC, a committee member of Tokyo ADC, the director of JAGDA and a visiting professor at Tokyo Zokei University. As a Japanese representative of AGI (Alliance Graphique Internationale), Asaba actively participates in international conferences every year. He also holds the title of sixth degree master in table tennis (Japan Table Tennis Association).

http://www.asaba-design.com

1940년 출생이다. 1975년 아사바카쓰미 디자인 스튜디오를 설립한 이후 아트 디렉터로서 일본 광고 디자인 역사에 남는 많은 작품을 제작했다. 대표적인 작업으로 민주당 로고, 1988년 나가노 동계올림픽 포스터 등이 있다. 문자와 시각표현의 관계를 연구하고 있으며, 동아시아 문자 가운데 중국에서 전해져 내려오는 상형문자인 '동파문자'에 대한 조예가 깊다. 도쿄 타이프디렉터스클럽 TDC상, 도쿄 ADC 아트디렉터스클럽 ADC상, 일본아카데미상 최우수미술상, 자수포장 등을 수상했다. 현재 도쿄 TDC 이사장, 도쿄 ADC 위원, JAGDA 이사, 도쿄조형대학 객원교수를 맡고 있다. 국제그래픽디자이너연맹(AGI)의 일본 대표로서 매년 세계 각지에서 열리는 총회에 적극적으로 참가하고 있다. 일본탁구협회 평의위원이며 탁구 6단이다.

asaba katsmi

570

아사바.카쓰미.浅葉克己.

asaba.katsumi

japan 1940-

asaba katsmi

poster. agi portugal mind hap. 728 x 1,030. 2010.

Earth letter explorers

지구문자탐험가

asaba.katsumi.

아사바.카쓰미.浅葉克己.

asaba katsmi

572

What do the earth explorers depend on? There is something that directs them to the right direction. It is this map in a compilation by Doctor Nishida Tatsuo called *Letters of the World*. The Distribution Summary of Major Letters in Modern World is the name of this map. It has become ragged now but I open it up from time to time. It is easy to read because it is simple and divided by different colors. Moreover, as it contains important meaning, I want to enlarge it and remake it more accurately if I was given an opportunity. Based on this book, there are three thousand languages and four hundred types of letters on earth. There are also letters that disappeared today. There may have been forceful fights, intensity, and puzzles at the risk of ascendants of people who used these vanished letters.

When you look at a map, you can see multi-colored letters in band-pattern sparkling just above the equator as if they are surrounded by Roman letters. These letters are lined up from Japan to Africa. Exploring each of these countries take a lot of time and money, but it is a given mission to me.

It was when I went out on a program called "Miracle World of Chinese Characters" of NHK as a truth-seeker of Chinese Characters and visited his house where I met Doctor Shirak Shizuka, who received an Order of Cultural Merits. It's been 17 years already. It was when he just finished completing a Chinese dictionary called *Mastering by Oneself* that compiled studies on Chinese Characters. Returned manuscript papers were piled up on his windowsill in a living room like the Great Wall of China. He brought inscriptions on bones and tortoise carapaces and read it to me with his naturally loud voice. I couldn't help admiring because it was like hearing a king's

지구문자탐험가는 어디를 의지할 곳으로 삼으며 살아가는 것일까? 그 방향을 가리켜주는 편리한 것이 존재한다. 니시다 타쓰오(西田龍雄) 박사 편저인『세계의 문자』의 안에 끼워져 있었던 '현대 세계 주요문자의 분포개략도'이다. 이제는 너덜너덜하게 해져버렸지만 때때로 펼쳐 보고 있다. 간단한 지도면서도 색으로 나누어져 있어 보기에 편리한데다, 중요한 의미를 지니고 있기 때문에 기회가 닿으면 크기를 키워 보다 정확한 것을 만들어보고 싶다. 이 책에 의하면 지구상에는 3천 개의 언어와 4백 종의 문자가 존재한다고 알려져 있다. 이미 사라진 문자도 있는데, 나는 그중에서 '잃어버린 문자'에 마음이 강하게 끌린다. '문자의 발생'이라는 말이야말로 우리들, 아트 디렉터, 그래픽 디자이너가 가장 관심을 나타내지 않으면 안 되는 것이다. 문자의 발생이 있고 어떠한 이유에 의해 사라진 문자에는 나라의 존속을 건 싸움과 치열함, 수수께끼가 있었을 것이다. 그 수수께끼에 도전해보고 싶다는 마음이 요동을 친다.

지도를 펴보면 적도의 조금 위에 띠 모양으로 다색인쇄가 된 라틴 문자들이 반짝반짝 빛나면서 존재하고 있다. 일본에서 아프리카까지의 긴 거리에 분포되어 있는 것이다. 특히 아시아는 대단하다. 그 한 나라 한 나라를 찾아가며 탐험 조사하는 것은 돈과 시간도 많이 들지만, 나에게 주어진 하나의 사명이라고 생각한다.

너무 늦게 문화훈장을 받은 시라카와 시즈카(白川靜) 박사를 처음 만난 것은, NHK방송 프로그램 '한자미라클월드'의 한자의 구도자(求道者)로서 출연하여 교토(京都)의 시라카와 시즈카 박사를 취재했을 때였다. 벌써 17년도 전의 일이다. 박사는『자통(字通)』-한자문화 연구를 집대성한 한자사전 3부작-을 완성한 지 얼마 안 됐을 때였고, 자택 응접실의 창가에는 반환되어 온 원고용지가 만리장성처럼 높게 쌓여 있었다. 박사는 타고난 큰 목소리로 갑골문자가 조각된 거북의 등을 들고 와서 갑골문을 읽

art.　metamorphose noten.　520 x 630.　2009.

voice in a kingdom 3500 years ago. It was like this great strength was hidden underneath tortoise's carapaces. When he finished reciting and got up from his seat, I secretly touched the carapaces. I felt this beautiful line drawing at my fingertip. When I touched it thinking who could have possibly carved such hard shell, the corner of its carapaces snapped with a snapping sound. I got so surprised that I immediately returned it back to its place. He came back. "How did you get this amazing thing?" I asked. "Ah…. Well, I found it in an ancient palace when I went to Taiwan," he answered. "It is a copy replica, of course." Then I was relieved.

Dr.Shirakawa lives near Katsurarikyu in Kyoto. After taking a walk early in the morning, he focuses on his research. A rubbing of inscriptions on bones and tortoise carapaces that he has never seen before… Especially, the quantity of inscriptions on bones and tortoise carapaces he collected amazed me. It was the same joy that I felt when I saw an artist's sketchbook. It was also a moment of inscriptions on bones and tortoise carapaces' birth.

His explanation that it hasn't been longer than 100 years since inscriptions on bones and tortoise carapaces, the Chinese character, was discovered in a capital city of Eun Dynasty, surprised me. I became a captive of inscriptions on bones and tortoise carapaces within a day. I had goose bumps all over my body when I saw letters that seemed to forecast amazing intelligence capabilities and future of human beings.

Typography refers to the design that expressed close relationship between language and letters. The person who taught me this importance was a teacher named Sato Keinoske. On 31st Street Yokohamashi Kanagawagu Kogaya, there is Sato Keinoske typography lab. He was fascinated by music that he often played Chopin and Bartok. He didn't stop at 'the Galaxy of Gutenburg' but constantly challenged himself. The type planning that he and I worked together and got selected in Nitsen Vision became a very important piece for me. Taking this opportunity, the term 'typographer' came after my name.

After that, I entered Light Publicity as a teacher

어 주었다. 시공을 초월하여 3500년 전의 은 왕조(殷王朝) 때로 돌아가, 왕의 목소리를 듣는 것 같아 경탄을 금할 수 없었다. 또 거북의 등에 대단한 힘이 감추어져 있다는 것에 놀랐다. 박사가 자리를 일어난 사이에 그것을 만져 보았다. 손끝에 아름다운 선묘(線描)가 느껴졌다. '이런 단단한 등을 어떤 도구를 사용하여 조각하였을까' 하며 만지작거리는 사이에 모서리가 딱 하는 소리를 내며 부러져 버렸다. 너무 놀라며 가만히 제자리에 돌려놓았을 때 박사도 돌아와 자리에 앉았다. "박사님, 이 대단한 물건은 어떤 경로로 사시게 되었습니까?" "아, 그건 말이죠. 타이완에 갔을 때 고궁에서 사온 거예요. 물론 복제품이지요." 그제야 한숨을 놓았다. '복제품이었구나. 타이완에 가면 살 수 있는 것이다. 진품은 국보이고 연구자료이니 개인이 가지고 있으면 죄가 된다'고 속으로 생각했다. 장개석(蔣介石)이 가벼우면서 중요한 문물을 중국에서 타이완으로 많이 가져왔기 때문에, 갑골문과 문장에 관한 것은 베이징의 고궁보다 타이완의 고궁에 더 대단한 물건들이 소장되어 있다.

시라카와 시즈카 박사는 교토의 카쓰라리궁(桂離宮) 근처에 살고 있으며 이른 아침의 산책 이후 시간에는 줄곧 연구에 전념한다. '벽면을 향한 생활'을 계속하고 있다고 들었다. 본 적도 없는 갑골문의 탁본과 금문(金文)의 소장본…….특히 반투명 종이에 갑골문자를 연필로 덧대고 그린 것과 대학 노트에 빽빽이 쓰인 갑골문자들이 놀라웠다. 화가의 스케치북을 봤을 때와 같은 기쁨이 전해져 온다. 도상 스케치가 현실처럼 다가오고, 은 왕조의 갑골문자 탄생의 순간을 본 것만 같은 느낌이 들었다.

한자의 원형인 갑골문자가 은 왕조의 수도인 안양(安陽)에서 발견된 지 아직 100년 밖에 지나지 않았다는 사실에도 놀랐다. 나는 하루 만에 갑골문자·금문의 포로가 되어 버렸다. 인간의 위대한 정보력, 미래를 예고하는 문자들을 보며 전신에 전류가 찌릿하며 흘렀다.

언어와 문자의 깊은 관계를 표현한 디자인을 타이포그래피라고 부른다. 이 중요성을 가장 먼저 가르쳐 준 분이 스승 사토 케이노스케(佐藤敬之輔)였다. 요코하마시 카나가와구 코가야 31번지(横浜市神奈川区幸ヶ谷三十一番地)에 사토케이노스케 타이포그래피 연구소가 있다. 그는 도쿄대학 이학부 동물학과를 중퇴하고 교토에서 공예가를 목표로 공부했다. 그는 수학

asaba katsumi

art. metamorphose noten. 520 x 630. 2009.

through my professor named Hosoyagan's introduction. There are many people who gave me good teachings, such as Hayakosi Jo, Tsuchiya Koichi, Suhayasaki Osamu, Wada Makoto, Akiyama Sho, and Shinoyama Kishin. Learning photography was another accomplishment for me. I developed advertisement method called Overseas Location and was able to work around the world as I took pictures after that independence. I had to go to a back district of minorities many times then. Fortunately, I was fascinated by their habits, language, culture, and wisdom. In 1987, I established Tokyo Typo Deluxe Club with Terunuma Takako who is known to be strict and sharp that people's interest would be all on letters at the end of the century. This meeting holds exhibition once every year and opens symposium, called TDC Day, in an auditorium at Jyoshi Art College every April with invited exhibition prize winners in all over the world and developed into an international exhibition.

It has been 15 years since I became associated with Liziang of Wonansung, China to find Dongba script that came out in *Last Hieroglyphics on earth* by Dr.Nishida Datsuo. That tie was precipitated in Dongba script written in pen by Hwa Gook Sang of Dongba Letter Research lab. Dongba script by brush is a true expression indeed. I bought few pieces that were hung on the laboratory wall and have been viewing them everyday.

It is desirable to know calligraphy to study Japanese typography in depth. <Jumping Typography> exhibition was held in Oosaki Museum in 1994, and letters from all over the world were exhibited here. I was one of the exhibitionists. A symposium was held as well and Matsuoka Seigo was the host. I was fascinated at how Ishikawa Kiyo stated, "the brush touch thinks." After that, I entered Ishikawa Kyuyo Academy to study the square style of Chinese handwriting. I decided to challenge on that joy, depth, and difficulty. I practiced at Kandajinbocho once a month. I stayed at a spa in Hakone's Matsujakaya for 3 days once a year. I like staying in spa very much. I like the spa, but staying up all night to write improves my concentration and eels as though letters are melting into my body. The printed style of writing came into being in the west coast of Tango Dynasty.

asaba katsmi

이 특기인 이론가이자 예술가이다. 음악을 좋아하여 쇼팽과 바르톡을 들려주었다. '구텐베르크의 은하계'에 그치지 않고 끊임없이 도전해 나갔다. 그 분과 함께 닛센비전(日宣美展)에서 입선한 활자 설계는 나에게 중요한 작품이 되었다. 그것을 계기로 나의 등에는 '타이포그래퍼'라는 말이 붙었고 '아트 디렉션'이라는 말을 동경하게 되었다.

스승 호소야간(細谷巖)의 소개로 라이트 퍼블리시티에 입사했다. 하야코시 죠(林越義), 쓰치야 코이치(土屋耕一), 스하야사키 오사무(早崎治), 와다 마코토(和田誠), 아키야마 쇼(秋山晶), 시노야마 키신(篠山紀信) 등 스승들을 만났으며, 사진을 배운 것이 라이트 퍼블리시티에서의 수확이었다. 해외 로케이션이라는 광고 작법을 개발하고 독립 후에도 사진 작업을 하면서, 지구의 259지점에 설 수 있었다. 특히 소수 민족이 살고 있는 벽지(僻地)에 갈 일이 많다. 그 민족이 가지고 있는 습관, 언어, 문학과 지혜에 매료되었다.

세기말에는 인간의 관심이 문자에 쏠릴 것을 예감하여 엄하며 예리하다고 정평이 나있는 테루누마 타카코(照沼太佳子)와 함께 1987년에 도쿄 타이포디렉터스클럽을 창설했다. 일년에 한 번 있는 전람회와 연감, 4월에는 조시미술대학 강당에서 수상자와 함께 'TDC DAY'라는 심포지엄을 개최하고 있다. 전 세계로 수상자를 배출하며 국제전으로 발전한 것은 주목할 만하다.

스승 니시다 타쓰오의 『지구의 마지막으로 살아 있는 상형문자』에 나온 동파문자(東巴文字)를 찾으러 중국 원난성 리장(中国雲南省麗江)과 인연을 맺은 지 15년째다. 동파문자연구소의 화국상(和国相)이 쓴 서예에 의한 동파문자에 촉발되었다. 붓에 의한 동파문자의 표현이야말로 진짜가 아닐까 생각한다. 벽에 걸려 있던 작품을 몇 점 사와서 매일 바라보고 있다. 그렇다, 일본의 타이포그래피를 깊이 연구하기 위해서는 서예를 아는 것이 중요하다. 1994년 오사키(大崎)에서 <점핑 타이포그래피 전>이 있었는데, 세계 각지에서 모은 문자표현이 전시되었다. 나는 출품자 중 한 명이었고 서가(書家) 이시카와 큐요(石川九楊)도 출품했다. 심포지엄도 열렸는데 마쓰오카 세이고(松岡正剛)가 사회를 보았다. '필촉(筆蝕)은 사고한다'는 말을 내세운 이시카와 큐요에게 매력을 느꼈다. 한자의 정서체인 해서(楷書)를 깊이 연구하기

576

art.　syomyo.　520 x 630.　2010.

There are immeasurable beauties hidden in the printed style of writing. Under the influence of the printed style of writing, Gana of Japan, the Kitan letters, Tangut script letters, Vietnamese Chunom script and many other letters originated. Journey to Seoan where Dae An Tower is standing tall to solve puzzles of the printed style of writing continues. The most precious jewel in Seoan is the forest where tombstones under the emperor's name were collected from all over China. 650,000 letters in square style of Chinese handwriting are carved in the first room of forest. It is the textbook of Tang Dynasty. The teachings of Confucius, such as *The Leading Role, Fengsui* and *the Nine Chinese Classics* quoted this place, and this place was used as a reference when era name of Japan was to be determined. Showa was derived from *Somyeonghyeophwa* (昭明協和) and Heisei from *Jipyeongcheonseong* (地平天成). In Dae An Tower, 657 discussions of Samzang Monk who brought them after 17 years of studying abroad in India are preserved here. Tai Tsung sponsored translating the discussions as a national enterprise and the tombstone by *Samjangseonggyoseo* (三蔵聖教序) and *Jeosuryangseo* (褚遂良書) is erected on either side of the gate. Letters carved on the tombstone are said to have resilience, have a lot of dynamic changes, and playing clear flavor. I head directly to the calligraphy desk as soon as I wake up in the morning. Then, I grind an ink stick and do the calligraphy copying exercise 28 letters. I have been continuing this warming up for 17 years.

In October, 2003, the World Graphic Design Conference was held for the first time in Nagoya in 40 years. I did presentation with Dr.Nishida Datsuo on 'the essence and development of letters – from prehistoric rock to letters.' This presentation handled 1)sentimental graphonomy that relishes the surface of letters, 2)linguistic graphonomy of researching correlation between language and letters by analyzing the framework of letters, and 3)artistic graphonomy that creates new sides of letters by exciting artists' desire to create. Among them, I believe typography is a new direction that artistic graphonomy should progress towards in the future.

위해 이시카와큐요학원에 입문했다. '그 즐거움, 깊이, 어려움'에 도전하기로 결의했다. 한 달에 한 번 칸다 진보쵸(神田神保町)에서 연습을 했다. 일년에 한 번은 하코네 마쓰자카야(箱根松坂屋)에서 3일 동안 합숙을 했다. 나는 합숙이 너무 좋다. 온천에 들어가는 것도 좋지만, 밤을 지새우며 글을 쓰는 편이 집중력이 높아지고 육체가 글 안에 녹아 들어간다. 당대의 서안(西安)에서 해서가 생겨났다. 그 매력에는 헤아릴 수 없을 정도의 아름다움이 숨겨져 있다. 해서의 영향에 의해 많은 문자가 창출되었다. 일본의 가나, 거란문자, 서하문자, 자남계문자(字喃系文字)까지. 해서의 수수께끼에 다가가고 싶어 대안탑(大雁塔)이 우뚝 솟은 서안으로의 여행은 계속된다. 제일의 보물은 황제의 이름으로 중국 각지에서 모아놓은 비림(碑林: 여러 비석을 한데 모아 세워 전시한 곳)이다. 제1실은 65만 문자의 해서가 조각되어 있다. 당대의 교과서이다. 공자의 가르침인 『주역』, 『풍수』, 『사서오경』에서 인용했고 일본의 연호도 이중에서 취했다고 한다. 쇼와(昭明)는 '소명협화(昭明協和)'에서, 헤이세이(平成)는 '지평천성(地平天成)'이라는 글에서 유래되었다. 그리고 대안탑에는 삼장법사(三蔵法師) 현장(玄奘)이 17년에 걸친 인도 유학을 마치고 『경론』 657부를 가지고 귀착했다. 번역을 개시하면서 태종(太宗)은 국가사업으로서 후원했고 『삼장성교서(三蔵聖教序)』, 『저수량서(褚遂良書)』에 의한 비석이 입구에 좌우로 세워져 있다. 글씨는 탄력성이 강하고 강약의 변화가 많으며, 맑은 풍운을 연주하고 있다고 한다. 나는 아침에 일어나면 곧장 서예 책상으로 향한다. 그러고는 먹을 갈고 28자 임서(臨書)를 한다. 이 워밍업은 벌써 17년이나 계속되는 일이다.

2003년 10월에 일본 나고야에서 40년 만에 세계그래픽디자인회의가 개최되었다. 나는 스승 니시다 타쓰오 박사와 함께 〈문자의 본질과 발전-암벽화에서 문자로〉를 발표했다. 내용은 ①감상적 문자학(문자의 표면을 감상하여 그 작품을 음미한다) ②언어학적 문자학(문자의 골격을 분석하여 언어와 문자의 상관관계를 연구한다) ③예술적 문자학(예술가의 창조의욕을 촉진시켜 문자의 새로운 면을 창출한다)으로 특히 ③은 이제부터 타이포그래피가 나가야 할 방향을 제시했다.

art. metamorphose noten. 520 x 630. 2009.

korea 1916 - 1988

Hangeul designer and typeface researcher. Choi was born in Icheon, Kangwon. He graduated from Kyungsung Cheil High School, which is the former school of today's Kyunggki High School. He moved to Japan and acquired various printing skills by working at a print shop. Choi studied in Yodobashi Art Academy. Requested by Donga Publisher's founder Kim Sang-moon, he developed Donga Publisher typeface in 1957. As this typeface was favorably noticed, numerous publishers and print shops, such as Samhwa Print and Bojinjae, continuously placed their order. With the request by Shaken and Morisawa, the Japanese photocomposition machine manufacturers of 1970s, Choi developed Hangeul typefaces. In his late years he focused on the research and wrote articles on Hangeul design philosophy and theory. Not only Hangeul text types, such as SeMyungjo, JMyungjo, TMyungjo, KMyungjo, SeGothic, JGothic, TGothic, KGothic, but also various display types were developed, such as Gungsuh, Hwalja, Fantail, JHGothic, Yetgulja, and more. Choi's original drawings are acknowledged for raising Hangeul typeface quality to the higher level, and became the basis of Hangeul digital fonts of today.

choi.jung-ho

최정호.崔正浩.

한글 디자이너이자 서체 연구가이다. 강원도 이천에서 태어나 현 경기중·고의 전신인 경성 제일고등보통학교를 졸업했다. 일본으로 건너가 인쇄소에 취직해 다양한 인쇄 기술을 습득했고 요도바시미술학원(淀橋美術学園)에서 수학했다. 동아출판사를 창립한 김상문(金相文)의 의뢰로 1957년 '동아출판사체'를 개발해 큰 호평을 받은 후 삼화인쇄, 보진재 등 다수의 출판사와 인쇄소에서 주문이 쇄도했다. 1970년대 초반 일본 사진식자기 제조사 샤켄(寫研)과 모리사와(モリサワ)로부터 의뢰받아 한글 서체를 개발했고 말년에는 한글 디자인 철학과 원리에 대한 기고를 하며 연구에 몰두했다. 세명조, 중명조, 태명조, 견출명조, 세고딕, 중고딕, 태고딕, 견출고딕 등 한글 본문 서체뿐만 아니라 궁서체, 활자체, 공작체, 중환고딕체, 옛글자 등 다양한 변형체도 만들었다. 한글 서체 완성도를 한 단계 끌어올렸다는 평가를 받는 그의 원도(原圖)는 오늘날 한글 디지털 서체의 바탕이 되었다.

HAB JoongMyungjo Korean MS

꽃 보 까 카 빼 쾌 야 제 쓰 을 하 사 호 최

타 찾 싸 표 유 않 은 화 짜 파 음 입 의 정

꽃 보 까 카 빼 쾌 야 제 쓰 을 하 사 호 최

타 찾 싸 표 유 않 은 화 짜 파 음 입 의 정

가 꽃 남 를 말 보 빼 사 것 관 네 노

대 랑 싸 유 제 차 최 카 쾌 표 파 호

가 꽃 남 를 말 보 빼 사 것 관 네 노

대 랑 싸 유 제 차 최 카 쾌 표 파 호

꽉 짊 컥 틔 앨 녜 틸 뻴 칫 략

엎 주 재 쉈 뭇 뮐 롤 쫑 댐 뒈

인 한 정 뎗 애

noh.eun-you.

노은유.盧恩裕.

hangeul designer
한글 디자이너

reference by Morisawa,
 King Sejong the Great Memorial Society,
 AG Typography Research Lab

자료협조. (주)모리사와
 (사)세종대왕기념사업회
 AG 타이포그라피연구소

choi jung-ho

Choi Jung-ho is a representative Hangeul designer who devoted his whole life on typeface design and research, from movable type[1] to photocompositions. It is within bounds to say that digital text typefaces have their foundation on Choi Jungho's sweat and toil, as their structures and forms are based on Choi Jung-ho's original drawings. In spite of the voluminous amount of his work done, there are only a few original drawings left today, which cannot be to freely accessed. The <TYPO-JANCHI 2011> was a meaningful opportunity to gather his original drawings which are scattered in Korea and Japan. Here I would like to introduce the details of his typeface design, and characteristics of each typeface.

1.

Hangeul types can be divided into Old Type Period(1443-1863), New Type Period(1864-1949), and Original Drawing Period(1950-1989), depending on the production method. Old Type Period refers to Korean traditional casting type and wooden type in the period which Hunminjeongeum was invented. New Type Period refers to the type produced by engraving actual size of Seed Type, which took place after the adoption of modern movable type printing from the West. Original Drawing Period refers to the type made from the enlargement and reduction of hand drawn original drawings with matrix cutting machine.

'Donga Publisher typeface'

Choi Jung-ho's Hangeul original drawings initiated from Donga Publisher typeface. Donga Publisher president Kim Sang-moon adopted Benton-matrix cutting machine, and requested for original drawing production. After multiple experiments and failures of two years, one set of typeface with approximately 2,000 letters was complete. This typeface was well received for it outstanding quality and high legibility. It was popularly ordered from

최정호는 활자(活字)[1]에서 사진식자(寫眞植字)에 이르기까지 평생을 서체 설계와 연구에 몰두한 대표적인 한글 디자이너이자 서체 연구가이다. 디지털 본문 서체는 그의 땀과 노력을 딛고 지금에 이르렀다고 해도 과언이 아닐 정도로 그 구조와 형태가 최정호의 원도(原圖)를 바탕으로 하고 있다. 그러나 그의 방대한 작업량에 비해 존재하는 원도는 많지 않으며 있다 하더라도 직접 관람하기는 어렵다. 이번 〈타이포잔치 2011: 서울 국제 타이포그래피 비엔날레〉에서는 한국과 일본에 흩어져 있던 최정호의 원도를 한자리에 모아 그 원본을 직접 관람할 수 있는 의미 있는 시간이었다. 다음 글은 최정호의 일생에서 서체 설계를 한 경위와 각 서체의 특징을 차례로 소개하고자 한다.

582

1.

한글 활자는 제작 방법에 따라 옛활자시대(1443-1863), 새활자시대(1864-1949), 원도활자시대(1950-1989)로 나눌 수 있으며 옛활자는 훈민정음이 창제된 시기에 우리나라 전통 주조 활자 및 나무 활자를 말하고, 새활자는 서양의 근대식 활판 인쇄술 도입 이후 씨글자(種字)를 실제 크기로 직접 새겨 제작한 활자를 말하며, 여기서 말하는 활자는 원도를 그린 후 자모조각기로 확대, 축소해서 만드는 원도활자를 말한다.

동아출판사체

최정호의 한글 원도 디자인은 '동아출판사체'로부터 시작한다. 1955년 동아출판사 김상문(金相文) 사장이 '벤톤 자모 조각기'를 도입하면서 원도 제작을 의뢰했고, 2년간 여러 번의 실험 끝에 1957년 약 2000자의 서체 한 벌을 개발하게 된다. 이 서체는 완성도와 가독성이 높아 큰 호평을 받았으며 이후 삼화인쇄, 보진재 등 다수의 출판사와 인쇄소에서 주문이 잇따랐다. 〈그림1〉과 〈그림2〉는 1956년 출간된 『이상전집』의 활자체를 집자(集字)하여 '동아

그러나 네 말은 이와 다르다。 즉 結婚式 같은
서겠다는 것이다。 살아도 같이 죽어도 같이
게 될른지도 모르는 것을 그냥 입을 딱 벌리고
없단다。 그리고 또 男子의 마음 믿기도 어렵고ㅡ
가 苦生 한번 해보는 것도 좋지 않으냐는 네
아직은 이 社會機構가 男子 標準이다。 즐거울
그러나 苦生살이에 女子는 자칫하면 男子를 結縛
그래서 어느만큼 자리가 잡히도록은 B 혼자 내
告하였드니 너도 OK의 빛을 보이고 할수 없이
는데서 B에게 굳게 굳게 어려가지로 다짐을 받
이제 와서 알었다。 너이 두사람의 愛情에 내
너도 없었다는 것을 말이다。 또한 내 마음이 든
三男妹의 망내둥이로 내가 너무 早熟인데 比해

<pic 1> typeface. 1956.

<pic 2> donga publisher typeface. 1957.

생각했고 그가 보여 준 관심도 알게 되었으니 나는 그에
게 감사를 했다。 우리는 서로 합의를 보아 내가 그와 그
의 가족을 나의 마차를 가지고 적당한 시간에 그 케이블
카의 아래 정류장에서 기다리기로 하였고, 거기서부터 그
들과 같이 그 구경할 장소까지 가기로 했다。 쿠쿡 씨는
미리 말해 두어야겠다고 생각했음인지, 아마 거리가 사
람으로 부풀 테니까 마차로 오기가 더딜 것이라고 하는
것이었다。 일요일날, 만약의 경우를 고려하여 일쩌 감치 두
시 십 오 분에 호텔을 나섰을 때 나는 그 말이 틀림 없
었다는 것을 알았다。 오직 한 번 있는 투우인데 확실히
그래서 더구나 모두 나서게 한 것 같었다。 아베니다의 화
려한 그 넓은 거리는 마차와 인간들, 말과 노새들, 나귀
를 탄 사람과 걷는 사람으로 뒤덮였었다。 거리는 그런 상
태였으니 나는 그 속을 뚫고 그 분잡 때문에 거진 쪽 아
우구스타 거리까지 보통 걸음으로 타고 갔다。 이 구석 저
구석에서, 구 시가와 교외에서, 주위에 산재한 동리에서
도회지 사람과 시골 친구들이 소란스럽지도 않고 소리도
지르지 않으며, 싸움질 하는 기색도 없이 평온한 분위기
라 생각되는 속에 일치 단결하여 깡뽀 빼께노와 원형극
장의 방향으로 물밀듯 몰려 가고 있었다。 그들은 대개 경
축일답게 모양을 내고 단 하루 오늘을 위한 옷을 꺼내 입

choi jung-ho

many publishers and print shops such as Sam-hwa Print and Bojinjae. <pic 1> and <pic 2> are comparison of typeface scanned from *Lee Sang Complete Collection* printed in 1956 and 'Donga Publisher typeface'. As 'Donga Publisher typeface' used matrix cutting machine instead of human hand, its outstanding accuracy and dense vertical typesetting enhanced the quality of the book. Another remarkable point is the angle of cross-bar from initial consonant to medial consonant. The angle evidently has become gradual, which seems to be a device to preparing the foundation for horizontal typesetting.<pic 2> Unfortunately, 'Donga Publisher typeface' original drawings are not passed down today thus we can verify them only through the books printed with Choi Jung-ho's typeface by Donga Publisher. *Confessions Of Felix Krull* by Thomas Mann, printed in 1957, was exhibited in the <TYPOJANCHI 2011>.<pic 3>

Photocomposition typeface of 'Morisawa' and 'Shaken'

In the photocomposition machine, loading a type board allows the lens to freely change size or create transformed types, such as condensed, extended, slanted. Type-picking and typesetting can be operated at once, thus it was more efficient compare to the letterpress printing. In 1950s, the early adoption of photocomposition machine, Japanese Kanji typeface was partially equipped so it was not as useful. Later, type original drawings were loaded, but they were inappropriate as they were too thin to be used as the photocomposition. In the late 1960s, 'Morisawa' and 'Shaken', the photocomposition companies, realized the need to develop Hangeul typeface exclusively for the photocomposition and requested the job to the famous Hangeul typeface original drawing designer Choi Jung-ho. His photocomposition typefaces of these two companies are significant. This is because the balance of typefaces were redesigned for horizontal writing as this was the period of vertical writing changing into horizontal writing. It is one of the reasons for the suitability of these typefaces as the foundation of today's digital fonts.

출판사체'와 비교해 본 것이다. '동아출판사체'는 사람의 손이 아닌 자모조각기를 사용했기 때문에 원도를 그대로 구현하는 정밀도가 뛰어났고 세로쓰기 조판 상태도 조밀하여 책의 완성도를 한층 높였다. 또 하나 주목할 점은 초성에서 중성으로 이어지는 이음줄기의 각도가 이전에 비해 눈에 띄게 완만해졌는데 이것은 가로쓰기로 나아가는 발판을 마련하기 위한 장치로 보인다.(그림2) 안타깝게도 현재 '동아출판사체'의 원도는 전해지지 않으며 당시 최정호의 활자로 인쇄된 동아출판사 책을 통해 그 모습을 확인할 수 있다. 〈타이포잔치 2011〉에서는 1959년 동아출판사에서 출간된 세계문학전집 '토마스 만(Thomas Mann)'의『펠릭스 크룰의 고백』이 전시되었다.(그림3)

모리사와, 샤켄의 사진식자체

사진식자기는 하나의 문자판을 탑재하면 렌즈를 이용해서 크기를 바꾸거나 장체(長體), 평체(平體), 사체(斜體) 등 변형문자를 만들어내는 것이 자유로웠으며 문선(文選)과 식자(植字)작업을 한 번에 할 수 있기 때문에 활판인쇄보다 능률적이었다. 그러나 사진식자기 도입 초기인 1950년대에는 일본 한자서체의 일부분만을 탑재한 것이었기 때문에 그다지 많이 활용되지 못했으며 이후 활자용 원도를 가져다가 탑재해 보았으나 사진식자용으로 쓰기에는 너무 가늘었기 때문에 적합하지 않았다. 1960년대 후반에 이르러서 사진식자전용 한글서체 개발의 필요성을 느낀 모리사와와 샤켄은 활자용 한글원도 설계로 유명했던 최정호를 만나 서체 개발을 의뢰했다. 최정호가 개발한 모리사와, 샤켄 사진식자체는 한글이 세로쓰기에서 가로쓰기로 변모하던 시점에서 가로쓰기를 중심으로 균형을 재설계한 점에서 큰 의미가 있으며 이것이 디지털 폰트의 바탕이 되기에 적합했던 이유 중 하나이다.

모리사와 사진식자체

1971년 최정호는 일본 효고현(兵庫縣) 아카시시(明石市)에 있던 (주)모리사와 분켄(モリサワ文研)에서 네거티브 촬영, 유리 문자판 작성 등 사진식자기를 다루는 공정을 배우고 한글 원도를 그리며 반 년 동안 머물렀다. 귀국 후 서울 모리사와 무역대리점에서 1972년부터 6년

<pic 3> donga publisher typeface. *confessions of felix krull.* 1957.

Photocomposition typeface of Morisawa

In 1971, Choi Jung-ho stayed at Morisawa Bunken in Akashi City, Hyogo Prefecture, Japan, for half a year. He learned to generate the photocomposition machine, such as shooting negatives and producing glass type board, and drew Hangeul original drawings. After returning to Korea, he completed nine kinds of typefaces with approximately 1,600 letters each over six years from 1972 at Seoul Morisawa Trade Agency. Some of them were exhibited at <TYPOJANCHI 2011>; HAB JMyungjo, HA300 Type, HBC SGothic and HB TGothic drawn on translucent drawing paper.<pic 4> HBDB JHGothic drawn on graph paper,<pic 5> HA TMyungjo, HMA30 KMyungjo, HBB JGothic, HMB30 KGothic as films.<pic 6> At the center of Morisawa drawing paper, there is a 40x40mm sized box with corner marked as clamps. Vertical and horizontal center lines are drawn outside the box, which seem to be the base preparation to balance the letter before beginning the original drawing. The actual drawing is composed of outline in pencil which is multiple times revised into a complete first design. Black ink is filled to complete the second design, where white ink is over painted to make modifications.

Photocomposition typeface of Shaken

Records vary, but Shaken photocomposition typefaces are known to be requested in 1969, developed over 1971 and 1974, and released. There are text types such as HAN-LM SeMyungjo, HAN-MM JMyungjo, HAN-BM TMyungjo, HAN-HM TTMyungjo, HAN-LG SeGothic, HAN-MH JGothic, HAN-BG TGothic, and HAN-HG TTGothic. There are other variations such as Gungsuh, Graphic, Naru and more. The existence of original drawings are unconfirmed. Glass type board of HAN-MM JMyungjo[2] was photo-letter composed and was developed into a poster which was exhibited at <TYPOJANCHI 2011>.<pic 7>

2.
The print of this photocomposition is a reproduction of Shaken HAN-MM type board provided by Kyobashi Tatsuma from Shaken, introduced by Torinoumi Osamu of Jiyukoko in May, 2011.

에 걸쳐 한 벌에 1600자 정도의 서체 9종을 완성했다. 그중 〈타이포잔치 2011〉을 통해 소개된 것은 반투명한 원도 용지에 그린 'HAB 중명조', 'HA300 활자체', 'HBC 세고딕', 'HB 태고딕'[그림4]과 모눈종이에 그린 'HBDB 중환고딕'[그림5] 그리고 필름으로 남아 있는 'HA 태명조', 'HMA30 견출명조', 'HBB 중고딕', 'HMB30 견출고딕'이다.[그림6] 모리사와 원도를 자세히 살펴보면 중심에 가로 세로 40밀리미터의 네모 틀을 그려 양 끝 모서리를 꺾쇠로 표시한 다음 바깥 쪽에 상하좌우 중심선을 그었는데 이는 원도를 그리기 전에 글자의 중심과 균형을 맞추기 위한 바탕 작업으로 보인다. 본격적인 원도 작성은 연필로 외곽선을 그리고 여러 번 다듬어서 1차 도안이 완성되면 검은색 잉크로 속을 채워 2차 도안을 완성했으며 수정이 필요할 경우 흰색 잉크로 덧칠해서 마무리했다.

샤켄 사진식자체

샤켄 사진식자체는 기록에 따라 조금씩 차이가 있지만 1969년 원도 제작을 의뢰받아 1971년, 1974년에 걸쳐 완성된 서체를 발표했다고 한다. 본문용 서체는 'HAN-LM 세명조체', 'HAN-MM 중명조체', 'HAN-BM 태명조체', 'HAN-HM 특태명조체', 'HAN-LG 세고딕체', 'HAN-MG 중고딕체', 'HAN-BG 태고딕체', 'HAN-HG 특태고딕체'가 있으며 그밖에 궁서체, 그래픽체, 나루체 등의 변형체도 만들었다. 하지만 원도의 존재 여부가 확인되지 않고 있다. 〈타이포잔치 2011〉에서는 'HAN-MM 중명조체'의 유리 문자판을 구해 사진식자 인쇄를 한 후[2] 이를 이용한 포스터를 전시했다.[그림7]

2.
이 사진식자 인쇄본은 2011년 5월 자유공방(字遊工房) 도리노우미 오사무(鳥海修)의 소개를 받아 샤켄의 교바시 다쓰마(杏橋達磨)를 통해 '샤켄 HAN-MM 문자판'을 구한 후 '문자도(文字道)'에서 인쇄한 것이다.

그의 마지막 원도 '최정호체'

1986년경 안상수의 부탁을 받고 1987년에 완성했으며 그의 이름을 따서 '최정호체'라 한다. 모눈종이가 인쇄된 두꺼운 원도용지에 연필로 외곽선을 그리고 검은색 잉크로 속을 채운 후 흰색 잉크로 수정해서 마무리했는데 마음에 들

<pic 4>

hba jmyungjo. 1972.

ha300. 1979.

hbc sgothic. 1972.

hb tgothic. 1972.

<pic 5>

hbdb jhgothic. 1978.

<pic 6>

ha tmyungjo. 1973.

갓 갔 간
각 가 곽 곁
게 급 귀 금
괜 귀
겠

hma30 kmyungjo. 1973.

검 공 긁
기 격 곤
접 게 궁 갸
곳 굼 겠
가 길

hbb30 jgothic. 1973.

금 굼 궐
굉 곽 권
근 겠 글
갸 가 고
거 겨 계

hma30 kgothic. 1973.

궐 거 귓
꿔 꼴 갑 갚
견 꾼 깊
갖 겸 균
갠 고

choi jung-ho

587

<pic 4> drawing paper. morisawa. 1972, 1979.

<pic 5> graphic paper. morisawa. 1978.

<pic 6> films. morisawa. 1973.

choi jung-ho

His last original drawing, "Choijungho" typeface

'Choijungho' typeface was requested by Ahn Sang-soo in 1986, and was completed in 1987. It was named after himself. Its outline was drawn in pencil on a thick drawing graphic paper, filled with black ink and modified in white ink. Unsatisfying letter was redrawn on a separate piece of graphic paper, which was pasted on the right position. Such letters show his trial and error processes. It remains to be the most in number so far, together with Morisawa original drawings. It was not developed into practical use, and is known to be his last Myungjo series.[3] It is owned by AG Typography Research Lab.<pic 8>

3.
Choi Jung-ho is assumed to have worked with Kumsung Publisher at that period.

Other typefaces

In the early 1970s, Choi Jung-ho completed text type family of Se·J·T·TT. From late 1970s, he focused on many variant development which could be used with the text type. King Sejong the Great Memorial Society in Hongreung King Sejong the Great Memorial Hall is safekeeping original drawings and keepsakes from Choi Jung-ho's family, which are as follows;

CTGothic

This is a heavier Gothic series than KGothic. It was estimated to be the original drawing of ChoTukTae Gothic, which was mentioned in <Publishing Culture(1985)>, so the name was shortened to CTGothic.[4] Because maximum weight stroke had to be drawn within the square, letters with many strokes such as 'ㅃ' were adjusted lighter to create appropriate counter space and balance the density. This typeface does not have small bumps which often appear in most of Choi Jung-ho's Gothic series. It has a unique form of 'ㅆ'. The copy is safe-kept in the King Sejong the Great Memorial Society.<pic 9>

4.
Choi Jung-ho, 'The development and future of Hangeul typeface'.

지 않을 경우 다른 모눈종이에 그려서 오려 붙이는 등 그의 시행착오 과정이 고스란히 담겨 있다. 모리사와 원도와 함께 가장 많은 글자수가 남아 있는 자료이며 실용화되지는 않았으나 이것이 그의 마지막 명조계열 원도가 되었다.[3] AG타이포그라피연구소에서 소장하고 있다.
〈그림8〉

3.
이 무렵 최정호가 금성출판사와 함께 일을 한 것으로 추정된다.

그밖의 서체

최정호는 1970년대 초중반에 걸쳐서 '세(細)·중(中)·태(太)·특태(特太)'와 같이 본문 서체의 글자가족을 완성한 후 1970년대 후반부터 본문 서체와 어울려 쓸 수 있는 다양한 변형체 개발에 몰두했다. 홍릉 부근에 위치한 (사)세종대왕기념사업회는 최정호 가족으로부터 건네받은 원도와 유품을 세종대왕기념관에 보관하고 있으며 그중 몇 가지를 소개한다.

초태고딕체

견출고딕보다 더 굵은 고딕계열 서체로 1985년 〈출판문화〉에서 언급했던 '초특태고딕체' 원도로 추정되어 줄여서 '초태고딕체'라 이름 지었다.[4] 네모난 틀 안에서 최대한 획을 두껍게 그려야 했기 때문에 'ㅃ' 등과 같이 줄기 수가 많은 경우 굵기를 가늘게 조절하여 속공간을 적절히 안배하고 농도를 맞추었다. 최정호의 고딕계열 서체에서 주로 나타나는 돌기가 없으며 'ㅆ'의 형태가 독특하다. 세종대왕기념사업회에서 소장하고 있으며 복사본이다.〈그림9〉

4.
최정호, '한글활자 서체의 개발과 장래성', 〈출판문화〉 1985년 4월호

옛글자체

'ㆍ, ㆁ, ㆆ, ㅿ, ㅸ' 등 훈민정음 창제 초기에 쓰이던 옛 자소와 낱자 3개의 합자를 넣어 고문서를 적기 위해 만들어진 서체이며 명조계열과 고딕계열이 있다. 낱자 3개의 합자는 균형 맞추기가 여간 까다로운 것이 아닌데도 불구하고 최정

588

숨섬슬버벌벼변므머림렁류
　속새별복볼뿌많목린럼루
닭스섯북뿐붙빛멀밀룻런료
덕살쇠　박반발문매름량롭
떼설슨써밥밭빼막몇른략론
될셨상세번법벽먼민르래록
뜨쉬섭술볍본봄못맞　랑렸
디싸손색분불비　명먹란령
딸석쓰성빠박받빨미몸락력
떠셔삼순밤방배백망밎립레

꽃노났농면수학에던동단데
굴놓님님정야도공또든땅된
글난논냐소히었시두닥덩드
길너눈네저와주동득답돈등
값년남놈우였산인　먼뒤달
걸높넓늘은부읍는람독듯더
결　녹낸갈선만기대둘딱떻
곳갔누넝　거를무물든당돌
군검날눌냥리없전사따떨뛰
근경녁너느과내생을담똑뜻

빵빛펐폭퐁푹헤흑홀흡헛인
벗빵푼퓬픔픔혈흝휘햇행
빡뼛　핀핍핑홋햇흔흄흄형
베뼌뺀필펼펼횐험혁홉흄혁
벴벤뻔펼펼휜헙허홈흐흡
봐뽀뻐페폰푸휼홍헨힌휩횟
뺨뵀뽁픗프플흡혹헌흘홋
뿐붓삐비픠핌핏　휠흴힐휴
빗빨봉팍팔팽픅홍훈혜헐흠
밥빙뻠펀페펠펌휨휘핫헹힛

몽맨뭘메밀컴킨컨백벗뼈뱀
뭍멋밈몬맡쳤캄교봅뺌뼷벅
뭇멱맘묵맹뤼컷킴뽀뿐벱벙
댔뫼맴뮤멘콧커뺑뻑붕볏
떴뭐멍밉몰맣클케삐뷰뿔뿡
톨믹멸맘문맷칼퀘뵉브뷹
튜만묘맴믈멜컵킬컨빼빈쁘
틸맥뛴밋밋몸콜캐켤켈빤빌
닷멉믠뫄맛뭉류컹쿨뻴뼅밤
텃멧맑묵맷믐카쾅컥범뺨벨

큰출초짜짝잘잡심강균격긴
크찬칠재적접겨습께급골갑
콩철책겼쪽종죠실계간꾸건
코추쳐죽줄즉증씀관개끄걷
켜차친찌진짐짓신권겠끝굽
　천찻　작잔잠슴꼭갈국
테최체척쩨절접씩싫꽝깨극
털　충총족줌좋쓸씨귀겨끼
틀키참침준중쯤식십금곤감
터큼첫처직질집　승각교꺼

했유언웅예암까것가때서튼
협　열안용양바러의학어태
환항왔애원엇　로마하해특
흥호움얼익온앗오모고요탕
항황육염않욱억치이보려트
현힘았왜액월역니있일제탄
확행언웃엄임을그나구여통
호형연읍영알운아라장되타
합활웃악외약위틀말다게토
혀회울앞워업입으즈자지

윗언완욺엽얻둚떤뒷꽐굽긋
읽윤움읋옳엿뜩득듬괴꿩깁
앉잃융웅왕옴띄퇴딩꾼규껍
앵앓잉웠웠왱됨둔꿈꿈꼿
양안압잉윽웬둠딘뙈궐낌겸
엔애얄앙잇읇듀뚜듬궘겁곤
옆엘엤얇앤잎듭뜽딜긿궛꼽
옵옛엣엄얌앨　뜬뚝김겨꽝
왼웅옥엥엉얘얬떠됬　곡꾀
윈옥욪은엽엇읖딥뜰뜲꼼굼

몽맨뭘메밀컴킨컨백벗뼈뱀

　　　：∴　：　《〉　절
　　축4　∵　／・＼　쪼좌
　　　　：　｜◇　　줏쥬
　　　’“　$　　？！　찜
　　　―　　；　’　｜
　　　～　　！‘’｛
　　찻4　　：W　｜

<pic 7> glass type board. Han-mm jmyungjo.　shaken.　1974.

Yetguelja

Classic letters from early invention of Hunmin-jeongeum, such as ' · , ㆁ, ㆆ, ㅿ, ㅸ', together with three letters ligature, are included in this typeface to write old documents. There are Myungjo series and Gothic series. It is extremely difficult to balance the three letters ligature, yet Choi Jung-ho's remarkable sense of balance resulted a stable expression.<pic 10> The copy is safe-kept in King Sejong the Great Memorial Society, and the original is owned by Lee Byung-do, the nephew of choi jung-ho's wife. The stroke is shaped like the paper fan, or the tail of peacock, so it is called 'Fantail'. Light vertical stroke and heavy horizontal stroke are drawn based on the structure of Graphic typeface.<pic 11> Eight original drawings on Morisawa drawing paper exist, which are safe-kept in the King Sejong the Great Memorial Society.

Comparison of Morisawa HAB JMyungjo, Shaken HAN-MM JMyungjo and Choijungho typeface

Choi Jung-ho's Myungjo, Gothic series appear to have different forms depending on the manufacturers. This may be result of evolving production environment, such as from type to photocomposition, and user environment, such as from vertical writing to horizontal writing. The two similar looking Myungjo series have differences when studied closely. In order to appreciate the Hangeul typeface design theory which he completed through his lifetime experience, it is important not to miss these small changes.

Next, Morisawa HAB JMyungjo, Shaken HAN-MM JMyungjo and Choijungho typeface were compared.<pic 12> In letter '꽃'(flower), Shaken HAN-MM JMyungjo has narrow and delicate counter space. Its beginning and ending of serif, and curve stroke have smooth finish. On contrast, Morisawa HAB JMyungjo has relatively wide counter space, and curve strokes in final consonant 'ㅊ' are longer with stronger finish. Choijungho typeface has larger 'ㄲ', lower position of horizontal stroke in 'ㅗ'. Compare to JMyungjo of Morisawa and Shaken, the letter width is narrower. This seem to be the same phenomenon as today's digital font adjustments where the size of initial consonant is

호 특유의 균형 감각으로 안정된 표정이 돋보인다. 세종대왕기념사업회에서 복사본을 소장하고 있으며 원본은 최정호의 처조카 이병도가 소장하고 있다.<그림10> 공작체(Fantail) 획의 모양이 마치 공작의 꼬리처럼 부채 모양으로 되어 있어서 팬테일(Fantail) 즉 공작체라 한다. 세로줄기가 가늘고 가로줄기가 굵은 형태이며 기본 구조는 그래픽체를 바탕으로 하고 있다. 모리사와 용지에 그려진 원도 8장이 남아 있으며 세종대왕기념사업회에서 소장하고 있다.<그림11>

모리사와 HAB 중명조체 + 샤켄 HAN-MM 중명조체 + 최정호체 비교

최정호의 서체는 같은 이름의 명조, 고딕체라도 그 형태는 제작사에 따라 조금씩 다르다. 이는 활자 또는 사진식자와 같이 제작환경에 따라 조금씩 변했거나 세로쓰기 혹은 가로쓰기 등 사용환경에 따라 영향을 받았기 때문일 것이다. 그러므로 엇비슷해 보이는 두 종의 명조체는 하나하나 잘 살펴보면 조금씩 차이가 있다. 그가 평생을 통해 몸으로 익힌 한글 서체의 조형 원리에 조금이나마 가까워지기 위해 이 작은 변화를 놓치지 않는 것이 중요하다. 다음은 '모리사와 HAB 중명조체', '샤켄 HAN-MM 중명조체', '최정호체' 이상 세 가지 서체를 비교해 보았다.<그림12>

먼저 낱자 '꽃'을 비교해 보면 '샤켄 HAN-MM 중명조체'가 속 공간이 좁고 오밀조밀하며 부리의 시작과 맺음, 곡선 줄기가 부드럽게 마무리된 것에 비해 '모리사와 HAB 중명조체'는 속 공간이 비교적 넓고 받침 'ㅊ' 등의 곡선 줄기가 조금 더 길고 힘있게 마무리되었다. '최정호체'는 초성 'ㄲ'이 커지고 중성 'ㅗ'에서 보가 아래쪽으로 내려왔으며 모리사와와 샤켄의 중명조체보다 글자 폭이 좁아졌는데 이는 오늘날 디지털 서체에서 시간이 지날수록 초성의 크기를 점점 키우고 가로 폭은 좁혀서 가독성을 높이는 현상과 같은 맥락으로 보인다.

마치며

최정호의 한글 서체는 원도활자시대에 세로쓰기 서체의 완성도를 높였고, 가로쓰기 서체의 균형을 제시하여 사진식자시대를 풍미했

591

choi jung-ho

<Pic 8>

| 저 | 꽃 | 곳 | 곱 |
| 골 | 곤 | 꼭 | 계 |

<Pic 9>

| 넉 | 너 | 빨 | 발 |
| 발 | 반 | 밖 | 박 |

<Pic 10>

볐	벘	볐	샀
샀	쏙	쏜	쏠
뿍	뿐	뿔	뿜
뻣	쑤	쑥	쑨

<pic 8> drawing paper. choijungho. 1987.

<pic 9> drawing paper. ctgothic. 1985.

<pic 10> drawing paper. yetguelja. year unknown.

reduced and letter width is narrowed to enhance the legibility.

Conclusion

Choi Jung-ho's Hangeul typeface enhanced the quality of vertical writing in the original drawing type period, suggested letter balance for horizontal writing which influenced the photocomposition period. He also developed various typefaces for different purpose and use; from text types, such as Myungjo series (serif) and Gothic series (Sans Serif), to HGothic (rounded Gothic) and Fantail (display type), Gungsuh (handwriting) series. He suggested type family with various weights in order of Se(細)-J(中)-T(太)-TT(特太). In late years, he summarized Hangeul design basic principles by evaluating type design theory and matrix analysis. On the foundation cultivated by Choi Jung-ho, Hangeul design has sprout and grown. It is now time to work beyond his foundation, and blossom in the higher position. Together with Choi Jung-ho, the modern Hangeul design archive materials and research should be done before more time pass by. I wish to end this essay with articles of Choi Jung-ho interview. In addition, I appreciate the support of archive materials from the King Sejong the Great Memorial Society, Morisawa, and AG Typography Research Lab.

으며 부리 계열(Serif)의 명조체, 민부리 계열 (Sans-serif)의 고딕체와 같은 본문 서체에서 부터 둥근고딕 계열의 환고딕체, 변형체 계열 의 공작체, 손멋글씨 계열의 궁서체 등의 목적 과 용도에 따른 다양한 서체를 개발했다. 또한 세(細)-중(中)-태(太)-특태(特太) 등 굵기에 따른 글자가족을 제시했으며 말년에는 서체 설 계 원리와 자형 분석을 통해 한글 디자인의 기 초 개념을 정리했다. 이렇듯 최정호가 다져놓 은 바탕 위에서 한글 디자인은 싹을 틔우고 성 장해 왔으며 이제는 그가 다져놓은 바탕을 넘 어 조금 더 넓은 곳에서 꽃을 피워야 할 때가 온 것 같다. 시간이 더 지나기 전에 최정호는 물론 근대 한글 디자인에 대한 자료정리와 연구가 계속되길 바라며 부족한 이야기는 다음 장에 최정호 선생의 기고 글을 발췌, 정리한 것으로 대신하겠다.
아울러 전시를 위해 (사)세종대왕기념사업회, (주)모리사와, AG타이포그라피연구소의 자료 협조에 감사드린다.

592

<pic 11> drawing paper. fantail. year unknown.

593

shaken han-mm jmyungjo

shaken han-mm jmyungjo + morisawa hab jmyungjo

morisawa hab jmyungjo

shaken han-mm jmyungjo + choijungho

choijungho

choijungho + morisawa hab jmyungjo

<pic 12> comparion of morisawa hab jmyungjo, shaken han-mm jmyungjo and choijungho.

'My experience, my attempts' by choi jung-ho

<div style="float:left">choi jung-ho</div>

The following article is excerpted from Choi Jung-ho's writing in magazine <Kumim> (1978). The interview was initiated by Ahn Sang-soo, who was Hongik University Typography lecturer at that time, over six times under the title of 'My experience, my attempts'. In these writings, Choi Jung-ho has mentioned about his philosophy and design principles of Hangeul design. Instead of guessing with the original drawings he has left us, we have the chance to take a glimpse into his thoughts, thanks to these writings. Choi Jung-ho rejected the interview proposal at first, but decided to accept it with following comment; 'I had to face many challenges, when I begun to work in this field. There was no particular teacher nor specific reference book. I do not want young designer to follow my footsteps by becoming a humble guidance for them. I begin my unworthy writing as I look forward to designing beautiful and stylish Hangeul by talented young designers.' <Kumim no.11>

Hangeul design philosophy

We must begin with the basic principles of Hangeul. As I have repeated several times, without learning the letter principles, it is difficult to understand the fact that moving a horizontal stroke for 0.1 mm will break the entire balance. You should never try to use techniques to fly when you cannot even crawl. <Kumim no.7>

Writing one beautiful letter does not make the type designer a good designer. It is because all letters must be designed to create a harmony. In this sense, 'spacing' is one of the very difficult jobs in Hangeul. Same sized letter may look smaller or larger depending on the density or the weight. <Kumim no.11> A letter is a tool of convey-

최정호의 '나의 경험, 나의 시도'

다음 글은 1978년 최정호가 잡지 〈꾸밈〉에 기고한 글을 발췌한 것이다. 그는 당시 홍익대학교 타이포그래피 강사였던 안상수와의 인터뷰를 시작으로 6회에 걸쳐 '나의 경험, 나의 시도'를 연재했다. 이 글을 통해 한글 디자인에 대한 자신의 철학과 조형 원리에 대해 기술했다.

덕분에 우리는 그가 손으로 그려 놓은 원도를 통해 추측하는 것이 아닌 글을 통해 직접 그의 머릿속을 엿볼 수 있다. 처음에는 안상수의 제의를 한사코 거절했던 최정호는 다음과 같이 기고를 결심한 이유를 밝히고 있다. "나는 이 분야에 손을 대기 시작했을 무렵 여러 가지 난관에 부닥쳤다. 이렇다 할 스승도 없었고 특별한 참고 서적도 없었음은 물론이었다. 나의 이러한 전철이 나와 같은 길을 걷고자 하는 젊은이들에게도 똑같이 되풀이되길 원치 않기에 그들에게 조그마한 길잡이가 되고픔 따름이다. 나보다 훨씬 유능한 젊은 디자이너들이 보다 아름답고 세련된 한글을 만들어 주기를 바라면서 두서 없는 졸문을 적는다." <꾸밈11호>

한글 디자인 철학

"한글의 기본원칙부터 알고 시작해야 합니다. 몇 번이고 얘기하지만, 가로획이 0.1밀리미터 움직여도 전체의 균형이 깨진다는 사실은 글자의 원리를 터득하지 못하고는 이해하기 힘듭니다. 기지도 못하는데 뛰려고 기교를 부리는 것은 금물이라니까요." <꾸밈7호>

무릇 글자 디자이너는 글자 한 자만을 예쁘게 쓴다고 해서 훌륭한 디자이너가 되지 못한다. 모든 글자가 모여 하나의 조화가 이루어지게끔 만들어 주어야 하기 때문이다. 이러한 연유에서 글자의 '사이 띄우기(spacing)'는 한글의 경우 정말 힘든 일 중 하나이다. 글자의 '농담(density)'이나 '무게(weight)'에 따라 글씨 한 자 한 자는 같은 크기라도 커 보이기도 하고 작

594

ing an idea or meaning. Therefore letters must be designed so that readers would not feel tired reading it. Writing each letter is not an art. I prefer saying 'designing letter shape' instead of 'writing letters'.<Kumim no.11>

Design principles of Hangeul design theory

There are five kinds of Myungjo forms; Square, trapezoid, triangle, diamond, hexagon. Square forms are letter with double final consonants, such as '끓', which are very rare. These square forms appear larger than other letters, so it is slightly patted inwards. Trapezoid forms are letters like '도, 고, 노, 드, 보, 크'. Most letters belong to this form. When the letter is horizontal stroke oriented, the overall form becomes a regular trapezoid. Other 50% are letters with vertical stroke in the lower half. For example, '워, 어 서'. Triangle forms are '소, 오', diamond forms are '응, 숭, 쿠, 우'. Hexagon forms are '를, 듣, 금, 든, 는, 촘, 솜', which take up 20% of the letter forms.

The weight center used to be on the right only. But now during the type procedure, the center is divided into two positions. In the word '가을(fall)', '가' has it on the right, '을' has it in the middle. Letters with horizontal vowels, such as 'ㅜ, ㅠ, ㅡ' have the weight center in the middle. The rest letters have it on the right.<Pic 13> <Kumim no.11>

There is a Chinese calligraphy theory of enlarging right side when a letter has two identical units side by side, and enlarging bottom side when a letter has two identical units top to bottom. This is a good theory to be adopted in Hangeul. In 'ㅃ', right is enlarged than the left. In 'ㄹ', bottom is enlarged than the top. So in '를', bottom 'ㄹ' is enlarged than top 'ㄹ'. The difference is subtle at a glance, it can be identified clear by flipping the letter up side down.<Pic 14> <Kumim no.18>

In the case of 'ㅇ' and 'ㅎ', when the bowl has a stroke on the top, the weight of top bowl is made lighter; when the bowl has no stroke on the top, the weight of top bowl is made heavier and bottom is made lighter to keep in balance. It applies

아 보이기도 하는 것이다.<꾸밈11호> 글자란 사상 이나 뜻을 전하는 도구이다. 그러므로 읽는 사람이 피로감을 느끼지 않게 글자가 디자인되어야 한다. 글자를 하나하나 쓴다는 것은 예술이 아니다. 그래서 나는 '글자를 쓴다'고 말하지 않고 '자형설계(字型設計)를 한다'고 말하기를 좋아한다.<꾸밈11호>

한글 디자인 조형 원리

명조의 형태를 다섯 가지로 분류하여 보면 네모꼴, 사다리꼴, 마름모꼴, 육각형 등을 들 수 있다. 먼저 네모꼴을 살펴보면 '끓'과 같이 쌍받침이 있는 경우를 네모꼴로 들 수 있는데 이러한 경우는 극소수에 속한다. 그리고 이러한 네모꼴의 자형은 다른 글씨에 비해 크게 보이므로 안으로 약간 다독거려 주었다. 사다리꼴로서는 '도, 고, 노, 드, 보, 크' 등을 들 수 있다. 이 사다리꼴이 글씨 형태의 가장 많은 꼴에 속하는데, 가로 획일 때에는 정사다리꼴이지만 이에 못지않게 약 50%를 차지하는 꼴이 정사다리꼴의 밑부분을 세로 획으로 하는 사다리꼴 세운 형이 많이 차지하고 있다. 예를 들면 '워, 어, 서'를 들 수 있다. 세모꼴로는 '소, 오'를 들 수 있으며 마름모꼴로는 '응, 숭, 쿠, 우' 등이 있다. 육각형으로는 '를, 듣, 금, 든, 는, 촘, 솜' 등으로 전체 글씨 형태의 약 20%에 속한다

한글이 가지는 무게의 중심은 원래 우측에만 있었다. 하지만 오늘날 활자화하는 과정에서 그 중심이 두 곳으로 나뉜다. '가을'의 경우 '가'는 오른쪽에 '을'은 가운데에 그 중심이 놓이게 되는 것이다. 이는 곧 'ㅜ, ㅠ, ㅡ' 모음을 포함하는 글씨는 모두 중앙에 그 중심이 있으며, 그 이외의 글자들은 우측에 그 중심이 있다는 말이다.<그림13> <꾸밈11호>

한자에서 좌우 동형일 때는 오른쪽을 키우고, 상하 동형일 때는 아래쪽을 키운다는 서법의 원리가 있다. 이는 한글에도 적용될 수 있는 좋은 법칙이다. 'ㅃ'이나 'ㄹ'의 경우 오른쪽을 왼쪽보다 크게 하고 아래를 위보다 크게 하였다. 그래서 '를'의 경우 위의 'ㄹ'보다 아래의 'ㄹ'을 크게 하였다. 언뜻 보아서는 잘 모르지만 위아래를 분명히 식별하려면 뒤집어 보면 쉽게 알 수 있다.<그림14> <꾸밈11호>

'이응'이나 '히읗'일 때 고리의 경우를 보면 위에 획이 있을 경우에는 고리의 윗부분을 가늘고,

596

<Pic 13>

<Pic 14>

<Pic 15>

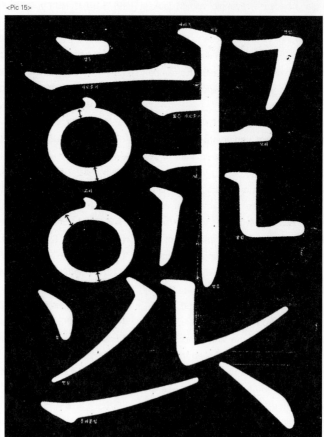

<Pic 13> in the case of 가 and 을.

<Pic 14> in the case of 뿌리 and 田.

<Pic 15> in the case of ㅇ and ㅎ.

like '흐' on 'ㅇ' when used as the final consonant. For example, '긍' has a stroke on top of 'ㅇ', so top bowl becomes light and bottom bowl becomes heavy. These two cases are formed due to the existence of the stroke. When it does exist, weight of top bowl is shared with the stroke to maintain the balance. When the stroke does not exist, for example '위', as there is no stroke on the top of 'ㅇ', the top bowl has to be made heavier to maintain the balance. Thus The top bowl is made heavier and bottom bowl is made lighter to maintain the balance.^{<Pic 15> <Kumim no.16>}

In the image, beginning and ending of Myungjo serif is marked black. Drawing a horizontal center line shows the distinct difference. The reason for this angle is because Myungjo visually looks horizontal when right shoulder is slightly raised. Especially in Myungjo, which is close to handwriting, shoulders look dropped when drawn horizontally, thus they are distinctively raised. This can be called as the use of vision in an opponent way.^{<Pic 16> <Kumim no.16>}

When the beginning and ending of stem serif are compared, the finish of beginning was slightly drooped. Because the stem itself appears to be bent like a bow, slightly drooping the bent part based on the handwriting method enhance maintaining the overall balance. The factor that influences the aesthetics of Myungjo is to keep these modifications subtle enough that they do not appear visually impractical. The ending tail of stem is slightly slanted to the left. This was also based on the handwriting method. When it was drawn straight along the centerline, it looked somewhat disconnected. So I studied the handwriting method and found out that the stroke was slightly slanted from center to left, and applied this natural looking appearance to the type.^{<Pic17> <Kumim no.16>}

Gothic is the brush force. The extreme use of brush force applied from hand drawn stroke, which sacrifices all serifs of handwriting, is what makes a Gothic. Therefore, it has the same hand drawn stroke as a Myungjo yet conveys a totally different nuance. The aim of Gothic is to maximum use the given space and within the same space every letter must be distinguished. Thus the aesthetics of hand drawn stroke has to be sacri-

아래 획은 굵게 하며 위의 획이 없을 경우에는 윗부분을 굵게, 아랫부분은 가늘게 하여 전체 균형을 살려주었다. 이는 받침일 경우 '이응'이라도 '히읗'과 같은 경우가 적용된다. 예를 들면 '긍'일 때는 위에 획이 있기 때문에 윗부분이 가늘고 아래는 굵어진다. 이러한 고리의 두 가지 경우는 획이 있고 없고의 차이 때문에 생겨났는데, 획이 있을 때는 고리의 부분의 무게를 나누어 균형을 유지하는 방향으로 하였다. 그리고 획이 없을 경우, 예를 들면 '위'와 같은 경우는 획이 없는 만큼 '이응'의 윗부분에 무게를 주어야 균형이 유지되기 때문에 위의 획은 굵고 아래 획은 가늘게 해줌으로써 적절한 균형유지가 되도록 하였다. ^{(그림15) (꾸밈16호)}

그림을 보면 시작과 맺음에 까맣게 표기된 부분이 명조의 세리프이며, 수평의 중심선을 그어보면 뚜렷한 차이를 느낄 수 있을 것이다. 이러한 각도의 연유는 명조의 경우 오른쪽 어깨가 조금 올라가야 시각적으로 수평으로 보이기 때문이다. 특히 필기체에 가까운 명조체는 수평으로 하면 어깨가 처져 보이기 때문에 뚜렷하게 올려서 그랬으며, 이는 시각의 역이용이라고 말할 수 있다. ^{(그림16) (꾸밈16호)}

기둥에 있어서 세리프의 머리 부분과 맺음을 살펴보면 머리 부분의 뒷부분을 약간 처지게 하였다. 이것은 기둥 전체가 활 모양으로 굽어져 버리는 느낌이 들기 때문에 필법을 근거로 꺾임 부분을 약간 뒤로 처지도록 하여 전체의 균형을 유지해 보았다. 이러한 모든 변형을 시각적으로 무리하지 않게 하는 것이 명조의 미적 감각을 좌우하는 요인이라고 생각된다. 기둥에 있어서 꼬리의 맺음선은 중앙에서 왼쪽으로 치우치게 하였다. 이것은 필법에 근거를 두고 처리한 것인데, 보통 제도식으로 중심선에 맞추어 꼬리를 맺어 주었더니 가다가 뚝 끊어진 느낌이 들었다. 그래서 필법을 분해해 보니 중앙에서 왼쪽으로 끝을 맺어 주고 있었고, 이것이 자연스럽게 느껴져서 왼쪽으로 살짝 치우치게 처리하였다. ^{(그림17) (꾸밈16호)}

고딕체는 붓의 필력, 필체(stroke)를 응용하여 필력을 극도로 살리며 필체에 의한 세리프를 다 희생시켜버리는 것이 고딕이다. 그러므로 명조와 필력은 같지만, 전혀 다른 뉘앙스가 있다. 고딕의 목적은 같은 공간 안에 최대한 공간을 이용하고 다른 글씨와 달리 구분이 되어 돋보이게 하는 것이 목적이기 때문에 미적 필체를 희생시켰다. 그렇지만 도안글씨와는 다른

<Pic 16>

<Pic 17>

<Pic 18>

<Pic 19>

<Pic 20>

599

choi jung-ho

<pic 16> beginning and ending of beam serif.

<pic 17> beginning and ending of stem serif.

<pic 18> marginal zone.

<pic 19> in the case of ㅎ and ㅍ.

<pic 20> in the case of 그, 교, 의 and 최.

ficed. Gothic must result a different atmosphere than lettering, and should have a sense of duty as a typeface.

Marginal zone is the spread ink due to the pressure of print. The corners of typeface sometimes have ink spread. This happens when letterpress is pressed thoughtlessly. But still, weak pressure will not be enough to evenly spread the ink thus appropriate uniform pressure is the best method to reduce the marginal zone. Depending on the printing machine, good machines result less marginal zone. No matter how good the machine may be, the marginal zone cannot be totally eliminated. Marginal zone in Korean term could be 'surplus belt'. The familiar appearance and phenomenon from letter press period is counter used in Gothic. When there is a marginal zone at the end of a stem of Gothic, it visually looks strong.<Pic 18> <Kumim no.22>

Detailed descriptions of the letters

Hieut

There were trials and errors in writing Hieut. I initially tried drawing it with focus on the angle of topknot but did not look good. Secondly I tried drawing the topknot after the horizontal stroke, but it did not harmonize with the stem. I realized that there was a spacing problem in the letter. Finally I modified the Hieut I had initially drawn. The initial drawing had appeared to have too light topknot when used in small size, so I lengthened the stroke and changed the angle which became almost horizontal. It resulted no visual chaos.<Pic 19> <Kumim no.16>

Pieup

I initially connected all strokes to draw Pieup, but it was smudged when printed. So I disconnected both stokes but looked too awkward. I disconnected the first stroke and reduced it to a point. The second stroke was refined inwards.<Pic 20> <Kumim no.16>

운치가 느껴져야 하며, 활자체로서의 사명감을 가져야 한다.<꾸밈18호>

인쇄 효과에 있어서 '마지널 존(Marginal Zone)' 이라는 것이 있는데 이것은 인쇄 압력 때문에 잉크가 밀려 나온 것을 말한다. 활자체에서 모서리를 보면 잉크가 밀려 나온 경우가 있다. 이 경우는 덮어놓고 활판에 압력을 주었을 때 일어나는 현상인데 그렇다고 살짝 갖다 대기만 하면 잉크가 골고루 묻지 않기 때문에 균일한 압력을 주어야만 마지널 존을 줄일 수 있는 제일 적절한 방법이다. 인쇄기계에 따라서 좀 다르지만, 기계가 좋은 것은 마지널 존이 적다. 아무리 좋은 인쇄기계라도 마지널 존을 줄이는 것이지 마지널 존을 아주 없앨 수는 없다. 마지널 존을 우리말로 인쇄 여분 띠라고 할 수 있는데, 이것은 활판 인쇄 때 우리 눈과 많이 친숙해진 현상으로 그런 친숙한 느낌을 고딕에서는 역이용하였다고 할 수 있다. 고딕의 획 중에 기둥의 모서리에 마지널 존이 있을 때 시각적으로 힘 있게 보인다.<그림18> <꾸밈18호>

600

글자 세부 설명

히읗

'히읗'을 쓰는 데 시행착오를 하였다. 처음에는 상투의 각도에 중점을 두고 써 보았는데 모양이 썩 좋지 못하였다. 두 번째는 가로줄기에 상투를 내리그어 보았으나 기둥과 조화가 되지 않고 한자체 내에서의 스페이싱(spacing)에 문제가 있음을 알았다. 마침내 나는 처음에 썼던 '히읗' 모양을 조금 수정하였다. 처음에 썼던 것은 실제로 조그만 활자로 사용될 때 상투의 획이 너무 빈약해 보인다는 점을 보완하여 획의 길이를 길게 하고 각도를 거의 수평에 가깝도록 고쳐보니 시각적인 혼돈은 일어나지 않았다.<그림19> <꾸밈16호>

피읖

'피읖'의 변천 과정은 처음에 획을 둘 다 붙였을 때 활자로 나오니까 범벅이 되어 버렸다. 그래서 둘 다 띄워 보니 이것 역시 어색하여 앞의 획을 더 띄워서 그 획은 점으로 줄여 주고 옆에 획을 안으로 다듬어 주었다.<그림20> <꾸밈16호>

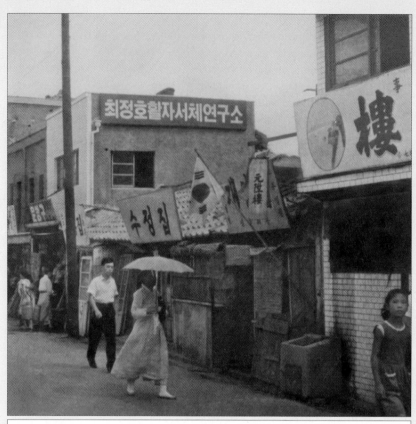

in front view of choijungho typeface research lab.

choi jung-ho with his works.

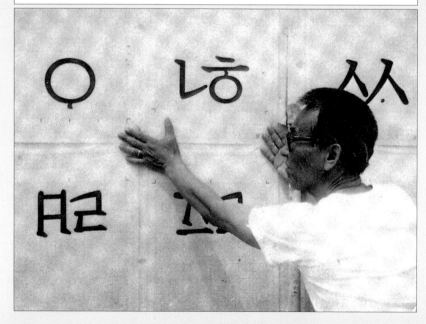

My request

My Hangeul Myungjo is my own way of refining Haeseo among the Gungsuh series. Myungjo in fact is the term used to describe the popular Chinese typeface used in Ming Dynasty of China. I wonder why people named my Hangeul in this term, Myungjo. It is ironic. I hope someone will change into a good name.

I still have a few letters which I wish the next generation would resolve. I wrote and erased over dozens of times in my own way, but they were never up to my satisfaction. '그' looks exceptionally large however I would write it. '교' looks exceptionally awkward as three vertical strokes withstanding side by side. In '최' or '의', the angle and serifs of 'ㅗ' and 'ㅡ' have always been the pain in the neck for me.^{<Pic 20> <Kumim no.11>} Hangeul Gung Hengseo, and archaic words are urgently in need to be developed into typefaces by the designers with desire.^{<Kumim no.20>}

choi jung-ho

부탁

내가 만든 한글 '명조체'는 이 궁서체 중 해서체를 내 나름대로 다듬은 것이다. 사실 명조체라는 말은 중국 명나라 시대에 유행했던 한문서체인데, 왜 사람들이 내가 쓴 이 한글에다 명조체란 이름을 붙였는지 모르겠다. 참 아이러니하다. 누군가가 좋은 이름으로 바꿔 주었으면 한다.^(꾸밈11호)

아직도 나는 후배들이 해결해 주었으면 하는 글자들이 몇 개 있다. 물론 내 나름대로 수십 번 썼다 지웠다 하며 최선을 다해 써놓았지만 내심 늘 마음에 걸려 왔다. '그'자는 어떻게 쓰든 유난히 커 보였고 '교'자는 내리긋는 작대기 3개가 각각 잘난 듯이 버티어 서서 유난히 어색해 보이는 것이다. 또 '최'나 '의' 등에 붙는 'ㅗ'나 'ㅡ'의 각도와 세리프의 처리도 그동안 나를 애먹였던 골칫거리 글자들이었다.^{(그림20) (꾸밈11호)}

뜻있는 분들에게 한글 궁체의 행서체가 활자로의 개발을 기다리고 있고 또한 우리 고어(古語)의 활자화도 시급하다.^(꾸밈20호)

his glasses on the drawing papers.

completing in the details.

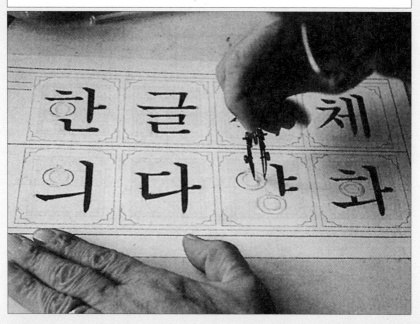

choi jung-ho

chung.byoung-kyoo

정병규.鄭丙圭.

Chung Byoung-kyoo, a pioneer of modern Korean book design, was born in Daegu in 1946. He graduated from Korea University and studied at Ecole Estienne, Paris. His professional field is book design and newspaper design. After working as an editor at several publishers, he became a book designer in 1979. He founded his own design studio Chung Design in 1985. Chung served as a professional member of Seoul Olympics in 1988 and as an art director at Minum Publishers from 1980 to 1993. He redesigned 'The Kugje Daily Newspaper' in 2007, and worked as an art director at 'The Joongang Daily Newspaper' in 2009-2010. Chung received awards including Kyobo Book Design Grand Prix in 1989, Special Award of Korea Publishers Society in 2006 and Special Achievement Award of Publishing Culture in 2010. He was president of Visual Information Design Association of Korea (VIDAK) and Korean Association for Visual Culture (KAVIC). He held personal book design exhibition in 1996 and 2006. He is an international judge for The Beauty of Books in China, 2010-2012.

604

korea 1946-

1946년 대구에서 태어났다. 고려대학교 불문학과를 졸업 후 EA 파리 에콜에스티엔느에서 타이포그래피를 공부했다. 민음사 편집부장 및 아트 디렉터, 홍성사 주간, 서울올림픽 전문위원, 한국시각정보디자인협회 (VIDAK) 회장, 한국영상문화학회(KAVIC) 회장, 중앙일보 아트 디렉터를 지냈다. 한국출판학회상, 교보 북디자인상 대상, 한국출판인회의 특별공로상, 한국일보 출판문화상 백상특별상 등을 수상했다. 1996년과 2006년 〈정병규 북 디자인 전〉을 열었으며, 저서로 〈정병규 북 디자인 1977-1996〉, 〈정병규 북 디자인 1997-2006〉이 있다. 현재 정병규학교 대표, 경원대학교 초빙교수, 〈중국의 아름다운 책들〉 국제 심사위원을 맡고 있다.

poster. letter. 790 x 1,090. 2007.

chung byoung-kyou

poster. city and poetics. 720 x 1,020. 2008.

chung.byoung-kyoo.

 정병규.鄭丙圭.

In the history of design,

here was a time when capital letter design was

treated as a problem.

There are times when

we must tell what design is,

through design works and reasoning.

Now is the time when we, designers, are

demanded to reason and practice design at the

same time.

Digital revolution is in progress.

디자인의 역사를 살펴보면

대문자 디자인이 문제가 될 때가 있다.

디자인 작업과 동시에 사유를 통하여

디자인이란 무엇인가를

말해야 하는 시대가 있다.

지금은 우리 디자이너들로 하여금

디자인적 사유와 실천을 동시에 요구하는

시대라고 생각한다.

디지털 혁명이 진행 중이다.

606

607

chung byoung-kyou

book cover. mountain2. 750 x 1,040. 2005.

To those designers using Hangeul,	한글을 사용하는 디자이너들에게
it forces them with a new question of	이것은 한글이 무엇인가라는 질문과
'what is Hangeul?'	새롭게 만나도록 강요한다.
This is because the reasoning and practicing to	이 질문에 대한 사유와 실천이
this question is how we think about the capital	우리로서는
letter design.	대문자 디자인을 생각하는 방법이기 때문이다.
And this is not a problem of Hangeul and	그리고 이것은 단지
Hangeul typography only.	한글과
	한글 타이포그래피만의 문제가 아니다.
It is believed that through this the typography of	이를 통하여 알파벳 중심으로만 펼쳐 온
Western Modernism typography,	서구 모더니즘 타이포그래피의 지형이
which had been focused only on Roman Alphabet,	
could be deterritorialised.	탈영토화될 수 있다고 믿기 때문이다.

608

poster.　hangeul day.　560 x 810.　2007.

한글날 561돌
우리말이 우리의 미래입니다

poster.　book design exhibition.　620 x 930.　2006.

The possibility of capital letter design

reterritorialisation through Hangeul could rather

be a burden for Hangeul users.

한글을 통하여 대문자 디자인을

재영토화할 수 있다는 가능성은

한글 사용자들로서는

오히려 짐이 될 수가 있다.

This is because the root of typographic ideology,

focused on Roman Alphabet, is incredibly deep.

알파벳 중심의 타이포그래피적 이데올로기의

뿌리는 엄청나게 깊기 때문이다.

It is also a deep rooted ideology in Korean modern

visual communication reality.

그것은 한국 현대 시각 디자인의 현실에서도

역시 뿌리 깊은 이데올로기이기 때문이다.

poster.　picture book.　600 x 840.　2007.

art. ˙ untiled.　600 x 840.　2007

Deterritorialising Roman Alphabet centrism in

typography is not easy for us twice as much.

타이포그래피에 있어서

알파벳 중심주의를 탈영토화한다는 것은

우리에게 이중으로 쉽지 않다.

Western metaphysics that seem impregnable

exists in deep of Roman Alphabet typography.

알파벳 타이포그래피의 심층에는

난공불락처럼 보이는

서양의 형이상학이 자리하고 있다.

Initially, the West must get over the

deconstructionism of that time which its own

metaphysics was reflectively introspected.

우선 서양이 스스로의 형이상학을 반성적으로

성찰한 저간의 해체론을 넘어서야 한다.

Hangeul typographic reasoning must alternatively

pass through the meandering path of Western

humanities.

한글 타이포그래피적 사유는

서양 인문학의 구절양장(九折羊腸)을

대안적으로 통과하여야 한다.

art. untiled. 600 x 840. 2007

In here, the Hangeul typography has no choice

but to meet with our humanities.

여기서 한글 타이포그래피는

우리의 인문학과 만날 수밖에 없다.

And we must reterritorialise it through the

typographic practice.

그리고 우리는 그것을 타이포그래피적 실천을

통하여 재영토화하여야 한다.

Furthermore, this is also the measurement of

Korean design historical consciousness and

identity.

나아가서 이것은 한국 디자인의 역사의식과

정체성을 따져보는 일이기도 하다.

614

It is a tough job,

yet could be a blessing for the Hangeul users.

힘든 일이지만,

그러나 한글 사용자들로서는

축복일 수가 있다.

book. business ethics. 145 x 210. 2009.

book. way without ways. 145 x 210. 2009.

book. the essay. 145 x 195. 2009.

book. on photography by kang. 2011.

book. the herring and morning. 135 x 210. 2010.

Because we have *Hunminjeongeum*.

우리에겐 『훈민정음』이 있기 때문이다.

Let's return to *Hunminjeongeum*.

『훈민정음』으로 돌아가자.

As it is the time for us to think about the capital

지금은 대문자 타이포그래피를

letter typography.

생각해야 하는 때이기에 그렇다.

chung byoung-kyou

book. china town. 120 x 185. 2004.

book. sea-god. 152 x 225. 2003.

book. design for human. 145x210. 2009.

book. book design by chung byoung - kyoo. 220 x 305. 1996.

book. photograph collection by yoon joo yung. 145x210. 2008.

book. adults school. 140 x 210. 2001.

book. the chronicle of manchwidang. 120 x 185. 2004.

book. the cry of the magpies. 120 x 185. 2003.

히라노.코가.平野甲賀.

hirano.kouga.

618

1938년 경성(京城, 지금의 서울)에서 태어났다. 무사시노 미술대학 시각전달디자인과를 졸업하고 다카시마야 홍보부를 거쳐 프리랜서 그래픽 디자이너로 활동했다. 1960년대부터 언더그라운드 연극(기존의 상업 연극과 선을 긋고 실험적인 무대 표현을 했음)에 참여하며 포스터를 다수 제작한다. 1964년부터 1992년까지 쇼분사(晶文社) 북 디자인을 담당했으며 거의 모든 책 장정을 담당하면서 회사의 이미지를 정착시켰다. 1973년부터 반체제 문화잡지 〈원더랜드〉, 〈보물섬〉을 창간하며, 아트 디렉팅을 했다. 1978년부터 현대음악가 다카하시 유지(高橋悠治)의 물소악단(水牛楽団), 물소통신(水牛通信)운동에 참여했고 1984년부터 기노시타준지(木下順二)의 『본향(本郷)』으로 고단샤출판문화상 북디자인상을 수상했다. 1992년부터 작업했던 장정을 석판화(리소그래프)로 재생하여 개인전 〈문자의 힘〉을 안팎으로 전개했다. 1997년 이후 잡지 〈책과 컴퓨터〉 아트 디렉팅을 담당했으며 2005년부터 2011년 소극장 시어터이와토를 설립, 종합 프로듀서를 맡았다. 2007년에 〈Kouga Grotesque 06〉 서체를 개발 및 발매했다.

Born in Seoul in 1938. Graduated from the Department of Visual Communications Design at the Collage of Art and Design in Musashino Art University. Became a freelance designer after working in the publicity department at Takashimaya Department Store. Joined the underground theater movement in the 60's and designs posters and flyers for theater events up to the present. Designed most of the books by Shobunsha Publishing from 1964 to 1991 and established the company image. Founded a counterculture magazine "Wonderland" in 1973 and worked as Art Director. Since 1978 an active member of the movement "Suigyu Gakudan" (Water Buffalo Band) and "Suigyu Tsushin" (Water Buffalo News) initiated by the contemporary musician Yuji Takahashi. His design for Junji Kinoshita's novel *Hongo* won the Cultural Award by Kodansha Publishing in 1984. Since 1992 his book designs were made into lithographs and exhibited in solo exhibitions entitled "The Power of Fonts" (Moji no Chikara) from home and abroad.Has been Art Director for a magazine "Book and Computer" since 1997. Founded Theatre Iwato and became Producer from 2005 to 2011. Releases a hand-drawn font "Kouga Grotesque 06" in 2007.

hirano kouga

karawan concert. 355 x 465. 1990s.

Letters I draw.

내가 그리는 글씨

hirano.kouga.

히라노.코가.平野甲賀.

I recently decided to call 'draw texts', not 'writing texts'. According to Shirakawa Shizuka's Janpaness dictionary(常用字解: Sangyongjahae), '描(myo)' is described as to draw an object's form only with lines. For Dessin, first you draw a rough sketch then trace the outline and then fill the inside. And this is exactly how I "draw letters". I think my drawn letter are far from the holy letters, like '書', that are written, bundled up, then put in a bowl to be dedicated to God.

Then, since we are talking about the Chinese character formation process, what is 描(myo) then? It means the grown grass from farm (田). Why is Japanese rice transplantation so well-ordered into regular space and line? Could this be just like any other Asian paddy field, which allows grass to grow on its free will? Is this some kind of national traits of the Japanese: meticulousness? Let's just skip further more associations. Why is Japanese straight matter is well-organized horizontally and vertically? My senior Sugiura Kouhei said, "Japanese is like sitting a circle universe on a square sitting matt". Obviously, Japanese letters are different from alphabets, which have various width, so its sitting matt does not change whatever letter is sitted on. Not only the type but also the digital fonts are basically in a form of a perfect square. Even small punctuation marks or symbols are the same. Rest pays attention to line-up the sitting matts, like a rice transplantation.

I remembered Fukuzawa Yukichi's A Study of the Writings 1872, which designer Sofue Shin showed me some time ago. The body text was written in a manner of woodblock printing's Romaji Renmentai (連綿体: like an illustrated literature, Kusazōshi, Kana is written subsequently). When this becomes the forth edition, it was changed to letterpress typesetting, and when the new edition

문자를 '쓴다(書く)'고 하지 않고 '그리(描く)'기로 한 것은 꽤 최근 일이다. 시라카와 시즈카(白川静, Shirakawa Shizuka)의 『상용자해(常用字解)』에 의하면 '그릴 묘(描)'란 물건의 모양을 선으로만 그린다고 되어 있다. 또 데셍이란 먼저 연필로 밑그림을 그리고 아웃라인을 따고 속을 채운다는 말이다. '그리는 문자'는 그 뜻과 만드는 작업이 그대로 들어맞는다. '글 서(書)'처럼 쓴 것을 묶어 그릇에 넣어 신께 올려 바치는 신성한 문자와 내 작업은 많이 동떨어져 있다고 생각된다.

한자의 성립과정을 탐색하는 김에 '그릴 묘(苗)'를 설명하자면 그것은 '밭 전(田)'자에 싹이 자라는 풀을 뜻한다. 그러나 모내기는 왜 그렇게 일정한 간격으로 정연하게 정돈되어 있는가. 풀이 나는 대로 두면 안 되는 것일까. 이는 철저한 일본인의 국민성인가. 이어서 연상(連想)은 비약이 된다. 일본어 본문 조판은 왜 가로, 세로가 깔끔하게 정돈되어 있는가. "일본어는 네모난 방석에 동그란 우주를 앉힌 것과 같다"고 선배인 스기우라 코헤이(杉浦耕平, Sugiura Kouhei)가 멋진 말을 했다. 분명 일본 문자는 각각의 너비가 다른 알파벳과는 달리 어떤 모양이 앉아 있어도 정해진 규격의 방석은 그대로다. 활자뿐만 아니라 디지털 폰트에서도 기본적으로 문자는 한 글자씩 정방형 틀 안에 놓여 있다. 작은 구두점이나 기호마저도 그렇다. 나머지는 방석의 줄을 맞추는 일에 전념한다. 마치 모내기처럼.

언제였던가 디자이너 소부에 신(祖父江慎, Sofue Shin)이 보여 준 후쿠자와 유키치(福沢諭吉, Fukuzawa Yukichi)의 〈학문의 권유〉(1872, 메이지 6년)가 떠올랐다. 본문 문자는 목판인쇄의 연면체(連綿体), 가나 등이 그림소설(조시, 草双紙)처럼 이어서 쓰여 있다. 그것이 제4판이 되자 활자 조판으로 바뀌고 새로운 판이 나오면서 또 연면체로 돌아가거나 다시 활자 조판으로 되돌아오기를 반복한다. 도대체

hirano kouga

miyake haruna duo takahashi yuji.　397 x 298.　1990s.

nise sakka no real life.　440 x 376.　1990s.

bin no naka no ryosyu.　374 x 405.　1990s.

comes out, they went back to the Romaji Ren-mentai or letterpress typesetting again and again. What a coincidence! Of course they had publication issues but I am sure they considered of the legibility before anything else. Through all these offensive and defensive battles, the result of this trials and errors made them to choose today's rice transplantation method. Of course history of the rice transplantation has been much older, planting rice in a straight line is just for harvesting and has nothing to do with design. Someone from Niigata reminded me that.

I am familiar with current Japanese typesetting, so it is hard to accept other then rice transplantation style. Chinese characters are seem to be well-ordered in the first glance, however there are gaps between Kana letters which makes me wonder if I can do something about it.

Designer devises a method to make one impact line by narrowing down wordings in the name of the book or on the strip. I have been binded many of Uekusa Jinichi's books. Of course the author's name is marked everywhere. I can deal with the typesetting of body text somehow. However I had to awfully think about the letter "一"(from his name) on the cover design. This is also a great letter and it has a value of presence for one sitting matt. It is hard to order to narrow the space of top and bottom in a vertical typesetting. The result is successful, as you can see on the shelves in book stores, if it does not stand out. But the body text typesetting is not so easy. I have seen a book which had narrower letter spacing in body texts but a typesetting ignoring the rule is just not working. Even if that was a fine sentence, in that position, people can only see designer's selfish and self-righteous thought.

It is possible to put letters on square and arrange them vertically or horizontally. There was a foreign designer who admired that Japanese type is fully functional and magnificent. But in this culturally unusual rationality, mixture of Chinese character and Kana, Chinese character has many meanings per one letter, Hiragana is in charge of one's way of speaking, and Katakana is for foreign words and sometimes alphabets make its own ideology. Are there any language like this free and unrestricted?

어떻게 된 인연인가. 당시 출판 사정도 있었겠지만 먼저 가독성을 우선했을 것이다. 시행착오 결과가 이 시절의 공방전(攻防戰)에서 현재의 '모내기 방석 스타일'로 정착했는지도 모른다. 물론 벼 농사의 역사는 더 오래되었다. 그리고 모내기를 하나씩 똑바로 간격을 두고 심는 것은 수확에 관련된 일이지 일단 디자인이랑은 상관이 없다며 니가타현 출신자가 깨우쳐줬다.

현재 일본어 조판 규칙에 익숙한 나로서는 이미 모내기 방석 스타일 말고는 다른 스타일을 받아들일 수 없게 되었다. 하지만 한자 나열은 그렇다 해도, 가나는 변형 가능성이 많아서 어떻게 하면 스타일로 적용할 수 있을까 고민하며 고개를 갸우뚱하게 되는 것도 사실이다.

디자이너는 책 이름이나 띠지에 들어가는 문언을 좁혀 어떻게든 임팩트 있는 한 줄을 만들고자 궁리를 한다. 나는 우에쿠사 진이치(植草甚一, Uekusa Jinichi) 작가의 책을 꽤 많이 장정했다. 당연히 저자 이름을 곳곳에 표기한다. 본문 조판에서는 그나마 참을 수 있지만, 표지 디자인에서는 성함의 '일(一)'자는 고민하지 않을 수 없었다. 이것 또한 훌륭한 한 글자이고 방석 한 장의 가치가 있는 존재. 세로짜기에서는 상하에 약간 틈새가 있기에 쉽게 좁힐 수 없다. 결과는 서점에 꽂혀 있는 책을 보면 알겠지만 특별히 튀지 않았다면 대성공이다. 그러나 본문 조판은 그리 쉽지 않다. 본문 글자간격을 좁힌 책을 본 적이 있지만 규칙을 무시한 조판은 도무지 머리에 들어오지 않는다. 모처럼 멋진 문장임에도 불구하고 천박함과 디자이너의 독선적인 태도가 느껴진다.

정방형 위에 문자를 놓고 세로든 가로든 바꿔 나열할 수 있다. 일본 활자는 가히 기능적이고 훌륭하다고 감탄한 외국 디자이너가 있었다. 그러나 한자와 가나가 섞인 문화와 그 속에 스며든 유연한 합리성이 있다. 이를테면 한 글자로 여러 의미를 지닌 한자표현과 구어체 성격이 강한 히라가나와 외래어는 가타카나, 알파벳을 그대로 써 하나의 사상을 자아낸다. 이렇게 자유자재인 언어가 또 있을까. 디자이너의 사소한 궁리도 허락되지 않을까 싶다. 아름다움, 읽기 편함 같은 것은 반드시 모양만의 문제는 아니다. 오히려 그 문장 자체에 있는 것이라고 내 졸문도 제쳐둔 채 생각한다.

이제 나는 문자를 '그리는' 것을 택했다. 한 문자로 여러 뜻을 지닌 한자와 가나는 여러 가지

hirano kouga

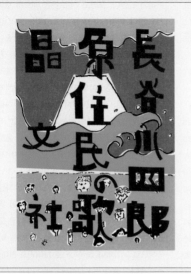

genjumin no uta. 381 x 562. 1990s.

fukkoukino seishin. 385 x 560. 1990s.

yogoreteinai ichiniti. 365 x 556. 1990s.

sannin no heitai. 385 x 562. 1990s.

Maybe it would be okay to allow designer's little deliberation. Something that is beautiful or reader-friendly is not all about the form. I think, setting aside unworthy writing, rather it is in the sentence itself.

Now, I decided to "draw" the letters. It shows different aspects from what Chinese character or Kana, which has several meanings over one letter, shows. Sometimes it is beautiful and sometimes it is ugly. And sometimes they show bad attitudes to each other. Therefore a "hand-drawing job by looking at an object" is not always possible like song of the painter, a character from Hasegawa Shirou's play. To "see" the object without any preconceived ideas is difficult and "draw" things suitably is even more difficult. It is such a danger-ous thing to do to judge what is right and what is wrong in this innumerably changing world.

I have been drawing many letters for titles or theaters. Sometimes there are the same letters appearing but I get confused when the letter becomes in words and have completely different image. Even the same letter can be both tragical and farcical. I tend to draw the same letter over and over again by adding my own judgement and impression.

Just forget about all this cumbersome thinkings, we have so many pre-existing typefaces, including Myungjo, Gothic and other ones. Let the readers to do some work of "seeing things". It is needless for designers to put their thoughts. And here is Shirou's song again —

> There is no horn on rhinoceros' forehead.
> That is disabled.
> but,
> more so,
> the sky is getting wider.
> It is not a handicap.

> Only that part is unnecessarily rich
> Only that part has unnecessarily wide sky
> Only that part is unnecessarily
> more tormented.

I decided to make typefaces out of letters I drew.
I laid down all the letters I drew so far. One drawn

모습을 보여준다. 어떤 때는 아름답기도 하고 추하기도 한다. 그리고 서로 못된 태도를 보이기도 한다. 이것은 '사물을 보고 그리는 손의 일'이라고 말할 수도 있는데, 하세가와 시로(長谷川四郎, Hasegawa Shirou)의 희곡 〈심판–은행원 K의 죄〉에 나오는 다락방의 화가 티틀레이리 노랫말처럼 '아무 걱정도 없이 태평하게 말할 수 있느냐'라면 당연히 그렇지 않다. 아무런 선입견 없이 '물건을 보는' 일은 어렵고, 적합하게 '그리는' 일은 더욱 어렵다. 무엇이 옳고 확실한 것인지 천변만화(千変万化)하는 이 세상에서 판단하기란 위태로운 일이다.

나는 책이나 연극의 타이틀, 기타 여러 문자를 그려왔다. 거기에는 때로 같은 말(문자)이 등장하지만 일단 문자가 말이 되면 전혀 다른 모습을 보여서 당황하곤 한다. 같은 문자라도 비극적으로 보이거나 희극적으로 보이기도 한다. 거기에 나의 생각이나 감상까지 들어가게 되면, 같은 글씨를 몇 번이고 쓰게 되어 이체자(異体字)가 늘기만 한다.

이렇게 고민할 거면 거추장스러운 일은 제쳐두고 명조체, 고딕체, 기타 여러 기성 서체를 사용하면 될 것이다. '사물을 보는' 일은 독자에게 맡기고, 디자이너의 생각을 넣는 일 따위는 불필요한 일이다. 여기서 하세가와 시로의 노래를 덧붙인다.

624

> 코뿔소 이마에
> 뿔이 없어
> 저것은 불구라고 하지만
> 그만큼 더
> 넓은 하늘
> 불구 같은 게 아니다

> 그곳만 쓸데없이 부유하여
> 그곳만 쓸데없이 넓은 하늘
> 그곳만 쓸데없이 괴로워하기도 한다

그러다 그려 모아둔 문자를 폰트화하기로 마음 먹었다. 얼른 여태까지 그려왔던 문자를 늘어놓았다. 하나의 문언에는 하나의 그린 문자. 이것이 지금까지의 내 사고방식이었다. 그러나 어딘지 부족함을 느끼기 시작했던 것이다. 하나의 성구(句)에 적합해 보이는 문자를 그리는 일은 적합해 보이는 글꼴을 고르는 일과 그리 다르지 않을지도 모른다.

그래서 전에도 썼지만 소위 '섞어 붙이는' 타이

yaneura no sanposya. 342 x 417. 1990s.

kurayamie no walt. 380 x 560. 1990s.

seionna hibi. 300 x 378. 1990s.

bokuwa asakusa no furyoshonen. 350 x 380. 1990s.

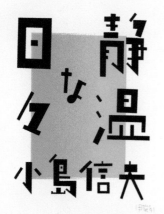

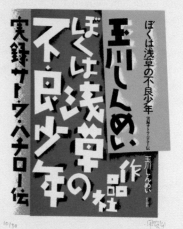

letter for one wording. This was my way of thinking so far. However I started to feel shortage somehow. Maybe drawing a suitable letter for one phrase is not so different from choosing suitable typefaces. I could feel hidden manner of reliance on a phrase that everything depends on the viewer's imagination.

So, I decided to adopt so-called "mixing and pasting" typography. Every single letter is drawn with completely different mind. By respecting each letter's characteristic, I mix and paste them. I thought maybe this could become somehow delicate but severely spiced dish.

Even though I started to draw letters, I could not fill even the half of Joyokanji(1945 letters). So I am going to check and draw all the undrawn letters from a mystery fiction by Reginald Hill that I am reading now! If I do this, maybe I could make this dignified Gothic Roman book filled only with my font "Kouga Grotesque" (I named it). This secret pleasure was added up.

Fortunately, it is possible to control and preview all typefaces that I am going to use with the computer softwares such as Illustrator or Indesign. Moreover, there is a function to store, select and use the same letter but different design. And this is such an easy job for me.

Whatever is working. I converted some texts moderately. This is awesome. It is even gratifying. One drawn letter for one wording. My way of thinking was turned over. And this way was much more fun. Jagged and rugged. Hmm… should I come up with deterrence logic again? So to speak, wearing head to toe with one brand is unfashionable. It is much stunning to digest different things. And that is a true chic... something like this.

포그래피를 채용하기로 했다. 각 문자는 전혀 다른 생각으로 그려진 문자, 그 개성을 존중하며 신중하게 생각하며 섞어 붙인다. 은은하면서도 톡 쏘는 맛을 낸 요리가 탄생할 것인가, 엉뚱한 생각을 했다.

작업에 들어갔지만 상용한자표(1945자)의 반 정도도 메울 수가 없었다. 그래서 마침 읽고 있던 레지널드 힐(Reginald Hill)의 대장편 미스터리 소설에 나오는 아직 그려 본 적이 없는 글자를 체크하여 닥치는 대로 그리기로 마음먹었다. 완성할 즈음에는 이 책을 내 폰트로 본문 편집할 수 있을 거란 즐거운 상상을 했다.(나중에 이 서체들은 '코가 그로테스크'라고 이름 지어 발매했다.)

컴퓨터로 문자를 다룰 수 있는 소프트웨어에는 지금 쓰고자 하는 폰트 전체를 표시해 볼 수 있고, 더 나아가 동일한 문자이면서 디자인이 다른 문자(이체자)를 수납하고 선택하고 표시하는 기능이 있다. 이는 내게 있어 굉장히 편리한 일이다.

뭐라도 좋다. 적당한 텍스트를 '주루룩' 변환해 봤다. 이건 엄청나다. 통쾌하기까지 하다. 한 문언에는 하나의 그린 문자. 내 사고방식이 뿌리부터 뒤집어졌다. 이쪽이 훨씬 더 재미있는 것이다. 들쭉날쭉. 이것은 또 한 번 어떤 억지 논리를 펼칠지……. 이를테면 머리에서부터 발끝까지 한 브랜드로만 차려입다니 촌스러워, 각기 다른 것을 멋지게 소화해 내는 것, 이것이 진정한 멋이야…… 라든지.

626

A.p.

mon no muko no gekijo.　271 x 600.　1990s.

heisi syubeiku no boken (jo).　356 x 412.　1990s.

heisi syubeiku no boken (ge).　356 x 412.　1990s.

ibukurowo kaini.　296 x 400.　1990s.

8/30

hirano kouga

Make the letters alive

문자에 생명력을 불어넣다

김경균.金炅均.

(professor, korea national university of arts)
(한국예술종합학교 디자인과 교수)

hirano kouga

Crooked, jagged and ugly letters, like cut and pasted confettis by a child, are placed in a large size and seemed to want to get out of the wriggly and narrow backbone of a book. The fall of 1995, I visited a book store by chance while I was waiting for the Shinkansen at Tokyo Station and shortly, I was attracted by some books on the shelf across the entrance. Needless to open them, I figured those were Hirano Kouga's designs. Even though I do not know the contents of those books, I could imagine him sitting like a large rock, blinking his large camel-like eyes. For how many times would he smiled on them like a boy while he was

마치 어린아이가 삐뚤삐뚤 색종이를 잘라 붙여 만든 것 같은 못생긴(?) 글자들이 꿈틀거린다. 좁은 책등을 벗어나고 싶은 듯이 큼직큼직하게도 놓여 있다. 1995년 가을, 도쿄역에서 신칸센 시간을 기다리다 우연히 들어간 서점의 건너편 책꽂이에 놓여 있는 책들이 금방 눈에 와 꽂힌다. 책을 펼쳐 확인할 필요도 없이 그것은 히라노 코가의 디자인이다. 그 책의 내용이 무엇인지는 몰라도 낙타같이 생긴 깊은 눈을 껌벅거리며 커다란 바위처럼 앉아 있을 그의 모습이 먼저 떠올랐다. 그는 저 글자들과 놀면서 몇 번이나 소년 같은 미소를 흘렸을까. 다 완성된 표지를 앞에 두고 담배 한 대 피워 물고 보일 듯 말 듯 눈가에 미소를 흘리고 있었을 그의 모습을 상상하니 피식 하고 웃음이 나왔다.

628

일본 출판계에서 '히라노 스타일'이라 불릴 정도로 그의 손글씨는 독보적인 존재로 정착되었다. 책 표지 안에서 금방이라도 꼬물꼬물 움직일 것처럼 하나하나에 강한 생명력이 담겨 있다. 문자에 표정을 불어넣는다는 것은 바로 이런 것일까? '谷尺永一'라고 쓴 네 글자의 저자명을 들여다보고 있노라면 한 번도 보지 못한 그 사람의 생김새나 성격을 금방이라도 느낄 수 있을 것만 같다. "얼마 전 예쁜 척 잘하는 한 여류 수필가는 내가 자기 책을 디자인한다니까 싫어했다더군. 내가 자기 이름을 쓰면 그 표독스러운 표정이 금방 드러나 버릴까 봐 그게 아마 무서웠던 게지. 그런데 언젠가 자네 이름도 한번 써보고 싶군!" (웃음) 당황하는 나를 바라보며 장난기 어린 표정으로 그가 했던 말이 문득 생각났다.

"한국에는 혁필이라는 게 있지요." 내 아버지 연배인 그를 처음 만났을 때 나는 우리나라 혁필과 문자도를 이야기해 준 적이 있다. 문자가 이미지를 머금고 있다는 점에서 그의 타이포그래피와 어딘지 닮은 데가 있는 것 같아 짧은 지식을 동원해서 꽤 장황하게 설명을 했다. 긴 속눈썹의 눈을 껌벅거리며 내 이야기를 열심

russia avant-garde. 351 x 374. 1990s.

haiyu ron. 365 x 400. 1990s.

rousha. 344 x 399. 1990s.

shokutaku ichigoichie. 370 x 415. 1990s.

playing with those letters? Imagining him smoking a cigarette and grinning in front of the finished cover design made me giggling.

His hand drawing, so called 'Hirano Style', has an enormously strong vitality one letter by one letter, seems like it will start to wriggle and is unequaled presence in Japanese publishing industry. Is this what instilling an expression to letters like? '谷尺永一' Looking at this 4 lettered author name allows me to draw his appearance and personality even if I've never seen him. "Not long ago, a female essayist, who loves to pretend pretty, did not like me doing a cover design for her book. She probably got afraid of me writing her name because it will show her unfriendly facial expression. By the

히 들어주면서도 이미 잘 알고 있다는 표정으로 빙긋이 웃기만 하더니 "문자는 참 재미있는 놈이야. 조금씩 만져 주면 꿈틀꿈틀 알아서 살아 움직이거든. 옛 선인들도 그것을 알았던 게지……." 장황한 설명에 짧고 명쾌한 대답. 언제나 그의 대화에는 군더더기가 없다. 나는 결국 공자 앞에서 문자를 쓴 꼴이 되고 말았다.

그의 주변에 있는 편집자의 글에서 "히라노의 작업실에는 아무것도 없다. 그저 거기에 그가 있을 뿐"이라는 표현을 읽은 적이 있다. 그의 북 디자인을 보면 문자 이외에는 아무것도 없다. 사진도, 일러스트레이션도, 하다못해 라인도 한 줄 없다. 그저 꿈틀거리는 문자들이 서로 다른 표정을 감추지 않고 맞춰 놓은 줄을 이탈하여 뛰쳐나가고 싶어 하는 자유로움만이 가득하다. 따라서 그의 북 디자인에는 그저 거기에 문자가 있을 뿐이다.

문자가 그를 닮아가고 있는 걸까? 그가 문자를 닮아가고 있는 걸까? 두툼한 그의 손가락을 닮은 이 글자들은 20여 년 전 백내장으로 시력을 잃어버리기 전까지 한 자 한 자 그의 손끝에서 새롭게 만들어졌다. 눈의 부담을 덜기 위해 컴퓨터를 사용했지만 역시 그 손맛을 벗어나지는 않았다. "초보라서 그렇겠지만 컴퓨터에서는 내가 마음먹은 대로 선이 그어지지 않아. 그런데 그게 오히려 재미있더군. 컴퓨터라는 도구가 나의 컨트롤을 벗어나 삐뚤삐뚤 제멋대로 가게끔 적당히 내버려두고 그걸 즐기는 것이지." 눈을 반짝거리며 소년처럼 미소 짓는 히라노 코가. 환갑에 시작한 일러스트레이터 프로그램을 다루는 수준이 달인의 경지에 이르렀다는 평을 듣고 있지만 쓸데없는 기능이 너무 많아 필요 없는 기능은 알려고 하지도 않았다는 이야기에서 다시 한 번 그의 성격을 읽을 수 있었다.

그가 처음부터 북 디자인을 한 것은 아니었다, 일본의 명문 무사시노미술대학(당시 미술학교)을 다닌 그는 대학 시절 지금은 없어졌지만 당시 일본 그래픽 디자이너의 등용문으로 절대적인 권위를 자랑하던 닛센비(日宣美, 일본선전미술가협회의 공모전)에서 특선을 했고, 졸업과 동시에 최고 엘리트 디자이너의 전당으로 불리던 다카시마야(高島屋)백화점 홍보실에 입사했다. 그러나 그는 모두의 선망 대상이었던 직장을 2년 만에 그만두었다. 연극운동 관련 디자인 작업에 참여하기 위해서였다. 그의 아방가르드 정신은 여기서부터 시작된 것이

630

631

zoku tanigawa syuntaro33 no sitsumon. 382 × 378. 1990s.

watasigatari higuchi ichiyo. 390 × 378. 1990s.

hirano kouga

yamaneko no yuigon. 436 × 380. 1990s.

way, I want to write your name someday!(laugh)"

All of sudden, I remembered this phrase he said

mischievously, while gazing me losing my head.

"There is a style called Hyuk-pil(painting colored

with a piece of leather) in Korea" When I first

met him, in my father's age, I told him about

Korean Hyuk-pil and MunJan-Do(decorated text

drawing). I thought those were very similar to

typography because the text is keeping in image,

so I explained about them to him for a while with

my short knowledge. He was blinking his long

lashes and listened intently to my explanation but

seemed like he knew about those already and

said, "Text is such an interesting one. It starts

to wriggle and comes to life when I touch them.

hirano kouga

아닐까. 1960년대 중반, 학생운동과 함께 당시 일본 지식인들의 좌파적 움직임은 여러 가지 예술형식으로 전개되고 있었는데 그중에서도 연극은 가장 대표적인 표현 장르였다고 한다. 지금도 그가 러시아 아방가르드를 '나의 영원한 교과서'라고 서슴없이 이야기하는 것을 보면 20대의 뜨거운 피를 가진 히라노에게는 별로 어울리지 않는 엘리트주의적인 직장생활이었으리라 짐작된다. "주머니는 비어 있었지만 항상 즐겁게 일할 수 있었지. 직장에서처럼 이거 하지 마라, 저건 안 된다, 그런 것이 없었으니까 말이야. 그저 내가 느끼고 표현하고 싶은 것을 표현하면 주변 사람들이 좋아해 주더군. 그리고 한국 운동권 사람들과의 교류도 종종 있었고 김지하 씨의 작품을 연극으로 올리기도 했지. 지금도 그 노래를 기억하고 있다네." 이렇게 연극 포스터와 전단지 등을 디자인하면서 그의 자유로움은 싹트기 시작했을 것이다.
그리고 당시 '구로텐트'라는 극단을 이끌고 있던 쓰노우 우메타로와의 운명적인 만남이 이루어졌다. 이후 쓰노우가 연극계를 떠나 쇼분샤라는 출판사 편집장으로 옮겨가면서 히라노는 자연스럽게 그 출판사의 북 디자인을 하기 시작했던 것이다. 그리고 그의 독특한 손글씨는 바로 여기에서 정착되기 시작하여 한때는 쇼분샤 책의 아이덴티티로 완성되었다. 쇼분샤의 거의 모든 출판물이 히라노의 손을 거쳤고, 디자인만 보아도 그 책이 쇼분샤라는 출판사의 책임을 알 수 있게 된 것이다. 1990년대 초반 쓰노우가 〈책과 컴퓨터〉라는 잡지를 창간했을 때도 아트 디렉팅 역할은 자연스럽게 히라노 코가의 몫이 되었다. "창간하기 이전부터 서로 많은 이야기를 나눴지. 요즘 나오는 컴퓨터 관련 잡지들은 큰 판형에 화려한 사진, 내용은 신제품 소개나 소프트웨어의 설명서 같은 것들로 가득한데 우리는 그에 대한 불만이 많았다고 할까? 미디어 사회의 급격한 변화에 대한 근본적인 문제를 다루고 있지 못한 것에 대한 아쉬움이 많아서……. 미디어의 변화와 함께 대두되는 사회적인 문제점이라든가, 지금까지 역사적으로 가장 강력한 미디어였던 책과의 상관관계, 그런 것들이 서로가 어떻게 영역을 공유하면서 살아남을 수 있을지, 이런 문제에 대해서 좀 더 깊이 있게 다루고 싶었던 것이지." 쓰노우 우메타로와 히라노 코가는 젊은 시절 연극판에서 처음 만나 편집장과 아트 디렉터의 관계로 발전하면서 결국 친구가 되어 이제는

kuki no ongaku. 299 x 398. 1990s.

engeika 12kagetsu. 330 x 412. 1990s.

kuginuki tokichi torimono oboegaki. 351 x 442. 1990s.

shinsei kigeki. 363 x 457. 1990s.

Maybe ancestors knew about that..." Short and

clear answer to long-winded explanation. Conver-

sation with him is always precise. It was like recit-

ing in front of Confucius.

I read a description about him, written by an edi-

tor he knew: "in Hirano's studio, there is nothing.

He is just in there." In Hirano's book design, there

is nothing but text. No photography, illustration, or

even one line. It is just full of freedom of wriggly

texts wanting to desert out from an ordered line

without hiding their personal expressions. There-

fore, in his book design, text is just right there.

Is text getting similar to him? or is he getting

similar to text? These texts, similar to his thick-

서로의 영역에 대해 충고하고 도와주는 최고의 파트너가 되었고, 이렇게 두 사람은 평생의 동지로 살아가고 있는 것이다.

2000년 겨울, 히라노 코가가 서울에 왔다. 건강을 걱정해서 절대로 많이 걷지도 않고 술도 마시지 않게 해야 한다는 부인의 전제가 붙은 2박3일의 짧은 일정이었다. 〈책과 컴퓨터〉에서 한국 특집호를 구성하게 되었는데, 아트 디렉터인 히라노 고가가 직접 서울의 폰트 회사나 서점을 돌아보고 한국을 대표하는 디자이너 몇 사람과 대담도 하기 위한 기획에서 의도된 여행이었다. 그리고 당시 나는 한국 특집호의 기획을 함께 진행하게 되어 그의 일정에 동행 했다. 그런데 그에게는 서울과의 묘한 인연이 있었다는 것을 알게 되었다. 그는 1938년 서울에서 태어나 어린 시절을 보냈다. 아버지가 철도 관련 일을 해서 서울역 근처에서 살았다고 한다. 우리는 서로의 아픈 역사의 기억은 들춰내지 않으려고 조심하면서 시내 거리를 돌아다녔다. 60여 년 만에 찾은 출생지 서울에서 그는 약간 흥분하고 있었다. 서점도 돌아보고, 폰트 회사도 방문하고, 남산에도 올라가고, 그의 부인이 들으면 기절하겠지만 저녁에는 막걸리도 한 잔 마셨다. 그리고 그가 살았던 곳으로 짐작되는 숙명여대 근처에서 몇 채 남아 있는 적산가옥을 발견하는 극적인 만남도 있었다. 그리고 안상수, 한재준 두 디자이너와의 긴 대담. 밤 1시가 넘어 호텔에 돌아온 그는 많이 지쳐 있었지만 즐거운 표정이었다. 60여 년 만에 찾은 서울과 거기에서 같은 직업을 가지고 비슷한 생각을 하고 살아가는 사람들을 만난 기쁨, 그리고 도쿄에 돌아가 이 내용을 한 권의 책으로 묶어낼 생각에 잔뜩 기대에 찬 표정이었다.

"즐거웠어. 한국에는 뭔가 강한 힘이 있다는 걸 느꼈어. 이제 돌아가서 열심히 그 힘을 표현해야겠군." 2000년 여름 〈책과 컴퓨터〉에서는 한국을 다룬 별책이 출간되었고 그 책에는 히라노가 한국에서 느낀 그 힘이 여기저기 표현되어 있었다. 책을 넘기며 그 한 글자 한 글자마다 입을 실룩거리며 열심히 마우스를 움직이고 있었을 그의 표정이 겹쳐져 보였다. 5년 뒤인 2005년 겨울 도쿄 가구라자카의 한 찻집에서 대담을 위해 그와 마주앉았다. 여전히 그 큰 눈을 껌벅이며 나를 맞아 주었다. 서점에서 히라노 스타일이 많이 보이던데 요즘도 북 디자인 작업을 많이 하냐는 질문을 던지자 "이제 나이도 있고 하니 젊은 편집자들이 이런 할아버

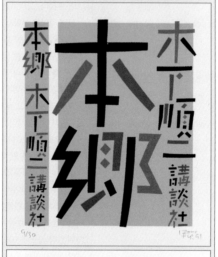

635

dokushojin no kochu. 398 x 399. 1990s.

hongo. 298 x 398. 1990s.

hirano kouga

bungakuteki kaiso. 398 x 399. 1990s.

fleshed fingers, were created one by one through

his hands until he lost his vision to cataract 20

years ago. He used computer to ease his eyes but

it did not leave his hand style. "I am not expert to

computer so I cannot draw a line as I want with

computer. And this was actually rather interesting.

A tool, computer is taking over my control to my

hands, and I let it draw wriggle and crooked lines

and just enjoy it."

Hirano Kouga, flashing eyes and smiling like a boy.

He started to use illustrator around 60 and almost

mastered it. But I can read his character by a story

that he did not wanting to know any unnecessary

function because there were too many useless

functions.

지에게 별로 일을 주려고 하질 않아. 이전에 나와 일을 함께 했던 편집자들은 은퇴했거나 이미 이 세상 사람이 아니야. 서점에서 가끔 보이는 책들은 최근 내가 한 작업들이 아니라 이전에 한 것들 가운데 스테디셀러가 있어서 지금도 가끔 눈에 띄는 정도가 아닐까 싶군." 여전히 군더더기 없는 간결한 말투에는 반가움이 묻어나 있었다.

그리고 내가 출판사를 시작했다고 말하자, "언제나 아방가르드는 그렇게 시작하는 것이지. 시대를 앞서 나가는 정신 말이야. 러시아 아방가르디스트들도 바로 그런 정신이었지. 우리와 같은 크리에이터에게 매너리즘이라는 덫은 죽음을 의미하는 것이 아닐까?"라며 용기를 불어넣어 주었다. 그러고는 "최근에는 오랜 친구들과 함께 극단을 부활시켰다. 40~50년 전에 '구로 텐트'라는 극단을 함께 했던 친구들이 이제 대부분 은퇴해서 할 일이 없어졌어. 그래서 낡은 창고를 하나 빌려 극장으로 개조했지. 요즘 이 일을 준비하는 것이 너무 즐거워 디자인 작업은 거의 잊어버리고 살지." 칠순을 바라보는 그는 여전히 아방가르디스트의 삶을 살고 있었다.

〈타이포잔치 2011〉에서 6년 만에 그를 다시 만났다. 담배를 한 대 피워 물더니 포토그래퍼로 일하는 아들을 소개해주면서 "난 이제 늙어서 멍청이가 되어버렸어. 이 녀석이 옆에 없으면 해외여행도 힘들어. 나는 이만 빠질 테니 젊은이들끼리 교류해야지. 그런데 오늘 광장시장에 갔다 왔는데 10년 만에 다시 찾았지만 여전히 서울이라는 도시에서는 강력한 힘이 느껴지더군." 여전히 담배를 피울 수 있다는 것이 오히려 건강하다는 증거로 생각되어 안심이 되었다. 이번 여행을 통해 서울에서 새로운 힘을 듬뿍 받아 앞으로도 건강한 모습을 오래 간직하기를 바란다.

636

637

27/30

1942년 광둥성 판위에서 태어났다. 1967년 홍콩에 정착하면서 디자인과 예술창작 분야에 종사하기 시작했고, 각종 상을 받으며 학술계에서 높은 평가를 받았다. 디자이너로서는 최초로 '홍콩 10대 걸출한 청년'(1979)으로 임명되었으며, 시정국 디자인 대상(1984)을 받았다. 또한 『세계그래픽 디자이너 명인록』(1995)에 기록된 첫 번째 화가이다. 홍콩 특별행정구 정부로부터 Bronze Bauhinia Star 상 (1999)을 받았으며, 2010년에는 Silver Bauhinia Star 상 명예훈장을 받았다. 칸타이큥은 홍콩과 해외에서 몇 차례 개인전을 기획했으며 그의 디자인 및 예술 작품은 해외 각지에서 전시되어 있다. 특히 2002년에 홍콩문화박물관에서 개최한 〈생활, 소원(心愿) – 칸타이큥 디자인과 예술대전〉은 약 20만 명의 관람객의 이목을 집중시켰다. 2003년 일본 오사카 DDD갤러리 및 일본 시즈오카문화예술대학의 요청으로 〈묵과의(墨與椅) 칸타이큥 + 류쇼캉 예술과 디자인 전〉, 2008년 홍콩대학미술박물관에서 〈화자아심 – 칸타이큥 회화〉 수묵화 개인전을 열었다. 2010년 칭화대학미술학원에서 편찬한 『100, 100, 100 x 10 – 칸타이큥 디자인 작품전』은 〈칸타이큥 디자인상 – 전 세계 화인대학생 경기〉의 10주년을 축하하기 위한 것이다. 2005년 홍콩 이공대학에서 디자인학 박사학위를 받았으며 중앙미술학원 객원교수, 칭화대학 객원교수, 국제그래픽디자이너연맹(AGI) 회원 및 중국 분회 주석, Leisure & Cultural 서비스 분야 고문, 홍콩 예술관 명예고문이다.

kan.taikeung

칸타이큥.靳埭强.

china 1942-

Kan Taikeung was born in 1942 in China. From 1967, Kan settled in Hong Kong and started his career as a designer/painter. The awards he received had brought him to immediate prominence. Kan was the first designer elected as one of the "Hong Kong Ten Outstanding Young Persons" in 1979; the only designer to receive the Urban Council Design Grand Award in 1984; and was the first Chinese to be included in "Who's Who in Graphic Design" of Switzerland in 1995. He was conferred Honour of Bronze Bauhinia Star in 1999. In 2010, he commended officially by receiving the Honor of Silver Bauhinia Star. Kan's art and design works have earned him international publicity through exposures in overseas exhibitions. He held a number of solo exhibitions in overseas and Hong Kong, which included "From Life to Mind: Kan Tai-keung's Design & Art" at the Hong Kong Heritage Museum in 2002, over 200,000 visitors had been to the exhibition; "Of Ink and Chairs – Kan Tai-keung + Freeman Lau, Art and Design Exhibition" exhibited at both DDD Gallery, Osaka and Shizuoka University of Art and Culture in 2003; "Feelings of the Brush: Paintings by Kan Tai-keung" at the University Museum and Art Gallery, The University of Hong Kong in 2008. His solo exhibition "100, 100, 100 x 10 – Design Exhibition by Kan Tai-keung" was organized by Tsing Hua University in Beijing to mark the 10th anniversary of "Kan Tai-keung Design Award –Worldwide Chinese University Students Design Competition". Kan also actively involves in educating and promoting art and design profession. He is now Guest Professor of Central Institute of Fine Arts and Guest Professor of Tsing Hua University. He is also a Fellow Member and Chairman of Chinese Committee of Alliance Graphique Internationale; Advisor of the Leisure & Cultural Services Department and Honorary Advisor of Hong Kong Museum of Art. In 2005, Kan was awarded an Honorary Doctor of Design in the Hong Kong Polytechnic University.

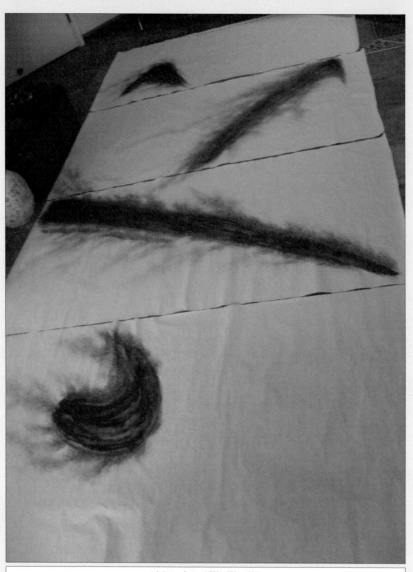

kan taikeung

painting. fire. 1,790 x 970. 2011.

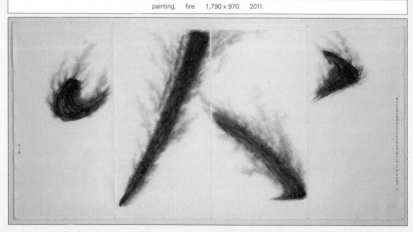

The way we say, create, think of and appreciate words.

문자를 말하고, 만들고, 생각하고, 음미하는 방법

kan.tai.keung.

칸타이쿵.靳埭强.

Words are the most important communication tool to human beings. In the ancient time, people use simple visual symbol to express and communicate their thoughts and those symbols formed the earliest words. Afterward, different languages, words and fonts are derived in different regions and eras. Some of the less-popular languages may disappear along with the social change; however, words that widely used in populated area can last long in history. Latin and Chinese characters best represent one of those. Considering the existing words in the world, most of them were created phonetically except Chinese, which is an ideogram to show its meaning and pronunciation. It is unique with its long history. As the differences of writing tools, like how Chinese have used writing brush to write for a long period of time, the reading-oriented Chinese ideogram has developed into another form of art, the Chinese Ink Calligraphy.

문자는 인간에게 가장 중요한 소통 수단이다. 고대 사람들은 자신의 생각을 전달하기 위해 단순한 시각 상징물들을 사용했으며, 이 상징들은 초기 문자가 되었다. 후에 다양한 언어와 문자 그리고 활자들이 여러 다른 지역 및 시대에 걸쳐 나타나게 되었으며, 대중적이지 못한 언어들은 사회 변화와 함께 사라지기도 했다. 하지만 대중들이 많이 사용하는 문자들은 역사에서 오랜 기간 남아 있게 된다. 대표적인 것이 로마자와 한자이다. 오늘날 지구상에 존재하는 문자들을 생각해볼 때, 대부분은 표음문자임을 알 수 있다. 하지만 의미와 발음을 모두 담고 있는 표의문자인 중국어는 예외다. 오랜 역사와 함께 중국어는 독특한 지위를 갖고 있다. 중국인들이 오랜 기간 붓을 사용하여 글을 쓴 사례에서 볼 수 있듯이 필기구가 지니는 다양성과 마찬가지로 읽기 경향의 중국 표의문자(Reading-oriented Chinese Ideogram)는 '중국 서예'라는 또 하나의 예술 형식으로 발전하게 된다.

Also new kinds of drawing or craving fonts have been derived from the original hand-writing Chinese and Latin in respond to the improved printing art and printing technique which have facilitated typesetting and publishing. The rapid development of printing technology in the Europe after industrial revolution also accounts for the advancement of Latin typesetting. Considering the limited numbers of Latin characters, it is easy to develop a new font style in full set. Albeit the history of the typography development in the West is short, there are abundant font styles. On the contrary, the structure of Chinese characters is much more complicated and the number of commonly-used words is large so that it is very difficult to create a complete set of font. Although typesetting has entered digital year recently, the font design is still

또한 조판과 출판을 용이하게 만든 인쇄 예술과 기술 발전에 발맞춰 본래 손으로 쓴 중국어와 로마자에 기원을 둔 새로운 활자들이 그려지거나 새겨졌다. 무엇보다 로마자 조판이 발전할 수 있었던 것은 산업혁명 이후 유럽에서 빠르게 진행된 인쇄 기술의 발달 덕분이다. 한정된 로마자의 수를 생각해 볼 때 한 벌의 새로운 글꼴 개발은 쉽다. 비록 서구의 타이포그래피 역사는 짧지만 매우 풍부한 활자가 서구에는 존재한다. 반면 한자는 이보다 더 복잡한 구조를 갖고 있으며 일반적으로 사용하는 단어들이 많기 때문에 완벽한 글꼴 한 벌을 만들기가 매우 어렵다. 조판 방식이 최근 디지털 방식으로 바뀌었음에도 불구하고 활자 디자인 발전은 더디다. 하물며 중국의 인쇄술은 어떤가. 문제는 무엇보다 높은 디자인 비용 때문이다.

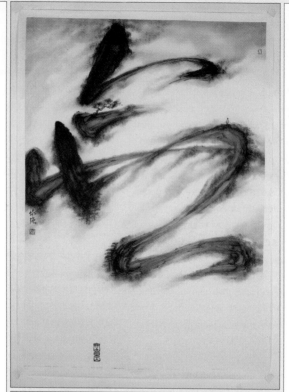

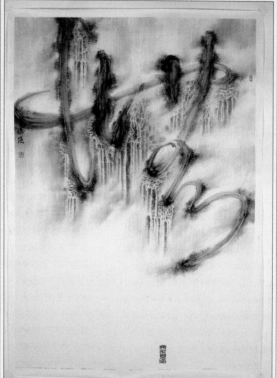

poster. mountain in mind. 700 x 1,000. 2010.

poster. water in mind. 700 x 1,000. 2010.

641

a bit under-developed, not mention the Chinese printing works. This is greatly because of high design cost.

In the field of visual communication and design, typography takes a very important position in the four major presenting materials. If you can manage the skill of font design, you already build a consolidated foundation of good design. It is what I always tell the students. However, it is sorry to find out that students nowadays are over-dependent on computer but seldom work on hands. In return, they are unable to realize that high technology is insufficient to solve the aesthetical problems of typesetting. They forgo the chance to learn about the principal function of words and space in design and loss their sense. Misunderstanding that technology is all-powerful will end up being enslaved to the new tools only.

Font design has been valued high internationally in university research and creative practice in the industry. Not limited to large proportion of time and academic credits of the school curriculum are included, there are professional societies and associations formed particularly for typography design. Typography design competitions and feature exhibitions are organized yearly, as well as publishing year book and works collection in the way to promote excellence of typography art and praise those outstanding typography designs. However, English, including Latin, is still the major language for those organizations and campaigns. Japan has also become a powerful design country after the rapid post-war economic development. The typography design enthusiasts from the graphic design field has established the Japanese Professional Type Design Association (日本タイポグラフィ協会) and Tokyo Type Director Club (東京TDC)successively. Exhibitions and yearbooks organized by these two organizations meet a very high standard and both the advantage of Latin and Chinese character in Japanese are considered here which raise the international's attention on Chinese character design. In the early 80s, Japaneses Typography

타이포그래피는 시각 디자인 및 관련 분야에서에서 매우 중요한 역할을 하고 있다. 활자 디자인에 재능이 있는 사람은 이미 좋은 디자인의 기본기를 탄탄하게 쌓은 것이다. 나는 이 점을 항상 학생들에게 강조한다. 하지만 유감스럽게도 오늘날 학생들은 컴퓨터에 너무 의존한 채 손으로 작업하는 경우가 드물다. 그 결과 이들은 조판의 미적 문제를 해결하는 데 첨단 기술이 다가 아님을 깨닫지 못한다. 디자인에서 문자와 공간이 지닌 기본 기능에 대해 공부하는 것을 포기하고 그에 대한 감각 또한 잃게 되는 것이다. 기술은 전지전능하다는 오해는 오로지 새로운 도구의 노예가 되는 것과 다름 없다.

전 세계에 걸쳐 활자 디자인은 대학 연구 및 디자인 현장에서 중요한 것으로 여겨진다. 활자 디자인은 대학 커리큘럼에서 많은 시간을 할애하여 교육될 뿐만 아니라 타이포그래피를 위해 별도로 구성된 전문 학회 및 협회들이 있다. 타이포그래피 예술의 우수성을 고취시키고 뛰어난 디자인을 알리기 위해 매년 타이포그래피 공모전과 기획전시들이 열리고 관련 연감들이 출판된다. 하지만 이러한 행사와 캠페인에서 로마자를 포함한 영어가 여전히 중요한 언어로 자리하고 있다. 일본은 전쟁 이후 급속한 경제 발전을 이루어 막강한 디자인 국가가 되었다. 그래픽 디자인 분야에서 활동하는 열광적인 타이포그래피 지지자들은 일본전문활자디자인협회(Japanese Professional Type Design Association)와 도쿄 타이프디렉터스클럽(Tokyo Type Directors Club)을 차례로 만들었다. 이들 두 협회가 풀어 가는 전시들과 연감들은 매우 높은 수준이며 일본어에서 로마자 및 한자가 지니는 장점들을 함께 고민하고 고려한다. 이는 한자 디자인에 대한 국제적인 관심을 촉구하는 것이기도 하다. 1980년대 초반, 일본 타이포그래피 연감은 해외 공모도 시작했는데 세 명의 홍콩 출신 디자이너들이 선정되었을 뿐이다. 여기서 1990년대 최우수 디자인 상을 받게 되었음을 나는 다행으로 생각한다. 세대가 흐르면서 이 두 협회가 기획하는 연례 전시들은 점차 인기를 끌었으며 많은 홍콩 디자이너들이 관련 대회에서 좋은 성적을 거뒀다. 지난 20년 동안 일본활자디자인연구 주식회사(Japan Type Design Researching Co., Ltd.)에서는 로마자 및 한자 디자인을 촉진하

kan taikeung

642

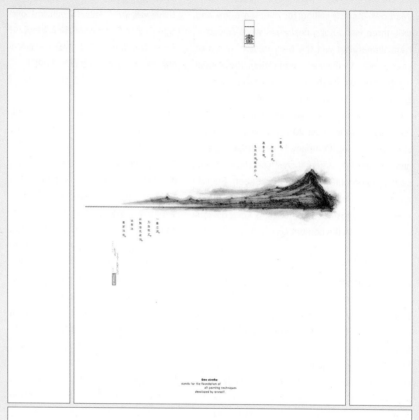

One stroke
stands for the foundation of
all painting techniques
developed by oneself.

book. ten principles of landscape painting. 211 x 300. 2009.

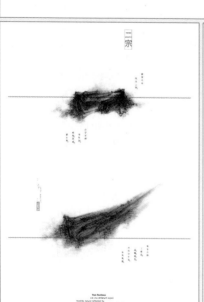

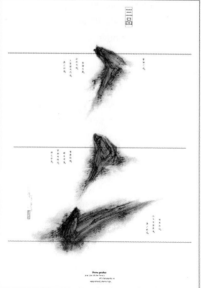

yearbook started calling for oversea entry and only three Hong Kong designers were selected. I am thankful to win the best design award of year in 90s. In the new generation, the annual exhibitions held by these two organizations have become more and more popular; and many Hong Kong designers have great achievements in the competition. In the past 20 years, Japan Type Design Researching Company Limited (株式会社写研) has organized the International Type Design Competition to encourage the creation of both English and Chinese words which is the only Type Design award for Chinese and some Hong Kong designers have won in the competition.

Korean designers are also good at type design. My friend, Professor Ahn Sang-soo is one of the best. Not only has designed an epoch-marking Korean Black Bold called "Ahn" (安體), which is popular in Korea, he is also the curator of the East-Asian Type Exhibition in Seoul ten years ago. Outstanding designers, calligrapher and type designers from China, Japan and Korea were invited to exhibit jointly. Luckily being one of the exhibitors, this experience broadened my view. He also organized a World Type Design Exhibition and published a very important and inspiring feature book about typography. It was my pleasure to be one of few Asian designers being invited. This year, designers from these three countries join again together for other exhibition held by Professor Ahn, which is named 2011 Typojanchi (東亞火花); around hundred of designers exhibited their recent works. In this exhibition, three designers' works from each country were selected to be the feature exhibition in the show. It is an indelible function and always my biggest honor to represent China together with Xu Bing and Lv Jinren.

Being the cradle of Chinese calligraphy, Chinese is mainly used in China. Because of its vast region size, the literacy rate was originally low. However, China is the first country which invents printing press for wider use of words, as well as the first country using linotype typesetting. Italics (楷體)

기 위해 국제 활자 디자인 공모전(International Type Design Competition)을 열었는데, 이 공모는 중국 및 홍콩 디자이너들이 유일하게 상을 거머쥐는 활자 디자인 관련 대회이다.

한국 디자이너들 또한 활자 디자인을 잘한다. 내 동료인 안상수 교수가 그중 최고라고 생각한다. 그는 한국에서 많은 사람들이 좋아하는 획기적인 '안상수체'를 디자인했을 뿐만 아니라 10년 전에 서울에서 열린 동아시아 활자 디자인 전시 〈타이포잔치 2001〉의 큐레이터이기도 하다. 중국, 일본 그리고 한국의 훌륭한 디자이너와 서예가 그리고 활자 디자이너들이 초대되어 함께 전시했다. 운이 좋게도 나는 그중 한 명이었으며 이 경험은 나의 시야를 넓혀주었다. 그는 또한 세계 활자 디자인 전시(World Type Design Exhibition)를 기획했으며 타이포그래피의 중요성과 영감을 주는 전시 도록『Feature Book』을 출판했다. 아시아 디자이너로서 기쁜 일이었다. 올해 다시 한중일 세 국가의 디자이너들이 모여 안상수 교수가 기획한 또 하나의 전시에 참여하게 되었는데, 바로 〈타이포잔치 2011〉이다. 100여 명의 디자이너들이 참여하여 자신의 최근 작품을 선보였으며 특별전에는 각 국가의 두 명 내지는 세 명의 대표 디자이너 작품들이 전시되었다. 이것은 나로선 잊을 수 없는 경험으로서 쉬빙, 뤼징런과 함께 중국을 대표할 수 있었던 것은 매우 큰 영광이 아닐 수 없다.

중국어는 중국서예의 산실이자 주로 사용되고 있다. 중국의 방대한 크기 때문에 사람들의 문맹률은 본래 꽤 높은 편이었다. 하지만 문자를 더 널리 보급하기 위해 인쇄를 먼저 개발한 곳이 중국이었으며 라이노타입 조판을 처음 사용한 나라 또한 중국이었다. 해체(Italics)와 송체는 송나라 때 만들어진 손글씨에서 유래한다. 명나라 때 인쇄 기술이 번창하고 수준이 높았음에도 불구하고 시장 통제로 인하여 인쇄 기술은 침체기를 맞이할 수밖에 없었다. 중국에서는 서구에 대해 공부하는 것이 점차 인기를 얻게 되었으며 보다 더 진보한 인쇄 기술이 유입되기 시작했다. 청나라 때 서구 선교사들이 납으로 된 첫 라이노타입을 주조했다. 하지만 라이노타입을 위한 활자 디자인은 여전히

644

五彩

the colours
are the five hues
revolve from the
use all the and world.

六法

the canons
are the six main concepts of painting
They also represent concepts that
a painting should breathe with life.

book.　　ten principles of landscape painting.　　211 x 300.　　2009.

七情

seven emotions
are the sixteen moods
duly reflected by
the powers in painting.

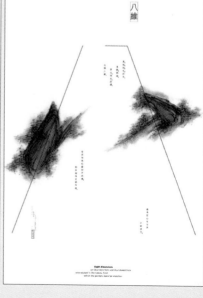

八維

eight dimensions
are four dimensions and four dimensions
encapsulated in the nature, from
which the painters learn for practice.

and Times New Roman (宋體) were derived from the original handwriting early in the Song Dynasty. Although printing press had been flourished and sophisticated in the Ming Dynasty, its development stagnated because of the market's constraint. Western learning has gradually become popular in China and advanced printing technique was introduced. In the Qing Dynasty, western missionaries made the first foundry of lead linotype. However, the font design for linotype was still unrefined and there were only three kinds of font style. It is believed that the history of Bold (黑體) is less than a hundred year. The popularity of words has become higher and higher in the past sixty-year after war; however the printing technology and font design is still not yet fully-developed.

Due to the change of political environment, as well as the discrepancy of social development rate, the conditions of font design and words application in Mainland China, Taiwan, Hong Kong and Macau are varied. Simplified Chinese has been promoted radically in Mainland China in the 50s in which many drawbacks were found. In the 60s and 70s, there were still some exquisite font designs which could be commonly applied in books and newspaper printings as well as the graphic design of advertisement and packaging. Seeing that the advanced typesetting is not yet fully developed, designers followed the New Cultural Movement and created a decorative form of word in hand-writing and hand-drawing.

Modern design develops significantly in the past three decades after the cultural reform in China. The invention of computer helps the digitalization and simplification process of Chinese typesetting in order to avoid Chinese from assimilating in Latin. In the past ten years, digital Chinese font design is developing in China. Founder Group has organized the only competition which is a pure Chinese Type Design Competition. Being the judge of the competition for many years, it keeps a very high standard on its fairness and the quality. It can be understood that creating a full set of

정교하지 못했으며 오로지 세 개의 활자 종류가 있었을 뿐이다. 사람들은 흑체(黑體)의 역사가 100년도 안 된 것으로 믿는다. 전쟁 후 지난 60년 동안 문자의 대중화는 더 빠르게 진행되었다. 그러나 오늘날에도 인쇄 기술과 활자 디자인을 여전히 완벽하게 구현시키지는 못하고 있다. 정치 환경의 변화 및 사회 발전의 불균형 때문에 중국 대륙과 타이완, 홍콩과 마카오에서 활자 디자인의 조건과 문자 향유는 서로 다른 모습을 보이고 있다. 이체(異體)는 1950년대 중국 대륙에서부터 추진되었으나 많은 결점들 또한 발견되었다. 1960년대와 1970년대에는 책이나 신문과 더불어 광고 및 패키지 디자인에도 일상적으로 적용시킬 만한 매우 아름다운 활자들이 있었다. 하지만 더 나은 조판 환경이 만들어지지 않으면서 디자이너들은 신문예운동(New Cultural Movement)에 동참했고 손으로 쓰고 그림으로써 장식적인 문자들을 만들어 냈다.

중국 문화혁명 이후 지난 30년 동안 중국의 현대 디자인은 눈에 띄게 발전했다. 컴퓨터의 발달과 그로 인해 디지털화되고 간소화된 중국어 조판 과정은 중국어가 라틴 알파벳에 흡수되는 것을 피할 수 있었다. 지난 10년 동안 중국에서는 디지털 중국어 활자 디자인을 개발해 오고 있다. Founder Group은 활자 개발뿐 아니라, 중국어를 중심으로 한 활자 디자인 공모전을 주관하며 공정성과 높은 수준을 유지하고 있다. 한 벌의 글꼴을 만들기 위해서는 많은 시간과 비용이 필요한데 이런 이유로 인해 많은 이들이 활자 디자인에 열과 성을 쏟지 않으려는 것으로 보인다. 다행히 대기업들뿐만 아니라 몇몇 디자이너들은 여전히 활자 디자인과 관련 연구에 열정적으로 임하고 있다.

타이완, 홍콩, 마카오에서는 중국 정체를 대부분 사용하고 있는데 이 정체의 발달과 조판 적용 방식은 중국대륙의 것과 거의 흡사하다. 1950~60년대에 이곳 디자이너들은 중국 대륙의 디자이너들과 마찬가지로 손으로 쓰고 그리면서 활자를 만들었다. 1970년대 경제 발전이 대대적으로 이루어지면서 일본에서 건너온 조판 기술(사진식자)이 홍콩에 소개되었다. 형식과 스타일을 떠나 사진식자는 라이노타입보

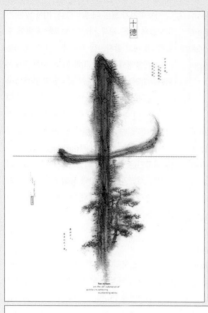

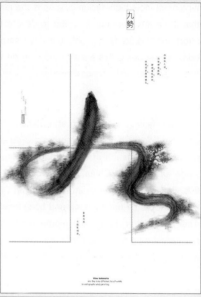

book.　ten principles of landscape painting.　211 x 300.　2009.

type must incur high design cost so is the reason that there are few people willing to devote their efforts on it. Luckily, not only the large corporations, some designers are still working on type design and research enthusiastically.

Although Taiwan, Hong Kong and Macau mainly use traditional Chinese characters, its development and application of typesetting is quite the same as Mainland China. In between 50s and 60s, designers, like those in the Mainland China, created fonts by hand-writing and hand-drawing. After the great economic development in the 70s, the typesetting technique (photographical typesetting) from Japan has been introduced in Hong Kong. No matter its forms and styles, typesetting is much better than the use of linotype. Albeit Japanese companies only provided three font styles for Hong Kong, which is a small overseas market, it becomes dominant in Hong Kong. Limited by the market size, Chinese-font designing company is rare in the region. It is commendable that few designers are still supporting font design. The reason is simply because of their interest. Nowadays, design has been computerized. However, font design is still posing problems before the copyright protection policy and system is completed.

In Hong Kong, we have no professional type association, font exhibition and text design yearbook. However, there are still many font-enthusiasts devoting their time and resources to study and promote Chinese font design. Hong Kong has organized some forums and exhibitions about type in the past few years. Recently, I am excited and pleased to hear that some designers are working on a new line of bold font.

다 사용하기가 훨씬 더 용이했다. 비록 일본 기업체들은 작은 해외 시장에 불과한 홍콩에 오로지 세 개의 활자만을 제공했지만 이 활자들은 곧 홍콩에서 널리 쓰이게 된다. 시장 규모가 제한적이어서 활자 디자인 회사는 홍콩에서 매우 드물다. 이런 상황에서도 아주 적은 수의 디자이너들이 여전히 활자 디자인을 지지하고 있다는 점은 칭찬하지 않을 수 없다. 이들이 이렇게 하는 이유는 개인의 관심사 때문이다. 오늘날 디자인은 컴퓨터화되었다. 하지만 활자 디자인은 저작권 보호 정책 등이 아직 완벽하게 자리 잡지 못한 상태에서 여전히 문제점을 안고 있다.

홍콩에는 전문적인 활자 관련 협회, 전시회 및 편집 디자인 연감을 찾기 힘들다. 하지만 중국 활자 디자인을 연구하고 확산시키고자 열성을 다해 자신의 시간을 할애하는 많은 활자 지지자들이 있다. 지난 몇 년간 홍콩에서는 활자와 관련된 몇 개의 포럼 및 전시들이 있었다. 최근 나는 몇몇 디자이너들이 볼드체(Bold Font) 시리즈를 디자인하고 있다는 소식을 듣고 매우 흥분되고 기뻤다.

kan taikeung

648

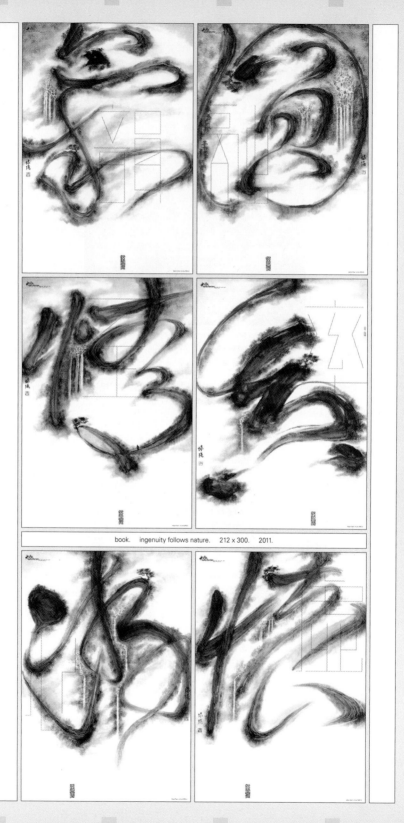

book. ingenuity follows nature. 212 x 300. 2011.

Lv Jingren was born in Shanghai, China, in 1947. He served on the editorial committee and was senior art editor for the China Youth Publishing House. During the 1990s, he studied with designer, Prof. Sugiura kohei of the College of Art Engineering in Kobe, Japan. In 1998, Lv Jingren established 'Jingren Art Design Studio'. He is currently professor of Academy of Arts and Design, Tsinghua University and guest professor at the Central Academy of Fine Arts. He is the member of AGI. Works of editing, translating, authoring and designing include *Theories by 4 Book Designers, Jingren Book Design, Jingren Book Design No.2, From Book Binding to Book Design, Hiking in the Space of Book Design, Flip: Chinese Contemporary Book Design, Tao of Book Design, Lv Jingren Bookdesign Courses, A Play of Book: 40 Contemporary Chinese Book Designers* and so on. His works awarded 'Lifetime Achievement Honorary Award of the first session of Chinese Designer Competition', 'the 4th Chinese Exhibition of Bookbinding and Design', 3rd National Book Design Research Exhibition, Hong Kong Print Awards, Best designed books from China, National Book Awards, the Best Designed Book from The World, and so on.

china 1947- 뤼징런.呂敬人.

lv.jingren.

1947년 상하이 출생이다. 1978년부터 중국 청년출판사에서 편집위원 및 수석 아트 디렉터로 일했다. 1989년 일본으로 건너가 디자이너 스기우라 고헤이의 지도를 받은 뒤 1998년 베이징에서 징런디자인공작실을 열었다. 현재 칭화대학 미술학원 교수이자 석사과정 지도교수이며, 중앙미술학원 객원교수, 한국 아시아 크리에이티브 아카데미(Asia Creative Academy) 객원교수, 국제그래픽디자이너연맹(AGI) 회원으로 활동하고 있다. 저서로『4인이 말하는 북 디자인』,『징런 북 디자인』,『징런 북 디자인 2호』,『장정에서 북 디자인으로』,『북 디자인의 성공에서 회유하다』,『중국 당대 북 디자인/뒤집다』,『북 디자인의 도에 관하여』,『뤼징런 북 디자인 교과서』,『책의 놀이: 중국 현대 북 디자이너 40인』등이 있다. 전국 책장정예술전 금상, 전국 책장정예술논문 금상, 홍콩 프린트 어워드, '중국에서 가장 아름다운 책' 선정, '세계에서 가장 아름다운 책' 선정, 국제 제도대회(ICC) 도시류지도 금상, 중국 출판정부상 등 다수의 상을 수상했다.

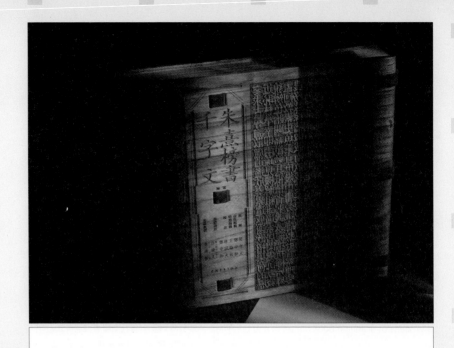

book. calligraphy of zhu xi. 350 x 530. 1999.

lv jingren

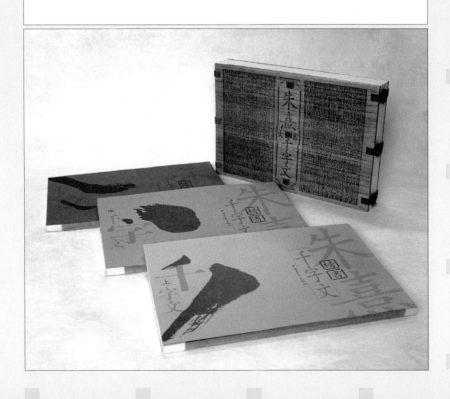

Editorial design and my philosophy on book design.
편집 디자인 – 나의 북 디자인 철학

lv.jingren.

뤼징런.呂敬人.

Edit and design, which can be explained under the term of 'editorial design', make up the most important part in my book design philosophy. Editorial design as a process of both editing and designing is a part of book, design book binders of the past did not use to pay attention to and writers and editors did not even take into account. It was a part of book design left untouched. Editorial design is a process of introducing the concept of design; it is a process of scanning book contents and bringing up a subject of the book by visualizing the book structure and setting up a reading system. At the same time, it is about presenting the most effective form of communication in order to meet the need for good information delivery and aesthetic demands.

And it is this task that a book designer needs to perform. Adding some painterly or decorative elements is not enough. For a book designer, it is necessary to grasp the knowledge of various media other than the visual language of a book. In fact, a book designer needs to know the very purpose of book design and understand the structure of the book just as a film director works out with his scenario. In addition, s/he needs to know that book design is not about making the look of the book beautiful. It is imperative we change our way of thinking of a book designer from a mere decorative artist to an information designer.

However, editorial design does not only rest on merely laying out the texts. The editor should not be a proofreader; s/he needs to understand the characteristics of today's media and visual communication. In this respect, not only the eye for the aesthetic and knowledge about various genres but also an open attitude for embracing the variety

편집 디자인은 북 디자인 철학 중 가장 중요한 부분이다. 이것은 과거의 장정(裝幀)가들이 미처 관심을 가지지 않은, 글 쓰는 작가와 책임 편집자가 침범할 수 없는 영역, 일종의 참견이었다. 편집 디자인은 북 디자이너가 적극적으로 책의 내용에 대해 시각화하는 디자인 관념을 권장하는 일종의 도입, 즉 작가, 출판인, 책임 편집, 인쇄 기술자 등이 책의 내용을 선택하는 과정 혹은 내용 선택 후 그 주제에 대해 심도 있게 내용의 '읽기 형태'를 토론하고 시각언어의 각도에서 디자인할 책 내용의 구조와 시각적 보조 시스템을 구축하는 것이다. 동시에 내용의 정보전달의 완성도를 결정하고, 독자가 쉽게 받아들이고 읽는 행위를 즐길 수 있는 외양과 정신을 겸비한 형태적 기능의 방법과 대책에 대한 요구이다.

이것은 마땅히 북 디자이너가 제시해야 할 더 높은 요구이다. 약간의 회화적 요소나 장식의 가미로는 모자라다. 또한 책의 시각언어 외의 새로운 매체 등 경계를 허문 지식의 보완이 필요하다. 마치 영화 감독처럼 극본의 창작의도와 구조를 이해하는 방법을 터득해야 하고, 책의 외형적 아름다움만을 위한 북 디자인 행위를 재고해야 하며, '정보 디자인 예술가'로서의 역할적 전환이 필요하다.

하지만 또 다른 방면으로 편집 디자인은 결코 문자의 편집적인 기능만을 대체하는 것이 아니다. 책임 편집자 또한 이와 같이 단순한 교정의 측면에서 그치면 안 되며, 현재와 미래의 열람(閱覽) 매체가 가지고 있는 특징과 점점 시각화되는 현재의 정보전달 특성을 이해해야 한다. 심미 능력과 여러 영역을 아우르는 지식은 물론, 정보전달의 예술적 형식의 다양성을 흡수하고, 주동적으로 창조적인 방안을 건의하고 구상할 수 있어야 한다. 이 과정을 수행하기 위해서는 디자이너와 편집인의 암묵적인 협력이 필요하

lv jingren

book. the story of paper-cut. 185 x 250. 2011.

of artistic forms in visual communication and being a leader in paving the road for a new creative methodology are required. In order to carry this out, a mutual understanding and cooperation are needed between a designer and editor, which is the way to a good book. Neither side can be regarded as something separate. Behind a good edition, there is always a cooperative work of good editing and design. This is what Sutaixi (Professor of Nanjing Arts University, Creative Director of Jiangsu Literature and Art Publishing House), a renowned Chinese book designer tried to tell us by saying, "Book design is the second main cultural factor in book."

The process of editorial design is about getting into the essence of book design, which is the purpose of reading, by thoroughly understanding the text and applying the design concept of the book. The true purpose of editorial design lies in delivering the book contents in a most accurate way by expanding the message and enhancing the value of the contents; that's what the editorial design exists for. The role of a book designer is not to make a beautiful book cover and form. Rather, it is the responsibility of a book designer to make a visually unique and rhythmical structure, which makes a book worth for appreciating and reading. The capability of a book designer, thus, can be measured by to what extent s/he can freely manage the level of quality and understanding of reading.

My book design philosophy has evolved over the years from "book binding" into "book design". At the beginning, lots of things around book design were ambiguous. However, with accumulated practice and learning in the field, I have come to realize that publishers and editors were as much idealistic and hopeful as book designers. It's good to see how designers and editors are finding more subjects of common interests. And these days, I feel a certain cultural trend in China of understanding and supporting creative minds of designers and editors.

During the last few years, I have made friends

다. 이러한 탓으로 시각 정보와 문자 정보가 서로 협력해야만 한 권의 좋은 책이 탄생할 수 있는 것이다. 그 어떠한 것도 따로 떨어뜨려 생각할 수 없다. 합격한 편집에는 반드시 우수한 감독과 우수한 북 디자인의 공동 창작가가 존재한다. 중국의 저명한 북 디자이너 쑤타이시(난징예술대학 교수, 강소문예출판사 스튜디오 주임)가 "북 디자인은 책의 두 번째 문화적 주체이다." 라고 말한 것이 여기에 해당한다.

편집 디자인의 과정은 문자의 깊은 이해와 더불어 책의 디자인 언어 개념을 주입시켜 북 디자인의 본질(읽기의 목적)을 완성하는 것이다. 편집 디자인의 진정한 목적은 책 내용의 정확한 전달에 있다. 내용 정보의 전달을 확충하고, 내용의 진정한 가치를 높이는 것이야말로 편집 디자인이 해야 할 일이다. 우수한 북 디자이너는 그가 얼마나 아름다운 표지와 형태를 만드는가에 달려 있는 것이 아니라, 다른 사람이 미처 생각지 못한, 천천히 음미할 수 있는, 구조의 시각적 독특함뿐 아니라 리듬이 있는, 다시 말해 독서가치가 있는 책을 만들어 내야 한다. '品(품평하다)'과 '度(도량)'의 의미를 얼마나 자유롭게 운용할 수 있는가, 그것이 북 디자이너의 역량을 나타낸다고 본다.

나의 북 디자인에 대한 관념 또한 '장정'에서 '북 디자인'으로 바뀌는 과정에서 서서히 체득해 온 것이다. 모호한 것에서부터 뚜렷해지는 학습과 실습의 과정에서 출판인과 편집자들의 마음은 사실 더 높은 이상과 기대를 품고 있다는 것을 알았다. 디자이너와 그들은 통하는 점이 점점 늘어나고 있다. 이로 인해 창작 열정을 가진 사람(디자이너 혹은 편집자)을 응원하는 풍조가 서서히 생기고 있다.

몇 년 동안 나는 수많은 출판사의 사장, 책임 편집자, 편집인들과 좋은 친구로 사귀어 왔다. 왜냐하면 공통의 이념 아래 북 디자인의 전 과정에 참여하는 것에 누가 누구의 말에 복종해야 한다는 규칙 따위는 존재하지 않기 때문이다. 서로 토론하고 상호 이해하며, 공통으로 책의 아름다움을 창조하는 과정에서 책에 남다른 애착이 생기며, 서로가 온 힘을 다해 노력하는 열정이 책을 제작하는 제작자들과 공예가들에게 전염되어 최종적으로 모두가 다 함께 공동으로 한 권의 아름다운 책을 만들 수 있는 것이다.

654

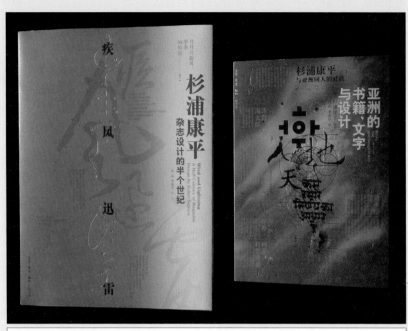

book. books, text and design in asia. 150 x 210. 2006.

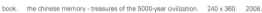

book. the chinese memory - treasures of the 5000-year civilization. 240 x 360. 2008.

with a number of publishers and editors. Sharing the common book design philosophy, there was not a hierarchical working system in the book design process. By discussing and mutually understanding each other and thus, creating the beauty of the book all together, everyone participating feels a strong affinity to the book, and this positive energy even affects the manufacturers and book artists, which results in a beautiful book in the end. Today, a number of publishers, editors and writers keep coming to my office with a bunch of manuscripts. They know how to suggest a clear editorial concept and are ready to discuss the beauty of the book with me. In fact, they respect book designers and at the same time, understand the value of the job as a book designer.

lv jingren

In the following, I have introduced some of my latest works where my concept of editorial design was well reflected.

Complete Works of the Actor Mei Lanfang

(China Youth Publishing Group, 1996)

By the time the client asked me to do this job, there was nothing but about 500,000 Chinese characters. No images at all. However, after several meetings with the editor, the original contents became much richer by adding some one hundred photos with the support of the writer and editor-in-chief. Also, one could add another dimension to the book through four-edge printing. Thus, the book could be enjoyed from two perspectives by either reading from right to left or from left to right, the one showing Mei Lanfang's real life and the other showing his life on stage, which represented the actor's double life. Due to the long editing process, the book could not be published on time. However, it was worth it. After it came out, the book was celebrated by a number of Chinese

오늘날 사무실에 원고를 가지고 회의하러 오는 여러 출판사의 사장, 편집자, 편집장, 혹은 작가들이 자신의 편집 방향을 제시하고, 책의 아름다움을 토론하고자 하는 이들이 늘고 있다. 이들은 북 디자이너를 존중함과 동시에 북 디자이너가 하는 일의 노동가치를 이해하고 있는 사람들이다.

아래 글은 본인 스스로의 편집 디자인 개념을 응용한 작품의 후기들이다.

『매란방 전집(梅兰芳全传)』

(중국청년출판사, 1996)

최초 의뢰가 들어왔을 때는 글이 50만 자에 사진 한 장 들어 있지 않은 상태였다. 이러한 것을 편집자와 디자인 회의를 거친 후 저자와 책임 편집자의 열렬한 지지로 100장에 가까운 사진을 첨가해 내용을 더욱 풍부하게 할 수 있었다. 또한 책의 형태 구상 중 책의 배면에도 인쇄를 하여 입체적인 책이 탄생하게 되었다. 독자들이 오른쪽, 왼쪽으로 책을 넘기는 과정에서 매란방의 무대 위 모습과 평소의 모습이 생동감 있게 교차해 보이면서 매란방이 살아간 인생의 두 가지 무대를 상징적으로 보여주고 있다. 비록 편집 과정에서 시간이 많이 걸려 출판시기가 연기되는 해프닝도 있었지만, 이 책이 출판된 후에 매란방의 가족들과 저자를 포함한 많은 사람들의 사랑을 받아 중국도서상을 받았다. 결국에는 사회적·경제적 이익이라는 두 마리 토끼를 잡을 수 있었던 것이다.

『회주아집(怀珠雅集)』

(화북교육출판사, 2003)

한 질의 책으로 5명의 화가의 장서표(藏書票) 작품집이다. 출판사의 편집자가 처음 원고를 가져왔을 때 작품집과 같은 형식으로 만들 예정이었다. 하지만 당시 나의 생각으로는 현대인들의 장서표에 대한 이해가 점점 줄어들고 젊은 사람들의 책 문화에 대한 인식과 관심이

book.　　painting of he youzhi.　　175 x 260.　　2011.

readers including Mei Lanfang's family members and author and it even had the honor of being given the Chinese Book Prize. In the end, the book was a success in both social and economic perspective.

Florilegium of Book Labels
(Hebei Education Press, 2003)

This series of books are five volumes of book labels collections by five artists. When the editor first came to me with the manuscript, he had a simple illustrated book in his mind. But I had a different opinion. As people of modern society don't know much about book labels, the book if coming out in a form of illustrated book would only have a limited readership. So I suggested to include critical essays by a famous scholar who would be able to explain about the aesthetic function of reading, library and book labels on every single page in each volume. In this way, not only the contents but also the topic of the book could be elaborated and the meaning of the book labels cleared. Finally, an editorial team was set up specializing in collecting and editing book label-related materials under the direction of Zheng Yi Gi, the master of editing. The book itself was an experiment in every aspect of form and contents. As soon as it was published, it attracted public interest and became even popular as a collectible item and gift. Of course, it sold fairly well.

Green Tea, Oolong Tea, Black Tea
(Chinese Light Industry Press, 2006)

This series of books, which can be categorized as cultural books, are about various Chinese tea such as green tea, oolong tea and black tea. At first, the publisher wanted to make an easy-to-handle guidebook. However, as I met the author and talked about Chinese tea over time, I was very much impressed by the author's deep affection for tea. So I came up with the idea of making a book, not in a form of a mere "product" but as a work of art, hoping that the book would contribute to introducing Chinese tea culture. It was my own respect for Chinese culture as well. Since I and the author had much in common in terms of editorial concept, we tried persuading the publisher to

얕아지고 있었기에, 독자층은 한계가 있을 것이라 생각했다. 화가의 작품만으로도 물론 좋았겠지만, 만약 유명한 학자의 독서, 장서, 장서표의 심미기능에 대한 평론이나 문장의 일부가 편집 과정에서 5권의 책에 매 페이지마다 들어간다면, 책의 내용뿐만 아니라 주제가 더욱 명쾌하고 풍부해지며, 장서표의 창작의의 인증과 보완될 점이 많다고 생각했다. 그리하여 이 책을 위한 전문 편집팀이 편성되어 편집의 대가 정이치 선생의 지휘 하에 많은 양의 자료를 수집 및 편집하는 작업을 거쳤다. 이 책은 책의 형태와 내용면에서 모두 그 전에 없던 새로운 시도였다. 출판되자마자 대중의 관심을 받으며 독자들의 수집품과 선물로도 인기가 있었다. 판매 부수가 좋았던 것은 당연지사다.

『영운천성(灵韵天成)』,
『온방함향(蕴芳含香)』,
『한정아질(闲情雅质)』
(중국경공업출판사, 2006)

각각 녹차, 우롱차, 홍차를 소개하는, 일종의 차(茶)에 관한 교양서이다. 출판사에서 처음 타깃 층을 정할 때는 패스트푸드와 같은 소비가 빠르고 상업적인 책자를 만들 생각이었다. 하지만 작가와 만나고, 중국 차에 관한 여러 가지 이야기를 하다 보니, 작가의 차에 대한 깊은 사랑에 감동을 받아서 만들어질 책의 성격이 상품이라기보다는 작품과 가깝게, 책에서 중국의 차 문화를 느낄 수 있게 만들어야겠다고 마음 먹었다. 이것은 중국 문화에 대한 존중이기도 하다. 또한 편집 의도가 작가의 생각과 일치하는 점이 많아 출판사와 함께 문화와 시장, 자본과 책의 가치에 대해 반복하고 또 반복해서 강조하고 토론한 끝에 출판사의 동의 하에 만들어졌다. 책 전체의 분위기가 완전히 뒤바뀐 것이다. 우아하고 담백한 북 디자인 언어로 책 전체의 리듬과 구조를 서술하고, 주제를 설명한다. 녹차, 우롱차 두 권의 책은 전통적인 바인딩 방식을 이용했고, 본문은 포배장(책 장정 종류의 하나)으로 그 속에 찻잎의 일부를 인쇄해 넣어서 속에 인쇄된 찻잎이 연하게 비쳐 보이게 하여, 책을 읽는 과정에서 독자로 하여금 차의 은은한 향기를 느낄 수 있도록 했다. 반대로 홍차 책은 앞의 두 권과는 다르게 바인딩과 본문 디자인을 서양의 방식으로 디자인하여 영국식 차 문화를 느낄 수 있게 했다. 전 권의 책에는 그 어떤 튀는 장식이나 일부러 꾸미는 듯한

lv jingren

book. florilegium of books labels. 140 x 180. 2003.

agree with our concept, discussing, emphasizing and repeating the value of culture and market as well as the value of the money and book. And we made it. The whole concept of the book changed. The book design of the book made the book full of rhythm and solid in its structure and topic. The book on green tea and oolong tea were bound in a traditional way. On some pages inside, parts of the tea flowers were printed translucently so that the reader could see the flowers and appreciate the delicate smell of the tea. On the other hand, in the case of the book on black tea, the book was bound in Western style and so was the inner layout. The reason was to make the readers feel the British tea culture. Overall, none of these books had any superfluous decoration. But the readers could feel how every single part of the book was edited and designed with care. The publishing company of the book could demonstrate a new kind of book concept that it had never had before. Although the price of the book got higher than expected, the value of the book will compensate the profit the book might have brought.

Ukiyo-e

(Hebei Education Press, 2008)

The author of the book is a researcher on Japanese art. When he first came to me with his thesis on Ukioy-e art, he was ready to talk about the design and layout with me. Then, something popped up in me; the fact that Ukiyo-e was an expression of everyday life of the Japanese lower class. In the background of Ukiyo-e painting lies the daily life of Japanese lower class. The subject, surroundings, customs are still well preserved up until now. So I suggested to show Japanese customs in two contexts; in the context as depicted in Ukiyo-e and of today's life. If the customs from the past are read in today's context, young readers including people of modern society might approach it with more curiosity, and it might also act as a meaningful documentary in terms of academic research. The author flew back to Japan in order to collect photographic data based on the revised editorial concept. I also helped the author providing him with photos that I had taken in Japan. In the end, the book became much more

디자인을 하지 않았으나, 독자로 하여금 책의 그 어떤 곳에서도 성실히 디자인한 인상을 남겨주기에는 충분했다. 이 책을 출판한 출판사는 그 전에 없었던 책의 면모를 새로이 보게 되었다. 비록 책의 가격은 처음 예상보다 조금 더 높아졌지만, 책의 가치는 물질적 이익에 상응하리라 본다.

『우키요에(浮世絵)』

(화북교육출판사, 2008)

일본 예술을 연구하는 학자가 나에게 우키요에 예술에 관한 연구 논문을 가지고 왔을 때 표지나 레이아웃 등의 작업에 대한 시간 제한을 두지 않았다. 마침 우키요에가 서민들의 일상생활을 표현한 것임이 기억나 바로 작업을 진행했다. 우키요에는 내용과 형식이 모두 일본의 서민 생활을 담은 회화이다. 회화 표현 중의 주제, 환경, 민생, 풍속 등이 오늘날에도 거의 완벽히 보존되어 있다. 그래서 편집 과정에서 현재 남아 있는 풍속의 모습과 우키요에 회화 속의 모습을 독자들에게 교차해서 보여주고 싶었다. 역사 속 유물에서만 보던 풍경을 지금의 생활과 대조한다면, 젊은 독자들로부터 호기심을 유발시키고 현대인에게 좀 더 흡인력 있는 책이 될 수 있으며, 연구학술의 관점으로도 상세하고 엄격한 논거를 제시할 수 있기 때문이다. 이 방안을 제시 한 후 작가는 다시 일본으로 날아가 원고의 내용에 의거해서 다시 사진 자료들을 수집하기 시작했다. 본인 또한 과거 일본에서 찍었던 사진 자료들을 살펴 작가에게 제공하여 이 책의 표정을 더욱 풍부하게 만들었다. 작가는 이런 새로운 편집 요구가 가져온 결과에 굉장히 감사했다. 이 경험을 바탕으로 작가는 새로운 원고를 쓸 때마다 어김없이 나의 사무실을 찾는다. 당연히 시간은 넉넉히 두고, 편집의 방향과 스타일을 의논하며, 편집에 대한 새로운 생각을 요구한다.

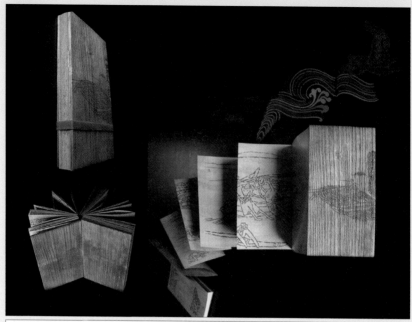

book. yellow river. 200 x 380. 2005.

lv jingren

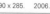

book. flip: chinese contemporary book. 190 x 285. 2006.

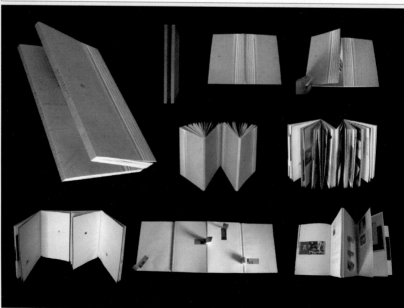

"colorful" than it was first thought, and the author thanked me a lot for what had become thanks to the revised editing. Since then, the author always visits me first whenever he conceives something new. Of course, he always gives me plenty of time to think about and discuss with me about the possible revision in editing and style.

Books such as *The Chinese Memory – Treasures of the 5000-year Civilization, Elegant Article in Sleeve – The Pieces Folding Fan of Suzhou , The Beauty of Opera, Dashiyecongshu and A Play of Book* were made with success, and they were outcomes of my sincere attitude and philosophy on editorial design. However, they were not my individual outcomes; rather, they were the results of a cooperative energy of the publisher, editor, printer and designer which made such books possible. These days, still a number of editors end up with giving some comments in manuscripts and think their works are done. There are even editors who think responding to my emails would do enough. Making a book is a cultural activity. Without deep understanding for the book and sincere interaction and communication with a book designer, the editor's aim for a good book will never be realized, nor will s/he be able to feel devoted to book. Making a book enclosed in one's office means giving up making a good book, and this is also relevant to design. A designer might be able to make eye-catching book covers with fancy decoration but in most cases, it can end up with a mere show off without getting into the essence of the book contents. No wonder that a book having gone through a process as such will never gain any respect. It will rest low-rate.

Book design is not just about designing the cover and the inner layout. A complete change of mind and attitude around book design is needed. The difference of book design from binding is that

나의 편집 디자인 철학은『중국기억(中国记忆)』,『회수아물(怀袖雅物) - 수저우의 부채』,『아름다운 경극(美丽的京剧)』,『대시야총서(书戏)』,『A Play of Book』 등의 책에서도 발휘되어 좋은 성과를 거두었다. 이것은 개인의 능력이 아닌, 출판인, 편집자, 인쇄소, 디자이너가 서로 협조하여 낳은 공통의 성과이다. 요즘 적지 않은 책임 편집자들은 원고에 아무 의미 없는 몇 마디를 적어 보내면서 자신의 책임을 다했다고 생각한다. 심지어 어떤 편집자들은 만남은 고사하고 이메일이라도 회신해주면 감지덕지인 경우가 많다. 책을 만드는 것은 문화적 행위이다. 책에 대한 이해, 작가의 스타일과 자신의 요구는 필히 북 디자이너와의 깊은 교류와 소통의 과정에서 더욱 견고해지고 이 과정에서 만들고자 하는 책에 애정을 쏟을 수 있으며, 이로 인해 한 권의 좋은 책이 탄생할 수 있는 것이다. 사무실 안에서만 편집을 한다는 것은 좋은 책 만들기를 포기하는 것과 같다. 같은 의미로, 디자인도 마찬가지이다. 겉으로 화려하여 사람의 눈길을 끄는 표지 디자인밖에 하지 못하고 저자, 편집자 등과 함께 원고 본연의 숨은 뜻은 찾아내지 못한 채 겉치레에만 치중한다면 북 디자인에 대한 편집 방향과 창조적 건의는 고사하고 영원히 낮은 단계에서 벗어나지 못할 것이다.

북 디자인의 개념을 표지, 레이아웃만 디자인한다는 것에서부터 그 사고방식이나 수단 등을 바꿔야 한다. 북 디자인과 장정의 가장 큰 차이점은 디자이너가 시각언어로 원고의 내용 정보를 구조적으로 디자인한다는 것이다. 내용(정보)의 더 나은 전달력과 창의적 집행능력이 필요하며, 심지어는 그 책의 제2의 저자라고 생각할 수 있어야 하는 것이다. 이것은 과거 출판사의 아트 디렉터와는 또 다른 영역이다. 하지만 우리는 마땅히 시대적인 요구와 정보매체의 시각화 전달 특징을 이용하여 디자인 작업에서의 주동적 의식과 작업범주를 넓혀야 할 것이다. 북 디자이너는 이러한 책임감과 직업적 자질을 가지고 있어야 한다.

북 디자인 중에는 편집 디자인, 레이아웃 디자인, 장정 디자인 세 가지가 포함되며, 이 세 가지가 동시에 맞물려 굴러가게 되어 있으며, 절대로 하나가 빠져서는 안 되며 다른 장르, 기능, 생산비, 독자 등 각기 다른 구성 요소들에 의해

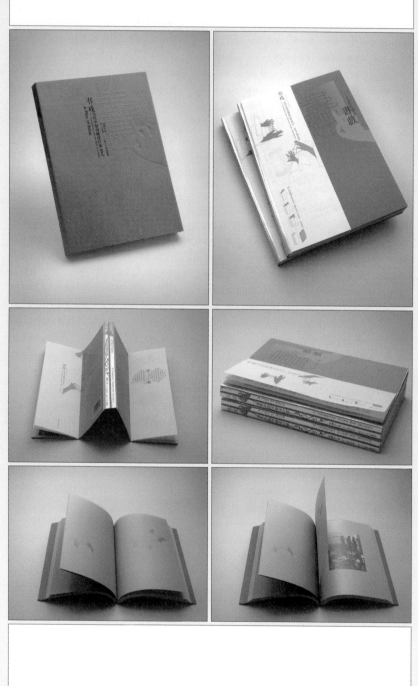

lv jingren

book.　a play of book -40 contemporary chinese book designers.　185 x 260.　2007.

the designer visualizes the contents of the book in an informative and structural way. Thus, the designer should be capable of delivering the message in the most visually effective way and be an art director at the same time. This is the reason why we can even think of a book designer as the second author of the book. And this is different from the art director model in many publishing companies in the past. Designers need to meet the needs of the times and grasp and use the characteristics of today's visual communication models, which means taking the lead in book making and understanding the design process in a much broader spectrum. This is what today's book designers should be responsible and talented for.

Book design includes editorial design, layout design and binding. These three factors in book design make up the whole book design process. And it's the genre, function, money, or the readership that determine the book design. However, there are cases in which the three factors cannot be met. For example, in case of designing books for philosophy and literature, publishers often commission the book cover design only since the contents are text-based (or due to the limited time and money), and in most cases the cover design usually will do. When I was commissioned to design a dictionary called *Cihai*, I dedicated myself to the book cover design and selection of the material only since it was already good in its layout and editing. And on the colophon, I made my job clear by using the term "book binding" instead of "book design". In the same sense, in *The History of Chinese Press* I used "book cover design". There are also cases, where the pages are already laid out and editors add pictures or texts. I then give my opinions on the paper and printing only, which in fact is the job of a book binder. But overall, the book design entails a process of giving ideas on the book concept in general and structurally visualizing the contents and lastly, binding the book, which are the three factors and steps of book design.

With the age of technical development and the social needs, designers also tend to become

디자인을 결정 짓게 된다. 하지만 디자인 과정에서 이 세 가지를 다 못 지키는 경우가 발생하기도 하는데, 예를 들어 철학, 문학류 등의 책은 문자가 주체가 되어 정보를 전달하기 때문에(혹은 시간, 생산비의 제약으로 인해) 출판사들이 가끔 책의 겉옷만 위탁을 해오는 경우가 있다. 그래서 이런 경우에는 책의 장정 디자인의 단계만으로도 충분하다. 『사해』(辞海: 단어와 각종 영역의 어휘를 수록한 종합적인 대형 사전)라는 사전 의뢰를 받았을 때 이미 내용이나 레이아웃 부분에서는 더 나은 시스템이 나올 수 없기에 표지 디자인과 재료 등의 선택에 더 많은 노력을 기울였다. 그래서 책의 판권에 북 디자인이 아닌 '장정 디자인'이라고 표기했다. 또한 『중국출판통사』는 표지만 디자인하여 판권에 '표지 디자인'이라고 명시해 두었다. 어떤 경우는 원고의 레이아웃이 있지만 이것은 단지 심미적 측면에서 틀을 하나 만들어 두고, 여기에 다른 편집자들이 텍스트나 사진을 넣는 작업을 한다. 그 후에 표지의 종이 재질이나 인쇄 기법에 대해 의견을 내는데, 이것은 장정 디자인의 범위에만 들어가는 것이다. 하지만 어떤 원고에 대해 전 방위적으로 의견을 제시하고 책의 시각화 정보전달에 대한 구조와 디자인에 개입하는 동시에 편집 디자인과 장정 디자인, 즉 위에서 예로 들었던 몇 권의 책의 디자인 과정이 바로 북 디자인의 3단계 과정이다.

시대의 발전, 사회의 요구와 함께 디자이너들도 차츰 편집 디자인에 대한 의식이 능동적으로 변화하고 있다. 각기 다른 주제에 맞추어 주제에 영향을 주지 않는 범위에서 시각 정보전달의 전문적인 관점으로 당당히 자신의 의견을 밝히고 다른 이들과는 차별화된 역할을 수행한다.

중국에서는 아주 오래전, 고대부터 발달한 서적 예술과 서권 문화(书卷文化)가 있어왔다. 북 디자인 또한 오늘날의 신흥 영역이 아니다. 〈제5회 중국 북 디자인전〉에서는 표지 디자인, 레이아웃 디자인, 책의 총체적 디자인, 삽화 디자인의 영역으로 나누어 심사를 했는데, 이때부터 '책의 총체적 디자인' 즉 편집 디자인의 중요성을 인정받았다고 할 수 있다. 그럼에도 불구하고 그 당시에는 평면의 기준으로 아름다움을 평가할 뿐이었다. 북 디자인이 원고 정보의 시각적 전달과 편집 디자인 이념에 개입한 것은 책의 읽기 행위를 더욱 명료하고 유효하며 아

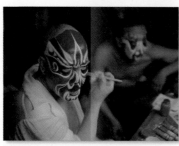

lv jingren

book. the beauty of opera. 165 x 245. 2007.

the new driving force in editorial design. These designers have been demonstrating a differentiated, new model of book designer with clear and professional view on visual communication.

There has been a long tradition of book art and book culture in China since the ancient time. Book design, thus, is not a new genre of today. In the Fifth National Exhibition of Chinese Book Design, books were screened, categorized into cover design, layout design, total book design and illustration, and it was since this exhibition that the importance of editorial design, the total design of the book, got attention. However, the beauty of the books was still evaluated in terms of layout and composition. Book design, which is the act of visualizing and editing the book contents, in the end makes reading activity clearer and more beautiful. The early concept of book design started out with book binding. And now, the ultimate purpose of book design lies nowhere but in the immaculate delivery of the book contents.

The art of Chinese book design is changing and developing. Book design in China does not only keep the tradition of good book culture but also expand the sphere of Chinese book art by creatively meeting the social needs. The digital age of the 21st century has brought a change to the traditional communication model. People receive information from the screen and it has become the everyday life. In this respect, it is imperative to ask the question how the traditional book medium should respond to this social change. We all need to keep a constant philosophy of design. And we need to get rid of the idea that book design is about mere decoration. Designers should always be able to co-work with authors, publishers and editors with open-mindedness and firm belief in oneself.

As the saying of the artificers "Good material and technology come if heaven's will and earth's energy meet" goes, only the perfect harmony and explorations of metaphysics and physical science will keep the brilliant glory of contemporary Chinese book design long.

lv jingren

름답게 만드는 것이다. 북 디자인의 개념은 장정 디자인에서 나와 발전한 것이다. 북 디자인 개념의 진정한 목적은 완벽한 정보를 전달하는 것이다.

중국의 북 디자인 예술은 진보하고 있다. 우수한 출판 문화를 이어 나가는 일뿐만 아니라, 시대의 요구에 발맞춰 창조적 작업을 해나가는 동시에 중국 서적 예술의 영역 또한 넓혀가고 있다. 21세기 디지털 시대는 사람들의 전통적인 정보수신방식을 바꿔 놓았다. 사람들은 '모니터 정보'를 보게 되었고, 일종의 생활 습관으로 자리 잡았다. 전통적인 책이라는 매체가 어떠한 방식으로 대를 이어 나가야 하는가? 우리 모두는 당연히 변하지 않는 디자인 철학을 가지고 있어야 한다. 또한 나아가 책의 겉모습만 치장하는 단계에서 벗어나야 한다. 디자이너는 저자, 출판인, 편집자 등 창조적 사고와 자신의 소신을 가지고 서적예술의 원대한 꿈을 꾸고 있는 이들과 함께해야 한다.

'천시(天时), 지기(地气), 재미(材美), 공교(工巧)', 중국의 공예기술 고서(古書)『고공기(考工记)』의 첫 번째 문장에서 알 수 있듯이 형이상과 형이하의 완벽한 조화와 탐구가 중국 북 디자인의 영광을 재현할 수 있을 것이다.

666

마지막으로 국제적으로 저명한 북 디자이너 스기우라 고헤이 선생의 말을 인용하며 이 글을 마무리하려 한다.

사람은 모두 두 발로 걷는 동물이다. 또한 남이 걸으면 걷고, 남이 뛰면 뛴다. 이것은 인간이 전진과 발전을 할 수 있는 동기이다. 만약 걸음을 걷는 중 앞서 디뎠던 발이 땅에 닿지 않으면 다음 걸음을 앞으로 옮길 수 없다. 앞서 내디뎠던 발걸음은 풍부한 역사와 전통 문화라는 대지 위에 있는 것이 아니겠는가? 진화와 문명, 전통과 현대의 두 발이 서로 번갈아 가며 내디뎌야 성큼 앞으로 나아갈 가능성이 생긴다. 다

book.　the chinese ancient poem.　210 x 290.　2009.

lv jingren

Lastly, I will wrap up my essay here by quoting the internationally renowned book designer Sugiura Kohei.

Human beings walk on two feet. They walk when others walk, and run when others run. It's the motivation of human progress and development. Advancing forward means taking one step and another. There is no step that is not made upon the Mother Nature of long history and traditional culture. Progress and civilization are realized based on the harmonious correlation between the tradition and the present. And so, behind an artistic energy and creativity, there are the cohesion of diversity and the meeting of the West and the East, of the tradition and the present.

Starting out from binding, editorial design has made an important step forward in book design. It's a meaningful challenge to make the book contents more distinguished by using the visual language of a designer. And it is the key design sense that Chinese book design should inherit and create. Last but not least, editorial design is the very act of making people read and feel the beauty of the book.

양성의 응집, 동서양의 만남, 과거와 미래, 전통과 현대, 이러한 요소들이 서로 융합되어야 깊은 뜻이 숨어 있는 예술적 장력을 표출시킬 수 있다.

북 디자인 중에서 편집 디자인은 장정 디자인의 기초 위에 아주 중요한 한 발을 내딛는 것이다. 이것은 디자이너가 시각언어를 이용하여 원고의 내용이 더욱 완벽하게 빛날 수 있도록 하기 위한 도전의 한 걸음이다. 이는 중국 북 디자인 예술의 전승과 창신이 마땅히 가져야 할 중요한 디자인 의식(意識)이다. 편집 디자인은 독자로 하여금 책의 아름다움을 읽게 하는 것이기 때문이다.

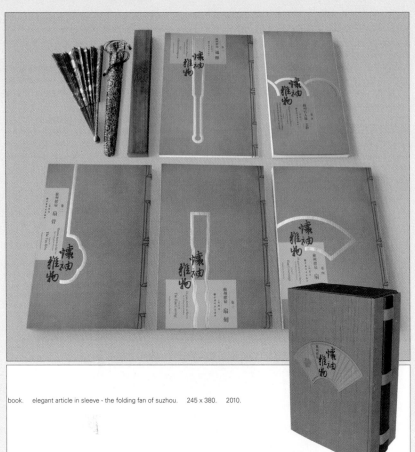

669 book. elegant article in sleeve - the folding fan of suzhou. 245 x 380. 2010.

Ikko was born in Narashi, Japan in 1930. He graduated from Kyoto City University of Arts. After working at Kanebo, he entered Sankei Shimbun Osaka headquarters office. He transferred to Light Publicity at Tokyo in 1957, and took charge in promotional design of World Design Organization. Ikko participated in founding Japanese Design Center in 1960, and 3 years later he independently founded his own design studio named Tanaka Ikko. He held graphic design exhibition titled <Persona>, and gave his first overseas solo exhibition in the Netherlands in 1965. By participating in large scale events, such as Tokyo Olympics ('64) and Osaka Expo ('70), Ikko expanded his fields including space design. He was, once again, appointed as creative director in Saison Group, where he synthesized the corporate image strategy through design including logos, CIs, commercial space and environmental design, galleries and cultural events. Also, Ikko internationally showcased Japanese graphic design via exhibitions, publications, cultural exchanges, and offered his best to establish organizations for design presentations and activities such as JAGDA, TDS, GGG, TOTO Gallery MA, and many more. His works have earned high praises internationally. Ikko was awarded with 'Shijuhosyo'(purple ribbon medal), and was advanced into the hall of New York ADC in 1994. In his later years, until his sudden passing in 2002, he played the central role in Japanese graphic design society including Cultural Contributor Award and Tokyo ADC the hall of honor.

photo by ishimoto yasuhiro.

tanaka.ikko.

japan 1930-2002 　　　　　　　　　타나카.잇코.田中一光.

1930년 일본 나라시 출생이다. 1950년 교토시립미술전문학교(현 교토시립예술대학)를 졸업한 뒤 카네보를 거쳐 산케이신문사에서 일했다. 1957년에 도쿄 라이트퍼블리시티에 입사해 1959년에 세계 디자인회의 홍보 디자인을 담당했고 1960년에 일본디자인센터 창립에 참여했으며 1963년에 독립하여 타나카잇코디자인실을 열었다. 1965년 일본에서 〈페르소나 전〉, 1965년에 네덜란드에서 첫 해외개인전을 가졌다. 도쿄올림픽(1964), 오사카엑스포(1970) 등의 대규모 행사에 관여했으며 1975년에 세이부유통그룹의 크리에이티브 디렉터로서 로고, CI부터 공간 디자인, 환경 디자인, 미술관이나 문화행사 등 기업 이미지 전략을 디자인적 측면에서 총괄했다. 또한 전시회, 출판, 문화 교류 등의 활동을 통해 일본의 그래픽 디자인을 해외에 널리 소개하고, 일본그래픽디자이너협회(JAGDA), 도쿄 디자이너스페이스(TDS), GGG갤러리, TOTO갤러리 등 디자인 활동을 넓혔다. 그의 작품은 일찍부터 국제적으로 높은 평가를 받았다. 1994년에 자수포장을 받았고 같은 해에 뉴욕 아트디렉터스클럽(ADC)에 입성했다. 2000년에 문화공로자, 도쿄 ADC 명예전당에 입성했으며 2002년에 급서하기 전까지 일본 그래픽 디자인계에서 중심적 역할을 했다.

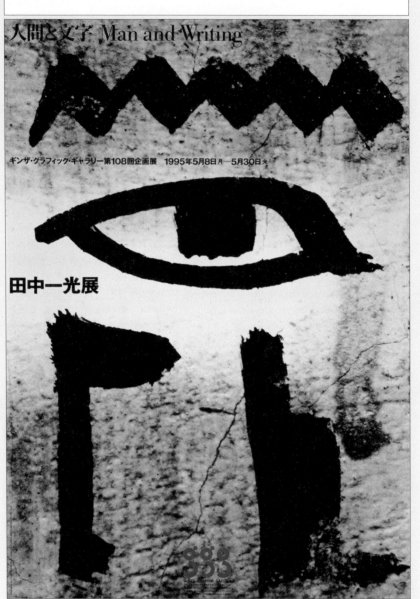

tanaka ikko

poster. ikko tanaka exhibition: man and writing. 728 x 1,030. 1995.

A lonely journey of the idea
발상(発想)의 외톨이 여행

tanaka.ikko.

타나카.잇코.田中一光.

Art director's job is to come up with the concept and its methodology and mostly it does not leave anything behind to the person who is actually involved in that project. It is the job behind the stage. For instance, if I cerated a product or a corporation mark, my name does not come forward. And this could be a part of backstage job.

But I like to work behind the stage. I like how I get to complete and fulfill the mission as an art director. When I do the theater stage art, I get excited very much until the curtain goes up. But when the moment comes, I feel this strange bashful feeling, so I leave the stage quickly. This is the same when I do publishing works. I love the tension of the process of completing one book, but I do not like the publication party. I want to get out of there as soon as possible and be alone. The fever of making books goes away promptly.

I figure that young generation designers do not like minor works or volunteering works. But I like minor works. In my generation, there were many non-paid works for friends who were musicians or acting-related. I feel easy on this kind works. Even if it did not go well, still I am in the position of helping them. I can experiment several things that I don't dare do with jobs for large corporations. It is perfect for idea training.

The origin of our job is to observe. We observe the world. We observe human. We observe the culture. I tell my assistant one thing; see good ones. I send them to abroad after 3 years working at my office. My intention of doing this is to let them to see the real paintings or architectures and get the real atmosphere in their body until they become proud of what they are doing. Knowing

아트 디렉터란 직업은 콘셉트와 그 방법론을 찾는 일이라 실재하는 이미지에 그 사람이 드러나지 않는 경우가 많다. 즉 무대 뒤의 일이다. 가령 내 자신이 손을 움직여서 상품이나 기업 마크를 만들었다 해도 그것은 어디까지나 무기명인 것이다. 이것 또한 무대 뒤의 일이라 할 수 있다. 그러나 나는 무대 뒤에서 일하는 것이 좋다. 내가 아트 디렉터로서 한 작업이 완성되어 임무를 다하는, 거기까지가 좋은 것이다. 연극의 무대미술을 맡았을 때에도 막이 열릴 때까지는 굉장히 기분이 고양되지만, 막이 열려버리면 관객들의 박수 소리에 묘한 부끄러움이 느껴져 얼른 퇴장해버린다. 출판 일도 그렇다. 책이 완성될 때까지 긴장감은 있지만, 출판기념 파티가 열리면 어느새 마음이 식어 있다. 빨리 그 자리에서 뛰쳐나와 혼자가 되고 싶어진다. 작업을 할 때의 열띤 흥분은 어느새 사라져버린다.

최근의 젊은 디자이너들은 '마이너'하거나 보수를 받지 않고 하는 일을 싫어하는 사람이 많다고 들었지만, 나는 마이너한 일이 좋다. 우리 세대는 친구가 음악가거나 연극인이라 공짜로 하는 일이 많았다. 돈이 안 되는 무보수의 일 말이다. 이것은 마음이 편하다. 잘 안 되었다고 하더라도 도와주고 있다는 입장이다. 덕분에 꽤나 용기가 필요한 실험을 할 수 있다. 발상의 훈련에는 최적이라고 할 수 있다.

우리 일의 원점은 우선 관찰하는 것이다. 세상을 관찰한다. 인간을 관찰한다. 문화를 관찰한다. 나는 조수에게 무조건 좋은 것을 보라는 말만 한다. 내 사무실에 들어와서 3년이 지나면 혼자 해외로 보내는데, 그것은 해외에서 건물이든 회화든 실물을 되도록 많이 보고, 지금 자신이 하는 일이 부끄러워질 때까지 실물이 가진 분위기 혹은 느낌에 흠뻑 취해서 오라는 의도이다. 정말 맛있는 것을 알지 못하면 맛없는

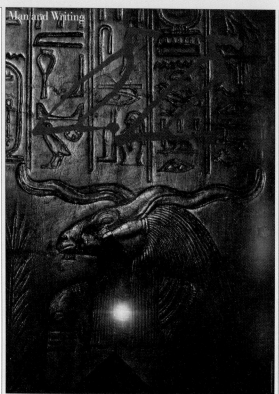

poster. man and writing - egypt 1. 728 x 1,030. 1995.

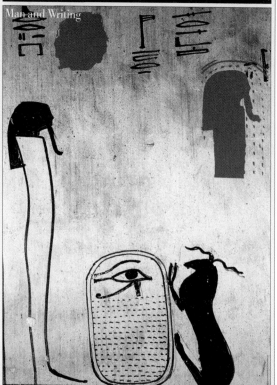

poster. man and writing - egypt 2. 728 x 1,030. 1995.

what is not delicious is impossible if they do not know what is really delicious. A person who paid as much time as possible on observing things can have the right for flexible idea. It is hard to expect the group work for the real creation. Idea is one person's job. Therefore traveling has more meaning when he or she goes by him or herself.

I guess every profession is the same, but there is no ending point of satisfaction. At least in Art, it is almost impossible to satisfy with the finished work.

I am greedy, so I wanted to satisfy both artist's personality and purposefulness somehow. Birth of runner-up or masterpiece could depend on fate, but to show visually organized works I need to take time. Maybe it is why my office, located on the corner of Aoyama 3 Chome 7th floor, never turned the light off. My precious youth was devoted to design.

것도 모른다. 관찰하는 노력을 아끼지 않은 사람만이 거침없고 자유로운 발상의 권리를 가질 수 있는 것이다. 진실의 창조에는 연대(連帶)를 기대하기 어렵다. 발상은 한 사람의 일이다. 따라서, 해외여행도 혼자 가는 것에 의미가 있다. 모든 직업에 할 수 있는 말이지만, 이 정도면 됐다는 도달점은 없다. 적어도 아트에 관한 한 그 완성도에 만족하기란 불가능에 가깝다.

나는 욕심이 많아서 어떻게든 작가의 개성과 합목적성, 이 두 가지를 양립하고 싶었던 것이다. 가작, 걸작의 탄생은 시대의 운에 맡긴다 해도, 최소한 빈틈없이 주의하여 살피는 작업을 하려니 아무래도 시간이 많이 걸린다. 아오야마 3초메 길 모퉁이에 있는 사무실 7층이 항상 늦게까지 불이 켜져 있다고 소문이 난 것도 이러한 정황을 보여주는 것인지도 모르겠다. 심야에 불이 꺼지지 않는 것도 우리의 청춘을 디자인에 바치고 있었던 까닭이다.

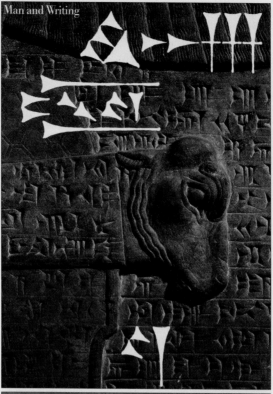

Man and Writing

poster. man and writing - mesopotamia. 728 x 1,030. 1995.

Man and Writing

tanaka ikko

poster. man and writing - greece. 728 x 1,030. 1995.

Man and Writing

인간과 문자

art work description
작품설명

tanaka.ikko.

타나카.잇코.田中一光.

(GGG, the 108th project / from a preface of *Tanaka Ikko exhibition*)
(『타나카 잇코』 서문 중에서, GGG 제108회 기획, 1995)

I produced 18 posters, which are packed up with my very personal sense of emotion and fantasy, to commemorate the publication of Man and Writing. The theme was too grand and it made me almost to give up, but now I am thankful that I could study for a variety of things about *Man and Writing* again.

The interview about Man and Writing started from shooting at Graffiti in New York's Soho district in 1983. In my case, everything started from a simple curiosity; "why did the human began to write the letter?". However I realized that this was such a huge world as I proceed the interview at Egypt, Greece, and Etruria.(omitted) I faced my 12th year of studying, still swimming in a deep history of writing.

When I finished interview in China last year, I was suggested to bind them up in one volume of book, *titled Man and Writing*. Getting help from Heibonsha Limited, I could loosely challenge for a writing expectation, which has never been published with a similar theme. Needless to say, this was possible by professor Yajima Fumio and professor Atsuji Tetsuji who supervised from interview to a dissertation. And I am truly thankful and pay homage to two cameramen, Hatakeyama Takashi and Hirokawa Taishi, who went out all over the world for photo shoots and to phototypesetter Morisawa Inc. for their passionate move to this long and grand cultural business.

나는 이번 『인간과 문자』 간행을 기념하는 의미로 지극히 사적인 정감과 환상을 담아 여기 18장의 포스터를 제작했다. 너무나 테마가 장대하여 기가 꺾일 듯한 작업이었지만 다시금 『인간과 문자』에 대해 다양한 공부를 할 수 있었던 것을 감사하게 생각한다.

인간과 문자를 주제로 한 취재는 1983년 뉴욕의 소호지구 낙서 촬영부터 시작되었다. 나의 경우 처음에는 '어찌하여 인류는 문자를 쓰게 되었는가' 하는 극히 소박한 호기심에서 접촉하게 되었다. 그러나 이집트, 그리스, 에트루리아로 취재를 진행함에 따라 이는 엄청난 세계라는 것을 실감한다. (중략) 너무나 깊은 문자의 역사에서 헤어나오지 못한 채 12년째를 맞이했다.

작년 중국 취재를 마친 즈음에 이 취재 필름을 바탕으로 『인간과 문자』라는 한 권의 책으로 묶으면 어떻겠느냐 하는 이야기가 나와 헤이본샤(平凡社)의 도움을 받아 엉성하나마 세계에 유서(類書) 없는 문자 전망에 도전하게 되었다. 물론 이는 취재에서 논문까지 나를 지도해주신 야지마 후미오(矢島文夫) 선생님과 아쓰지 테쓰지(阿辻哲次) 선생님에 의한 것이며, 또 십수 년에 걸쳐 지구 벽지를 뛰어다니며 촬영해오신 하타케야마 타카시(畠山崇), 히로카와 타이시(広川泰士)에게, 더 나아가 사진식자 모리사와가 이렇게 길고 거대한 문화사업에 힘을 쏟으신 것에 진심으로 경의를 표한다.

676

tanaka ikko

poster. man and writing - etruria. 728 x 1,030. 1995.

poster. man and writing - hebrew. 728 x 1,030. 1995.

Tanaka ikko - The sparkling flash

타나카 잇코, 반짝이는 섬광

gian.carlo.calza.
(director, the international hokusai research center)

잔.카를로.칼자.

(호쿠사이 리서치 센터 이사)

Light. Strong, transparent and illuminates everything. It is an integral element of Tanaka Ikko's graphic design. Light exists before color and line which are the origin of design. He uses the light in order to represent a modern form to his cultural values on poster, logo, trademark, gallery or shop display, package, calligraphy, new typeface, newspaper, magazine, textile and etc. Mitigate the light and fully penetrate. Thus, for Tanaka, graphic design becomes a vehicle that delivers Japanese nation's aesthetic consciousness. And this is a result of what Japanese people advanced over several centuries or their reinterpretation of what they absorbed by foreign stimulation. Tanaka Ikko makes forms based on traditional culture, but at the same time, it is a respond to modern mass-sharing imagination. Therefore it overcomes the limit of society and culture and allow us to visually evaluate wherever we are, such as Tokyo, Paris, Milan, Washington, Mexico city, London, Sao Paulo, or Warsaw. The true value of Tanaka Ikko's style is right there.

Today, in the field of Art, 'Style' is a word that should not be used frequently. Especially in the field that new forms or style elements occur and disappear often, like graphic design which is swayed easily by trend or whims. However, when we think of work of Tanaka Ikko, a modern Japanese graphic designer, it is difficult to make the right position order without using the word 'style'. By creating a wide variety of work, Tanaka has been shared Japan's post-war trauma, chaos, experience of living in an era of excitement and various agitation. What he creates, such as im-

강하면서도 투명한, 모든 것을 밝히는 빛. 그것은 타나카 잇코의 그래픽 디자인에서 불가결한 요소이다. 디자인 원점인 색과 선 그 이전에 먼저 빛이 있다. 포스터, 로고, 트레이드 마크, 갤러리나 매장 디스플레이, 패키지, 캘리그래피, 새 글꼴, 신문, 잡지, 텍스타일 등 본인의 문화 가치관에 현대적인 표현 형태를 부여하기 위해 그는 빛을 사용한다. 빛을 완화시킨 후 완전히 침투하는 것. 그렇게 하여 그래픽 디자인은 타나카에게 일본 민족의 미의식을 전달하는 매체가 된다. 그것은 일본인이 몇 세기에 걸쳐 갈고 닦아온, 혹은 외국에서의 자극을 흡수하여 일본적으로 재해석해낸 결과이다. 타나카 잇코는 전통문화로부터 착안한 형태를 만들어내지만 동시에 그것은 현대 집단공유 상상력에 호응하는 것으로, 사회·문화의 벽을 넘어 도쿄에서든 파리에서든 밀라노에서든 혹은 워싱턴, 멕시코시티, 런던, 상파울루, 바르샤바에서든 시각적인 평가가 가능하다. 타나카 잇코 스타일의 진가는 거기에 있다.

오늘날 예술 분야에서 '스타일'이라는 말은 자주 쓰지 말아야 할 단어이다. 그래픽 디자인처럼 어지러운 유행이나 변덕에 좌우되고 새로운 형태나 스타일 요소가 쉽게 생겼다가 사라지는 분야에서 특히 그렇다. 그러나 타나카 잇코라는 현대 일본 그래픽 디자이너의 작업을 생각할 때 그 누구보다 '스타일'이란 단어를 빌리지 않고서는 올바른 위치 규정을 하기가 어렵다. 타나카는 광범위하게 다양한 작품을 제작함으로써 제2차 세계대전 후 일본의 트라우마, 혼란, 그리고 흥분의 시대를 살고 그 수많은 움직임, 다양한 동요를 시대와 함께 공유해왔다. 타나카가 만들어내는 도상, 그림과 글의 관계, 색(명확하고 매끄러운 선, 어떤 망설임도 번짐도 보이지 않는 선에 의해 꼼꼼히 구분되고 구축된 경계 속에, 빛을 빨아들이고자 혹은 반사하고

tanaka ikko

678

poster. man and writing - india. 728 x 1,030. 1995.

poster. man and writing - arabia 1. 728 x 1,030. 1995.

age, relationship between picture and text, and color(which was painted to absorb or reflect the light in the boundary that was formed by an invisible, precise and slick line with no hesitation) reflects his passion about the traditional forms. Among currently active graphic designers, there are no artist like Tanaka who has been deeply related to cultural events. Most of Tanaka's posters and other design works are about exhibition, play, music event and publication.

His art can be seen as an art with a social meaning. Through his hands form and color start to show ethical value and it becomes an envoy that delivers value and principle for the better life. When we trace Tanaka's works, we can see his continuous efforts to renew some Japanese traditional art's principles and development directions in the frame of today's graphic design. Tanaka's this unique approach could be formed from his cultural formation of his childhood. In 1930 Tanaka Ikko was born in Nara, a cradle of Japanese civilization, learned in Kyoto, the center of Japanese classic culture, then he started his career in Osaka, the art supporting city. Soon after he moved his territory to Tokyo, where diversity coexists.

According to Kamekura Yusaku, Japan's great graphic designer, Tanaka is an artist who is well-versed in Japanese art interpretation and shows the pureness of tradition expression. Theorist Umehara Takeshi defined Tanaka as an Aristotelian artist who can pull out the power of meaning from many phenomena he expressed in his works. Clearly what Tanaka draws on his poster becomes a typical image of various ideas that exists in the world. Tanaka expresses those images with classical graciousness, strictness and pureness. There is nothing that can be left on something spontaneity or unreality. His talent and power of using the printing technology freely allowed him to integrate

자 발린 색)은 전통적인 모양에 대한 그의 열정을 반영한다. 현재 활동하는 그래픽 디자이너 중에서 타나카만큼 문화적 이벤트에 깊이 관여해온 작가는 없다. 타나카의 포스터, 또 디자이너로서 작업의 대부분은 전시회, 연극, 음악 이벤트, 출판에 관한 것들이다.

그의 예술은 사회적 의미를 지닌 예술이라 할 수 있다. 그의 손을 통해 모양과 색은 윤리적 가치를 띠기 시작하며 보다 나은 생활을 위한 가치관이나 원칙을 전달하는 사자(使者)가 된다. 타나카의 작품을 좇아가 보면 오늘날의 그래픽 디자인이라는 틀 안에 있으면서도 일본 전통미술에서 보이는 몇 가지 원칙이나 발전 방향성을 늘 쇄신해 나가고자 하는 노력이 엿보인다. 타나카의 이 독특한 접근의 근원은 어린 시절부터의 그의 문화적 형성에 있는 것 같다. 타나카 잇코는 1930년 일본 문명 요람인 나라(奈良)에서 태어나 고전적인 문화의 중심 교토(京都)에서 배우며 예술 옹호의 도시 오사카에서 일을 시작했다. 이윽고 다양성이 공존하는 도쿄로 활동 영역을 옮겼다.

일본의 위대한 그래픽 디자이너 가메쿠라 유사쿠(龜倉雄策)는 타나카야말로 일본적인 예술 해석의 정통이며 전통과 표현의 순수함을 보여주는 작가라고 말한다. 평론가 우메하라 타케시(梅原 猛)는 타나카를 작품 속에서 표현되는 온갖 현상에서 의미하는 것의 힘을 끌어낼 수 있는 아리스토텔레스적 작가라고 정의했다. 분명 타나카 포스터에 그려진 것은 세계에 존재하는 다양한 현상의 전형적인 이미지가 된다. 타나카는 그 도상(図像)들을 고전적인 우아함과 엄밀함 그리고 순수함을 가지고 표현한다. 자연발생적인 것, 비현실 세계에 맡길 수 있는 것은 하나도 없다. 그의 재능, 그리고 인쇄기술이라는 표현수단을 자유자재로 소화하는 능력은 예술과 그래픽 디자인을 늘 새로운 형태로 융합시키는 작품을 낳는다.

타나카가 작가로서 데뷔한 1950년대는 패전, 대전 후라는 망연자실의 상황이었고, 전통적인 형식을 타파하자는 기운이 일었던 시대이지만, 활동 개시 이래 타나카는 이 변혁의 시대에

poster. man and writing - arabia 2. 728 x 1,030. 1995.

poster. man and writing - new york. 728 x 1,030. 1995.

art and graphic design and create a new form of work.

1950s, the year that Tanaka debuted as an artist, Japan was hopeless after defeated in a war and there were movements to breakdown traditional forms. As Tanaka started his career, he has been involved in various social·art trends in this revolutionary and innovative period. 1960s was represented by 1964 Tokyo Olympics and Opening of Shinkansen(one of railway lines in Japan) and 1970 Osaka International Exposition. 1970s was Japan's renaissance. 1980s was the period of wild joy of bubble economy. And 1990s was the period of depression.

Tanaka went through those hardships, postwar contradiction of society and culture, and its stimulation. It is clear that he was influenced by an education from Kansai region, which has the oldest culture and art in Japan. Moreover, through relationship with nature, intention of the work, and practice the living rituals (Tanaka praised the tea ceremony for a long time), Tanaka practiced to see the life in the point of aesthetic view and this helped him to form the integral filter around aesthetic sensibility and graciousness in young Tanaka's inner side. And this formed sensibility led Tanaka to make his unique style, abundant color and light and dense Japanese tradition, which made him famous worldwide.

There are several source of Tanaka's ideas, but we can tell that he was particularly influenced by Rimpa school according to his aesthetic concepts, iconography details, constructing desire to find an architectural composition. contrasting usage of abundant color, and transparent and rational

연이어 일어났던 다양한 사회예술의 동향에 관여해왔다. 1964년 도쿄올림픽과 신칸센 개통, 1970년 오사카 만국박람회로 대표되는 1960년대, 1970년대의 부흥기, 그에 이어지는 버블경제 광희(狂喜)의 1980년대, 그리고 불황의 1990년대……. 타나카는 아마도 어느 나라보다 많은 시련을 겪었고 제2차 세계대전 이후 일본의 사회·문화적 모순 또는 그 자극을 몸소 체험해왔던 것이다. 칸사이(關西)라는 일본의 가장 오래된 문화·미술 풍토에 친숙하고, 그곳에서 교육을 받은 것이 작가 타나카를 형성하는 데 큰 영향을 미친 것은 틀림없다.

더 나아가 자연과의 관계 그리고 작품의 의도에 있어서도, 생활 의식화(儀式化)의 실천(타나카는 예부터 다도를 예찬해왔다)에 있어서도, 생활을 미적 관점에서 보는 연습을 계속해왔다. 그것은 젊은 타나카의 내면에 미적 감수성과 우아함을 둘러싼 불가결한 필터를 생성하도록 도왔다. 그렇게 훈련하여 형성된 감각이 있었기 때문에, 타나카를 세계적으로 유명하게 만든 독자적인 스타일 — 색과 빛이 풍부하고 일본 전통이 농밀하면서도 동시에 그것을 감지하기 어려운 레벨에서 독특한 스타일을 낳는 것이 가능해졌던 것이다.

그가 가진 미적 개념, 도상(圖像)의 세부에 이르기까지 질서와 건축적인 구도를 원하는 구축적 욕구, 풍부한 색채 부분의 대조적인 사용법 그리고 글자 쓰는 법을 둘러싼 투명하고 합리적인 탐구를 생각할 때, 그 착상의 원천으로 여러 가지가 떠오르지만 그중에서도 가장 중요한 것은 아마도 '린파(琳派: 일본 에도 시대를 통해 번성한 장식화의 유파)'일 것이다. 사실 손튼 등의 몇몇 비평가들은 린파가 나가이 카즈마사(永井一正), 요코오 타다노리(橫尾忠則) 등 일본 그래픽 디자인 전반에 큰 영향을 미쳤다고 말한다. 그러나 이들 작가의 경력이나 역사·문화적 루트는 복잡하여 그 원천을 린파에서 찾을 수는 없다고 나는 생각한다.

오히려 이것도 이차적이긴 하지만, 나가이는 옵아트에, 요코오는 19세기 후반 말기 우키요에(浮世繪: 일본 에도 시대에 성립된 풍속을 주

poster. man and writing - china 1. 728 x 1,030. 1995.

tanaka ikko

poster. man and writing - china 2. 728 x 1,030. 1995.

exploration of writing letters. Actually some critics like Thornton, says that Rimpa school has been influenced overall Japanese graphic designers including Nagai Kazumasa and Yokoo Tadanori. But I think their cultural root or career are too complicated so their origin cannot be found only from Rimpa.

And this is secondary but I think Nagai can be related to Op art and Yokoo can be related to late 19th century's Ukiyo-e. Tanaka is different. Tanaka has been always professed his interest in Rimpa and formal elements, that can make Tanaka as one of the big names of Rimpa, exist.

One of Tanaka's masterpieces is <JAGDA Graphic Designer> 1986, designed for Japan Graphic Designers Association Inc.. He drew a fawn and titled it Japan (JS017). Tanaka got the idea from the 12th century Scriptures, "*Heike nokyo*", preserved in Itsukushima Shrine, Hirosima. The fawn drawn in this scriptures became a parameters for everyone to compare. And 500 years later this was retouched by Soutatsu, speculatively.

Soutatsu left many same style works. For instance, a deer drawn scroll which Koetsu wrote on and preserved in MOA(Museum of Art) or a drawing scroll preserved in Seattle Art Museum. Deer drawings in those scrolls, fawn drawing in "Heike nokyo" and Tanaka's posters show common style. And there are some works influenced by Kōrin. For example, a large iris from Tanaka solo exhibition's poster in 1990 or Narita airport mural 1992 reminds of Kōrin's iris folding screen, preserved in Nezu Museum, Tokyo, and Yatsuhashizu folding screen, preserved in The Metropolitan Museum of Art, New York. Of course this is just a

제로 한 서민적인 회화)에 연결할 수 있다는 것이 나의 견해이다. 타나카의 경우는 사정이 다르다. 타나카 자신이 린파에 대한 관심을 늘 공언해왔을 뿐만 아니라, 타나카를 린파의 거장으로 간주할 수 있을 만한 형식적인 요소가 존재하는 것이다.

그는 1986년 일본그래픽디자이너협회 전시 포스터에 아기사슴을 그리고 'Japan'이라 제목을 지었다(JS017). 타나카는 히로시마(廣島), 이쓰쿠시마 신사(厳島神社)에 보존되어 있는 12세기의 그림이 있는 경전『헤이케노쿄(平家納経)』에서 이 작품의 착상을 얻었다. 이 경전에 그려진 아기사슴 모습은 누구나 자신의 매개변수로 비교할 수 있는 것이 되었다. 그리고 그 500년 후에 추측하건대, 소타쓰(宗達)에 의해 가필(加筆)되었다.

소타쓰는 같은 제재·스타일의 작품을 몇 개나 남겼다. 이를테면 아타미(熱海) MOA 미술관에 소장된 코에쓰(光悦)가 쓴 글이 들어가 있는 고명한 사슴 그림 두루마리. 혹은 시애틀미술관의 그림 두루마리 등이 있으나 이들의 사슴과 〈헤이케노쿄〉의 아기사슴, 그리고 타나카의 포스터 사이에는 스타일상 많은 공통점이 보인다. 또한 코린(光琳)을 염두에 둔 작품도 보인다. 이를테면 1990년 'GGG 갤러리에서의 타나카 개인전 포스터의 큰 제비붓꽃, 혹은 1992년 나리타공항 벽화는 도쿄 네즈미술관(根津美術館)에 소장된 코린의 제비붓꽃 병풍, 혹은 뉴욕 메트로폴리탄미술관의 야쓰하시즈 병풍(八橋図屛風)을 연상시킨다. 물론 17세기 거장 코린이 제비붓꽃을 제재로 그린 다양한 작품 중여기서는 두 점을 든 것에 지나지 않는다.

타나카를 혼아미 코에쓰(本阿弥光悦) 혹은 센노리큐(千利休)의 사후(死後), 라쿠호쿠 다카가미네(洛北 鷹ヶ峰)에서 코에쓰 슬하에 모였던 화가나 장인 그룹과 연결지어 생각하는 비평가도 있다. 이 코에쓰무라(光悦村)는 당시 문화에 지대한 예술적 영향을 끼쳤던 중심지이며, 시대를 훨씬 앞서 등장한 일종의 바우하우스와 같은 것이었다. 전 시대를 통틀어 보아도 일본의 예술, 미학의 최고봉에 해당하는 코에

tanaka ikko

Man and Writing

685

tanaka ikko

part of 17th century's master Kōrin's many works of iris.

There are some critics who relate Tanaka to artists or craftsman groups who gathered under Kōetsu at Hon'ami Kōetsu and Sen no Rikyū's Rakuhoku Takagamine (洛北 鷹ヶ峰). This Kōetsu-mura (artists' village) was the center of art that influenced culture very much and it was like an early version of Bauhaus. Even though it is so obvious that Tanaka would be pleased to be compared with Kōetsu, Soutatsu and Korin who are the great masters of Japanese art and aesthetics, Tanaka would prefer to be evaluated without being compared or classified. His art should be understood as it is and it does not require any comparison with others for evaluation. It is true that criticism on classification is too narrow for Tanaka. For instance, Rab's case, to define Tanaka as a chromatic artist, proved that it is necessary to classify Tanaka in other aspects. Even Tanaka stresses that he would not be classified to any groups or styles. Besides he describes himself as 'Bakeyakusha (actors in disguise, clown)', which means a mask for diverse roles in Nogaku (the classical Japanese dance theatre).

What leads Tanaka's study is completely spiritual thing. And by doing this Tanaka can be free from various schools or styles of the past and the present. And when Tanaka expresses the "spirit" of design he was looking in the form, this spirit maintains Japanese culture vividly even when the culture loses its spirit (this happened several times in the history of Japan). And this spirit is how Tanaka gives life to inner side. In Tanaka's short essay <simplification and design>, Tanaka included the key to understand his own internal developments of the spirit. Of course, even within the essay or other writings, Tanaka writes them with intention to advert the common aesthetic value than Japanese aesthetic value.

쓰, 소타쓰, 코린 등에 비견되는 일은 타나카를 기쁘게 하지 않을 리 없지만, 타나카는 비교나 카테고리화를 하지 않고 평가되는 쪽을 선호할 것이다. 그의 아트는 그 자체로 이해되어야 하며 올바로 평가하는 데 타인과의 비교는 필요하지 않다. 분류적 비평이 타나카에게 답답하게 느껴지는 것은 틀림없다. 예를 들어 래브즈처럼 타나카를 '색채적 작가'로 정의하려고 한 경우라도, 다시 또 다른 관점에서 분류되는 일이 일어나는 것은 어쩔 수 없다. 타나카 자신도 쓸데없는 의구심을 없애기 위해 어떠한 그룹이나 양식에도 속하지 않겠다고 스스로 강조하고 있다. 게다가 자신은 다양한 배역에 쓰이는 노멘(能面, 일본의 가면 음악극에서 쓰이는 탈)을 가리키는 바케야쿠샤(化け役者, 변장하는 배우)라고 말하고 있다.

과거와 현재의 다양한 유파와 양식으로부터 자유로울 수 있다는 것 ― 그러기 위해 타나카의 탐구를 이끄는 것은 완전히 정신적인 것이다. 타나카가 바라는 디자인 '정신'이 형체 속에 나타날 때, 그 정신은 문화를 상실해버렸다고 여겨질 때에도(이는 일본역사에서 몇 차례나 있었다) 일본문화를 생생하게 유지해온 정신과 같은 것이다. 그리고 그것이 타나카의 내면에 생명을 부여하는 정신이기도 하다. 타나카의 짧은 글 '단순화와 디자인'에는 이러한 정신의 자기 내부에서의 전개와 모든 시대의 일본 디자인·미술 안에서의 전개를 타나카는 어떻게 파악하고 있는지 이해하기 위한 열쇠가 포함되어 있다.

물론 그 글에서나 다른 저술에서도 타나카는 일본의 미적 가치라기보다는 보편적인 미적 가치를 언급할 의도를 가지고 쓰고 있다. 생각해 보면 이는 타나카의 한결같이 변함없는 태도이다. 심지어 자국의 문화 속에 흠뻑 빠져 있을 때마저도. 그렇기 때문에 그의 그래픽 디자인은 지리적·문화적인 울타리를 넘어 즉시 느끼고 음미하는 일이 가능한 것이다. 정신의 자유를 추구하고 끊임없이 유지하는 일, 디자인을 통해 그것을 표현하는 일 ― 그것은 개인적인 스타일 창출을 위한 불가결한 조건이기도 하지만, 타나카는 자신의 작가로서의 연구와 커리어를 그것을 위해 바쳤다. 그리고 자신의 생각을 관

tanaka ikko

Man and Writing

tanaka ikko

Looking backward, this is Tanaka's consistent manner. Even when he was immersed in his country's culture. And this is why it is possible to taste and feel his graphic design without any geographical·cultural boundaries. Even though obtaining and maintaining the freedom of the spirit and expressing it through the design is an indispensable condition to create personal style, Tanaka devoted his study and career as an artist for that. Then he accomplished his idea and added his own thoughts to that. Tanaka's simple but very difficult tip of the job is in the process of determining the value of spirit, experimenting on his own, creating the icons to express the core and transferring it to the form that has typical value.

There are several reasons how Tanaka created his own style and maintain it for a long time. It becomes obvious when we have a glimpse of his career as an artist and his life. Tanaka's study involves not only the profession but also the sum of things. Ordinary moment or activities that has distant to the theme can be a part of his study. And Tanaka's study becomes even more abundant by his talent of learning and getting hints from everything. This endless movement, from life to art, has been proved by numerous awards he received (The year of 1962 is the only year he did not receive any awards). It is because most of his professional works got characters by his interests on other things besides graphic design.

One of the most famous poster designs for Kan-zeno performance, hosted by Sankei Shimbun, Osaka, is the work Tanaka created one year after he moved to Tokyo. He drew a large white square and divided it to several squares and composed dense and fine colors fitted to the traditional style. Tanaka then drew the core parts of the graceful female Noh mask on top of it. That Noh mask is probably the Deigan. Somehow the fast brush

철하고 더욱이 독자적인 발상의 방법을 부여했다. 정신적인 가치를 확인하고 스스로 실험하는 일. 그 핵심을 표현할 수 있는 도상(図像)을 창조하고 그것을 전형적 가치를 지닌 형태로 옮기는 일. 거기에야말로 단순하지만 매우 어려운 타나카 작업의 비결이 있다.

타나카가 자기 스타일을 만들어내고 오랜 시간에 걸쳐 그것을 유지할 수 있었던 데에는 여러 가지 이유가 있다. 그것은 작가로서의 커리어와 그의 삶의 행보를 한눈에 바라보면 명확해진다. 타나카의 탐구는 그 직업뿐만 아니라 그의 모든 존재에 관여한다. 일상적인 한때라든지 그의 일과 언뜻 동떨어진 것처럼 보이는 활동도 탐구의 일부분이 될 수 있다. 그리고 타나카의 탐구는 모든 것에서 배우고 힌트를 얻는다는 그만의 재능에 의해 점점 더 풍부해진다. '생활에서 아트'라고 하는 끊임없는 운동은 그가 받은 수많은 상(타나카가 아무런 상을 수상하지 않은 해는 1962년뿐이다)에 의해 입증되었다. 왜냐하면 그의 프로로서의 작업의 대부분은 그래픽 디자인 이외의 것에 대한 관심에 의해 성격이 부여되었기 때문이다.

688

오사카의 〈산케이신문〉이 주최한 칸제노(観世能) 공연 포스터 중에서 가장 유명한 것 중 하나는 타나카가 도쿄로 옮긴 일년 후의 작품이다. 흰 종이에 큰 사각형을 그리고 그것을 다시 여러 개의 사각형으로 나누어 전통적인 스타일에 들어맞는 농밀하고 섬세한 면을 구성한다. 타나카는 그 위에 상부를 조금 비어져 나오게 하여 우아한 여성의 노멘(能面)의 핵심만을 그려냈다. 노멘(能面)은 아마도 데이간(泥眼, 노멘의 한 종류. 금가루를 용해시킨 물감을 눈에 칠한 여성의 탈)일 것이다. 재빠른 붓 터치는 어딘지 수묵화를 연상시킨다. 메시지를 전달하는 글자 부분은 다른 작품의 경우와 비교하면 그림보다 무게감이 떨어지지만 그래도 매우 효과적이다. 강하게 채색된 표면이라는 '현실'에 조금씩 얼굴 윤곽이 떠오른다. 마치 '삶'이 가지는 다채색의 힘에 이끌려 보이기 시작하는 비현실적 존재와 같은 얼굴 — 이것에서 느껴지는 것은 그러한 마법의 감촉이다. 이 작품을 포함한 포스터 시리즈는 타나카의 주요 작품 계열 중 하나로 손꼽힌다.

689

tanaka ikko

poster. man and writing - china 5. 728 x 1,030. 1995.

work reminds of in-and-wash painting. Compare to other works, the text part that delivers the message has less importance than the picture, but it is still very effective. The contour of the face emerges slightly due to the strongly colored surface. This face is like a unrealistic existence that is visible by attracted power from various colors of "life" and what we feel from that is such a magical touch. Poster series including this work is considered one of Tanaka's main works. This work made Tanaka internationally famous, and it is a valuable piece for study of Tanaka's development as an artist.

Another highly successful series is a huge human face design Tanaka developed in 1980s. the inspiration was <Japanese Dance>. It was a Japanese dance performance poster, held in 1981 at Asian Performing Arts Institute, LosAngeles, California. The poster is filled with the dancer's face. The combination of matt and dense colored geometrical figures strongly appeal visually. Tanaka took the traditional icons and transfer that to abstract concept that has visual impact. In <The New Spirit of Japanese Design>, poster for magazine "Print", Tanaka's face theme using many curves became his character. Similar thing happened in around 1790. The best graphic designers in that time presented polychromatic prints, Ookubi-e(大首絵), depicting the Kabuki actors, famous Oiran (prostitute), and upper body of beauties from ordinary life, to the world. This became famous soon after and contributed to the success of the outstanding publisher Tsutaya Jūzaburō and artists inclusing Utamaro, Sharaku, Shunko, Shunsai, etc. This genre was forbidden by the Tokugawa in 19th century. It is because this genre was considered "too luxurious" to Chōnin(townsmen) class people who were very rich but had a low social status.

이는 국제적으로 타나카를 유명하게 만든 작품이며, 1950년대부터 오늘날에 이르는 타나카의 예술가로서의 발전을 연구하는 데 귀중한 작품이다. 대성공을 거둔 또 하나의 시리즈는 타나카가 1980년대에 발전시킨 거대한 사람의 얼굴 디자인이다. 그 계기가 됐던 것은 〈일본무용〉, 1981년 로스앤젤레스 캘리포니아대학의 Asian Performing Arts Institute에서 열린 일본 무용의 공연 포스터이다. 포스터에는 무용수 얼굴이 지면 가득 그려져 있다. 그 모습은 매트하고 농밀한 색의 기하학이 조합된 것으로 시각적으로 강하게 호소한다. 타나카는 전통적인 도상(図像)을 채택하여 그것을 시각적 임팩트 있는 추상 개념으로 변모시킨 것이다. 이 포스터 경우에는 직선을 사용했고, 잡지 〈Print〉의 포스터 〈The New Spirit of Japanese Design〉에서는 곡선을 많이 사용한 얼굴 테마는 타나카 작품에서 특징적인 것이 되었다. 비슷한 일이 1790년쯤에 있었다. 그 당시 일본 미술사상 최고의 그래픽 디자이너로 여겨지는 사람들이 가부키 배우, 고급 유녀 오이란(花魁), 일상에서 볼 수 있는 미인들의 상반신을 그린 다색판화 초상화(大首絵, 오쿠비에)를 세상에 내놓았던 것이다. 이는 금세 평판이 나서 우타마로(歌麿), 샤라쿠(写楽), 슌코(春好), 슌사이(春菜) 등의 화가들의 성공 그리고 그들의 발행처인 가장 뛰어난 출판인 쓰타야 주자부로(蔦屋 重三郎)의 성공에 기여했던 것이다. 이 장르는 19세기가 되자 도쿠가와 막부에 의해 금지되었다. 가장 유복하면서도 사회적으로는 신분이 낮은 초닌(町人) 계급에게는 '너무 사치스럽다'고 여겨졌기 때문이다.

그것을 20세기에 부활시켰다. 타나카는 18세기 선인들과 마찬가지로 예민하고 정력적으로 이 장르의 모양을 완전히 새롭게 하여 다시금 세상에 내놓은 것이다. 18세기 당시에 혁신적이었던 것은, 이 초상이 당시 유명인들을 꼭 닮아있어서 마치 오늘날의 그라비아 잡지가 그렇듯이 이 판화를 보는 이들 누구나 자기들이 동경하는 사람이라고 한눈에 알 수 있었던 점이다. 이쪽은 미녀 배우 세가와 기쿠노조(瀬川菊之丞), 저쪽은 유명한 오이란(花魁) 하나오기(花扇), 이것은 그이와 미모를 겨루는 오히사, 오키타, 도요히나라고……. 타나카는 같은 장르를 다시 다루는 데 있어서 전혀 다른 접근방식

Man and Writing

tanaka ikko

poster. man and writing - korea. 728 x 1,030. 1995.

This was revived in 20th century. Tanaka brought out this genre to the world energetically and sensitively like what ancestors did in 18th century. Of course it was newly embellished. What was so innovative at 18th century was that whoever look at those prints were able to recognize the depicted person, someone they admire, which is like today's gravure magazines. This side is a beautiful actress Segawa Kikunojo, that is famous Oiran Hanaogi, and these are Ohisa, Okita and Toyohina who are emulating their beauty with them... something like this. Tanaka approached completely differently to handle the same genre again. Abstract faces he draws make different facial expressions, sometimes entrancing, sometimes intense, and sometimes humorous. Dense and delicate colors are drifted apart from abstraction and make contour and contrast due to accurate and geometric lines, then those colors made a new genre to picture ideal image and depict a person's characters. This could be the original form of portrait.

When we look at Tanaka's posters on <The 6th National Cultural Festival Chiba>(1991), <200th Anniversary of Sharaku> (1994), *Terrible taste* (1995) or <In Search of Elegance> (1996, Venice). it is obvious that Tanaka is interested in this genre and going at this direction. It is wrong to regard that Tanaka has a certain work in his mind. In that sense, this is different from the fawn from <Heike nokyo>, mentioned earlier. Instead, it is right to regard that Tanaka accumulated unmeasurable fortune of diverse value, principle, and style of tradition in his gene, and granted the new life and new form to bring those to the surface. Therefore it is impossible to assume that he referred to the certain Ukiyo-e painters on portraits but there is no doubt that the Ukiyo-e is in his blood like Rimpa. That appears in the form I described above.

을 취했다. 그가 그리는 크고 추상적인 얼굴은 어떤 때에는 황홀한 표정을 나타내고 어떤 때에는 엄한 표정을 보이며, 어떤 때에는 유머러스하다. 농밀하고 섬세한 색채는 정확하고 기하학적인 선에 의한 윤곽과 콘트라스트를 낳고, 소위 초상에서 멀어져 이상적 도상(図像), 인간의 성질을 그리는 새로운 장르를 만들어내고 있다. 이는 일종의 원형 초상화라고 할 수 있을 것이다.

<제6회 국민문화제 치바 1991>, 1994년 샤라쿠(写楽) 200년을 기념하는 전시회 <샤라쿠 200년>, 혹은 1995년 『무서운 맛』의 장정, 1996년 베네치아에서 열린 일본 현대아트 국제회의 <In Search of Elegance>의 포스터 순으로 보면 타나카가 적잖이 관심을 가지고 이 방향을 쫓고 있다는 것은 분명하다. 이 경우, 타나카가 특정한 작품을 염두에 두고 있다고 생각하는 것은 잘못된 것이다. 그런 점에서 아까 언급했던 <헤이케노쿄>의 아기사슴과는 다르다. 오히려, 타나카 안에 아니 이미 그의 유전자 자체에 전통의 다양한 가치, 원칙, 스타일 등 측량할 수 없을 정도의 재산이 축적되어 있고, 타나카는 그것들이 표면으로 나타나길 재촉하며, 새로운 생명, 새로운 형태를 부여한다고 생각해야 한다. 따라서, 가령 이것들의 초상에 대하여 타나카가 특정한 우키요에(浮世絵) 화가를 참고로 하고 있다고는 가정할 수 없으나 타나카 몸 안에 린파와 마찬가지로 우키요에 피도 흐르고 있음은 의심할 바 없다. 그것은 지금 위에서 설명을 시도한 형태로 나타난다.

타나카가 1980년대 후반부터 제작하기 시작한 <꽃>의 경우에도 같은 프로세스를 거쳤을 것이다. 단지, 이 경우에는 타나카보다 확실한 참고 예시가 있다고 하겠다. 이는 큰 꽃을 그린 것으로, 꽃은 마치 초상화와 같은 취급을 받으며 지면의 주인공으로서 명확하고 힘차게 화면에 떠오른다. 1990년 개인전 <타나카 잇코 그래픽아트 식물원>의 제비붓꽃에서는 전술한 코린의 작품을 연상할 수 있지만, 여기서는 한 송이 한 송이의 꽃이 이상적인 초상처럼 주목의 초점에 놓이는 것이다. 실제로 몇몇 작품에서는 꽃을 의인화한 경우도 있다. 이를테면 <제1회 일본 엑스포 도야마 1992>의 두 송이 튤립

Man and Writing

693

tanaka ikko

The same process could happened in <Flower>, Tanaka worked on since the late 1980s. But this case has better example than Tanaka. He drew a large flower and this flower is treated as a portrait and act clearly and strongly as the main object. Iris from the 1990 solo exhibition <Tanaka Ikko Graphic Art Botanical Garden> reminded Korin's works, but in here, a piece and piece of flower becomes cynosure of al eyes as an ideal portrait. And in some cases he personified flowers. For instance, two tulips from <the 1st Japan Expo in Toyama>. Would this be considered as an example of extension of ecology study to plants? Or rather, it shows the flow of old Buddhistic idea tangled with naturalism. It does not matter if it was done consciously or subconsciously. According to this idea, some level of consciousness exists in human, animal, and even plants and this allows plants to be able to get salvation. In Narita international airport's large mural, Tanaka promotes the flower to a majestic monument. This flower symbolizes that the nature gets a huge attention by the whole world. And the international airport is the perfect place to talk about it. In other hand, this flower is a mark of old religious and cultural practice, happened over several centuries, like how all the gods detect every single detail of the nature. New image but related to the past — Tanaka's flowers are connected to the huge print series of flowers by Hokusai in 1830s. Some designers say that Tanaka might has the sixth sense. That is why he is able to maintain the modernness and respond constantly and yet prettily to the creativity what contemporaries require. What an interesting hypothesis.

Studying his art work and its impact on Japanese culture makes me to think that Tanaka, rather preoccupied the shared imagination of the mass and made suitable vision and situation to express contemporaries' old and new yearning and desire. Tanaka's works stimulate and sensitize contemporaries, suggest the direction and finally educate them to be able to evaluate the forms and reality

이다. 생태 탐구를 식물까지 확장한 것일까. 그렇다기보다 여기에는 신도(神道)의 자연주의와 서로 얽힌 오래된 불교 사상의 흐름이 모습을 보인다. 의식적으로인지 잠재의식에 의해서인지는 이 경우에 중요치 않다. 이 사상에 의하면 어느 레벨의 의식은 인간, 동물뿐만 아니라 식물에도 존재하며 이에 의해 식물도 구제받을 수 있다고 한다. 나리타국제공항의 대벽화에서 타나카는 꽃을 위엄 있는 기념비로까지 승격시킨다. 이 꽃은 지금 전 세계에서 자연이 큰 관심을 부르고 있다는 것을 상징한다. 그런 의미에서 말하자면 국제공항만큼 적합한 장소도 없다. 그러나 이 꽃은 동시에 자연의 모든 것을 신들이 사는 거룩한 환경으로 감지하려고 하는, 몇 세기에 걸친 오랜 종교·문화 수련의 표시이기도 하다. 새로운 것이면서 과거에 연결된 도상(圖像) — 타나카의 꽃들은 호쿠사이(北斎)가 1830년에 그린 유명한 대형판 화조화(花鳥畵) 시리즈 정신에 연결된다. 타나카는 몇몇 그래픽 디자이너들은 육감(六感)을 가진 것 같다고 말한다. 그래서 늘 현시대성을 유지할 수 있고, 끊임없이 그리고 확실하게 동시대가 요구하는 창조력에 응할 수 있다고 말한다. 흥미로운 가설이다.

694

오랜 기간을 통한 그의 작품과 일본문화에서의 그 임팩트를 관찰하면, 오히려 타나카는 이러한 집단공유의 상상력을 선취하여, 동시대인의 오래되거나 새로운 여러 가치에 대한 동경과 욕구를 표현하는 데 걸맞은 비전과 상황을 만들어낸 것이 아닐까 하는 생각이 든다. 타나카의 작업은 동시대인들을 자극하고 민감하게 만들어 그 감각을 갈고 닦아 방향을 부여하며, 마지막으로 그 이전에 무시당해왔던 형태나 현실을 평가할 수 있도록 교육하는 것처럼 보인다. 그때까지 주목받지 않았던 형태들도 사회에 뿌리를 둔 미적 일관성을 유지한 표현이 되어간다. 즉 '스타일'이다. 자신의 작업을, 감정적으로 혹은 지적으로 살아갈 뿐만 아니라 몸으로도 사는 그 방식, 자국의 문화 도상을 현대를 향해 창조적으로 재해석하고 혁신하여 다시 제안하는 방법은 오늘날의 정체성 위기에 대한 타나카 나름의 대답이다. 다도의 미학 등 그래픽 디자인 외의 타나카의 활동도 그의 탐구의 활력을 유지하며 도달한 균형지점 저 너머로 자신을 투사하도록 돕는다. 다도의 미학과 공예품이나

695

tanaka ikko

they have been ignored before. Some forms that were not noticed before become an expression that maintain the aesthetic consistency rooted to the community. That is, style. The way of reinterpret, innovate and suggest his works through emotion, intelligence and his way of living, is Tanaka's way of answering to today's identity crisis. Tanaka's non-graphic design activities including tea ceremony and tea ceremony aesthetics help him to maintain his studying dynamism and project himself over the point of balance he achieved. Deep interests in tea ceremony aesthetics, crafts works, or materials were mingled with each other and offered Tanaka an environment that is similar to Takagamine's Kōetsu-mura in a manner. It was some kind of salon, but since it happens today, there is no limit on space and it exists all over Japan. And the participants are artists, master craftsmen, graphic designers, art directors, editors, printers, potters, masters of tea ceremony, poets, intellectuals, photographers, and calligraphers.

With his works, Tanaka sometimes serves as an interpreter and generalizer for their works. And this solved the disconnection between graphic design and art and design and crafts that existed since earlier. In the process, the immutable standard is the mother nature(and each part forms the nature) and fidelity to the subject matter, which is the natural substance. This attitude might come from Tanaka's mind toward the art and life. That is, the deep respect to animism root and human and respect to physical weight of producing products. And be faithful to his name.

That is, Tanaka Ikko (田中一光) — a shiny glare from the middle of the field.

소재에 대한 깊은 관심이 어우러져, 어떤 의미에서는 타나카가 타카가 미네(鷹ヶ峰)의 고에쓰 무라(光悦村)와 비슷한 탐구와 작업을 위한 환경을 만들어내는 데 이르렀다. 일종의 살롱과 같은 것이지만, 오늘날의 일이기에 현재에는 생활의 필요상 공간적인 제약은 없으며 일본 전국에 산재해 있다. 거기에 참여하는 사람은 아티스트, 장인, 그래픽 디자이너, 아트 디렉터, 에디터, 인쇄인, 도예가, 다도의 스승, 시인, 지식인, 카메라 감독, 서예가들이다.

타나카는 자기 작품을 가지고 때때로 그들 작업의 해석자 겸 보급자로서의 역할을 한다. 이리하여 예부터 있었던 그래픽 디자인과 예술, 디자인과 공예 간의 단절은 근본으로부터 해소되었다. 이 과정에서 불변의 기준이 되는 것은 자연(그리고 자연을 이루는 각 부분), 소재의 자연물질에 대한 충실함이다. 이 자세는 아마도 타나카가 예술에 대해 또 '삶'에 대해 늘 가지고 있는 것에서 생겨났을 것이다. 즉, 신도적 애니미즘적 루트, 인간 일에 대한 깊은 경의(敬意), 그리고 어떠한 사물을 만들어내는 것에 있어서의 육체 무게의 존중. 바로 자신의 이름에 충실하게.

타나카 잇코(田中一光) — 밭 한가운데 빛나는 한 가닥 섬광이라고……

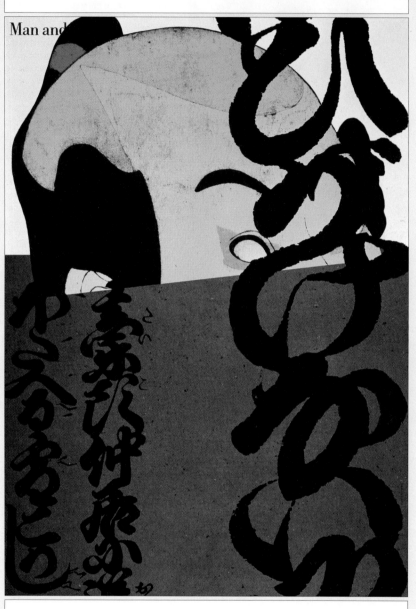

tanaka ikko

poster. man and writing - japan 3. 728 x 1,030. 1995.

xu.bing

쉬빙.徐冰.

china 1955-

1955년 충칭에서 태어나 베이징에서 자랐다. 주적(主敵)은 저장성 원링이다. 1977년 중앙미술학원 판화계에 입학하여 1981년 졸업하고 학교에 남아 후학들을 가르쳤다. 1987년 중앙미술학원 석사학위를 받았다. 3년 뒤 미국으로 이주하였다가 2007년에 돌아와 중앙미술학원 부원장, 지도교수로 임명받았다. 작품은 뉴욕 메트로폴리탄박물관, 런던 대영박물관, 프랑스 루브르박물관, 뉴욕 현대미술관(MoMA), 마드리드 레이나 소피아 국립미술관, 워싱턴 D.C. 아서 M. 새클러 갤러리, 체코 국립갤러리(Národní Galerie), 독일 루트비히미술관 등 예술기관에서 전시되었다. 베니스 비엔날레, 시드니 비엔날레, 상파울루 비엔날레 등 국제전에 참여했다.
작품은 미국 1997년 판 세계 예술사 교과서『지난 예술과 현대의 예술(Art Past – Art Present)』, 미국 및 유럽의 권위적인 세계 예술사 교과서『고금예술(Gardner's Art Through the Ages)』에 기재되었다. 2001년 미국 스미스소니언협회에서『쉬빙의 예술』(Brita Erickson), 2006년 미국 프린스턴대학교에서『지속성/전형 – 문자를 도상으로: 쉬빙의 예술』, 인민대학출판사에서『쉬빙: 연초기획』, 2009년 영국 Bernard Quaritch Ltd and contributors에서『천서를 창작하는 도로(Tianshu: Passages in the Making of a Book)』등을 출판했다.
1989년 중국 국가교육위원 훠잉둥(霍英东)교육기금회, 고교 청년교사의 교학 일등상, 1999년 그의 '독창성, 창조능력, 개인 방향과 사회에 대한, 특히 판화와 서법 영역에서의 중요 공헌을 한 능력'으로 미국에서 제일 중요한 개인 성과상인 천재상(MacArthur Award)을 받았다. 2003년 아시아문화의 발전에 대한 공헌으로 제14기 일본 후쿠오카 아시아문화상을 수상하였으며 2004년 웨일스 국제 시각예술상(Artes Mundi)을 수상했다. 심사위원이었던 오쿠이 엔벤조(Okwui Enwezor)는 축하말에서 "쉬빙은 문화의 경계선을 넘어 동서방 문화를 상호전환하고 시각언어로 그의 사상과 현실문제를 표현하는 예술가이다"고 말했다. 2006년 "문자, 언어, 서책의 사용에 대한 것과, 판화와 당대 예술에 관한, 두 영역 간의 대화와 소통에 거대한 영향을 주었다." 이에 전미판화가협회에서 판화예술 종신 성과상을 수여하였다. 〈미국예술〉 선정 '제일 주목받는 15명의 국제 예술계(2004 People in Review)' 인물로 평가받았다. 2010년 컬럼비아대학교에서 인문학 명예박사학위를 받았다.

Xu bing traces his family roots to Wenling, Zhejiang province. He was born in Chongqing, China in 1955. In 1977 he entered the printmaking department of the Central Academy of Fine Arts, Beijing (CAFA) where completed his bachelor's degree in 1981 and stayed on as an instructor, earning his MFA in 1987. In 1990, on the invitation of the University of Wisconsin-Madison, he moved to the United States. Xu currently serves as the Vice President of CAFA.
Solo exhibitions of his works have been held at the Arthur M. Sackler Gallery, Washington DC; the New Museum of Contemporary Art, New York; the Joan Miro Foundation, Spain; National Gallery of Prague and the Spencer Museum of Art, Kansas, amongst other major institutions. Additionally, Xu bing has shown at the 45th and 51st Venice Biennales; the Biennale of Sydney and the Johannesburg Biennale amongst other international exhibitions.
Over three years, Xu Bing's work has appeared in high-school and college text-books around the world including Abram's "Art Past – Art Present," Gardner's "Art Through the Ages" and Greg Clunas's "Chinese Art" a volume in the "Oxford History of Art" series, Jane Farver's Global Conceptualism: Points of Origin 1950s – 1980s (Queens Museum of Art Press) and Art Worlds in Dialogue (Museum Ludwig Press). In 2006, the Princeton University Press published "Persistence/Transformation: Text as Image in the Art of Xu Bing" a multidisciplinary study of Xu Bing's landmark work "Book from the Sky." In 2008, Professor Robert Harrist, Chair of Chinese Art at Columbia University, New York, began teaching a graduate seminar entitled "The Art of Xu Bing." London bookseller Bernard Quaritch publishes "Tianshu: Passages in the Making of a Book," a monographic study of Book from the Sky.
In 1989, Xu bing is honored with the Huo Yingdong Education Foundation Award from the China National Education Association for his contribution to art education. In 1999, Xu bing is the recipient of a MacArthur Fellowship in recognition of his "capacity to contribute importantly to society, particularly in printmaking and calligraphy." In 2003 Xu bing was awarded the Fukuoka Asian Culture Prize, and in 2004 he won the first Wales International Visual Art Prize, Artes Mundi. In 2006, the Southern Graphics Council awarded Xu bing their lifetime achievement award in recognition of the fact that his, "use of text, language and books has impacted the dialogue of the print and art worlds in significant ways." "Art in America" listed Xu Bing, along with 15 others, in their annual *Year in Review*. Is awarded Doctor of Humane Letters by Columbia University in 2010.

artistic calligraphy. men, nursery, women. 1998.

The calligraphic expression in Chinese contemporary art.
현대 중국 예술의 서예성 표현

from 6th art & clture in east asia
「동아시아 문화와 예술」제6집에서 발췌

liu.yuedi.

류에이디.刘悦笛.

(researcher, chinese academy of social sciences)
(중국사회과학원철학소 연구원)

translated.by.cho.insoo.

번역.조인수.趙仁秀.

(professor, korea national university of arts)
(한국예술종합학교 미술과 교수)

xu bing

Difference and relation between calligraphy and artistic calligraphy

From the world perspective calligraphy is a unique cultural phenomenon which is prevalent in East Asian culture of China, Japan and Korea and in the Arab culture with its Arabic calligraphy at the basis. This marks a clear difference from the use of logograms in the ancient Egypt and the non-calligraphic trend of phonograms in Indo-European languages. Chinese calligraphy with its basis on Chinese characters has been displaying its calligraphic style in a new context, that is, in the context of modern art and thus, opening up a new field of modern art from East Asian perspective. Tracing back the creative changes in the works of the internationally renowned artist Xu bing and examining the potential of calligraphy will give us some idea of how modern Chinese art can take a new road for 'new Chinese identity' through calligraphy.

In general, artistic calligraphy is understood as Chinese characters designed for decoration. Hence, it is usually believed as calligraphic art or applied characters. Thus artistic calligraphy is mostly well-shaped and eye-catching. Taking the meaning of artistic calligraphy into account, one can interpret artistic calligraphy as Chinese characters with artistic flavor. Not only has it more artistic characteristics than usual calligraphy, it shares the highest quality of art that calligraphy can achieve. However, one should keep in mind that artistic calligraphy in real life is considered as characters for practical use.

<A Book from the Sky> The reproductive energy of song typeface (放宋體)

Among the successful artists in Chinese modern art circle, there are few who use calligraphy in

서예와 도안문자의 차이와 관계

세계적인 차원에서 본다면 '서예(calligraphy)'는 한자를 사용하는 한중일 세 나라를 포괄하는 동아시아의 문화와 아랍 문자에 기초한 아랍의 문화에서 독특하게 나타나는 현상이다. 이는 고대 이집트의 상형문자에서 도상을 사용하는 것과도 다르고, 인도유럽어 계통의 표음문자의 비서예적 경향과도 구별된다. 중국의 서예는 한자의 형식에 기초하여 현대예술로 변모하면서 '서예성'을 드러내고, 이로써 동아시아 문화의 입장에서 참신한 현대예술을 개척해 나아가고 있다. 국제적으로 널리 알려진 쉬빙의 예술 창작에서의 변화를 사례로 하여 서예성의 풍부한 가능성을 살펴보는 것은 현대의 중국 예술이 어떻게 '새로운 중국성'을 획득할 수 있는지를 알려주는 중요한 일이다.

소위 도안문자는 일반적으로 다듬어 장식하고 미화시킨 한자이다. 일종의 장식을 위한 문자로 서예 예술인 동시에 실용성 있는 글자체에 속한다. 도안문자는 기본적으로 외관이 정리되어 있고 눈길을 끌기 쉽다. 영어로는 'artistic calligraphy'인데, 다시 중국어로 번역하면 '예술화 혹은 미술화된 서예'가 될 것이다. 따라서 이러한 해석에 기초하여 본다면 도안문자는 좀 더 예술성 있는 한자가 되는 듯하다. 서예보다 더 높은 예술 속성을 가지고 있으며, 게다가 서예가 가지고 있는 훨씬 높은 예술품격을 공유한다. 다만 현실에서 도안문자는 실용문자라는 점이다.

artistic calligraphy. men, nursery, women. 1998.

the traditional way. Rather, they reinterpret calligraphy in a brand new context. And Xu bing is one that stands out. The breath-taking work <A Book from the Sky>, which spanned over four years from 1987 to 1991, is a work of art based on the creative transformation of Song typeface (宋體字) and also one of his earliest works to adopt language into his works. Now the question: what are the characters that are used in <A Book from the Sky>? According to Xu-bing, they are false characters which he has invented himself. They have neither meaning nor concept. When seeing them for the first time, they rather look similar to simplified Chinese characters (異體字), giving an impression they have broken rules of the traditional Chinese characters (正體字). However, when taking a close look, one notices that they derive from the transformation of the radicals and strokes of Chinese characters. Thus, they can be described as imitated Chinese characters. Looking into them more carefully reveals that Xu bing's characters are similar to Tangut script (西夏文字) in terms that they are very rectangular, similar to bafen style and repetitive. Tangut script (西夏文字) was made by Tangut people of Western Xia (西夏) in a short period of time by imitating the Chinese characters, and one can assume that Xu bing's way of creating characters is similar to Tangut script (西夏). Both characters have lost their original meanings Chinese characters used to have. In this respect, Xu bing's original <A Book from the Sky> characters are hollow inside with no meanings in themselves and thus, become "dead" as soon as they are invented.

Through this, the Song typeface (放宋體) as depicted in <A Book from the Sky> becomes the characters of the heaven. And this is the very reason Xu bing sticks to Song typeface (放宋體). There is neither personality nor individuality in it, which prevents people from talking about certain styles. Here one can carefully draw a conclusion that what Xu bing created for the first time in the world can actually be explained as anti-calligraphic. Using 4000 movable types, which were all carved out by himself, Xu bing created a great work of art resulting in numberless reproductions of Song typeface (放宋體) characters. No

『천서(天書)』 방송체자(放宋體字)의 복제역량

현대에 성공한 중국 미술가들 중에는 전통적인 방법으로 서예를 사용하는 경우는 없다. 오히려 현대의 서예성으로 변모시킨다. 쉬빙은 이러한 예술가들 중에서 걸출하다. 1987년에서 1991년까지 4년에 걸쳐 완성하여 세상을 놀라게 한 『석세감: 세기말권』은 이후 『천서』라고 널리 불리게 된 작품이다. 이 작품은 '송체자(宋體字)'의 변형 형식으로 창조한 예술품이며, 그가 가장 일찍 언어를 사용하여 시도한 작품이다. 『천서』에서 사용하는 글자는 무엇인가? 쉬빙의 소개에 따르면 자신이 스스로 만들어낸 것이고, 세상에는 존재하지 않는 문자이다. 따라서 이렇게 만들어낸 글자는 의미도 개념도 없다. 처음 보면 이 글자들은 마치 한자의 '이체자(異體字)'와도 같다. 즉 공식 정체자(正體字)의 규범을 벗어나는 글자처럼 보인다. 그러나 자세히 살펴보면 이 글자는 한자의 부수와 필획을 변형시켜 만든 글자임을 발견하게 된다. 그러므로 한자라고 부를 수 없을지라도 일종의 모방한자라고 할 수 있다. 좀 더 신중히 살펴보면 쉬빙이 만든 글자들은 '네모반듯하고 팔분과 비슷하며 중복되는' 서하(西夏)의 문자와 비슷하다. 이는 서하의 당항족이 한자를 모방하여 단기간에 만들어낸 문자인데, 아마도 쉬빙이 글자를 만드는 기본 방식이 서하문자를 만든 방법과 흡사했기 때문일 것이다. 양자 모두 한자가 원래 가지고 있었던 의미는 완전히 상실했다. 따라서 쉬빙의 독창적인 천서의 문자는 내용이 없고 비어 있는 형식으로 세상에 나오자마자 사멸해버린 죽은 글자이다.

이렇게 『천서』에 나타나는 방송체(放宋體) 글자는 실제로 하늘의 글씨가 되는 것이다. 쉬빙이 방송체 글자를 사용하여 창작하는 이유는 이러한 문자에는 이미 개성이 철저하게 빠져 있기 때문이다. 여기에서는 조금도 양식을 이야기할 수 없기 때문이다. 따라서 쉬빙이 최초로 창작한 것은 사실 일종의 '반서예' 경향에 속하는 것이었다. 쉬빙이 직접 깎아 만든 4000여 개의 활자로 인쇄하여 이렇게 광대한 작품을 만들었을 때, 수많은 방송체 글자가 대량으로 복제되었을 때, 『천서』는 사람의 마음을 뒤흔드는 요소로 충만했다. 그러나 이렇게 가짜를 진짜처럼 하는 것은 황당한 것이었다. 보다 중요한 것은 이렇게 새로운 문자가 지닌 일종

artistic calligraphy. men, nursery, women. 1998.

wonder that it caused awe and admiration among viewers. However, what counts more is not the fake inspiring reproduction itself but the effect of interculturality that the new characters have brought about. According to Xu bing, Westerners believe these characters to be the true Chinese characters, whereas Chinese think they are from the ancient times. Furthermore, Japanese regard them as Hangeul and Koreans as Japanese Katagana. This in the end makes an explanation for <A Book from the Sky> necessary since it can be interpreted differently according to what culture the viewer belongs. And whatever the case is, artistic calligraphy regardless of viewers' backgrounds cannot be regarded as art. Rather, it's a form of calligraphy that can become art. Pointing out the anti-calligraphic feature of Xu bing's characters, some argue that the formal transformation of artistic calligraphy goes against the traditional rules of Chinese characters.

<ABC> Phonetic experiment in the style of chinese pidgin english(洋經浜)

After moving to the USA in 1990, Xu bing did some artistic attempts –not very successful- during his language switch between the two cultures of China and the USA. Among them, <ABC> is one of the most significant works he displayed in his early phase of his life in the USA. <ABC> is made up of series of terracotta installations in the shape of movable type, on which the sound of the Roman alphabets is inscribed. Although there is the International Phonetic Alphbet(IPA), it does not apply to Chinese due to the unique cultural phenomenon in China. For instance, English 'Yes' is transcribed to '이에서' in Chinese, English 'Husband' to '黑漆板凳'. And one calls this Chinese Pidgin English, a term for a mixed language of English and Chinese that came into vogue in Yangjin Bang(洋經浜). Here, one traces the characteristic of language, that of transforming and mingling, which in the end becomes the language that is neither Chinese nor English. And that's how we come to meet Chinese English, in fact Chinglish now.

Besides, a single Chinese character represents another single Roman alphabet. For instance, the

의 문화교차(inter-culturality)의 적극적인 효과이다. 쉬빙의 설명에 따르면 서양인은 이를 진짜 한자라 믿고, 중국인은 고대 문자라고 생각한다. 일본인은 한글이라고, 한국인은 일본 가나라고 인식한다. 이는 다른 문화적 배경을 지닌 사람들이 『천서』를 대면했을 때 불필요한 문화적 설명을 하도록 만든다. 관람자들이 그 뜻을 모르더라도 전통 관념에 따라 도안문자는 예술이 아니고 서예가 예술이 된다. 쉬빙이 창작한 '반서예성'의 기초로 혹자는 도안문자의 형식변화는 중국전통의 문자 규칙과 반대라고 한다.

<ABC> 양경빈(洋經浜)식의 표음 시도

쉬빙은 1990년에 미국으로 건너간 이후, 중국어와 영어의 언어 전환의 와중에서 그다지 성공적이라고 할 수 없는 예술적 시도를 하였다. 그중에서 <ABC> 설치는 그가 미국에서 발표한 초기의 중요한 작품이다. 토기로 만든 활자 모양의 물건인데, 영어 알파벳의 발음을 한자로 표시한 것이다. 널리 알려져 있듯이 발음부호는 국제화된 표기방식이지만, 한자의 발음은 중국의 독특한 문화현상이다. 예를 들어 Yes를 '이에써(也司)', Husband를 '헤이치반등(黑漆板凳)'이라고 하는 것이다. 이를 언어에서 '양경빈화(洋經浜化, 조계지인 양경빈에서 유행한 중국어가 섞인 영어)'라고 한다. 이러한 언어의 특징은 변화하고 뒤섞이는 것으로 영어도 아니고 중국어도 아닌 언어가 되는 것이다. 이로써 중국어 냄새가 나는 영어, 즉 중국어식 영어 혹은 칭글리시(chinglish)가 된다.

쉬빙은 한편으로는 하나의 한자로 하나의 영어 알파벳을 표시한다. '아이(哀)'로 A를 표시하고, '비(彼)'로 B를 표시한다. 또 한편으로는 여러 개의 한자로 하나의 알파벳을 표시한다. '아이(藹)' '커(克)' '스(思)'로 X를 표시하는 것인데 물론 이 표시와 중국어에서 자주 사용하는 '마커스(马克思, Marx)'의 유사성은 별도의 은유(metaphor)가 된다. 따라서 쉬빙은 '중영 26 알파벳 대조표'를 만들었고, 이는 중국어와 영어의 간단한 대조라고 할 수 있다. 이때 쉬빙

English letter 'A' is rendered by the Chinese 'ai', which means sadness. 'B' is rendered 'bi', which means land. But there are also cases where several Chinese characters represent one single Roman alphabet. 'ai'(溰) 'ke:r'(克) 's'(思) compose the alphabet X. Of course, the similarity between such signs and Marx (马克思) that is frequent in use become another metaphor. Xu bing created a comparative list of 26 Chinese-English alphabets, which is a simple comparison between Chinese and English. Through this process, Xu bing in an excitement about the new culture saw China and the West in the context of language pronunciation. His way of communication method was to incorporate Chinese and English language into his artistic methodology. By doing so, he revealed that the two languages form a kind of unequal relationship whereby Chinese relies more on English. However, an artistic communication as such rests on the surface level only by not getting more in-depth. Anyways, Xu bing during his years on <The Book of the Sky> worked as a imitated letters (仿漢子), which later developed into a comparative research between Chinese and English.

<Chinese character calligraphy> compatibility and misunderstanding of chinese and english

After the year 1993 Xu bing presented works of great success, the so-called <Chinese Character Calligraphy(한자서예)>. At the exhibition <Breakout: Chinese Art outside China> organized by Asia Society in 2007, Xu bing for the first time publicized that English is the lingua franca. Although he used the English language in an experimental way, the result was not successful. However, with the font 'English Chinese Character' which he designed he finally made a hit. How can this be explained?

At the base of Xu bing's works lie the questions on the relationship of philosophy, language and characters. Thus his philosophy in general bears traces of skeptical thoughts on language. Characters make up an important part in Xu bing's works and they are remodeled compared to the traditional ones. In the words of Xu bing, characters play a central role in the cultural anthropology. Thus, remodeling characters means remodeling

은 새로이 이주한 문화에 대한 흥분 속에서 언어의 발음 측면에서 중국과 서양을 서로 바라본 것이다. 그는 중국어와 영어로 예술 속에서 언어에 의한 소통을 얻어낸 것이다. 게다가 중요한 것은 중국어와 영어 두 언어가 불평등하며, 기본적으로 중국어가 영어에 의존한다는 것이다. 사실 이러한 소통은 표면에 그치고 두 언어의 심층까지 들어가는 것은 어렵다. 여하튼 쉬빙은 이미 『천서』의 시기에 '방한자(仿漢字)'의 상황에서 창작을 하였고, 이를 전환하여 중국어와 영어 사이에서 줄타기를 하는 것이다.

『한자서예』 중국어, 영어의 호환과 오해

쉬빙은 1993년 이후 크게 성공한 작품을 발표하기 시작했다. 1994년 완숙한 경지에 이른 『한자서예(方块字書法)』 유형이다. 쉬빙은 2007년 아시아소사이어티(Asia Society)에서 주최한 〈돌파: 중국 밖의 중국미술(Breakout: Chinese art outside China)〉이라는 전시에서 처음으로 공개적으로 언급하기를 자신은 일찍이 영어가 세계언어라고 인정했다고 하였다. 그는 영어를 사용하여 시험적으로 창작을 하였지만 성공적인 성과를 거두지는 못했다. 그러나 '영어한자'라는 자신이 만든 폰트로 성공을 거두었다. 그 이유는 무엇인가?

쉬빙의 사고는 근본적으로 사유, 언어, 문자 사이의 근본적인 관계에 대한 것이다. 이러한 그의 사고는 언어에 대한 회의론적인 색채를 띤다. 쉬빙의 예술에서 중요하게 드러나는 것은 문자이다. 보다 정확히 말한다면 개조를 거친 문자이다. 쉬빙 자신의 방식으로 본다면 "문자는 인류문화 개념의 가장 기본적인 요소이다. 문자의 개조는 인간이 사유에 대하여 가장 본질적인 측면을 개조하는 것이다." 〈한자서예〉는 속칭 '영어한자'이다. 원래는 신영어서예(新英文書法, New English Calligraphy)라고 하였는데, 왜 '새로운 한자서예'라고 하는가? 이유는 간단하다. 이는 '가짜 한자'의 도식(圖識)과 흡사하다. 사실 영어 알파벳의 구성은 간단하므로 하나의 한자로 하나의 영어 단어를 만든다. 예를 들어 〈ABC〉는 아직 중국어를 사용

xu bing

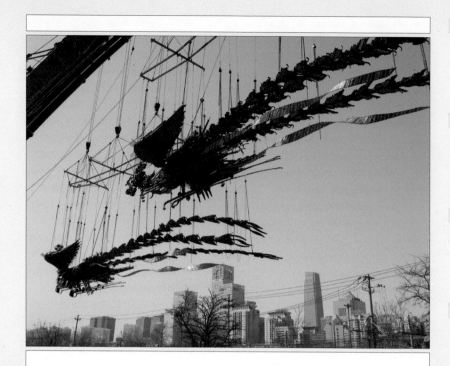

phoenix project. 2008 - 2010.

the very essential features of human philosophy. <Chinese Character Calligraphy> is commonly known as 'English Chinese Character'. At the beginning, it was called 'New English Calligraphy'. Then why is it renamed as 'New Chinese Character Calligraphy'? The reason is simple. This new calligraphy is similar to the diagram of the 'fake Chinese characters'. Since the composition of a Roman alphabet is simple, one composes one English word through one single Chinese character. For example, whereby <ABC> ends up with a visualization of English pronunciation using Chinese language, <Chinese Character Calligraphy> on the other hand uses Roman alphabets as radicals, which form a character. In other words, <ABC> rests on a parallel and respective correspondence of one Chinese character to another single Roman alphabet. However, in <Chinese Character Calligraphy> the single Chinese character becomes a meaningful space full of richness. One character corresponds to one word. The arrangement and combination of Roman alphabets are based on the structure of the Chinese character. However, arranged and combined from left to right, from top to bottom or vice versa, Roman alphabets roam freely in the square without any formality and constraint.

<Chinese Character Calligraphy> is also called 'New English Calligraphy'. Then why does Xu bing name the new art as calligraphy? First, the new Chinese character has to be useful. Xu bing already demonstrated how such a new character can be written using a Chinese brush. A character as such does have its own style of writing. Xu bing worked it out in a creative way. Since Roman alphabets are made up of phonemes and syllables, it's difficult to write them in calligraphic style. However, Xu bing's English Chinese characters overcome this limit. They become calligraphy. Here, a certain irrationality exists. Chinese try to read out and understand the Chinese Character Calligraphy. But in the end they find out that it is not Chinese language. On the other hand, those who have a command of English language will have a hard time figuring out the meaning of Chinese Character Calligraphy at first sight. However,

하여 영어 발음을 표현한 것이라면 『한자서예』는 영어한자의 조형요소가 되는 영어 알파벳으로 한자의 부수를 구성하고 이를 조합하여 글자를 만든다. 예를 들어 〈ABC〉는 오직 하나 혹은 여러 개의 한자로 하나의 영어 알파벳에 대응하도록 한다. 그러나 『한자서예』는 작품 속의 하나의 글자가 더 큰 의미가 있는 공간을 포함한다. 한 글자는 하나의 단어에 해당한다. 단어의 알파벳 배열과 조합이 한자의 방식일뿐더러, '왼쪽에서 오른쪽으로'라는 배열이 변하여 위쪽도 되고 아래쪽도 되고, 왼편이었다가 오른편이었다가 하면서 자유로운 배열을 이룬다.

『한자서예』는 '신영어서예'라고도 부른다. 쉬빙은 왜 그의 '새 글자' 예술을 서예라고 했는가? 우선 새로운 한자는 쓸 수 있어야 한다. 쉬빙은 이미 이러한 새 글자가 어떻게 중국의 붓을 사용하여 쓸 수 있는지를 실연을 통해 보여주었다. 이러한 새 글자도 일정한 필법을 갖추고 있다. 그러나 새 글자도 쓸 수 있다는 특징이 이것과 중국 전통의 서예가 질적으로만 다를 뿐 구성은 같다는 것을 의미하는 것은 결코 아니다. 쉬빙은 그 속에 창의성을 개입시켰다. 현재의 영어는 음소로 음절을 구성하는 문자이므로 서예로 쓰는 것이 어렵다. 그러나 쉬빙의 영어한자는 서예가 될 수 있다. 여기에는 흥미로운 불합리성이 있다. 중국인은 이러한 한자서예를 읽고 이해하려고 하지만 중국어가 아니다. 반대로 영어를 이해하는 외국인은 이러한 새 글자를 이해하는 것이 매우 어렵다. 그러다가 자세히 살펴본 후, 점차 개념을 그려내는 일종의 원칙이 있다는 것을 파악하는 순간 갑자기 깨닫게 되고, 영어문자를 판독할 수 있게 된다. 이런 종류의 표리불일치의 효과는 쉬빙 예술의 매력이다. 중국인과 외국인에게 한편으로는 오인하는 효과를 준다. 외국인은 한자의 특징을 이해하지만, 중국인은 판독하지 못한다. 새 글자는 한자의 글씨 형태나 구성 방식과 유사하지만 나중에는 그것이 사실 영어라는 것을 발견하게 된다. 또 한편으로는 상호 판독이 가능하다. 중국인은 표면만을 인식하고 뜻은 알지 못하고, 외국인은 표면을 이해하지 못하고 뜻만 안다. 더 나아가 쉬빙은 양방향의 발전으로 자신의 영어한자를 만든다. 한편으로 그는 신기술의 발전으로 향하고, 또 한편으로는 정치문화로 확장한다. 전자의 예는 쉬빙이 컴퓨터 글씨가 만들어지는 방식으로 영어한자를 만들

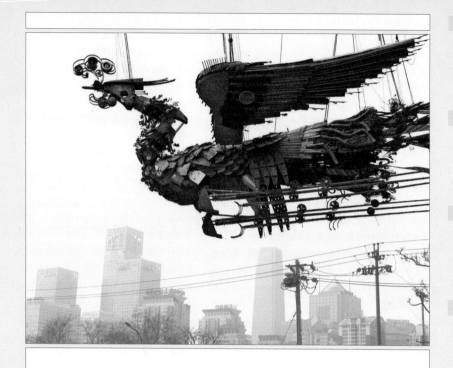

phoenix project. 2008 - 2010.

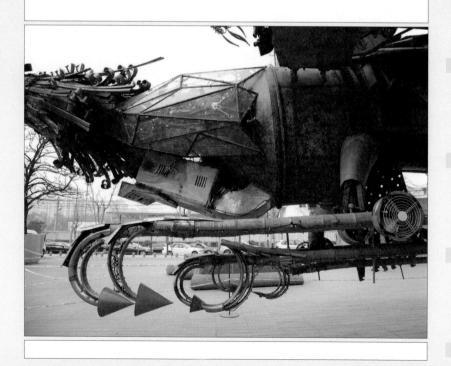

as soon as they find out that there is a kind of rule behind this concept, they manage to read the Roman alphabets. And this is the dual discordance which makes Xu bing's works appealing. This is the effect of misconception, where foreigners understand the characteristics of the Chinese characters but Chinese do not. The new character at its surface level is similar to the form of a Chinese character and its composition but it later reveals that it is English. This characteristic of Chinese Character Calligraphy makes a mutual deciphering possible; Chinese recognize the surface only and do not get the meaning behind it. Foreigners with English knowledge can decipher the meaning but do not recognize the surface image. Furthermore, Xu bing's way of composing English Chinese character develops into two directions: one into the terrain of new technology and the other, it expands onto the politics and culture. The former case explains his way of composing English Chinese Character based on digital fonts. The most representative would be <Your Surname Please> from the year 1998. When one types in his name in English on the computer, a new letter appears then on the screen set in various typefaces such as Song typeface (放宋體), traditional Chinese character (正體) and regular script (楷体). In the case of the latter, Xu bing incorporated a number of Chinese literature and lyrics from traditional to Chinese pop as well as quotes that have a tint of the Cultural Revolution by using his new characters.

One of the most famous works in this line is <Art for the People>. The title comes from Mao Zedong's key philosophy "Our culture and art must serve for the People". The slogan was laid out on a red banner. And there is another work called <New English Calligraphy: Excerpted Quotes by Mao>(2003). Using new characters he visualized a part of Yanan Forum on Literature and Art which Mao announced in 1942. The part he excerpted was "Becoming Popular"; "Why should we achieve popularization? We all should unite together regardless of what mentality we have. Whether it's the mentality of the creative class or of the labor, farmer and soldier class, we should come together by learning one single language of the

면서 시작되었다. 가장 대표적인 작품이 1998년의 〈당신의 성은?(你貴姓)〉이라는 작품이었다. 여기에 참여하는 사람이 컴퓨터로 자신의 영어 이름을 기입하면 스크린에 이에 해당하는 새 글자가 나타난다. 동시에 중국어의 방송(放宋), 정체(正体), 해체(楷体) 같은 몇몇 도안문자의 변화형식도 있다. 후자로는 이러한 새 글자를 사용하여 수많은 중국 고전 시가, 대련, 가요를 쓸뿐더러, 또한 특별히 문화대혁명 색채를 띠는 구절도 많이 쓴다.

예를 들어 가장 유명한 것은 〈예술은 인민을 위해 복무한다〉인데 이는 모택동 주석의 어록 중 "우리의 문화 예술은 반드시 수많은 인민을 위하여 복무해야 한다"는 기본 사상이다. 쉬빙은 특별히 이 작품에서 붉은 깃발의 표어로 펼쳐 보였다. 글자가 비교적 많은 2003년의 『신영어서예: 모택동 어록 발췌』가 있다. 여기서 쉬빙은 새 글자를 사용하여 모택동이 1942년에 발표한 '연안 문예강화'의 내용을 적었다. 그중에서도 특별히 '대중화'에 대한 부분을 선택하였다. "왜 대중화를 달성해야 하는가? 우리의 문예공작을 하는 사람들의 사상감정과 노동자, 농민, 병사 대중의 사상감정이 하나가 되어야 한다. 이를 위해서는 군중의 언어를 배워야만 한다. 군중의 언어를 잘 이해하지 못한다면 어떻게 문예창조를 이룰 수 있겠는가?" 여기서 쉬빙은 한편으로는 예술의 평민화를 실현하고 예술이 군중의 언어를 사용하여 발언하도록 한다. 또 한편으로는 현실에서 예술을 바라보며 언어화 및 관념화를 시도한다. 결국 자신의 예술로 일종의 요셉 보이스가 의미한 광대한 '사회조각(社會雕塑: The Social Sculpture)'을 시도하는 것이다.

쉬빙이 파악한 '중국 서예 정신'의 실질성

전체적으로 본다면 쉬빙의 예술에서 운용하는 '서예성'은 실제로 앞에서 파악한 중국 전통 서예의 기본정신이다.

xu bing

711

book from the ground. 2003.

mass. If there is no language of the mass, there will be no cultural revolution, either." Quoting this, Xu bing aimed at delivering two messages: one is that art should exist for the common people. The other message is about the importance of the real world, which can also be explained in terms of "The Social Sculpture" once manifested by Joseph Beuys.

Substantiality of the 'Spirit of Chinese Calligraphy' in the words of Xu bing

In general aspect, the calligraphy that Xu bing demonstrates in his art works has its basis on the philosophy of traditional Chinese calligraphy.

1.

Xu bing presents calligraphy where diagrams and figures unite. Xu bing's art is based on the philosophy of Chinese iconography. He knows the mechanism of Chinese character and accomplished the what-so-called 'the age of reading images' which Chinese had already experienced thousands years ago. In China, the forms of the Chinese characters come before reading. Xu bing attempted sentences that are made up of diagrams and figures. In his <Book of the Sky> there were figures without diagram. Or it can be the figure or diagram of the language as seen in <English Chinese Character>. In <Birds Fly> figures become diagrams, and in <Reading Landscape> the opposite occurs. In fact, Xu bing knows how to play energetically between the tension that diagrams and figures create. What is more important is the relationship between calligraphy and artistic calligraphy. In <A Book of the Sky> it was the artistic calligraphy that was heavy in use, but the new characters that Xu bing made after the invention of 'English Chinese Character' are results of unique forms which share the characteristics of artistic calligraphy and calligraphy at the same time. Since <Book from the Ground> aims at popular signs thoroughly, it has lost its calligraphic expressiveness totally.

2.

Calligraphy is a living form of art and works as an impetus in Xu bing's creativity. Xu bing does

1.

도식과 도형이 합일된 서예 관념을 시사한다. 쉬빙은 결정적인 중국 사유방식의 각도로부터 예술을 창작한다. 그는 한자의 작용을 깊이 인식하고 중국인이 수천 년 전에 이미 달성한 소위 '그림을 읽는 시대'를 고려했다. 중국인은 한자를 읽을 때 글씨의 형태가 이미 보는 것에 영향을 주기 때문이다. 쉬빙의 작품도 도식과 도형의 관계로 만들어지는 문장을 시도하였다. 혹은『천서』처럼 도식이 없는 도형, 혹은〈영어한자〉처럼 언어의 도형이기도 하고 도식이기도 하다. 혹은 〈새가 난다〉처럼 도식이 점차 도형으로 변하기도 하고, 〈풍경읽기〉처럼 도형이 점차 도식으로 변하기도 한다. 쉬빙은 도식과 도형의 장력 사이에서 창작의 왕성한 역량을 드러낸다. 또한 중요한 것은 서예와 도안문자의 관계인데, 예를 들어『천서』에서 주로 사용하는 것이 도안문자라면, 쉬빙이 '한자영문'을 발명한 이후 그가 창조한 새로운 글자는 도안문자와 서예 사이에 위치하는 독특한 형태이다. 〈지서〉 계열은 철저하게 '통용기호'를 추구하므로 '서예성'이 표현을 완전히 상실했다.

712

2.

서예는 살아 움직이는 생활예술이며 쉬빙의 창작을 계발한다. 쉬빙은 그가 창작하는 것을 예술이라고 인정하지 않는다. 그는 실제로 예술로써 기본적인 생활형식을 만들어낸다. 비록 보이스가 사회조각이라는 관념을 제창하지만 쉬빙은 마오쩌둥이야말로 진정한 최고의 사회조각가라고 여긴다. 쉬빙은 종종 그의 오랜 말을 인용한다. "예술은 생활에서 기원한다." 생활이 어디에 있고 그 문제에 직면하여야 하고, 문제가 있는 곳에 바로 예술이 있다. 그는 인터뷰에서 예술 계통에서 이탈하여 사실로부터 창작할 것을 표시한다. 이러한 계통의 내부에서 작업을 하는 것은 '이루어낼 수 없는 것이고 공헌하는 바가 없다'고 생각하기 때문에 중요한 것은 이러한 계통과 함께 어떠한 거리를 유지하느냐이다. "당신은 창작을 생각할 필요 없고 예술 자체를 고려해야 한다. 양식, 유파, 재료 등의 문제를 고려할 필요가 없고 예술 계통의 중간에서 작업을 할 필요도 없다." 쉬빙은 예술의 진전에서 사유능력의 진전을 보기 때문에, 서예가 본래는 생활예술이기 때문

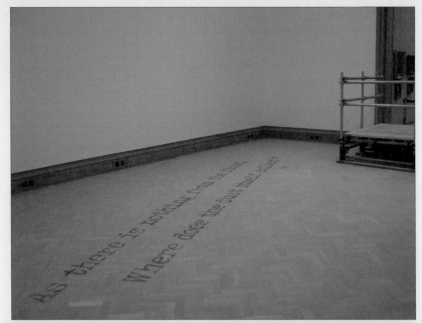

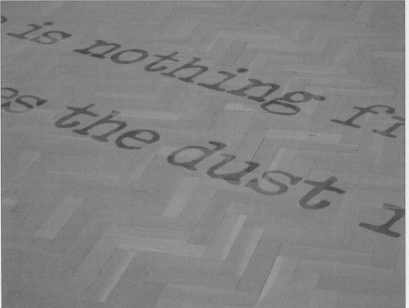

xu bing

where does the dust itself collect. 2004.

not regard his works as art. Rather, he creates everyday life through art. Although it was Beuys who manifested 'The Social Sculpture', to Xu bing it's Mao who is the true and best social sculptor. Xu bing often quotes old sayings by Mao, one of which goes "Art has its roots in daily life." Art becomes visible where life exists. In an interview Xu bing insisted on getting rid of art. Anything that is creative should start from daily life and facts. He thinks that working within art field won't do much and does not contribute to anything. Since it is useless, he suggests to keep a healthy distance from the art field. Xu bing believes in the parallel progress of art and thinking. And since calligraphy originates from everyday life and language, Xu bing tries to set up his own creative language through calligraphic expressiveness.

3.

Calligraphy is another process of writing and takes a critical role in Xu bing's philosophy of art. Xu bing's purpose is not to show off the dynamic movement of a calligrapher in statically appearing Chinese characters. His working method is more similar to Jackson Pollock's dripping technique as seen in Pollock's Abstract Expressionism. He also tries to make his calligraphy more interactive through viewer's participation. In the work <Your Surname Please> each outcome has a different meaning depending who takes part in. By becoming a part of the working process, the viewer finds out that each outcome is another new English calligraphic art. An interaction as such has been more emphasized in his original work <Introduction to New English Calligraphy>. Visitors even learn new calligraphy in an art museum calligraphy class. And after finishing the class, the participant can take home a set of calligraphic tools such as a brush, an ink stick, a scrapbook of writings and pictures and letter specimens with him/herself for free, through which artistic creativity expands onto the daily life and becomes a part of it.
Lastly, Xu bing's way of thinking is basically Chinese. This is due to the heavy influence of the iconographic characters on Chinese way of thinking and aesthetics. It's not about drawing; it's

에(따라서 훨씬 더 생활 계통과 언어체계에 속한다) 쉬빙은 '서예성'으로 새로운 예술언어를 만들고 드러낸다.

3.

서예에서 관심을 기울이는 것은 글씨를 쓰는 과정이며 또한 쉬빙의 예술이념을 계발하는 것이다. 쉬빙은 보는 이로 하여금 정태적인 한자에서 서예가의 운동을 알 수 있게 하는 것이 아니다. 추상표현주의의 드리핑에서 예술가 폴락의 작업과정과 흡사하다. 또한 보는 이가 직접 참여하여 서예창작을 하도록 시도한다. 〈당신의 성은?〉에서는 이름이 다른 사람들이 각기 다른 의미를 지닌다. 그들은 참여하는 과정을 통하여 이것이 동일하지 않은 새 영어서예 작품이란 것을 알게된다. 특별히 〈신영어서예입문〉이라는 독특한 작품에서 보는 사람들이 직접 미술관의 서예교실에서 새 서예를 배우도록 한다. 또한 보는 이가 교실을 떠날 때 무료로 붓, 먹, 서첩, 글씨본의 한자서예 연습교재 세트를 받아간다. 이로써 계속하여 예술창작이 연장되어 생활 속에 들어온다.

마지막으로 사유방식의 각도에서 본다면 쉬빙의 기본적인 방식은 중국식이다. 이는 도상화의 문자가 이미 중국인의 사유와 심미방식에 영향을 끼쳤기 때문이다. 서예는 결국 글자를 쓰는 것이지 그림을 그리는 것은 아니다. 필요한 것은 읽는 것의 기초이며, 글자를 그린다는 말은 별도의 논의 사항이다. 특히 이러한 영문 한자로 시를 쓴 작품에는 예술가가 중국과 서양 양쪽의 문화를 서로 융합하려고 노력하는 것을 볼 수 있다. 이러한 시도는 매우 성공적이라 하지 않을 수 없다. 다만 한자와 영어는 결국 두 개의 글씨를 쓰는 체계이지만 한자의 서예성으로 영어를 쓰는 것은 쉬빙의 대단한 창의성과 창조이다. 이러한 원본의 선형 글쓰기의 통시성이 영어 글자, 단어, 어구가 한자의 부수와 같은 방식으로 더해지면서 공시성이 공간조합을 이룰 때, 영어의 언어가 중국어 시사와 대련을 이루는 방식을 따르면서 서예성을 드러낼

about writing. Thus the importance of reading rises up. Drawing characters is another issue. When looking at his works where he wrote poems in English Chinese Characters, one feels Xu bing's endeavor to fuse and unite Chinese and Western culture, which was truly successful. It is this superb and great creativity of Xu bing that he writes English that is based on the calligraphic nature of Chinese characters. Thus when the diachrony of the linear writing system of English language adds on a new level of synchrony by incorporating English letters, words, phrases as radicals, and when English language reveals its calligraphic expressiveness by sparring with Chinese, and lastly, when the viewer catches the meaning of English words and appreciates the new calligraphic style at the same time, Xu bing's voice becomes silent and the English way of thinking becomes Chinese character alike.

Xu bing always seeks for a universal language. And this search for universality is analogous with the way Xu bing's art drifts apart from the Chinese tradition. We see thus how calligraphic expressiveness retreats more and more in his works.

때, 보는 사람이 영어의 의의를 이해하는 동시에 새로운 서예 양식을 감상할 때, 쉬빙의 확신이 숨겨지고 침묵으로 바뀌면서 영어의 사유방식은 한자화된다.

쉬빙은 보편화되는 언어를 추구한다. 이러한 보편성의 모색은 마치 쉬빙의 예술과 중국 전통이 점점 더 멀어지는 것과 비슷하다. 따라서 우리는 그의 작품에서 서예성이 점차 희박해지는 것을 본다. 그러나 쉬빙이 세계어를 획득한 것을 알지 못할 때, 현대 중국 예술은 어떻게 중국어를 사용하여 이야기할 수 있을까?

The irresistible charm of letter

- thoughts from Typojanchi

ahn.sang-soo.

(graphic designer, organizing committee chair of Typojanchi 2011)

1.

East Asia

According to the research of genetic anthropologists, mankind evolved from East African Pithecanthropus erectus150,000 years ago. Through mutation and evolution, the Africans spread into continents, and finally reached East Asia.

After that, history of mankind begun with invention of the letter, and civilization rapidly developed with invention of metal type 600 years ago.

The first letter born in East Asia was Chinese characters. It initially was a numinous letter which was used as a shamanistic instrument to receive a divine revelation. Chinese characters, responding to objects and meanings, once became mythicized into a fetish, and soon begun to rule over the East Asia.

However, the surrounding countries, using different spoken languages, attempted to make letters of their own. Kitan, Minyak, Jurchen, Vietnam, and more countries each made letters that resembled the Chinese character. Mongolia made Paspa script based on the Tibetan letter. None of them survived until today, the only survived were letters of Japan and Korea.

Spoken languages of Japan and Korea, the Altaic language, was different from that of China, the Sino(Tibetan) language from the beginning. Japan and Korea had no letter to write their spoken language, thus decided to borrow the Chinese character. The difference

억누를.수.없는.글자의.매력.

타이포잔치.생각

안상수.安尙秀.

(시각.디자이너,.타이포잔치.2011.조직위원장)

1..동아시아.

유전인류학자들의.연구에.따르면,.
인류는.15만.년.전
동아프리카의.직립원인에서.진화했다고.한다..
그.아프리카인은.돌연변이와.진화를.거쳐.
대륙으로.퍼졌고
이윽고.동아시아에.다다랐다..

그.뒤.글자가.발명되면서.인류.역사가.
시작되었고.
600여.년.전.발명된.금속활자로.인류.문명은.
급속히.발전했다..

동아시아에서.가장.먼저.태어난.글자인.한자는.
처음에는.주술적.도구로.하늘에.계시를.청하는.
신령스러운.글자였다..
사물과.뜻에.대응하는.한자는.신화화되어.
물신(物神)이.되기도.하더니.
이내.동아시아를.지배하게.되었다..

그러나.한자를.사용하는.중국과.입말이.다른.
주변.나라들은.
제각기.제.나라의.글자를.만들려고.했다..
그렇게.거란,.서하,.여진,.월남.등은.각각.
한자를.닮은.글자를.만들고.
몽골은.티베트.글자를.참고해.파스파.글자를.
만들었으나.
모두.지금까지.이어지지.못했다..
살아남은.것은.오로지.한국과.일본이.
만든.글자였다..

한어(漢藏語,.Sino-Tibetan.Language)를.
사용하는.중국과.알타이어를.사용하는.
한국과.일본은.애초부터.입말이.서로.달랐다..
입말을.적을.글자가.없었던.한국과.일본은.
한자를.빌리기로.한다..
그렇게.한국과.일본은.각각.한자를.

722

ahn.sang-soo

between languages and letters were complemented by adopting Edu(吏讀), which used the interpretation(釋) and reading(讀), or meaning(訓) and sound(音). Japan, with simple syllables, made Kana transformed from Chinese character in 8c. Chosun, with thousands of syllables, designed a new conceptual phonogram Hangeul in 15c. It was a wisdom to preserve their languages from living under the Chinese character.

The three East Asian countries then begun to retain uniquely different letter systems on the historical foundation of Chinese character.

Thus East Asia is living under different yet harmonic letters; China under pictograph-ideograph Chinese characters, Japan under grapheme Kana, Korea under a new phonogram Hangeul.

This is a contrast to all European regions using Latin Alphabet, or many Arabic countries using same letters.

Because the term "Typography" is Western, when people hear the word they immediately reminiscent of Gutenberg. However, the history of East Asian typography has existed for much longer time. Not only the skills, such as clay type, wooden type, metal type, but also the cultural and artistic spirit in it is old and deep.

2.
Dance of ink and brush

East Asian's attitude towards the letter is unique. To them, letter is a philosophy, an artistic contemplation target, a means of expression. In the center exists the calligraphy.

Calligraphy is the hidden strength of East Asian typography. Brush is the center of gravity.

말과.글자의.차이를.새김(釋)과.읽음(讀)으로.
구사하는.이두(吏讀)로.
또한.훈(訓)과.음(音)으로.응용했다..
낱내가.단순한.일본은.8세기에.한자를.
변용(變容)해.가나를.만들고.
낱내가.1천여.개가.넘었던.조선은.15세기에.
새로운.개념의.소리글자인.한글을.멋지었다..
이는.한자.글자살이에서.
제.나라.말을.보존하려는.지혜였다..

이렇게.동아시아.세.나라는.
이렇게.한자의.역사적.바탕.위에.
서로.다른.특수한.글자체계를.지니게.되었다..

이로써.동아시아에서.
중국은.그림글자-뜻글자인.한자로.
일본은.낱내글자인.가나로,
한국은.새로운.소리글자인.한글로.
서로.다른.독특한.어울림의.
글자살이를.하는.것이다..

이는.유럽.지역.모두가.라틴.알파벳을.
사용하거나.
아랍의.여러.나라가.같은.글자를.사용하는.
것과는.대조적이다..

타이포그래피가.서양말인.탓에.
사람들은.이.말을.들으면.
가장.먼저.구텐베르크를.연상하지만.
동아시아.타이포그래피의.역사는.
그보다.훨씬.오래되었다..
진흙활자,.나무활자,.금속활자.등.
기술은.물론이려니와.그에.담긴.문화와.
예술의.정신은.오래고.깊다..

2..먹과.붓의.춤.

글자에.대한.동아시아인의.태도는.독특하다..
그들에게.글자는.철학이고,.
예술적.관조의.대상이며,.표현의.수단이다..
그.중심에는.서예가.있다..

서예는.동아시아.타이포그래피의.알심이다..
붓은.그.무게중심이다..
이는.서양.글자꼴이.펜과.끌.같은.

723

ahn sang-soo

This is a contrast to Western letter formation from hard tip pen.
In the mental world of accumulated training, there exist the harmony of slow and fast brush strokes, light and shade ink, and white space form changeable scene. In between the dance of ink, paper and brush, aesthetics and emotions are erupted. Surprise and joy are sprang.

Rounded, bent, pointed, broken, warped, raised, widened, closed, deepened, shallowed, lengthened or shortened, quickly and slowly flown, formed. Points and strokes arranged or stressed in the squared format. The strength to spring out and the strength to suppress within, the tension confronts each other and creates equilibrium.

Most of typefaces are formed from calligraphy or handwriting. Selecting, harmonizing, standardizing them become typefaces. The trace of brush stroke remains not only in beaks and bumps of Serif typefaces but also in Sans Serif typefaces. Beauty of letter. Letter itself becomes a drawing and a poem. According to the handling person, letter is born once again.

Chinese character has a deep taste. Hangeul has printing aesthetics. Kana has speedy charm.

For a long time, East Asian typography had been covered up by Latin Alphabet. Though we had letter glowing aesthetics and culture, we were not able to revive it properly until today. Now, we should discover new possibilities from our traditions, experiment with it, and cultivate the new land for new path.

3.
Letter fragrance

Letter is a primal design itself. It is an

딱딱한.것에서.비롯된.것과.대비된다..
수련을.통해.쌓은.정신세계.속에.
느리고.빠른.필획과.먹의.농담,.
여백이.어우러지며.
변화무쌍한.풍경을.이루고.
먹과.종이와.붓이.이루는.춤.사이에서.
미의식과.감정이.분출된다..
놀람과.기쁨이.솟는다..

둥글고,.구부리고,.삐치고,.꺾이며,.
휘고,.올려.치고,.벌리고,.닫고,.깊고,.얕고.
길거나.짧게,.빠르고.느리게,.흐르다가.맺고.
네모틀.안에서.점과.획이.안배되거나.강조되고.
튀어나가고자.하는.힘과.가두려는.힘.
그.형태의.긴장이.서로.대립하며.평형을.이룬다..

거의.모든.활자꼴은.
서예나.손글씨에서.비롯되었다..
이를.고르고.조화롭게.표준화시킨.것이.
활자꼴인.것이다..
붓의.느낌을.살린.부리와.맺음은.
부리.활자꼴뿐만.아니라.
민부리.활자꼴에.흔적으로.남아.있다..
글자의.아름다움.
글자는.그.자체로.그림이.되고.시가.되었다..
글자를.다루는.이에.따라.
또다시.글자는.태어난다..

한자는.깊은.맛이.있다..
한글은.해서적.아름다움이.있다..
가나는.빠른.멋이.있다..

그동안.동아시아.타이포그래피는.
라틴.알파벳에.가려져.있었다..
빛나는.글자.미학과.문화가.있었으나.
우리는.지금까지.그것을.제대로.살리지.못했다..
이제.우리는.우리의.전통에서.
새로운.가능성을.다시.발견하고.
실험하고.
새.길을.찾아.
새.땅을.일구어야.할.것이다..

3..글자의.향기.

글자는.그.자체로.원초적인.디자인이다..

ahn sang-soo

724

abstraction created through numerous people's spirits and hands over a long period of time. In each letter exists the aesthetics of its country. It is a completion of condensed culture.

When facing letter, I feel the scaturient irresistible charm. Time and deep wisdom respond to the aesthetics concentrated as a diamond.

Kim Jung-hee(1786-1856) once mentioned about the 'Letter Fragrance'. Letter must carry fragrance. Only those who can feel the letter fragrance are able to cherish the letter.

Where does the Typojanchi fragrance come from?

Probably from the theme and density of the feast.

Typojanchi is typography plus something.
Typography plus literature.
Typography plus movie.
Typography plus feminism.
Typography plus city.
Typography plus body.
Typography plus life.
......

Letter stands in the center, and invites other fields. It is a delightful chemical reaction. Typographic imagination has a pleasant expansion force.

On the land of letter, culture grows as a tree into a forest. Typography is the flower blown by the letter tree.

Typojanchi, grows into a millenary tree. Humbly blow flower of letter fragrance every other years.

Along with it, Hangeul feels new day by day.

725

오랜.세월.수많은.사람의.정신과.손을.거쳐.
추상화된.것이.글자인.것이다..
글자.한.자.한.자에는.
그.글자를.사용하는.나라의.미감이.배어.있다..
그.나라의.문화가.응축된.총체이다..

글자를.마주할.때.억누를.수.없는.
매력이.뿜어져.나오는.것을.느낀다..
시간과.깊은.슬기가.금강석처럼.
농축된.미감에.감응한다..

추사.김정희(1786~1856)는.
'글자향(文字香)'에.대해.말한.바.있다..
글자는.향기를.지녀야.하고.
글자향을.느낄.수.있어야.
글자를.애지을.수.있다는.말이리라..

타이포잔치의.글자향은.어디서.나올까?

잔치의.주제와.밀도일.것이다..

타이포잔치는.타이포그래피.더하기.무엇이다..
타이포그래피.더하기.문학.
타이포그래피.더하기.영화.
타이포그래피.더하기.페미니즘.
타이포그래피.더하기.도시.
타이포그래피.더하기.몸.
타이포그래피.더하기.생명.
......

글자가.중심에.서서.다른.분야를.모신다..
즐거운.화학반응이다..
타이포그래피적.상상은.유쾌한.팽창력을.
지닌다..

글자의.땅에서.문화는.나무로.자라.숲이.된다..
타이포그래피는.글자.나무가.피우는.꽃이다..

타이포잔치.
천.년.나무로.자라라..
두.해마다..겸손히.글자향의.꽃을.피우라..

한글이.더불어.나날이.새롭다..

The status and future of east asian typography

동아시아 타이포그래피의 위상과 미래

forum

2

won.you-hong.

(professor, sangmyung university / president, korean society of typography)

원유홍.元裕弘.

(한국타이포그라피학회 회장 / 상명대학교 디자인대학 교수)

1.

The identity of East Asian typography

The first feature of East Asian typography identity is that it is a target of awe with dignity, mystery and rite. Cultural features of East Asia are Confucian tradition, Chinese character culture, unity of nature and man, organic holistic perspective, ethic as an community, and cyclical way of thinking.

China, Japan and Korea, the major countries of East Asia have been immersing on picking out their differences, rather than learning from each other and respecting them. The effort to refocus on East Asian typography identity is the result of our desire and confidence to form 'self-defense community' against the Western-oriented values.

Eastern letter culture has a distinctly different traditions from the West. In the East, letter is considered with awe of dignity, mystery and rite. Western typography focused on functional features, whereas Eastern typography focused on aesthetics values as well as the legibility. This is a big difference.

The second feature of East Asian typography is the hieroglyphic characteristics. Chinese character is known as the writing system of China, but strictly speaking, it is a writing system for the Han tribe. The Han tribe occupies more than 95% of Chinese population, thus it practically is the writing system of China. Historically, Chinese character is the root of all East Asian letters, which was initially created by the Han tribe than shared with millions and billions of East Asians.

Chinese characters are an hieroglyphic of course. Japanese 'Kana' is known to be cre-

1.

동아시아 타이포그래피의 정체성

동아시아 타이포그래피 정체성의 큰 특징은 첫째, 존엄과 신비 그리고 제의가 함유된 경외의 대상이다. 동아시아의 문화적 특징은 유교적 전통, 한자 문화, 자연과 인간의 합일사상, 유기체론적 시각, 공동체로서의 윤리관, 순환적 사고방식 등이 거론된다.

동아시아의 주요 국가로 거명되는 한국과 중국, 일본은 그간 서로를 배우고 존중하려는 자세보다는 오히려 서로의 차이점을 찾기에 골몰했던 것이 사실이다. 그러나 이 자리처럼 동아시아 타이포그래피의 정체성을 재조명하려는 노력은 서양 중심적 가치관에 맞서 '자위적 공동체를 형성'하려는 우리의 욕구와 자신감이 빚어낸 담론이라 할 수 있다.

동양의 글자문화는 서양과는 엄연히 다른 전통이 있다. 즉 동양에서의 문자란 존엄과 신비 그리고 제의가 함유된 경외의 대상이다. 서양의 타이포그래피가 기능에 역점을 두고 있다면, 동양의 타이포그래피는 잘 읽혀야 하는 기능뿐만 아니라 오히려 미적 개념이 더욱 중요한 관심사였다는 점에서 큰 차이가 있다.

두 번째 특징으로 동아시아 문자의 뿌리는 상형성이다. 보통 한자를 중국의 문자라고 생각하지만, 엄밀히 말하면 한자는 한족의 한어를 기록한 문자이다. 하지만 한족이 중국 인구의 95% 이상을 차지하고 있으므로 실질적 의미에서 한자를 중국의 문자라 말하는 것이다. 그러나 역사적으로 볼 때, 한자는 한족에 의해 탄생한 이후 수십억, 수백억 또는 그 이상의 동아시아 사람들 모두에게 공유되면서 자라온 동아시아 문자의 뿌리이다.

한자는 물론 상형문자이다. 그리고 일본의 '가나

ated by transforming the form and structure of cursive writing style and the squared writing style of Chinese characters during the transition period to the mid-feudalism. Therefore, Kana surely has its roots in the hieroglyphics.

Relatively new Korean 'Hangeul' has form of geometric imitation of the human sound organ. This is a different perspective from Chinese characters, yet still has its roots in the hieroglyphics. Chinese characters combine glyphs to create a secondary meaning. Hangeul glyphs combinations of first, middle, last sounds in top and bottom, left and right positions is similar to the combination of Chinese characters thought the aim is different. As a result, Hangeul structure also contains the 'unconscious hieroglyphic features'.

The third feature of East Asian typography is the fact that their pursue of metaphysical value meet at a single point. The East Asian typography begins from Chinese calligraphy. Connecting points and strokes using the four precious things of the study, striving for the essence of objects, artist spirit, and aesthetics. Chinese calligraphy is a unique philosophical art of East Asian regions. This calligraphy is called shufa(書法: writing method) in China, seoye(書藝: writing art) in Korea, shodo(書道: writing ways) in Japan. According to the Zhuāngzǐ's aesthetics, 道 (way) is the ultimate beauty which is 藝 (art), and 法 (method) is the logic of following 藝 (art). Though they are called differently in each country, 法, 藝, 道 all pursue for a single goal. The East Asian typography, with value of 法, 藝, 道 in its center, has the important feature of pursuing for the ultimate metaphysical status.

2.
The status of East Asian typography in the world

China has 4,000 years of cultural resources and paper invention along with Chinese characters. Korea has the oldest printed materials *Jikjisimcheyojeol* and *the Tripitaka Koreana*. Japan is the

문자'는 일본이 중세 봉건제로 이행되는 과도기에, 한자의 초서와 해서의 편방(偏旁)을 변형해서 만들었다고 전해진다. 그러므로 가나문자는 어김없이 상형성에 뿌리를 두고 있다.

또한 한반도의 비교적 신생문자인 '한글'은 특히 자음의 형태를 구성하면서 사람의 소리기관을 기하학적으로 본뜸으로써 한자와는 관점이 다소 다르지만, 이 또한 상형성에 바탕을 두고 있다. 뿐만 아니라 한자처럼 자소를 서로 조합하여 2차적 의미를 얻어내려는 목적은 아닐지라도, 초·중·종성을 상하좌우로 연접시키는 한글의 조합방식은 한자의 구성패턴과 흡사하다. 따라서 한글의 형식적 구조에는 마찬가지로 '무의식적 상형성'이 흐른다고 판단된다.

세 번째 특징으로 동아시아 타이포그래피가 추구하는 형이상학적 가치는 서로 같은 지점에서 만난다는 것이다. 동아시아 타이포그래피의 출발은 서예에서 비롯된다. 문방사우를 이용하여 점과 획을 이어가며 사물의 본질과 작가정신 그리고 미의식을 추구하는 서예는 동아시아 지역만의 특유한 철학적 예술이다.

이러한 캘리그래피를 중국에서는 서법(書法), 한국에서는 서예(書藝), 일본에서는 서도(書道)라 각기 지칭을 달리하고 있다. 그러나 장자의 미학에 따르면, '도'란 궁극적인 아름다움, 즉 예를 말하고, 법은 또한 예를 따르는 이치로서, 이들이 서로 지칭은 달리하지만, 법·예·도가 추구하는 목표는 모두 하나로 일치한다. 이처럼 법·예·도를 가치의 중심에 두고 있는 동아시아 타이포그래피는 모두 하나같이 극도의 형이상학적 경지를 추구하는 중요한 특징이 나타난다.

2.
세계 속의 동아시아 타이포그래피의 위상

중국은 4000년이 넘는 찬란한 문화 자원과 종이의 발명 그리고 한자, 한국은 세계에서 현존하는 가장 오래된 『직지심체요절』 그리고 『팔만대장경』, 일본은 동아시아의 전통을 근대 방식으로 되살린 출판강국임에 틀림없다.

그럼에도 불구하고 지정학적으로 매우 가까운 이

powerful nation of printing, as they evoked the East Asian traditions into the modern method. However, these three geopolitically close lingual regions were unable to have a truly meaning-ful communication. This is because they went through interruption, injury, and competition of rapid growth in the modern history of 20th century. This phenomenon in art and design fields was not any different. Though they had possessed the infinite spiritual and cultural con-tents, the root of philosophical perspective was absent. Due to the absence of 'overall energy' in East Asian typography, it unfortunately is not standing in the center of the world design. This is the realistic status of East Asian typography today.

I would like to suggest that now is the time for the East Asia to prepare the 'post-international typography style' in order to prove our overall status in the world. The major countries of East Asia belong to the same culture yet each speak different languages. Evolution of letters carry its mythology while depositing the traditions and cultures. The East Asian typography shares similarities due to this evolution, but there are certainly differences. This is often known as 和而不同(harmonizing with others while not losing one's own principles). We are most harmonious as we stand together. This can yield a greater power.

As we all know, the international typography style which has been dominating the world in last 100 years was created from the Swiss printing environment. They inevitably had to use three languages, French, German, Italian, thus created a grid system which is now known as the international style. The three countries of East Asia has similar circumstances. Based on the stable commonality, we need to recom-mend a new alternative for the outdated inter-national style.

In conclusion, it is the time for us to build the East Asian vessel to sail into the world. Looking back the past history, Asia had waken Europe

세 언어권은 과거 격동의 20세기 근대사로 인해 단절과 상처 그리고 고도성장이라는 각축의 장을 벌이는 과정 속에서 진정한 의미의 소통이 있었다고 보기는 어렵다. 이러한 현상은 예술과 디자인 분야에 있어서도 별반 다르지 않았다. 정신과 문화적으로 무한한 콘텐츠를 보유하고 있으면서도 그 뿌리가 될 철학적 관점이 부재했다. 안타깝지만 동아시아의 타이포그래피는 '총체적 에너지'가 부족했던 까닭에 오늘날 세계 디자인의 중심점에 서 있지 못한 것이 현실이다.

마지막으로, 그러면 세계 속에서 우리의 총체적 위상을 입증하기 위해 동아시아 스스로가 지금부터라도 '포스트' 국제 타이포그래피 양식을 준비해야 할 때라는 말씀을 드리고자 한다. 동아시아의 주요 각국은 강력한 동일 문화권에 속해 있지만 서로 다른 언어를 사용한다. 전통과 문화를 퇴적시키고 자신만의 신화를 담아가는 문자 진화과정으로 인해 우리 동아시아의 타이포그래피는 서로가 많이 닮아 있지만, 그러나 분명 다름도 있다. 흔히 하는 말로 화이부동(和而不同)이라 한다. 이처럼 우리는 서로가 같이 있으므로써 더 조화롭기 때문에 더 큰 힘을 발휘할 수 있다.

728

잘 아는 바처럼, 지금까지 어언 100년간이나 세상을 지배하고 있는 국제 타이포그래피 양식은 스위스의 출판환경이 부득이 3개 국어인 스위스어·독일어·이탈리아어를 사용해야 하는 필요성 때문에 그리드 시스템을 탄생시켰고 그것이 오늘날 국제양식으로 자리를 잡았다. 그렇다면, 이와 아주 비슷한 조건을 갖추고 있는 동아시아 3개국은 서로의 두터운 공통성을 바탕으로, 이미 연식이 노화된 국제양식에 새로운 대안을 촉구할 필요가 있다.

결론적으로 우리는 지금 세계로 출항할 동아시아의 타이포그래피 모함을 축조해야 할 때가 되었다. 지난 역사를 돌이켜 보면 500년이라는 긴 잠 속에서 유럽을 깨운 것은 아시아였다. 이후 또다시 500여 년이 지난 지금 우리 아시아는 형식적으로 한계에 이른 그래서 따분하기 이를 데 없는 국제양식의 전횡에 변혁을 모색하고, 거친 정보의 집합이 아니라 질적 깊이를 인식하는 관점에서 다시 한 번 서양을 깨워야 할 때이다. 그렇다면 이제 우리는 동아시아 및 국제 타이포그래피의 미래를

from its 500 years of deep sleep. Another 500 years from then, we Asia must wake the West once again by attempting revolution against the tyranny of formally limited, boring international style. Instead of rough set of information, we must recognize the depth of quality. For the future of East Asian and international typography, we must seek for the 'independent aesthetics' which is 'our natural identity'.

As a culture communicator, we have the mission of solving contemporary community problem within East Asia, with a new paradigm. Thus we now must focus on connecting our cultures and taking care of them with mature attitude. We must excavate and redefine the spiritual and cultural traits to set up 'our natural identity', the subjective perspective shared in East Asian typography.

'The beginning of the world where the sun rises first, let's take a look at the world from here.'

books have provided to us all.A finely printed

위해 서양의 모더니즘에 대처할 '독자적 미학' 즉, '우리다움 찾기'에 힘써야 한다.

문화 전달자인 우리는 동아시아라는 울타리에서 동시대의 공동체적 문제를 새로운 패러다임으로 해결해야 할 사명을 갖고 있다. 그러므로 우리는 이제 성숙된 자세로 국가 간의 문화를 잇고 살피는 일에 전념해야 하고 그러기 위해서는 서로가 공유할 수 있는 동아시아 타이포그래피의 '주체적 시각' 즉, '우리다움'을 설정하기 위해 우리의 정신적, 문화적 특질을 발굴·재정립해야 한다.

'태양이 가장 먼저 뜨는 세상의 시작, 이곳에서 세상을 보자.'

The history of Japanese character

3

katsui.mitsuo.

카쓰이.미쓰오.勝井三雄.

The northernmost piece of land in Japan is Ben-tenjima, Wakkanai, Hokkaido, located 45° 21′ north latitude and 121°56′ east longitude. The southernmost land is Okinotori Shima, south of Tokyo, located at 20°25′N 136°05′E. Seoul, Shanghai, Ningbo and Beijing are located within the range of 3000km from Tokyo. Japan exists as an archipelago and it is surrounded by the sea according to the East Asia continent. The total length of Japanese Archipelago is approxi-mately 3,000km and its coastline is approxi-mately 35,000km, which is about 87% of the distance of the earth's circuit. This coastline is composed of the intricate rias coast and beauti-ful sandy beaches. Because of the monsoons, tsunamis and typhoons, Japan is formed with windbreak forest and tide-water control forest around sand beaches. The place is formed with strongly rooted pine trees, which is like the hieroglyphic '木', strong against wind and rain, and it creates a great scenic beauty. In addition, Japan is a seafood-rich maritime nation.

In Japan, climate, temperature, and the change of four seasons are moving from South to North, and this makes the quantity-rich forests and rice paddies. Thus, in spring, they plant seedlings and through the summer, they harvest rice in a single cropping way in autumn. Rice farming in Japan started from middle of Jōmon period and rice forms the lifestyle as the staple food of Japanese and sustains a mature culture of rice in Japan. An extract of rice is, the rice is immersed in the liquor barrel of 'sake'. Also, the rice har-vested in the autumn is wrapped in straw and it is called komedawara (米俵: sheaf of rice = 4 mal(approximately 72L) = approx 60kg). A straw rope becomes Shimenawa (注連縄), the straw

일본의 최북단은 홋카이도 왓카나이시 벤텐지마(北海道稚内市弁天島)로, 북위 45도 21분·동경 121도 56분에 위치한다. 최남단은 도쿄도 오키노토리시마(東京都沖ノ鳥)로 북위 20도 25분·동경 136도 04분. 서울, 상하이, 닝보, 베이징의 각 도시는 도쿄에서부터 3000km 권내에 위치하고 있다. 일본은 동아시아 대륙에 따른 형태로 바다에 둘러싸인 열도로 존재하고 있다. 일본열도의 전체 길이는 약 3000km로, 해안선 거리는 지구 일주의 87% 남짓에 상당하는 약 3만 5000km이다. 그 해안선은 복잡하게 얽힌 리아스식 해안과 아름다운 모래 해변으로 구성되어 있다. 일본에는 계절풍과 태풍, 해일이 많기 때문에 모래 해변에 방조림과 방풍림이 형성되어 있다. 그곳에는 비바람에 강한 상형문자 '木'와 같은 강인한 뿌리를 내린 소나무가 사용되어 풍광명미(風光明媚)한 풍경을 만들어내고 있다. 또한 일본은 해산물이 풍요로운 해양국이라고도 말할 수 있다.

일본에서는 기후, 기온, 춘하추동의 변화가 남쪽에서 북쪽으로 이동하여 수량이 풍부한 산림과 논의 환경을 만든다. 그리하여 봄에는 모종을 심고 여름을 거쳐 가을에 수확하는 '쌀'의 일모작이 행해지고 있다. 일본에서 벼농사는 조몬시대(縄文時代) 중기부터 시작되어, 쌀은 일본인의 주식으로서 생활양식을 형성하고 일본의 쌀에 관련된 성숙된 문화를 지탱하고 있다. 쌀의 엑기스로는 '니혼슈(日本酒)'를 담그고 술통에 보관한다. 또한 가을에 수확되는 쌀은 볏짚에 싸서 '코메다와라(米俵: 벼 한 섬=4두(약 72L)=약 60kg)'라고 부른다. 볏짚으로 만들어진 새끼줄은 신성한 영역과 외부 세계 사이를 나누기 위한 시데(紙垂)를 단 '시메나와(注連縄: 금줄)'가 된다. 신사(神社) 주변 혹은 신체(神体)를 새끼줄로 둘러 그 안을 신성한 영역이라고 한다. 일본의 정월에 집집마다 문, 현관, 출구 등에 장식하는 '시메카자리(注連飾り)'도 이 시메나와의 한 형태이다. 새끼줄의 재료는 수확하여 말린 볏짚 또는 삼베이며, 풍작을 기원

730

festoon, which has Shide (紙垂), a zigzag-shaped paper streamer to divide a sacred world and the outside world, attached on. Shinto shrine (神社) and Shintai (神体) are roped-off with a straw and those are called a scared area. The Shimekajari, a Japanese new year decoration on doors, entrances and exits,is one kind of Shimenawa. The material of the straw rope is harvested and dried straw or hemp cloth and it is started as a priests to pray for good harvests. It is considered that anything that is related to harvesting, including agricultural tools, are traditions that are deeply related rice farming.

The origin of Sumo (相撲) goes back to B.C.. Yokozuna is the highest ranking of Ōzumō (大相撲). Etymologically, it is also Shimenawa because it means the white hemp ropes that only Yokozuna can tie at the waist. The modern version of Sumo ring is 16 platforms, called Shobudawara, 4.55 metres (14.9 ft) in diameter and 16.26 square metres (175.0 sq ft) in area, made of clay mixed with sand, and including other platforms, it uses the total 66 platforms, When they do Dohyō matsuri, a festival to celebrate the making of new Sumo ring, in a belief of supersitition, they bury kajikuri(dried and pounded chestnut), seaweed, rice, dried squid, salt and nut of nutmeg tree as a tribute to God. In Japan, Noshiahwabi (熨斗蚫), thin and long stretch of dried abalone, shrimp, kelp are used even for Shōgatsu Kazari (正月飾り: New Year's day decoration) and Kagami Mochi (鏡餅), a traditional Japanese New Year decoration consisting two round rice cakes, and this shows how they considered seafood as a source of valuable nutrients and respected it as a token for long life. Noshi is formally called Noshiawabi and it is made of dried abalone. For New Year's Kagami Mochi they decorate a big noshi and bundled noshi and for the wedding gift, they use bundled noshi. Folded noshi is simplified to a yellow paper instead, and it is more simplified now to a 'print noshi' which is far from the original form of noshiawabi. Moreover, sometimes they use 'のし', hiragana letters for Noshi as an extremely simplified version.

731

하는 제사로부터 시작되어 농경작업 도구 등 어느 것이나 다 벼농사와 깊은 관련이 있는 풍습이라고 생각된다.

스모(相撲)의 역사는 기원전까지 거슬러 올라간다. 요코즈나(橫綱)는 오즈모(大相撲)의 역사(力士) 서열 중 최고 순위의 명칭이다. 어원적으로는 요코즈나만이 허리에 맬 수 있는 흰 삼베 밧줄(쓰나, 綱)의 명칭으로, 요코즈나도 시메나와이다. 현대의 스모판은 높이가 34~60cm, 한 면이 6.7m의 정사각형에 흙을 쌓아올려 그 중앙에 '쇼부다와라(勝負俵)'라고 불리는 16개의 섬(俵)으로, 직경 4.55m(15척)의 원이 만들어지고 그 이외에 네 군데에 놓이는 섬(德俵)과 정사각형에 배치된 섬(角俵) 등 합계 66개의 섬이 사용된다. '도효마쓰리(土俵祭: 오즈모의 본 장소에서 새로운 스모판을 만든 것을 기념하는 축제)'를 할 때, 미신을 믿어 길흉을 따지는 의미에서 카치구리(勝栗, 말린 밤을 절구에 가볍게 찧어 껍질을 없앤 것)와 다시마, 쌀, 말린 오징어, 소금, 비자나무 열매를 신에게 바치는 공물로서 땅에 묻는다고 일컬어진다. 일본에서는 정월에 하는 쇼가쓰카자리(正月 飾り: 정월에 하는 장식)와 카가미모찌(鏡餅: 신불에게 올리는 대소 두 개의 동글납작한 찰떡) 등에도 노시아와비(熨斗蚫: 얇게 저며 길게 늘려서 말린 전복의 살), 새우, 다시마가 곁들여져, 예부터 사람들이 얼마나 해산물을 귀중한 영양원으로 생각하는지, 그리고 장수의 증표로 존중했는지 짐작할 수 있다. 노시(熨斗)는 정식으로는 노시아와비라고 불리며, 말린 전복이 쓰인다. 정월의 카가미모찌에는 큰 노시, 묶음 노시를 장식하며, 혼례 때의 예물로서는 묶음 노시가 사용된다. 접은 노시는 간소화되어 전복 대신 노란색 종이가 사용되었고, 현재는 더욱더 간소화가 진행되어 노시아와비의 본래 형식에서 멀어져 '인쇄 노시'라고 불리는 노시가 사용되고 있다. 또한 극단으로 간소화되어 '노시(のし: 熨斗의 히라가나)' 두 글자가 사용되는 일도 있다.

스모에 관련된 것으로는 서열 일람표와 흥행장 등으로 손님이 만원일 때, 관계자에게 위로와 축의를 겸하여 내는 돈을 넣기 위한 붉은 바탕에 빈틈없는 스모 글자로 '大入(만원)'이라고 쓰인 만원 봉투가 있다. 또한 무장(武將)의 싸움의 표시로 사용된 깃발에 쓰인 무늬나 글자는 '大名(다이묘, 막부(幕府) 직속 무사)'의 문장(紋章)이 되었고, 가계(家系)를 나타내는 가문(家紋), 상품의 브랜

katsui mitsuo

In Sumo, when the stadium is packed with visitors because of the rank lists or show place, there is a full house envelop, red color envelop with '大入' letter written on, to put money in and contribute to the persons concerned. In addition, the patterns or letters used for the battle flag as a symbol of Armed became a sign of Daimyo (大名: immediate warrior for the Shogunate), then family representing plate, then to a trademark for the product brands. This can be considered that it came from Japan's own thinking which sublimated and simplified the forms.

In Japan, the expression, 'Mitate (見立て)' is used a lot. This is a way of seeing through an object's state from others and it is a play on words to express the object with other things and it is also called a play of figure of speech. In Japan, there is a wide range of the writers' play to create a flow of artistic expression, such as a Japanese traditional poetry, humor, light literature, Kabuki, Rakugo, and etc. For example in Ryōan-ji 's Houjyo garden, the scenery is described with stones and sands.

Japan, has a rich forest, has a culture of '木'. In Isejingu Shrines, the transmission of traditional techniques of 'Jingu Shikinen Sengu (神宮式年遷宮)' is enacted every 20 years by rebuilding two main palaces and fourteen secondary palaces. According to the record, this was decided by Tenmu Tenno of Asuka period, the prima volta was enacted in Jit Tenno, a year of Tenbyo 690. This tradition was suspended for about 120 years at Warring States Period, however it is repeated and continued to the 61th ceremony, 1993 (Heisei 5th) through 1300 years. In this ceremony, there is a technique called Kidori, which is to pull a square pillar in from the center of the tree. The diagonal of the square on one side has a ratio of '5:7=1:1.4' and it is called Baekeunbi (白銀比). 5,7,5, used in Haiku, Japanese poetry consists of 17 ons, in three phrases of 5,7, and 5 ons respectively, are prime numbers. A prime number is a natural number greater than 1 that has no positive divisors other than 1 and itself. Prime number has a character of Baekeunbi which has no wastefulness, and through this we can peep Japanese' primitive

드를 나타내는 상표로 발전했다. 형태를 단순하게 승화시킨 일본의 독자적인 사고로부터 온 것이라고 말할 수 있다.

일본에서는 '미타테(見立て)'라는 표현이 자주 쓰인다. 이것은 어떤 사물의 상태로부터 그것과는 다른 사물의 상태를 간파하는 것으로, 다른 사물로 대상물을 표현하는 일종의 언어유희로도 흔히 볼 수 있는, 비유놀이라고도 말한다.

일본에서는 문인의 놀이로서 하나의 흐름을 만들어두고 예술표현으로서 일본 고유의 정형시, 해학, 희작, 가부키, 만담 등 넓은 범위에서 볼 수 있다. 류안지(龍安寺)의 호우조정원(方丈庭園)에서는 돌이나 모래 등으로 산수의 풍경을 비유하고 있다.

풍부한 산림을 가지고 있는 일본에는 '木'의 문화가 존재한다. 이세진구(伊勢神宮)에서는 20년마다 2개의 정궁(正宮)의 정전(正殿), 14개의 별궁의 모든 사전(社殿)을 다시 세워 신위(神位)가 있는 곳을 옮기는 '신궁식년천궁(神宮式年遷宮)' 기술의 전승이 행해지고 있다. 기록에 의하면, 이것은 아스카시대(飛鳥時代)의 천무천황(天武天皇)이 정하여 지통천황(持統天皇)의 치세 690년에 제1회, 그 후에 전국시대(戦国時代) 120년 이상의 중단과 몇 번의 연기 등이 있었지만, 1993년(평성 5년) 제61회 식년천궁까지 1300년에 걸쳐 반복되고 있다.

거기에는 한 자루의 나무 중심에서 사각 기둥을 빼내는 '키도리(木取り)' 기술이 존재한다. 그 사각의 대각선과 한 변에는 '5:7=1:1.4'의 관계가 있으며, 이것을 '백은비(白銀比)'라고 부른다. 하이쿠(俳句: 5·7·5의 3구 17음절로 된 일본 고유의 단시)에 사용되는 5·7·5는 소수이다. 소수라는 것은 '1과 자신 이외의 수로는 나누어 떨어지지 않는 자연수'이며, 소수가 아닌 수(합성수)는 모두 소수를 조합함으로써 존재한다. 소수는 모든 자연수의 '원료'이며, 있는 그대로의 수이다. 소수는 헛됨이 일절 없는 백은비에 상통하는 성격을 가지고 있다고 하여, 일본인의 미의식에 얽힌 원시적 사고를 엿볼 수 있다.

일본간(日本間: 전통적인 일본풍 가옥에 바탕을 두어 만들어진 방)의 공간을 나타내는 단어에는 '마도리(間取り)'가 있다. 볏짚마루 위에 골풀을 엮은 '다타미(畳)'는 한 장을 1첩(畳)이라 세며, 직사각형의 긴 변은 1간(間: 인간의 신장에 가까운 척도), 짧은 변이 반 간(半間: 인간이 앉았을

thinking on aesthetic sense.

The space nihongan (日本間), a room made in a base of the traditional Japanese house, is called 'madori (間取り)'. For Tatami, the woven straw floor with rushes, a single piece of mat is called 1 jō, the longer side of rectangular shape is called 1Gan, and the shorter side is called hanjō. This is the basic of all midori, the plane of the building plan, and it is established with the concept of space and time, '間'. Also the size, '4畳半', is used in tea-ceremony rooms, chashitsu. The space is created according to the extension and reduction of midori, and the new space is created with a sliding door which divides the space. This space is displayed in 2 dimensional wall paintings and folding screen paintings, like Tawaraya Sōtatsu's Fūjin-raijin-zu (17th century). This is a plane surface but it has a three-dimension due to the attachment of precious gold leaf, 0.0001mm thickness, in about 10cm area to express time and space. This way of thinking had an impact on cultural forms.

The Wakoku, which never had their own letters, started exchange from B.C., and with the Buddhism introduction, they took Chinese character and transit it to reading culture due to Japanese grammar. Year of 712, the oldest history book, *Kojiki* was written in an anomalous Chinese characters and established to a ordinance nation. In the year of 764, *million sutra pagodas* (百万同陀羅尼), the oldest existing print, was printed on paper with wooden type and it was distributed to Judaiji (十大寺). 300 copies are existed in Hōryū-ji. The letters are set in type on 1:1 length and breadth grid. Hiragana was appeared for the first time in the year of 905 with the mix of Kanji, in *Kokin Wakashū* (古今和歌集). The origin of Hiragana is Man'yōgana(万葉仮名). Like how 'あ'is originated from '安', and 'い' is originated from '以', the derivation of Kanji went extreme and struck out from the original Kanji's cursive style, and it is Hiragana. And this is the first moment that Japanese gained the first phonogram. Japanese were used to represent the object's name with Kanji for a long time, therefore when Hiragana was born, they started to use it with Kanji. Important works of classical

때의 척도)으로 되어 있다. 이것이 모든 마도리, 즉 건물의 평면 계획의 기본이며, 여기에 '間'이라는 영역개념이 시간과 공간으로서 성립되어 있다. 또한 '4畳半'이라는 공간을 나타내는 사이즈는 차실(茶室)의 기본 크기로 되어 있다.

마도리에 의해 확장, 축소 자재의 공간이 그 용도에 따라 만들어지고, 개폐되는 맹장지에 의한 칸막이로 새로이 대소의 공간이 창출된다. 이렇게 해서 만들어진 공간은 다와라야 소타쓰(俵屋宗達)의 '풍신뢰신도병풍(風神雷神図屏風)'(17세기 전반) 등에 보이는 2차원 장벽화와 병풍화에 의해 연출된다. 거기에서는 시간과 공간을 표현하는데 두께 약 0.0001mm에 약 3촌 6분각(10cm)의 귀중한 금박이 붙여져 평면이지만 그것엔 3차원이 존재한다.

이러한 사고의 틀은 문화 형태에 영향을 끼쳐왔다고 생각된다.

글자를 가진 일이 없었던 일본 '왜나라(倭国)'는 기원전부터 중국과의 교류가 시작되어 6세기의 불교 전래와 함께 한자를 일본어 어법에 따라 읽는 문화로 이행했다. 712년(화동 5년)에 일본 최고(最古)의 역사서 『고사기(古事記)』가 한식화문(漢式和文) 혹은 변체한자로 쓰여져 율령국가의 확립으로 향하게 된다.

764년, 세계 최고(最古) 현존하는 인쇄물로서 『백만동타라니(百万同陀羅尼)』가 목활자에 의해 종이 위에 인쇄되어 주다이지(十大寺)에 분치되었다. 호류지(法隆寺)에만도 300기(基)가 현존하고 있다. 여기에서는 '1대1의 종횡=모눈'의 위에 글자가 조판되어 있다.

905년에 『고금화가집(古今和歌集)』이 한자와 히라가나가 섞인 문장으로 쓰여 히라가나가 처음으로 공적인 문서에 나타났다. 히라가나의 기원은 '만요가나(万葉仮名)'이다. 'あ'는 '安', 'い'는 '以'에 유래하는 것처럼 만요가나로 사용되고 있던 한자의 모체화가 극도에 이르러 원래 한자의 초서체로부터 독립한 것이 히라가나라고 말할 수 있다. 일본인이 처음으로 표음문자를 얻는 순간인 것이다. 일본인은 사물의 이름을 한자로 나타내는 일을 이전부터 행해왔기 때문에, 히라가나가 생겼을 때 바로 한자와 히라가나를 섞어서 표시하는 일이 시작되었다. 『이세모노가타리(伊勢物語)』, 『겐지모노가타리(源氏物語)』, 『콘자쿠모노가타리(今昔物語)』 등, 일본 고전문학의 중요 작품은 전부 한자와 히라가나가 섞인 문장으로 쓰여 있고, 현재까지 1100년 이상에 걸쳐 일본어의 표준적

Japanese literatures, such as *The Tale of Ise* (伊勢物語), *The Tale of Genji* (源氏物語), *Anthology of Tales from the Past* (今昔物語), and etc, were written in a mixture of Kanji and Hiragana, and it is continued for more than 1100 years until now as a standard written language. In addition to literature, this kind of written language system was used in Waka(Japanese poem) and even in *Nijūichidaishū* (勅撰和歌集). Poetry and short songs were written in a melody of 5, 7, 5, 7, 7, especially Haiku was to create a complete world in a composition of 17 letters. Ryōkan, Japanese waka poet, was particularly great in this kind of writing; fancifulness of layout, simplification of letters, and freedom on ideas. Tawaraya Sōtatsu, artist in Edo, period and Honami Kōetsu, calligrapher, produced a collaboration work, *Anthology with Cranes* (鶴図下絵和歌巻). The drawings and letter were scattered in a space and were placed without snapping in the line, and this shows the sense of the origin of the contemporary graphic design.

Meanwhile, in <Kirishitanban (キリシタン版)> and <Kōkatsushiban (古活字版)>, written in TsusukeJi (made type blocks), we can see the characteristics of Japanese printing type. This became an opportunity of transition to wood-block printing which was possible to carve letters and images in papers freely. Woodblock printing started from the <Sagabon (嵯峨本)>, middle of Edo period, however the mainstream of printing turned to platemaker printing. The Edo period had 40% literacy rate, and base on this, many Ezousi(print of simple text and image) were published and later, the 'wood and paper' culture blossomed due to the woodblock printing for 800 years. Around 1870, metal type printing first appeared by Motogi Syojo and others, and it was continued for 80years. In Japan, the sort of typesetting is based on the main letter, size 5 and it is divided into 3 system, 'Choho-2-5-7', '3-6-8', and '1-4'. '2' is a double size of '5', 'choho' is quadrupled, '7' is 1/2 size and respectively it has an equal ratio relationship of double and 1/2. And this is Japan's own unit that applied Madori space intervals. and this existed by the 1950s with the point type.

인 글말이다. 여류문학이 히라가나로 쓰인 것 이외에도 와카(和歌) 등에서는 성별을 불문하고 사용되었으며, 『칙찬화가집(勅撰和歌集)』에 쓰이기까지 했다.

시가(詩歌)와 단가(短歌)는 각각 5, 7, 5, 7, 7 등의 음률로 쓰여 있고, 특히 바쇼(芭蕉)로 대표되는 하이쿠는 5, 7, 5의 17자 구성 안에 완결된 세계를 창출하는 것이다. 그것은 쓰는 방식의 위치 관계 등 레이아웃의 기발함과 문자의 단순화, 자유스러운 발상이 특징인 료칸(良寛)의 문장에서 뛰어나게 우수하다는 것을 알아챌 수 있다. 또한 에도시대(江戸時代)에 화가 다와라야 소타쓰와 서예가 혼아미 코에쓰(本阿彌光悦)의 공동작업에 의한 〈쓰루즈시타에와카칸(鶴図下絵和歌巻)〉이 제작되었다. 거기에는 그림의 공간에 글자가 줄이나 행간을 맞추지 않고 띄엄띄엄 흩뜨려 쓰여 있어, 현대의 그래픽 디자인의 원형적인 존재를 보여주고 있다.

한편 고활자(古活字)에 의한 〈키리시탄판(キリシタン版)〉과 〈고활자판(古活字版)〉에서는 '연면체(連綿体)'를 많이 써서 활자의 블록을 만든 점에서 일본 활자의 특징을 볼 수 있다. 이것은 지면 안에 글자와 그림을 자유롭게 조합하여 자유롭게 조각하는 것이 가능한 '목판'으로 이행되는 계기가 되었다.

에도시대 중기에 만들어진 〈차아본(嵯峨本)〉을 시작으로 하는 목활자인쇄였지만, 그 후 판본(版本)의 주류는 활자가 아닌 판목에 의한 제판인쇄본으로 바뀌었다.

에도시대 식자율 40%의 백만 도시 에도를 배경으로 수많은 에조우시(絵双紙: 에도시대에 항간의 사건 등을 간단한 그림을 넣어 설명한 인쇄물)가 출판되었으며, 이후 800년 동안 목판 출판에 의한 '나무와 종이의 문화'가 꽃피었다.

1870년 무렵, 모토기 쇼조(本木昌造) 등에 의해 그 이후 80년 동안 계속되는 활판활자(금속활자)가 처음으로 등장했다.

일본에서 '호수활자(号数活字)'는 본문활자인 5호 활자를 기준으로 하여 '초호(初号)-2호-5호.-7호'를 중심으로 '3호-6호-8호', '1호-4호'라는 3개의 계통으로 나뉜다. 5호의 배의 크기가 2호로, 초호(初号)는 4배, 7호는 1/2이며, 각각 서로 이웃하는 사이가 2배, 1/2의 등비 관계를 가지고 있다. 이것은 일본의 마도리 공간의 간격을 적용한 독자적인 것이다. 이것은 1950년대까지 포인트 활자와 병행하여 공존하게 된다.

<pic1> the technique called kidori, which is to pull a square pillar in from the center of the tree.

天
人 √ 2 = 約 1.4
地

<pic2> the diagonal of the square on one side has a ratio of '5:7=1:1.4' and it is called baekeunbi.

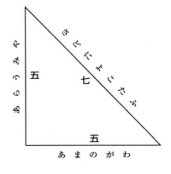

あらうみや
さどによことたふ
五
七
五
あ ま の が わ

<pic3> used in haiku, japanese poetry consists of 17 ons, in three phrases of 5,7, and 5 ons respectively, are prime numbers.

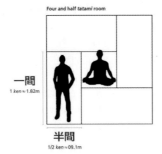

Four and half *tatami* room

一間
1 *ken* ≈ 1.82m

半間
1/2 *ken* ≈ 09.1m

<pic4> four and half tatami room, a single piece of mat is called 1jō, the longer side of rectangular shape is called 1gan, and the shorter side is called hanjō.

活 （初号） 42pt
活 （一号） 27.5pt
活活 活活 （二号） 21pt
活 （三号） 16pt
活活 活活 （四号） 13.75pt
活活 活活 （五号） 10.5pt
活活 （六号） 8pt
（七号） 5.25pt
（八号） 4pt

<pic5> the sort of typesetting is based on the madori which a room made in a base of the traditional japanese house.

The year of 1929, Ishii Mokichi and Morisawa Nobuo invented phototypesetting and this machine became a main type-setting machine since then. By using photography skill, the matrix of main type-setting machine was scorched on to the photographic paper with the light through the lens. And for the first time, the printing system of converting physical material to optical work was developed. This system was generally used from 1948 with a development of Offset and it was maintained nearly 40 years until the advent of the DTP, electronic media. There was a time lag with Europe and America because of their rapid growth in 60s since they used the Linotron, projecting letters to the film, for offset printing through phototypesetting. I consider this was happened because of Europe and America's unique typesetting system, pica. Newspaper and magazines in Japan have the vertical typesetting enough and to spare in the market. On the other hand, horizontal typesetting is basic on web, however when fictions and novels are released in e-print, the vertical typesetting is used, and horizontal typesetting is used for e-print planned magazines and fictions. This mixed use of vertical and horizontal typesetting is a characteristic of Japan and this comes from how they look at the paper surface, detect it as a pictorial image when they try to understand the surface. In addition, the question of how to control this complex information environment matters from now.

Lastly, I dare to include this example.

This is Japan's passing phase. Since 2001 when the electronic communication was possible without any matter of place and time, because of propagation of cell phone and generalization of internet, the 'mobile fiction' became a trend among young generations, especially high school girls. Mobile fiction is a e-book that can be written and read with mobile phone, it is published through fiction submission website and those websites are accessible besides mobile phones. Deep Love series (The Story of Ayu) by Yoshi was released in 2000 and became

1929년, 이시이 모키치(石井茂吉)와 모리사와 노부오(森沢信夫)에 의해 개발된 '사진식자기(写真植字機)'가 주식기(鑄植機)의 연장·발전으로서 착상되었다. 사진기술을 이용하여 주식기의 모형(母型)을 문자반(文字盤)으로 하여 렌즈를 통한 '빛'을 인화지에 그을리는 것이다. 그때까지의 물리적인 재질을 광학적인 작업으로 바꾸어 인쇄되는 시스템이 처음으로 개발되었다. 옵셋의 발달과 아울러 1948년경부터 일반적으로 사용되었고, 이후 전자 미디어인 DTP가 등장하기까지 40년 가까이 유지되었다.
유럽과 미국에서는 사진식자기로 옵셋 인쇄를 하기 위해 글자를 필름에 투영한 라이노트론이 1960년대에 급속하게 성장해 나가는 시간차가 있었다.
이는 유럽과 미국의 활자 특유의 조판 시스템(파이카)에 의한 점이 많았던 것이 아닌가 생각된다.

일본에서 신문, 잡지는 아직 세로조판이 일반적인 것으로 시장에 넘칠 만큼 많이 존재한다. 한편 웹상에서는 당연히 가로조판이 기본이지만, 종래의 소설이나 읽을거리가 전자출판될 때는 세로조판이 그대로 쓰고, 사전에 전자출판화가 의도된 잡지나 소설은 가로조판이 쓰인 경우도 있다. 이처럼 세로조판과 가로조판이 혼재해 있는 점이 일본의 특징이지만, 지면을 파악할 때 지면이 무엇을 나타내고 있는지 회화적인 영상으로 감지하는 것에서 온 것으로 보고 있다. 게다가 복잡한 정보환경을 얼마나 제어할 수 있는지는 이제부터의 문제이다.

마지막으로 다음의 예를 감히 첨부하려고 한다.

일본의 독자적인 일시적 현상으로서 2001년 이후 휴대전화에 의한 통신이 생활에 밀착한 단계에서 비약적으로 보급되고 더욱이 인터넷의 일반화로 장소와 시간에 구애받지 않고 여러 세대에 의한 전자 커뮤니케이션이 가능해졌을 때, 특히 일본의 젊은층(특히 여고생)에서 유행했던 것이 '휴대소설'이다. 이것은 휴대전화를 사용하여 집필, 관람되는 소설(전자서적)로, 인터넷 상의 소설 투고 사이트 등에서 발표되며 그 많은 사이트들은 휴대전화 이외에서도 접속이 가능하다. Yoshi에 의한 Deep Love 시리즈(아유의 이야기)는 2000년에 공개되어 여고생을 중심으로 입소문이 나서 화제가 되었다. 그 후 서적으로 자비 출판되어 10만 부의 매출을 올렸고, 2002년에 상업 출판물로

famous through word-of-mouth among high school girls. Later, it was published on her own account, sold one hundred thousand copies, and the first volume was officially published in 2002 and became one of best selling books by selling more than 2.7million copies. Other fictions were published, made into cartoons, movies and even soap operas as well.

Since the typesetting for mobile phone is horizontal, each sentence is short and conversational. Also, use of graphic characters, symbols, semitones (i.g. small 'わ') and descriptions from main character's point of view and consciousness are unique characteristics. This kind of literatures have many white spaces because of change of lines a lot, however this is enacted in terms of making proper spaces considering the scroll speed of mobile phone. By inserting a single white page in some cases, a flexible device is installed due to awareness of leading space. It is interesting how a free and instant mobile fiction becomes a publishing phenomenon and created a stir on the original purpose of books.

Considering the transferred electrons from establishment process of East Asian typography in this internet era, the role of <TYPOJANCHI 2011> is significant and should be respected how it became a starting point and created a stir. I confidently assure how TYPOJANCHI will be grew more and effectively used in the future.

서 제1권이 출판되어 시리즈 누계 매출 270만 부를 넘은 대 히트작이 되었다. 그 밖에도 서적화, 만화화, 영화화, 게다가 드라마화 된 것도 있다.

휴대소설의 문자조판은 가로조판으로, 한 문장 한 문장이 짧고 회화가 많다. 또한, 그림 문자·기호·반음(히라가나의 작은 글자 'わ' 등)의 사용과 주인공의 주관시점·의식의 흐름적 기술이 특징적이다. 행을 바꾸는 일이 많기 때문에 여백이 많이 생기지만, 이것은 실제로 글을 휴대전화의 화면으로 읽을 때의 스크롤 속도를 상정하여 적당한 공간을 만들기 위해서 행해지고 있다. 경우에 따라서는 공백 페이지를 한 장 끼워두기도 하며, 행간을 의식한 공간에 유연성 있는 장치를 설치한 것이다. 무료로 읽고 버리는 휴대소설이 출판화 현상으로까지 이행되고 기억장치로서 서적의 본연의 모습에 파문을 일으킨 일에는 흥미를 품게 된다.

이제부터 인터넷시대에서의 동아시아 한자권(漢字圈) 성립과정에서 편입된 전자(電子)를 생각하며, 이번의 타이포잔치가 출발점이 되어 파문을 일으킨 역할은 중대하면서도 존중받아 마땅하다. 차후 계속해서 효과적으로 활용해나갈 것을 믿어 의심치 않는다.

special

feature

yamamoto.taro.

야마모토.타로.山本太郎.

yamamoto taro

<TYPOJANCHI 2011>, a biennale of typographic design works from China, Japan, and Korea, was held from August 30th to September 14th at Seoul Calligraphy Museum. Symposium, participated by main exhibition designers, and panel forum was held for two days, the 29th and 30th.

Total of 99 designers, 33 designers each from the three East Asian countries with different languages, participated in the main exhibition. Despite political, cultural, and social differences in these three East Asian lingual regions, their typography must be developed by establishing the recognition of historically sharing in readers' cultural trends, and becoming aware of their individual identities. Such idea lies in the background of hosting TYPOJANCHI.

I enjoyed the presented works in the exhibitions and designers' speeches in the symposium in person. I would like to mention a few challenges I found in this <TYPOJANCHI 2011>.

1.

The characteristics of Chinese character, Kana, and Hangeul, and their typographical possibilities.

Japanese, Chinese and Korean each has their own writing system. It is clear that typography in each region has recognized the identity of each writing system(Chinese character, Kana, and Hangeul) and developed it. Therefore, it is a natural for a Chinese designer to praise the modern significance of traditional calligraphy or artistic greatness of historical calligraphy works. For example, he can develop "書画同源(calligraphy and drawing come from one origin)" way of thinking and apply it in his graphic design. A Korean designer can speak about the identity,

한·중·일 디자이너가 모여 타이포그래피를 주제로 열린 〈타이포잔치 2011〉이 2011년 8월 30일부터 9월 14일까지 서울서예박물관에서 개최되었다. 주요 출품 디자이너들이 참석한 심포지엄과 토론회는 29일과 30일 이틀에 걸쳐 개최되었다. 동아시아 3개의 다른 언어권에서 각각 33명, 합계 99명이 본전시 작품을 출품했다. 타이포잔치의 개최 배경에는 동아시아 3개 언어권이 정치적·문화적·사회적 차이가 있음에도 불구하고 독특한 문화적 경향을 역사적으로 공유해왔다는 인식을 정립하고, 그 독자성을 자각하여 타이포그래피를 제각기 발전시켜나가야 한다는 생각이 깔려 있다.

나는 전시회에서 출품 작품을 감상하고 심포지엄에서 직접 디자이너들의 설명을 들었다. 이번 〈타이포잔치 2011〉에서 발견할 수 있었던 몇 개의 과제에 대해 언급하려고 한다.

1.

한자·가나·한글의 특성과 타이포그래피의 가능성

일본어·중국어·한국어가 각각의 독자적인 문자 체계를 가지고 있으므로 각 지역의 타이포그래피가 저마다 문자 체계(한자·가나·한글)의 특수성을 인식하고 발전시켜온 것은 자명한 일이다. 따라서 중국 디자이너가 전통적인 서법(書法)의 현대적 의의와 과거 능필 작품의 예술적인 위대함을 칭송하고, 예를 들어 '서화동원(書画同源: 서예와 회화는 근원이 같다)'의 사고방식을 발전시켜 자신의 그래픽 디자인에 응용하거나, 한국 디자이너가 한글이라는 문자 체계의 독창성과 구조의 논리성, 그 표현 가능성에 대해 자신 있게 말할 수 있는 것은, 일본 디자이너가 히라가나 형태의 독자적인 아름다움을 칭찬할 수 있는 것과 같이 당연한 일이라고 할 수 있다.

타이포그래피는 손으로 쓴 글씨를 기본으로 한다. 따라서 손으로 직접 쓴 문자의 형태, 그 역사적인

738

structural logicality, and expressional possibility of Hangeul, as confidently as a Japanese designer complimenting about the independent aesthetics of Hiragana forms.

Typography is based on hand written letters. Thus, hand written letter forms, historical styles and great calligraphic works, historical style transitions can not be overlooked. On the other hand, typography does not use the raw hand written letters. Typography uses standardized letter forms which are replicated by the molds, i.e., "type". Even the handwriting or calligraphy based typeface can not be free from the limitations and advantages of type attributions, as long as it is a typeface. However, awareness of the limitations and advantages can lead to various possibilities. For example, determining aesthetic visible letter width or expressing random form changes can become a challenge when applying handwriting characteristics onto a typeface. On the other hand, of course, there can be opinions that typography should aim for visual order and socially easy readability via standard of type and combination of standardization. Such idea could result challenges such as consistency and modularization of typeface design, and trade off of visual effects.

Current status of <TYPOJANCHI 2011> is exploring the possibilities of typography in each culture; Chinese characters, Kana and Hangeul. Most of graphic designers freely use types facing possibilities and limits of fixed type format. Many of them boldly adopt handwritings and writing formats. The challenge will be to clearly distinguish handwritten letters from type while thinking and appreciating new formats and methods of future typography. There is no doubt that typography using Chinese character, Kana and Hangeul will achieve variety of developments in their own unique ways.

2.

Regarding the relation between syntax and East Asian letters.

English has become universally dominant language due to internet diffusion, and such fact is affecting cultures of individual regions. Some

양식과 과거의 능필이 남긴 작품, 역사적인 양식의 변천 등을 무시할 수 없다. 한편 타이포그래피는 손으로 쓴 문자를 그대로 사용하지는 않는다. 타이포그래피는 정형화된 문자의 형태, 그 틀에 의해 복제된 문자의 형태, 즉 '타입(type)'을 사용하는 것이다. 아무리 손글씨와 캘리그래피 양식에 바탕을 둔 타입페이스라고 해도, 타입이라는 것에 기인하는 제약과 이점에서부터 자유로울 수는 없다. 그러나 그 제약과 이점을 인식함으로써 다양한 가능성으로 발전할 수 있다. 예를 들어 손글씨의 특징을 타입페이스에 적용시키려고 한다면, 보았을 때 아름다운 문자의 너비를 결정하는 방법과 임의의 형태 변화를 어떻게 표현할 것인가 등이 과제가 될 것이다. 그렇지 않고 타이포그래피는 어디까지나 타입의 정형성, 정형화된 형태를 조합함으로써 얻을 수 있는 시각적 질서와 사회적으로 읽기 쉬운 것 등을 추구해야 한다는 생각도 당연히 있을 수 있다. 그 생각에서는 타입페이스 디자인의 일관성과 모듈화, 시각적인 효과와의 트레이드오프 등이 과제가 될지도 모른다.

〈타이포잔치 2011〉의 현시점에서는 아직 한자·가나·한글을 사용하는 각각의 문화 내의 타이포그래피 가능성을 모색하고 있는 단계이다. 그래픽 디자이너의 대부분은 각자의 일상적인 작업에서 정해진 형식의 타입 가능성과 한계에 직면하면서 타입을 자유자재로 사용하고 있으며, 손글씨와 글의 양식을 대담하게 도입하는 디자이너도 적지 않다. 손으로 쓴 문자와 타입을 명확하게 구별하면서 앞으로 창출될 타이포그래피의 새로운 양식과 방법에 대해 사고하고 음미하는 일이 이후 과제가 될 것이다. 한자·가나·한글을 사용한 타이포그래피는 각기 독자적인 방법으로 다채로운 전개를 이루어나갈 것임에 틀림없다.

2.

구문(歐文)과 동아시아 문자의 관계에 대하여

인터넷의 보급으로 영어가 세계적인 지배 언어로 대두되는 일이 개별 지역의 문화에 영향을 주는 것, 그것이 동아시아의 타이포그래피에서는 한자·가나·한글 저마다의 문화적 전통을 보호하고 발전시켜나가는 데 장애가 될 것이라는 의론이 있었다. 무엇에나 영어 또는 영어와 비슷한 언어를 쓰려고 하고, 라틴 알파벳(로마자)을 쓰고 싶어 하는 경향이 패배주의적이라는 생각은 옳다. 한편 우리가 라틴 알파벳이라 일괄적으로 부르는 것에는 역

yamamoto taro

said it will become an obstacle in East Asian typography, in protecting and developing cultural traditions of Chinese character, Kana and Hangeul.

I agree that the tendency to use English, English-like language, or Latin Alphabet in everywhere is a defeatism. On the other hand, people dealing with typography must be aware that among what we en bloc call Latin Alphabet, there exist vast of history and geography together with extremely fine diversity.

For example, Latin Alphabet is a tiresome in Japanese typesetting. In general body text typesetting, vertical strokes of almost all Latin Alphabet fonts are too bold. Baseline is sometimes too low, Latin Alphabet often appears smaller in same body size. In this sense, the properties of Latin Alphabet is generally different. But when we focus on each Latin Alphabet typeface designs, we can see a rich diversity based on the tradition of European handwritings and the long history of typeface design since the Gutenberg. The visual coordination of how much disparate Latin Alphabet can be accepted in the visual space of Japanese typesetting is a challenge when combining Japanese and Latin Alphabet. We also need to immerse in selecting which style of typeface to use for Japanese typesetting. There can be a tension and certain harmony, as two very different writing systems are mixed on same typography on same page.

Submission of a disparate writing system by the other writing system is not the solution to this problem. Rather, the tension by proximity of disparate forms will create either the visual stability or unstable parallel status.

The ability to freely use Latin Alphabet may become one of the main challenges in the future.

3.

New graphic design, the possibility of typography.

One of the worthy of special mention in <TYPOJANCHI 2011> was the fact that there were many works by relatively young generation of graphic designers.They are each practicing unique forms of expression

사적·지리적으로 광대하면서 극히 섬세한 다양성이 있음을 의식하는 것이 타이포그래피를 다루는 사람에게는 필요할 것이다.

예를 들면 일본어의 타입 세팅(type setting)에서 라틴 알파벳은 성가신 존재이다. 통상적인 본문 조판에서 거의 모든 라틴 알파벳 폰트의 세로획은 너무 두껍다. 베이스 라인은 너무 낮은 경우가 있고, 같은 보디 사이즈에서는 라틴 알파벳이 작게 보이는 경우가 대부분이다. 그런 의미에서 일반적으로 라틴 알파벳은 성질이 다르다고 말할 수 있다. 그러나 개개의 라틴 알파벳의 타입페이스 디자인에 주목하면, 거기에는 유럽 손글씨 문자의 전통과 구텐베르크 이래 타입페이스 디자인의 긴 역사를 배경으로 한 풍요로운 다양성이 있다. 일본어와 라틴 알파벳을 조합하는 경우에는 이질적인 라틴 알파벳을 얼마만큼 일문 조판의 시각적인 공간에 정합시키는가뿐만 아니라, 어떠한 양식의 서체를 선택하여 일문 조판에 사용할 것인가라는 과제에 몰두할 필요가 있다. 여기에는 크게 다른 두 가지 문자 체계가 같은 타이포그래피와 같은 페이지 위에 함께 섞인다는 긴장감과 일정 부분 조화가 있을 수 있다.

어느 한쪽의 문자 체계가 이질적인 다른 한쪽을 굴복시키는 방법이 문제의 해결이라고는 볼 수 없다. 오히려 이질적인 형태의 근접으로 인한 긴장감을 동반하면서 시각적인 안정 혹은 불안정한 평행 상태를 만들어내게 될 것이다. 얼마나 자유자재로 라틴 알파벳을 사용할 수 있는가가 앞으로 가장 큰 과제가 되지 않을까.

3.

새로운 그래픽 디자인, 타이포그래피의 가능성

이번 〈타이포잔치 2011〉에서 대서특필할 만한 한 가지는 비교적 젊은 세대 그래픽 디자이너의 작품이 상당수였다는 점이다. 그들은 이 망망한 21세기의 동아시아에서 일상적인 디자인의 문제 해결에 쫓기면서도 제각기 개성적인 표현 형식을 실천하고 있다. 이것은 당연한 일이지만, 그 활동에서 자신의 개성을 단순히 직선적으로 추상화된 구조에 의한 예술적 표현과 미술사적 재능이나 기량에 의해 초월적인 시각 예술로 변환시켜버리는 것이 아니라, 문제 해결의 안건으로 바라본다. 관념이 아닌 실제의 사물에 비추어 각각의 디자인을 설계하고 객관적으로 제시하면서, 여러 각도에서 바라보기도 하고 음미하기도 하며 재인식할 수 있

though they are chased by the daily design problem-solvings of precipitous 21C East Asia. Naturally, one's personality in this practice is not converting design into a kind of transcend visual art by simply straightforward abstract structural artistic expression and magical talents or skills. Rather, I could realize that it attempted for very interesting visual experience as a problem-solving agenda. This visual experience plans each design based on the actual object instead of the concept, objectively suggests while looking from multiple angles, enjoys and has a new understanding. High regard of the concept formation prior to visualization, and tendency to visually express various aspects and polysemy of the context are prominently shown in works such as Sulki & Min's.

Traditionally, typography has always been the technology to visually convey human language and settle them as prints. The aesthetic expression was limited to the finally printed type form, typesetting or layout. Perhaps the challenge, presented by the young generation designers, must be the self-satisfaction and lightness of preoccupying to value system of such traditional typography. They may be questioning the necessity of Cliche aesthetics.

If so, I doubt the possibility of experienced graphic designers sharing this critical minds of young designers' works. However, even if young generation and older graphic designers pretended to understand each other, it would be meaningless. Experienced designers have the keen aesthetic sensibility to intuitively derive visual concept from a given task, and the skill to execute it into a great magnificent print. For example, I was amazed by Asaba Katsumi's precise form choices of design developments on Paul Klee. Also, I could understand that Chung Byung Kyoo's book designs were aiming for the ultimate possibility of Hangeul letter expression. Kan Tai-keung's works seemed to be leading us into the ideal world of "書画同源".

All generation designers of East Asia have clearly begun to think deeply about the importance of exquisite typography. I could confirm it in my first visit to Seoul.

는 매우 흥미로운 시각적 체험을 부여하려고 한 것을 깨달을 수 있었다. 작품이 시각화되기 이전의 개념 형성 부분을 중요시하고 그 내용이 가진 다면성·다의성을 시각적으로 표현하려는 경향은, 예를 들어 슬기와 민의 작품에서 탁월하게 나타나고 있다.

전통적으로 타이포그래피는 늘 인간의 언어를 시각적으로 전달하고 인쇄물로서 정착시키기 위한 기술이었다. 거기에서 심미적인 표현은 최종적으로 인쇄되는 타입의 형태, 조판이나 레이아웃에 한정되어 있었다. 아마도 젊은 세대 디자이너들이 제시하는 과제라는 것은 그러한 전통적인 타이포그래피의 가치 체계에 매달리는 데 대한 자기만족 또는 가벼움이 틀림없다. 진부한 아름다움에 그 필연성 유무를 묻고 있는 것이 아닐까.

그렇다면 경험이 풍부한 그래픽 디자이너들은 그러한 젊은 디자이너들의 작품이 지닌 문제 의식을 공유하는 일이 가능한가라고 묻는다면, 그것은 의문이다. 만약 젊은 세대와 연배 있는 그래픽 디자이너들이 서로 이해하는 척하여 친해진다고 해도 그것은 무의미한 일일 것이다. 경험이 풍부한 디자이너는 주어진 과제로부터 시각적인 구상을 직관적으로 이끌어낼 수 있는 예리한 심미적 감성과, 그것을 훌륭한 인쇄물로 완성시킬 수 있는 기술을 가지고 있다. 예를 들면 나는 아사바 카쓰미의 작품에서 파울 클레의 디자인 전개에서 볼 수 있는 정밀한 형태 선택에 놀랐다. 그리고 정병규의 북 디자인은 한글 문자 표현의 극한을 목표로 하고 있음을 알 수 있었다. 또한 칸타이큥의 작품 세계는 서화동원(書画同源)의 이상세계로 우리를 이끌어가는 것 같았다.

동아시아 모든 세대의 디자이너가 타이포그래피라는 기예가 가진 중요성에 대해 깊게 생각하기 시작했다는 것은 분명하다. 처음으로 방문한 서울에서 그 사실을 확인할 수 있었다.

yamamoto taro

From 2D to 3D

development of visual sense for a better typography

2D에서 3D까지
보다 좋은 타이포그래피 결과를 얻기 위한 시감각의 개발

2011.08.28-29.at.hongik.university.

niijima.minoru.

니이지마.미노루.新島実.

Of course, a decisive difference exists between the backgrounds of typography design of East Asia countries and of countries using Roman alphabets. This is a difference resulted from criteria of font design, and can be rephrased as the difference between square letter culture and rectangular letter culture. Also, subtle difference in square letters in a relationship with literation exists even in square letter culture, and they are each creating their own very interesting world of typography.

Gutenberg's belief of attempting the presswork of using different typeface of different width of letters on *bible* written on both sides established 550 years of western letter typography history. As we belong to the square letter culture, it is perhaps difficult for us to fully understand the principle of western letter typography that's lined up from left to right. To be blunt, typesetting letters is practically the same as molding in rice measure of square letters to us, who belong to the square letter culture. If counting the number of letters is possible, the square letter solves everything hereinafter. However, realizing this mistake(delusion) as a mistake itself is a tough problem.

The standard of this handy typeface design, called square letter, is making attitudes regarding fundamental basis of typography, the 'typeset,' very ambiguous. Although clearly understanding desirable design of square letter typography and its concept is being required as digital devices and applications are being developed substantially, we have not yet come up with clear and decisive solution.

당연한 이야기이지만, 동아시아 나라들의 타이포그래피 디자인과 로마자를 사용하는 나라들의 타이포그래피 디자인의 배경에는 결정적인 차이가 존재한다. 그것은 서체 설계의 기준에서부터 오는 차이이며, '정방형(正方形) 문화'와 '장방형(長方形) 문화'의 차(差)라고도 바꾸어 말할 수 있다. 또한 정방형 문화권에서도 문자 표기와의 관계에서 정방형에 대한 인식에 미묘한 차이가 존재하며, 매우 흥미로운 타이포그래피 세계를 저마다 형성해나가고 있다.

양쪽 정렬로 쓰인 『성서』를 글자 너비가 서로 다른 활자 서체를 사용해 인쇄를 시도해본 구텐베르크의 소신이 550여 년에 걸친 구문(歐文) 타이포그래피의 역사를 쌓아올렸다. 이러한 구문 타이포그래피의 기본적인 소신에 대해 정방형 문화권에 속하는 우리가 좌우를 정렬하는 구문 타이포그래피의 소신의 깊이를 완전히 이해하는 것은 아마도 무리일 것이다. 정방형 문화권에 속하는 우리에게 글자를 조판한다는 것은, 극단적으로 말하면 정방형의 되를 메워 넣는 것과 다름없다. 글자 수만 셀 수 있다면 그 뒤엔 정방형이 모든 것을 해결해준다. 어찌 보면 엄청난 착각이지만 이 착각을 착각이라고 자각하는 것 자체가 어려운 일이다.

정방형이라고 하는 서체 설계의 편리한 기준이 '활자를 조판한다'는 타이포그래피의 근본적인 명제에 대한 태도를 애매하게 만들고 있다. 디지털 기기와 애플리케이션이 충실(充實)하게 발전하면서 정방형에 의한 타이포그래피 디자인의 바람직한 모습과 그 개념을 분명히 하는 일이 요구되고 있지만, 아직 명확한 답은 없다.

Based on this current situation, I became responsible for the typography design workshop. I put fair amount of time worrying about which theme I should choose in order to establish the workshop and which content would be possible to be organized.

Looking back on the history of typography design, discovering high-quality typography design from wide array of productions is not easy as its standard is ambiguous. The first thing that comes into my mind is a saying by Stanley Morrison, 'the unreadable typography is meaningless.' However, there were few pieces that left great impression even though I was unable to read them because of their beauty as they transcended culture or ages. Why did I see these works beautiful? In every work, the space quality commonly exists in different backgrounds of beauty. This quality of space is a manipulation, called 'color-control' of typography in form-manipulative aspect. The typography design is basically comprised of drastic contrast of black and white. It is natural that there is no chromatic color in typography design. However, gray texture is created as different types entangle with each other, and correction of such gray texture is called the 'color correction.'

I remember the image of Nicolas Jenson's work of different typesets. This piece of paper with Jenson's letters reminded me of surface of the water without any tiny little waves as every noise was completely removed. This piece of paper is a perfect 2-dimensional flat surface. The frontispiece of *Typographische Gestaltung* by Jan Tschichold is creating 3-dimensional space just by arranging different typefaces. Furthermore, it represented usage and historicity of the typeface by using different fonts of different origins from fonts such as Script(copperplate printing), Egyptian(wooden printing type), Bonodi, and Roman(metal type). A desirable image of typography design is depicted here as Tschichold's knowledge on typography and his sensitivity is making a remarkable harmony. This 'color correction' of echoing deep into the

이러한 현상에 입각하여 나는 타이포그래피 디자인 워크숍을 진행하게 되었다. 워크숍 테마를 무엇으로 설정해야 하는지, 또 어떠한 내용으로 구성하는 것이 가능한지에 대해 적잖은 고민을 했다.

타이포그래피 디자인의 역사를 되돌아보면, 그 방대한 제작물 속에서 양질의 타이포그래피 디자인을 발견한다는 것은 그 기준이 모호한 만큼 쉬운 일이 아니다. 가장 먼저 생각나는 것은 스탠리 모리슨의 '읽을 수 없는 타이포그래피 디자인은 의미가 없다'는 말이다. 맞는 말이다. 그렇지만 나에게는 읽을 수는 없으나 지역이나 문화 혹은 시대를 초월하여 그 아름다움에 감동할 수밖에 없었던 작품이 몇 점 존재한다. 그 작품들은 왜 아름답게 느껴지는 것일까. 작품마다 아름다움의 배경에는 공통적으로 보이는 공간의 질(質)이 있다. 이 공간의 질은 조형조작(造形操作)적으로는 타이포그래피의 '색 조정(color control)' 이라고 불리는 조작이다. 타이포그래피 디자인은 기본적으로 흑백의 강한 대비로 구성된다. 타이포그래피 디자인의 화면에서 유채색이 보이지 않는 것은 당연하다. 그러나 타입과 타입이 얽혀 회색의 텍스처가 생성되고 이 회색 텍스처의 조정을 '색 조정'이라고 부른다.

니콜라스 젠슨(Nicolas Jenson)의 활자와 활자로 조판된 모습을 떠올린다. 젠슨의 활자로 조판된 지면에는 모든 노이즈(noise)가 완전하게 제거되어 작은 물결도 일지 않는 수면을 상기시킨다. 이 지면은 완전한 2차원의 평면이다. 얀 치홀트(Jan Tschihold)가 제작한『타이포그래피의 형성(Typographische Gestaltung)』의 속표지는 서로 다른 활자 서체의 배치만으로 3차원적인 지면 공간을 만들어내고 있다. 게다가 사용된 서체는 스크립트체(동판 인쇄문자), 이집선체(목활자), 보도니·로만체(금속활자)와 태생이 다른 서체를 이용함으로써 서체의 사용 방법과 역사성을 나타내고 있다. 치홀트의 타이포그래피에 관한 지식과 타이포그래피에 대한 감성이 훌륭하게 융화되어 타이포그래피 디자인의 바람직한 모습을 보여주고 있다. 타이포그래피 디자인의 기능을 받쳐주

brain while supporting the function of typography design is a sense that has connection with Chirasigaki(a type of Japanese poetry/ writing letters sparsely without following the lines on colored paper or small paper), which is a technique of recording the Waka(a type of Japanese poetry). It is a form-manipulation that needs to be passed through in order to approach the heart of typography design whether it is a space formation by 'beauty' or space formation needs 'beauty.'

Among square letter cultures, Korean is the letter orthography of least noise occurrences. In contrast, Japanese is the most bothersome language in typography design as noise itself is increasing the readability of letters. Although the balance of letters in Japanese font family is perfectly designed to some extent, complex noise occurring from the letter system, a mixture of Hiragana, Katagana, and Kanji, makes color correction by the weight of letters rather difficult. Flat and slippery nature of the Korean font typeset has something in common with the flat and slippery nature of western letters. Therefore, the color correction of typography can be regarded as the most important form manipulation in achieving high quality outcome.

By the same token, I designed a workshop with color control of typography as the theme.

Purpose:
Introduction and production of color correction learning method of 'typography' with a purpose of 'visual sense' acquisition that can freely control the acquisition of 'visual sense' by sensitively responding to the fine alteration of space on the flat surface created by formative elements which compose typography.

Summary:
Typography design is treated almost the same as 3-dimensional space with perspective rather than simply understanding it as the flat composition. This signifies control of black and white(colors in typography) which is created by

면서도 뇌의 깊은 곳까지 울려 퍼지는 듯한 이 색 조정은 일본의 와카(和歌)를 기록하는 기법인 '치라시가키(색지나 작은 종이 등에 줄이나 글줄 사이를 맞추지 않고 띄엄띄엄 흩뜨려 씀)'의 표정과도 통하는 감각이다. '아름다움'에 의한 공간 형성인지, 혹은 공간 형성이 '아름다움'을 필요로 하는 것인지, 타이포그래피 디자인의 핵심에 다가서기 위해서는 반드시 통과해야만 하는 조형 조작이다.

정방형 문화권 중에서도 한글은 가장 노이즈 발생이 적은 문자 표기법이다. 그에 비해 일본어는 노이즈 자체가 글자 표기의 가독성을 높이는, 타이포그래피 디자인에서는 매우 성가신 언어이다. 일본어 폰트 패밀리의 글자 무게 조정이 어느 정도 완벽하게 디자인되어 있어도, 한자와 가나가 섞인 표기 체계 때문에 발생하는 복잡한 노이즈는 글자 무게에 의한 색 조정을 어렵게 하고 있다. 그것에 비해 한글 서체 조판의 평활성(平滑性)은 구문의 평활성과 상통하고 있다. 그러므로 한글의 타이포그래피 디자인에서 타이포그래피 색 조정은 양질의 결과를 얻기 위해 필요한 것은 조형 조작일 것이라고 추측할 수 있다.

위와 같은 이유로 이번 워크숍에서는 타이포그래피의 색 조정을 테마로 한 워크숍을 계획했다. 다음은 그 구체적인 내용을 기록했다.

목적
타이포그래피를 구성하는 조형 요소에 의해 창출된 평면상의 미세한 공간 변화에 민감하게 반응하여, 그것들을 자유롭게 제어할 수 있는 '시감각(視感覺)'의 획득을 목적으로 한 '타이포그래피에서의 색 조정'을 연습한다.

개요
타이포그래피 디자인을 단순히 평면적인 구성으로 이해하는 것이 아니라, 원근감을 가진 3차원 공간과 거의 흡사한 것으로 다룬다. 이것은 활자에 의해 생성되는 흑백 명암(타이포그래피에서의 색)의 조정을 의미한다. 이 3차원 공간과 같은 공간을 제어하기 위해서는 타입을 포함한 형태의 무

letters. Weight control of shapes including the type(thickness of lines composing the type and shape) and modification of class by change in weight are required to control such 3 dimensional space. A remarkable typography design makes the control of 3 dimensional space to accomplish the purpose of design, and its completed result is extremely beautiful.

The basics of detailed method of obtaining high-quality 'visual sense' will be treated in this workshop through 'exercise of weight and class control.'

Prior Assignment:
After standardizing the size by selecting one letter out of 4 different types of shape and print, each shape will be substituted with a class of the same perspective of 5 dimensions.

• Select circle, plus sign, triangle, x-mark, and one letter from families of univers or Helvetica. 5 characters will be selected.
• 4 different characters, except the typeface, will be given with the weight of different letters from each other.
• The weight of 4 different characters is adjusted by the weight of one letter selected from fonts and the weight will be controlled for 5 characters to change with each other.

A practice, which was carried out in this workshop, is one of the studies from a typography design class for sophomores in Visual Design department where I am teaching at Musashino Art University. Actually, everything is handled manually by putting in more time. Here, computer is used to produce materials due to the time limitation, but other than that, it was composed by directly working with eyes and hands. Students at Hongik University seemed to hesitate quite a lot at first as they did not have much experience of manual work, but as they got accustomed to manual works, they produced results beyond my expectation by displaying good concentration as they gradually got used to the process of manual work.

nijima minoru

게(타입과 형태를 구성하는 선의 두께) 조정과 무게의 변화에 따른 계층의 조정을 필요로 한다. 뛰어난 타이포그래피 디자인은 그 3차원 공간과 같은 공간의 제어가 디자인의 목적을 이룰 수 있게 하며, 완성된 결과는 무척이나 아름답다.

이번 워크숍에서는 '무게와 계층의 조정 연습'을 통해 양질의 '시감각'을 얻기 위한 구체적인 방법의 기초를 배운다.

사전 과제
서로 다른 네 종류의 형태와 활자 중 한 글자를 골라 크기를 통일한 뒤, 각 형태를 5단계의 동등한 원근감을 부여한 계층으로 치환한다.

• 원, 덧셈 부호, 삼각형, 엑스표(X)와 유니버스 혹은 헬베티카의 패밀리에서 한 글자를 골라 5개의 캐릭터를 설정한다.
• 타입페이스를 제외한 4개의 캐릭터에 서로 다른 글자의 무게를 준다.
• 폰트에서 선택한 한 글자의 무게를 기준으로 다른 4개 캐릭터의 무게를 조정하여 5개 캐릭터가 서로 같이 변화하도록 무게를 조정한다.

이번 워크숍에서 실시한 연습은 내가 교편을 잡고 있는 무사시노미술대학 시각전달디자인학과 2학년 타이포그래피 디자인 수업에서 하고 있는 학습이다. 실제로는 몇 배의 시간을 들여 모든 것을 손으로 작업하고 있다. 이번에는 시간의 제약 등으로 구성 재료의 제작은 컴퓨터를 사용했지만, 그 외에는 손과 눈으로 직접 작업하며 구성했다. 홍익대학교 학생들은 수작업 경험이 거의 없어서 처음에는 상당히 망설이는 듯했지만, 점차 익숙해지면서 재미있어졌는지 마지막엔 꽤나 집중력을 발휘하여 내가 상상한 것 이상의 결과를 내주었다. 시작은 5단계의 원근감을 가진 계층을 상정하여 작업이 진행되는데, 어떤 학생은 모든 요소를 하나의 계층에 얹어놓는 것을 먼저 시험해보고 거기서부터 다시 정확하게 5단계의 원근감을 가진 계층을 설정하고자 했다. 이것은 상당히 어려운 접근법이지만, 그만큼 매우 흥미로워 어떤 결과가 나올지 기대가 되었다.

The beginning was progressed by introducing classes with 5-dimensional perspective. Some students placed every element on one class and attempted to set-up a class with 5-dimensional perspective again more accurately. This is a rather difficult approach, but the outcome was anticipated as it being very interesting.

How would the typography design with square letter culture of Chinese letters as its standard be unfolded in which direction? In western typography design world, the history was carefully described and left behind for posterity. Also, we were greatly blessed by this repeated history. In terms of Chinese letter culture, interpretation of square letter culture became the topic which was brought up in the <Typojanchi 2011> symposium repeatedly. Japanese Gana leters were not of characters that needed to be designed within square letters. However, Gana letters are assumed to have changed into a current shape as letters became more square-like from its strong characteristic of vertical connection when letters were only written vertically. Whether the letters are the same shape as today is not definite if necessity of horizontal writing existed in the process of writing square letters. In order to learn about the big picture of Korean typography culture, the relationship of literation, study on the typography design, and practice are expected.

한자문화권의 정방형을 기준으로 하는 타이포그래피 디자인이 앞으로 어떠한 방향으로 갈 것인가. 서구의 타이포그래피 디자인 세계에서는 정성을 들여 세심하게 역사를 기술하여 후세에 남겨왔다. 그 거듭된 역사에 의해 우리는 대단히 큰 유산을 받게 되었다. 한자문화권에서 정방형의 해석은 <타이포잔치 2011>의 심포지엄에서 반복되어 논의되었다. 일본어의 '가나 문자'는 본래 정방형 안에 디자인되어야 하는 성격의 문자는 아니었다. 그러나 '가나 문자'의 형태가 가진 세로 연결의 강함과 세로쓰기 표기만 했던 시대에 점점 정방형화됨으로써 현재의 형태에 이르렀다고 추측된다. 만약 정방형화 과정에서 가로쓰기 표기의 필요성이 있었다면 현재와 같은 형태가 되었을지는 알 수 없는 일이다. 한자문화권 타이포그래피의 전체 상을 알기 위해, 다시 한 번 문자 표기와의 관계부터 타이포그래피 디자인이 연구되길 기다리고 또 기다려진다.

pan.qin.

판친.潘沁.

2011.08.31.at.university.of.seoul.

'XXX' can be interpreted in three different ways. First, in 2005 I was invited to the main exhibition of <Shenzhen Graphic Design in China >.It was an occasion where I began to work on my first series of 'In China-XXX'. Second, 'xxx' represents 'denial', which means that the work is done as a part of self-reflection. Third, *Diamond Sutra* is an on-going project as a part of 'In China-XXX' series and will take several months to finish. In today's lecture I will present you some of my representative design projects done during the last few years. I hope this will give you some pleasant time.

In China-XXX

Chinese character is the oldest and one of the most complicated writing systems in the world. According to an official document, Chinese character dates 4500 years back to Shang Dynasty and the bone-and-shell script is regarded as the most systematic Chinese character ever created in a short time. However, during the last few years some new artifacts have been excavated and we have come to learn something new history of Chinese character. What was excavated was a piece of jade plate, where some characters were inscribed. It was found in some parts of Inner Mongolia and one presumes that it has a history of 8500 to 1000 years. If this is true, it will be inevitable to move up the origins of Chinese character by several thousand years. Also, in some parts of Jiangnan, artifacts of 10000 years of history have been found including containers for everyday life and works of art. Additionally, some characters were also discovered, which means that the history of China can date back by 6500 to 10000 years or even more.

'XXX'는 세 가지 의미를 담고 있다. 첫 번째, 'IN CHINA-XXX'는 2005년 〈선전 그래픽 디자인 비엔날레〉의 주제 초청 전시를 위해 완성한 작품으로 그 후 연속작업을 해왔다. 두 번째, XXX는 '부정'이다. 지난날 전공 이력에 대한 자아반사이다. 세 번째, '금강경', 이것도 'IN CHINA-XXX' 프로젝트의 연속으로 현재 진행 중인 선의(禪意)가 있는 프로젝트이다. 아직 수개월의 지속적인 작업이 필요하다. 강의 내용은 주로 최근 몇년 동안의 대표적인 디자인 프로젝트를 맥락으로 되돌아보는 것으로 그래픽 디자인의 즐거움을 공유하고자 했다.

IN CHINA-XXX

한자는 세계에서 오래되고 복잡한 문자 시스템 중 하나이다. 공식적인 문헌에 의하면 한자의 역사는 4500년 전의 은상 시기부터 시작되었으며, 갑골문은 가장 빠르고 시스템화된 한자로 인정받고 있다. 하지만 최근 몇 년간 새롭게 출토된 문화 물품 중에서 또 다른 새로운 발견이 있었다. 8500년 전부터 1만 년 전의 내몽골 일대 고대 옥기(옥그릇)에서 문자 배열 조각이 발견되었다. 만약 이것이 확실하다면 한자의 기원은 수천 년 더 앞당겨질 것이다. 중국 강남 일대에서도 1만 년 전 인류가 생활한 유적이 발견되었고 당시 일상생활에서 사용했던 용기와 예술품도 남아 있었다. 그중 문자 메시지도 담겨 있어 중국 인류의 역사가 이미 6500년 전에서 1만 년 전으로, 혹은 더 거슬러 올라갈 수도 있다.

한자의 필획 구조는 아주 복잡해 한 벌의 폰트 상자에는 3000개의 필획이 있어야만 완전한 시스템을 구성할 수 있다. IN CHINA-XXX 프로젝트는 〈선전 그래픽 디자인 비엔날레〉 'IN CHINA' 디자인 초청 전시를 위해 제작된 것으로, 한자 형

The writing structure of Chinese character is very complicated. Thus, one needs 3000 strokes to set up a complete set of one font. In the project 'In China-XXX' I made use of the most frequently used typefaces such as Song type, Hei type and Kai type. From each of these typefaces I picked out twenty representative strokes and made atomic seals with these strokes inscribed, which can also be rubbed. For the project I invited people and made various name combinations with people's names in a form of a game. This acts as an interactive process of triggering new feelings and experiences about Chinese characters and as a challenge to traditional culture as well, which in the end produce unexpected outcomes. However, I do not regard this as a creative performance using Chinese characters. Rather, it's an experiment on Chinese characters.

Design for Zhejiang Association of Creative Design

Zhejiang Association of Creative Design is located in Hangzhou, a well-known place for West Lake. People in Jiangnan believe that all the spirit of arts is preserved at this place. The symbol design for Zhejiang Association of Creative Design is based on hexagons composed of 'Jiangnan' 'lotus flower' 'window' etc. The symbol in this case is not static. It constantly changes in countless variations based on several basic patterns.

Poster for the Exhibition <Discover Asia >

This poster was designed for the exhibition <Discover Asia > organized by Taipei Poster Design Association. The word 'ASIA' derived from the Chinese lucky symbol 'cracked ice pattern' also stands for the state of China in Asia. This concept goes well with the exhibition theme <Discover Asia> and the poster visually expresses the dynamics of Asia. Characteristic features such as 'matt black', 'the combination of black of bright color and silk printing craft' all give a rich texture to the monotone printed works series.

태 중 가장 흔히 사용되고 있는 송체, 흑체, 해체를 원형으로 글씨체마다 20개의 대표적인 필획으로 제작된 탁본이 가능한 원자 인감(도장)이다. 다른 대상을 초청하여 그들의 이름으로 조합을 진행(XXX-○○○), 게임 방식으로 한자에 대한 체험과 사고를 유발하고 전통적인 문화에 대한 도전으로 언제든지 의외의 결과물을 창출할 수 있다. 하지만 이는 한자에 대한 체험이 아닌 한자에 관한 실험이다.

저장성 창의디자인협회 시각형상 디자인

저장성 창의디자인협회(Zhejiang Association of Creative Design)는 서호로 유명한 항주에 자리하고 있다. 강남 사람들은 예술의 혼이 이곳에 있다고 믿는다. 저장성 창의디자인협회의 심벌은 강남, 연꽃, 창문 등으로 이루어진 육각형의 기본 요소를 바탕으로 수천, 수만 가지 변화된 시각적 표현을 창조했다.

〈아시아의 발견〉 전시 포스터

타이베이 포스터협회 〈아시아의 발견〉 전시를 위해 제작되었다. 중국의 행운 요소인 '얼음무늬'에서 'ASIA'를 발견하고, 또 'ASIA'에서 중국을 발견함으로써 '아시아의 발견'이라는 주제를 표현하고, 전체 포스터가 시각적으로 아시아 판도를 연상케 한다. '매트한 블랙', '밝은 광채 블랙 + 실크 인쇄 공예'는 모노톤 시리즈 인쇄 작품이 더 풍부한 층차를 띠게 한다.

211창의슈퍼마켓 시각형상 디자인(211 Creative Supermarket)

211창의슈퍼마켓은 디자인전공 학생을 위해 제공하는 창의적인 교외 실험 공간이다. 8000m²에 달하는 낡은 공장을 개조해 만든 LOFT로, 지도교사의 지도 아래 학생들은 이곳에서 창의적인 실천 등 훈련을 받는다. 졸업한 학생들이 취업을 앞두고 참여하는 훈련 캠프로, 시각형상은 'DESIGN'을 메시지 요소로 삼아 영어 폰트 중 여러 가지 '심

pan qin

Design for 211 Creative Supermarket

211 Creative Supermarket is an outdoor experimental space for students majoring in design. An old factory of 8000 m² in size was remodeled into a loft. With the help of tutors, students here are trained to do a variety of experimental practices here. It is a part of training camp that graduates need to go through before getting jobs. The logo design for this space is based on various symbol types; each symbol type represents the alphabets of the word DESIGN. Thus students in each workroom select their preferred symbol types for 'DESIGN' on their own terms and make logos. The unknown and strange, the diversified and the experiment are what make the characteristics of 211 Creative Supermarket.

Design Research

I am also conducting a personal research during the last several years, which is studying and analyzing the design phenomenon that had taken place in Taiwan before becoming the Republic of China. By looking into the period, where no design discourses had taken place, I want to reflect on the design phenomenon and the possibility of today's Asian graphic design.

Experimental Ink Design Project

Experimental Ink Design Project was occasioned by the 'Ink Design' part of the <The 5th International Ink Painting Biennale of Shenzhen>. Here I was an invited artist. In this work, I tried to talk about ink design, ink-and-wash painting, printing and finally, the motivation that lies behind this work. By using photos of landscapes of solid colors and overlapping them through printing, I tried to create a new aspect of ink-and-wash painting. Traditional ink-and-wash painting pursued "less is more" but in my case, I tried to express "more is more."

Diamond Sutra

I printed *Diamond Sutra* with Chinese characters which are made up of combined strokes of Song-type from the work 'In China-XXX'. *Diamond Sutra* is the earliest Buddhist scrip-

벌체'를 선택해 211창의슈퍼마켓의 로고로 사용할 수 있다. 작업실마다 모든 학생이 주동적으로 자신이 선호하는 'DESIGN 심벌체'를 선택해 로고로 제작할 수 있다. '미지의', '변화가 많은', '실험적인'이 211창의슈퍼마켓의 특징이다.

전 시기의 디자인 계시 연구 항목

최근 개인적인 연구 주제로 타이완중화민국 이전의 '디자인 현상'을 정리, 분석하며, 디자인 콘셉트, 디자인 교육, 디자인 업계, 디자인학과 등이 없었던 시기의 사람들이 창조한 놀라운 '디자인 형상'을 되돌아보고, 디자인의 본질로 돌아가 현재 아시아 그래픽 디자인의 가능성을 연구하는 것이다.

디자인 수묵(水墨) 실험 프로젝트

〈제5회 선전 국제 수묵예술전〉의 '수묵 디자인' 주제 초청 전시를 위해 제작한 실험작품이다. 수묵 디자인, 산수와 수묵, 인쇄와 디자인, 직접적인 창작 모티프를 제공하고 있다. 4폭의 단색 풍경 사진으로 이루어진 4장의 필름, 임의로 2폭을 인쇄로 겹치게 하여 새로운 분위기의 화면을 표현했다. 전통적인 수묵화 예술은 '적은 것이 많은 것보다 낫다'를 추구해왔지만 나의 실험은 오히려 '많은 것이 적은 것보다 낫다'를 표현하려고 했다.

금강경

2005년에 열린 〈선전 그래픽 디자인 비엔날레〉 초청 작품인 'IN CHINA-XXX'의 송체 필획을 본으로 조합하여 『금강경』을 인쇄했다. 『금강경』은 불교 경문 중 초기 경전으로 전문 6900자, '금강'은 인도의 금강석(즉 다이아몬드)에 대한 비유이다. 금강석은 밝고 견고하며 또 고귀한 것으로, 모든 것을 파괴할 수 있고 모든 외적인 파괴를 이겨낼 수 있다. 그것은 파괴할 수 없는 무적의 존재라고 볼 수 있다. 그래서 반야를 금강석에 비유하여 표현했다. 또 반야가 어떤 것의 침범과 파괴도 이겨낼 수 있음을 비유했다. 금강은 유리를 자를 수

ture composed of 6900 characters. The word 'diamond' is a comparison to Indian Diamond. Diamond is the brightest and the most solid as well as the most precious that can destroy everything and endures all the other external pressures and destructions. It is the strongest, the sharpest and the undestroyable, thus an invincible being, which is the very reason of comparing diamond to Paññā(般若), which can be translated as the wisdom in Buddhism. In Buddhism Paññā(般若) is described as something that can resist any external invasions and destructions. Diamond has a sharpness that can even cut the glass. *In Diamond Sutra*, the character 'kong(空)' meaning 'emptiness' or 'nothing' in English never appears; it's invisible. However, the meaning of 'kong' is discussed in the Sutra; thus it is visible. The way this term is discussed shows the very essence of Oriental Philosophy. During my daily free time I worked on reinterpreting the Sutra by writing one stroke after another on a scroll of white paper that is 1.6m in width. This project became a part of my daily life and it ended up in a work stretching out to 50m in length. Everyday life became the content of the work; the repetitive work pattern became the trace of the work; the naturalness became the logic of the work and finally, the freedom from avarice became the appealing point of the work.

있는 예리함을 갖고 있다.『금강경』전문에는 '공(空)'자가 한 번도 나타난 적이 없으나 토론의 방식으로 공의 지혜를 표현하고 있으며, 이 또한 동양 철학의 핵심이라고 볼 수 있다. 매일 여가 시간을 이용하여 너비 1.6m의 두루마리 백지에 필획으로 한 획 한 획 경문을 조합하며 작업했다. 일상 생활처럼 자연스럽게 일상의 한 부분이 되었으며 전문을 조합하여 완성한 작품은 길이가 50m에 달했다.

'일상'이 창작의 내용이 되고, 중복 작업이 작품의 궤적이 되었으며, 인위적이지 않음이 작품의 논리가 되고, 무욕이 작품의 소구점으로 표현되었다.

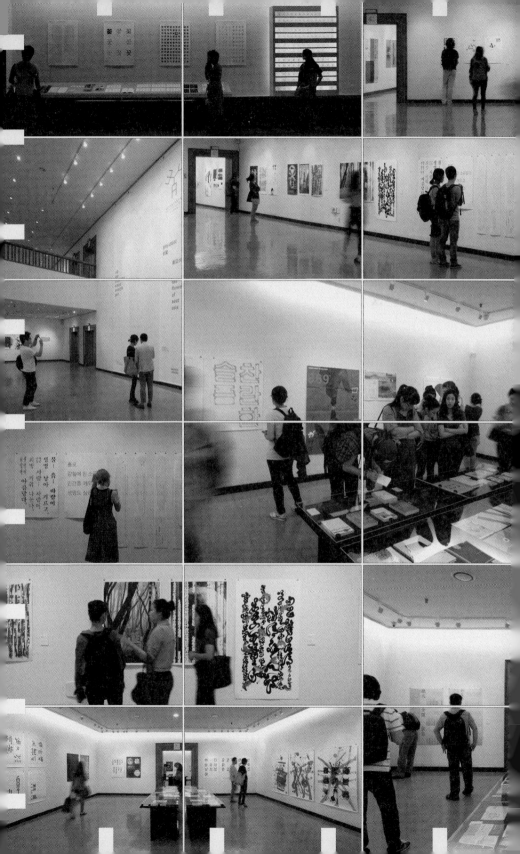

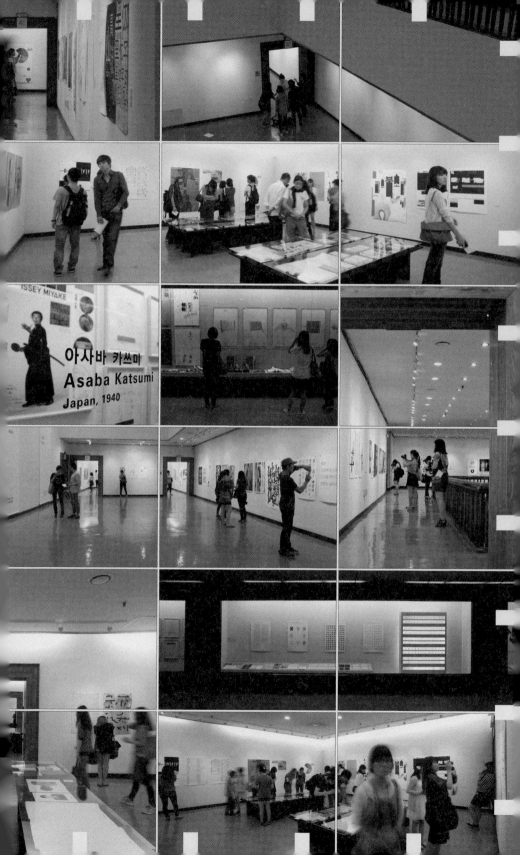

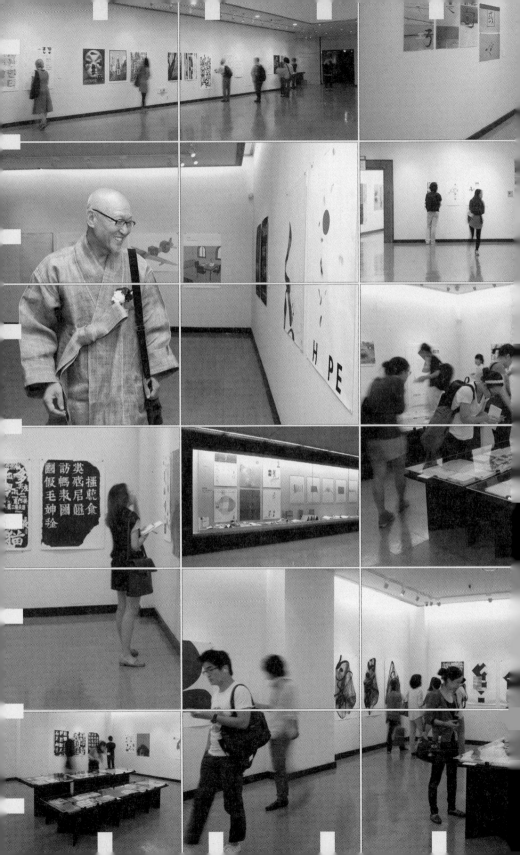

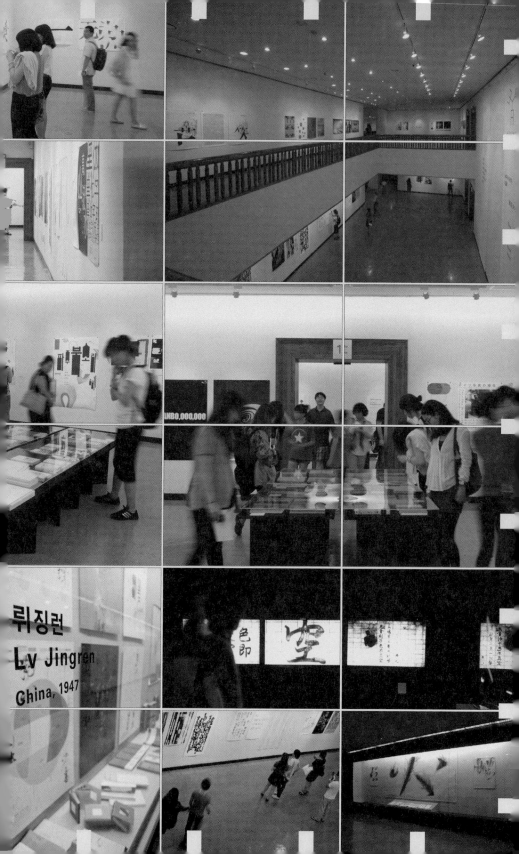

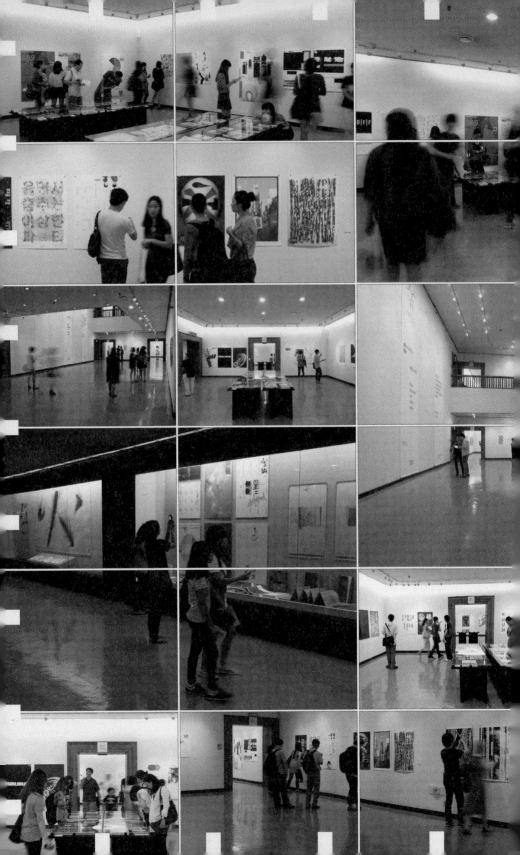

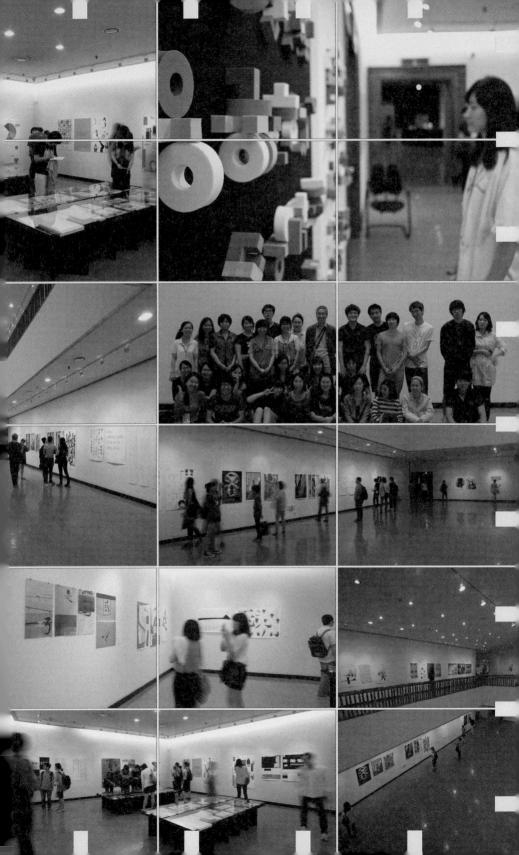

TYPOJANCHI 2011: Seoul International Typography Biennale exhibition credit

title
TYPOJANCHI 2011:
Seoul International Typography
Biennale

theme
fire flower of east asia

dates
august 30th -
september 14th, 2011
(16days)

venue
calligraphy museum of
seoul arts center, seoul, korea

hosted by
ministry of culture, sports
and tourism

organizers
korea craft & design foundation
korean society of typography
seoul arts center

endorsement
ICOGRADA

main sponsor by
NAVER

sponsor by
601 Bisang
ahn graphics
workroom
S/O Project
hong design
FRUM
Haingraph Ltd.
I&I
Sandoll Communication Inc.
The-d Co.,Ltd
Yoon Design Inc.
The Japan Foundation, Seoul

organizing committee
ahn.sang-soo.,chair
choi.jeong-sim.
hara.kenya.
katsui.mitsuo.
lee.dong-kook.
wang.min.
wang.xu.
won.you-hong.

curating director
lee.byung-joo.

steering commitee
han.chang-ho.
jun.mi-yeon.
kim.doo-sup.
kim.hyun-mee.
kim.sang-do.
kymn.kyung-sun.
min.byung-geol.
niijima.minoru.
suh.seung-youn.

secretary of steering committee
ahn.mano.
choi.won-hyuk.
chung.bo-ra.
huang.lliling.
jung.jae-hoon.
kim.byung-jo.
kim.eun-young.
kim.hyunkyung.
kim.jiwon.
kim.na-youn.
ku.ja-eun.
lee.so-yun.
lee.youngmi.
noh.eun-you.
park.chan-shin.
seo.min-kyung.
song.you-min.

assistant
choi.min-su.
choi.yoon-ho.
hwang.myung-hwan.
hwang.ah-sun.
jang.eun-hyang.
jang.yoon-jung.
jin.min-sun.
jung.je-il.
kim.eun-ju.
kim.yoo-hwan.
lee.ji-yoon.
li.zhe.
lim.nu-ree.
lin.xing-hui.
moon.sang-eun.
noh.min-ji.
oshima.ayako.
sakabe.hitomi.
seo.young-mi.
yoo.ri-wang.

homepage
ahn.mano.
kim.jun.
lee.kwangsik.
shin.sooyeon.

exhibit graphic
chun.jun-hyuck.
jung.jae-hoon.
kim.jin.
kim.sung-hoon.
lee.ji-hyun.

photograph
lm.hakhyun.
kim.jun.

TYPOJANCHI 2011 secretariat
5f haeyoung bldg.,
53 yulgong-ro,
jongno-gu, seoul, korea
t. +82.2.398.7935
f. +82.2.398.7999
e. typojanchi@kcdf.kr

http://www.typojanchi.org

TYPOJANCHI
타이포잔치
International Typography Biennale
2011 SEOUL

타이포잔치 2011: 서울 국제 타이포그라피 비엔날레 전시 크레딧

전시명
타이포잔치 2011:
서울 국제 타이포그래피
비엔날레

주제
동아시아의 불꽃
東亞火花

기간
2011년 8월 30일 -
2011년 9월 14일
(16일간)

장소
예술의전당
서예박물관

주최
문화체육관광부

주관
한국공예·디자인문화진흥원
한국타이포그라피학회
예술의전당

공인
ICOGRADA

후원
NAVER

협찬
601 비상
안그라픽스
워크룸
에스오프로젝트
홍디자인
(주)프럼
(주)해인기획
(주)아이앤드아이
(주)산돌커뮤니케이션
(주)더디
(주)윤디자인연구소
일본국제교류기금 서울문화센터

조직위원
안상수.安尙秀.,조직위원장
최정심.崔庭心.
이동국.李東蓂.
원유홍.元裕洪.
왕쉬.王序.
왕민.王敏.
하라,켄야.原研,哉.
카쓰이,미쓰오.勝井三雄.

총감독
이병주.李炳周.

추진위원
김경선.金京瑄.
김두섭.金枓燮.
김상도.金相道.
김현미.金賢美.
니이지마.미노루.新島実.
민병걸.閔炳杰.
서승연.徐承延.
전미연.全美娟.
한창호.韓昌豪.

간사
구자은.具滋恩.
김나연.金那燕.
김병조.金炳助.
김은영.金恩英.
김지원.金志원.
김현경.金賢京.
노은유.盧恩裕.
박찬신.朴燦信.
서민경.徐敏璟.
송유민.宋侑珉.
안마노.安마노.
이소연.李素姸.
이영미.李榮美.
정보라.鄭普羅.
정재훈.鄭宰勳.
최원혁.崔元赫.
황리링.黃俐玲.

보조간사
김유환.金留煥.
김은주.金恩紬.
김인엽.金仁燁.
노민지.盧珉智.
문상은.文相恩.
사카베.히토미.坂部仁美.
서영미.徐英美.
오오시마,아야코.大嶋彩子.
유리왕.柳利旺.
이지윤.李智允.
이철.李哲.
임누리.任누리.
임성회.林星恵.
장윤정.張允禎.
장은향.張恩香.
정제일.丁第一.
진만선.陳珉仙.
최민수.崔旻水.
최윤호.崔潤豪.
황명환.黃明晥.
황아선.黃牙宣.

홈페이지
김준.金俊.
신수연.辛受姸.
안마노.安마노.
이광식.李光植.

전시 그래픽
김성훈.金城薰.
김진.金珍.
이지현.李智賢.
정재훈.鄭宰勳.
천준혁.千埈赫.

사진
김준.金俊.
임학현.朴榮勳.

타이포잔치 2011 사무국
서울시 종로구 율곡로 53
해영회관 5층
t. +82.2.398.7935
f. +82.2.398.7999
e. typojanchi@kcdf.kr

http://www.typojanchi.org

서포터즈

(전시, 이벤트)

강려화.姜麗花.
강주연.姜周延.
곽민선.郭旼宣.
권서윤.權瑞潤.
권수지.權秀智.
권지연.權志娟.
김경환.金景煥.
김미연.金美然.
김민경.金玟炅.
김민진.金民珍.
김소망.金素望.
김수정.金隨貞.
김승태.金昇泰.
김웅호.金雄豪.
김유환.金留煥.
김은주.金恩紬.
김인엽.金仁燁.
김인우.金仁遇.
김주현.金周賢.
김지완.金知完.
김지현.金志泫.
김현희.金賢姬.
김호정.金灝靜.
노금희.魯今囍.
노성경.盧聖慶.
문상은.文相恩.
문소슬.文소슬.
문충실.文忠實.
문혜지.文惠智.
박민수.朴珉秀.
박선정.朴宣淨.
박준형.朴俊炯.
박해민.朴海旻.
박희지.朴姬枳.
배현경.裵玹卿.
송민근.宋旼根.
송민우.宋民愚.
심지현.沈智賢.
안민지.安敏智.
오혜림.嗚惠林.
용현식.龍泫植.
유리왕.柳利旺.
윤민수.尹敏洙.
윤샘.尹샘.

이다빈.李多彬.
이동현.李東炫.
이소희.李韶姬.
이슬.李瑟.
이영.李呤.
이예진.李叡珍.
이은정.李恩禎.
이은종.李垠鐘.
이일주.李一柱.
이지윤.李智允.
이청.李靖.
이혜경.李惠景.
임누리.任누리.
임덕환.林德桓.
임재형.林載亨.
장보영.張寶榮.
장세진.張世珍.
장윤정.張允禎.
장은향.張恩香.
정제일.丁一.
정주연.鄭朱淵.
조은해.曺恩楷.
조진구.趙辰九.
진민선.陳珉仙.
진진.金金.
채승원.蔡昇元.
최민수.崔旻水.
최민아.崔玟雅.
최윤찬.崔允燦.
최윤호.崔潤豪.
최은진.崔銀眞.
최인영.崔仁永.
홍수지.洪受志.
황기성.黃起成.
황리나.黃俐娜.
황명환.黃明晥.
황아선.黃牙宣.
황효연.黃孝淵.

(홍보)

박준형.朴俊炯.
박진유.朴辰裕.
신보경.申寶景.
양유진.梁裕珍.
이다영.李多玲.
임슬기.林슬기.
정영옥.鄭永鈺.
주다엉.朱多英.
최민아.崔玟雅.
최우리.崔우리.
최지원.崔智媛.

(설치)

고슬기.高슬기.
공정빈.孔晶斌.
권건희.權虔輝.
김건웅.金健雄.
김민기.金民基.
김부연.金敷淵.
김선구.金善九.
김소미.金笑美.
김희수.金喜秀.
류호열.柳浩烈.
박민지.朴旻智.
방원영.方元映.
백승돈.白昇暾.
변우석.卞宇錫.
서윤경.徐允敬.
설주환.薛朱桓.
송민근.宋旼根.
송승아.宋昇芽.
오민정.嗚珉政.
유두호.柳斗浩.
윤성주.尹盛柱.
윤재훈.尹載訓.
이성우.李聖宇.
이영채.李玲彩.
이정기.李情耆.
최성우.崔成宇.
최평국.崔平國.

TYPOJANCHI
International Typography Biennale
2011 SEOUL

TYPOJANCHI
타이포잔치
International Typography Biennale

2011 SEOUL

KB082447